Modern Art

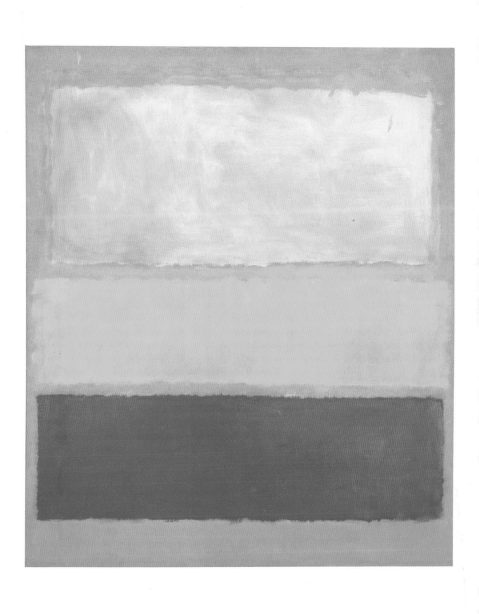

Modern Art

With Essays by
Dietmar Elger, Anne Ganteführer-Trier, Karin H. Grimme,
Barbara Hess, Hans Werner Holzwarth,
Klaus Honnef, Cathrin Klingsöhr-Leroy, Sylvia Martin,
Daniel Marzona, Kerstin Stremmel, Norbert Wolf

TASCHEN
Bibliotheca Universalis

Contents

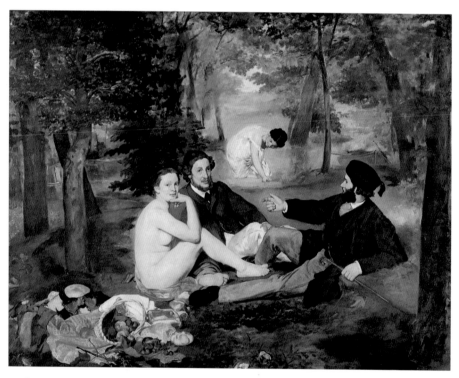

Édouard Manet
Le Déjeuner sur l'herbe
1863, oil on canvas,
208 x 264 cm (82 x 104 in.)
Musée d'Orsay, Paris

Preface

To be modern means to be innovative, forward-looking: modern technology, modern society – and Modern Art. Modernism began in the 18th century with industrialisation and the French Revolution and brought fundamental change to all areas of society, causing a break with old traditions. It established itself as an explicit model of thought in the 19th century, and from that time on, the fighters in the vanguard, be it in science or the arts, had a new task: to be a motor, an avant-garde, often misunderstood by their contemporaries. They made history by dividing the normal run of things into a "before" and an "after".

Modern Art also followed this pattern, feeding off artists and groups of artists who did not follow common ideals or seasonal fashions, but who instead time and again consciously sought out new and uncomfortable territory, questioning and expanding the boundaries of artistic media – from painting and sculpture to installation and purely conceptual art – opening up new ideas as to what art could be. None of these avant-garde movements were homogeneous: each had its own time, place and concerns and emerged from a concurrence of strong artistic characters with their own personal styles and iconographies. For that reason, on closer inspection one sees that an individual work of art in fact also seems to defy the styles of its own time – and here exactly the constant drive for innovation in Modern Art is most clearly demonstrated in the work itself.

The year 1863 is often given as marking the beginning of modernism in art. That is when Manet painted *Le Déjeuner sur l'herbe* and *Olympia*, two pictures that soon caused legendary scandals. But what was so scandalous about these paintings that today are considered such classical works of art? In spite of the harbingers of Impressionism in *Le Déjeuner sur l'herbe*, they do not stylistically overtax the beholder. Certainly, the naked woman among the men in evening dress displayed an obviously profane carnality, but Manet's colleagues were not that prudish. Instead, his pictures were a deliberate challenge to the cut and dried rules governing the way art was created at the time, which among other things stipulated that female nudes should be elevated spiritually through their allegorical or classical context. In contrast, Manet subordinated the then prevalent code of painting to his individual creativity.

Émile Zola, whose writings on the exhibitions in the Paris Salon repeatedly emphasised Manet's central role in the Modern Art of their time, was of the same opinion as the painter: "I have the deepest admiration for individual works, which are created in one fell swoop by a unique and powerful hand. This is not about what is pleasing and what unpleasant; it is

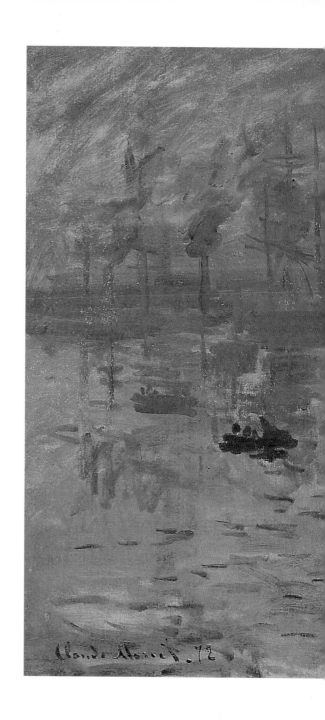

Claude Monet
Impression – Sunrise
1872, oil on canvas,
48 x 63 cm (19 x 24¾ in.)
Musée Marmottan, Paris

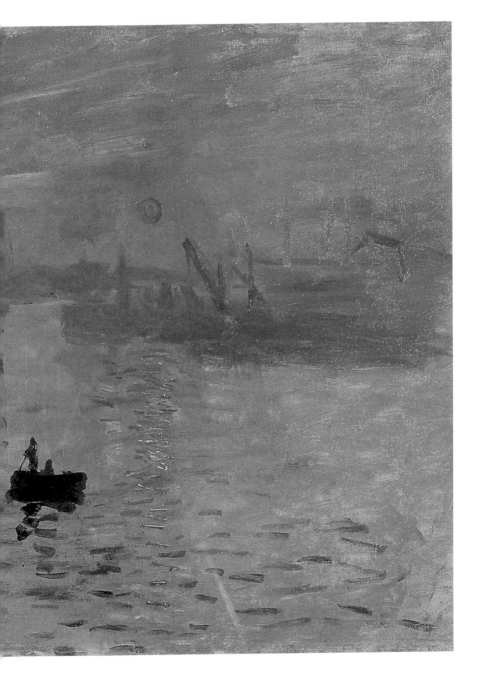

about being oneself, displaying an undisguised heart and energetically expressing a strong personality."

A few years later, with the advent of Impressionism around 1870, a whole movement of artists emerged who, almost as a matter of course, no longer stuck to the prevailing rules, who had not necessarily come up through the Academy and for whom individual expression was more important than any models of idealisation. Parallel to this, the second avant-garde current of the late 19th century, Symbolism, was carrying the spiritual and classical references in official painting to new extremes, setting the individual imagination above all artificiality. Whereas Impressionism and its offshoots provided the formal iconographic framework for the modernist concept of an artistic avant-garde, Symbolism provided the appropriate attitude to life, challenging bourgeois views and maintaining an almost aristocratic decadence in conspiratorial fraternities even under conditions of personal poverty.

More or less all the subsequent avant-garde movements driving the development of so-called classical modern art in the first half of the 20th century alternated between these two poles. Cubism in Paris, Futurism in Italy and Expressionism in Germany – the story of modernism at the beginning of the 20th century seems almost to be the story of the competition among artists to come up with the most radical formal innovations. The race to create the first completely abstract work of art culminated early in the second decade (befitting the mood of the times: the race between Amundsen and Scott to be the first to reach the South Pole for example took place in the winter of 1912). The artists really saw it as a race, and Wassily Kandinsky, for instance, would predate his first abstract watercolour by three years to 1910, in order to be historical first. The conscious and deliberate exploration of new territory that was a precondition for being an artist had now become a fundamental characteristic of art itself.

Abstract Expressionism in the period after the Second World War can be considered the last epoch of classical modernism with its concept of the artist as some sort of heroic innovator. With the advent of Pop Art in the 1960s, the image of the artist began to crumble and everyday life became more important than creative genius. In the Minimal Art that followed, reduction seemed carried to a point where individual artistic decisions hardly played a role any more. Then, around 1970, Conceptual Art ultimately rendered the work of art itself redundant. One can see this final development of art without artefact as a turning point with the same significance that Kazimir Malevich's *Black Square* had in 1915. Now everything became possible again: on the

one hand, figurative painting was constantly be-
ing reborn, while on the other, artists expressed
themselves in the most widely differing media
and were painters, sculptors, video artists,
writers, producers and much more, all in one.
The key figure for this later group was Andy
Warhol, in whose work industrial production re-
placed a belief in progress. To that extent, he was
already part of Post-Modernism, where avant-
garde movements have abdicated their position
and art is understood as a function of life.

And yet, despite this paradigm shift, one
thing remains unchanged: artists are still totally
committed to uniqueness. The same restless-
ness, the same urge constantly to break new
ground also exists in Post-Modernism. And
because of that, art at the turn of the millennium
seems more heterogeneous and more alive than
ever; we might not have any terms left to name
the many individual developments but, in its his-
torical awareness, the artistic spirit remains in-
debted to that of the pioneer: "I'm aligned with
many people in history, especially those who
were interested in expanding the parameters of
art," is the way Jeff Koons puts it. The once op-
posing poles of tradition and innovation have
combined to create an artistic strategy in which
modernism has lost none of its explosiveness.

Hans Werner Holzwarth

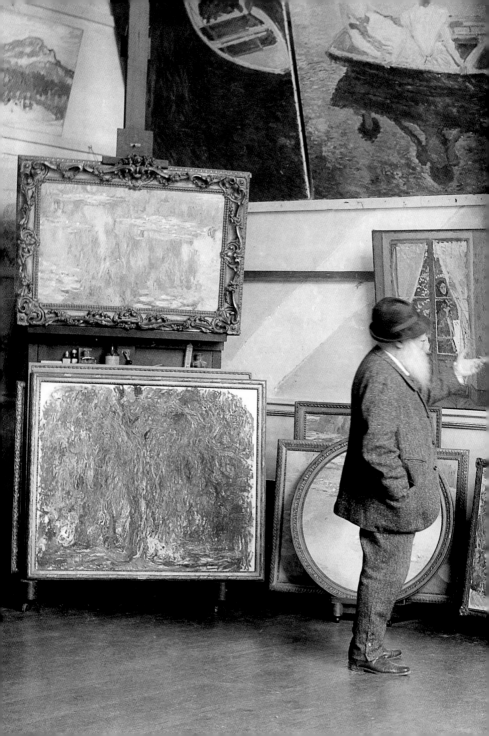

**Impressionism –
From Édouard Manet
to Paul Cézanne**

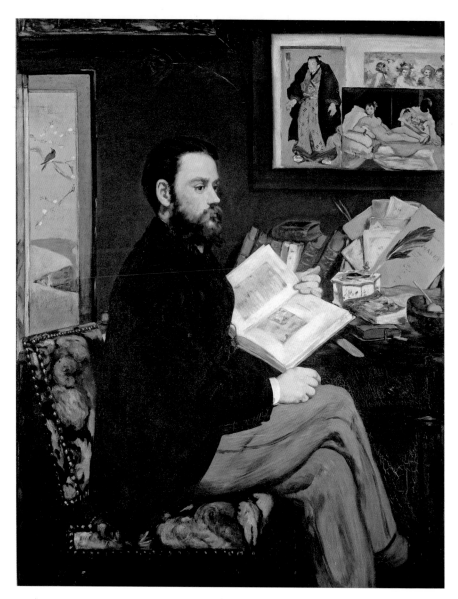

Édouard Manet
Émile Zola
1867–1868, oil on canvas,
146.5 x 114 cm (57¾ x 45 in.)
Musée d'Orsay, Paris

Pages 14–15
Claude Monet in his first
studio at Giverny
ca 1913, showing
The Picnic (1865) to a visitor

Pictures Created from Light and Colour

Karin H. Grimme

On the Banks of the Seine

Shortly before his death in 1927, Claude Monet, one of the best-known Impressionist painters, wrote in a letter: "I always hated theories… My only merit is to have painted directly from nature and to have tried to reproduce my impressions of the most fleeting moods; I am deeply depressed to have been the cause of a name that was applied to a group, most of whose members were not Impressionists." And indeed, there is no general theory of Impressionism and no general agreement as to who was, or was not, an Impressionist. Pierre-Auguste Renoir, too, said of his art: "I have neither rules nor methods. Anyone can come and look at what I use, or watch me painting – they'll see that I have no secrets."

The demarcation of Impressionism from other currents in art is not any clearer than the waters of the Seine which reflect the light in all directions. This was a motif that the French Impressionist painters at the end of the 19th century depicted time and again. And just as the light is reflected by the surface of the water, no less strong was the effect of a small group of painters who jointly exhibited their works between 1874 and 1886 on their immediate environment and the art world as a whole. They influenced not only other artists worldwide, but showed the bourgeois society of their age a new, modern way of painting and of seeing. In so doing, they excited so much uproar that they were regarded as revolutionaries and were largely excluded from the traditional art community of the academies. The Impressionists formed an opposition to the conservative art world and became a role model for all subsequent avant-gardes. The term Impressionism was applied to a whole current of art that started in France in the 1860s, although, as Monet said, most of the painters thus labelled were not Impressionists. Monet regretted the fact that it was the title of his picture *Impression – Sunrise*, shown at their first joint exhibition in 1874, that provided the label in the first place. Apropos this title: the French art critic Louis Leroy wrote very disparagingly of an "exhibition by the Impressionists": "Oh, it was a strenuous day when, in the company of the landscape painter Joseph Vincent, a…recipient of medals and awards from various governments, I ventured into the first exhibition on the Boulevard des Capucines… He thought he would find, as one does everywhere, good and bad painting – more bad than good – but not crimes of this nature…against the great masters and against form." The exhibition-going public were incidentally no less dismissive than some of the critics. The artists who had taken part in the exhibition soon adopted the negatively intended description for themselves, for the "impression" was a central aspect of their art, and not just the title of one of the pictures on display at this first exhibition.

Pierre-Auguste Renoir
Alfred Sisley and His Wife
1868, oil on canvas,
105 x 75 cm (41¼ x 29½ in.)
Wallraf-Richartz-Museum, Cologne

"Perfection Rests on What They Share in Common"

… thus the painter Eugène Boudin on the Impressionists as a group. He even thought: "Without the others, none would have achieved the perfection which they did achieve." The individual artists would not have been in any position to resist the power of the Academy, nor their massive rejection by art collectors, art dealers and the public at large. But their solidarity and consistency gave them the strength to survive and eventually overcome the lack of interest shown by the art market. The special thing about the Impressionist movement is that the artists who comprised the group were bound by ties of friendship. Claude Monet, Pierre-Auguste Renoir, Edgar Degas, Alfred Sisley and Camille Pissarro worked and lived together, they suffered jointly during the years that their art was ignored and joined forces to organise their own exhibitions and thus combat their constant exclusion from the annual exhibitions held by the French Academy of Art. For they were profoundly convinced that their pictures were worth exhibiting.

In 1867 Frédéric Bazille reported to his parents of his friends' plan to organise a special exhibition: "I'm sending nothing to the hanging committee anymore. It is just too ridiculous…to be exposed to their moods… Besides me, a dozen talented young people are of this opinion. We have therefore decided to hire a large studio every year in which we can exhibit as many works as we want." They were unable to implement the exhibition plan, as they could not get enough money together. Years later, they had another try. At the end of December 1873, Monet, Renoir, Sisley, Degas, Pissarro, Berthe Morisot, Édouard Béliard, Ludovic Lepic, Leopold Levert, Henri Rouart and Armand Guillaumin formed the "Société anonyme des artistes, peintres, sculpteures, graveures etc."

This company provided the organisational framework for the eight exhibitions which were held between 1874 and 1886. It was laid down that each of the artists should share in the costs, and that ten percent of the proceeds of any sale would be paid into the joint kitty. The hanging of the pictures was to be decided by lot in order to avoid any dispute. The photographer Nadar placed his studio, which he had cleared out because he was about to move, at their disposal free of charge. The rooms were on the second floor of a building on the Boulevard des Capucines.

On 15 April 1874 they were ready to open their doors to the public with 165 paintings on display. Edmond Renoir, Pierre-Auguste's brother, compiled the catalogue. The exhibition ran for four weeks and was not exactly overrun with visitors: a total of some 3,500 came to see the unusual works of the young artists. This was an insignificant number compared with the official Salon,

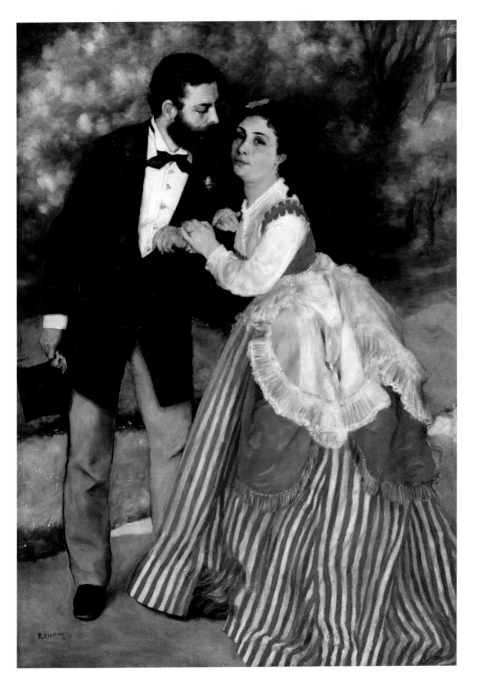

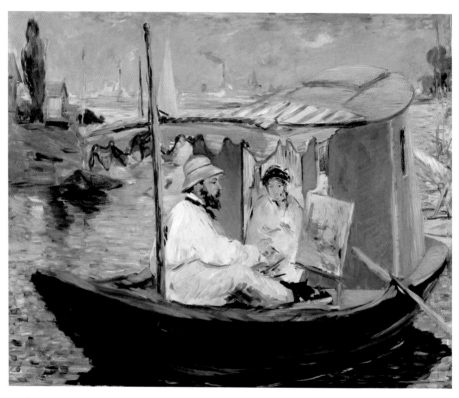

Édouard Manet
Monet Painting on His Studio Boat
1874, oil on canvas,
82.5 x 100.5 cm (32½ x 39¼ in.)
Neue Pinakothek, Munich

which was visited by some 400,000 people. By 1886, a total of 55 artists had taken part in the Impressionists' exhibitions. Thirty were involved in the first show in 1874, but already by the time the second was held in 1876, this number had approximately halved. The founding members of the company had, to start with, successfully persuaded other painters of the advantages of a self-organised exhibition. Later, the friends concentrated on a smaller number of artists.

For all the differences between the individual members of the group, and in spite of the fact that it dissolved in the late 1880s, the Impressionists remained in close touch. In 1899, Monet hurried to see the dying Sisley, in order to perform a final duty of friendship. In the years following 1893, Renoir acted as the executor of Gustave Caillebotte's will and attempted to ensure that matters were arranged as his friend had wished. Paul Gauguin said, and it was meant critically, that the Impressionists were "tomorrow's official painters", but this tomorrow still seemed a very long way off. Gauguin himself had turned away from Impressionism in 1895, but stood by his Impressionist roots: "He [Pissarro] has borrowed something from everyone, it is said! Why not? Everyone else has borrowed from him… He was one of my masters, and I do not deny him."

Camille Pissarro was also known by other artists and critics as the "father of Impressionism".

Pissarro's works showed the way for the modern art of the 20th century. He influenced Gauguin and Cézanne no less than they influenced him. In fact with numerous Impressionist pictures, the amazing similarity of painting style, technique and choice of motif is striking. Pissarro himself thought that it was wrong to think that "artists were the sole inventors of their style and they lacked originality when they resembled others."

Apart from the motifs and comparable painting technique, the French Impressionists also shared the same paint dealer, namely Julien Tanguy, known as Père Tanguy, who started off as an itinerant trader before opening a shop in Paris in 1871. Tanguy supported the young artists, who were always in financial difficulty, by accepting their pictures, which most contemporaries regarded as worthless, in exchange for paint and canvases. In this way he was not just a supplier of paints, but also an art collector. Without his support, many a picture could never have been painted. One has only to think how Renoir gathered the paint tubes thrown away by other students, and how Monet and Pissarro scraped off the paint from finished pictures in order to use the canvas a second time.

Camille Pissarro
Hillside of the Hermitage, Pontoise
1873, oil on canvas,
61 x 73 cm (24 x 28¾ in.)
Musée d'Orsay, Paris

Henri de Toulouse-Lautrec
in his studio,
Paris 1894

The Circle of the Impressionists

The appearance of an artistic current like Impressionism was only possible because there were open-minded young artists looking out for ways of doing something new. So who were these young men and women who were to form the core of the Impressionist movement?

Unlike the others, Monet was no longer a beginner, but had already painted alongside Johan Barthold Jongkind and other older artists. To those young artists who were searching for new forms of expression, his acquaintanceships and wide contacts put across the new ideas of the Realists: open-air painting and the endeavour to depict, in as immediate a fashion as possible, what was there in nature before their eyes.

Monet met Camille Pissarro at the Académie Suisse. In the late 1850s, this academy was a well-known institution in Parisian art circles. It was run by Père Suisse, who had long worked as a model in the studios and now gave artists the opportunity, in a large well-lit room, to paint from life without a teacher, without compulsory attendance and without instructions.

Here, Monet stood out from the crowd by dint of his unusual talent; he could draw rapidly and accurately, and capture the essentials. Pissarro was technically less mature, even though he was ten years older than Monet and probably no less ambitious. Pissarro and Monet were bound by the common ideal of open-air painting, and they wanted above all to paint landscapes. They wanted to capture artistically all that they saw, irrespective of whether or not it matched society's norms of beauty. Their strong orientation to the Realist school encouraged them to implement nothing but their personal, subjective visual impressions. It was not for nothing that Camille Corot said to Pissarro: "Since you are an artist, you need no advice other than this: you must study the colour values above all. We do not all see identically: you see green, and I see grey and 'blond'. But that is no reason for you not to work out the colour values, because they are the starting point for everything, however one feels and wishes to express oneself; without them there is no good painting." To reproduce the mutual relationships of the colour values on a finely graduated scale from light to dark according to their own perception – that was the method used by most of the young painters in order to gradually distance themselves from Realism. It was no longer objectivity that was at the centre of their endeavour, but totally subjective perception.

Pissarro had probably already been in contact with the Realist Camille Corot since the late 1850s, since he described himself in the following decade as the latter's pupil. In 1866 Pissarro was mentioned in the press for the first time. The not-yet-famous French writer Émile Zola, then an art

critic, wrote with an ironic undertone: "M. Pissarro is an unknown, who will probably not be talked about... Many thanks, Monsieur, on my journey across the great desert of the Salon I was able to rest for half an hour in front of your landscape. I know that your painting was accepted with some difficulty, my hearty congratulations. Otherwise, be aware that no one likes your picture; they say it is too bald and too black. How the devil can you be so blatantly inept as to paint honestly and study nature so frankly? How can you just depict the winter, a simple stretch of road, a hillside in the background and open fields stretching to the horizon? Nothing for the eye to rest on. An austere, serious style of painting, with an extreme care for truth, an acerbic, strong will. You are very maladroit, Monsieur – you are an artist after my heart." This notice brought Pissarro no customers, and by then he was already married and the father of two children, so he found himself in great financial distress.

Landscape artist and picture-frame maker Eugène Boudin put Monet in touch with Constant Troyon, in whose Paris studio the young artist continued his training after 1859. Troyon in turn introduced Monet to the Realist landscape painters, Corot and Charles-François Daubigny. In 1862 Monet met the Dutch painter Jongkind in Le Havre. Monet himself said later: "From then on he was my real master. I owe the definitive training of my

eye to him." As to the impulses he received from other artists, Monet wrote in a letter to his friend Frédéric Bazille as follows: "You may find a certain reference to Corot, but that has nothing to do with imitation; the motif, and above all the tranquil crepuscular atmosphere are alone to blame for that. I worked on it as conscientiously as possible, without thinking of any particular painter."

Monet, Bazille and Renoir lived together for a time, they painted together and shared their idealistic faith in modern art. Renoir's father was a tailor and lived a lower-middle-class life with his family. The son, Pierre-Auguste, had consequently to learn a trade while still quite young, and as he displayed a talent for drawing, he became a porcelain painter. He often copied onto plates and cups the masterworks of French 18th-century art. Boucher's *Diana Leaving Her Bath* (1742) was for Renoir the first picture "to really grab me, and I have never ceased to like it." But then the hand painting of porcelain was overtaken by technological developments and Renoir abandoned this job. He had saved some money in order to begin a course at the École des Beaux-Arts.

The group of friends to which Renoir belonged was the one most strongly oriented towards traditional art. Unlike Pissarro, who absolutely refused to visit museums or to study the old masters, Renoir, Monet, Degas and Bazille were among the many copyists who frequented the halls of the

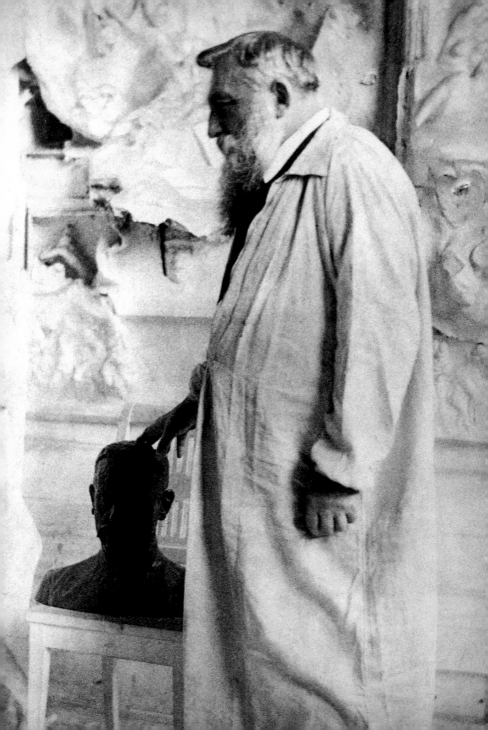

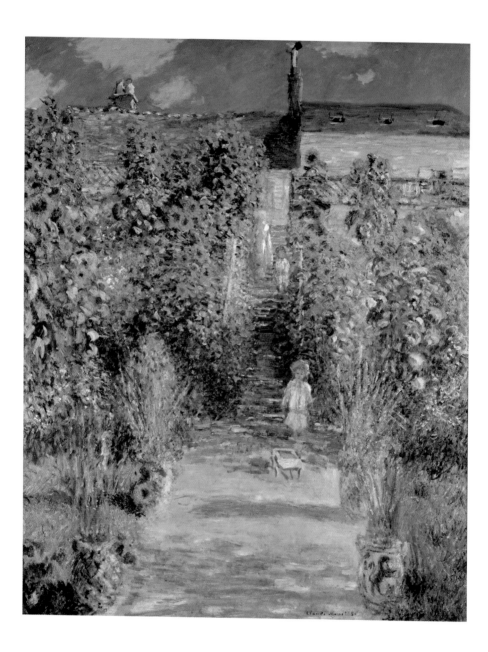

Louvre. The Louvre was of course an appropriate place to meet like-minded artists. These included Berthe Morisot, who copied paintings in the Louvre together with her sister Edma. The hobby which she pursued as "a well-bred girl" had long since become her profession. She sat a number of times for her close friend Édouard Manet, whose brother Eugène she married, and she also features, together with her daughter Julie, in several works painted by Renoir in the 1880s.

In spite of the double burden of being a wife and mother, Morisot took part in all but one of the Impressionist exhibitions. With her more personal motifs, her pale colours and her daring brushwork, she brought a breath of fresh air into the exhibition rooms. And unlike the other Impressionists, who later went their separate ways, Morisot remained an Impressionist always.

Alfred Sisley, born in Paris as the son of an English merchant family, had belonged since the 1860s to the inner circle of friends of Monet, Renoir and Bazille, with whom he often painted together. Renoir has left a loving memorial to him in his *Alfred Sisley and His Wife*, which depicts him with his wife Marie. Claude Monet also portrayed Sisley in his family circle, where he was a frequent guest.

Monet's painting *Dinner at the Sisleys* provides a very private glimpse by a friend into the warmth and intimacy of a family atmosphere.

The Influence of Realism

From today's point of view, Impressionism certainly did not arise from nowhere. On the contrary, it was part of a continuous development from Realism, Naturalism and Neoclassicism. Alongside the various currents in French art, another major influence was Japanese woodcuts, which were on show in Europe for the first time.

Otherwise, the exponents of Realism, Théodore Rousseau, Camille Corot, Johan Barthold Jongkind, Charles-François Daubigny, to name but a selection, had already helped the landscape genre, which hitherto had not counted for very much, to obtain an equitable status. In the relevant works by these artists, we already see the reflecting light which was to play such an important role in Impressionist art. The atmosphere and the colours resulting from this atmosphere were no longer used merely as a means to cast the scenery "in the right light", rather, the light effects took on a certain life of their own, which pointed the way to Impressionism. Corot's painting *Daubigny at Work on His Boat near Auvers-sur-Oise* depicts, with the boat, a motif which the Impressionists were later often to choose. Corot allows the reflected light to float on the water and sketches the trees in the foreground with rapid brushstrokes. The "master of light", as he was known, was doubtless one of the pioneers of Impressionism. Corot's painting shows a fellow

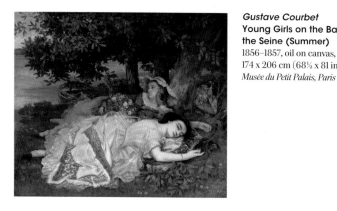

artist working on the water; Claude Monet and the Post-Impressionist Paul Signac were later also to paint in boats.

Édouard Manet, who can only be assigned to the Impressionist circle for a short time, watched Monet doing so. *Monet Painting on His Studio Boat* is one of Manet's most strongly Impressionist paintings. Manet asserted that "the light appeared to him in such unity that a single shade of colour was enough to depict it, and it was better, even if it might come across as coarse, to move abruptly from light to shade than to pile up things that the eye does not see and that not only dulls the power of the eye but also weakens the colouring of the shadows – which are precisely what ought to be emphasised." It was in similar discussions about light and shade that Manet, who stressed the contrast, set himself off clearly from the Impressionists.

Modern Moments
The Impressionist vocabulary includes without a doubt the direct, living "impression" of a moment, which is often reproduced in what seems a chance detail of the total event. These are scenes and figures of modern everyday life as opposed to the depictions from Classical or mythological stories, such as formed the stock-in-trade of traditional art until the end of the 19th century. Workers and prostitutes, passers-by in the street or guests

in the café – the Impressionists were the first to regard such people as artworthy. "I have chosen something from our present age, because I understand it best and it seems to me to be the most alive for the living," wrote Frédéric Bazille.

Edgar Degas described the spectrum of his motifs in a notebook in 1859: "To depict all kinds of utilitarian objects in such a way that one can still see what they were used for, in such a way that one can feel in them the life of the man or woman – a corset for example, that has just been taken off, and still bears the shape of the body… Monuments and houses have never been depicted from close up, as one sees them when walking along the street…" His list of the contemporary things that he wanted to study and paint continued: "Musicians with their various instruments, bakeries from various angles… Smoke: cigarette smoke, smoke from railway engines, chimneys, steamers etc… Dancing-girls of whom one sees nothing but the naked legs, observed in full movement, or having their hair done; countless impressions such as all-night cafés with the various graduated shades of light reflections in the mirrors etc." The locations of modern life were depicted in ways as modern as they were unusual: railways and bridges, streets and parks, stations and cathedrals, opera-house foyers and cafés, the pleasures of bathing, beach life, regattas and horse races. Life in the city of Paris, the

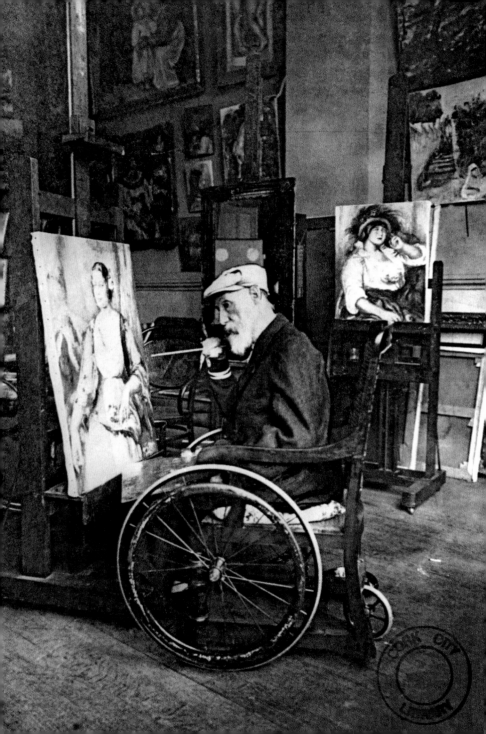

anonymous, big-city passers-by and their leisure and pleasure became the focus of attention. The innovation of the Impressionists lay not just in their choice of motifs, for depictions of cathedrals or cafés were nothing new. What they added was a specific execution and goal: "The joint intentions of the group, which lend it collective strength in the midst of our disunited age, consist not in striving for a polished execution, but in being content with a particular general aspect. Once the impression has been captured, their activity seems to be at an end. If one wished to characterise their intentions in a single word, one would have to create the new term Impressionist. They are Impressionists in the sense that they do not reproduce a landscape, but the impression that it invokes." (Jules-Antoine Castagnary)

In contravention of the existing rules of traditional painting, the works of the Impressionists seemed sketchy, spontaneous and "unfinished", as though they had been done in a few minutes and had not progressed beyond the preliminary stage. The rapid brushstrokes and the abandonment of painterly perfection are deliberate metaphors of the fleeting moment and the speed of everyday life. Speed and dynamism were identical with modernity for 19th-century man. Movement was staged and celebrated via the depiction of ships and railways, horses and dancing-girls. In addition, the movement of the brush in the hand

of the painter remains visible as a brushstroke or spot of paint – spontaneity becomes the hallmark of the painting process. Impressionism unites dynamic movement in the motif and the execution.

Inseparable from the creative concerns of Impressionism is its treatment of colour and light. The fact that shapes, contours and lines played a relatively subordinate role was one of the innovations which many of those who viewed these pictures at the time found incomprehensible, indeed ridiculous. For Monet, colour and light were more important than the motif itself. What comes across as "normal" for today's beholder – corresponding as it does to today's visual habits – was in the 19th century tantamount to an unheard-of sensation, a revolution in seeing.

Even in Pierre-Auguste Renoir's most sensual nudes, it was primarily about perception as far as the artist was concerned: "I look at a naked body and see innumerable tiny colour shades. I have to find those that bring the flesh to life and vibrancy on my canvas." Just how unfamiliar and disturbing this manner of seeing was is made clear by the reaction of the art critic Albert Wolff, who, in an article for Le Figaro on the second Impressionist exhibition in 1876, interpreted the colourful sunspots on the skin of a female nude by Renoir as "rotten meat".

The great importance of colouration in Impressionist art went hand-in-hand with a growing

Medardo Rosso
Aetas Aurea (The Golden Age)
1884–1885, wax over plaster,
height 41.9 cm (16½ in.)
Fine Arts Museums of San Francisco,
Legion of Honor and de Young
Museums

colourfulness in the world outside art. From the beginning of the 19th century, various chemical and technical advances had led to an enormous growth in the availability of dye stuffs. The market had been flooded with synthetic dyes like mauve (since 1856) and alizarin red (since 1868) which were more permanent than natural dyes. Textiles and clothing became more colourful, and, thanks to mass production, they also became cheaper and consequently more affordable to a broad public. One visitor to the first Impressionist exhibition in 1874 expressed the view, more or less jokingly, that the artists must have loaded a pistol with a number of tubes of paint and fired them at the canvas, leaving only the signature to be added.

The Impressionists very much preferred working in the open air, and a further development in paint technology also encouraged this: in 1841, paints were supplied for the first time in metal tubes with replaceable caps. The laborious fiddling around with powdery pigments that could be blown away by every breath of wind was no longer necessary, nor did the pigment any longer have to be stirred.

After Impressionism

At the eighth and last Impressionist exhibition, which opened on 15 May 1886, few of the original artists were represented. Instead, two new talents, who further developed the Impressionist painting technique, turned up in the list of artists on display for the first time: Georges Seurat and Paul Signac. Edgar Degas called the young Seurat "the notary" on account of his invariably correct attire, complete with top hat, the way he always arrived home punctually for dinner with his family and his world of ideas, which was systematic and scientific. Seurat occupied himself intensively with optical phenomena and laws and developed contemporary colour theories to the extent of creating the Pointillist technique. His starting point was the colour circle worked out by the chemist Michel Eugène Chevreul, who had influenced all the Impressionists.

Pointillist painting technique involved applying the paint to the canvas in little dots in such a way that a diaphanous, shimmering synthesis arises from the interplay of different colours. This so-called Divisionist style was the basis of the Post- or Neo-impressionist school, to which, alongside Seurat and Signac for a time also belonged Camille Pissarro. Seurat set up a series of rules, the first of which was: "Art is harmony." The painting *The Bathers at Asnières* (1883, p. 51) was the first work in which he applied the scheme he had developed. The great importance of Impressionism for the future development of art was clearly recognised by Vincent van Gogh, who only came to Paris in 1886: "What the Impressionists achieved by way of colour will be further

increased; but many forget that they are directly linked with the past…" When van Gogh visited Paris and his brother Theo, he still had no proper idea of Impressionism and arrived just in time to see the last Impressionist exhibition. For van Gogh, Impressionism was no more than a transitional phase in the search for a style of his own. It was in his relationship to reality that he himself saw one important difference between him and the Impressionists: "For instead of depicting exactly what I see in front of me, I use colour in a more individual way in order to express myself very intensely." In his use of colours, van Gogh came close in particular to Claude Monet, whom he profoundly admired. "Oh, to paint figures the way Claude Monet paints landscapes! That's something I still have to do, in spite of everything…"

The works which van Gogh painted in Paris show his approach to colour under the influence of Impressionism. Monet valued van Gogh's work, telling Theo that he thought his paintings the best in the Indépendants exhibition held in Paris in 1890. Camille Pissarro was the most open to van Gogh's influence and introduced him to Dr Gachet in Auvers, who hoped to deal with his psychological problems. It was here that Vincent van Gogh took his own life in July 1890. Pissarro said of him: "This man would either go mad, or leave us all far behind. I had not reckoned on him doing both."

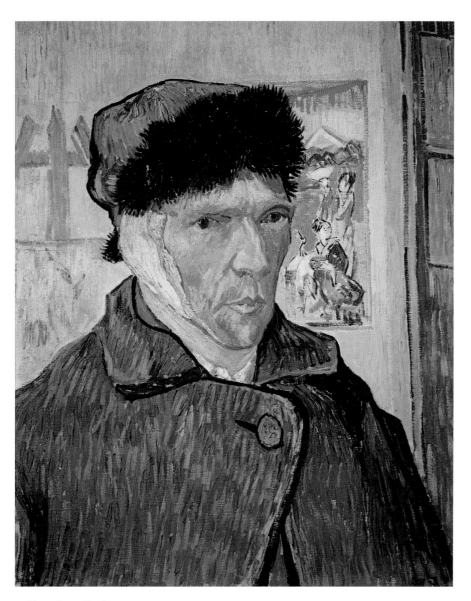

Vincent van Gogh
Self-portrait with Bandaged Ear
1889, oil on canvas,
60 x 49 cm (23½ x 19¼ in.)
The Courtauld Institute Galleries, London

Gustave Caillebotte

b. 1848 in Paris, France
d. 1894 in Petit-Gennevilliers

Gustave Caillebotte joined the Impressionist circle in the early 1870s. He had begun to paint under the influence of Monet and his friends. At first self-taught, he then enrolled at the École des Beaux-Arts. Unlike the rest of the Impressionists, Caillebotte had substantial independent means. He could afford to support his friends by buying their pictures. The collection which he built up in this way he bequeathed to the French state on condition that a large part of it should be publicly exhibited. When he died in 1894, Renoir, his executor, had great difficulty in actually executing the will, because those in charge of cultural policy found it inconceivable to display in a museum the works of an Impressionist which the public still largely rejected. Renoir was able to transfer only parts of the collection to state ownership, including *The Floorstrippers*.

Caillebotte here depicts working men going about their business. *The Floor-strippers* can be seen in the context of similar works such as Degas' *Women Ironing* (ca 1884), Paul Signac's *The Milliners* (1885–1886) and *Young Woman Washing Dishes* by Camille Pissarro (1882). The Impressionists depicted urban labour alongside the rural tasks which already featured in the works of the Barbizon school of landscape painters. That Caillebotte, a member of the privileged haute bourgeoisie, who himself led a Bohemian lifestyle, should have chosen to depict such a motif, came as a surprise to his contemporaries. And to consider simple workers like these floor-strippers as at all artworthy, especially on a large canvas, was at the time a provocative innovation. *The Floor-strippers* was for this reason rejected by the hanging committee at the Salon, and Caillebotte did not, as planned, take part in the official Academy exhibition, but in the second Impressionist exhibition of 1876.

The light entering the room through the balcony door in the background produces a magnificent contre-jour effect. The light is reflected off the backs and arms of the workmen, which appear shiny as a result. The strips of remaining dark varnish on the floor glisten in the light, while the already stripped floorboards come across by contrast as matt, whether they are illuminated from the door or in the shadow of the workmen's bodies. The rhythm of the workmen seems to accord with the rhythm of the floor. The two at the front perform an identical movement and are further linked to each other by their heads, inclined in mutual conversation. Their workmate, who is further back, is cropped by the edge of the picture, thus emphasising the snapshot nature of the depiction. His back is aligned with the horizontal line of the wood panelling and seems to be bent beneath some confining surface. These are rhythmic movement studies, comparable to Edgar Degas' ballerinas and racehorses.

(K. G.)

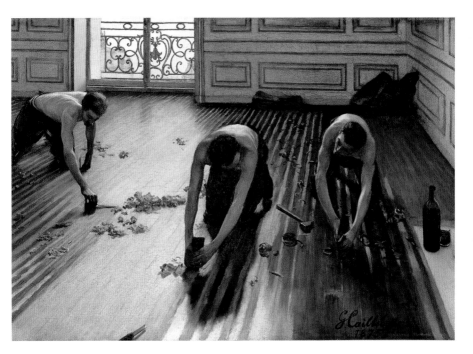

The Floor-strippers
1875, oil on canvas,
102 x 146.5 cm (40¼ x 57¾ in.)
Musée d'Orsay, Paris

Edgar Degas

b. 1834 in Paris, France
d. 1917 in Paris

Absinthe
1876, oil on canvas,
92 x 68 cm (36¼ x 26¾ in.)
Musée d'Orsay, Paris

In 1876, when it was exhibited at the second Impressionist exhibition in Paris and the following winter in London, this picture bore the more harmless-sounding title *In a Café*. Edgar Degas depicts a woman and a man sitting next to each other, the woman with a glass of absinthe in front of her on the table, while the man, dressed in clothes that have seen better days, is holding a pipe. Among contemporary British art critics, the name *Absinthe* for this picture quickly caught on, obviously under the influence of a novel by Émile Zola. A well-known model, Ellen Andrée, who often worked for the Impressionist artists, and the engraver Marcellin Desboutin were the sitters here. They are depicted in the Café de la Nouvelle Athènes, a meeting-place for friends in the Impressionist circle.

Degas also depicted Desboutin as a pipe-smoker in an identical pose in a lithograph. Another painting executed the same year shows him together with their mutual friend Ludovic Lepic. A year earlier, Édouard Manet had completed a portrait of Desboutin. Manet's work *The Artist* (1875) shows Desboutin once again with a crushed hat pushed boldly to one side. The open white collar with a cravat loosely tied in a bow is a hallmark of all the pictures. It is only in these details that Degas keeps to Manet's original, but

he turns this motif and composition into something quite different, because he does not centre the picture on Desboutin, who is placed right on the right-hand side of the picture, so much so, in fact, that he is cropped by the edge of the painting. The woman too, demoted in the same way to a marginal position, appears in some way to underline the impression of a spontaneous, immediate snapshot. The hurried brush strokes hinting to a certain extent at clothing create the impression of a sketch.

The composition is determined by the oblique lines of the table edges and the chair back, between which the figures come across as captives. This emphatically asymmetric arrangement was inspired by Japanese woodcuts, which Degas admired. The artist makes bright light fall mercilessly and frontally on the wretchedness of the two figures, the dark shadows of their heads in the mirror seeming only to double their woe. On the table next to the woman Degas has placed a little Impressionist still life: an empty bottle on a silver tray.

The absinthe-drinking woman has become a metaphor for the dark side of the modern age. She stands for loneliness and helplessness, the anonymity and harshness of modern city life.

(K. G.)

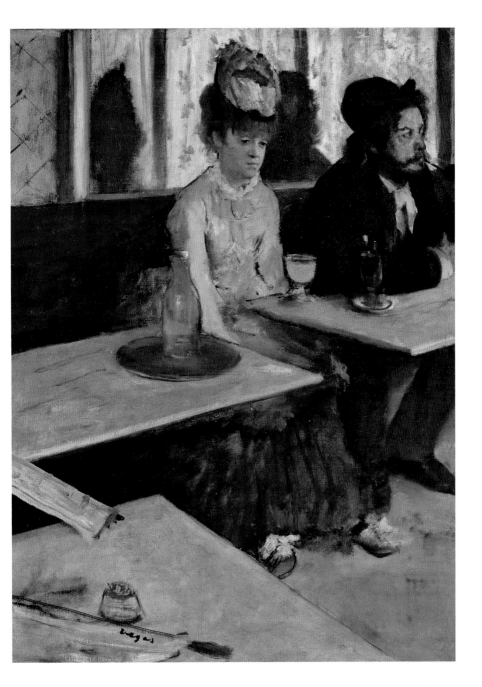

Claude Monet

b. 1840 in Paris, France
d. 1926 in Giverny

"This year Monet has exhibited magnificent interior views of stations. In them one can hear the hissing of the arriving trains, one sees the steam pouring out and being stirred up in the spacious train shed. This is painting's place today… Just as their fathers discovered the poetry of the woods and rivers, our artists today must discover the poetry of railway stations."

Thus Émile Zola, the great French writer and friend of the Impressionists, wrote enthusiastically of the seven station motifs that Claude Monet displayed at the third Impressionist exhibition in 1877. Of the total of 250 paintings exhibited, very few were sold. During these decades, the railway station and the railway as such had become the symbol of speed and mobility, indeed of modern life. Édouard Manet, Gustave Caillebotte and many other artists devoted themselves to this motif. In about two months Monet painted twelve views of the Gare Saint-Lazare and the neighbouring bridge, the Pont de l'Europe. He himself lived with his family very close to the bridge and the station in the Rue Moncey. The hoped-for artistic recognition was some time in coming, and Monet found himself in financial difficulty. His friend Renoir wrote in relation to this period: "Monet stood above all the changes and chances of life. He put on his best clothes, arranged the lace of his cuffs, and, casually swinging his cane with the gold pommel, handed over his visiting card to the director of the Western Railway line at the Gare Saint-Lazare. The official at the door stiffened,

and led him in immediately. The lofty personage asked the visitor to take a seat, whereupon the latter introduced himself with great simplicity: 'I am the painter Claude Monet.'"

Monet was interested above all in the light effects produced by the steam and smoke. That's why he depicted the locomotives going up and down in the train shed and under the Pont de l'Europe. In this way he produced his own poetic image of modernity. The fact that it was a staged picture did not bother him overmuch. Monet's station pictures are neither authentic, spontaneous impressions nor exclusively open-air painting. His works are the result of precise observation and construction, and not at all as snapshot-like as they appear.

Numerous preliminary sketches for the paintings of the Gare Saint-Lazare and the Pont de l'Europe have been preserved, and they show how considered and unspontaneous the paintings were. Monet's painting Le Pont de l'Europe lives from the tense contrast between the austere geometric form of the stone and iron bridge, and the moving smoke and steam dissolving in the hazy sky. The locomotive pushing into the painting brings a targeted movement from left to right and thus crosses the diagonal formed by the bridge and the ensuing canyon of the street. The crossing area is additionally emphasised by the two pillars of the bridge. Monet's art of composition is particularly apparent here.

(K. G.)

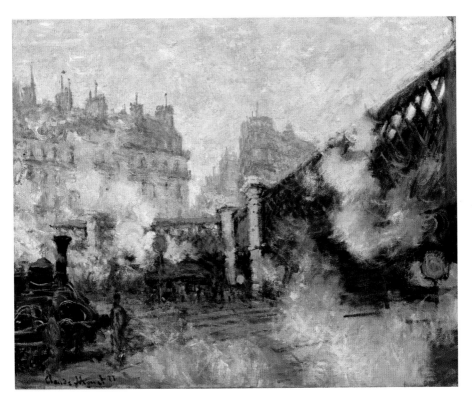

Le Pont de l'Europe
1877, oil on canvas,
64 x 80 cm (25¼ x 31½ in.)
Musée Marmottan, Paris

Mary Cassatt

b. 1844 in Allegheny City (today Pittsburgh), USA
d. 1926 in Château de Beaufresne, France

Woman with a Pearl Necklace in a Loge
1879, oil on canvas,
81.3 x 59.7 cm (32 x 23½ in.)
Philadelphia Museum of Art

As a foreigner in Paris Mary Cassatt had relatively good career prospects. Many American women artists reported that Paris offered them more opportunities than they had back home, where bourgeois conventions still held considerable sway.

Mary Cassatt arrived in the French capital to continue her artistic training in 1865. From 1868 she was regularly represented at the exhibitions of the Salon, and was the only American woman represented at a number of the exhibitions of the Impressionists. The painting *Woman with a Pearl Necklace in a Loge* was first shown at the fourth Impressionist exhibition, where a whole room was filled by Mary Cassatt with subjects from the world of the theatre and the opera. This picture was one of the few to find a buyer at the exhibition, being sold to the French collector Alexis Rouart.

Her introduction to the circle of Impressionist painters was largely due to Edgar Degas, who had become her friend and mentor. Like Degas and Renoir, Mary Cassatt painted the major theatres and the Paris Opéra as centres of modern culture and modern life. With their evening glitz and colourful audiences, these places provided numerous motifs.

In her theatre pictures, Cassatt devoted less attention than Degas to what was happening on the stage or in the orchestra pit; she was more interested in the women in the audience. These ladies thus became objects of dual attention: first, from fellow theatregoers, and then from behold-ers of the pictures. The theme of the theatre as such receded as a result into the background, forming no more than an appealing setting for the mise-en-scène of the female visitor.

Exhibiting her physical charms, be it on a walk in the park or in the audience at the theatre, was an expected part of a woman's behaviour in the late 19th century. Mary Cassatt's theatregoers seem perfectly aware of this. The fans in their hands, which could if need be provide shelter from prying eyes, remain closed. Hence the woman in the pearl necklace is obviously being observed by the audience in the background of the picture. She, though, is looking not at the stage, but at the seats in the box which are reflected in the mirror behind her. By adding a mirror directly behind the red armchair, Cassatt creates a surprising spatial effect. The elegant curve of the boxes only becomes apparent through the reflection, which also generates the strangely two-dimensional spatial effect. The radiance of the chandelier not only illuminates the lady with the pearl necklace from the front, but thanks to the reflection produces a backlight at the same time. It lights up her bare white shoulders and her glove too, with which she is holding the fan in her right hand. The whole painting comes across as being steeped in a reddish-gold light, and can be seen as one of Mary Cassatt's most harmonious colour compositions.

(K. G.)

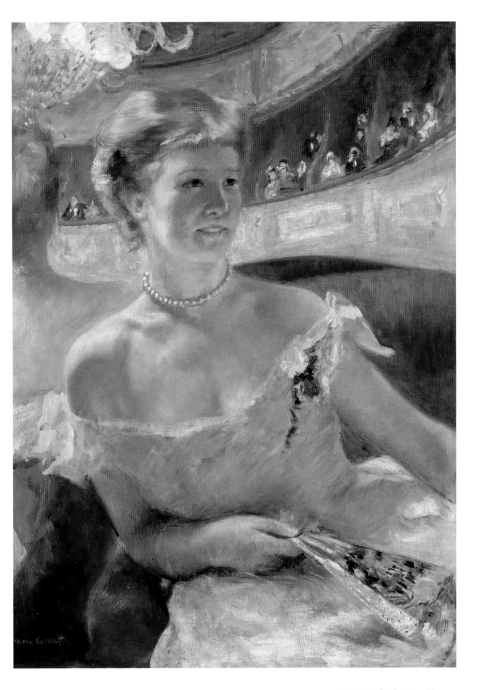

Pierre-Auguste Renoir

b. 1841 in Limoges, France
d. 1919 in Cagnes-sur-Mer

The Seine at Asnières
1879, oil on canvas,
71 x 92 cm (28 x 36¼ in.)
The National Gallery, London

Pierre-Auguste Renoir had as a young man been apprenticed as a porcelain painter, and was consequently highly familiar with the use of soft round brushes and applications of transparent paint. He then moved on to painting fans, onto which, for example, he copied the early-18th-century motif of *The Embarkation for Cythera* by Antoine Watteau. Then he accepted a number of commissions to decorate Parisian cafés. "I chose as my motif Venus rising from the waters. I can assure you that I was not sparing with my Veronese green or cobalt blue... I decorated some 20 cafés in Paris... Even today I would like to paint decorations like Boucher, transform whole walls into an Olympia..."

And indeed, with the best will in the world, it is impossible to overlook the decorative aspect in Renoir's pictures: sunny, luminous harmonies full of a lust for life, one long "Sunday".

Renoir does not appear to have been sparing with paints in *The Seine at Asnières* either. His palette however consisted of just seven intensive colour pigments: cobalt blue, viridian (a dark green with a large blue component), chrome yellow, lemon yellow, chrome orange, vermilion and a transparent red gloss. White was also abundantly used for the numerous dabs all over the picture. Black is however absent from this particular painting, as are the earth colours such as brown, sienna, ochre and the like.

The Seine at Asnières is one of a group of related motifs to which Renoir devoted himself in Chatou on the Seine in 1879–1880. Compositionally, the picture is similar to Monet's *The Bridge at Argenteuil*, which had been executed five years earlier. Both artists placed a bridge on the right-hand side of the picture, in both cases with a train passing over it, against the background of a riverbank with a house. But while Monet depicted a specific place, Renoir was concerned with the general depiction of a Sunday atmosphere: two elegant young ladies are having themselves boated down the Seine on a bright Sunday. Renoir structured the brilliant "mosaic" of the water using a number of different painting techniques. The rapid application of liquid paint on a wet surface alternates with more viscous, almost dry paint on a dry surface. At the point where the boat intersects with the surface of the water, we see little white specks of foam. They consist of dabs of thick paint, loosely applied to the canvas. Seemingly random structures like these demonstrate the specific technique of Impressionism.

The contrast of the complementary colours which Renoir chose for *The Seine at Asnières* is what determines the whole picture. The combination of orange and blue follows Michel Eugène Chevreul's colour theory dating from 1839, according to which these colours, when juxtaposed, intensify each other. In Chevreul's colour circle, orange and blue are diametrically opposite, precisely those colours, in other words, which Renoir chose here. By exploiting the contrasting effects and using exclusively pure, unmixed colours, the artist obtained a unique, radiant light.

(K. G.)

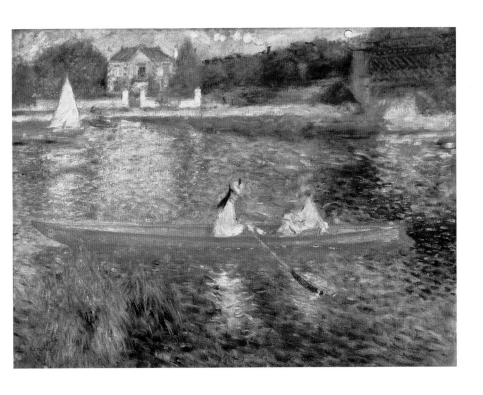

"For me a picture must always be something lovable,
pleasurable and pretty, yes, something pretty.
There are enough unpleasant things in the world;
we do not have to produce any more."
— **Pierre-Auguste Renoir**

Alfred Sisley

b. 1839 in Paris, France
d. 1899 in Moret-sur-Loing

In many of Alfred Sisley's landscapes, water is the central subject. For *The Path to the Old Ferry*, he painted a ferry across the river, a village on the riverbank, a path running down to the bank and little human figures as accessories, all motifs he had already used in earlier works and with added activities in *Regatta in Molesey near Hampton Court*.

Not only are the colours stronger, Sisley's brush-strokes too have become more powerful, and the application of paint is no longer quite so transparent as in the 1870s. As his composition line, Sisley once again uses a path, which here runs inwards from the bottom left-hand corner and creates the necessary depth. At the same time, the artist directs the eye of the beholder to the rectangular red patch in the centre of the picture, which is on the opposite riverbank. This red patch in the midst of green surroundings is particularly striking, as Sisley here makes use of the complementary colour pair of red and green. Immediately below this red roof, for that is what it is, we see a group of people standing waiting on the near bank. Thus the beholder anticipates visually the movement that the waiting people still have ahead of them, namely being ferried to the far bank. In this clever fashion, Sisley succeeds in integrating the beholder into the picture, and above all into the movement.

The picture is given, in addition, expected tension by the crossing of two divergent directions of movement. The river, which follows a calm horizontal line from right to left, is painted with horizontal brushstrokes. This is crossed by the ferry and the gaze of the beholder into the depth of the landscape. The resistance of the water to the ferry becomes positively palpable.

Sisley himself wrote of movement in the landscape: "Apart from the motif itself, the chief interest in landscape painting is in life and movement. The animation of the canvas is one of the hardest problems in painting. Everything must contribute: the form, the colour, the execution... The artist's impression is the life-giving factor, and only this impression can free that of the spectator. Though the artist must remain master of his craft, the surface, at times raised to the highest pitch of loveliness, should transmit to the beholder the sensation which possessed the artist."

Sisley thought the artist should leave out superfluous details and that thus "the spectator should be led along the road that the artist indicates to him, and from the first be made to notice what the artist has felt." In the painting *The Path to the Old Ferry* and in many others of his works, the fascinating thing is the crossing of the water, be it on the ferry, over the bridge or with the eye.

"Every picture shows a spot with which the artist has fallen in love..." Sisley felt finding this particular spot to be extremely stimulating when looking at a work of art.

(K. G.)

The Path to the Old Ferry
1880, oil on canvas,
50 x 65 cm (19¾ x 25½ in.)
The National Gallery, London

Camille Pissarro

b. 1830 in Charlotte-Amalie, Danish Antilles
d. 1903 in Paris, France

Camille Pissarro had been painting market scenes such as we see in *The Pork Butcher* since 1881. *The Pork Butcher* is accompanied by *Potato Market in Pontoise* (1882) and *Poultry Market in Gisors* (1889). All these paintings depict numbers of people trading, chatting, debating, tasting, buying and selling. Pissarro reported on his work in July 1883: "I have not worked much outside this season, the weather was inclement, and I am pursued by the thought of painting particular figure-pictures with whose conception I am struggling. I make a kind of little cartoon, and when I've thought the thing through properly, I set to work. Nini [Pissarro's niece] sat for me as the 'charcutière' in the wind on the Place du Grand Martroy, and I hope it exudes a certain juiciness. The problem is the background. We'll see."

The composition was, then, well thought through, and Pissarro shows himself, in humorous fashion, concerned to express a commonality between the goods and the woman selling them. Both the person and the ham she's selling should exhibit a "certain juiciness". The harmonisation of colour in red and white shades, in any case, right down to the butcher's clothes, is successful. With the hustle and bustle of the market scenes Pissarro returned to a theme which had already occupied him at the outset of his artistic career.

Camille Pissarro was born on the island of St Thomas in what was then the Danish Antilles and now forms part of the United States Virgin Islands. The Jewish Pissarro family came from southern France to the capital of the Danish Antilles to engage in the flourishing trade between Europe, South America and the United States. Camille worked in his father's business for some years, and consequently had first-hand experience of commercial life. He had been an enthusiastic draughtsman since his youth, and his first motifs were vibrant markets and the market-women calling their wares.

His birthplace, his Jewish ancestry and the experiences of his youth all meant that Pissarro lived in opposition to the spirit of the age and refused to bow to social or artistic conventions. His capacity for prolonged resistance to social pressure and to organise a group of artists to hold joint exhibitions made him the core of the Impressionist movement. His background also contributed to his political attitude. Pissarro considered himself "an anarchist through and through". His depictions of peasant life have, then, nothing to do with any purported socialist ideals. Pissarro was not a precursor of Socialist Realism. Maybe it was only logical that in the 1880s, when the Impressionist movement entered a crisis, he should return to the motifs of his youth and thus to the wellspring of his strength. The artistic views of his Impressionist friends were becoming gradually incompatible and the joint exhibitions came to an end in 1886. What Pissarro wrote about this can be understood as his motto: "As far as I'm concerned, I will stick by my right to pursue my path freely."

(K. G.)

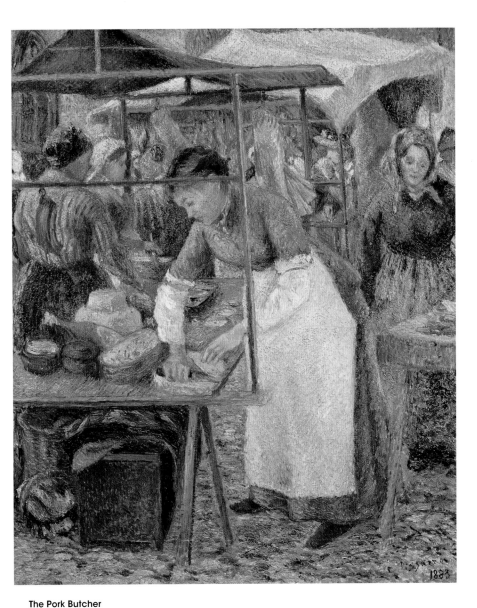

The Pork Butcher
1883, oil on canvas,
65.1 x 54.3 cm (25¾ x 21½ in.)
The National Gallery, London,
loan from the Tate Gallery

Auguste Rodin

b. 1840 in Paris, France
d. 1917 in Meudon

The Kiss
1888–1889, marble,
181.5 x 112.3 x 117 cm (71½ x 44¼ x 46½ in.)
Musée Rodin, Paris

Auguste Rodin's *The Kiss* has become a cliché; reproduced endlessly, on book covers and post-cards, in kitsch plaster replicas, it has largely lost its original meaning. Set in its biographical and historical contexts, however, it can be seen as a superbly accomplished expression of Rodin's belief in the power and importance of the erotic, and as a work that marks the transition to the modern age.

Obsessed by the body – young and old, healthy and decrepit, posed and intimately casual – Rodin spent his entire career exploring the potential of the nude. He came to prominence in the 1870s with the *Age of Bronze*, a life-sized figure of a male nude that was so finely observed, so convincingly full of life, that he was accused of simply taking a cast of a model. Made famous by the controversy, and easily disproving the accusation, he began receiving a wide range of important public com-missions. By the end of the century he would be the best-known sculptor in the world.

One of these commissions was for the orna-mental doors for a proposed school of design. Rodin took his subjects from Dante's *Inferno*, and though he worked on the project for the rest of his life it was never completed. He did, however, develop a number of the motifs in larger works, including *The Kiss*. This represents the adulterous lovers Paolo and Francesca, who were condemned eternally to the Second Circle of Hell, reserved for those who sinned through lust. When Dante sees them he is overcome by "sorrow and pity", and over the centuries the fate of Paolo and Francesca, key archetypes of ill-fated romantic lovers whose passion leads to sin and damnation, attracted many artists, writers and musicians, particularly 19th-century Romantics.

Rodin's treatment, however, differs from typi-cal depictions: there is almost no indication of the subject, and no suggestions of intense romantic emotion, of Hell, torment, sin or damnation. It is, rather, an unashamed affirmation of the power of sexual love, depicted with little of the prurient eroticism of those many nudes created largely to titillate the male gaze. Rodin's treatment is re-strained, almost chaste. With a supreme mastery of anatomy and perfectly controlled carving, he employed a classical "decorum" that makes the sexual theme all the more subtly effective.

It is in his bronzes that Rodin's belief in the centrality of the erotic in life and art found more direct and disruptive expression. And not primar-ily through his subjects – though some works proved controversially frank – but through tech-nique. The clay (or plaster) used to model a bronze can vividly record the thoughts, actions and emotions of the sculptor during the various stages of a work's creation, a fact Rodin exploited to the full. The erotic (understood as the creative energy that animates nature, man and art) appears in the way his vigorously modelled flesh can convey sentience, vitality, emotion and desire. So much so that even a fragment – a torso, a hand – became a complete work. (C. M.)

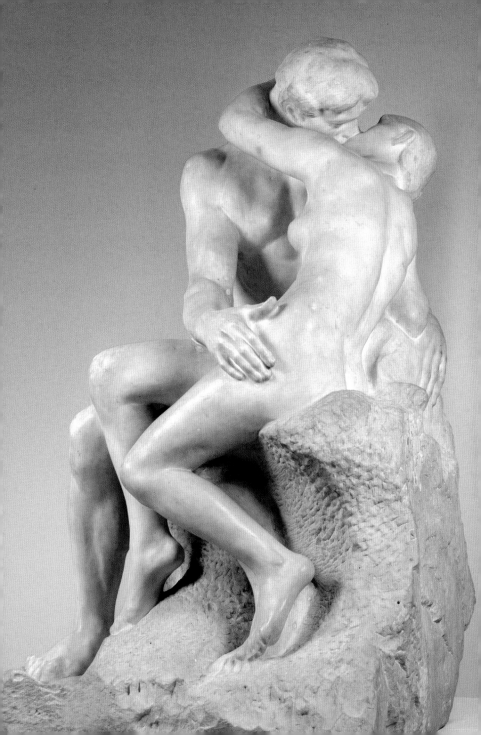

Georges Seurat

b. 1859 in Paris, France
d. 1891 in Paris

With *The Bathers at Asnières* Georges Seurat completed his first example of the synthetic style of Neo-Impressionism. He displayed this eye-catching painting at the Salon des Indépendants in 1884, after it had been rejected by the official Salon. In 1886 the French art dealer Paul Durand-Ruel, who worked closely with the Impressionist artists, took The Bathers to an exhibition in New York. It was the most controversial of all the exhibits.

Seurat was also controversial among his fellow artists. His and Paul Signac's participation in the eighth Impressionist exhibition triggered a heated debate. Finally, Pissarro achieved a decision in favour of the two young artists. In protest, Monet, Renoir, Sisley and Caillebotte withdrew, and the Impressionist group broke up. A series of articles in the press fêted Seurat and Signac as representatives of a new style which made Impressionism obsolete. The two were then given the still-current epithet of Neo-Impressionists.

Seurat addressed his total energy to the intensity of his artistic work. His oeuvre in the space of about twelve years comprised just four large paintings, alongside a number of smaller pictures, draughts and oil sketches. His working method differed substantially from that of the Impressionists. He painted a great deal in the studio and not in the open air and in a fashion not spontaneous and immediate, but systematic and considered.

For *The Bathers at Asnières* a number of individual studies were done on the island of Grande Jatte; these grew together to create the total composition. The study *Horses by the River* makes it clear how Seurat worked. He followed Corot's maxim of first indicating the strongest colours, and then proceeding systematically to the palest. Accordingly, Seurat first marked the darkest shades, and then the lightest. The brown and white horses, with which he experimented in this way for a long time, ultimately failed to make an appearance on the finished painting *The Bathers at Asnières*.

The execution of the painting then followed exclusively in the studio, which, given the size of the canvas, was virtually inevitable. The work depicts people on the bank of the river opposite the island of the Grande Jatte. In the background can be seen a factory building and a bridge. A ferry is carrying passengers to the island. Although Seurat conceded the highest priority to the Impressionist criteria of colour and light, he came to a completely different result. Seurat's goal was not the fleeting impression, but the configuration of many moments. Addition was what determined the motif. Not the transitory, but the enduring – that was what he wanted to capture on canvas. Accordingly, Seurat's style has been termed "synthetic". His return to the traditional, academic working method was accompanied by a scientific examination of colour. In the following years, Seurat developed, on the basis of physics, optics and geometry, the Pointillist colour theory, which Camille Pissarro also followed for a time.

(K. G.)

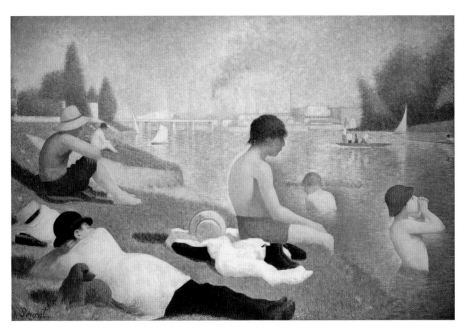

The Bathers at Asnières
1883, oil on canvas,
201 x 300 cm (79¼ x 118 in.)
The National Gallery, London

Paul Cézanne

b. 1839 in Aix-en-Provence, France
d. 1906 in Aix-en-Provence

Paul Cézanne was a revolutionary in art. His modernity lay in the creation of an idiosyncratic new painting style no longer based on illusion but on a painterly architecture that did without perspective, precise detail and narrative content. In the resulting compositions, especially the famous still lifes with apples and the landscapes around Mont Sainte-Victoire, Cézanne produced a new, autonomous pictorial reality, a sort of "spiritualised" view of nature.

One special artistic challenge that Cézanne repeatedly addressed from the 1860s onwards was the depiction of nude figures in the landscape. On the one hand, this was a classical motif that gave artists since the Renaissance the opportunity to depict idealised human bodies in idyllic surroundings. On the other, the subject was linked with the happy boyhood hours Cézanne had spent with his friends Émile Zola and Jean Baptiste Baille by the banks of the river Arc. In the course of a decade, over 140 paintings and sketches on this theme emerged, generally divided into female and male bathers.

As in the group pictures, this individual bather is depicted with a rough, well-nigh ungainly corporeality. His movements, too, appear awkward, conveying a certain archaic monumentality.

As Cézanne was extremely shy of naked models, he frequently recurred to drawings of nudes made at the Académie Suisse during his Paris period, to illustrations of ancient sculptures or to photographs from his sisters' fashion magazines. All in all, he avoided all individual expression or erotic allusion in his male models. What counted for him, was solely the figure's formal traits and its integration into the natural surroundings. Nude figures constituted a kind of prototype to represent Cézanne's personal ideas about naturalness and an ideal life.

As in most of his *Bathers,* blue and an ochre-tinted orange are the two dominant colours. Here, they appear in the upper half of the picture in a lighter form, and below in darker gradations. For Goethe, who concerned himself with the effects of colours, blue was capable of eliciting both disturbance and calm. Yet Cézanne was interested less in the emotional effects of colours than in their role as form-inducing elements. As in the landscapes, the forms alone determine the distribution of coloured planes across the canvas in the *Bathers.* The result is a "harmony in parallel with nature", a unity of man and nature in an ideal image, something Cézanne dreamed of his whole life long. (U. B.-M.)

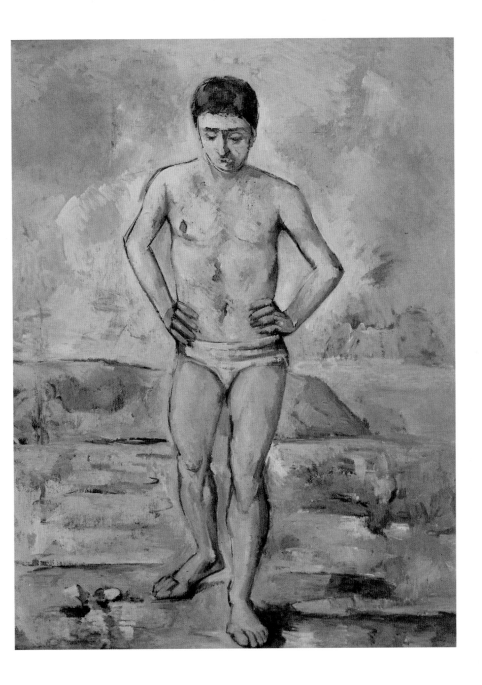

Vincent van Gogh

b. 1853 in Groot-Zundert, Netherlands
d. 1890 in Auvers-sur-Oise, France

Vincent van Gogh painted three different portraits of his paint dealer and friend Julien Tanguy, known to all the Impressionist artists who went in and out of his shop as Père Tanguy. This last version dates from the winter of 1887–1888. Tanguy was an important institution both for the Barbizon artists and for the Impressionists. After all, for impoverished artists he represented the only possibility of obtaining the materials they needed, for he was prepared to take their pictures in payment. In this way he also became the first collector of Cézanne's works. His shop thus became a rendezvous for the painters, and an exhibition room for their pictures, while he himself was a friend and father figure, hence his nickname. "He's a droll, good-hearted fellow, and I often think of him," wrote van Gogh in a letter from Arles to his brother. "Don't forget to give him my regards…and tell him, if he needs pictures for his shopwindow, he can have some from here – in fact, the best." Tanguy thus had a considerable number of van Gogh's most magnificent works in his shop to sell on commission.

During the whole of his artistic activity from 1882 until his suicide in 1890, van Gogh worked with a "sensuous love of materials" and an existential urgency that reflected that of the Impressionists before him. While Cézanne, Seurat and Pissarro slowed down the painting process in the 1880s, van Gogh accelerated it once more, and produced an incredible body of work in just a few years.

"For I only have a lust for life when I work like a wild thing," he had once commented. This fast, spontaneous, immediate way of painting in a certain sense contributes to his work a strongly marked "Impressionist" aspect.

Van Gogh has composed a frontal portrait of the seated Père Tanguy, with his hands folded, a pose that he had seen in portraits by Rembrandt. The wall behind Tanguy is covered in Japanese woodcuts, which van Gogh had acquired cheaply from Siegfried Bing, the specialist for Japanese art in Paris. A depiction of the holy mountain, Mount Fuji, can be seen in two of van Gogh's portraits of Tanguy directly behind the sitter's head. The mountain comes across as a symbolic image of Tanguy's appearance and personality, above all of his dignity and humanity.

The painter Émile Bernard was close friends with both van Gogh and Gauguin. Van Gogh dreamed of a community of artists in his house in Arles. In their portraits of Tanguy, both van Gogh and Bernard used the divisionist method of the Neo-Impressionists. They placed dots or lines in close proximity, and broke up the local colour in any one place into its individual colour components. Both artists placed their sitter in front of a wall and chose the two-dimension pictorial space which they so greatly admired in the Japanese woodcuts. Although Bernard depicts Tanguy from much closer up, van Gogh's portrait is more intense and penetrating. He really has succeeded in making reality more "intensive" through the use of colour.

Van Gogh later wrote to his brother Theo: "When I am old enough, I may become like Père Tanguy. Of course I can know nothing of our personal future. We only know that Impressionism will last." (K. G.)

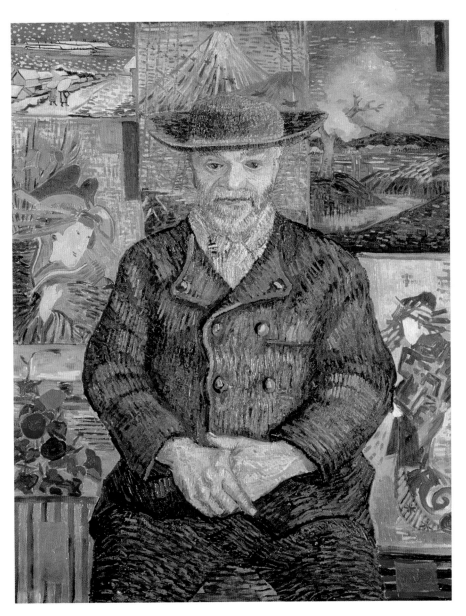

Portrait of Père Tanguy
1887–1888, oil on canvas,
92 x 75 cm (36¼ x 29½ in.)
Musée Rodin, Paris

"The painter of the future is a colourist, as there has never been before. Manet has prepared him, but you know very well that the Impressionists have worked harder with colour than Manet." — **Vincent van Gogh**

Like many other Vincent van Gogh paintings, *Starry Night*, an evocation of the fatefulness of the night-time hours painted from the barred window of a cell in the Saint-Rémy insane asylum, relies on the motif of trees.

Two of the cypresses so typical of the artist – trees symbolic of death – rise vertically like flaming torches parallel to the left edge of the picture. Visible behind them, as if pressed down by the horizontal of a mountain ridge, are the small houses of a village where a few lights are burning. The course of the horizon is interrupted only by a church spire, pointing like a finger towards heaven. Between village and mountains spread olive groves in regular billows.

The main feature of the composition, however, is the night sky, in which the tiny lights in the human dwellings below are amplified to apocalyptic proportions. The flaming rings that appear there no longer have anything in common with the romance of gentle starlight and moonlight. Rather, the violence of the brushstrokes and heavy impasto paint convey an impression of exploding galaxies.

For van Gogh, the night sky was a metaphor for the mysterious universe. As he once admitted to his brother, Theo, he felt a "terrible need for – shall I say the word – religion…then I go outside in the night and paint the stars…"

As in a whirlwind engulfing the entire firmament – sketched in energetic hatchings to corre-spond with the overall surface texture – the nocturnal dark blue is permeated by sinuous bands of light and bright stellar coronas. The composition reaches a grandiose culmination in the motif of the waning moon with halo at the right edge. The American art historian Albert Boime believes that beyond the emotionally expressive quality of the composition, one of van Gogh's most significant works, *Starry Night* contains a substantial statement – an attempt on the artist's part to read his destiny in the stars and render it visible. The darkly agitated yet so luminous night sky, Boime says, can be understood both as an inquiry into the artist's future and as a utopian model of salvation. All of this conforms with what van Gogh admired about the American poet Walt Whitman, who was "someone who sees a world of healthy, sensual love in the future and even in the present, daring and free – a world of friendship, of work under the wide, star-studded firmament – something one can ultimately only call God and Eternity…"

Even though this interpretation may go too far in detail, one thing remains incontestable: the painting's translation of a universal drama into an aesthetic event, a handling of form and colour that conveys the submission of the dark earth under the well-nigh violent dominion of the stars. Apart from the symbolism of this landscape cowering beneath the infinity of the universe, van Gogh's painting rests on empirical facts, by no means denying its basis in nature. (N. W.)

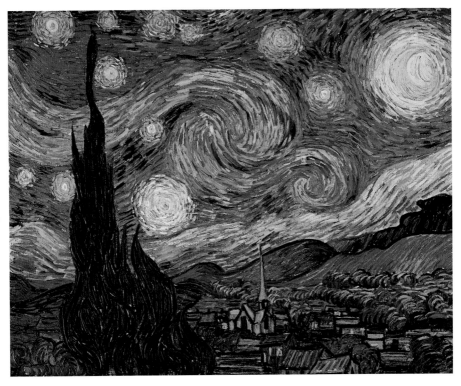

Starry Night
1889, oil on canvas,
73.7 x 92.1 cm (29 x 36¼ in.)
The Museum of Modern Art, New York

Paul Gauguin

b. 1848 in Paris, France
d. 1903 in Atuona, Hiva Oa, Marquesas-Islands

In terms of its content, The *Vision after the Sermon* is one of Paul Gauguin's most ambitious paintings. As its alternative title of *Jacob Wrestling with the Angel* makes clear, it takes up a subject from the Old Testament, namely an episode from the life of the Patriarch Jacob. According to the account in the Book of Genesis, an angel of the Lord appeared to Jacob in the night and wrestled with him until he dislocated Jacob's hip. Even then, Jacob called out: "I will not let you go unless you bless me." Together with this blessing he also received the name Israel, meaning "one who struggles with God".

Following the compositional structure of Japanese woodcuts, a tree trunk divides the pictorial surface diagonally and separates the women in Breton dress in the foreground from the two ornamentalised figures wrestling in the right-hand background, namely the angel with his great wings outspread and the future Patriarch, who is bracing himself against his opponent. Concepts such as "foreground" and "background" become largely meaningless in this painting, however, as the dominant impression is one of a composition organised into flat planes. The dark violet oblique of the trunk (of an apple tree) does not in fact divide phenomena existing in three-dimensional space, but two different spheres of reality: on the one hand the women, their figures simplified in the manner of folk art, who have apparently just come out of church and are reflecting devoutly upon the subject of the sermon, and on the other the metaphysical vision of the subject of that same sermon, namely Jacob and his battle with the angel. This latter takes place against an "unreal" red ground, which may be interpreted as a successor to the gold ground of medieval art. It is the setting for a scene existent only for faith, an event that the women in the picture comprehend as a mental image and the viewers of the painting as a vision.

The dominance of the two-dimensional plane, the suggestive handling of outline, the palette liberated from naturalism and the symbolic expressiveness of pictures such as this also made Gauguin the revered figurehead of the Nabis. With this painting, Gauguin affirmed his conviction that the role of art was not simply to describe nature or recount a literary episode word for word, but rather to seek, with the simplest means, symbolically effective lines and colours so as to lend expression to feelings and passions. The artist thereby becomes a kind of priest or magician who – in the case of the work discussed here – causes a vision to appear before the eyes of people rooted in everyday life. Gauguin's search for primal instinctual forces in rituals linked him very closely with the corresponding wishes of the Symbolists. Indeed, *The Vision after the Sermon* inspired Albert Aurier to write an article, published on 2 March 1891 in the *Mercure de France*, entitled "Le Symbolisme en peinture. Paul Gauguin", in which he elevated Gauguin to the head of the Symbolist movement. The vicar of Pont-Aven, on the other hand, to whom Gauguin originally wished to make a gift of the picture, would not accept it.

(N. W.)

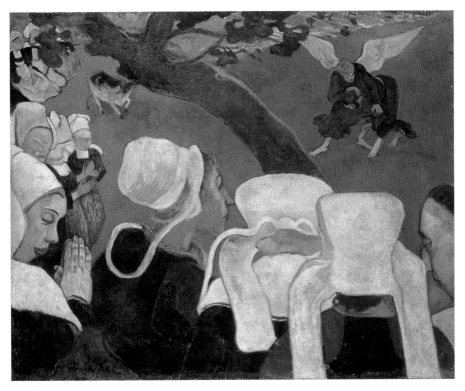

The Vision after the Sermon
1888, oil on canvas,
74.4 x 93.1 cm (29¼ x 36¾ in.)
National Gallery of Scotland, Edinburgh

Henri Rousseau

b. 1844 in Laval, France
d. 1910 in Paris

I-Myself, Portrait-Landscape
1890, oil on canvas,
143 x 110 cm (56¼ x 43¼ in.)
National Gallery, Prague

With *I-Myself*, Henri Rousseau wanted to create not only a self-portrait – he believed he had invented an entirely new genre: the portrait-landscape. Yet anyone who looks for the artist's hidden character traits in this view of Paris is bound to be disappointed. What concerned Rousseau most was to present himself as a significant artist, an ambition reflected in the large format alone. Here, a painter literally lent himself stature.

This was important to Rousseau. It wasn't until he had turned 40 that the amateur painter decided to devote himself to art, and a few more years would pass before he was able to resign his position with the customs department. Being self-taught, Rousseau found himself between two eras. His dream was academic painting, for which he did not possess the skills, but he found recognition – after showing from 1886 onwards at the Salon des Indépendants – among modern artists (Gauguin, for one, went on record as having greatly admired *I-Myself*). Then, by the onset of the 20th century, Rousseau became venerated as a father figure by the young avant-garde, especially Picasso, who in 1908 organised a now-legendary banquet in his honour. Picasso formulated the credo of the new era as follows: "Starting with van Gogh, all of us are in a certain sense self-taught – you might almost say naive painters. Painters no longer live within a tradition, so each of us must create all of his expressive possibilities from scratch." As the self-testimony of a man who did just this, *I-Myself* became a key image for the entire circle around Guillaume Apollinaire. The artist stands larger than life-size in the middle of a riverside street, wearing a beret and holding a palette and paint-loaded brush. For this occasion he seems to have donned his Sunday best, complete with a purple medal on his lapel: the Palmes Académiques, which he was mistakenly awarded in 1905 due to a confusion of names but which he still claimed for himself his whole life long. Rousseau added the medal to the picture at a later point in time; before that he had supplemented the name of his deceased first wife, Clémence, on the palette with that of his second wife, Joséphine. In other words, the picture was always kept up-to-date.

Visible in the background is the harbour of St Nicholas, which would remain Rousseau's workplace for the next three years. Larger than life in the painting, he has already outgrown his regular profession. A ship flying mostly imaginary flags lies at the pier, not only bringing dutiable goods but evoking voyages to unknown lands. The Montgolfière in the sky, along with the Eiffel Tower, represent not only the achievements of the French nation – among which Rousseau quite unironically included his own art – but stand for a yearning for exotic climes. And when we consider the sun behind the reddish clouds on the left, along with its reflection in the water and a forlorn pair of figures seen from the back, we can easily assemble a romantic sunset landscape painting from these thematical parts. Such covert hints about Rousseau's special yearnings likely provide the deepest insight here into the mind of an artist who would paint the first of his imaginary jungle pictures in the following year. (L. E.)

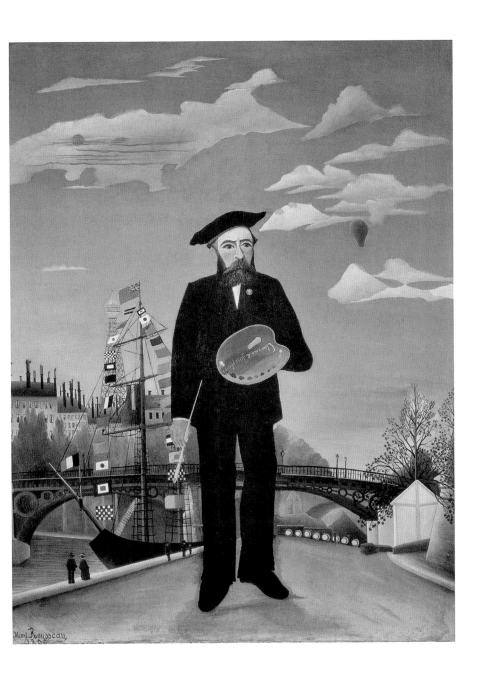

Henri de Toulouse-Lautrec

b. 1864 in Albi, France
d. 1901 in Château de Malromé

La Goulue at the Moulin Rouge
1891–1892, oil on board,
79.4 x 59 cm (31¼ x 23¼ in.)
The Museum of Modern Art, New York

In the early 1890s, the Moulin Rouge nightspot in Paris served Henri de Toulouse-Lautrec as a source of inspiration for numerous masterpieces. On the painting shown here, which dates from 1892, the dancer La Goulue, to whose image with the arabesque-like beehive-style coiffure the artist had already contributed in his first poster the year before, is seen entering the establishment. She is accompanied by her corpulent sister Victorine, and by a considerably younger and prettier girl on the right, with both of whom she is walking arm-in-arm. A bullish-looking man with a top hat in the background, and the reflection of lamps in perspective echelon, together with the diagonal lines of the ceiling, represent the remains of a traditional three-dimensionality inherited from the Renaissance, while otherwise the impression is dominated by a novel flatness.

The three women with their angular silhouettes occupy the foreground of the painting. That they are cropped by the frame, that Victorine even loses her face as a result, brings them nearer to the beholder, as in a film close-up. At the same time this bold cropping technique, this apparent chance snapshot, shows the extent to which Toulouse-Lautrec had been influenced by the Japanese woodblock prints which were then circulating on the Paris art market in their thousands. The diagonal formed by the two companions interrupts the frontality of the dancer herself, who is clothed in a filmy white. On the one hand this singles her out as the star making her entry, as the posing main character, while on the other this view of the décolleté reaching down to the navel, appropriately revealing the "public" woman adored by the Parisian fast set, stages her immodesty as professional shamelessness.

The colouration of the relatively small oil painting is characterised by subdued pastel tones, subtly gradated, and by the absence of any too garish contrasts. In addition, the fact that the paint has been applied in a dotted fashion in many places is a clear hint that Toulouse-Lautrec, like almost no other artist of his time, had removed the boundaries between drawing and painting.

Toulouse-Lautrec is a name that now evokes particular concepts: belle époque, Moulin Rouge, the entertainment district on Montmartre, dancing girls, brothels, whores, wine, absinthe, walls covered in posters. And a name that in addition brings with it the story of a tragic life: following a serious riding accident, the 14-year-old body of Count Henri Raymond de Toulouse-Lautrec-Monfa stopped growing. As any other socially fitting pursuits were now out of the question, the young aristocrat fell back on painting and drawing, and became the registrar of a Parisian society which was addicted to pleasure, and drained already by that addiction behind the scenes.

During the last decade of his life, Toulouse-Lautrec created 351 colour lithographs, which he used for placards. They are among the most significant work that this new medium, situated somewhere between painting and graphic reproduction, has ever brought forth. Like his paintings, especially those in the manner illustrated here, these images have contributed to the evolution of a modernist pictorial language.

(N. W.)

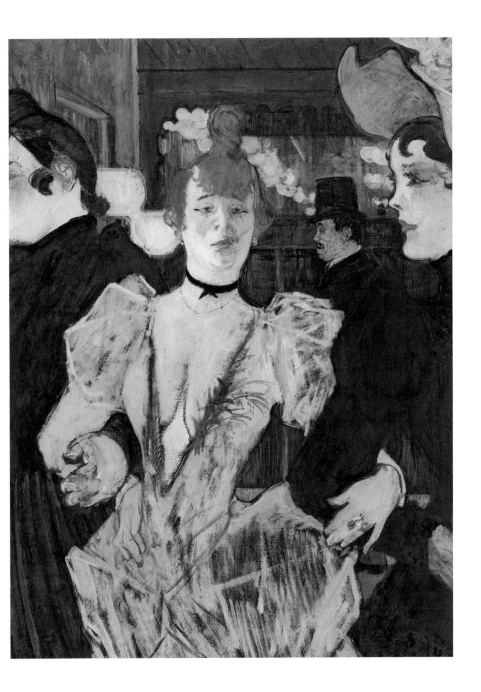

Claude Monet

b. 1840 in Paris, France
d. 1926 in Giverny

Poplars, Three Pink Trees in Autumn
1891, oil on canvas,
92 x 73 cm (36¼ x 28¾ in.)
Philadelphia Museum of Art,
Chester Dale Collection

To symbolise an earthly paradise in landscape – where but in Impressionism has this aim been more convincingly achieved? Landscape is generally viewed as the principal subject of this direction in art.

After the greatest Impressionist, Claude Monet, had completed his series of *Haystacks,* he addressed a further landscape motif – *Poplars*, in a series of paintings based on studies made outdoors. The story of these trees in Limetz has been recorded. They were to be cut down and sold to a lumber dealer. Monet paid a certain sum for the poplars, under the condition that they be left standing until he had finished painting them. *Poplars, Three Pink Trees in Autumn* clearly illustrates the consequences of the subject for Monet's art. On the one hand, it confirms the fact that for this painter, nature was a visual event. This is the typically Impressionist component of the picture. Yet conversely, the verticals of the trunks lend the composition a rhythmically structured solidity that runs counter to the typically Impressionist flickering surface and engenders a covert pictorial

geometry to which a protagonist of geometric abstraction, Piet Mondrian, would later be able to refer. This consolidation appears to spread to the dabs of colour, which on the whole recall the regularity of Pointillism without going so far in colour division.

The Neo-Impressionists or Pointillists would systematise the Impressionist division of colour into increasingly abstract, regular patterns of dots, a kind of screen that lay over and absorbed everything in the picture. This principle is illustrated by *Le Bec du Hoc, Grandcamp* by Georges Seurat.

In his Grandcamp seascapes the grand master of Pointillism took the refinement of brushwork to an extreme, producing a finely patterned paint surface of great homogeneity. It was surely no coincidence that the abstracting tendencies of Pointillism developed largely, if not exclusively, in the subject of landscape, because in the 19th century it was less charged with meaning than other subjects and therefore virtually predestined for formal experiments.

(N. W.)

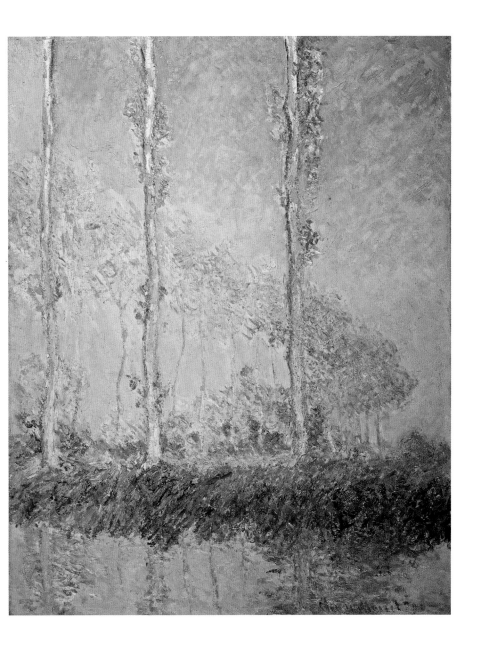

Paul Signac

b. 1863 in Paris, France
d. 1935 in Paris

Capo di Noli
1898, oil on canvas,
91.5 x 73 cm (36 x 28¾ in.)
*Wallraf-Richartz-Museum, Cologne,
Fondation Corboud*

"I began *Capo di Noli*, in which I wanted to obtain extreme polychromy. In order to practise, I used my sample of silk dyes, which are so intense and luminous. I shall transfer them one after the other onto my canvas. I do not want one single centimetre of matt colour to remain and I want to transform every bit of the painting to something extreme. If it gets a little garish, it can always be toned down."

As far as we know, Paul Signac did not tone down the colours, but left them as they were. The painting *Capo di Noli* was seen as the climax of Signac's intoxication with colour.

The Mediterranean surroundings doubtless contributed to the use of such strong colours. Capo di Noli is on the Italian Riviera, which Signac liked to visit from his base in Saint-Tropez, where he lived from 1892 to 1900, exploring the surroundings in his yacht *Olympia*. He also discovered a new colour dimension in nature, which was reflected in his work of this period. The white and red cliffs, the pale violet horizon, the blue shadows with patches of golden sunlight – all bear witness to Signac's attempt to elevate colour to heights of intensity.

After Seurat's death in 1891, which affected him greatly, Signac increasingly sought artistic paths of his own. His statements at this time constantly centred on concepts such as freedom and harmony. "Let us liberate ourselves! Our goal must be to create beautiful harmonies." By this he meant getting away from the idea of painting from nature, such as he had done until then. It now seemed to

him a waste of time to produce an image of nature as precise and faithful as possible. In the years around the turn of the century, he crystallised a personal approach out of Seurat's scientific theory of colours.

In contrast to his earlier works, Signac no longer followed the colour theory determined by the use of two contrasting colours. *Capo di Noli* displays a free and harmonious juxtaposition of a whole variety of colour values, which Signac applied in vertical and horizontal brushstrokes. The cliffs on the left-hand edge of the picture and the vegetation on the right-hand side are reproduced with vertical strokes in accordance with their structure. The path, and the calm, motionless sea have been executed in horizontal brush movements. The sky is painted on the horizon with little dots, and towards the foreground of the picture with diagonal strokes that cross each other. With this structural use of the brush, Signac supports the impressively harmonious composition of the painting. It seems to be an "ideal" view of a timeless, sunny landscape.

In 1894 Signac wrote: "A few years ago, I sought with great effort to prove to others, using scientific experiments, that these blue tones, these yellow colours and these variations on green all existed in nature. Now I am content to say: I paint in this way because this technique seems to me to be the most appropriate way to obtain the most harmonious, the most light-filled and the most colourfully luminous result…and because I like it."

(K. G.)

"The anarchist painter is not the one who will create anarchist pictures, but the one who will fight with all his individuality against official conventions." — **Paul Signac**

André Derain

b. 1880 in Chatou, France
d. 1954 near Garches

In the spring of 1905 André Derain was a young artist aged just 25, whose pictures submitted to the Salon des Indépendants had remained more or less unnoticed. Matisse, ten years his senior, suggested he join him in Collioure, a small fishing port close to the border with Spain. Since May, Matisse had had a studio there, in order to paint well away from the influences of Paris. Derain arrived at the beginning of July, and during this summer, in reciprocal, highly fruitful collaboration, the two were to usher in nothing less than a new era of art.

From morning to night they devoted themselves to painting landscapes from nature, thereby continuing on the Mediterranean a tradition which the Impressionists had started some 30 years earlier on the coast of Normandy. Influenced by the experience of the light of southern France, which permeated everything evenly, "a blonde, golden light, which drives away the shade", their work took a radical new turn, which Derain characterised in a letter to de Vlaminck dated 28 July. He invoked a "new concept of light, which consists in the negation of shadow" and brings forth "a revival of the power of expression".

In addition he emphasises the challenge of overcoming Neo-Impressionism, which the year before Matisse had systematically investigated under the influence of Signac.

While the divisionist theory of Seurat and Signac presupposed the optical fusion of the primary colours and the simultaneous contrast of the complementary colours through brushstrokes corresponding to the size of the picture, Derain and Matisse invented a new way of painting, a mixed technique combining a flat application of paint with dabbed lustre effects on the canvas, whose structure often remains visible. The pictorial composition crystallises directly out of the use of pure colours, whereby the painted canvas, "denying" the shadows and consequently also reducing the depth, regains its original quality of a two-dimensional surface.

In October 1905 the press railed against Hall VII of the Salon d'Automne, where the works of Matisse, Derain (who displayed nine pictures, including six views of Collioure) and their friends were on show. It was described as a "coarse practical joke, the gruesome and naive daubings of a child trying to see what it could do with a paintbox". The critic Louis Vauxcelles spoke of a "wild beasts" (*les fauves*) and thus mockingly christened this new painting style which had been born in Collioure, a style which Derain was to further develop the following summer in L'Estaque. The first art scandal of the century made the Fauves famous at a stroke. In November Ambroise Vollard bought 89 paintings and 80 drawings by Derain. The rumours associated with the *éclat* spread across Europe. The story of art in the 20th century could begin.

In 1929, recounting this decisive period for his oeuvre to Georges Duthuit, Derain summarised as follows: "Fauvism was our baptism of fire... The colours became dynamite charges. They were to discharge light... The great merit of this procedure was to free the picture from all imitative and conventional associations. The Flemish painters staged the landscape within the picture. The Impressionists tried to reproduce light regardless of the picture. And we concentrated on colour from the outset."

(X.-G. N.)

Fishing Boats, Collioure
1905, oil on canvas,
38.2 x 46.3 cm (15 x 18¼ in.)
The Museum of Modern Art, New York,
The Philip L. Goodwin Collection

Henri Matisse

b. 1869 in Le Cateau-Cambrésis, France
d. 1954 in Nice

The Green Stripe (Madame Matisse)
1905, oil on canvas,
40.5 x 32.5 cm (16 x 12¾ in.)
Statens Museum for Kunst, Copenhagen

In 1905, during his stay in Collioure, Henri Matisse suffered a serious crisis, which culminated in a struggle against the "tyranny of divisionism", and finally in a new aesthetic: the Fauvist solution of deploying colour as an autonomous pictorial means. "A Fauvist painting", he wrote later, "is a luminous block made up of the consonance of several colours. They form a possible space for the spirit (as a musical chord does, I believe). The created space might be empty, like an empty room in a flat, but still it exists."

This definition is especially valid for *The Green Stripe (Madame Matisse)*: the greenish-yellow stripe is indeed a "luminous block" in which the light is not caught by the canvas, but radiates from its own structure, the "consonance" of colours. In this respect, the stripe that gives the work its name plays a crucial role beneath the mass of black-edged blue hair: this abstract element of the picture illuminates the face and gives it its plasticity by separating a bright area, the red-outlined pink, from the green-contoured ochre in the semi-darkness. Thus the face resists being absorbed into the background, on which violet, cinnabar, emerald-green and crimson tones are juxtaposed. The composition lives by the tension in the relationships between the large areas of two-dimensional colour.

The provocative aspect of the work lies in the fact that it buries the bourgeois portrait in favour of a decorative icon in the typical Matisse style. He dispenses with the technique of a three-dimensional representation aimed at creating a special expression or physiognomy, as though the face were a psychological object which needed deciphering. Instead, he constructs a picture out of the free play of the colour and the two-dimensional nature of the canvas. Like a Byzantine work of art, the resulting picture exudes presence, and thus creates space, while the mimetic depiction pretends to reproduce a model. "I don't paint a woman," said Matisse, "I paint a picture."

The effect of the picture was to shock most contemporaries. When Sarah Stein showed the work, which she had bought immediately and enthusiastically, to her friends in San Francisco in 1906, they reacted with consternation, and saw in it "an aberration", the "caricature of a portrait", a "crazy picture". When Matisse "paints his wife with a thick green stripe going all the way down her nose," wrote a journalist in 1910, "then he is himself punished for all time, even though it is a surprising depiction for the public; it makes clear that she is presented to be seen from such a strange and frightful point of view."

And yet, just as Picasso was able to say to those who despised his 1906 portrait of Gertrude Stein and accused him of having betrayed the sitter, "She'll look like that one day," the authenticity of Matisse's picture was eventually settled. "When I first saw Madame Matisse," said Pierre Schneider, for example, "I recognised in her precisely the woman who had sat for *The Green Stripe* 45 years earlier."

(X.-G. N.)

Paul Cézanne

b. 1839 in Aix-en-Provence, France
d. 1906 in Aix-en-Provence

**Mount Sainte-Victoire,
view from Lauves**
1904–1906, oil on canvas,
60 x 72 cm (23½ x 28¼ in.)
Kunstmuseum Basel

Paul Cézanne's view of nature always entailed an observation of his own perception – nature and the resulting picture stood in a close, reciprocal relationship with one another. The artist expressed this in his famous definition of art as a harmony in parallel with nature. In his search for a new beginning in the wake of Impressionism, Cézanne had a crucial encounter with a mountain, the Sainte-Victoire in Provence, which, so to speak, became his new home. From the 1880s onwards he devoted about 60 oil paintings, drawings and watercolours to the subject. Eight of these paintings date from Cézanne's final years, after the turn of the century, including the one in the Kunstmuseum Basel, finished in 1904–1906.

If one were to describe the small painting in conventional terms, there would not be much to say. It has an almost continuous horizon line, set at about two-thirds of picture height, and resting on it, as if on a pedestal, the geologically characteristic formation of the Sainte-Victoire mountain, rendered in gradations of dark blue, in contrast to the green flecks covering the sky. Below the horizon extends a wide plain, dominated by the green of vegetation, then a few ochre-coloured houses with red roofs, and the diagonal of a road or path. Despite the free treatment, the topography is clearly identifiable: the landscape is seen from the vantage point of the Plateau d'Entremont, a good kilometre north of Cézanne's studio on the Chemin des Lauves, with the mountain at a distance of about 20 kilometres as the crow flies. It is very much more complicated, however, to analyse the overall impression of the picture, its diverse yet so calm composition, void of framing elements or elements that would draw the eye into the picture. There is no foreground we could imagine walking into, yet nor is there any true distance, for the things in the picture do not grow smaller in accordance with their location in space.

The Sainte-Victoire is a monument of permanence not only as a motif, but also as part of a conception that diverges entirely from Impressionism, one that treats visual data not as signs of permanent change but as the sum of tiny building blocks, an order in which calm, stability and motion are united. The mountain and plain in themselves embody an equilibrium between rising and recumbency, a harmonious interplay of vertical motion with horizontal stasis. The Basel painting is characterised by dark margins around a lighter centre, which in turn grows more shadowy towards the middle. Out of this circling configuration the mountain rises like an individual thing, yet at the same time is integrated in the picture plane, which consists of a texture of dabs, or *taches,* of paint. These dabs are visible even from a normal viewing distance.

As we may gather from the harsh chrome green, bright blue, violet and heavy ocher, the artist is nowhere concerned with an illusion or imitation of nature. Instead, with the type and "artificiality" of his paint application, Cézanne decides in favor of form, sees colour as form. Thus the colour itself ultimately becomes a building block, what Gottfried Boehm describes as "part of that matrix out of which depicted nature takes shape". Nature appears as a model of a universal building plan; order is not simply given but first has to assume form. (N. W.)

"The landscape reflects on itself, humanises itself, thinks itself inside me. I objectify and fix it on my canvas… Maybe I'm talking nonsense, but it seems to me as if I am the subjective consciousness of this landscape, and my canvas its objective consciousness." — **Paul Cézanne**

Symbolism –
From Gustave Moreau
to Gustav Klimt

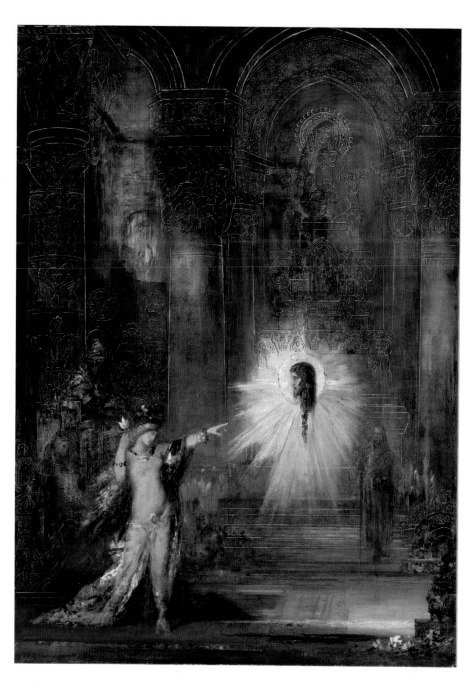

Faced with the Sphinx

Norbert Wolf

Gustave Moreau
The Apparition
ca 1874–1876, oil on canvas,
142 x 103 cm (56 x 40½ in.)
Musée Gustave Moreau, Paris

Pages 74–75
Alphonse Mucha in his studio,
Rue du Val-de-Grâce,
Paris ca 1903

An Extravagant Paradise

In 1884 Paris saw the publication of a cult fin-de-siècle novel, one that would create a sensation little short of perverse in the art scene in France and rapidly, too, in the whole of Europe. Its title: *À rebours* (translated both as *Against the Grain* and *Against Nature*). Its author, Joris-Karl Huysmans, the son of a Dutch painter and a French mother, wrote it as a seductive textbook of decadence, as an antidote to the prevailing naturalism of the day. Fleeing the banality of everyday life, the "hero" Floressas des Esseintes withdraws to his country estate, where he creates an artificial world of art embracing all conceivable forms of aesthetic pleasure and morbid sensory stimuli and wallowing in colours, perfumes and fantasies. Realism remains excluded from the artificial sultriness of this extravagant "paradise".

Des Esseintes, who redesigns his bedroom to look like a monk's cell and has his maidservant dress as a nun, is the last scion of an ancient noble house, sickly and neurotic. (Who can fail to think at this juncture of corresponding tales of horror by the American author Edgar Allan Poe?) He is not a man of action but a voluntary recluse, a hermit for reasons not of faith but rather of taste. For page after page he holds forth on the aesthetic forms of refuge taken by one who has despaired of the trivial world and describes fantastical universes of scents and colours.

Within the sphere of painting, he considers Odilon Redon and Gustave Moreau – two of the chief representatives of Symbolism – the supreme embodiment of aesthetic sophistication. Moreau had already attracted the admiring attention of critics in 1864 with his painting *Oedipus and the Sphinx*. The winged beast, barely the size of a cat and with the face of a pubescent girl, appears less to be sinking its claws into the man's classically handsome body than to be clinging to him in mid-air: the monster has surrendered not to physical aggression but to rapt contemplation of Oedipus's face.

Active deeds were not the stuff of a des Esseintes, and depicting action was evidently not the stuff of Symbolist art. Instead it favoured the meditative, a timelessness that stirred the soul and the symbol cloaked in magnificent surfaces of colour.

The Face of the Unpaintable

If Symbolism found its "bible" in the novel *À rebours*, in 1886 it was also given a manifesto. On 18 September of that year, the editors of the Paris newspaper *Le Figaro* invited the poet Jean Moréas to set out the innovative principles of the literature that was stirring contemporary emotions. He entitled his article "Le Symbolisme". According to Moréas, poets such as Stéphane Mallarmé and Paul Verlaine were no longer concerned with ex-

ternal nature for its own sake, but with the "Idea" concealed within and behind concrete phenomena. The artistic form was used by the Symbolists only as a vehicle through which to reveal the metaphysics and the emotional impact of the Idea. Since the work of those authors whom Moréas called as chief witnesses was governed by morbidity and exaggeration, Symbolism was immediately equated by its contemporaries with Decadence, with the obsessive exploration of the depths of the soul.

Symbolist poetry, music, painting and sculpture claimed no more and no less than to fill an intellectual and spiritual vacuum. Ever since the 16th century and Copernicus, the world, the home of humankind, had no longer been the centre of the cosmos; ever since Darwin's theory of descent, man no longer appeared to be sovereign over a divine Creation designed around him, but a chance product of evolution. Modern psychology, meanwhile, was increasingly negating the idea of man even as master of his own ego self. Art historian Jean Clair consequently sees Symbolism as a last great rescue attempt by Western humanism, whose goal was to transform the cultural crisis that had reached its peak in the belle époque to a culture of crisis.

Against such a background, Symbolist art offered many intellectuals and aesthetes a kind of alternative religion, a spiritually charged cult of beauty that stood in opposition to the prevalent materialism and utilitarianism of the day.

William Butler Yeats, probably the most important English-language lyricist of the fin de siècle, summarised this creed in an essay on the "Symbolism of Painting", published in his *Ideas of Good and Evil* in 1898: "All art that is not mere storytelling, or mere portraiture, is symbolic... If you liberate a person or a landscape from the bonds of motives and their actions, causes and their effects...it will change under your eyes, and become a symbol of an infinite emotion, a perfected emotion, a part of the Divine Essence."

Symbolism is not a style in the strict sense. It is more an "open" intellectual position which deploys the most diverse stylistic means, depending on which seem the best suited to clothing the intended symbolic message in visual form. Or to put it another way: a Symbolist picture, a Symbolist sculpture remains deliberately enigmatic; in place of intellectual understanding, the work demands an empathetic response and wishes the viewer to experience its mysterious profundity in the manner of an inner vision.

Symbolism implies various part tendencies, trends in art that identified with it for a while but then went their own way again, such as the Pre-Raphaelites in England, the Nabis in France and the German mysticism of an Arnold Böcklin or a Max Klinger (who, like artists elsewhere in

Fernand Khnopff
The Sphinx
1896, oil on canvas,
50 x 150 cm (19¾ x 59 in.)
Musées royaux des Beaux-Arts, Brussels

Europe, showed himself strongly influenced by the philosophical writings of Friedrich Nietzsche). It extends to the symbolically charged Jugendstil of the Austrian Gustav Klimt, the existentialist psychology of the Norwegian Edvard Munch, whose pictures incorporated vehemently expressive elements, up to the early works of certain members of the avant-garde, artists whose names today stand for the beginnings of abstraction.

The Historical Janus Face of Symbolism

One might suspect that Symbolist art was in principle the programmatic antithesis of all classical "perfection". In truth, this was only partly the case. There was also much common ground: Classicism, too, wanted to give shape first and foremost to an idea, an ideal that was elevated far above everyday banality. In essence, however, this ideal was to be accessible to the intellect and rooted in nature. It was here that Symbolism and Classicism parted company: the former was profoundly convinced that the deeper meaning underlying existence could ultimately never be penetrated by reason and that it would never be discovered through a surrender to nature. Such a conflict explains why many Symbolists continued to deploy formal elements of Classicism but infused them with a pronouncedly Romantic "obscurity" and a patent ambivalence of meaning. No wonder, therefore, that many of those tracing the genealogy of Symbolism start from artists in whose work Classicism exhibits a heightened state of symbolic intoxication – artists such as Johann Heinrich Füssli, known under his anglicised name as Henry Fuseli, or William Blake. No wonder, it thus also follows, that Symbolism is hard to differentiate from Romanticism, which of course continued to flourish until well into the 19th century. The maxim formulated by the outstanding painter of German Romanticism, namely Caspar David Friedrich – "The painter should not merely paint what he sees before him, but also what he sees within him. Should he see nothing within himself, however, he should also forebear from painting what he sees before him" – could later have served equally well as the motto of Symbolism.

The "modern" spirit, opposed to the materialism of the day, signified not just the mysterious, the melancholic and the occult, but for many Symbolists also the embrace of unbridled libido, the abnormal and the gruesome, of monstrous products of the imagination, of lust and violence, of the shady sides of existence, whose artistic expression was admired, be it in the "black paintings" of Goya, the sadomasochistic tales of the Marquis de Sade, or the horror stories of Edgar Allan Poe.

Symbolism as a Substitute Religion

Art as a spiritual "drug" and a substitute religion, and the abnormal as a poisoned dart aimed at all

that was natural – that was the holy/unholy alliance that explains the primary origins of many of the artistic products of Symbolism. The lean towards the abnormal resulted not least from a consciousness that had settled upon part of European society since the second half of the 19th century, namely a sense of Decadence and a fear – expressed euphemistically in the term fin de siècle – of belonging to a culture that was in the process of decline. Not without reason did the history painting of the day experience an increase in images of the moral decay of Ancient Rome and – thus the intended warning – the resulting fall of the Roman Empire.

On 10 April 1886 the first issue of the periodical *Le Décadent* was published in Paris. Readers were informed that religion, morality and justice were in a state of degeneration. Attendant symptoms included not only the hypersensitivity of exalted taste, infinitely refined luxuries and pleasures, but also neurosis, hysteria, hypnotism, morphinism, academic charlatanism and "Schopenhauer-ism". In England around 1895, too, Decadence had already become the name for a phenomenon, a "fever" that had been caught from France. In Aubrey Beardsley's drawings for the play *Salomé*, written in French by Oscar Wilde, the "sickness" of Symbolism seemed more than clear. This impression was further reinforced when Wilde – poet and supreme dandy – was sentenced to two

years' forced labour for homosexual practices in a highly publicised court case in May 1895.

Decadence mania, which fed on its anti-bourgeois and anti-Naturalistic mood of impending doom like a hummingbird sucking nectar from an orchid, inevitably sailed into the aesthetic waters of Friedrich Nietzsche, who certified that all great art was predicated upon the world of symbols; mention should also be made of the French philosopher Henri Bergson, who equally held so-called objective reality and its rational knowability to be wrong tracks. A decisive contribution to the intellectual mood of the fin de siècle and Symbolism was also made by the thinking of Arthur Schopenhauer, the German philosopher of Romanticism, whose profoundly pessimistic treatise *The World as Will and Representation* of 1819 enjoyed international acclaim as from the 1860s and in particular after 1886 and 1889, when it was published in French translations. "A new truth has recently appeared in literature and art," wrote the novelist and magazine publisher Rémy de Gourmont in his remarks on Schopenhauer in his *Book of Masks* published in 1896. Gourmont summed up the core of Schopenhauer's philosophy thus: "With regard to man, all that is outside him exists only in the idea that he forms of it. We know only phenomena, we base our reasoning only upon appearances; all truth in itself escapes us; the essence is unassailable."

Under the impact of contemporary 19th-century studies of mythology, however, the concept of the symbol had also categorically changed. The symbol no longer served as a means of communication between man and the supernatural, but rather as the medium through which the mythic forces that had "sunk" into the unconscious depths of human existence could once more be felt. Symbolist art needed symbols in order magically to invoke this deep-lying stratum: through words and pictures that still preserved their original mythical meaning and therefore deserved to be freed from all conventional cultural wraps.

In his monumental work *The Golden Bough*, published between 1890 and 1910, Sir James Frazer investigated the many commonalities shared by the various mythologies, the connections between knowledge and belief that can be found in the rites of all the world's cultures. In his view, which corresponded to the convictions of most of the Symbolists, the ancient symbols should be understood not just as cultural archetypes but as the "vocabulary" of an elementary "language" of fear, longing and the desires of the instinct.

The ambiguity, indeterminacy and obscurity of meaning that characterise the symbol became leitmotifs of Symbolist art and found expression not just in its cryptic contents but also in its formal means of design and in the execution of the composition as a whole. The Symbolist painters, for example, adopted the indefinable pictorial space established by Romanticism, one that renounced rational mathematical perspective and provided an unreal setting for their complex ideas. The relationships between the figures and the proportions of the human body were frequently "disjointed" in order to irritate the eye or indeed entirely to negate traditional visual conventions.

The elevation of art to the status of substitute religion paralleled the yearning for a new religiosity, something that manifested itself in the latter years of the 19th century in the founding of sectarian communities. These included the esoteric Rosicrucian movement in France, which attached great value to an aestheticised culture and was very closely linked with Symbolist artists. Probably originally dating back to the Middle Ages, Rosicrucianism was revived in 1888 in Brussels and Paris by Sâr Mérodack Joséphin Péladan. With his pale features, black beard, long black hair and full-length caftan, Péladan cultivated the image of a grand magician (Sâr was the obscure "professional term" for a sorcerer) and gathered around himself a circle of spiritualists, cabbalists and necromancers (leading Huysmans to dismiss him as a "magician of tripe"). In the portrait painted by Alexandre Séon, co-founder of the French Rosicrucians and a pupil of Puvis de Chavannes,

Alfred Kubin
The Snake God
1902–1903, pen, ink and watercolour,
sprayed on cardboard,
20.8 x 21.2 cm (8¼ x 8¼ in.)
Oberösterreichisches Landesmuseum,
Grafische Sammlung, Linz

Egon Schiele in his studio,
Vienna 1915

Péladan – who had initially preached an extremely sensual libertinism – cuts a correspondingly solemn figure against a mysteriously undefined background. The members of the "Order", most of them artists, called themselves magicians or aesthetes and embraced an orthodox Catholicism. On 10 March 1892 they opened their first art exhibition, the famous Salon de la Rose-Croix, in the gallery run by the Parisian art dealer Durand-Ruel. Despite the high entrance price, it drew 11,000 visitors on the very first day! In the foreword to the catalogue, Sâr Péladan set out the Salon's aesthetic programme: all representation of pure nature, uninhabited landscape, animals and plants, in other words all realism was to be rejected. Artistic technique was to be entirely subordinate to a work of art's mythical content, idea and mystical composition. According to one of Péladan's maxims, art was a mystery and the artist its high priest; when the latter's efforts were rewarded with a masterpiece, a divine ray shone down as if onto an altar. This programme briefly fascinated artists such as Paul Gauguin, Emile Bernard and the Nabis.

Parallels in Literature and Music

In its early days, as already mentioned several times above, Symbolism drew its intellectual nourishment chiefly from literature. The tales of Edgar Allan Poe, for example, exerted a decisive influence upon the new aesthetic and literary theory in France long before their author's discovery and recognition in the United States and Britain. Poe's fame in Europe was spread in particular by Charles Baudelaire. The dream, the extravagant art of imagination in contrast to bourgeois banality; beauty as a weapon against weariness of life – these are the favourite themes of the great French poet, as found in his *The Flowers of Evil*, the most famous volume of poems of the 19th century.

In his novel *À rebours*, Joris-Karl Huysmans not only created the supreme incarnation of Decadence in the aristocratic personage of Des Esseintes, but also demonstrated in exemplary fashion the compositional principles of Symbolism. In a description of precious stones and their effects of light and colour that runs for page after page, his lavish stream of exotic phrases ultimately loses all concrete meaning for the reader, so that the text becomes a bizarrely proliferating pattern of words. In the novel *Là-bas* (Down There), which appeared seven years after *À rebours*, the author drew upon the sum of his occult studies and focused amongst other things upon Satanism. At the same time he showed himself to be on the road to faith and Catholicism – in 1900 Huysmans entered the Benedictine Order as a lay monk.

There were particularly close contacts, too, between Symbolist fine art and the writings of Victor Hugo, Gérard de Nerval, Arthur Rimbaud,

Gustav Klimt at Lake Attersee,
ca 1910

Aubrey Beardsley
Enter Herodias
ca 1893, ink drawing,
23.2 x 17 cm (9½ x 6¾ in.)
Los Angeles County
Museum of Art

Stéphane Mallarmé, the Irish-born Oscar Wilde and the Flemish Maurice Maeterlinck, to name but the most important. In Germany, too, a literary scene devoted to Symbolism and in lively exchange with the fine arts was also flourishing in the figures of Stefan George, Rainer Maria Rilke and Richard Dehmel, and in Austria in the writings of Arthur Schnitzler and Hugo von Hofmannsthal.

It is impossible to speak of Symbolism without speaking of music! The music, for example, of Richard Strauss, Claude Debussy, Alexander Scriabin and of course first and foremost of Richard Wagner. Wagner's concept of the *Gesamtkunstwerk*, the "total work of art", first formulated in 1850, reached one of its apotheoses in conjunction with Max Klinger's monumental *Beethoven* sculpture of 1902. Wearing a clouded expression, the composer is seated on a mighty throne like a new Prometheus and at the same time like a majestic new Jupiter, a heroically stylised nude figure of compact stature whose lower body is swathed in lavish draperies. On the rocky plinth at his feet Beethoven is confronted by the powerful figure of an eagle, less as an instrument of torture as in the legend of Prometheus than as the symbol of an unfettered genius that knows no earthly chains. As the attribute of St John the Evangelist and visionary, the eagle is also the herald of divine inspiration. Klinger invokes further such symbolic

references in the reliefs on the back and arms of the throne: in the central field on the throne back, for example, he juxtaposes the Crucifixion of Christ with the Birth of Venus and has the striding figure of St John the Evangelist rain curses upon the goddess arising from the waves. Venus and the Crucified Christ – the two might signify that the creator of the Ninth Symphony, in *conformitas Christi*, is seeking to unite the religion of this world with that of the hereafter. In his *Beethoven* statue Klinger celebrates the titanic artist-god. The naked white body of the composer, sculpted from insular Greek marble, is embedded within a polychrome setting of various stones and metals. Onyx is used for the draperies, black marble for the rock and the eagle, with the eagle's wings studded with agate, jasper and polished antique glass paste; the angelic heads on the bronze throne are carved in ivory with opals as their background. The nude figure is lent a restless surround by the shimmering gleam of exquisite materials, in a contrast that effectively emphasises its pale spirituality. The degree to which Klinger's *Beethoven* sculpture fulfilled the requirements of the fin-de-siècle cult of the artist, pursued with such enthusiasm after 1880 not least due to the influence of Richard Wagner and Nietzsche's concept of the "superman", is witnessed by its installation in the Vienna Secession of 1902, which was transformed into a shrine for the occasion: surrounded by a frieze of

John Everett Millais
Ophelia
1851–1852, oil on canvas,
76.2 x 111.8 cm (30 x 44 in.)
Tate, London

paintings specially created by Gustav Klimt and accompanied by the music of Gustav Mahler, the Beethoven sculpture rose to become a total work of art.

Music and Symbolism repeatedly attempted to go beyond a mere marriage of their two genres to arrive at an absolute symbiosis. One of the most revolutionary figures in this field was the Lithuanian Mikalojus Konstantinas Čiurlionis: having started out as a composer, at the age of 30 he also became a painter, studying at the Warsaw Academy. Drawing upon an extensive knowledge of art history, he created a cosmos of powerful Symbolist imagery. He understood colour – embodying the "Promethean spirit" – as the link between the individual arts, and within painting specifically as the link between contrapuntal motifs. In the same way, he perceived music as a sort of reflection of the divine world order, in an echo of Pythagorean philosophy. Čiurlionis' "synthetic" programme propelled him to an impressive modernity, to a proto-abstraction that paralleled if not preceded the early works of Wassily Kandinsky, who was also operating in an abstractive and Symbolist vein.

Whatever the case, with the advance into abstract dimensions, the musicalisation of avantgardist painting would further increase after the turn of the century.

The Symbolist Portrait

A portrait can be "treated" in a Symbolist manner if the artist evokes, in the guise of a face, the psychic depths that surface within it, the inner being, the "secret" of a personality. This secret can be housed in particular in the eyes, those great and "unfathomable" mirrors of the soul (to invoke a time-honoured topos), and in the case of female portraits in flowing hair. Baudelaire compared the eyes of a woman with cold jewels combining steel and gold; he celebrated her thick tresses, issuing their magnificent symphony of scents, as a billowing sea.

For Dante Gabriel Rossetti, the eyes set in the pale face are the mirror of a melancholy soul full of yearning. The mouth – and again this applies above all to female portraits – is either shown with full lips "opening" like a rose as a symbol of love and sexuality, or – as often the case in the portraits of Fernand Khnopff – with lips that are pressed shut as the physical sign of stillness and silence.

The bulk of Symbolist portraits are characterised by a strange ambivalence. On the one hand, the physiognomy is surrendered to the moment and forces of introspection, to a self-withdrawal from the world, while on the other hand it is bathed in an aura intended to exert an irresistible force of attraction upon this same world. To this must be added the synthesis of a detailed realism,

Max Klinger
Beethoven (detail)
1902, stone of various colours and bronze inlaid
with glass, metal, ivory and precious stones,
height 310 cm (122 in.) (monument),
150 cm (59 in.) (figure)
Museum der bildenden Künste Leipzig

in places overly acute, and a formal and colouristic stylisation that underlines the artificial nature of the scene of which the portrait forms part. The primary aim is to capture the sitter utterly absorbed in his or her own psyche, his or her own existence. The face as medium of reflection and narcissistic self-admiration! As a rule, the self-portraits of Symbolism attest to the concept of the artist as a visionary, a prophet, but also as an exponent of experiences on the outer perimeters of existence.

In his book *Studies in the History of the Renaissance* of 1873, the English historian Walter Pater wrote of the portrait of a woman: "All the thoughts and experience of the world have etched and moulded there, in that which they have of power to refine and make expressive the outward form, the animalism of Greece, the lust of Rome, the mysticism of the Middle Ages with its spiritual ambition and imaginative loves, the return of the Pagan world, the sins of the Borgias." No, Pater was not referring to one of the female models of the Symbolists or Pre-Raphaelites. He was talking about Leonardo da Vinci's *Mona Lisa*, painted between 1503 and 1506! Such lines betray the massive extent to which Symbolist thinking had altered the image of the feminine.

Symbolism, while not alone, was nevertheless the chief amongst the art movements of the 19th century to employ distinctive symbols for man-

eating "woman". These included the sphinx, the female vampire and the biblical figure of Salome, who rose to become the archetypal femme fatale. She had other embodiments, of course, in the figures of Messalina, Judith and Cleopatra, or quite simply in the many paintings of young girls with yearning in their eyes, their lips parted in a lascivious manner and long-flowing hair.

Sin, incarnated in male fantasies of the era in the biblical figure of Eve and in every woman demonstrating her sensuality, found its way into one of the most famous "icons" of Symbolism, created by the Munich painter Franz von Stuck (1893, p. 97). Sin, the Fall of Man, was one of the most frequently treated pictorial motifs of the age – as was the temptation that preceded it, and its psychology.

At the Threshold of Modernism

In the art theory of more recent times, Symbolism has been regularly interpreted as the opposite of the avant-garde and Modernism. In the wake of Post-Modernism, which has entirely destroyed the philosophical claims of non-representational art, Symbolism's adherence to a figurative manner of representation and to literary impulses is played off against abstraction and its supposed abandonment of the "human" element and meaningful content. The "melancholy" that informs the mood of so many Symbolist works is interpreted as

Pierre Puvis de Chavannes
The Dream
1883, oil on canvas, 82 x 102 cm (32¼ x 40¼ in.)
Musée d'Orsay, Paris

mirroring a grief at the loss of these values, a loss that had started to make itself felt much earlier in the 19th century and to some extent, indeed, at the end of the 18th century.

We need not make an ethical judgement about the relationship between Symbolism and the non-representational avant-garde, but we can acknowledge the historical evidence for their differences. It is true that the Symbolists sought above all to communicate a message to their public, even if its content was formulated in enigmatic terms, and were doing so at a point in time when – from a superficial point of view – the protagonists of Modernism were already focusing their attention upon purely formal visual experiments.

The situation was not quite that clear-cut, however, for Kandinsky, Mondrian, Malevich and other early abstract artists by no means sought to eliminate a profound symbolic dimension from their works. Unlike the Symbolists, they no longer believed that this dimension needed to be tied to identifiable themes and naturalistic imagery.

Why, then, did the great leading figures of modern painting – Picasso, Mondrian, Kandinsky, Malevich – all start out from Symbolism or at least from Symbolist tendencies? This fact proves that Symbolism, in its search for a means of expressing the essential, often stylised its formal repertoire in such a way that abstraction became conceivable and possible, namely as a continuation of this simplification of form. Only after the triumphal advance of abstraction was interrupted in the 1920s by New Objectivity, and above all by Surrealism, did Symbolism's heritage truly resurface once again, be it in the work of the founder of Pittura Metafisica, Giorgio de Chirico, or in individual pictures by Max Ernst and Salvador Dalí, or in the figures of the Belgian Surrealists René Magritte and Paul Delvaux.

Fernand Khnopff
The Deserted City
1904, pastel and pencil on paper,
mounted on canvas, 76 x 69 cm (30 x 27¼ in.)
Musées royaux des Beaux-Arts de Belgique, Brussels

Edward Burne-Jones

b. 1833 in Birmingham, UK
d. 1898 in London

In England the themes and aesthetics of Symbolism were anticipated by the group of artists known as the Pre-Raphaelite Brotherhood, founded in 1848 and remaining in existence officially until 1853, although it influenced painting and graphic art for very much longer than that. The Pre-Raphaelites had a predilection for medieval legends and classical mythology, which provided them with a pseudo-historical guise in which to present sexual messages otherwise taboo in Victorian England, and make them respectable. Their techniques included enamel-smooth application of paint and "hyper-realist" attention to detail. One of the outstanding Pre-Raphaelites was Sir Edward Burne-Jones, the highest-earning English painter of the fin de siècle. Especially in his late work, he effortlessly transcended the boundaries between Victorian history painting, Symbolist yearning for the Middle Ages, and an indulgence in ornamental contours and luxuriant decorative accessories which anticipated Art Nouveau.

In 1875, the future British Prime Minister Arthur Balfour asked Burne-Jones to decorate the reception room of his town house in London with pictures. He left the theme to the artist, who chose the story of Perseus from Greek mythology. The execution of the commission dragged on for 20 years. The penultimate picture in the cycle bears the title *The Doom Fulfilled*, as it shows the final liberating deed of the hero. Perseus, who a short while earlier had overcome the terrible Medusa, espied, in the course of a fantastical flight through the air, a naked girl sprawled on a rock: Andromeda, who was being threatened by a sea monster. The scene of the battle which now begins is a narrow stage in the foreground, behind which looms a bizarre rocky landscape, derived from the Renaissance painting of Andrea Mantegna. Like some future Art Nouveau ornament, the sea monster winds itself, arabesque-like, around the imaginatively armed hero, who is of ageless beauty, giving his body an almost terpsichorean-eurhythmic pose.

In the preceding picture in the cycle, Perseus first meets the princess chained to the rock of doom, and there we have a full-frontal female nude, while during the actual fight Andromeda turns her back on the proceedings, allowing us only a glimpse of her face, reminiscent of Botticelli's Venus, in profile. She resembles a balanced classical marble statue, the contrapost seemingly only chosen to do fitting justice to every attractive curve of her body. Andromeda becomes an erotic promise. Soon she is no longer the booty of the beast (who vainly stretches the tip of his tail like a phallic symbol over the body of the young woman, dazzlingly white against the monotonous dark-blue background), but the playmate-to-be of the victorious man. Burne-Jones transforms his Andromeda into a template of femininity for the fin de siècle, a type somewhere between man-eating femme fatale and innocent girlhood. Although the chosen theme might lead one to expect the dynamics and arousal of combat and psyched-up reactions of all involved, the composition conveys, in its balance, the timelessness of the myth.

(N. W.)

The Doom Fulfilled
1885–1888, oil on canvas,
155 x 140.5 cm (61 x 55¼ in.)
Staatsgalerie Stuttgart

Odilon Redon

b. 1840 in Bordeaux, France
d. 1916 in Paris

The Golden Cell
1892, oil on paper,
30.1 x 24.7 cm (12 x 9¾ in.)
The British Museum, London

The name of Odilon Redon, the brilliant French graphic artist, draughtsman and painter, a poetic visionary of mysterious, dreamlike themes, tends to be discussed even today only amongst a small circle of specialists: the same Redon who stood at the zenith of the Symbolist movement in art, who created icons of Symbolist painting, who to a certain extent paved the way for the Surrealists' exploration of the unconscious; the same Redon who with pictures such as *The Cyclops* and its bold formal freedom – comparable with the Nabis in this regard – already had abstraction in his sights.

The small work reproduced here, executed in oil on paper, presents a female profile of almost icon-like simplicity inside a medallion form within the composition. It was shown from 29 April to 14 May 1894 together with 134 other works by Redon in an exhibition devoted to the artist in Durand-Ruel's gallery in Paris. In his use of pigments of intense luminosity from the 1890s onwards, Redon seems to have proceeded more or less intuitively. To his contemporaries, even those who were well-meaning, this was for the most part

highly suspect. The fact that Redon did not deploy colour for its representational value meant that he "opened" it up to a host of possible associations. Just like the gold ground, the luminous dark blue belonged to the tradition of Christian mysticism and also to the colour symbolism of Romanticism.

As so often the case in Redon's oeuvre, it is impossible to assign a single or even a clearly delimited meaning to *The Golden Cell*. Critics spoke instead of a general impression of an otherworldly, spiritual quality, of a transcendence that was connected not exclusively with the Christian religion (and in the case of the present picture, with an eventual reference to the Virgin Mary) but equally with other, not least Buddhist conceptions of the world. A number of authors have also wondered whether the word *cellule* chosen by Redon for the title is not intended to recall a monastic cell. In Redon's eyes, artists were the most important "seers" of the beyond – and precisely for this reason were cast out from society and exiled to the "seclusion" of solitude.

(N. W.)

Franz von Stuck

b. 1863 in Tettenweis, Germany
d. 1928 in Munich

Sin
1893, oil on canvas,
94.5 x 59.5 cm (37¼ x 23½ in.)
Neue Pinakothek, Munich

This picture by Franz von Stuck is one big challenge, or at least it was in its day. That we hardly get worked up about it today is due to the changed artistic and moral imperatives of our age. What catches the eye nowadays is rather, for German speakers at least, the title of the picture, idiosyncratically spelt, carved conspicuously into the specially made frame: *Sin*. The unusual is not confined to the frame, though; the picture itself depicts a lecherously half-naked woman, giving us a come-hither look from the semi-darkness, her moon-pale body in the coil of a large snake. This is one of Stuck's successes: between 1891 and 1912, he painted numerous versions of this theme.

At this time Stuck, who had worked his way up from very simple beginnings, was achieving major recognition, both artistically and socially. In 1892 he was one of the founders of the Munich Sezession, in 1895 he was appointed professor at the Munich Academy, where his pupils included Josef Albers, Wassily Kandinsky and Paul Klee, and in 1906 he was ennobled (hence the "von" in his name in later years).

Visual perception can give rise to a high degree of satisfaction as a result of a wide variety of stimuli, including, not least, erotic allusions. These "sexual perversions", as science classified them at the time, were put on a level with sadism,

masochism and fetishism. From the point of view of content, Stuck's *Sin* is related to Leopold von Sacher-Masoch's *Venus in Furs*. Viewed aesthetically, however, there is more to the picture: the convincing composition of fascinating mystery and a fantastical digression into the no-man's-land between what can be said or shown and the unmentionable or taboo. But this tightrope act is an integral component of painting generally. What can be shown without giving offence? To what extent, in fact, must significant art give offence?

Stuck has given expression to these questions in his picture, whose significance lies between mystery and the truth open to painting, in suggestion, and in the confident mastery of revelation and concealment.

It plays a skilful game with the set pieces of pleasure-in-looking: with this picture, the artist ministers to the overt or covert voyeurism of his clientele in particular and ultimately of all beholders of art in general. The scopophilia, or "love of gazing", which Sigmund Freud identified as a part of the human psychological apparatus, relates not just to looking at forbidden things and pictures, but also represents one of the basic human needs, in common with curiosity, visual discovery and exploratory recognition.

(W. S.)

Edvard Munch

b. 1863 in Løten, Norway
d. 1944 at Ekely

Self-portrait with Cigarette
1895, oil on canvas,
110.5 x 85.5 cm (43½ x 33¾ in.)
Nasjonalgalleriet, Oslo

By 1895, Edvard Munch had his first successes and first scandals behind him. Following several trips to Paris, and from 1892 longer sojourns in Berlin, the painter who was beginning his career in Kristiania (now Oslo) had become captivated by the hectic flair of cosmopolitan life. To find his own place in the front line of artistic developments obliged him to take up the appropriate lifestyle. For a bohemian plagued by crises, so long as the rise to *haut bourgeois* representational styles was denied him, there were two options: monkish withdrawal, working in the spirit of poverty and loneliness on the one hand, or to play the flaneur.

"Monks" react to the growing complexity of modern life by renouncing distraction; flaneurs by contrast devote themselves to it. Under the shelter of the one or the other attitude, one could at any rate find security. Scope remained for experiments, and there was time too for working over self-doubt. As circumstances dictated, Munch pursued both styles. The *Self-portrait with Cigarette* reveals how he wished to see himself in 1895.

The very illumination is confusing. As though a flash were coming from the floor, the light rakes the man standing in mysterious darkness. There is enough light to see that he is wearing a suit and bow tie, as he stands there, depicted in three-quarter length, holding a cigarette between the fingers of his raised right hand, and that his staring face is dazzled by the flash, as though it were hanging onto a thought or looking in amazement at someone who had unexpectedly turned up in front of him.

Are we supposed to see how he has suddenly "seen the light"? How he, in a flash, has comprehended something which we are to share with him as a moment? As we can pin down the smoker neither in his thoughts nor in a specific action, except for his staring, thinking and smoking, we have all the more reason to see him in his particular situation as a painter. We then notice a process that so to speak portrays itself. Light and shade (nighttime) are only the pretended reason for his appearance. It stands to reason that they can and must be associated by an unquiet spirit strolling through the nights. For when does the hour of inventive spirits strike, if not in the lights of the recently electrified cities, of illuminated shop windows and variety billboards? And where else, if not in the all-night cafés or on the way to them, can one reflect on new books, on new pictures that have been created during the daytime?

But really adequate, this consideration is not. Munch's so finely modelled hand with the cigarette helps us along. The ultramarine and cobalt blue that so to speak "rises" in the cigarette smoke, sinks down in the transparent glaze towards the edge of the picture, dissolving the figure and the surrounding space. The rising smoke is mixed with opaque white, producing a more solid paint layer than the thin paints used for the room, in places smeared right down to the canvas. Rivers of blotches, streams of drops of paint, traces of scratches in the paint form, along with contour lines – a reality of their own in this painting. Munch's figure is surrounded by this painterly movement as by a protective aura. (The neutral portrait background has always been one of the secret birthplaces of abstract painting; after all, as a space without objects, it remains free for moods and expression.) The painting process here doesn't serve to create a self-depiction; it *is* to a large degree the self-depiction.

(E. R.)

James Ensor

b. 1860 in Ostend, Belgium
d. 1949 in Ostend

Self-portrait with Masks
1899, oil on canvas,
117 x 82 cm (46 x 23¼ in.)
Menard Art Museum, Aichi

The pictures of James Ensor, who was initially regarded with scorn or total lack of understanding, had to wait a long while to be appropriately interpreted and appreciated, for they were far ahead of their time. In particular, it is the events of the era of Fascism and National Socialism in Europe that have caused beholders to view his pictures in a different light. Thus the estimation of Ensor has changed from viewing his role as that of an eccentric loner to that of a unique and fantastical visionary. The son of an English engineer and a Belgian souvenir dealer, he studied at the Académie des Beaux-Arts in Brussels from 1877 to 1879. A recluse, he attained official celebrity at a relatively late stage. In 1899 the Albertina in Vienna bought a hundred of his works. In 1901 his hometown acquired a series of 118 etchings, and finally in 1930 he was ennobled.

Colourful masks – his studio was full of them – were a constant feature in Ensor's thespian-droll imagery. His pictures with the masks provide a premonition of the endgames of the modern era: after all, is not the mask the means used by Ancient Greek theatre to de-individualise an actor and to replace him with a "persona", through which only his voice penetrates?

Ensor's self-portrait in Baroque pose, *Self-portrait with Masks,* was painted at the climax of his creative period; it was influenced by the self-portrait by the great Antwerp painter Peter Paul

Rubens. The painter is surrounded by masks, though his own face – whether naively or by design – is uncovered for all to see. Ensor is almost crushed by the masked figures, whose bloodless faces and painted lips embody the artist's obsessions, namely with being crushed by the mass, with the human abysses behind the beautiful.

Ensor's very specific colouration underlines the visualisation of a latent danger: the fresh, rosy flesh suddenly comes across as raw. With a fine pen and a palette of glossy transparent paints, including some garishly poisonous hues, he turns all the masked figures into an unpredictable threat.

The comic aspect of the scene thus imperceptibly keels over into a deadly game with assigned roles: in the midst of a crowd determined to do anything, even if, like here, it is only a large-scale grimace, the individual has no choice but to flee. In Ensor's picture, while the individual is offered up to the mocking laughter of the horde, he is at the same time fitted out with the protective insignia of the normal citizen, which allow him to escape. The bourgeois world is grotesque, its abyssal depths concealed behind masks, but by that very fact capable of being displayed. That Ensor was able to register this so clear-sightedly in his inconspicuous lifestyle between the wars, and implement it in great painting, is what secures his status as a visionary of the fantastic. (E. R.)

Ferdinand Hodler

b. 1853 in Berne, Switzerland
d. 1918 in Geneva

The Swiss painter Ferdinand Hodler stands in the tradition of a fantastical art which comes across as, if anything, "heroic". In Hodler's case too, the dominant feature is the sweeping gesture, which always seems to point away from and beyond itself. The decisive feature is Hodler's strict renunciation of Realism in favour of Symbolism.

In *Truth II* all is gesture, reference, appeal, stature, expression. As in an anthroposophical eurythmic dance, six enraptured male figures, scantily covered with curiously draped veils, are moving around a statuesque, sovereign-looking female figure – a symbol of incorruptible truth, standing above all else. The ground is a stylised meadow, into which delicate flowers are woven, as if into a counterpane or carpet. The background is brightly illuminated. The dancers have their backs turned to the beholder: we can tell that they are men only by their muscular arms and legs. They are naked, their dark flowing veils doing little to cover their nakedness. Their arms are raised over their heads, their legs frozen out of the delayed movement into dramatically stable columns. On the one hand it seems as though the dancing men in this circle are seeking to protect truth in the guise of the woman, while on the other, the men seem to be covering their heads when confronted by the sight of the naked truth, and, dazzled, are trying to take flight.

The woman herself is not frightened; unabashed, she is giving the beholder a full-frontal eyeful. Her dark hair is gathered in long strands which surround her head like a halo, like the wigs worn by British judges, or like the well-arranged snakes of the Medusa. The picture is reminiscent of Art Nouveau and Symbolist tableaux, revealing the artist's accommodation of the fashionable endeavours of the time. However the exaggeration, and the way he turns to the fantastical, give the painting a palpable internal dynamic, which can be felt arising between the undemanding and relatively conventionally depicted figures. It exaggerates the usual arrangement of beautiful bodies, which, detached from the real person, are presented to the beholder as if on a confined theatrical stage. It is only at first sight that Hodler's art is Symbolist: superficial, arranged emotionally by form and colour, and largely devoid of content. On closer inspection, however, the rational and intellectual (and intellectually demanding) elements and aims of his painting are revealed as an intention to educate. The picture is intended to make clear that the truth – in philosophy, in everyday life or in a court of law – always has to be more than a mere idealistic embodiment of an aesthetically stylised gesture such as that associated with the mythological figure of Justice portrayed – as so often on European and American court buildings – with her eyes blindfolded.

Hodler wishes to say that truth is, rather, a direct feature of human action and behaviour, an integral part of our lives. It should be as irrefutable and impartial as the beauty of the female body – based in itself and radiant of itself. With this austere certainty, Hodler's naked figure can, alone amongst the whole group, encounter the beholder face to face, self-assured and with open eyes. It is in this subliminal and subtle communication that the fantastical charm of this imposing picture resides. (W. S.)

Truth II
1903, oil on canvas,
207 x 293 cm (81½ x 115¼ in.)
Kunsthaus Zürich

Pablo Picasso

b. 1881 in Málaga, Spain
d. 1973 in Mougins, France

Life
1903, oil on canvas,
196.5 x 123.2 cm (77¼ x 48½ in.)
The Cleveland Museum of Art

Pablo Picasso loved and made a practice of permanent stylistic change. At the beginning of his career, over the subsequent course of which he would become the most famous artist of Modernism, his personal, subjective feelings were combined with a markedly Symbolist *weltschmerz* – namely in his Blue Period (1901–1904). In the literary and painterly tradition of Romanticism, he created ciphers and symbols of human affection, but even more so of misfortune and misery, isolation and the existential suffering of humankind in and on account of this world. Picasso clothes these fundamental human issues in an exemplary, almost emblematic manner in family groups, and hereby in particular in the leitmotif of the mother-child relationship.

The large, portrait-format composition *Life* may be interpreted neither as a picture of despair nor as one expressing an optimistic outlook upon the world, but rather as striking a balance between these two opposites. In formal terms, Picasso has drawn some of his inspiration from the thin figures, the pathos of loneliness and the palette found in the few early works by Émile Bernard, a member of the Nabis.

In this masterpiece from 1903, set within an indeterminate interior with a greenish floor and a background in various nuances of blue, Picasso has worked with the device of the "picture within a picture". Standing on the left is a naked young couple (the man wearing only a sort of loincloth), the woman draped tenderly against the man's body but casting her eyes downwards in a dejected manner, while her partner, completely distracted, looks towards the right (from the viewer's perspective). Standing opposite them, directly parallel to the upright of the frame, stands a dressed albeit barefoot woman cradling a sleeping infant in her protective arms. It is hard to judge the age of this female figure, who is seen in profile, but in comparison to the naked woman on the left, she appears substantially more mature in years. The caesura in the centre of the picture, between the lovers on the left and the mother and child on the right, is filled by paintings: above another couple, albeit clinging to each other more out of despair than physical affection, and below a figure huddled in obvious despondency.

The statement at the heart of the composition remains enigmatic. Does maternal love, as an "enduring" moment, replace sexual love, whose pleasures will fade? Does the silent grief that overshadows the features of the figures in the foreground (with the exception of the sleeping baby) contain a premonition of the moments of loneliness and mental crisis that dominate the "pictures within the picture"? To what extent do biographical references play a role? X-ray investigations have revealed that Picasso executed this picture over an existing painting, namely the composition *Final Moments* (!) that the artist had contributed to the Exposition Universelle of 1900 in Paris. When he embarked on the new subject, Picasso originally intended to give the young, almost naked man his own features, but in the end he portrayed his former friend Carlos Casagemas, who had committed suicide in 1901 to the horror of his friends following a tragic love affair. Its infinite melancholy and existential symbolism make this work a masterpiece both within Picasso's oeuvre and in the context of Symbolist art.

(N. W.)

Gustav Klimt

b. 1862 in Baumgarten (today part of Vienna), Austria
d. 1918 in Vienna

Gustav Klimt is regarded today as the undisputed master of Viennese Art Nouveau. As a central figure in Viennese artistic and social life, he was the recipient of numerous honours during his lifetime, but he was also vehemently rejected by many, on account of the fact that he delt with taboo subjects linked to sexuality and death.

The major portrait commissions occupy a special position within his oeuvre: not only the portrait of Fritza Riedler, but others as well, such as those of Adele Bloch-Bauer and Margaret Stonborough-Wittgenstein.

The *Portrait of Fritza Riedler* is the first portrait of the "golden period", which culminated in *The Kiss*. The style is reminiscent on the one hand of the early Christian mosaics and icons which Klimt had seen in Italy in 1903. He reduces the body to the level of decoration, pure surface, albeit beautifully arranged. This particular treatment of the surface in turn places Klimt in the tradition of East Asian art, which was very much alive in the Europe of his day. Above all the elaborately produced room-screens by the 17th-century Japanese maker Ogata Korin show motifs such as wave movements that Klimt adopted directly in order to hint, for example, at the woman's throne-like chair. The sitter is placed in front of a large reddish wall, which is broken by two semicircular openings. One of these could at the same time be a Far Eastern headdress, but maybe also an echo of the hairstyle of the *Infanta Maria Teresa*, as depicted by Velázquez in 1652, a portrait which Klimt had seen in Vienna.

The ambivalence of this fantastical arrangement rests on its pure two-dimensionality, the clearly structured surface which appears to harbour no secrets. It is only the apposition of the several levels that comprise the room in which the lady is sitting, and diffusely reflect her figure, and that culminate in a condensed juxtaposition of incompatibles. The longer the beholder tries rationally to discern the various parameters of the suspected space in this picture, the less the enterprise will meet with any success: the space somehow spreads out into a two-dimensional surface once more. It is a space with no beginning or end, no entrance and no exit, a place – nowhere.

The charisma of the sitter is untouched by all this. On the contrary: it is precisely the ornamental and decorative statuesque quality of the depiction which lends her such grace. For the beholder, the result is an ideal projection screen. There are no narrow limits set to the imagination: rather, they are so broad that unimagined perspectives open up – even in more than three dimensions.

At the same time, the real sitter is enveloped in a fog of recognition. After all, Vienna, the city in which the picture was painted, was also the city in which the secret emotional sufferings of – precisely – women were at the same time being discovered and revealed to the world by Sigmund Freud. In any case, it was not done for a woman of the better sort to show her true face or her real feelings. This restriction did not however deprive her of any of her personality, but rather caused its transfiguration, at least in the visual arts. (W. S.)

Portrait of Fritza Riedler
1906, oil on canvas,
152 x 133 cm (60 x 52¼ in.)
Österreichische Galerie Belvedere, Vienna

Egon Schiele

b. 1890 in Tulln on the Danube, Austria
d. 1918 in Vienna

Self-portraits are never just mirror images. The reflected self is actively processed: clarified, enhanced, often mysteriously defamiliarised. If we use the jargon of modern cognitive science and say that the underlying self-image is "constructed", this expression can be taken quite literally where portraiture is concerned. For a physical and psychological presence is like an edifice, when artists "build up" human characters in the proportions of pose to facial expression, from the bodily plinth to the turn of the head, from the gesture to the frame. This is all the more enlightening in those phases of art history which revolutionise the traditional order.

When, in about 1910, during the first heyday of avant-garde radical concepts, the old pictorial systems were being exploded in Vienna too, it was Egon Schiele's self-portraits in particular that tested this process drastically and constructively. In this picture Schiele is presenting himself with curiously spread fingers. The whole body, the whole surrounding space seems to be under pressure and tension. Spaciousness and calm are missing, the beholder's gaze is drawn into painful constriction. Hard, in a vehement counter-rhythm, the half-length figure presses into the left-hand half of the picture, in such a way that away from the left side of its body the areas of an indefinitely marked two-dimensional space that remain free are all the bigger. Schiele has pulled his left arm like a chain close to and around his upper torso, his hand spread to form a V-shape. A melancholy state beneath raised eyebrows meets our gaze. It all happens as if this scrawny black-shirted figure

needs to provide proof of its multiple distortions. Where the forces are exerted so one-sidedly, counter impulses are needed to open things up.

Next to Schiele's head, towards the middle, there is therefore a vaguely patterned dark mass. It contrasts and complements. Only gradually can it be seen to be a black, head-shaped clay vessel, with nose, lip and eye. Its relationship to the feverish and sickly flesh colour of the face is that of a monster mask to the natural face, or a nightmare to a daydream. Just a few coloured accents, whose objective origin (garments, spines of books?) is barely identifiable, structured the white and wan-green empty spaces, which in turn are reminiscent of distempered housefronts or primed canvases. Only a tender branch with leaves at the top right breaks through the mysterious weave of flat areas with a hint of nature and the outside world. Confined and wide-open, beautiful and ugly, form and deformation are mutually reassigned a new, literally under tension.

In other works too, Schiele experiments time and again with the oppressive trialogue of body, space and surface. When in 1914 he was given a wall-sized mirror, he adopted some curious poses in front of it for his photographer friend Anton Trčka. Thus he echoes the frame geometry of the mirror, locks himself in and at the same time hints at bursting it open. His own body is for him a trial run for new pictorial architecture. He seeks to use it to examine how to build up figure-like arrangements while breaking down the tensions of emotional life.

(E. R.)

Self-portrait with Black Clay Vessel
1911, oil on panel,
27.5 x 34 cm (11 x 13½ in.)
Historisches Museum der Stadt Wien, Vienna,
Bequest of Arthur Roessler

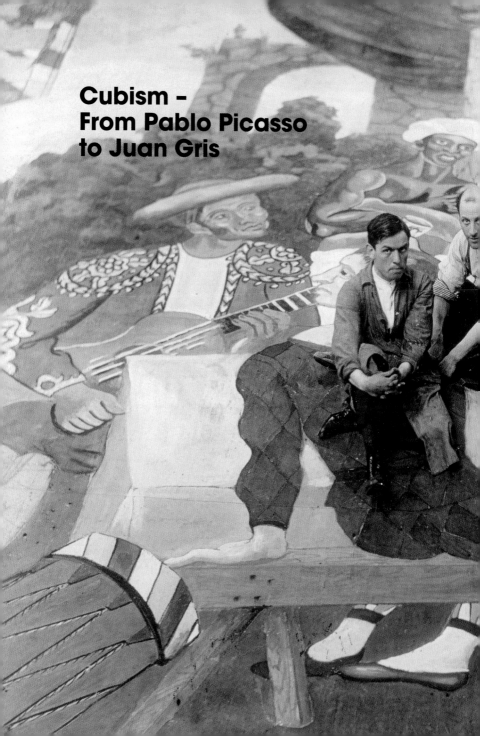

Cubism –
From Pablo Picasso
to Juan Gris

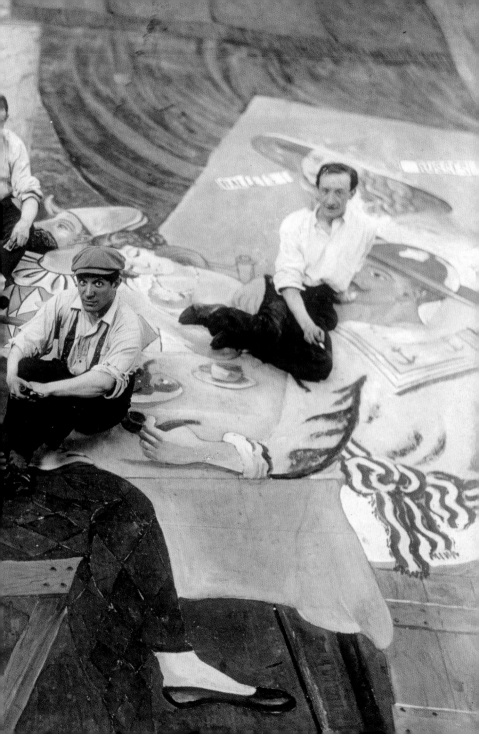

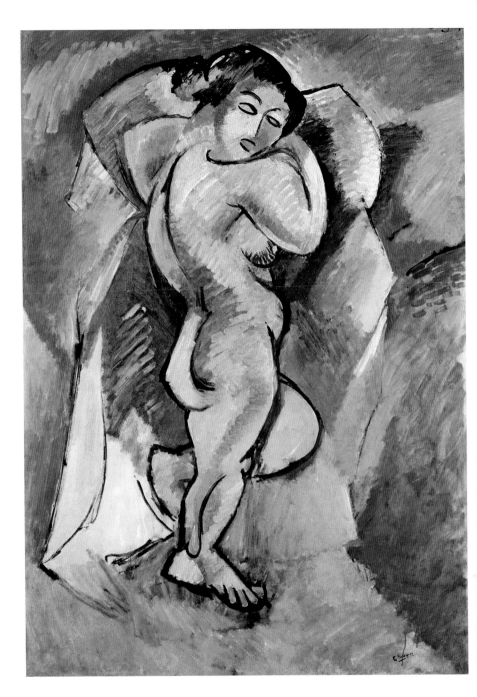

A New Cognitive Order?

Anne Ganteführer-Trier

Paintings with Little Cubes

"What is a Cubist? It is a painter of the Braque-Picasso School." This statement was to be read on 23 April 1911 in the daily paper *Le Petit Parisien*, shortly after the opening of the scandal-rife Salon des Indépendants, which took place from 21 April to 13 June of that year. The Cubists – including Albert Gleizes, Jean Metzinger and Fernand Léger – had their own exhibition room at the Salon; works by Pablo Picasso and Georges Braque were not included in the presentation.

The origins of the word Cubism can be traced back to a remark from Henri Matisse. In September 1908 the renowned French journalist and art critic Louis Vauxcelles spoke with Matisse, who was a member of the jury of the Salon d'Automne. Matisse reported that Georges Braque had submitted paintings "with little cubes" to the autumn salon. Thereby Matisse was characterising a landscape painting Braque had created in the same year in L'Estaque in the South of France. Because of negative criticism Braque removed the painting from the Salon on the evening before the opening of the exhibition.

Vauxcelles originally established the term Cubism in a report about the Salon des Indépendants in the year 1909. From then on the latest paintings by Pablo Picasso and Georges Braque would be attributed to the newly created style, without either artist having played an active role in coining the term. Picasso later recalled: "Cubism has tangible goals. We see it only as a means of expressing what we perceive with the eye and the spirit, while utilising all the possibilities that lie within the natural properties of drawing and colour. That became a source of unexpected joy for us, a font of discoveries." One could not speak, either at that time or later, of a Picasso or Braque "school". Right until Cubism's end, it remained equally difficult to associate it with a clearly defined programme.

Les Demoiselles d'Avignon

As varied as the surviving descriptions of Cubism's origins are, agreement nonetheless exists over the fact that Pablo Picasso with his large-format painting *Les Demoiselles d'Avignon* (p. 131) – measuring approximately 244 x 234 cm (96 x 92¼ in.) – laid the cornerstone for the first revolution in 20th-century art. The painting, produced between 1906 and 1907, marks the beginning of "Cubist thought". With this work Picasso was the first artist to ignore the rules of perceptible space, naturalistic colouration and the rendition of bodies in natural proportions. The three-dimensionality of the female nudes, and the space they move in, fragment into a two-dimensional type of ornamentation and unite different perspectives simultaneously. The illusion of space and plasticity takes second place to the question of the

Marcel Duchamp
Nude Descending a Staircase, No. 2
1912, oil on canvas,
147.5 x 89 cm (58 x 35 in.)
Philadelphia Museum of Art,
Louise and Walter Arensberg Collection

representation and structuring of forms. The sum of these innovations that contradicted all academic conventions of the 19th century caused concern among many of Picasso's contemporaries and prompted sometimes violent criticism.

Cézanne

In 1904 Paul Cézanne expressed the following to his fellow painter Émile Bernard: "All natural forms can be reduced to spheres, cones and cylinders. One must begin with these simple basic elements, and then one will be able to make everything that one wants. One must not reproduce nature, but represent it; but by what means? By means of formative coloured equivalents." A number of Cubist artists invoked the theories of Cézanne. Picasso stressed: "What Cézanne did with reality was much more progressive than the steam engine." Picasso first encountered Cézanne's pictures in the rooms of Henri Matisse, who had acquired the painting *Three Bathers* from the artist in 1899.

In 1911 Michel Puy wrote: "Cubism is the culmination of simplification, which was begun by Cézanne and continued by Matisse and Derain... Cubism seems to be a system with a scientific basis that allows the artist to base his efforts upon a reliable coordinate system." Puy's description reduced Cubism to a rule-dominated method used by artists; a system that as such had never existed.

A comparison of Cézanne's *Bathers* with Picasso's painting *Les Demoiselles d'Avignon* reveals several surprising parallels. The cloth hung as a tent over a branch in Cézanne's painting reappears as a draped background in *Demoiselles*. The poses of two bathers can be described nearly identically with the poses of the second standing figure from the left and the squatting figure in the lower right in Picasso's work.

African Art

The artists of Fauvism had discovered African tribal art's merits in the years after 1905. De Vlaminck speaks of an outright "hunt for negro art", which had begun among the avant-garde artists. Paris – the capital of French colonial power – was a good hunting ground at this time. De Vlaminck personally participated in this as well when he acquired three African statuettes and a white hunting mask in a café in Argenteuil in 1905. Matisse possessed a remarkable collection of African sculptures purchased primarily in Parisian second-hand stores. This list of examples could be extended indefinitely.

Picasso is particularly well known for the fact that he allowed his passion for collecting to flow into his work: thereby he also discovered African tribal art for the art of painting. In addition to many statuettes and masks, the numerous photographs of African origin archived in his estate

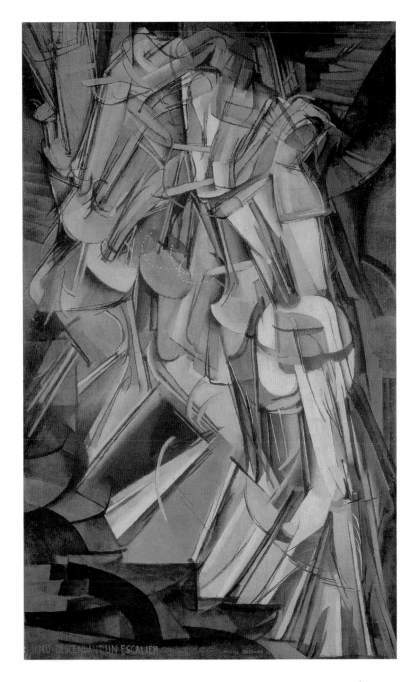

NU DESCENDANT UN ESCALIER　　　MARCEL DUCHAMP

tell of a sophisticated preoccupation, for example, with the hair and head decoration of the women. Works created in this period – including *Les Demoiselles d'Avignon* – tell of Picasso's dependence on African portrayals.

During these years Picasso's studio seemed to visitors like a cabinet of curiosities. André Salmon describes the impression made by the studio in the Boulevard de Clichy: "Grimacing back from every piece of furniture are strange wooden figures, which are among some of the most exquisite pieces of African and Polynesian sculpture. Long before Picasso shows you his own works, he allows you to admire these primitive wonderworks."

Max Jacob recalls that Picasso had discovered African sculpture for himself in the studio of Matisse. There Matisse had placed a black wooden figure into his hands, which Picasso could not separate himself from for the entire evening. On the following day drawings of women's heads with, for example, only one eye or a long nose in place of the mouth appeared in Picasso's studio, and Jacob confirmed: "Cubism had been born."

History of a Friendship
It was Guillaume Apollinaire who at the end of November or beginning of December 1907 presumably accompanied Georges Braque to Picasso's studio. At that time Picasso had just finished his *Demoiselles d'Avignon*. Braque's reaction to the painting was extraordinary. According to statements by Picasso's relationship partner at that time, Fernande Olivier, Braque exclaimed: "With your paintings you apparently want to arouse in us a feeling of having to swallow rope or drink kerosene." Braque was overwhelmed and initially seemed unable to deal with what he had seen.

That must have changed very quickly, for Braque's paintings testify from that point on to a knowledge and deep understanding of Picasso's latest pictures. A close friendship also developed between the two painters which made Braque receptive to new subject matter in his work. He created one of his few female nudes, the picture *Large Nude* of 1908, which with its modest 140 x 100 cm (55 x 39¼ in.) dimensions counts as one of Braque's larger paintings.

In Braque's nude, viewers are faced with distorted female body forms equipped with over-proportioned muscles, and even the correlation of the extremities to one another is fictitiously laid out. Musculature and body mass are greatly emphasised by means of a few clearly placed lines, such as in the region of the buttocks and the right calf.

The female nude appears a little awkward in front of an angular, rigidly draped cloth. Both the cloth, with which the woman seems to conceal

herself from the background, and the bordering colour surrounding the cloth, which fluctuates from red through ochre to yellow, are reminiscent of Paul Cézanne's *Bathers* and Picasso's *Les Demoiselles d'Avignon*. Comparable to Picasso's work, Braque's colour is no longer realistically bound to the object being represented, or to put it in Picasso's words: "Cubism was never anything other than this: painting for painting's sake, while excluding all concepts of unimportant reality. Colour plays a role in the sense that it helps to depict volumes." Thereby the Cubists always remained faithful to the object in the early phase of this artistic movement. "I refuse to accept that there should be three or four thousand possible ways to interpret my painting. I want there to be only one single way, and in this one it must be possible to a certain degree to recognise nature, which after all is nothing but a type of struggle between my inner being and the exterior world, as it exists for most people. As I have often said, I am not trying to express nature."

Picasso and Braque saw each other more or less daily, and intensively exchanged their ideas on artistic questions. Picasso recalls: "Nearly every evening either I came to Braque in his studio or he came to me. We both simply had to see what the other had done during the day."

The closeness of the two artists led to the fact that the subject matter they selected was identical. Thus they were occupied in the winter of 1908–1909 with the subject of still life, taking up one of Paul Cézanne's primary subjects. And here it must be noted that Braque had formerly been concerned predominantly with depicting landscapes, while Picasso felt a connection to the human figure.

Salon Cubists – Gallery Cubists

The works of the other Cubists appear in exhibitions beginning only in 1910. Albert Gleizes, Fernand Léger and Jean Metzinger presented their current work in the Salon des Indépendants. Metzinger stood out here with the first Cubist portrait, which he had made of Guillaume Apollinaire.

They experienced their public breakthrough as a "group of cubistically working artists" in 1911 at the Salon des Indépendants already mentioned above, along with Robert Delaunay, Marie Laurencin, Henri Le Fauconnier and others. According to Apollinaire's description, "Room 41 which was reserved for the Cubists" left "a deep impression on the public". Today the exhibition is considered Cubism's first group manifestation.

After this presentation the Cubists were divided into two groups: those in the exhibition who were referred to as "Salon Cubists" – Delaunay, Gleizes and Metzinger – as opposed to the "Gallery Cubists" Braque and Picasso. Braque took

part one last time in an exhibition of the Salon des Indépendants in the spring of 1909. Then he joined Picasso's decision to no longer exhibit in the Salons. After that, works by Picasso and Braque were only to be seen in exhibitions at the galleries of Kahnweiler and Vollard, and in various exhibitions abroad.

Kahnweiler's Artists

To Braque and Picasso, Daniel-Henry Kahnweiler was more than just a gallery owner. As a scholarly author and exhibition curator he was also largely responsible for disseminating Cubism as an art style. Over the course of time close friendship bound him to both of them. In 1915 Kahnweiler began work on his book *The Rise of Cubism*. Besides the 1912 publication *On Cubism* by Albert Gleizes and Jean Metzinger, it is one of the groundbreaking publications about Cubism from that time.

In 1907 at only 22 years of age Kahnweiler, who had been born in Mannheim and who, in 1902 at the instigation of his parents, had travelled to Paris to apprentice with a stockbroker, opened his own gallery in the city. Located in the Rue Vignon, it was about 4 x 4 metres in area and had previously served as a tailor's studio. After attending the Salon des Indépendants in March of that year, Kahnweiler acquired paintings from the artists involved, including works by de Vlaminck,

van Dongen, Signac and Braque. Soon thereafter he concluded his first exclusive contracts with Derain, de Vlaminck and Braque.

In May 1907 a young man visited Kahnweiler in the gallery, whom he described as "small, stout, badly dressed… but with wonderful eyes". The following day the young man came again, this time in the company of another gentleman. The two turned out to be Pablo Picasso and the art dealer Ambroise Vollard, who maintained a gallery in the Rue Lafitte and who represented Cézanne, Gauguin, Renoir and Picasso, besides other well-known artists.

Kahnweiler visited the artist for the first time in July 1907 in his studio at the Rue Ravignan, and was thus one of the first viewers of the *Demoiselles d'Avignon*. He became Cubism's most important art dealer, and through exclusive contracts he secured for himself as *marchand de tableaux* the entire production of the artists he represented.

At the beginning of September 1908, after returning from L'Estaque where he had spent the summer, Georges Braque handed over a series of new works that he had created there to the jury of the Salon d'Automne. The work was rejected by the jury. Even after attempts by two jury members to nonetheless allow two pictures, Braque withdrew all the paintings. Kahnweiler thereupon offered him a solo exhibition in his gallery. The presentation took place from 9 to 28 November 1908,

Fernand Léger
The Balcony
1914, oil on canvas, 130 x 97 cm (51¼ x 38¼ in.)
Kunstmuseum Winterthur

comprised 27 works and was accompanied by a small catalogue for which Apollinaire wrote a foreword.

In the same year Kahnweiler bought about 40 paintings from Picasso and he decided in agreement with his artists to present no more solo exhibitions after the end of the year, but simply to hang the works. No more advertising would be done for the gallery; instead, its reputation would be supported solely by word-of-mouth propaganda and a few loyal clients.

In the autumn of 1910 Picasso began to paint a portrait of Kahnweiler, who visited him in his studio for about 20 sittings. Kahnweiler placed Picasso under contract for the first time in 1911. They agreed upon a three-year term.

Analytical Cubism

During early Cubism from 1907 to 1909 the pictures of Picasso and Braque acquired a reality of their own in which they were no longer constrained by central perspective, naturalistic body forms or local colour of the represented object. Many paintings united several perspectives from positions the artist had taken while viewing the subject. The subjects of the pictures thus became art objects and Guillaume Apollinaire stated appropriately: "Cubism differs from earlier painting in that it is not an art of imitation, but an art of imagination."

Analytical Cubism dates from 1909 to 1912. The style remains primarily characterised by the works of Picasso and Braque. Their motifs are not only portrayed from various perspectives simultaneously but are also fragmented into smaller forms, which let them become set pieces of a physical whole. In 1910 Michel Puy wrote: "Braque embodies the most extreme theories, which he then carries to further extremes. He reduced the universe to the simplest geometrical lines in space. He saw landscape through the chemist's retort..."

Picasso also carried the fragmentation of an object into smaller forms into the work's readability: "One sees a picture only in sections; always just one section at a time: Thus for example the head, not the body, if it is a portrait; or the eye, but not the nose or the mouth. Therefore everything is always correct. Each deformation is correct, for exactly that reason."

Orphic Cubism

The works of Robert Delaunay and Fernand Léger created around 1911 make particular use of the design principles of colour, light and dynamics. In a series of treatises about Cubism this has led to a further distinction for Orphic Cubism being made. In 1908 Léger had already settled in La Ruche (the beehive), the artists' colony on Montparnasse. There he met Guillaume Apollinaire, Robert Delaunay and many others. In 1910 these people

Juan Gris
The Breakfast
1915, oil and charcoal on canvas,
92 x 73 cm (36¼ x 28¾ in.)
Musée national d'art moderne,
Centre Pompidou, Paris

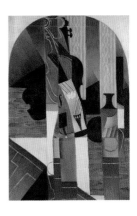

Juan Gris
Still-life (Violin and
Ink Bottle on a Table)
1913, oil on canvas,
89.5 x 60.5 cm (35¼ x 23¾ in.)
K20 – Kunstsammlung
Nordrhein-Westfalen, Düsseldorf

introduced him to the Kahnweiler gallery and there he became acquainted with the works of Braque and Picasso.

Juan Gris was Picasso's studio neighbour. His early work proves in an exemplary manner the tremendous effect Cubism had on younger artists of the time, whose production then provided new impulses to late Cubism. Gris' intellectual abilities gave a theoretical basis to the movement that had not been formulated until then. In his painting Gris summarised Cubism's developments and achievements.

Synthetic Cubism

After approximately 1912 the Cubists' artistic techniques changed immensely. The pictures again become more readable. In the so-called Synthetic Cubism phase from about 1912 until 1914, artists such as Braque, Picasso, Gris and Léger started with abstract picture elements and composed these into new motifs. The papier collé technique was invented, which can be seen as the basis for all subsequent collage techniques all the way to the readymade.

With Georges Braque's picture *Fruit Dish and Glass* the first papier collé was created. The work was produced during Braque's summer stay in Sorgue in the South of France at the beginning of September 1912. Braque later recalled that by complete coincidence during a stroll through Avignon he had discovered a roll of paper with an imitation oak-wood pattern in the display window of a wallpaper store. He said the material laid out in the shop window had inspired him to consider how he could employ it in his artistic work. Before his first attempts Braque waited until Picasso had left for Paris, where the latter had to supervise the move into his new studio. Braque then bought a roll of the paper and created the picture *Fruit Bowl and Glass* as well as a few further papiers collés before Picasso returned from Paris.

Following the use of imitation wood paper, the step of inserting further materials and found objects into the pictures was not great. Soon Picasso also began to experiment with Braque's newly discovered technique. In October 1912 he wrote to Braque: "I am availing myself of your newest paper and sand process. Right now I am devising a guitar and am using a little earth on our hideous canvas."

From this point on, paper, newspaper, wallpaper, imitation wood grain, sawdust, sand and similar materials appeared in the Cubists' pictures. The boundaries flowed freely together between painted and real subject, all the way to object. The pictures worked in this way acquire a tangible, material character that creates a new pictorial reality: the reality of the picture.

Interdependencies: Cubism and Journalism

Albert Gleizes and Jean Metzinger were known as early theoreticians and artists of Cubism, but they were not close to Picasso and Braque, who wouldn't admit them to their studios. It is therefore not surprising that from Gleizes' and Metzinger's point of view neither Picasso nor Braque had played a decisive role in the development of Cubism as an artistic style.

Picasso paid close attention to the literature published about Cubism. In October 1912 he wrote to Braque, who was staying in Sorgues: "Apparently the book by Metzinger and Gleizes has already appeared, and the one by Apollinaire will appear in a few days. Salmon has also written a book about painting. He treats you with outrageous injustice."

Despite his closeness to the artists of Cubism, Apollinaire's statements met with relatively little acceptance. When in 1913 he published a collection of essays about the Cubists, Picasso informed Kahnweiler: "I have received Apollinaire's book about Cubism. I am really depressed by all of this drivel." Apollinaire learnt of the criticism and wrote to Kahnweiler: "Thank you for your subscription to my book. – On the other hand I have heard that you found my statements about painting uninteresting, which I find strange on your part. – As a writer I have solely supported painters who you yourself have discovered after I have. And do you think that it's good to attack someone who on the whole is the only one who can create the foundation for future artistic understanding? In such a case he who seeks to destroy will be destroyed, for the movement that I support is not finished; it cannot be stopped and everything that is undertaken against me can only fall back on the movement itself. Take this as the simple warning of a poet who knows what must be said, who knows who he is and what others are in matters of art."

The First World War

With the outbreak of the First World War the situation for the artists changed abruptly. Many of them were conscripted to military service. The exchange of information between the artists and their friends came to an almost complete halt; information often only still flowed if it was passed on by third parties. Juan Gris informed Kahnweiler on 30 October 1914 (from Collioure): "Matisse also writes from Paris, that...Derain is on the front, that de Vlaminck is painting in Le Havre for the army and that when the war broke out Picasso withdrew a large sum, talk is of 100,000 francs, from a bank in Paris... I have no news of Braque, who interests me the most." Braque, who was promoted to lieutenant in December 1914, suffered a severe head wound in 1915, and after

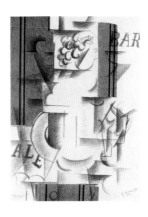

Georges Braque
Fruit Dish and Glass
1912, charcoal and
papiers collés,
62 x 44.5 cm
(24½ x 17½ in.)
Private collection

surviving an operation required more than a year to recover.

Cubism as an independent artistic style was lost in the confusion of the First World War. The war also broke up the deep friendship between Picasso and Braque, whose personality had changed as a result of his severe head wounds. After the war the protagonists of Cubism, above all Picasso, Braque and Léger, surmounted their previous achievements. They devoted themselves anew to the human figure and realism in their work.

Picasso recalls his farewell to Cubism: "They wanted to make a type of physical culture out of Cubism. Thus you saw weaklings who suddenly began acting important. They imagined that reducing everything to a cube meant elevating everything to force and greatness. Out of this arose an overblown type of art, without a real relationship to the logical work that I aspired to do."

The Reception of Cubism

With the exception of a few gallery presentations and the Salon exhibitions in the spring and autumn there were few possibilities of seeing the Cubists' current works in Paris and France. Beginning in 1910 Kahnweiler sent works by the artists he represented to avant-garde exhibitions abroad. The *Sonderbund* exhibitions in Germany offered an important forum, and in 1910 a Munich gallery presented an exhibition with works from both artists. Works by the Salon Cubists around Gleizes could be seen in the recurrent exhibition *Knave of Diamonds* in Moscow from 1912 onwards, and *Moderne Kunst Kring* in Amsterdam the same year united works by Braque, Gleizes, Léger, Metzinger and Picasso.

Despite the slowly growing acceptance of Cubist art, exhibitions of the work provoked violent criticism again and again. In the 1912 Salon d'Automne new pictures from Gleizes, Léger and Metzinger were displayed. A Paris city councillor reacted to them with extreme agitation and questioned the use of a public building by "a gang of evildoers, who behave like apaches in the art world". A socialist member of parliament even went so far as to label the Salon d'Automne as a joke "in the worst possible taste". He called the exhibition an event "which risks compromising our marvellous artistic inheritance. And the worst is that it is mostly foreigners who knowingly or unknowingly bring our French art in our national temples into discredit."

Despite the relatively low public acceptance of the Cubists the interest of other artists in their work was great. This could be seen from the studio visits of artists among themselves and the influence of Cubist design methods beyond Cubism. For example the Futurists Gino Severini, Umberto Boccioni and Carlo Carrà visited Picasso's studio.

Vladimir Tatlin
Model for the Monument
to the Third International
1919 (reconstruction 1979),
wood, steal and glass,
420 x 300 cm (165¼ x 118 in.)
Musée national d'art moderne,
Centre Pompidou, Paris

After his meeting with Picasso, Boccioni was inter-
ested in learning all the new developments, and in
the summer of 1912 he wrote to Severini in Paris:
"Procure all news about the Cubists and of Braque
and Picasso… Go to Kahnweiler and see whether
he has photos of newer works (which have been
created since my departure), and purchase one
or two of them. Provide us with all information
that you can obtain." In the first half of April 1914,
Vladimir Tatlin visited Picasso; Jacques Lipchitz
acted as interpreter.

In retrospect, Cubism had considerable influ-
ence on the later movements of importance in
the 20th century, particularly on Italian Futurism,
Rayonism and Suprematism in Russia; French
Orphism and Purism; the Blauer Reiter in Ger-
many; the De Stijl movement in the Netherlands;
and finally on the internationally spread Dadaist
movement and all Constructivist art. Almost all
leading artists of the first half of the 20th century
were influenced by Cubism during their early
years of production and their works were shaped
by its discoveries and compositional forms.

In 1922 Alexander Archipenko summarised:
"One can say that Cubism had created a new
cognitive order in respect of pictures. The viewer
no longer takes delight; the viewer is himself cre-
atively active, and speculates and creates a pic-
ture by building upon the plastic characteristics
of those objects that are sketched out as forms…"

Pablo Picasso

b. 1881 in Málaga, Spain
d. 1973 in Mougins, France

In the year 1906 Pablo Picasso developed his first ideas for *Les Demoiselles d'Avignon*, a pioneering picture for Cubism. That spring out of dissatisfaction Picasso had already broken off a portrait sitting with the American authoress Gertrude Stein, with whom he was friends. She and her brother Leo were committed collectors of his work. He finished the picture during the summer of 1906 in her absence, by portraying her face with features similar to those of an Iberian mask. The faces of the five women in the picture *Les Demoiselles d'Avignon* – all of them women of pleasure in a Spanish bordello – are also all reminiscent of masks.

They pose naked in a stage-like setting before a coarsely structured cloth that resembles a curtain. They present themselves frankly to the viewer: They stand upright, thereby touting their breasts with raised elbows, or sit with legs spread. Only the second figure from the left and the central figure cover themselves partly with a light-coloured cloth. The body forms of the represented figures are angular and unproportionally arranged: breasts of shadowed diamonds, the pelvis no more than a triangle, over-dimensional hands and feet.

Their faces cannot be interpreted in perspective. One of them combines both a frontal and a side view. The eye region of the figure sitting on the right is displaced; the colouration of the face resembles a painted-on mask. A still life of fruit, in colours matching the rest of the picture, lies in the lower central portion of the picture. "Fleshy" colours fluctuating from ochre to pink dominate, set against white and blue. The picture's readability is hampered by changing perspectives within the figures, by unnatural proportions and by the flat, masklike faces.

The title refers to the so-called Maisons d'Avignon, the houses of pleasure in Avignon Street in Barcelona. Picasso, who had lived there before Paris, allowed memories of it to flow into this picture.

The painting *Les Demoiselles d'Avignon* met rejection even among Picasso's closer circle of friends and collectors, since some rejected the representation of a bordello scene – with its emphasis on carnality and nakedness – in unusual proportions and perspectives. The picture's unusually large size stresses the artist's unorthodox way of looking at things for his time. Leo Stein felt the painting to be a "terrible muddle" and Derain is said to have remarked, "One day Picasso will be found hanged behind his large picture." According to Derain, this painting appeared "somehow crazy or hideous to everybody".

Initially, the title of the picture was *Le Bordel d'Avignon*. An early study for *Les Demoiselles d'Avignon* shows the picture with two further figures, probably male visitors of the establishment, surrounded by female figures that seem rather static. Nothing was yet to be seen of the mask-like design of the heads. As early as March 1907, Iberian sculptures in the Louvre had aroused Picasso's interest. Shortly thereafter he acquired two Iberian heads from the art dealer Géry Piéret, and a visit to the Musée Ethnographique in the Palais du Trocadéro also contributed to Picasso reworking three of the five female figures.

Picasso first exhibited the picture publicly for a short time in 1916. In 1924 through the mediation of André Breton it went into the collection of the Fashion Designer Jacques Doucet, and finally in 1939 into the Museum of Modern Art in New York. Only here was the significance of this picture to the history of art adequately reflected in its presentation and representation.

(A. G.-T.)

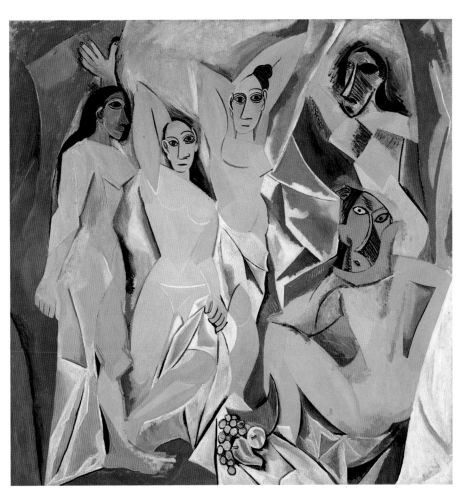

Les Demoiselles d'Avignon
1906–1907, oil on canvas,
243.9 x 233.7 cm (96 x 92 in.)
The Museum of Modern Art, New York

Georges Braque

b. 1882 in Argenteuil, France
d. 1963 in Paris

Among the artists with whom the collector Daniel-Henry Kahnweiler opened his famous gallery in Paris in spring 1907 was also Georges Braque. It was Kahnweiler who introduced Braque to Picasso – a meeting that has been called the hour of birth of Cubism. That same year, Braque began to abandon the approach of Fauvism. While participating in the Salon d'Automne he marveled at a Cézanne retrospective, which confirmed him in his intention to consolidate forms on the picture plane. Spring 1908 consequently saw Braque's first Cubist works, which were probably not coincidentally devoted largely to the motif repertoire of landscape.

Since 1907 Braque had been staying in L'Estaque, a town on the coast near Marseille where Cézanne had also occasionally lived. The landscape compositions he produced there included the one illustrated, which is dominated by a nearly monochrome palette – primarily shades of grey with a few accents of green and ochre – and makes a virtually gloomy impression. However, this tonal range merely echoes certain earlier associations of subjective moods with the genre of landscape. Otherwise, the small painting is largely "objectified", that is, reduced to simple cubic or facetted configurations based on intrinsic laws. Nature, said Braque in words reminiscent of

Cézanne's credo, must not be imitated, its appearances not be slavishly copied. Instead, the structural principles underlying appearances must be expressed in analogous formal structures.

Braque submitted the landscapes created during the summer months of 1908 to the Salon d'Automne in Paris. Their evaluation led Matisse to the description of a picture made up of little cubes: It was this comparison that prompted the critic Louis Vauxcelles to call the new art style Cubism.

In 1910, Braque's *Landscape* was on view in the second exhibition of the New Artists Association in Munich, the group from which the southern German Expressionist group Der Blaue Reiter would soon emerge. The idea of showing the Parisian Fauvists and Cubists in Munich surely went back to Wassily Kandinsky, a Russian artist active there at the time and one of the founders of Der Blaue Reiter. While Braque's pre-Cubist and Cubist works – identifiable landscapes despite their abstracting tendencies – found a great resonance among many members of that group, Kandinsky, its most important representative, rapidly abandoned every objective reference and trod the path to pure abstraction. In this process too, landscape played a cardinal role as point of departure and catalyst. (N. W.)

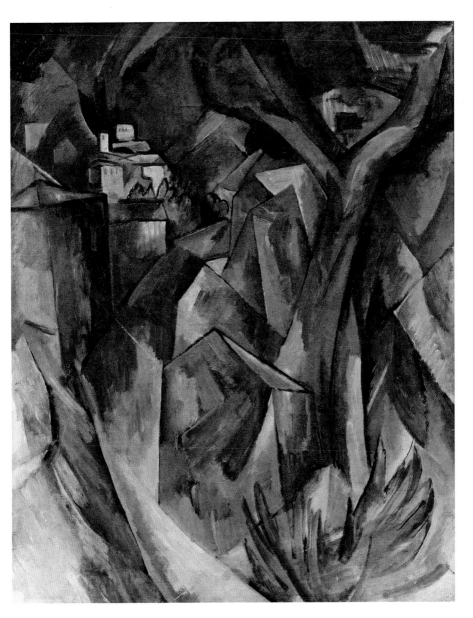

Landscape
1908, oil on canvas,
81 x 65 cm (32 x 25½ in.)
Kunstmuseum Basel

Robert Delaunay

b. 1885 in Paris, France
d. 1941 in Montpellier

"I live. Art is a way to enjoy oneself or to live, and that's that." — **Robert Delaunay**

Robert Delaunay started on two sequential series of pictures in 1909. One showed different versions of the gothic church of Saint Séverin in Paris, the other views of the Eiffel Tower. In both series Delaunay varied his position and the perspective only minimally or not at all. By the end of the series in 1912, the Eiffel Tower paintings would comprise over 30 pictures, among them oil paintings and works on paper. Delaunay took up the subject again from 1920 to 1930.

For a young artist living in Paris the modern iron construction of the Eiffel Tower, built from 1885 to 1889 and which became a symbol of technical progress in architecture, must have been a fascinating subject. Delaunay records the Eiffel Tower in the picture *The Tower behind Curtains* through a window that permits a view both of the roofs of Paris and of the imposing tower construction. The curtains pulled to the side of the window take up almost half of the picture on its right and left borders. The background of the perspectively distorted architecture is formed by clouds that resemble ascending soap bubbles, and that are in remarkably clear formal contrast to the soaring spike of the tower construction. The view of the Eiffel Tower portrayed within a window frame, in which the window becomes the picture and the picture the window, was the prelude to an extensive series that occupied Delaunay in his subsequent phase of work. Soon thereafter his interest in colours was to take priority above problems of form in his work. This was accompanied by his abandonment of natural, object-bound colouration and manner of representation. After a relatively short Cubist practice Delaunay came to the conclusion: "As long as art does not free itself from the object, it condemns itself to slavery."

Delaunay decided upon a pure colour architecture for which Guillaume Apollinaire coined the term "Orphic Cubism", and later "Orphism". Delaunay, who initially rejected the term, defined the new direction as follows: in Orphism, colour relationships are employed as independent construction materials; they "form the basis for painting that is no longer imitative". He states elsewhere: "Colours express performances, modulations, rhythms, counterbalances, fugues, depths, oscillations, chords, monumental accords; that is to say, order."

While the Cubists were creating a sensation with their presentation in the Salon des Indépendants in 1911, Delaunay took part with three paintings in the first Blauer Reiter exhibition in Munich. Even thereafter, Delaunay became an important propagator in the spread of Cubist ideas: In 1912 Paul Klee, Franz Marc, August Macke and Hans Arp visited Delaunay in his studio. Delaunay and Apollinaire in turn met Macke in Bonn. In addition, participation in exhibitions abroad contributed to the international understanding of Cubism.

(A. G.-T.)

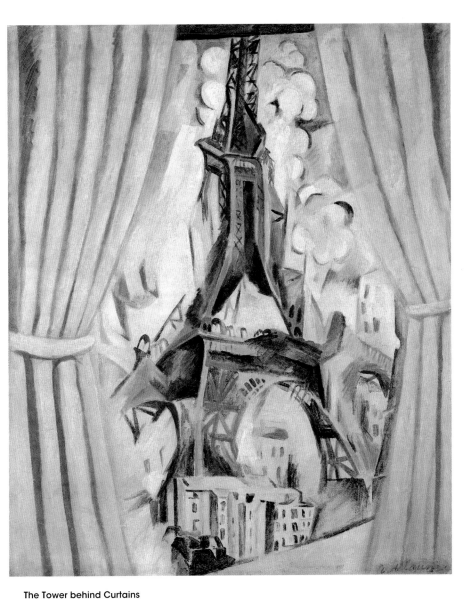

The Tower behind Curtains
1910, oil on canvas,
116 x 97 cm (45¾ x 38¼ in.)
K20 – Kunstsammlung
Nordrhein-Westfalen, Düsseldorf

Marc Chagall

b. 1887 in Liozna, Russia
d. 1985 in Saint-Paul-de-Vence, France

During his stay in Paris from 1910 to 1914, Marc Chagall quickly made contact with the latest avant-garde art styles of the time and began to integrate these into his works. Chagall loved Paris. For the Russian Jew from poor circumstances, the city on the Seine stood for a freedom which he did not know from his Tsarist homeland. For this feeling of freedom, in fact for the Modern Age generally, the Eiffel Tower was the symbol, and Chagall was often to capture it in his works. The light of Paris, which he called *la lumière-liberté*, "freedom light", was for him unique, and it inspired him to create more and more new works of radiant colour. But also boundlessly free for him were the colours and shapes which he saw in the museums and galleries and in the works of the Fauvists and Cubists, works which he found ravishing.

In the winter of 1911–1912 Chagall moved into a larger studio in the middle of an artists' settlement in the 15th Arrondissement. Here he met the avant-gardists Albert Gleizes, Fernand Léger, Amedeo Modigliani and Robert Delaunay, with whom he quickly formed friendly relationships. Delaunay in particular influenced him greatly.

In *The Soldier Drinks*, a painting completed that winter, a man in a green military uniform is sitting at a bar. With the thumb of his right hand, which has taken on the grey of the wall, he is pointing out of the window into a landscape with a colourful log cabin against the menacing red glow of the sky. With the index finger of his left hand he is pointing to his glass, which is standing on the table next to a samovar. The glass is scarcely distinguishable from the background, and also seems to be foundering in water coloured in a variety of shimmering blues. In the foreground can be seen a miniature couple dancing on the tabletop. This is presumably a dream sequence from the soldier's thoughts, made visible in "real" space. It could point to a past event or represent the vision of a future one, for example a reunion with a lover. The figure of the soldier, then, is in two worlds at once. Once again it is a window which allows a view from an inner space to an outer space. It functions as a kind of airlock, a transition between inside and out, present and future, imagined and real.

This painting already unites everything that would later be seen as Chagall's hallmark: strong, luminous colours combined with a magic, symbolic imagery.

(C. O.)

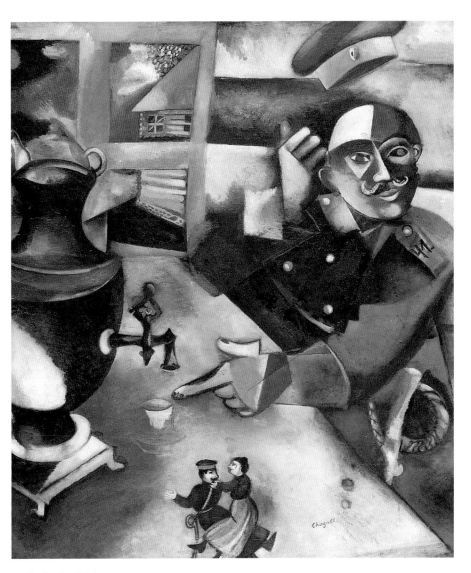

The Soldier Drinks
1911–1912, oil on canvas,
109 x 94.5 cm (43 x 37¼ in.)
Solomon R. Guggenheim Museum, New York

Albert Gleizes

b. 1881 in Paris, France
d. 1953 in St-Rémy-de-Provence

Albert Gleizes had been involved in the important Cubist exhibitions since 1910: that was the year he had participated for the first time in the Salon des Indépendants as well as the Salon d'Automne presentation. In 1911 some of his pictures were to be seen in the *Jack of Diamonds* exhibition in Moscow, and Gleizes also exhibited together with Fernand Léger in the presentation *Les Indépendants* in Brussels. Together with Jean Metzinger he authored the book *On Cubism*, which appeared in 1912 from the Parisian publishing house Figuière, and is considered the first comprehensive publication about Cubism. In their writings, they both stress the difference between the so-called "Salon" and "Gallery" Cubists.

Thus in his text "Chronicles of Cubism" from 1928 Gleizes writes: "Braque and Picasso exhibited only in the Galerie Kahnweiler, where we ignored them." As the group of Cubists he names only Jean Metzinger, Le Fauconnier, Fernand Léger, Robert Delaunay and himself. Moreover he noted: "On the one hand there is the work of a Braque or a Picasso, to whom one must also count Juan Gris; who live and work for themselves, who have already been ensnared by the art dealers, who have gone through the analysis of volume and of the object, and who are getting close to the actual substance of painting, the plastic nature of the flat plane. On the other hand, in the breach, in the midst of the commencing turmoil of battle, are Jean Metzinger, Le Fauconnier, Fernand Léger and I myself; we are internally preoccupied with investigations about weight, density, volume, analysis of the object; we study the dynamics of line; we finally capture the true nature of the plane."

The book *On Cubism* by Albert Gleizes and Jean Metzinger made them more widely known than their paintings had been able to achieve previously. They programmatically state: "At the risk of condemning the whole of modern painting we must consider only Cubism as suitable to lead painting forward. We must see it as currently the only possible conception of compositional art. To express it differently: Cubism at present is painting itself."

In choosing the famous High Gothic cathedral for his painting *The Cathedral of Chartres*, Gleizes selected a prominent building as a pictorial subject, which he depicted in a reduced colour range of grey and green tones. The architectural forms are only very hesitantly reduced or fragmented. The shadows painted in dark green appear to reproduce the real effects of the fall of light.

Although their pictorial language was generally less radical than that of the so-called "Gallery Cubists", Metzinger and Gleizes saw themselves induced again and again to defend their art: "Some people – and not only the least intelligent – see the intentions of our methods as exclusively the study of volume. If they would add that it would suffice to reproduce an outline, since the planes delimit volumes and the lines delimit planes, then we could admit that they were right; but they restrict themselves to a pursuit of the impression of relief, which we judge to be insufficient. We are neither geometricians nor sculptors. For us lines, planes and volumes are only nuances of the experience of abundance. To simply copy the volumes would mean to deny these nuances in favour of an extraordinary monotony. We could just as well immediately renounce our yearning for variety." (A. G.-T.)

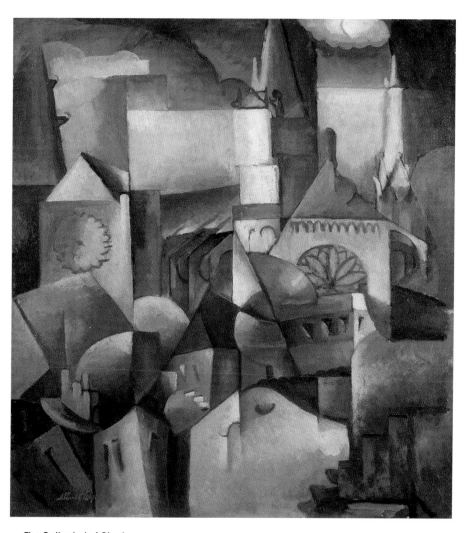

The Cathedral of Chartres
1912, oil on canvas,
73.6 x 60.3 cm (29 x 23¾ in.)
Sprengel Museum, Hanover

Fernand Léger

b. 1881 in Argentan, France
d. 1955 in Gif-sur-Yvette

Smoke
1912, oil on canvas,
92 x 73 cm (36¼ x 28¾ in.)
Albright-Knox Art Gallery, Buffalo

The subjects of Fernand Léger's paintings, which were geared to technology and contemporary life, enrich the Cubist vocabulary of motifs. Léger was receptive and positively inclined towards urban industrial society. In 1913 he emphasised: "Since painting is part of the visible world, it is necessarily a mirror of external conditions and not psychological ones. Every work of painting should contain this value in contemporary life and an eternal value that constitutes its validity, even independently of the epoch of its creation." Léger made this subject matter public in his pictures even before the time of his dynamic Futurist works. In contrast to the analytical fragmentation of industrial forms, which Léger carried out with Cubist stylistic means, his handling of colour must be seen as unique within Cubism.

In 1910, together with his artist friend Robert Delaunay, Léger visited the Galerie Kahnweiler where they saw a number of Cubist pictures: "There, in surprise before their grey pictures, we cried out together with the great Delaunay: 'But these guys paint with cobwebs!' That gave a bit of relief to the situation. When I spoke to Apollinaire and Jacob, I saw the contrast between them and me."

Elsewhere Léger remarked: "Cubism, which is to be understood as a necessary reaction, began as grey in grey and became open to colour only a few years later. But local colour with its far more powerful colour intensity then recaptured its old position. If Impressionism, for example, plays red against blue it doesn't 'colour', rather it constructs, and its frail construction is not capable of fulfilling two functions at the same time (namely those of

colour intensity and hue); the result is 'grey'."
Léger did not necessarily feel secure about his handling of colour, which must be interpreted as contrary to that of the other Cubists. He recalls: "When I had captured the volume the way I wanted it, I began to place the colours. But that was difficult! How many pictures have I destroyed … Today I would be happy to look at them again."

At the end of 1910 or beginning of 1911 Léger left the Parisian artist colony La Ruche. He then lived and worked in a loft studio in the Rue de l'Ancienne Comédie. The series *Smoke over Rooftops* is clearly influenced by the view out of his new window of the Notre-Dame church and buildings in his neighbourhood. This is where he encountered the smoke rising from the chimneys, which gave the picture its name: *Smoke*.

Regarding his vocabulary of form for representing smoke amongst the rigid architecture, Léger wrote: "Contrasts = dissonances, and consequently maximum effectiveness. I take the visible impression of rounded smoke masses rising between buildings and transform this impression into plastic values. That is the best example for the application of the principle of self-augmenting, multifaceted physical dimensions. I place these curves in as diversely eccentric a manner as possible without, however, their unity becoming lost; I interleave them into the hard and dry structure of building walls, of dead surfaces, which nonetheless are made dynamic by the fact that they form a colour contrast with the mass in the middle and a counterpoint to the animated forms: this results in maximum effectiveness."

(A. G.-T.)

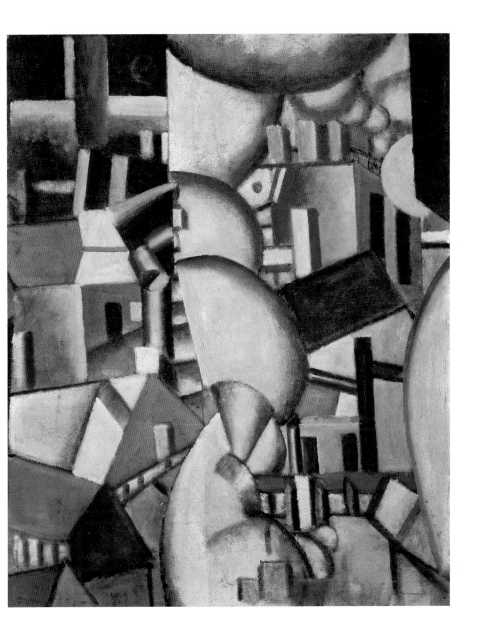

Jean Metzinger

b. 1883 in Nantes, France
d. 1956 in Paris

Albert Gleizes and Jean Metzinger wrote in 1912 in their book *On Cubism:* "To understand Cézanne is to foresee Cubism. Even now we can assert that between Cubism and the previous methods of painting there is only a difference of intensity, and that – in order to assure ourselves of this – we only have to study the process of the interpretation of this reality, which beginning with Courbet's superficial reality, plunges ahead with Cézanne to a deeper reality by pushing back the absolute." Metzinger later qualified these remarks in his text "The Birth of Cubism": "Thus for example while writing our work *On Cubism* Gleizes and I gave in to general opinion and placed Cézanne at the beginning of this way of painting."

Metzinger painted his picture *The Bathers* in 1912. In this year 31 artists joined together to form a Cubist exhibition group called Section d'Or, from the Golden Section theories of proportion. These included, for example, Robert de la Fresnaye, Albert Gleizes, Juan Gris, Auguste Herbin, Fernand Léger, André Lhote, Jean Metzinger and Jacques Villon. Pablo Picasso, Georges Braque and Robert Delaunay did not take part in the movement. Gleizes recalled in 1928: "Also in the winter of 1912 the Section d'Or exhibition took place in Paris, the most important private event of

that time, which united the best forces of the generation who all consented to appear under the banner of Cubism."

Metzinger's painting testifies to the artist's intensive preoccupation with the different variations of Paul Cézanne's *Bathers* as well as with the Cubist depictions of nudes by Pablo Picasso, above all *Les Demoiselles d'Avignon* (1906–1907, p. 131). The bathers from which the painting takes its name, however, occupy only a small section of the vertical format. Two female nudes in front of a landscape can be recognised at the lower edge of the picture. In the upper third of the picture a railway bridge pierces the natural space. Behind it extend a number of architectural details, the outside forms of which in turn become horizons, upon which isolated trees stand.

With *The Bathers* Metzinger took up a motif from art history, which he used to test new design possibilities. True to the stylistic devices of Analytical Cubism, he fragmented the closed volumes of bodies, trees and architecture. Metzinger seems to have included the architectural fragments of a train bridge, which form a pictorial counterbalance to the bathing women, to refer to the diversity of social and technical progress.
(A. G.-T.)

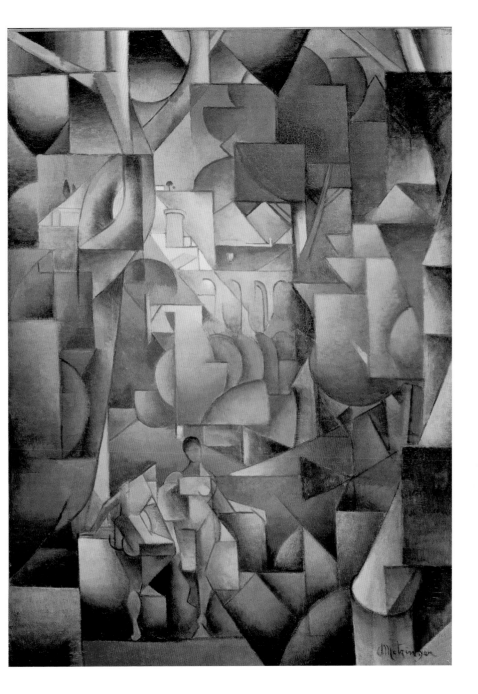

Juan Gris

b. 1887 in Madrid, Spain
d. 1927 in Boulogne-sur-Seine, France

The Smoker (Frank Haviland)
1913, oil on canvas,
73 x 54 cm (28¾ x 21¼ in.)
Museo Thyssen-Bornemisza, Madrid

During August 1913 Juan Gris left Paris and travelled to Céret, where he met Pablo Picasso and the Spanish sculptor Manolo. During this time Gris began an intensive exchange of letters with his dealer Daniel-Henry Kahnweiler. Kahnweiler used the letters, which he quoted in excerpts, for his famous book *Juan Gris. His Life. His Œuvre. His Writings*, which appeared in 1946 in the Paris publishing house Gallimard.

By Kahnweiler's estimation, Gris' work gained in simplicity and clarity during his stay in Céret. About the pictures that the artist brought back with him from his summer sojourn, Kahnweiler noted: "How strictly Gris adhered to the theories to which his reflections had led."

The Smoker is one of the pictures created in Céret. Intensely bright colour planes are arranged around an imaginary picture centre, which is approximately at the height of the nose. Dismembered fragments of a head can be quickly recognised such as, for example, an eye with eyebrow, the auricle of an ear and a hat. The hat appears composed in black in the left half of the picture, interrupted by a green plane of colour, and then formulated in blue somewhat further to the right. This suggests a radius of movement for the head. The white collar at the head's neck is portrayed once frontally, and a second time from the side with the inclusion of a hairline. In this way the picture unites different perspectives with one another and records the movement. The colours are applied without strong shading, so that the colour planes appear to be arranged next to each other equivalently. The surface ornamentation only gains volume if the readable details are pieced together to form a head. Only the smoke of the cigar moves upward without being affected by the segmented colour planes.

The art historian Werner Hofmann stated appropriately: "The problem of making all picture zones equivalent, thus eliminating the formal and objective rank difference between the 'intended' forms and the intervals lying between them; this problem would occupy Analytical Cubism from then on and first experience its solution in the work of Juan Gris."

A sketch created in the design phase of this picture contains a dedication to the American amateur painter Frank Burty Haviland, who had also been portrayed smoking by Amedeo Modigliani in 1914. It is very probable that Haviland was also Gris' smoker.

Following Gris' stay in Céret, Kahnweiler and he became even closer, as the dealer recalls: "From that time on I saw Gris frequently. He often picked me up in the evening from the Rue Vignon and accompanied me to the Place de la Concorde, where I took the Seine steamer to Auteuil. He visited us in the Rue George Sand, and I spent whole mornings with him in the Rue Ravignan… The better I got to know the modest but determined Gris, the greater became my admiration and affection."

(A. G.-T.)

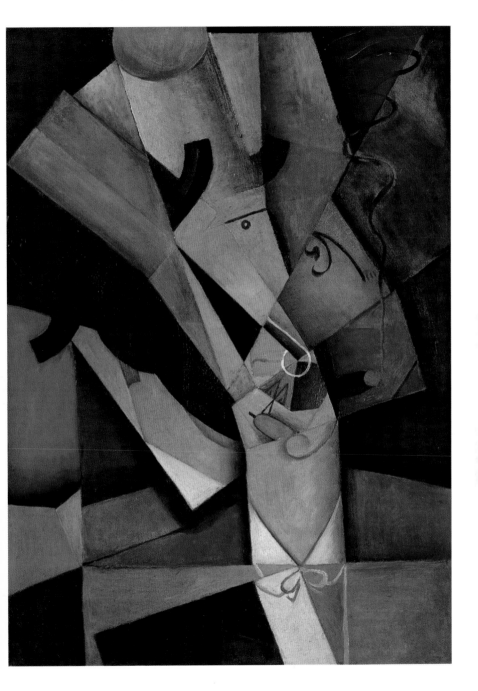

Expressionism –
From Ernst Ludwig Kirchner
to Lyonel Feininger

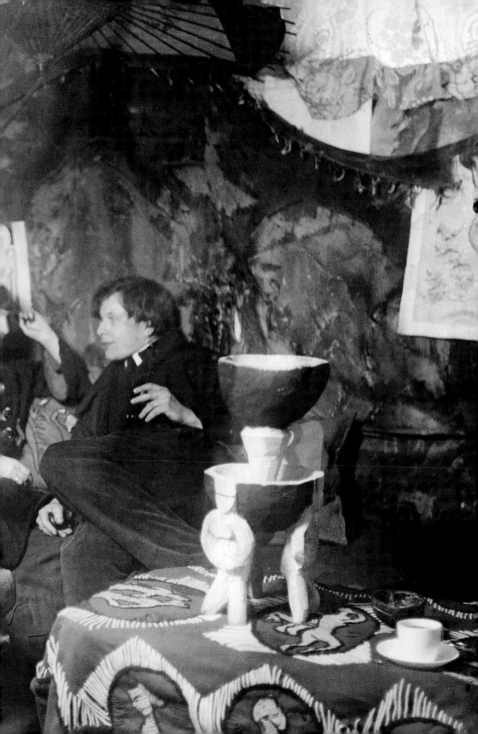

A Metaphysical German Meatloaf

Norbert Wolf

Ernst Ludwig Kirchner
Potsdamer Platz
1914, oil on canvas,
200 x 150 cm (78¾ x 59 in.)
Staatliche Museen zu Berlin,
Nationalgalerie, Berlin

Pages 146–147
Ernst Ludwig Kirchner and his future
wife Erna Schilling in his studio
Berlin ca 1913

Rapturous Birth Pangs

"What does my shadow matter? Let it run after me! I – shall outrun it…" This proud credo was penned in the 1890s by Friedrich Nietzsche in *Thus Spake Zarathustra*. Twenty years later, Expressionist artists took the philosopher they idolised at his word and outran the shadow of academic rules, bourgeois taste and the backward-looking costume plays of Historical Revival art.

The words "expressionism" and "expressionist" first cropped up in the art literature around 1911, initially as blanket terms for avant-garde art in Europe around the turn of the century. Paul Cassirer, the Berlin art dealer, reputedly applied the term to the emotion-charged paintings and prints of Edvard Munch, in order to distinguish the Norwegian's work from Impressionism. The same word was used by art historian Wilhelm Worringer, in the journal *Der Sturm* from August 1911, to characterise the art of Paul Cézanne, Vincent van Gogh and Henri Matisse. At the *First German Autumn Salon* of 1913, Herrwarth Walden introduced the artists group Der Blaue Reiter as "German Expressionists", and thus limited this stylistic category to the German-speaking countries.

This tendency would soon become the rule. A breakthrough in this regard was Paul Fechter's 1914 book *Der Expressionismus*, which focused on the art of Die Brücke and Der Blaue Reiter. In the field of literature, too, the term became current around 1911, and a year later, the first "German Expressionist drama" was staged, in the shape of Walter Hasenclever's play *The Son*.

By the outbreak of the First World War, Expressionism had become almost synonymous with the German contribution to current international developments in art and literature. This national restriction took place despite the great and obvious impulses that German art received from abroad. Although many on the German scene denied such influences, cosmopolitan artists like the Russian El Lissitzky and Hans (Jean) Arp of Alsace saw them very clearly, while scoffing that German artists had only half-digested them. In their book *The Art Isms* (1925) the two authors declared: "Cubism and Futurism were minced up to create mock hare, that metaphysical German meatloaf known as Expressionism."

Nevertheless, the myth had long since been born; or perhaps rather, a myth that had existed since the Sturm und Drang of the late 18th century had received fresh fuel: the supposed prerogative of Germans for the expression of extreme emotional states in art.

Now, about 1905, German artists appeared to be bringing what were seen as their Faustian gifts into modern art with revolutionary verve, finally establishing a counterweight to the French avant-garde in an outpouring from their national psyche.

Ernst Ludwig Kirchner
A Group of Artists
1926–1927, oil on canvas,
168 x 126 cm (66¼ x 49½ in.)
Museum Ludwig, Cologne

In 1920, the creative urge spurred by such mental "buffeting" was evoked by the former Brücke painter Max Pechstein. In an agitated staccato, Pechstein exclaimed: "Work! Intoxication! Brain racking! Chewing, eating, gorging, rooting up! Rapturous birth pangs! Jabbing of the brush, preferably right through the canvas. Trampling on paint tubes…" Shock, provocation, a revolt of the young against the hidebound establishment – these, not only Pechstein believed, were the driving forces behind Expressionism.

A feverish restlessness, an emphasis on the painting process rather than on the creation of serene, self-contained form, a tendency to mysticism – elements of the "German psyche" that seemed to predestine it for the new style. "The Expressionist does not look, he sees," declared Kasimir Edschmid; that is, Expressionist artists were formative rather than imitative minds who shaped their view of the world out of their own volition, who in effect "created" reality by dint of their visionary powers.

What would be gained by taking Expressionism at its word and raising the expression of emotions to the main criterion of good art? In 1917 Herwarth Walden gave a terse definition of Expressionist art, saying that it was not an "impression from outside" but an "expression from inside". Yet again, this definition is not so apt as it might seem. When we think about it, it applies just as well to countless past works of art, from the figures of Michelangelo to the prints of Albrecht Dürer, or from the altar paintings of Matthias Grünewald to the work of El Greco.

Art historians have always had their difficulties in accepting Expressionism as a style. One need only compare the paintings of Kirchner, Kandinsky, Kokoschka and Dix to see that they have next to no formal common ground. This is why many art historians now prefer to describe Expressionism less as a style than as a "tendency", a manifestation of a young generation's attitude towards life. This art can just as much be suffused by urban anxiety as reflect nostalgia for a past Golden Age, a paradisiacal state of innocence. And as frequently as the Expressionists probed new and suggestive forms within the force field of modern art, they just as frequently thought through old and familiar formulas, bringing them up to date, developing them to a radical peak – suggesting that they were not able to outrun that "shadow" invoked by Nietzsche after all.

In fact, Nietzsche himself loomed like a shadow over them. His books were enthusiastically consumed by the younger generation, especially *Zarathustra*. The revolutionary philosopher presented a prime example of self-liberation from authoritarian constrictions, bourgeois narrow-mindedess, materialist thinking. As the poet Gottfried Benn would later recall, Nietzsche "was

the earthquake of the epoch for my generation."
The two most important artists' groups that
appeared in Germany in the years prior to the
First World War, Die Brücke and Der Blaue Reiter,
attempted nothing less than to realise the ideal of
a future existential world order. In their manifesto,
the Brücke artists appealed to a "new generation
of both creators and lovers of art", to anyone who
was capable of expressing "what urges them to
create, directly and without adulteration", as
welcome adepts of a new and progressive religion
of art.

Between Distortion and Abstraction

The dogmas of this art were fraught with contra-
dictions. On the one hand stood means of extreme
subjectivity; on the other, a desire for individual
immersion in and submission to the cosmos. At
the onset of the development, the crucial thing
was to overcome passive depictions of nature
à la Impressionism and tap individual emotional
powers by employing brash bright colours and
"brutally" reduced forms. The laws of perspective,
faithfulness to anatomy, natural appearances and
colours counted for little or nothing; distortion
and exaggeration became an equivalent for ren-
dering the material world transparent to the
psyche. *Concerning the Spiritual in Art* was the
revealing title Kandinsky gave to the book he pub-
lished in 1911. The development of an art of the

psyche, what Kandinsky termed "spiritualisation",
opened to painting the realm of abstract symbol-
ism, a turning point in art history for which both
Kandinsky and Der Blaue Reiter in Munich stood.

A certain overexcitement was characteristic
not of all but of many fields of Expressionist activ-
ity. Recall the agitated figures in Emil Nolde's reli-
gious compositions, the apocalyptic landscapes of
Karl Schmidt-Rottluff, Erich Heckel and especially
Ludwig Meidner, or the masklike, distorted big-
city faces of George Grosz or Otto Dix. Overexcite-
ment also marks the highly contrasting planes or
nervous, angular forms and hatching in the prints,
many of which are among the high points of
Expressionist art. An aesthetic of the ugly and bru-
tal came to the fore. This represented an appeal
on the artists' part to liberate art from the ghetto of
the "beautiful and true", where it had degenerated
into pretty, innocuous decoration for home and
fireside. This aesthetic went hand in hand with an
urge for the "elemental", everything exotic and
primitive, which along with free sexuality were
celebrated as an embodiment of "naturalness"
and the lust for life of Expressionist creation.

As early as 1905, French avant-garde artists
had begun to interest themselves in ethnological
collections and adorned their studios with African
masks and statues from the South Pacific. This
desire for supposed primitiveness served two pur-
poses for bohemians: as a way to revolt against the

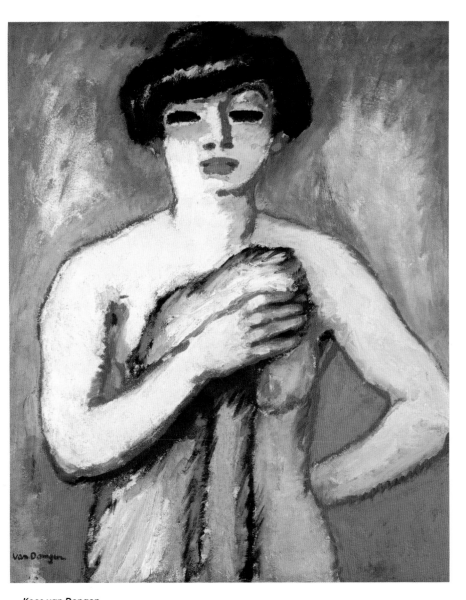

Kees van Dongen
Portrait of Fernande
1906, oil on canvas,
100 x 81 cm (39¼ x 32 in.)
Private collection

Franz Marc
Fighting Forms
1914, oil on canvas,
91 x 131.5 cm (36 x 51¾ in.)
Pinakothek der Moderne –
Staatsgalerie Moderner Kunst, Munich

bourgeoisie, and as a source of presumably un-spoiled principles of design, embodied in the art of the world's indigenous peoples. Masks, fetishes, ancestor figures – along with folk art, children's drawings and the picture-making of the mentally ill – advanced to the centre of artists' concerns.

Nolde set off in 1913 on an expedition to New Guinea. Pechstein considered settling in the Palau Islands in 1914. Aesthetically, such interests result-ed not least in a number of Expressionist carvings. Schmidt-Rottluff's wood sculptures were probably inspired by Carl Einstein's book *Negro Sculpture*, published in 1915. Kirchner, too, created similar works. Museums of ethnology became sources of Expressionist inspiration, as did the performances of "exotic artistes" at the circus or cabarets, or magazine photographs of "Negro combos".

Yet such excessive tendencies were always paralleled by more domesticated approaches. Kirchner's oeuvre can stand for many in this re-gard. Kirchner was not the sheer emotionalist for which he is generally taken. Especially after 1920, the intellectual underpinning of his art became increasingly important to him; he began to sup-press the impulsive factor in favour of a more con-sidered approach. The resulting decorative, flat structuring and serene, monumental composi-tions belied the cliché of the Faustian German modernism favoured by many later authors, who accordingly disregarded this phase of his career

and excluded it from the broad panorama of Expressionism.

Purging the World

In 1926, Ernst Jünger described the mood on the eve of the First World War in retrospect: "War sim-ply had to bring us grandeur, strength, dignity. To us it seemed a masculine act, a merry shootout on blossoming, blood-bedewed meadows. No finer death was there in the world…" Only a few artists, including Pechstein and to some extent Grosz, Meidner and Felixmüller, were immune to this fascination. Barlach and Corinth, in contrast, add-ed their voices to the patriotic choir. War euphoria swept through Europe from end to end.

The Futurists had long since declared war to be "the only hygiene for the world". Marc expected the war to bring a worldwide catharsis and a spiri-tual purging of humankind. Beckmann and Dix volunteered for service; Schmidt-Rottluff looked forward to the chance to "create something as powerful as could be". Yet such exalted visions rapidly gave way to trauma in view of the shell-holed fields, rank trenches and overflowing field hospitals of France and Flanders. Many young artists – Marc, Macke, Morgner – were never to return.

Prior to the First World War, Expressionist ex-periments in form and colour reflected above all individual artists' mental states and moods. Only

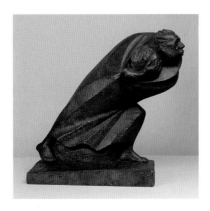

Ernst Barlach
The Refugee
1920, oak sculpture,
54 x 57 x 20.5 cm (21¼ x 22½ in.)
Kunsthaus Zürich

later did they turn clearly to social issues, depicting victims of war, pillorying social injustice or political repression. Now artists began to advance concrete arguments for improving the world. However, only a few, apart from Grosz and Felixmüller, were willing to go beyond the artist's role and engage in actual party politics.

The Expressionist groupings, whether more closely or more loosely knit, all envisaged a community of living and working that partook of Romantic ideals. Naturally they pursued more practical ends as well, especially that of making their work known through group exhibitions and publications. The Brücke painters in particular shared everything, from studios and models to painting materials, partly out of a lack of funds but mainly because fraternal cooperation meant a great deal to them.

Living and working in town was interrupted in the summer months by extended country vacations, where they painted from life, swam in the nude and generally enjoyed themselves with their models and girlfriends. This imitation of an innocent state of nature reflected the artists' yearning for that unity of art and life which had been among the demands of the avant-garde ever since the 1890s. This, too, was an attempt to purify a materialistic world by turning back to the utopia of an earthly paradise.

From the Reservoir of the European Avantgarde

What was the art scene like when the Expressionists came on stage? As a point of departure, let us take prewar Berlin, where Die Brücke moved after their first years in Dresden. Wilhelm II, King of Prussia and Kaiser of the German Empire, felt duty-bound to set the tone in artistic matters as well as political, despite the fact that progressive minds thought he had the taste of "a cook or baker's boy". What this dilettante on the throne enjoyed were the pedantic, overloaded pomposities of Anton von Werner, his court artist. Anything that diverged from painstakingly rendered historical costume scenes or innocuous salon paintings was relegated to the category of "gutter art", from the socially committed prints of Käthe Kollwitz and the earthy Impressionism of Max Liebermann to the absolutely crazy Expressionists and, of course, every foreign so-called "avant-garde". Most of the revolutionary advances in modern art had long since taken place in Paris and had been presented to the Berlin public by audacious art dealers, journals and collectors. The Belgian James Ensor and the Norwegian Edvard Munch, who was long active in Germany, likewise caused a sensation there.

The Expressionists in Berlin and elsewhere welcomed any brand of painting that was based without reserve on subjective experience and its

radical translation into expressive forms and colour arrangements, and that accordingly overcame art's conventional function of representing or illustrating appearances. This held for Ensor, who revealed the depravity behind the masquerade of modern mass society and by so doing deeply impressed Nolde, for one. And this held even more for the symbolistic art of Munch with its expressive graphic abbreviations, which affected the art of Die Brücke especially. Munch's famous *Scream* of 1893 projected all the torments of life into a child's face distorted into an emblematic, unforgettable grimace. Munch's inscription in the fiery red sky is indicative: "Could only have been painted by a madman."

And again and again, it was two "fathers of modernism" who cast their spell over the Expressionists: Vincent van Gogh and Paul Gauguin. The first van Gogh exhibition in Germany, whose significance cannot be overstated, was mounted in 1905, the founding year of Die Brücke, at Galerie Arnold in Dresden. The exotic, if Europeanised, mythical aura of Gauguin's Tahitian paintings, on the other hand, struck the Expressionists as a perfect synthesis of life and art. They admired Gauguin's emotionally moving figures and were inspired by his generous, sweeping planes and his tendency to the daringly decorative – stylistic means, in other words, of the kind which were later adopted in Gauguin's wake by the Nabis.

In 1905, a band of young artists had shocked Paris audiences, labelled by one critic as *les fauves*. Led by Henri Matisse, Georges Rouault, Maurice de Vlaminck and André Derain, they were joined the following year by Georges Braque and Raoul Dufy. A movement that was as influential as it was short-lived, Fauvism might be briefly described as painting rich in colours deployed in luminous, flat planes in which figures and objects were abstracted and reduced to essentials. The colours were released from the task of naturalistic description, and were therefore capable of developing an enormous power of expression. Around 1908, Fauvist painting became widely known in Germany, through the mediation of Die Brücke and the Neue Künstlervereinigung, or New Artists Association, in Munich. Fauvism became an inexhaustible reservoir, from which other Expressionists soon began to draw as well.

The representatives of Der Blaue Reiter tapped a different source: the Orphism of Robert Delaunay. The highly respected Delaunay began with Cubism, yet was bothered by the irrelevance of the studio still life motifs on which Cubist facetting of form was demonstrated. He was intrigued by the vitality and motion of the big city, the simultaneity of its phenomena, its electric lighting and its new perspectives in time and space, which he transformed into dynamic, increasingly abstract painting in exquisitely balanced colours.

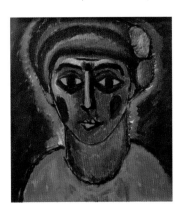

Alexej von Jawlensky
**Head of an Adolescent
Boy (Heracles)**
1912, oil on cardboard,
59 x 53.5 cm (23¼ x 21 in.)
Museum am Ostwall, Dortmund

A 1912 *Sonderbund* exhibition in Cologne reflected the rich spectrum of influences that shaped the development of Expressionism. At its centre stood van Gogh, Munch, Cézanne and Gauguin. Picasso, important for the Expressionists working both in Berlin and Munich, was likewise well represented, as were the Cubists, Matisse and the Fauves. Kokoschka and Schiele were on view, and Expressionists from Die Brücke and Der Blaue Reiter. Munch described the exhibition in a letter of May 1912: "The wildest things being painted in Europe are gathered here…"

Die Brücke

On 7 June 1905, the students of architecture Fritz Bleyl – who, however, was soon to turn his back on art – Ernst Ludwig Kirchner, Erich Heckel and Karl Schmidt-Rottluff formed in Dresden the artists' group Die Brücke (The Bridge). The name went back to a passage in Nietzsche's *Thus Spake Zarathustra*: "What is great in Man is that he is a bridge and not a goal; what is lovable in Man is that he is a passing over and a passing under…" The four viewed themselves as a chosen elite that set out to make "elbow room and free lives" for themselves "in face of the established, older forces", as stated in their founding manifesto. In 1906 Pechstein joined the group, as did Nolde, who, however, left it again only a year and a half later. Otto Mueller became a member in 1910.

The Brücke programme, published in 1906, was an appeal to all progressive makers of art to join forces and bring into being a revolutionary artistic existence. The appeal was too passionate to be satisfied with local effects, and was accordingly directed to artists outside Germany as well. It reached, for instance, Cuno Amiet of Switzerland, who was very knowledgeable about the Parisian scene, and Axel Gallén-Kallela of Finland. In 1908, the Dutchman Kees van Dongen, a Fauvist, joined as an honorary member for a good year. The ardently wooed Edvard Munch at least became a passive member, one of the friends and supporters of the group who wasted no time in becoming active – mounting 70 group exhibitions from 1905 to 1913, in Germany and abroad.

Break up encrusted structures – that was the war cry. When Kirchner and his friends painted from the model in group studio sessions they used to change places frequently. This spontaneous change of viewpoint and their rapid working speed facilitated an almost automatic approach to drawing and a summary painting style, and schooled their eye for simplified, reduced form. Summers were spent at the Moritzburg Lakes outside Dresden, where the group envisaged a harmony of man and nature, a life free of the compulsions of civilisation or, as it were, a Gauguinesque Tahiti at their doorstep. Yet the Expressionist revolutionaries who tried to leave tradition behind still

Emil Nolde
Prophet
1912, woodcut, 32.4 x 22 cm
(12¾ x 8¾ in.)
The Museum of Modern Art, New York

Ludwig Meidner
The Corner House
(Villa Kochmann, Dresden)
1913, oil on canvas on
cardboard, 92.7 x 78 cm
(36½ x 30¾ in.)
Museo Thyssen-Bornemisza, Madrid

looked back in awe to the greats of art history, were susceptible as much to Post-Impressionist and Fauvist influences as to medieval woodcuts. It is surely no coincidence that the styles of the individual group members at this time are hardly distinguishable from one another. They were all fascinated by the art of the South Pacific and sub-Saharan African peoples, which they studied at the Dresden Museum of Ethnology. The black contours, angular figure types, masklike faces and vital poses of the figures in their paintings derived in part from this experience. Kirchner discovered in an English illustrated volume examples of ancient Indian painting and rapidly adapted them to his needs.

The Gauguin exhibition at Galerie Arnold, Dresden, in 1910 provided a further impetus for the group's concern with the modes of perception and depiction of non-European cultures.

In 1911 the Brücke artists moved to Berlin. There Herwarth Walden had just opened his gallery, Der Sturm, and begun publishing the revolutionary journal of that name, one of whose editors was Kokoschka. Through *Der Sturm*, the Brücke artists made contacts with literary Expressionism, and also with the radical anti-bourgeois circle around Franz Pfemfert and his journal *Die Aktion*, established in March 1911. These contacts resulted in a stronger orientation on the painters' part toward issues of content.

Although the Brücke initially remained together in Berlin, divergences in their previous collective style soon became apparent. Each artist began to react in a different way to the moloch of the big city, from which they occasionally, if no longer as a group, fled to various idyllic places: the Moritzburg Lakes, the village of Dangast on the North Sea, Nidden in East Prussia or the Baltic island of Fehmarn. The differences within the group grew, until its final breakup was provoked by Kirchner, as Die Brücke informed its friends and supporters on 27 May 1913.

Der Blaue Reiter

"Munich was resplendent," declared Thomas Mann in his 1902 story "Gladius Dei". He probably meant this ironically, for around the turn of the century the Bavarian metropolis hosted not only relatively progressive, Art Nouveau-inspired tendencies but thoroughly commercialised conservative styles. Still, the art centre was resplendent enough to attract the genius of Kandinsky as the century got underway. Initially an adherent of Jugendstil, the German version of Art Nouveau, Kandinsky returned to his new home in 1906 from the Gauguin memorial exhibition in Paris with many new ideas. These he proceeded to combine with elements of Russian folk art, in which he naturally felt at home. Two years later Kandinsky and his pupil and long-time consort, Gabriele Münter,

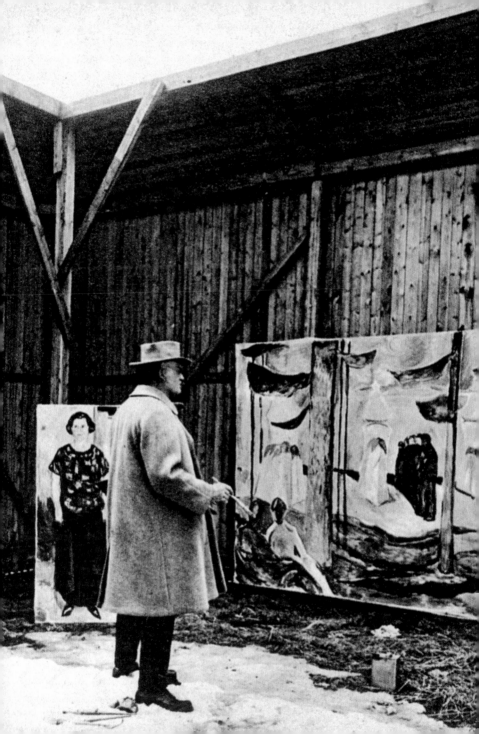

were working in Murnau, Upper Bavaria, studying the folk art of the Alpine foothill region, copying reverse glass paintings and adapting this technique based on flat stylised forms, brilliant colours and strong black contours. And another year later, in 1909, the two artists established the Neue Künstlervereinigung München (NKVM).

The other founding members were Alexej von Jawlensky, Marianne von Werefkin, Vladimir von Bechteyeff, the two future New Objectivity artists Adolf Erbslöh and Alexander Kanoldt, the significant Karl Hofer and finally, Alfred Kubin. Soon the group was joined by others, including art historians, dancers, musicians and literary people. The NKVM, by the way, was the first artists' association to include large numbers of women, as members or guests, a circumstance that was largely the result of Werefkin's strong personality.

Kandinsky, the association's chairman, envisaged a synthesis of all artistic ideals in the sublimating melting pot of the spiritual. Impulses from diverse quarters were welcome. This was illustrated particularly by the second association show at Galerie Thannhauser, Munich, in 1910, which included works by Picasso, Braque, Derain, van Dongen and others. Erbslöh exemplified the international networking of the NKVM at the time, in the way in which he proceeded from Art Nouveau, Post-Impressionist and early Cubist influences to a reduced and concentrated imagery in highly

luminous colours which could stand beside that of Fauvism. Yet Kandinsky, for his part, had already taken the next step. That same year he painted what he programmatically called his "first abstract watercolour" (1913, p. 229).

The press was shocked by the association's show. Franz Marc reacted with a positive review, and at the beginning of 1911 joined the NKVM. Yet that December, plans for a third exhibition led to controversy and a rupture. For spurious reasons the "moderate" faction rejected a largely abstract painting by Kandinsky. In reaction, he and Münter, Marc and Kubin resigned from the NKVM and rapidly arranged a sort of rival exhibition, likewise held at Galerie Thannhauser: *Der Blaue Reiter* (The Blue Rider), 1911–1912, at which Macke, Campendonk, Delaunay and the composer Arnold Schönberg were also represented with pictures. Thereafter the works were on view in several other German cities, including in Berlin, at the Sturm gallery. Walden additionally showed works by Paul Klee and the Russians Jawlensky and Werefkin (both of whom would leave the NKVM in 1912).

During these eventful years Kandinsky and Marc planned an almanac: *Der Blaue Reiter*, published in May 1912 by Reinhard Piper, which would not go beyond one edition. Kandinsky made ten different cover designs, most of them in watercolour. "Both of us loved blue, Marc horses, I riders. Hence the name," as Kandinsky would explain

years later. Conceivably associations with the mysterious "blue flower" which the poet Novalis had placed in the cradle of Romanticism also played some role here. Revealing for the interdisciplinary conception of the almanac were essays that represent some of the most crucial artists' statements of modernism. There was one by Marc, on "The 'Fauves' of Germany", Macke wrote about "Masks", Kubin about "Free Music". Kandinsky contributed an essay: "Concerning Stage Composition". Schönberg wrote an article about music and its relationship to words, and two of his paintings were reproduced in the almanac as well. Kandinsky in particular was deeply moved by Schönberg's compositions and paintings, and saw his dual gift as confirming his, Kandinsky's, theory of the analogy between music and art. "The latest painterly movement", postulated Marc in the almanac, displayed "its fine connecting filaments with the Gothic and the primitives, with Africa and the great Orient, with that so strongly expressive, primal folk art and children's art."

Despite the unity displayed in their yearbook, the artists involved formed no coherent group along Brücke lines. The now-legendary *First Comprehensive Exhibition* of Der Blaue Reiter at Galerie Hans Goltz, in February 1912, was not intended to manifest any common style, but to show "through the diversity of the forms represented, how the inmost desire of artists takes manifold shape". And

this was to be demonstrated on an international level, by the inclusion of pictures by Gauguin, van Gogh, Cézanne, Matisse, the "naive" painter Henri Rousseau, by Delaunay, Derain, de Vlaminck, Picasso, Braque, by various Brücke artists (despite Kandinsky's serious misgivings) and furthermore, by the Russian avant-gardists Mikhail Larionov, Kazimir Malevich and Natalia Goncharova.

Exhibitions by Der Blaue Reiter were on view from 1912 to 1914 in twelve cities, not only in Germany but also in Hungary, Norway, Finland and Sweden. The outbreak of the First World War put an abrupt end to these activities, which were such a crucial breakthrough for modernism. New hope followed the debacle when the German-American Lyonel Feininger, who had been affiliated with Der Blaue Reiter since 1913, joined with Kandinsky, Klee and Jawlensky in 1924 to form Die Blaue Vier (The Blue Four), a group that passed on ideas from the Munich period to the Bauhaus.

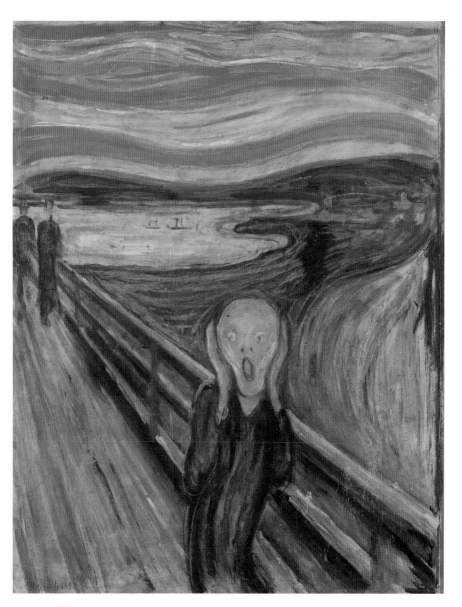

Edvard Munch
The Scream
1893, oil on canvas, 91 x 74 cm (36 x 29¼ in.)
Nasjonalgalleriet, Oslo

Max Pechstein

b. 1881 in Eckersbach, Germany
d. 1955 in Berlin

The Yellow-and-Black Swimsuit is a sensation. The salient stripes of the costume are the only lines in the picture to represent anything non-natural. Otherwise, everything here – the naked figures on the grass, the turbulent sky, the striking trees – is an unbroken weave of light, air and colour: green, red, blue, the Moritzburg triad. The sounds of nature which end abruptly with the zebra stripes of the swimsuit – and draw breath once more! The girl who with childlike calm makes such a striking appearance right in the forefront of the picture is of fragile build and has a bow in her hair. If we are not deceived, it is Fränzi, the Brücke's veritable mascot. While the collective stayed in Moritzburg for the summer, Max Pechstein adjusted his style and choice of motif during these weeks to Kirchner and Heckel like never before or since. In the inspirational community, his style became more complex and at the same time more homogeneous. This is manifested particularly convincingly in this painting.

Since his return from Paris in 1908, Pechstein had lived in Berlin and yearned for live models, "nature before my eyes". So in March 1910, he agreed with Heckel and Kirchner, "that the three of us would work by the lakes around Moritzburg near Dresden. We had known the landscape for a long time, and we knew that there we would have the opportunity to paint nudes in the open air undisturbed… We had to find two or three people who were not professional models and who could thus guarantee us movements not constrained by a studio training." This wish was fulfilled not only by the crowd of girlfriends, but now also by Fränzi, the daughter of a fitter's mate. "We were lucky with the weather: not one rainy day… Otherwise we painters would set out in the early morning heavily burdened with our equipment, and behind us the models with bags of grub and drinks. We lived in absolute harmony, working and swimming."

This summer freedom is reflected in Pechstein's decorative showpiece of the joint "Brücke style". Colour zones fitted together like inlay work gain conciseness in the depth of the picture. Against the glowing yellow aura, the flesh of the girl in the yellow-and-black swimsuit comes across as a luminous red. The phalanx of angular striding nudes is intensified by the lush green of the meadow. Reddish contours circumscribe the dark green of the treetops and the cobalt blue of the sky. In Moritzburg the Brücke fulfilled a dream which was at the same time a social experiment and an artistic statement. Confronting the conventions of society and turning their backs on the academic rules, the triumvirate of Kirchner, Heckel, Pechstein – in a close alliance of style and subject – formulated pioneering pictures of the harmony of the sexes in unconstrained nature. They created those semi-abstract concentrations of form, full of sensuous colour energy, which became the hallmark of Brücke Expressionism. While the abstract avant-garde was setting a course for the "great spiritual" (as postulated for example by Kandinsky), the Saxon *plein air* painters remained true, with their "totally naive pure compulsion to harmonise art and life", to the human figure and the world as the source and goal of their art.

(U. L.)

The Yellow-and-Black Swimsuit
1909, oil on canvas,
68 x 78 cm (26¾ x 30¾ in.)
Brücke-Museum, Berlin,
on loan from private owner

Alexej von Jawlensky

b. 1864 in Torzhok, Russia
d. 1941 in Wiesbaden, Germany

In 1896 Alexej von Jawlensky came with Marianne von Werefkin to Munich, where they met and befriended Wassily Kandinsky. At first the already accomplished artist retained the earthy palette he had learned at the St Petersburg Academy under Ilya Repin, who was then the dominating personality in Russian painting. Yet he soon shook off this naturalistic approach. The catalyst was a confrontation with van Gogh, modern French art – initially the Nabis, later the Fauves – and subsequently with the Dutch artist Kees van Dongen. In 1905 Jawlensky self-confidently announced that after a stay on the Breton coast near Carantec, he had finally managed "to translate nature into colours in conformance with my radiant soul". Ecstatic emotion conveyed through colour, and the ordering force of planar composition, remained the key concerns of this artist, who, like Kandinsky, was esoterically interested and continually pursued the intrinsic essence and harmony of things.

The following years brought numerous international contacts, and above all collaborative work with Werefkin, Münter and Kandinsky in Murnau, followed by participation in the New Artists Association in Munich and – from 1912 – in the Blaue Reiter. Apart from landscapes, representations of heads began to play a prime role in Jawlensky's œuvre.

In 1907 he began to concentrate in a very original way on the effects of colours on a plane surface. The resulting paintings convey the impression that the colours have been veritably stretched across the surface. They are contoured in heavy black lines that both define the figures and set them in vibrant motion, as in the superb *Portrait of the Dancer Alexander Sacharoff*. Sacharoff, a close friend of Werefkin and Jawlensky's, was a pupil at the Académie des Beaux-Arts in Paris from 1903 to 1904. A theatre performance by Sarah Bernhardt impressed him so deeply that he decided to become a dancer. In 1904 Sacharoff moved to Munich, where he would later contribute to the development of eurhythmic dancing. Above all in the 1920s and 1930s, tours through all five continents brought him world fame.

Reputedly Jawlensky painted the portrait at a single sitting, when the dancer, in make-up and costume, visited him shortly before a performance. And Sacharoff is said to have taken the still-wet picture with him, fearing that the artist might paint it over. The sweepingly rendered area of the figure and the made-up face, lasciviously androgynous – possibly Sacharoff was playing a female role – are dominated by the aggressive red of the costume and mouth, and the black contours of figure and coiffure (probably a wig). The greenish shadows in the face are echoed in the brushstrokes that set the background in an enigmatic staccato that seems to reflect the physical energy of the sitter. Jawlensky would later employ the synthesis of formal sensibility and expressive mysticism achieved here to create increasingly abstracted faces, in a sort of stenography of the soul. The colours became less and less naturalistic, the pictorial structure ever more geometric. The transcendental presence of Byzantine icons seemed to have been reborn in a configuration derived from Cubism.

(N. W.)

**Portrait of the Dancer
Alexander Sacharoff**
1909, oil on cardboard,
69.5 x 66.5 cm (27¼ x 26¼ in.)
Städtische Galerie im Lenbachhaus, Munich

Erich Heckel

b. 1883 in Döbeln, Germany
d. 1970 in Hemmenhofen

Pechstein Asleep
1910, oil on canvas,
110 x 74 cm (43¼ x 29¼ in.)
Buchheim Museum, Bernried

Erich Heckel tended more strongly to sentimentality and melancholy than any other Brücke artist. In view of the idyllic landscapes and human images that dominated his work, the group's move in 1911 from Dresden to the hectic big-city pavements of Berlin must have come as a shock. And as if girding himself against the rush of new impressions, he held fast to his previous motifs after that date. Yet the tenor of Heckel's paintings and prints – his woodcuts are among the best that Expressionism ever produced – nonetheless altered. The brushstrokes grew heavier, the contours harsher and the palette shifted from powerful complementary colours to subtle, earthy tones. Tragic figures full of melancholy supplanted carefree people depicted in unsullied natural surroundings.

A short time before the move, Heckel produced one of the most beautiful works of his early period, the present painting of Max Pechstein asleep. The history of this canvas is associated with the name of a modern connoisseur.

Author Lothar-Günther Buchheim began to collect Expressionist paintings, drawings and prints at an early date. In 1951 he founded a publishing house dedicated principally to promoting German Expressionism, which after 1945, when the art business concerned itself solely with abstraction, again threatened to fall into discredit. In 1956 Buchheim published a standard work on the Brücke, followed two years later by a book on the Blaue Reiter. It was also he who rediscovered Heckel's portrait of Pechstein.

At an auction Buchheim acquired a not particularly exciting Heckel painting of 1920–1921 that depicted rather wooden-looking nudes on a beach. Thanks to earlier research, he knew the back of the canvas must contain a masterpiece of Expressionism, concealed under a thick layer of white paint – Heckel's portrait of his artist friend, fallen asleep in a long chair, which he had finished in 1910 in Dangast and which the experts had long considered lost. They knew only the small woodcut based on this composition, which was reproduced in 1910 in the catalogue of the Brücke show held at Galerie Arnold, Dresden. Now the sensational picture finally came back to light.

The brushwork is no longer as furious as immediately after the founding year of the Brücke, 1905, and in the following storm-and-stress period, to 1909. Instead, the frontal figure is rendered in expansive flat planes suffused with intrinsic power and grandeur. On an Italian journey in 1909 Heckel had been confronted with the monumental rigour of Giotto and the Trecento, as well as with the iconic dignity of Etruscan sculpture, and these left their mark on his work. In his Pechstein portrait Heckel also avoided the wild, untamed orgies of colour that had previously dominated much of Brücke art, despite the intense red that determines the overall effect. A general disciplining of painterly means, a tectonic composition and striking figurative formulae now became Heckel's prime aims. Emotional expression continued to play a key role, but combined with well-considered, rationally controlled form. Heckel also addressed the problem of spatial depth in this period, and attempted to solve it by means of geometric reduction and overlapping pictorial planes.

(N. W.)

Ernst Ludwig Kirchner

b. 1880 in Aschaffenburg, Germany
d. 1938 in Frauenkirch, Switzerland

"My work comes from the longing of loneliness. I was always alone." Ernst Ludwig Kirchner, the strongest force of Brücke Expressionism, remained on the trail of the mystery of his own personality right up to his suicide in 1938. He wanted to be an aviator or painter. But torn between self-will and doubt, he was excoriated by internal and external contradictions. Passionate and full of pictures, vulnerable and irreconcilable, arrogant and sensitive, he loved life, art and the "dream". Kirchner was the alpha and omega of the Brücke. It was he who created the programmatic woodcut which publicly announced their appearance on the Dresden scene in 1906. In 1913, it was his chronicle that sealed the end of the group in Berlin. In the intervening period, he was the creator and guardian of the studio as habitat. It was from him that the impulses for new methods and impressions emanated. He faithfully recorded the group's most authentic testimony. The break with his artistic friends was followed by the real caesura in his own life: the Great War. In 1917, Kirchner fled to Switzerland, where he reconsidered his previous œuvre. Just as Kirchner believed he could "love people only through art", he perceived himself solely "through the medium of art". Self-design and self-reflexion are written into his pictures. This is where they can be read and interpreted. In 1910, at the height of the Brücke era, he drew an everyday studio situation: *Self-portrait with Model*. It was followed by a painting. But only the coloured chalk drawing gives any authentic information. Aristocratically, the Brücke's number one appears in a white shirt and patterned gown; in the surge of self-esteem, he can hardly keep his feet on the carpet. The earthy nude model, here casually attired in shirt and stockings, is sitting behind his back, displaced to one side. There is nothing to suggest any artistic work going on. With just a few bold contours, the figurative tension-field of the scene is outlined, and energetically filled out with rich broadsides of the stick of chalk. The pattern of the gown may be interpreted as the resonance form of mental tension. The physiognomy is marked by a ruthless strength of will. It is an expressive snapshot of current mood during the period of the artistic breakthrough in Dresden, homogeneous in its expressive escalation. There is nothing to be felt of "hieroglyphs" and other linguistic confusions of the Berlin days, but only "totally naive pure compulsion".

The corresponding oil painting, however, fell victim in the mid-1920s to the artist's vigorous critique. "Radically restored", like quite a few early works, it testifies today to the "new Kirchner" after the First World War. He updated his artistic intention in a number of stages between the poles of abstraction and the naturalism of the New Objectivity. He thought as little of the one as he did of the other. The painter is seen here conventionally complete with brush, palette and pipe, and has turned the restless pattern of his gown into classical stripes. What the picture loses in vigorous frankness and nervous tension, it gains in precision and in the structural density of its colour fields. The adding of white to the paint generates a creamy mildness. But the painting's magically luminous origin cannot be concealed entirely.

(U. L.)

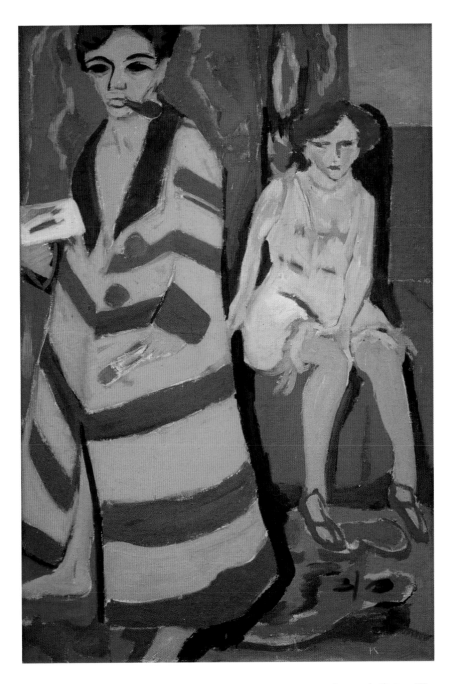

Oskar Kokoschka

b. 1886 in Pöchlarn, Austria
d. 1980 in Montreux, Switzerland

Oskar Kokoschka began his career as a commercial artist for the Wiener Werkstätte, the renowned crafts workshop in Vienna, while he was still a student at the Vienna School of Decorative Arts. His painting style, dominated by Art Nouveau influence, soon began to show features of Expressionism, such as bizarre idiosyncrasies and distortions, as well as a tendency to psychological penetration. The following year, at the Vienna Kunstschau, the young artist's tapestry designs were accompanied by drawings and gouaches of young nude girls that touched off a scandal and immediately made Kokoschka the *enfant terrible* of the Vienna scene. Yet there were others, like Gustav Klimt, who recognised his genius.

Between 1908 and 1912 there emerged a series of portraits in thin oils, applied almost like watercolour washes, and agitated lines scratched with the brush handle into the wet paint, which established his early reputation. In these portraits Kokoschka stripped the mask of centuries of convention from the human image. The facial features appear furrowed, the complexion flecked with various hues and incised or scratched off with a brush handle or fine needle. These portraits, accompanied by similarly structured illustrations and lithographs full of nervous lineatures and physical distortions, amount to a laying bare of the sitter's soul. Their intense Expressionist attack is combined with a refinement of brushwork that also makes them masterpieces of a highly cultivated aesthetic. Kokoschka's Expressionism, as was later often noted, bears "covert Baroque traits". Something ecstatic and visionary indeed suffuses his art, and distinguishes it from that of most of his Viennese contemporaries. This is why his portraits, in particular, are among the most compelling examples of Expressionist art. The nervous blurring of contours, the violent traces scratched into the paint surface, as if in an attempt to plumb the sitter's subconscious mind – some have credited Kokoschka with having "X-ray eyes" and psychoanalytical acumen – combined with a certain morbidity that lies over the faces of the people depicted, amount to a compelling analysis of the intellectual atmosphere of the fin de siècle.

Especially in the early portraits, Kokoschka's analytic eye focused on neurotic or even pathological traits. Even the half-figure portrayal of his patron Herwarth Walden, whom he met in Berlin in 1910 and in whose journal, *Der Sturm*, he immediately published his drama *Murderer, Hope of Women*, appears to reflect an overstrung mind, hypersensitivity or perhaps merely restlessness. Although the reality of the sitter's appearance, one of the main aims of portraiture, is retained, a veil of irrationality seems to lie over the features, as if actual appearances had been abandoned in favour of a spontaneous evocation of inward forces. As in his portrait of Walden, Kokoschka preferred the half-figure portrait type, since it permitted him to underscore the nervous tension of the facial expressions with gestures of the hands, which are usually disproportionately large. The space in the picture, diffuse despite its uniform tone, can be seen as an equivalent to the sitter's state of mind.

(N. W.)

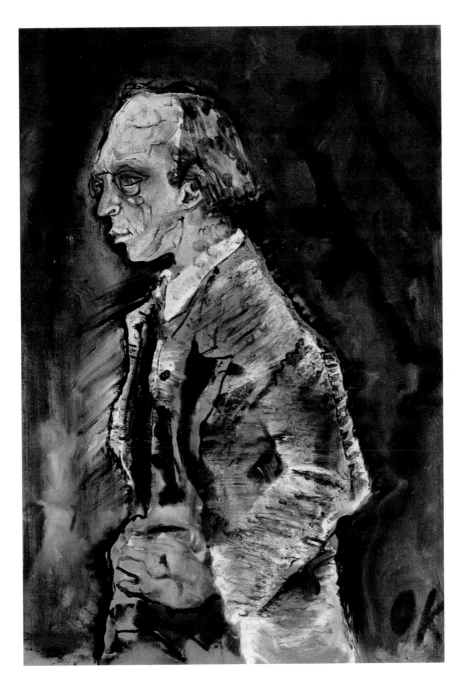

Wassily Kandinsky

b. 1866 in Moscow, Russia
d. 1944 in Neuilly-sur-Seine, France

In his search for new pictorial forms, Wassily Kandinsky also drew some of his inspiration from occult and esoteric sources. His theoretical writings on art contain multiple references to literature of this nature. Symbolists and theosophists such as Rudolf Steiner believed that the truth of the universe was hidden behind a superficial material veil that could be raised through appropriate meditation techniques.

Kandinsky, too, wanted to remove the material (representational) crust that had previously covered art in order to arrive at a new, true, spiritual form of expression. In colour and line, he sought metaphors for the conflict between matter and spirit. What was specifically contained within the "realm of the spiritual", however, Kandinsky could not say. Hence it remained confined to allusions and references at the level of theory, and in the practice of painting to a gradual process of abstraction away from naturalistic motifs towards a pure language of form and colour. *Improvisation 19* marks an important phase in this process.

On the right-hand side of the composition, against a background of varying nuances of blue painted in an energetic hand, stands a group of figures whose black silhouettes rise almost the full height of the canvas. Seemingly assigned to this first group is a second group on the left-hand edge of the painting, whose black outlines stand out forcefully from the background, which is here colourfully painted in reds and yellows. This second group is followed higher up by more figurations, in this case outlined in white. The scene concludes at the top with a large arching line like a threatening cloud. The dominant effect in the picture, however, is the blue that unfolds in a dynamic progression of differentiated tones and which pervades and illumines the outlines of the figures. A dramatic scene appears to lie beneath the composition, for the two groups of figures are brought into relation by the directions assigned to them: while the group of "giants" appears to be exiting the picture towards the right, the second group hovers on the opposite side of the canvas as if anxiously warding off the first – an impression heightened by the pointing gesture made by one of the figures. In the stage compositions to which Kandinsky was also devoting an increasing amount of his time during this period, he gives very precise instructions not only on the lighting but also on the movements of groups of people, which resemble those in this picture: "The people move slowly to the front of the stage as if in a trance and gradually move farther away from each other. As the music fades, the same recitative is heard. Soon they stop as if enraptured and turn around. They suddenly notice the tiny figures still walking over the hill in endless succession." (*Blaue Reiter Almanac*, 1912)

Kandinsky's stage compositions, too, were not concrete narratives that could be retold, but a constantly changing succession of enigmatic situations. *Improvisation 19* creates a similarly ambivalent sense of holding back and setting off, hesitating and hoping; everything is in transition, change and motion. This expresses itself all the more in the movements of the colours, movements that begin in loud, intense colours, extinguish in the spiritual shades of blue and move upwards beyond it. Does Kandinsky hereby wish to depict the transition from the material state to a higher, spiritual one? The mysterious, ritual treatment of colours and forms seems to want to communicate a hope of salvation, a promise of redemption. For according to Kandinsky, humankind stood on the threshold of an "epoch of great spirituality" for which painting, with its new signs and symbols, was paving the way. (H. D.)

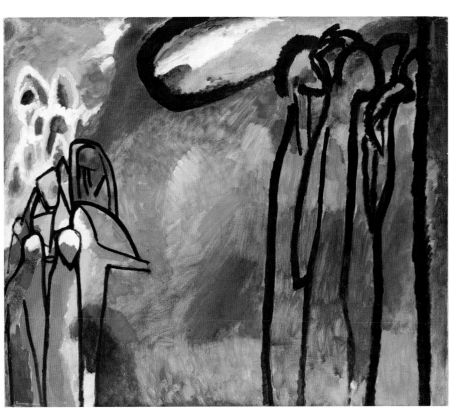

Improvisation 19
1911, oil on canvas,
120 x 141.5 cm (47¼ x 55¾ in.)
Städtische Galerie im Lenbachhaus, Munich

*"Moreover, the more the artist uses these abstracted
or abstract forms, the more at home he becomes in this sphere,
and the deeper he is able to penetrate it. The spectator,
too, guided by the artist, likewise increases his knowledge
of this abstract language…"* — **Wassily Kandinsky**

Franz Marc

b. 1880 in Munich, Germany
d. 1916 near Verdun, France

Blue Horse I
1911, oil on canvas,
112 x 84.5 cm (44 x 33¼ in.)
Städtische Galerie im Lenbachhaus, Munich

Blue Horse I numbers amongst the best-known pictures both by Franz Marc himself and by the Blaue Reiter as a group. A foal painted in blues, its head angled as if meditatively to one side, stands against an unnaturally coloured landscape. The contrasting palette – yellow, violet, red, green and blue – lends the picture a fairy-tale, magical atmosphere, which is reinforced in the lower right-hand corner by the strange agave, a plant that did not grow in Marc's latitudes. In this painting, Marc has taken the decisive step from the "colour of outer appearance" to the "colour of inner essence". Starting from the traditional animal painting, he has arrived at a first emblematic figure, as it were, a symbol for the "spiritualisation of the world". Invoking the imagery of yearning formulated by German Romanticism (as encountered in the symbol of the Blue Flower introduced by the poet Novalis in his unfinished novel *Heinrich von Ofterdingen*), the blue horse symbolised the search for a release from bondage to the material plane and earthly gravity. It embodied, as Marc expressed it in 1914, "the longing for indivisible being, for liberation from the illusions of our ephemeral life". According to Marc, this longing could be stilled only "insofar as I relocate the meaning of my life to the spiritual dimension, the spiritual dimension that is independent of the body, i.e. the 'abstract' ".

This process of "spiritualisation" is propelled in particular by colour, for which Marc evolved his own symbology: "Blue is the male principle, astringent and spiritual. Yellow the female principle, gentle, cheerful and sensuous. Red is matter, brutal and heavy and always the colour to be opposed and overcome by the other two! If you mix, for example, serious, spiritual blue with red, then you intensify the blue into unbearable grief, and conciliatory yellow, the complementary colour to violet, becomes imperative." If you mix red and yellow to make orange, Marc continues, you lend passive, female yellow a positively sensuous power. It then becomes necessary to add cool, spiritual, "male" blue. The two colours love each other: "Blue and orange, a thoroughly festive sound. If you mix yellow and blue to make green, however, you awaken red, matter, the 'earth', whereby here, as a painter, I always feel there is a difference: with green you never quite bring eternally material, brutal red to the same state of calm as with the previous colour sounds. Blue (the sky) and yellow (the sun) must once again always come to the aid of green, in order to silence matter…" (letter to August Macke, December 1910).

Out of the simple and familiar principles of colour mixing, Marc evolves a programme to raise paint colour to symbolic colour. As lofty in his ideals as Kandinsky in his own colour theory, Marc sees colours as the new basis for a spiritual refinement of the material world. They thereby transport his animal symbols to the "altars of a future religion" and make them the vehicles of expression for the "spiritual" – that numinous, unattainable dimension towards which the works and the entire wealth of the Blaue Reiter's ideas were directed.

(H. D.)

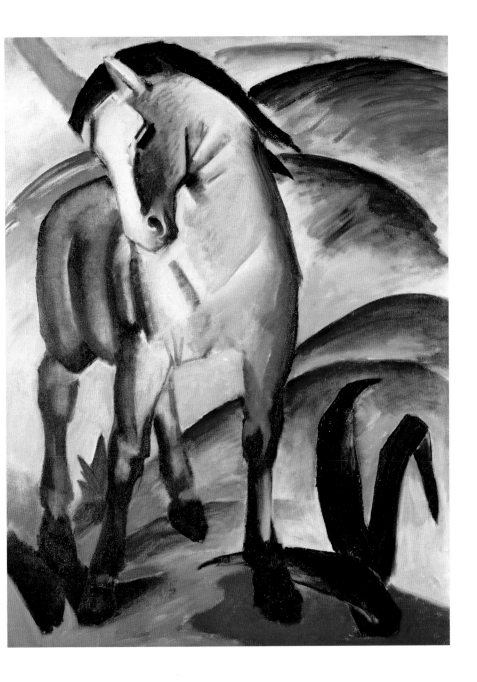

Ludwig Meidner

b. 1884 in Bernstadt, Germany
d. 1966 in Darmstadt

Ludwig Meidner has been called the most expressionist of the Expressionists, but this is true only of a limited part of his total œuvre, which is characterised by numerous caesuras. After studying from 1906 to 1907 in Paris, where he met Amedeo Modigliani, he moved definitively to Berlin in 1908, the city which he described as "the intellectual and moral capital of the world". In 1912, together with two other Jewish artists, he founded the group known as the Pathetiker, whose breakthrough was assisted by Herwarth Walden's gallery Der Sturm. At that time, Meidner, whom George Grosz had described as a restless little man, "like a figure out of one of E. T. A. Hoffmann's short stories", and who, in his youth, had devoured Nietzsche's *Thus Spake Zarathustra*, had begun creating not only his portraits in oils, Indian ink and other graphic media, but also his analytical self-portraits, which, in his own words, were "consciously demonic". All the energy was concentrated in rhythmic lines, zigzag folds, an almost caricature-like exaggeration and in gestures of great pathos.

In Berlin, encouraged by Max Beckmann, an extra component was added in the form of an emergent big-city euphoria, the fascination with a tumultuous and effervescent urban world, which was responsible for, among other pictures, the series of *Apocalyptic Landscapes* up to 1916, on which Meidner's fame was based. These were panoramic fantastical cityscapes, depicted from a bird's-eye perspective, bursting open as if under bombardment from the cosmos. The city in the present painting is the victim of such an infernal catastrophe; ant-like, a few people are fleeing from the exploding stars and the terrestrial conflagration. The tectonic interplay of verticals and horizontals is dissolved in distorted and disparate perspectives and shifted proportions. The whole structure is torn apart by extreme colour contrasts and by diagonals reminiscent of comets' tails.

In this and related compositions can be seen the extent to which Meidner was influenced by the flickering colourfulness and splintered picture backgrounds of the Mannerist El Greco, by the Italian Futurists (whose work could be seen in Berlin in 1912) and by Robert Delaunay's prismatically fanned-out views of the Eiffel Tower. In addition, he was familiar with the photographic double-exposure technique. For the film *Straße*, directed by Karl Grune in 1923, Meidner created the sets, staging a big-city street once more, with collapsing façades, houses seemingly transfixed by deep shadows and the atmosphere heightened yet further by cones of light.

The *Apocalyptic Landscapes* resulted, it is thought, from a premonition of the First World War. This may well be true in part, but above all they were triggered by Meidner's intense involvement with ancient Jewish prophecies of doom and with the New Testament Book of Revelation. In 1918, after the war, he was active in the revolutionary Arbeitsrat für Kunst, a kind of artists' soviet, and by 1923 at the latest he had turned his back on Expressionism and the "modern spirit" and rediscovered the faith of his fathers, orthodox Judaism, to which he gave expression in naturalistic symbolic depictions. Meidner, previously also at home in proto-Expressionist literary circles, and himself a superb writer, was in 1937 branded a "degenerate Jew". From 1939 to 1952 he lived – reluctantly – as an exile in England, before returning to Germany, where in 1964 he received the Bundesverdienstkreuz, the Federal Republic's award for merit.

(N. W.)

Apocalyptic City
1913, oil on canvas,
79 x 119 cm (31 x 47 in.)
LWL – Museum für Kunst und
Kulturgeschichte, Münster

August Macke

b. 1887 in Meschede, Germany
d. 1914 in Perthes-les-Hurlus, France

August Macke, one of the most highly regarded German artists of Classical Modernism, was a wanderer between two worlds. Although his name is inevitably mentioned whenever the topic of Expressionism comes up, emotional excess was not his thing. His art evinces neither the explosive forms, garish colours or primitivism of the kind the Brücke painters loved, nor the sociocritical subjects of Dix or Grosz, nor the brutal ugliness with which the Expressionists enjoyed provoking the philistines. Quite the contrary. Macke preferred to depict civilised urban scenes, well-kept streets and parks, cafés and shop windows, people on an evening stroll – and above all, colourful women's fashions.

In terms of palette and lyrical approach to nature, Macke's works resemble those of Franz Marc, with whom he was befriended from 1910. Yet he did not share Marc's pantheism despite the fact that he, too, was impelled by the vision of an earthly paradise. And although Macke maintained close contacts with the New Artists Association of Munich and contributed to the *Blaue Reiter Almanac* in 1911, he was sceptical of the mysticism indulged in by Kandinsky. This may explain why after moving to Bonn in 1911, he never trod the path to abstraction, apart from a few experiments in watercolour and drawing. Yet there was another new frontier he explored with great success, the frontier that ran between French and German painting. Like no other Expressionist, Macke translated the language of French art into German. And he began to do so at an early date. Already between his studies at the Düsseldorf Academy and a brief stint at the painting school run by Corinth in Berlin (1907–1908), Macke immersed himself in French Impressionism and Cubism, which were later supplemented by impulses from Fauvism. But what shaped him above all was his contact, beginning in 1912, with

Delaunay, which soon led to oils and watercolours of an expressive yet wonderfully harmonious character, always based on impressions of nature, and always taking the effects of light as their point of departure.

This is confirmed by one of Macke's major works, one of the first done after he and his family moved to Hilterfingen on Lake Thun. *Lady in a Green Jacket*, painted on a well-nigh square format, exudes compositional balance. The lady of the title is not only slightly shifted out of the central vertical axis, she is faceless – i.e., exemplary, like all of Macke's figures of that period. Her gracefully elongated figure is flanked by four smaller figures, farther in the background, a couple each to her left and right walking towards a wall, and behind them a panorama with river valley and houses simplified in the early Cubist manner of Georges Braque. The light-flooded foliage of the trees grows together at the top to form a roof accented in greenish-yellow, their limbs regularly branching in a compositional device perhaps taken from the writings of Leonardo da Vinci, in which Macke immersed himself at that period. The whole is suffused by an enchantment that recalls Romantic paintings by Caspar David Friedrich, with whom Macke shared a penchant for figures seen from the back. Spatial values are coordinated with principles of planar order and brought into a fine-tuned equilibrium. Compositional rhythm is established by prismatically broken hues, transparent, vibrating colour contrasts which themselves seem to be the source of light.

When the First World War broke out Macke donned a uniform, and was killed only a few weeks later. In his touching obituary his friend Marc says: "Of us all, he gave colour the brightest and purest ring, as clear and bright as his entire character."

(N. W.)

Lady in a Green Jacket
1913, oil on canvas,
44 x 43.5 cm (17¼ x 17¼ in.)
Museum Ludwig, Cologne

Emil Nolde

b. 1867 in Nolde, Germany (now Denmark)
d. 1956 in Seebüll, Germany

When in July 1905 Emil Nolde returned from Switzerland to northern Germany and the island of Alsen, he stopped over in Weimar and visited a Gauguin exhibition, noting, "I have never before seen such glorious colours in modern art." The exotic realm to which the French artist had escaped became a destination for which Nolde also yearned. Not that he was a Romantic escapist. Rather, he pursued a well-defined artistic goal – to recover the "primal", the source of all creativity that had been buried under the flotsam of civilisation. In 1911 Nolde planned a book on "Artistic Manifestations of the Natural Peoples", in which he intended to confront the ritual objects of the "savages", as he noted in his autobiography, with the "saccharine tasteless forms" exhibited in the "glass cases of the salons". The book was never published. But while preparing it Nolde studied objects by the Egyptians, Assyrians, the indigenous peoples of Africa, southeast Asia and the South Pacific, with which the Berlin Museum of Ethnology overflowed. Two years later the 46-year-old artist took an opportunity offered to him and his wife to accompany a scientific expedition to New Guinea. Their trip took them to the South Pacific by way of Russia, China, Korea and Japan. In addition to numerous sketches and watercolours, Nolde executed 19 oils in the provincial town of Kaewieng, on the northwest point of present-day New Ireland, an island the German colonial administration of the day called New Mecklenburg. One of this group of works is *Tropical Sun,* which was preceded by a small preparatory drawing. Having gone down to the beach, Nolde looked from sea level towards the horizon, where the sun is either rising or setting. The horizon line divides the horizontal format just below its central axis. Visible there is the dark green,

forested silhouette of Nusa Lik island. This undulating form penetrating the composition from the left finds a correspondence in the white cumulus cloud above the horizon and in the foaming breakers in the foreground. The sun stands over the treetops like an incandescent red disc in the midst of a radiant aureole that is surrounded by darker cloud formations. The range of colours, applied for the most part in broad, impasto strokes, rises to a frenzy of vermilion red, cadmium orange and cobalt violet. The individual tones are no longer applied wet in wet as in Nolde's earlier landscapes but spread into expansive areas. Their intensity or brilliance is not to be confused with garishness, as the artist repeatedly emphasised in view of his impressions of the South Pacific. Far from requiring any expressive exaggeration, he said, these colours conformed with actual phenomena in the tropics.

Nolde did not address the First World War in his art. He painted no visions of destruction or apocalyptic landscapes like, say, Meidner. Instead, to his tropical paintings Nolde added northern German lowland landscapes, coastlines and gardens, replying to the vicissitudes of the age by charging nature and religious subjects with an optimistic mysticism. Kirchner described Nolde's art in his diaries as "often morbid and too primitive". He thought Nolde's mysticism diverted his colleague too far from the formal issues of modernism. That same tendency led Nolde to make a grave error in 1933, when he stated that his Expressionist painting was a genuine expression of the "German soul". He was rudely awakened from this dream by the Nazis, who the following year delivered Nolde's paintings over to the derision of the philistines.

(N. W.)

Tropical Sun
1914, oil on canvas,
71 x 104.5 cm (28 x 41¼ in.)
Nolde Stiftung Seebüll, Neukirchen

Wilhelm Lehmbruck

b. 1880 in Meiderich, Germany
d. 1919 in Berlin

Wilhelm Lehmbruck was born near Duisburg, one of eight children of a miner and his wife. Despite difficult circumstances, he was able to attend the Düsseldorf School of Decorative Art from 1895 to 1899. In 1901 he became a master student at the Düsseldorf Academy, where he studied for five years, punctuated by trips to Italy, Holland and England. In 1910 he moved with his wife and child to Paris, where he lived until the outbreak of war in 1914, remaining largely uninfluenced by the formal breakthroughs of the Cubists, some of whom were his friends. In 1915 Lehmbruck was conscripted into medical service in a Berlin hospital. During the war years he produced only a few sculptures, including *The Fallen Man,* which might be considered a symbol of the generation who fell only months after the beginning of First World War at Langemarck in 1914. Between 18 October and 30 November of that year, 45,000 volunteers lost their lives, a slaughter that put an abrupt end to the war euphoria felt by so many Expressionists.

The elongated figure with its almost Gothic silhouette has very little surface texture, and the facial features are not pronounced. What remains is drama of expression. Due to the existential experiences of the Great War, many artists, and most of the Expressionists, lost their faith in the "exalted man" of the type Nietzsche had described and Wilhelm Worringer had advocated in his 1908 dissertation *Abstraction and Empathy.* Lehmbruck, who counted Henri Matisse, Amedeo Modigliani, sculptors Aristide Maillol, Alexander Archipenko and Constantin Brancusi among his acquaintances and inspirers, formulated his protest against the disastrous period in terms of a symbolic, melancholy, introverted formal language.

The man, fallen, despairing, crawls on all fours. But he is not finished yet. He still supports himself on knees, lower arms and head, and still grips his sword. In view of the original title, *Dying Warrior,* the weakened figure with torso extended horizontally over the long base recalls a bridge between life and death – a moving reply to all conventionally heroic war memorials. The figure's elongated slender limbs enclose an interior space, and embody Lehmbruck's credo: "Sculpture is the essence of things, the essence of nature, that which is perpetually human."

Ernst Ludwig Kirchner and Lehmbruck knew each other from 1912 at the latest and lived not far from each other in Berlin. Though their contacts were apparently not close, there is evidence that the Brücke painter knew and appreciated originals by Lehmbruck. So beyond a general Expressionist philosophy, the two probably shared interests, such as dance, which played an eminently important role in both artists' stylisation process. Such similarities led to parallels in their intentions and approaches for a brief period.

Lehmbruck was discharged from the army in 1916 because of a hearing impairment. In 1917 he began to suffer from bouts of deep depression, and in 1919 he put an end to his life.

(N. W.)

The Fallen Man
1915–1916, bronze,
78 x 239 x 83 cm (30¾ x 94 x 32¾ in.)
Pinakothek der Moderne – Staatsgalerie
Moderner Kunst, Munich

Amedeo Modigliani

b. 1884 in Livorno, Italy
d. 1920 in Paris, France

**Nude Sitting on a Divan
(The Beautiful Roman Woman)**
1917, oil on canvas,
100 x 65 cm (39¼ x 25½ in.)
Private collection

The story of Modigliani's life conforms with conventional notions of the bohemian milieu in a veritably tragic way. He lived in Paris, was commercially unsuccessful, but was admired by his fellow artists. When a patron helped him out, he spent the money on drink. He had countless affairs and painted pictures which, for all their modernity, were always concerned with human beings. Then alcohol took its tribute and Modigliani died of tuberculosis at age 35. He had had only one solo show, which was closed after a few hours due to causing public nuisance.

Modigliani's art does not fit seamlessly into the directions of the time. After coming to Paris in 1906 and settling in Montmartre, the artists' quarter, it took him a long while to find his way. In his eyes, Picasso and van Dongen were overwhelming figures out of whose shadow he was unable to step. In 1910 he began to devote himself to sculpture, initially clearly under the influence of his mentor, Constantin Brancusi. With time, however, this relationship became one of give and take, until their paths diverged when Brancusi moved into abstraction while Modigliani remained faithful to reality, the figure. In 1914 he began to paint again, especially portraits and nudes, from the live model whenever possible. And this time, schooled on the new, plastic conception of form, he found his own style.

The reception of his nude paintings was, and still is, coloured by Modigliani's reputation as a bon vivant. The blushing cheeks of his invariably female models are attributed to sexual arousal, and in the case of some of his nudes, lasciviously reclining on a divan with empty eyes, inviting smiles and softly curling pubic hair, not much imagination is needed to reach this conclusion.

The Beautiful Roman Woman, however, wears a loose-fitting slip, sits with legs crossed on the divan and gives us a friendly smile. She coquettishly conceals one breast and lets only part of the other peep out. The vivacious arch of her left thigh over her right leg is the true subject of the composition. This lends it a virtually private air, determined less by overt sexuality than by human warmth. All the more incisive here is a special trait of Modigliani's figures: their eyes. Even in his portraits he frequently left the eyes unpainted, giving them the appearance of dark caverns or greyish-blue introspective gazes. This feature is not unknown in modern art; it goes back to an involvement with sculptures of antiquity or from foreign cultures, in Modigliani's case Cycladian sculptures and Grecian bronzes, whose inlaid eyes are often missing. Picasso's *Les Demoiselles d'Avignon* (1906–1907, p. 131), for example, includes a figure whose left eye socket is black like an eye patch.

Yet the consistency with which Modigliani deprived many of his portraits of a gaze, scratched out or sutured with cross stitches, has something disturbing about it. In *The Beautiful Roman Woman* the contrast is particularly harsh, because she smiles in such a friendly way – and over the mouth there is a complete break with the repainted nose. Seen up close, the eyes have the effect of a scratched mirror mosaic some of whose tesserae have broken out. Here the artist, who throughout his life stubbornly stuck to depictions of the human face and figure, has established an unbridgeable distance between us and our counterpart on the picture plane.

(L. E.)

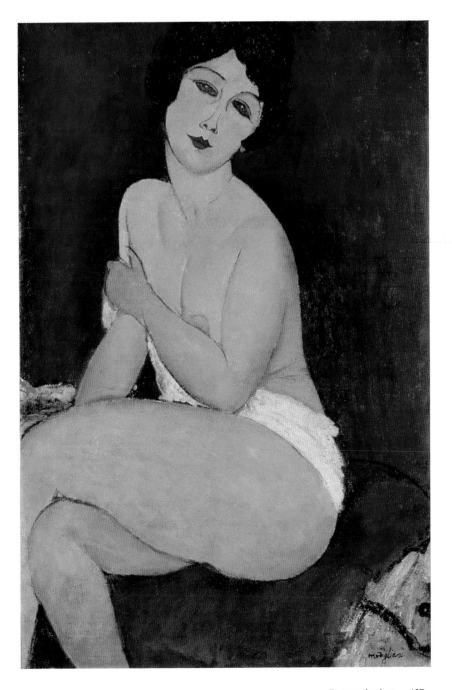

George Grosz

b. 1893 in Berlin, Germany
d. 1959 in Berlin

Even more than his future friend Otto Dix, George Grosz turned his art to political ends – although not in the sense of support for any party line, including that of the Communists, whom he joined in 1918. During his studies at the Dresden Academy from 1909 onwards, he followed the activities of the Brücke with interest, and soon those of the Blaue Reiter as well. Like every young artist in Germany who allied himself with the avant-garde, Grosz was familiar with progressive international developments in art.

In November 1914 he hesitantly registered for war service, but by the time six months had passed, he had become unfit for duty. These six months fuelled Grosz's hatred of war and the military, to which a disgust with war profiteers was soon added. In January 1917 he was reinducted, but only a day later he had to be sent to an infirmary, and a few weeks afterwards was admitted to a mental hospital. During the war years Grosz concerned himself with the subjects of circus and variety shows, crime and murder, war and the big city. The last-named would become a synonym for a world gone out of joint for him.

One of Grosz's most striking works on this theme is *Dedicated to Oskar Panizza*. The aggressiveness of the painting inheres not only in the motifs but in the incandescent reds of the palette and the violent energies that stream through the composition. Even the solid architecture is infused with a compelling dynamism. It recalls the vertiginous spaces and toppling housefronts in the sets of Expressionist films. The seemingly endless street is filled with a milling crowd of Cubistically simplified figures who intersect and overlap one another. In the tumult of pushing, jostling people with masklike faces, everyone seems to have lost all sense of direction.

This big-city scene was intended as a homage to Oskar Panizza, an Expressionist writer and physician whose satirical attacks on Church and State appealed to Grosz, who mixes Futurism and Cubism with a shot of James Ensor to form an overwrought boiling human mass that occupies the borderline between Dadaism and Expressionism. But Grosz's wildly gesticulating mob milling around the coffin on which a schnapps-drinking Death is perched, not only served him as an excuse to evoke urban chaos. He also pointed out its source, in an urban jungle where a tiny church is completely engulfed by nightclubs and bars and office buildings. A highly decorated old army officer brandishes his sword as a moon-faced clergyman pathetically holds the cross on high and a sheep-faced office employee, on the left, demonstrates the herd instinct. The neon sign over the building entrance next to the coffin, "Dancing tonight", says it all – this is a modern Dance of Death. As Grosz himself explained, "In a strange street by night, a hellish procession of dehumanised figures mills, their faces reflecting alcohol, syphilis, plague… I painted this protest against a humanity that had gone insane."

In his later work Grosz proceeded from Dadaism to the sober realism of New Objectivity and a sociocritical Verism, jettisoning Expressionist formulae but retaining their satirical and critical impact. So it was no accident that a "humanity gone insane" soon caught up with him – in 1933 Grosz became one of the first victims of Nazi persecution in the arts. He emigrated to the United States, where he received American citizenship in 1938. After the war Grosz planned to return to Berlin, and died there during a visit in 1959.

(N. W.)

Dedicated to Oskar Panizza
1917–1918, oil on canvas,
140 x 110 cm (55 x 43¼ in.)
Staatsgalerie Stuttgart

Otto Dix

b. 1891 in Untermhaus, Germany
d. 1969 in Singen

When Otto Dix returned to Dresden in 1919 – now as a master student at the Art Academy – he probed new ways to react to a society whose brutality and hypocrisy had become evident in the trenches of the First World War. His Expressionist vocabulary was first supplemented by the montage principle of Dada and its method of sarcastic, shocking provocation, before Verism with its hyperreal attention to detail completely replaced the revolutionary formal pathos of Expressionism in Dix's art.

Yet even after the war, life manifested itself in terms of extremes in the artist's eye. He was intrigued by outsiders, including intellectuals and artist colleagues, but above all it was working people, prostitutes and disabled war veterans who now populated Dix's paintings and prints. He focused mercilessly on the transitory nature of the human body, and created icons of sexual ugliness. The factors of exaggeration, distortion and grotesqueness so important to Expressionism were retained, in one form or another, in Dix's postwar work. His earlier main themes – war and the big city – likewise played a key role in the artist's continuing mergers of disparate elements into a "creative chaos".

Prager Strasse, from which this oil painting with collage takes its title, was Dresden's most opulent street. In Dix's starkly Dadaist scene, it metamorphoses into a boulevard of disillusionment. The canvas with its inscription "Dedicated to my contemporaries" centres on bizarrely alienated war veterans, two of the many at that time whose disablement left them no alternative but begging to survive. The wheels of the cart on which the leg-less man pushes his torso along the pavement are formed of tinfoil. The photos, paper, hair and tickets in the upper part of the macabre shop window displaying disjointed stereotype body parts – torsos, limbs – are likewise pasted on. Between the light-coloured prostheses in the right-hand window Dix has inserted a photo of his own face. The newspaper clipping in the lower left corner – the compositional extension of a barking dachshund's mouth – is another authentic piece of reality that reflects the growing anti-Semitism of the postwar years: "Jews Out!" screams the headline.

Unlike the Zürich Dadaists who had come together in Swiss exile in 1916, the Berlin Dadaists had a clear and definitely left-leaning political attitude, whose message they focused in imagery composed of actual slices of the reality around them. This collage device was supplemented by unreal, overlapping perspectives, disintegrated formal structures, garish colours and an aesthetic of the ugly – formal principles, that is, of typically Expressionist origin. With the aid of this art of combinations Dix shed a glaring light in *Prager Strasse* on the social injustices that characterised the young Weimar Republic, and he drew attention to the political perversions that would soon become embodied in tyranny. When Hitler saw paintings by Dix in Dresden in 1937, he declared, "It's a shame one cannot put these people behind bars." By this time Dix had long turned away from Expressionism, having in the 1920s adopted the sharp-focus objectivity of New Objectivity and especially Verism.

(N. W.)

Prager Strasse
1920, oil on canvas with collage elements,
101 x 81 cm (39¾ x 32 in.)
Kunstmuseum Stuttgart

Chaïm Soutine

b. 1893 in Smilavichy, Russia
d. 1943 in Paris, France

"I want to show Paris in the carcass of an ox."
— **Chaïm Soutine**

Chaïm Soutine's *natures mortes* simplify and convulsively deform their plastic elements. The existential suffering of the painter extends to the subject: the still life becomes a self-portrait full of despair, a mirror of a personal state of being.

Soutine painted a good dozen versions of the *Carcass of Beef* in the 1920s. The story of the origins of these paintings runs as follows: after Soutine had seen a copy of Rembrandt's *Slaughtered Ox*, he felt ill for several months and so resolved to paint the same subject himself. One day he asked his friend Leopold Zborovski to accompany him to the abattoir in order to buy a dead ox. He expressed his desire to show all of Paris in the carcass of an ox. The flayed pictorial motif was carted back to Soutine's studio, and the artist began painting with mad passion.

He worked for several days and nights. The meat became discoloured, went black, started to rot and emitted a terrible stench. In the end the neighbours called the police, who arrived just as Soutine was putting the finishing touches to his canvas. Picture and painter were taken to the police station, but not the third in the trio, the ox – the obligatory *tertium comparationis*. Zborovski eventually managed to save perpetrator and painting from the clutches of the law. What happened to the carcass of beef, on the other hand, is unknown. Soutine never made preliminary drawings, but executed his pictures directly on the canvas – in one go and after several hours of meditation, so it is said. In the present work he shows himself as a full-blooded painter and master of a generous, gesticulative impasto. Suspended head down, the animal carcass emerges into the light out of a blue chiselled, as it were, out of the semi-darkness with heavy brushstrokes. The flesh tones are heightened in an expressive manner, and the red has flowed out from the object and into the lower left-hand corner of the rectangular canvas, where it has transformed itself into pure painting. The rope from which the disembowelled animal is hanging becomes a virtuoso demonstration of line handled with ecstatic sensitivity. We are looking at a powerfully rhythmical battle with and for painting. Paul Guillaume wrote in 1923: "Eros cavorts festively in a whirl of initiates. Soutine sings and drinks with him, rejoices and paints in a joyful and holy ecstasy." Abstract Expressionism in postwar America has one of its roots in Soutine, in the same way as in the British artist Francis Bacon and the German painting of the Neue Wilde in the 1980s.

(G. C. B.)

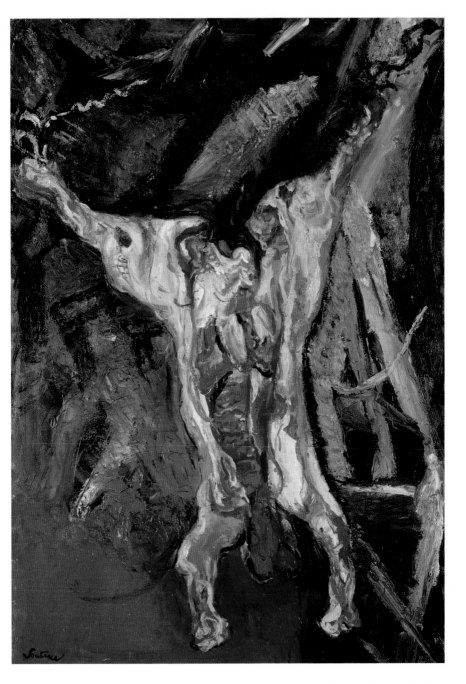

Lyonel Feininger

b. 1871 in New York, USA
d. 1956 in New York

Market Church in Halle
1930, oil on canvas,
102 x 80.4 cm (40¼ x 31¾ in.)
*Pinakothek der Moderne – Staatsgalerie
Moderner Kunst, Munich*

Lyonel Feininger's work is difficult to categorise: the American-born graphic artist and painter, who was also a talented musician and composer, was associated with several of the German Expressionist groups without truly belonging to them. In 1912 he maintained friendly relations with the Brücke, especially Heckel and Schmidt-Rottluff, in Berlin, and the following year exhibited with the Blaue Reiter in the *First German Autumn Salon*. He arrived at his typical style in 1911, in Paris, by way of a confrontation with Cubism. With its aid Feininger translated his favourite motifs – Gothic church spires, cityscapes, seascapes, sailing ships – into compositions of crystalline purity and timelessness.

Until 1913 many of his pictures were populated by marionette-like, elongated human figures which were subsequently abandoned. Feininger employed an exaggerated perspective to engender a pictorial tectonics consisting of a synthesis of cubic, prismatically refracted, energy-charged units. His early *Promenades* were probably known to Kirchner, who may well have adapted them in his *Potsdamer Platz* (1914, p. 148). On the other hand, Feininger paid homage to Kirchner's paintings of Berlin cocottes in his *Night Hawks*.

As *Market Church in Halle* shows, by this time Feininger's facetting had achieved a rigorous tectonics and intrinsic monumentality. Between 1929 and 1931, on the invitation of museum director Alois W. Schardt, the artist spent several periods of months at a time in Halle to paint a series of city views. Like other examples from this series,

the Munich painting has a subtle transparency of colour that reflects not only an adoption of the Orphist colour system of Delaunay but an affinity with international Constructivism, which paralleled Feininger's teaching activity at the Bauhaus, first in Weimar from 1919 to 1925, later in Dessau to 1932. At the Bauhaus, the rational, constructive principle was allied with Expressionist ideals *à la* Blaue Reiter. As a result, Feininger joined with Jawlensky, Kandinsky and Klee in 1924 to form a successor to the Munich group, Die Blaue Vier.

Feininger has depicted the Market Church in Halle from a vantage point that relegates its characteristic spired façade and flying buttresses to the background, and brings the massive late-Gothic nave diagonally into the foreground and to the left edge, like a conglomerate of vectors and dynamic prisms. The complex is rendered in subdued translucent colours of luminous clarity, forming a Cubistically reduced structure shot through with lines, rays and facets. In the refractions and vibrations, interpenetrations, overlappings and mirrorings of forms, the synaesthesia of painting, architecture and music has achieved an overwhelming polyphonic effect, as of light-pervaded space. "Where I used to strive for movement and restlessness," said the artist of such pictures, "I now attempt to sense and express the complete total calm of objects, and even the surrounding air – 'the world' that has moved farthest from reality."

(N. W.)

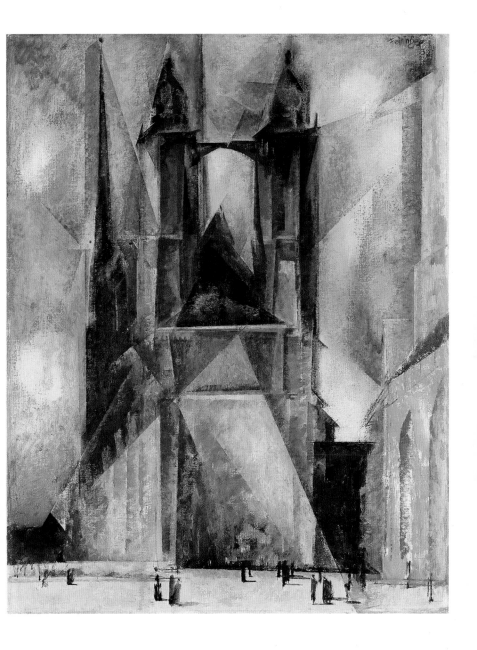

Futurism –
From Filippo Tommaso
Marinetti to Carlo Carrà

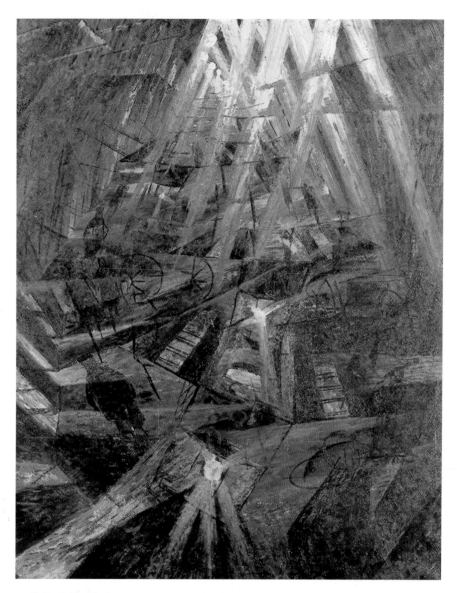

Umberto Boccioni
The Forces of a Street
1911, oil on canvas, 100 x 80 cm (39¼ x 31½ in.)
Private collection

Pages 196–197
Luigi Russolo and Ugo Piatti
with the Intonarumori
Milan 1914

Art + Action + Life = Futurism

Sylvia Martin

Mythical Visions of a New World

The year 1909 marked a watershed in cultural developments in Italy – a following reorientation that swept Italy into the current of progressive streams in modern art, such as Expressionism and incipient Cubism. On 20 February 1909, with the publication of his manifesto "Le Futurisme" in the popular French journal *Le Figaro*, Filippo Tommaso Marinetti founded the Futurist movement at one fell swoop. "I hesitated a moment", wrote Marinetti a few years later, "between dynamism and electricity. My Italian heart beat faster when my lips invented and loudly voiced the word Futurism. It was the new formula for art-action." Over the next three decades many artists from diverse fields – literature, visual art, theatre, the crafts, music, photography – would unite under the banner of Futurism. The aim they shared in common was a renewal of life in every social and aesthetic respect, taking current technological achievements and scientific insights as the point of departure and standard for their ideas.

Marinetti's manifesto became a nucleus of dissemination on which almost every member of Futurism relied. As *spiritus rector*, Marinetti set the standards. Without bothering to analyse the cultural and social situation in Italy, he proclaimed a new state of affairs and a new view of the world, contained in eleven points. To quote only four of these:

"1. We shall sing the love of danger, of habitual energy and daring…

4. We declare that the glory of the world has been enriched by a new beauty: the beauty of speed…

7. There is beauty only in struggle. No masterpiece without an aggressive aspect…

9. We shall glorify war – that sole hygiene for the world – militarism, patriotism, the destructive deeds of the anarchists, the great ideas one dies for, and a disdain of woman…"

The artists carried the catchword Futurism before them like ensigns of an advancing army. Futurism stood for an unqualified glorification of technology, speed and vital life within a social structure revolutionised by industrialism. The automobile – Marinetti thought racing cars lovelier than the *Nike of Samothrace* – streetcars, telephones, aeroplanes and railway networks were technical advances that since the late 19th century had altered not only the look of cities but people's conception of the world. Distances shrunk, perspectives were foreshortened or shifted, the entire world seemed caught up in accelerated motion.

In Marinetti's eyes, the products of the industrial revolution embodied the promise of a new model of life. He raised them to fetishes of an attitude fuelled by violence and rebellion, a revolutionary impetus that to him symbolised the

*Filippo Tommaso Marinetti
in his automobile*
ca 1908

**Antonio Sant'Elia
Electric Power Plant**
1914, ink and pencil on paper,
31 x 20.5 cm (12¼ x 8 in.)
Private collection

future. Yet with the first Futurist manifesto, this overthrower of mythology and ideals provided just that: a new founding myth. His followers, Marinetti declared, would become aware during a sleepless night of their technological environment, whose noises and smells would penetrate into their homes. "As we were listening to the dissipated prayer of the canal and the grinding of the skeletons of the moribund palaces in their beard of green, the hungry automobiles suddenly began roaring under our window." His friends would step out into the city streets, and go "over to the three snorting beasts, to lovingly caress their hot breasts". Mounting these beasts – i.e. cars – they would begin a careening ride through the city which finally ended in a ditch. "Oh, maternal ditch, filled nearly to the brink with filthy water! Oh, lovely drainage ditch of a factory!" Driver and car would rise from the mire as if reborn and vitally animated despite their bruises. Then they would recite the eleven points mentioned and launch into a swan song for old, doomed Italy.

Provocation and Uproar as Effective Publicity for Art

On 12 January 1910 the first *serata futurista*, or Futurist soirée, took place at the Municipal Theatre of Trieste. These soirées, frequently organised ad hoc by Futurist artists at various venues, had differing agendas. They extended from recitals of poetry and manifestos to musical performances, but these merely formed a framework for art-actions aimed at provocation and uproar. By histrionically declaiming their texts or inciting the audience "not to applaud but to boo us off the stage", the Futurists again and again challenged the audience to interaction. They purposely aimed at creating a state of emergency, as it were, in which members of the audience would become actors, and lawlessness and vital chaos reigned. Scandal was their express aim, and they relied on the ensuing press reports to spread their brand of anarchy among the respectable citizenry.

The first evening, on 12 January, went off rather uneventfully. In Milan, centre of Futurism until 1916 and scene of the second *serata futurista*, audience reactions were much more indignant. Held at the Teatro Lirico on 15 February 1910, the soirée spun completely out of control. Apart from an explanation of Futurist aims and a reading of the founding manifesto and poetry, an anti-Austrian debate of the kind then virulent in Italy triggered tumultuous reactions. Fuelled by provocative Futurist slogans and interruptions and catcalls from the audience, the situation escalated to the point of fist-fighting, which only two police officers on the premises were able to quell. Although the artists had to cut short the

La Centrale Elettr

event in the theatre, the tumult continued outside on the streets for some time. For the Futurists, the event was a perfectly staged scandal. Young Italian artists began to obtain increasing attention from the media, which inadvertantly disseminated their new ideas.

The Futurist soirées – many of which were held in larger Italian cities until the end of 1915 – were not only highly significant as an anarchistic forum but provided an important platform for artists and writers who had no other opportunity to show or publish their work. Luigi Russolo, for instance, who after beginnings in music went on to study painting, was able to present his Intonarumori, or noisemaking instruments, at the soirée held on 21 April 1914 in the Teatro dal Verme in Milan. This had been preceded by a manifesto, "The Art of Noises", dated 11 March 1913, which Russolo had sent in the form of a letter to his Futurist colleague, the composer Francesco Balilla Pratella. Russolo's instruments consisted of large crates mounted with amplifying trumpets, some operated by so-called "accumulators", which produced a diversity of sounds and noises. They hummed, rattled, rumbled, whistled, howled and hissed – in short, brought the acoustic world of technology and industry into the concert hall. Such acoustic material drawn from the real environment would subsequently be employed by musique concrète in the late 1940s. At the 1914

soirée in Milan, the music-and-art activity ended in a chaotic mêlée in which Futurists, audience and police went at each other's throats.

The Futurist Painters

The painter Umberto Boccioni had his first taste of the Futurist movement on 15 February 1910, as an onlooker at the soirée at the Teatro Lirico in Milan. Fascinated by Marinetti, Boccioni joined the group together with his friends Carlo Carrà and Luigi Russolo.

Before they became Futurists, the protagonists of the movement in the visual arts had few points of contact. Boccioni, the key Futurist figure alongside Marinetti, moved to Milan in 1907. Prior to that he and Gino Severini had taken instruction from Giacomo Balla, who at that time was interested in the working-class environment and social progress he was able to observe around him in the burgeoning metropolis of Rome. At this period Balla was interested in the labour milieu and the progress of civilisation, subjects of which the expanding metropolis provided ample illustrations.

With rapid industrial growth in Milan, Turin and other northern cities and a neglect of the crisis-shaken agricultural south, the young Italian nation stood on insecure footing. The economic boom, which should have prompted an adequate social welfare policy, collided with

Étienne-Jules Marey
Chronophotograph (detail)
1886

hidebound power structures, and their negligence was answered by unrest, strikes and repression. Milan was a key focus of unrest and Boccioni, along with Carlo Carrà and Luigi Russolo, who had likewise settled there, were caught up in the events. Carrà befriended socialists and anarchists and immersed himself in the writings of Karl Marx; Russolo frequented literary circles and early on began writing articles for Marinetti's journal *Poesia*. Gino Severini, on the other hand, lived from 1906 principally in Paris, thus establishing contacts between the Milan Futurists and the pulsating cultural capital of Europe.

On 11 February 1910, these five artists – Balla, Boccioni, Carrà, Russolo and Severini – signed the "Manifesto of Futurist Painters" and proceeded to take Futurist art to its first culmination.

Manifestos of Futurist Painting

In its pathos and rigorous rejection of all traditions, the Futurist painters' first manifesto echoed Marinetti's first proclamation: "Comrades! We hereby declare to you that the triumphant progress of science has caused such great changes in humanity that an abyss has opened between the obsequious slaves of the past and us free men who are certain of the radiant glory of the future." The art system was accused of corruption and lethargy across the board, and only

three painters in Italian history, a generation older than the writers and ignored by the critics – Giovanni Segantini, Gaetano Prevati and Medardo Rosso – were accepted as ideals.

The motifs of progress and its effects were easily identified: the automobile, the aeroplane, electric lighting, building construction, the hectic pace of life and demonstrations in the streets. Yet how could these signs and scenes be brought into conformance with the Futurists' new sense of life and translated into forms and colours on canvas? In this regard all of the artists involved had initial difficulties. During this phase when expectations and practice still greatly diverged, Boccioni admitted: "The obligation we have assumed is terrible, and the visual means appear and disappear the moment we try to put them into practice." The painters adopted familiar formal elements from Impressionism, Divisionism and even Symbolism. They experimented with the expressiveness of line, divided their motifs into countless dots of paint.

At the same time, they intensified their search for new, adequate means of representation in theory as well. As early as 11 April 1910 they published a second manifesto, the "Technical Manifesto of Futurist Painting". As the title indicates, their notions of Futurist imagery had now become somewhat more concrete. They spoke of complementary contrasts as an absolute

F. T. Marinetti
Futurist Poet
1911, photo and illustration
by E. O. Hoppé

Umberto Boccioni
The City Rises
1910–1911, oil on canvas,
199.3 x 301 cm (78½ x 118½ in.)
*The Museum of Modern Art, New York,
Mrs. Simon Guggenheim Fund*

prerequisite for modern painting, and noted how movement and light appeared to "destroy" solid bodies, thus paving the way for a representation of "dynamism".

The Italian Futurists publicly showed their works for the first time in spring 1911, at a self-organised exhibition in Milan. Severini, who had signed the manifestos but was not yet familiar with his confreres' paintings, immediately realised that they lagged behind the latest developments in Paris.

In autumn 1911, Marinetti, the only one in the group from a well-off background, financed a trip to Paris for Boccioni, Carrà and Russolo. There they were confronted with the beginnings of Cubism in the art of Pablo Picasso and Georges Braque, as well as with Robert Delaunay's paintings of the Eiffel Tower.

Unlike the Cubists, who defined an unconventional perceptual approach largely by reference to static objects, the Italians, with their faith in progress, attempted to visualise a universal model of movement. Yet the Futurist painters arrived at quite different pictorial strategies despite their common aims. Giacomo Balla's depictions of physical sequences of motion marked the one pole, and Boccioni's visualisation of the essence of motion the other. Russolo, Carrà and Severini worked between these two extremes, each arriving at an individual mixture

of solutions. Except for Russolo, who turned to music, these artists remained true to the painting medium; that is, they never tired of attempting to fix dynamic effects on a static surface: the canvas. As this implies, Futurism remained limited to an evocation of movement.

Dynamism and Simultaneity

Futurist art theory was dominated by two categories: dynamism and simultaneity. These are interrelated concepts and very difficult to consider in isolation. In the "Technical Manifesto of Futurist Painting", dynamism is described by reference to scenes in motion. "Thus a galloping horse does not have four but 20 legs, and their movements are triangular." Then the authors explain: "The 16 people around you in a moving streetcar are one, ten, four, three: they stand still, and they move; they come and go, they rebound, consumed by a zone of sunlight, back onto the street, then they return to their seats, persistent symbols of universal vibrations."

Boccioni defined these examples more precisely in his 1914 book *Futurist Painting and Sculpture (Plastic Dynamism)*. Here he distinguished between an "absolute motion", implying the intrinsic motion of objects as well as the realm of emotive feelings, and the "relative motion" generated by a moving object in relation to its moving or static environment. For the Futurists,

Filippo Tommaso Marinetti
Irredentism, Liberated Words
1914, ink, pastel and collage
on paper, 21.8 x 27.8 cm (8½ x 11 in.)
Private collection

reality was composed of these two forms of movement, which together added up to "universal dynamism".

In the practice of painting, subject matter now began to be dissolved by breaking open its forms and repeating certain elements. Passages of colour and abstract, dynamic lines derived from the subject served to interlock figure and ground. "Lines of force", the Futurist term for dynamic vectors of paint, animated the composition as much as the pure, brilliant colour values used, whose "virginity" and "rawness" corresponded to the Futurists' revolutionary mood. Not a few of their works were accordingly based on an aggressive red-blue contrast.

Futurist Architecture

If writers and artists were inspired in their futuristic considerations by the contemporary city-scape with its flourishing industrial zones, increasing traffic and pulsating life on the streets, architects such as Virgilio Marchi, Mario Chiattone and, foremost, Antonio Sant'Elia translated this universal dynamism into built superlatives. Exciting designs for the key architectural tasks of modern society emerged: houses, railway stations, power plants, airports. This renewal of architecture culminated in the vision of a city in which tall, narrow skyscrapers projected vertically into the air, surrounded by an encompassing, dynamic network of traffic arteries on several horizontal levels. Both the design of individual buildings and the entire urban area transformed the city into a pulsating organism that not only reflected the vitality of society but potentiated the phenomena of motion and speed.

Models for these ideas were provided especially by the interurban train system in Vienna, built on a series of traffic levels by Otto Wagner in the late 19th century. The Paris Metro and London Underground and the skylines of New York and Chicago likewise attested to the expansive, dynamic acceleration which had already been translated into reality in these proliferating urban centres. Yet the Futurist building designs and urban plans were never to be put into practice. They remained on paper, being visions that surpassed the limits of feasibility. Take the demand made by Sant'Elia in his 1914 manifesto "The Futurist Architecture": "Buildings will have a shorter life expectancy than we ourselves have. Every generation will have to build its own city." Although the architect's premise of a permanent renewal conformed with Futurist aims, in practice it made his projects unrealisable.

The Viewer Is in the Picture

The phenomenon of simultaneity, which was being discussed and applied by the Cubists and

Natalja Goncharova
The Harvest
1911, oil on canvas,
92 x 97 cm (36¼ x 38¼ in.)
Museum of Fine Arts, Omsk

Orphists at the time, became a key part of the Futurist aesthetic around 1912. Building on dynamism, it implied the concurrence in time of various different events and their crystallisation in a work of art. The concept of simultaneity was understood by the Futurists in a very general way, to include visual and emotional perception as well as memories and associations of thoughts and feelings. In Boccioni's view, simultaneity represented the basis of Futurist sensibility and the consequence of universal dynamism. This implied not only representing the life and bustle on the big-city streets in all their visual variety, but evoking the noises, smells, remembered happenings and the emotions they triggered to produce an atmospheric unity. Boccioni's *Simultaneous Visions* (1911) shows a street scene as viewed through the eyes of a woman at a window. The excerpt is fragmented into facets and various perspectives, figures are doubled, the palette is aggressive and unnaturalistic. The viewer is invited to identify with the figure represented from the back at the extreme edge of the picture and plunge, with her, into the visual and sensory experience. The Futurists even provided instructions for viewing, explaining: "We place the viewer right in the midst of the picture."

The *parole in libertà*, or liberated words, with which Marinetti began expanding the possibilities of literature and poetry in 1912, worked in an analogous way. He first amplified the dynamics of language by stringing together nouns and infinitives, avoiding adjectives and adverbs, and replacing punctuation by the mathematical symbols $+, -, =, :, <$ and $>$. The first-person narrator vanished and the sound of the words unfolded dynamically and actively in telegram style. This staccato addition of words that precluded any syntactical flux could be charged with various levels of perception and sensation simultaneously. Each word was forcefully set, like an incarnation of sheer power – as Aldous Huxley would aptly describe it in quasi Futurist mode in his *Brave New World*, where he compares words to X-rays which, if rightly used, could penetrate anything.

The speechmaker and provocateur Marinetti created onomatopoetic montages and, with his *tavole parolibere*, also liberated the typographical appearance of words. He replaced the traditional sequence of sentences in columns by visual texts in which words, letters and symbols danced freely across the page to unfold a previously unknown visual poetry. On these sheets, the device of simultaneity was employed to great effect, in terms of both form and content.

Transnational Painting

From its first publication in a French journal, Futurism aimed at an international audience. Its protagonists, Marinetti foremost, carried the movement's message with typical actionism to

Mario Chiattone
Construction for a Modern Metropolis
1914, watercolour and Chinese ink on paper,
106 x 95 cm (41¾ x 37½ in.)
Art Historical Institute of the University, Pisa

the cultural centres of Europe. By 1912 at the latest, with the great travelling exhibition that included major works by Balla, Boccioni, Carrà, Russolo and Severini, the Futurist agenda stood at the focus of debates on avant-garde rankings and approaches to the theory of perception. The presentation was organised in Paris by Severini together with the critic Félix Fénéon.

The travelling exhibition began in February 1912 at Galerie Bernheim-Jeune. In the accompanying catalogue the Futurist painters provocatively proclaimed: "With us, a new epoch in painting begins." They characterised Cubism, which was then in transition to its synthetic phase, as a brand of academic art that still cleaved to traditional subject matter.

In view of the overweening position of modern French art, just reaching a new culmination in the work of Picasso and Braque, Delaunay and Fernand Léger, the Futurists' claim was like a slap in the face. Yet the affront was necessary to garner attention among the rival avant-gardes. This claim to preeminence was repeated in the catalogue to the Berlin show of Futurism, held at Der Sturm gallery in April 1912: "We stand at the spearhead of the movement of European painting."

Such statements quintessentially reflected the Futurists' arrogance. At the same time, their paintings embodied the seriousness of their claims. In view of this ambivalence, the entire continent oscillated between reactions of indignation and rejection on the one hand, and approval and emulation on the other.

The first Futurist show at Der Sturm in 1912 was subsequently presented under Walden's aegis in various German cities, including Cologne and Munich. Wassily Kandinsky, co-founder with Franz Marc of Der Blaue Reiter in 1911, tended, unlike Marc, to view the Futurist movement with scepticism. Marc wrote to Kandinsky on 23 October 1912: "Just a brief note about things that may interest you, e.g., that I saw the Futurists in Cologne and am unreservedly excited about the larger part of the paintings (especially Carrà, Boccioni and Severini, too, in their more mature things); I hope this won't anger you... They are brilliant painters; naturally impressionists; very stringent naturalism; not the ideas of the Bl. Reiter and that which you view as coming..."

Marc's statements reflected a general interest in Futurism on the part of the young, avant-garde generation. This interest was cogently summed up by Alfred Döblin, who wrote in the journal *Der Sturm* in 1912: "With a shrug the Futurist makes room for himself, casts the nightmare off his chest." Nevertheless, few if any artists in Germany, or elsewhere, felt the urge to convert to the Futurist religion of life.

The Russian art scene around 1900 stood in a brisk exchange with Western Europe. Shortly

Umberto Boccioni
Simultaneous Visions
1911, oil on canvas,
60.5 x 60.5 cm (23¾ x 23¾ in.)
Von der Heydt-Museum, Wuppertal

after the emergence of Futurism in 1909, its agenda had already become known in Moscow and St Petersburg, and by the time Marinetti visited the country in 1914, Michail Larionov and Natalia Goncharova had already founded Rayonism. The two artists viewed their visual language, in which light-charged sheaves of rays seemed to dematerialise objects, as a synthesis of Cubism, Futurism and Orphism. Kazimir Malevich, too, before founding Suprematism, went through an orientation phase he called Cubo-Futurism. Around 1911–1913 Malevich began dissecting rural scenes into dynamically rhythmic segments, or – à la Cubism – into sharp-edged facets. Malevich analysed the world of objects with the ultimate aim of developing an entirely non-objective, elementary painting. The final Futurist exhibition organised in Russia, shown in 1915 under the title *0.10* in St Petersburg, included Malevich's renowned *Black Square* (1915, p. 245).

War, Glorified Violence and the Seeds of Decay

The Futurist movement was marked by a close link between art and physical struggle. From the first manifesto through the nearly concurrently beginning actions to the visual works, Futurist aims and language were infused with anarchy, revolutionary pathos and a glorification of violence. This belligerence went hand-in-hand with a patriotic attitude that was widespread at the time, a pan-Italianism that envisioned Italy at the forefront of Europe not only in the international rivalry of art isms but in every cultural and technical field as well. In the "First Futurist Manifesto" one can find the notorious statement already quoted: "We shall glorify war – that sole hygiene for the world – militarism, patriotism, the destructive deeds of the anarchists, the great ideas one dies for and a disdain of woman." This was not only a call to battle but to a war between the sexes.

Marinetti would cleave to the notion of an aesthetic war throughout his life. Walter Benjamin, in the epilogue to "The Work of Art in the Age of Its Technical Reproducibility", published in 1936, explicitly attacked Marinetti's stance and his inability to imagine humane uses for technological productivity. The violence underlying his attitude even infected artists' creative activity and aesthetic solutions. Under the impression of the Libya campaign of 1911, in which he took part as a war reporter, Marinetti wrote a poem, "La battaglia de Tripoli" (The Battle of Tripoli), and two years later published reflections on his experiences, "Assedio di Adrianopoli" (Siege of Adrianopolis). By the time the First World War broke out in 1914, Marinetti had gained first-hand experience of a kind his artist colleagues lacked. Many of them, and not only Italians, went

Enrico Prampolini
Tarantella
1920, oil on canvas,
80 x 80 cm (31½ x 31½ in.)
Muzeum Sztuki, Lodz

Kazimir Malevich
The Aviator
1914, oil on canvas,
125 x 65 cm (49¼ x 25½ in.)
State Russian Museum, St Petersburg

enthusiastically to war, thinking it the only way to break up the centuries of encrustation that blocked social progress. Among them was Franz Marc, who pathetically declared: "The war is being waged for purification, and the tainted blood is being shed."

It was out of the same conviction that the Futurists envisioned jettisoning the moribund past and celebrating the emergence of "universal dynamism". But now they were challenged to live out the heroism they had extolled in advance of the real war. Artists had to prove themselves as soldiers and workers. The idealised imagery of battle that suffused Futurist rhetoric and art was now confronted with the brutal, day-to-day reality of a bloody war.

Even though one or the other artist abandoned the Futurist agenda before the war – Carlo Carrà officially broke with Marinetti's movement in late 1913 – the First World War evidently marked the disbanding of the original Futurist group. Its members reacted differently to the reality of war. Some sought new certainties and followed a *richiamo all ordine*, the recall to order then heard all over Europe. Carrà joined Pittura Metafisica, the metaphysical painting initiated by Giorgio de Chirico; Mario Sironi founded the neorealist Novecento group; Balla and Severini turned to objective painting. Umberto Boccioni began experimenting with a style oriented to that

of Paul Cézanne, before a riding accident cut short his life in 1916. That same year the architect Sant'Elia fell in battle.

Umberto Boccioni

b. 1882 in Reggio di Calabria, Italy
d. 1916 near Verona

The Street Penetrates the House is one of the paintings which was on view in the great travelling exhibition of Futurist works. It began in February 1912 at Galerie Bernheim-Jeune in Paris and was subsequently shown in various European capitals.

One station was Berlin, where Herwarth Walden, an enthusiastic novice on the international art scene, presented the second exhibition of young Italian avant-gardists Umberto Boccioni, Carlo Carrà, Luigi Russolo and Gino Severini to German audiences at his gallery, Der Sturm. The show triggered an enormous public reaction, and was also a financial success. Albert Borchardt, a Berlin banker and collector, acquired a large numer of the paintings, including *The Street Penetrates the House*.

With their usual verve, the Futurist painters explained their intentions by reference to visual examples in the catalogue. The superscript to Boccioni's painting, for instance, read, "The intoxicating goal of our art is the simultaneity of states of mind in the work of art. A few more examples by way of explanation. When we paint a figure on a balcony, as seen from the room, we do not restrict the scene to what one can see through the square of the window, but attempt to convey the totality of pictorial sensations triggered in the painter standing on the balcony: the bustle of the sunlit street, the double row of buildings extending right and left, balconies with flowers, etc. This means simultaneity of the surroundings, and concomitantly a displacement and disassembly of objects, a scattering and merging of separate parts, liberated from common logic and independent of one another. In order to let the viewer live in the midst of the picture, as we put it in our manifesto,

the picture must be a synthesis of remembering and seeing."

There could hardly be a better description of the formal and substantial message of *The Street Penetrates the House* – various sense impressions depicted in simultaneity, combined with remembered or mentally associated experiences. The operative term here for the Futurists was simultaneity, and Boccioni was the first to put it into convincing visual practice in the present painting. A stylistic model was provided by the Eiffel Tower depictions of the French painter Robert Delaunay. Yet Boccioni had a much more comprehensive notion of reality than Delaunay, and faced the challenge of how adequately to depict it on a flat canvas. How he did so is also seen in subsequent paintings like *Simultaneous Visions* (p. 210) and *The Forces of a Street*, both 1911.

In *The Street Penetrates the House*, we as viewers are encouraged to watch, together with the female figure leaning over the balustrade, the unfolding spectacle in front of and around the balcony. The buildings tilt forward, are facetted like crystals; many individual elements, including the balcony scene itself, are repeated; objects interpenetrate, and a small horse, which one would think of as on the ground below, cuts across the woman's figure high above at the balustrade. The ordering effect of one-point perspective seems to have gone out of kilter. Solid bodies have lost their material properties and diffuse into the surrounding space. Everything in the picture appears to implode and stream towards the figure's head. Her mind is the focus of sense perceptions and reservoir for the multifarious impressions evoked by the scene.

(S. M.)

The Street Penetrates the House
1911, oil on canvas,
100 x 100.6 cm (39¼ x 39½ in.)
Sprengel Museum, Hanover

Gino Severini

b. 1883 in Cortona, Italy
d. 1966 in Paris, France

Blue Dancer
1912, oil on canvas with sequins,
61 x 46 cm (24 x 18 in.)
Private collection

Blue Dancer is a major work of Gino Severini's, an artist who devoted many paintings to the world of theatre, dance and nightlife in the big city. The ballet impressions of an Edgar Degas and the acutely observed milieu studies of a Henri de Toulouse-Lautrec were now superseded by a Futurist view which, in Severini's case, would have been unthinkable without the French Cubism of Pablo Picasso and Georges Braque.

Unlike his ballroom scenes, in which the turbulent events flow across the entire picture with an all-over, undirected energy, here Severini has concentrated on a single, main figure. He has reduced the palette to blue and whitish-grey values and underlain the depiction with a dominant, triangular composition that culminates in the dancer's head and swings out in the area of the dress. In this lower quarter of the picture the figure is divided into countless small segments of form, geometric parcels – arcs, angles, parabolas – that engender dynamic micro-states. Passages of colour are used to blend the female figure into the background. Portions of it, such as arms and head, appear multiplied and depicted in varying perspectives. Only a few props and other, smaller figures suggest the location of the scene.

Severini ideally utilised the means of the Futurist aesthetic to create pictorial correspondences for the movement and energy of the dance. Yet the vitality of these movements is counteracted by the solidity of the triangular composition and the blocky distribution of the two colour values. Harsh colour contrasts, which might have lent the painting a compelling energy, have been entirely avoided.

According to Wassily Kandinsky in his famous book *On the Spiritual in Art,* published in Munich in 1911, the triangular form was best suited to schematically representing the spiritual life. In addition, Kandinsky considered blue – as did Franz Marc, his friend and confrere in the Blaue Reiter group – the colour most adequate to conveying spirituality. In view of this symbolism, which was certainly known at the time, Severini's interplay of form and colour takes on an expanded meaning. In *Blue Dancer* he may well have wished to allude to a "spiritual" realm, by translating simple dancing movements into a transcendental event, a universal dynamism in which all sense impressions intermerge. This aspect is underscored by the application of shimmering sequins, which heighten the impression of dematerialisation and spirituality.

With the emergence of the collage technique in Cubism, the formal possibilities of art were considerably expanded. The Futurists adopted this method without delay. In 1912–1913, for instance, Boccioni integrated a section of window frame in his sculpture *Unification of a Head and a Window.* Beyond this, in a conversation with Severini the French art critic Guillaume Apollinaire pointed out that the old Italian masters had integrated real objects such as keys and precious gems in their depictions of saints. Severini was inspired to emulate them by integrating real sequins into the dress on the canvas, even if this ran counter to the Futurist doctrine of the jettisoning of every tradition.

(S. M.)

Giacomo Balla

b. 1871 in Turin, Italy
d. 1958 in Rome

In *Girl Crossing a Balcony*, Giacomo Balla applied his scientific interest in analyses of motion and light to a painting. The chronophotographs of Etienne-Jules Marey and the "photodynamism" of the Bragaglia brothers, his Futurist confreres, inspired Balla to multiply forms as a way of conveying an impression of movement. Balla's experiments with colour and light, on the other hand, went back to French Post-Impressionism. His first relatively long stay in Paris in 1900, on the occasion of the World Exposition, already brought an involvement with the Divisionism of George Seurat and Paul Signac.

Seurat modified the Impressionist practice of composing an image of short curving strokes or "commas" of paint. He built up his motifs of uniform, small dots in relatively pure colour values, which optically blend and congeal into an image in the viewer's eye. Among Seurat's sources was the colour theory of the chemist Michel Eugène Chevreul, whose essay on simultaneous colour contrasts, "Of the Law of Simultaneous Contrast of Colours", 1839, had already inspired artists like Eugène Delacroix to experiment with colour on a scientific basis. Simultaneous contrast refers to the supplementary colour which the eye automatically seeks when viewing a certain other colour. For example, yellow induces a reddish blue, blue a reddish yellow, and purple a green, and the interplay of these colour pairs engenders a harmonious overall image.

Before Balla made use of this effect in *Girl Crossing a Balcony*, however, he investigated the behaviour and effects of colour and light on a completely non-objective level. In 1912 he painted a series of *Iridescent Interpenetrations*, analyses of colour based on kaleidoscope-like diagrams. Balla first began developing these during a stay in Düsseldorf, where the Löwenstein family commissioned him to adorn their home with paintings and decorations. There the artist likely discovered the colour pyramids of Johann Heinrich Lambert, an 18th-century physicist and philosopher who devoted himself to the measurement of light intensity and the laws of light absorption. Balla now commenced to divide the colour spectrum into triangles of equal size, fill them with colours of different intensity – adding white to lighten a colour – and combine them into systems. These optical rhythms, by the way, emerged in parallel with Robert Delaunay's disc paintings, in which the French artist attempted a "rotating" colour analysis based on Chevreul's colour wheel.

Balla made use of the insights he had gained in *Girl Crossing a Balcony*. Bright light dissolves the balcony scene into countless units of colour. Augmented by a multiplication of forms, the subject diffuses into a pattern of pure colour. The separate elements – girl, balustrade, door frame – melt into a vibrating coloured plane in which spatial perspective is entirely negated. With his knowledge of colour relationships and their effects, Balla translated the objective motif into a conceptual system and, by so doing, inquired into the laws underlying real appearances.

(S. M.)

Girl Crossing a Balcony
1912–1913, oil on canvas,
125 x 125 cm (49¼ x 49¼ in.)
Galleria d'arte moderna, Milan

Carlo Carrà

b. 1881 in Quarguento, Italy
d. 1966 in Milan

Interventionist Manifestation
1914, collage on cardboard,
38.5 x 30 cm (15¼ x 11¾ in.)
*Collezione Gianni Mattioli, Venice, on loan
to the Peggy Guggenheim Collection – The
Solomon R. Guggenheim Foundation, New York*

On 1 August 1914, the collage *Interventionist Manifestation* was published in the journal *Lacerba* under the title *Patriotic Festival*. That year Carrà was exploring the potentials of this new technique, introduced by the Cubists Pablo Picasso and Georges Braque in Paris, and in the present work he arrived at an original variation of collage.

In the process Carrà completely relinquished reference to actual things. "I have suppressed every representation of human figures", he explained, "in order to depict the pictorial abstraction of urban tumult." Various newspaper clippings, labels, tickets and other typographical fragments have been arranged into a composition that appears virtually to rotate and whose forces seem to stream both towards the centre and to the picture edges and beyond. In the abstract structure of a rotating disk, likely familiar to Carrà from the *Disques* (p. 238) and *Formes circulaires* done by French painter Robert Delaunay from 1912 onwards, the Futurist dynamically evoked the tumultuous events that shook Italy in 1914. Reality confronts the viewer in the shape of authentic frag-ments and a linguistic kaleidoscope: "rumori", "strada", "sports", "tot", *"Noi siamo la Prima"* and at the hub of it all, "Italia".

It was the period just prior to the First World War, when Italians were divided into neutralists and interventionists and the mood was at fever pitch. With *Interventionist Manifestation* Carrà added his voice to the Futurist paean on the glories of war, and demanded that Italy enter it, which it in fact did in 1915. Here collage became an instrument of propaganda. It combined agitational language like that used in the written Futurist manifestos and, orally, at their soirées, with an aesthetic that condensed the image into visual poetry.

The ground for Carrà's collaged word-pictures had been prepared by Marinetti's *parole in libertà* and *tavole parolibere*, or liberated words and syntax. The writer exploded traditional grammar, condemned adjectives and adverbs, adopted a telegram style, introduced mathematical symbols into texts, created onomatopoetic linguistic montages, and proclaimed a free typography. Carrà's collage contains an explicit reference to these innovations: a narrow strip of paper pointing to the upper left corner and bearing the echoic words "Zang [Tu]mb Tuum," the title of a 1914 novel by Marinetti. It described his experiences during the Italian siege of Hadrianople in a language that was radically liberated, in both a semantic and a typographical sense. The book amounted to a visual and acoustic experience whose tone was set by violence, aggressiveness and dynamism.

In *Interventionist Manifestation*, Carrà brought fragments of reality, "liberated words" and visual art into an unprecedented synthesis. This form of collage was unknown to Cubism. Not until Dadaism in the 1920s would word-collages of this type again be taken up and modified to suit the Dadaists' purposes. Carrà continued to experiment along these lines in the context of Italian militarisation, in 1914 producing a work on paper called *Pursuit* and in 1915 publishing a book in Milan, *Guerrapittura*, a record of his war experiences in drawings, collaged elements and "liberated words".

(S. M.)

Filippo Tommaso Marinetti

b. 1876 in Alexandria, Egypt
d. 1944 in Bellagio, Italy

Elegant Speed – Liberated Words (1st Record)
1918–1919, collage and ink on paper,
53 x 26.5 cm (21 x 10½ in.)
Private collection

Emilio Filippo Tommaso Marinetti was the founder and leader of the Futurist movement, the man whose enthusiastic pronouncements and provocative public appearances swept all of the others along in his wake.

The "liberation of words" was Marinetti's revolutionary achievement, whose effect far outlasted the movement itself. The writer declared conventional syntax and grammar invalid in a series of manifestos, beginning in 1912 with the "Technical Manifesto of Futurist Literature", and followed a year later by "Liberated Words".

With such steps, which were accompanied by many other activities and publications, Marinetti soon moved in the direction of a visual poetry, as seen in *Elegant Speed – Liberated Words (1st Record)*. With complete syntactic abandon Marinetti cast letters, mathematical symbols – especially vectors, which indicate directions of force – words, semantic abbreviations, objects and sentence fragments onto the sheet of paper. The typography changes abruptly but continuously. The author writes, draws, cuts and pastes. We as readers can now no longer follow a consistent text word by word and line by line. Instead, our eye and mind are inundated by diverse set pieces of content, in word and picture. We are confronted with a visual text which opens a wide field of potential combinations and mental associations.

Yet Marinetti does provide a mental context, defined by the vitalistic philosophy of Futurism. It is a sort of manufacturers' fair that includes most every technological advance of the period. Cars, airplanes, ships, zeppelins and a train represent the potential energy of Italy, which also includes horsepower. The aim is to set records, to become the number one and conquer new terrain. The repetition of the word *moi* (French for "me"), draws both author and reader into the midst of the dynamic happenings.

Among Marinetti's painter colleagues, Giacomo Balla, Carlo Carrà and Gino Severini in particular likewise experimented with word-pictures around 1913–1914. They integrated letters, words and numbers in their paintings or constructed compositions in collage.

Marinetti's advance to the linguistic picture would become a key source for the Dada movement, which came immediately in the wake of early Futurism, as well as for the visual poetry of the 1960s. He himself was able to take a cue from early attempts at "liberating words" made by French *littérateurs* such as Alfred Jarry and especially Stéphane Mallarmé. Marinetti already recited pieces by both authors at his early lecture evenings, which prior to the founding of Futurism in 1909 anticipated the famous *serate futuriste*. Mallarmé wrote his work *A Throw of the Dice Will Never Abolish Chance* in a completely new form: words and word groups freely distributed across the page, some running across the pagefold, and changing line heights, insertions and parentheses that interrupted the syntactical flux. The book was published in 1897 and 1914 in quite different typographical versions. Mallarmé's innovative approach to the printed text provided key stimuli to Marinetti.

(S. M.)

Abstract Art – From
Kazimir Malevich to
Piet Mondrian

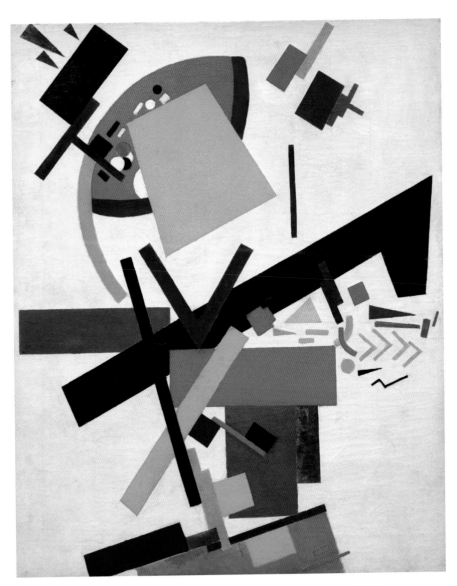

Kazimir Malevich
Suprematism
1915–1916, oil on canvas,
87.5 x 72 cm (34½ x 28¼ in.)
Russian State Museum, St Petersburg

Pages 224–225
*Kazimir Malevich and
assistants at the* Institute for
Artistic Culture, GINKhUK
Leningrad 1920s

Paintings of Autonomous Signs

Dietmar Elger

Realism and Abstraction

The triumph of abstraction is inseparably connected with the general development of art in the 20th century. The formulation of a world view freed from any dependence on the object was the most prominent achievement of 20th-century art. Previously, art had been mimetic: it portrayed the world as it appeared to the artist. Even when pictures visualised abstract ideas and concepts, they did so using the tools of representational painting. Illustrations of courage, faithfulness or unity were visualised for the viewer as personified virtues. Complex themes were depicted with skilfully composed groups of figures, or through idealised landscapes.

Abstract painting offered new and unsuspected possibilities. It could be autonomous, and did not have to refer to a known reality. Indeed, abstract painting functioned instead as an analogy to an unknown world. Its painterly elements stood first and foremost for themselves. If a blue area is no longer read as depicting the sea, and a horizontal line no longer marks a horizon, art may lose its quality as an analogy, but thereby it gains independence and assertiveness. The moment paint becomes free to accentuate its quality as a colour and not just to act as, for example, a flesh tone colouring an object, it gains an independent quality never before known in painting. The entire intensity, radiance and spatiality of that patch of colour can now act upon the viewer.

Concepts such as "realistic" or "abstract" can certainly not be defined as precisely as may seem at first to be the case, though. In truth, every painted representational depiction is an illustration done from a model in nature, and is thereby simultaneously an abstraction of that model. If painting projects three-dimensional models onto a flat plane, it necessarily changes and defamiliarises these models as well. In fact the transitions between the two categories are fluid, and their boundaries are by no means as clear as the two antithetical concepts would lead one to think.

The 19th-Century Conquest of Visual Abstraction

In 1890 the French painter Maurice Denis declared: "A painting, before being a warhorse, a naked woman or some anecdote or other, is essentially a flat surface covered with colours in a particular arrangement." Denis was thus an early proponent of the primacy of painterly means over their representational function. In abstract painting, the painted colours and forms ultimately manage without the reference system of the exterior world of objects.

The systematic conquest of an abstract world of imagery had its beginnings in Paul Cézanne's landscapes and still lifes. He reordered the

priorities within pictorial composition by no longer formulating nature as a model, but deconstructing it instead into an analytical structure of stereometric spatial units. According to one of the artist's most famous principles, all objects in nature are shaped like spheres, cylinders and cones. For his painting style Cézanne thereby formulated a premise he had derived from an abstract vocabulary. He no longer wished to illustrate, and thus simply reproduce the landscapes and still lifes of visible nature, but rather to represent them: that is, to transform them into an autonomous painterly equivalent. Correspondingly, another no less famous artistic maxim of Cézanne's reads: "Art is a harmony parallel to nature."

Two Parallel Harmonies

Paul Cézanne's ideas became a crucial inspiration for following generations. Although his pictures always remained representational, Cézanne managed to formulate a conception of painting that freed the painted motif from its dependency on reality as a model. According to Cézanne's credo, art and nature present themselves to viewers as two parallel harmonies, existing alongside one another and thereby being equal. A few decades later, this upward revaluation of the substance of painting itself also fascinated the young Spaniard Pablo Picasso. Cézanne's artistic con-

ception was one of the things that inspired Picasso to develop Cubism, undeterred by the lack of understanding of most of his artist colleagues and friends. Picasso went a decisive step further than his father figure Cézanne, by understanding the painted motif not just as something that exists in parallel with natural phenomena, but also as a reality detached from nature and existing in its own right. Picasso formulated his expanded aspirations in a pointed comparison: "In a painting by Raphael it is not possible to determine the distance between the tip of the nose and the mouth. I want to paint pictures in which that will be possible." Cubism accomplished a final and radical break with the illusionistic, one-point-perspective-based style of painting that had been relied upon for centuries.

In the summer of 1907 Picasso completed his epochal painting *Les Demoiselles d'Avignon* (p. 131). A few months later the painter Georges Braque saw this large-format composition. Braque was one of the few visitors to his friend Picasso's studio to understand that artist's compositions, and for whom the work would become a decisive inspiration in his own artistic development. In the autumn of the following year, when Braque submitted his new landscapes depicting austere, blocky architecture to the Salon d'Automne in Paris, the critic Louis Vauxcelles spoke disparagingly of "paintings with little cubes". Thus a new

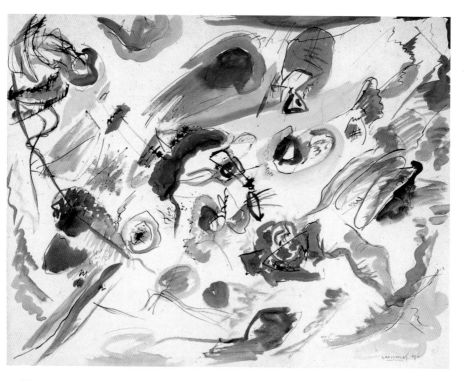

Wassily Kandinsky
First Abstract Watercolour
1913, watercolour,
50 x 65 cm (19¾ x 25½ in.)
Musée National d'Art Moderne, Paris

Franz Marc
Small Composition III
1913–1914, oil on canvas,
46.5 x 58 cm (18¼ x 23 in.)
Karl Ernst Osthaus Museum, Hagen

artistic style once again received its name out of ignorance.

From that time onward Picasso and Braque developed Cubism together, in sportsmanlike competition. The painted results were sometimes so similar that their works could hardly be distinguished from one another. During Cubism's first so-called analytical phase, the two artists withheld colour from their paintings and concentrated entirely on developing an innovative vocabulary of form. The cubic volumes in their works gradually gave way to the forms and fragments of geometric planes. By 1911 they had fully formulated this new pictorial language. Analytical Cubism disassembled visible reality into a faceted structure of symbols. Picasso and Braque gave up a unified one-point perspective in favour of a plurality of perspectives.

Cubism was the first innovative artistic current of the nascent 20th century. It stands as an example of the art of a modern industrial epoch and new scientific world view. Accordingly, Cubist work should also be understood as a perceptual model of our changed reality. It was at the beginning of the 20th century that the physical worldview underwent its most revolutionary expansion. New theoretical models and empirical research forced people to acknowledge some physical phenomena that evaded clear comprehension and logical understanding. "The social function of the great poets and great painters is to constantly renew the exterior image that nature assumes in the eyes of mankind," as the writer Guillaume Apollinaire demanded of literati and artists in his 1913 book *The Cubist Painters*. This correlation between scientific insight and the aesthetic compositions of art can be understood if one examines the subject of investigation they have in common. Physics and the plastic arts are both concerned with the perception and knowledge of reality, even though they use different means to further their inquiries.

Plurality of Perspectives

Since the beginning of the 20th century, the modern world has become altogether more complex and abstract. A full and direct description of it is becoming more and more difficult; only a fragmentary view of reality is now possible. That the viewer may occupy a neutral position outside the system being observed is an idea that no longer corresponds to existing realities. To artists of the 20th century, central-perspective paintings with their fixed vanishing points represented an outmoded world view that they wanted to replace with a new vocabulary of form. For the first time, Cubist paintings showed a dynamic view of the world with an infinite number of constantly changing viewpoints that directly incorporated the observer into the depiction.

The breakthrough to abstraction in European painting was in the air around 1913. Wassily Kandinsky in Munich, Kazimir Malevich in Moscow and Robert Delaunay and František Kupka in Paris each created their own unique pictorial solutions thereby.

An Intentional Influence upon the Human Soul

Wassily Kandinsky proved to be the crucial personality in this, and it was to him that the invention of abstract painting was ascribed for several decades, citing a watercolour dated 1910. Although that watercolour had actually been produced three years later than Kandinsky asserted, this Russian artist living in Munich had consistently pursued his concept of painterly abstraction and had promoted it publicly. As well, he supported the practical development of his painting style with a theoretical document. In 1912 his manifesto *Concerning the Spiritual in Art*, written two years earlier, was published. As a requirement of the new art form he stated in this document: "The harmonies of colour and form must be based solely on the principle of exercising an intentional influence upon the human soul."

At the same time he described a fundamental difference from the works of Picasso and his comrade Braque: forms and colours were no longer to be derived from an idea of nature, but created solely within the artist. The French Cubists' almost scientifically analytical approach was replaced in Kandinsky's works in Munich – but also in those of Robert Delaunay in Paris – by the emotional power of colour. From then on colour was no longer bound to a formal compositional framework, but instead could be employed freely and dramatically in a purely expressive manner. Abstract music, one of its precursors, became a crucial stimulus, not only for Kandinsky. Artists found an equivalent to their paintings in the contemporary music of composers such as Arnold Schönberg and Igor Stravinsky, and they also used rhythm, sound, dynamics and harmonies in their pictorial compositions. Accordingly, Kandinsky subdivided his works into impressions, improvisations and abstractions; concepts with which he simultaneously described his painting style's increasing degree of abstraction.

In 1913, after Kandinsky had long clung to landscape allusions in his compositions, he created his first purely non-objective, large-format painting. Franz Marc, together with whom he published the almanac *Der Blaue Reiter* in 1912, was the only Expressionist in Germany to follow him along this path. Marc's form paintings, which he also began creating in 1913, ascribe a central place in their compositions to colour dynamics. A work such as *Fighting Forms* of 1914 (p. 154), however, also shows the difference between

Robert Delaunay
The Windows
1912, oil on canvas,
92 x 86 cm (36¼ x 34 in.)
Morton G. Neumann Collection, Chicago

Marc's approach and that of Kandinsky. Here, red and black remained tied to prismatically broken but compact formal elements. Like the Cubists, Marc also placed his abstract painting in relationship to the modern scientific world order. "The coming art form", as he formulated in his aphorisms, "shall be our scientific convictions taking form; these are our religion, our central focus, our truth."

Pure Colour Harmonies

At the same time, Orphism developed in Paris. Guillaume Apollinaire, the Cubists' comrade, gave the movement its name. Apollinaire coined the term in reference to the mythical singer Orpheus and to the musical harmony of painting. Robert Delaunay was the leading personality of this group in which Francis Picabia, Jean Metzinger, Albert Gleizes and Fernand Léger also participated for a short time. Delaunay started primarily from colouration and attempted to give it form. In his *Windows* series, created in 1912, the urban architecture still appears in prismatically broken colours.

"As long as art does not break free from the object it remains description," Delaunay noted. He avoided this descriptive function of painting more and more in favour of pure colour harmonies. From then on his pictures were based upon simultaneous colour contrasts as Delaunay began to unite colour, light and rhythm within abstract compositions made up of centric circles.

The Invention of the Black Square

During the 1910s Moscow offered a more comprehensive opportunity than any other place for artists to inform themselves about current developments in painting. Not even in Paris itself would young painters have been able to study more than the 24 pictures by Cézanne and 51 works by Picasso collected there, and to measure their own works against them. As early as 1905 the two Moscow merchants Sergei Shchukin and Ivan Morozov were among the most progressive collectors of contemporary French painting. In addition to the works by Cézanne and Picasso, many paintings by Henri Matisse, Paul Gauguin and Claude Monet also made their way to Russia at that time. Moreover, the two collectors made their grand villas accessible to artists who were eager to learn.

Kazimir Malevich also took advantage of such opportunities, using these western influences to inform his own art. When he arrived in the capital in 1904 his painting style was still bound to the Russian folk-art tradition. After 1911, however, his work developed rapidly in the direction of non-objectivity. Cézanne, Picasso and Italian Futurism became Malevich's role models. He also made the personal acquaintance of the Italian

Kazimir Malevich
Suprematism
1915, oil on canvas,
44.5 x 35.5 cm (17½ x 14 in.)
Stedelijk Museum, Amsterdam

poet and theoretician Filippo Tommaso Marinetti upon the latter's visit to Moscow in 1914. By that time Malevich had already developed his own Cubist style. Unlike Picasso and Braque, Malevich did not concentrate on grey or brown values in his colouration, instead employing glowing colour contrasts in his compositions. Thereby he found his way to a unique Cubist vocabulary of form. In the first half of the 1910s, Malevich developed a constantly more reductive compositional style, using austere stereometric forms from which identifiable objects gradually disappeared. At the same time these stereometric volumes gained pictorial independence, so that Malevich began to speak of "realistic Cubo-Futuristic forms", thereby emphasising the independent qualities of his formal elements.

Despite this consistent development, in 1915 Malevich made a radical leap in his artistic production both theoretically and in his paintings, with the execution of the first Suprematist compositions. Suprematism asserts the supremacy of pure form. The black square on a white ground, which the artist first introduced at the exhibition 0.10 in 1915 in Saint Petersburg, took painting to a radical extreme.

With Suprematism Malevich made a decisive step in the development of abstract painting in the 20th century. Abstraction of the natural world had not just developed into a synthesis of the forms of reality (as in Synthetic Cubism), but also expressed the independent realism of absolute forms without any associative reference to a concrete model. Numerous Russian artists, like El Lissitzky and Vladimir Tatlin, followed Malevich along this path, or developed independent positions of their own out of his artistic achievements.

For a short time Suprematism and Constructivism managed to remain the official state art of the 1917 Russian Revolution. Only four years later Vladimir Ilyich Lenin's condemnation of the contemporary arts led to a reversal of this fruitful development. Thus ended one of the few historical epochs in which the prevalent political climate had allied itself with progressive artistic forces. Numerous artists including Kandinsky and El Lissitzky left Moscow for the West, where their ideas were taken up with great interest and enthusiasm not only at the Bauhaus in Weimar and later Dessau, but also in Berlin, Hanover, Paris and by the Dutch De Stijl group.

Artist Associations

The ideals of Suprematism and Russian Constructivism radiated out from Moscow to all of Europe. In the next few years painters, sculptors and architects with similar ideas came together in all metropolises. The European Constructivists emphasised their internationality more than

almost any other artistic movement. The First
World War and the revolutionary unrest that fol-
lowed it had been overcome. For artists a period
began during which they renounced feelings of
nationalism and made renewed contact with
like-minded people and comrades-at-arms in
other countries. In many places artists banded
together to jointly promote and implement their
ideals. Besides the Suprematists around Malevich
in Moscow, local groups were also founded such
as MA in Budapest, die abstrakten hannover in
Germany, De Stijl in the Netherlands and the
Polish group Blok. Many of these artist collectives
saw themselves as regional branches of an inter-
national movement.

In 1916 the painters Theo van Doesburg, Piet
Mondrian and Bart van der Leck joined forces
with the sculptor Georges Vantongerloo and the
architect J. J. P. Oud. In the De Stijl movement's
manifesto, published only two years later, they
ostentatiously demanded: "The artists of today,
all over the world, impelled by one and the same
consciousness, have taken part on the spiritual
plane in the world war against the domination
of individualism, of arbitrariness. They therefore
sympathise with all who are fighting spiritually
or materially for the formation of an international
unity in life, art and culture."

The members of the movement propagated a
universal language of form that was intended to
be concentrated, clear and logical. Its colour
spectrum was reduced to pure colours and the
non-colours, thus yellow, red, and blue, plus
black, white and grey. They applied these to the
canvas in unmodulated tones, using strict geo-
metric planes and orthogonal lines. Aesthetically
they aspired to surpass the narrow confines of
their own discipline, and to include all creative
areas of life: graphic design, architecture and the
applied arts. This humanist ideal found practical
application above all in the teachings of the
Dessau Bauhaus after 1925. Appropriate work-
shops were available there, and the famous train-
ing centre with its prominent teachers also main-
tained the necessary contacts with producers. To
this day, so-called Bauhaus design has retained
its aesthetic leading role in disciplines such as
architecture and product design.

Abstraction as a Universal Language of Art

The historic caesura occasioned by the Second
World War rearranged the map of contemporary
art. The new political powers would also climb
to be the leading nations in the field of art. The
great nation of France in particular lost its politi-
cal and cultural supremacy. The United States, on
the other hand, advanced to the position of the
world's leading art nation. The old art capital of
Paris was displaced by the young metropolis of

**Friedrich
Vordemberge-Gildewart
Composition No. 19**
1926, wood and oil on canvas,
80 x 80 cm (31½ x 31½ in.)
Sprengel Museum, Hanover

New York. The town attained this position for itself not just on its own, however; instead this conquest was initiated by the impulses coming from Europe. Many leading artists, but also some younger ones, had to leave their European homelands to flee to the United States to escape persecution by the Nazis and the terror of the war. Josef Albers, Max Ernst, Hans Hofmann, Marcel Duchamp and Piet Mondrian provided pioneering stimuli to a young generation of American artists. Eager to learn, the New York painters quickly developed independent artistic positions of their own, and an unbroken self-confidence.

In Germany the development of abstract modernism had been interrupted by the Nazi condemnation of any progressive artistic developments as "degenerate art". German artists were forced into either real or inner emigration. After the political liberation of 1945, early abstraction in West Germany also had moral arguments against realistic painting traditions on its side.

The catchphrase that abstraction was a universal language of art, however, has lead to a belief in a coherence and homogeneity that never existed in the abstract painting of the 1950s. The great number of different conceptions is more indicative of the coexistence of independent and contradictory artistic approaches than to a unified school of abstraction. The following list, as

extensive as it may seem, still gives only a selection of stylistic descriptions of the abstract painting of the time: Art Informel, Abstract Expressionism, Lyric Abstraction, L'Art autre, Emotional Non-Figurative, Tachism and Action Painting. Some of these concepts actually identify national schools such as the École de Paris or the New York School. While it was largely agreed that West German painting could be spoken of as Art Informel, the New York artists found themselves only very unsatisfactorily characterised by a term such as Abstract Expressionism. Other formulations described the artists' stylistic approaches. Action Painting stands for dynamic artistic expression based on bodily movement, employed as spontaneously and with as little control as possible. This title embraces such work as the Drippings of American painter Jackson Pollock and the spectacular Action Paintings of the French artist Georges Mathieu, who could boast of being able to finish his works in less than ten seconds.

In the Western section of a Germany divided after 1945, the artists first had to win their artistic freedom and develop an independent position through great effort. Finally in 1953, the critic John Anthony Thwaites, then living in Germany, could state: "The victory of Abstraction is so complete that it is difficult to find a young artist of quality who is not dependent upon it. The young

artists and their young audience alike regard abstract art as their natural element."

L'Art Autre – Another Kind of Art

After the liberation of Paris in 1944 an unbroken tradition of modernism continued to exist in France, although it had been driven to inner emigration during the years of occupation. Pablo Picasso and Henri Matisse had been the two outstanding representatives of this tradition during the 1950s, but they were also competitors. The younger representatives of abstract painting, including Georges Mathieu and the two German immigrants Hans Hartung and Wols, came together for the first time in 1948 in the Parisian gallery of Colette Allendy, in the exhibition *H. W. P. S. M. T. B.*, a title derived from the names of the participating artists. The works of this so-called École de Paris, which Pierre Soulages and Jean Bazaine also belonged to, but which never saw itself as a programmatic school, were characterised by non-objective spatiality and lyrical colour effects.

In contrast to this were the representatives of the artist group Cobra, whose paintings had developed out of a Nordic painting tradition. Its members came from the three capital cities Copenhagen, Brussels and Amsterdam, and the first letters of these cities' names were used for the group's name. However with only a few exceptions these artists, who included the Dutchman Karel Appel, the Belgian Pierre Alechinsky and the Dane Asger Jorn, always clung to figuration. Influences from graffiti, children's drawings and primitive art influenced their works, which they captured on canvas using unusually drastic motifs and with fantastic creative power.

New York as the World Capital of Art

The later art capital New York was not yet present on the map of the artistic avant-garde during the first half of the 20th century. Not until the end of the 1910s had an internationally connected Dada movement developed quickly in the city, fed primarily by the presence of European immigrants such as Marcel Duchamp and Francis Picabia, and supported by the photographer Man Ray, who though born in Philadelphia had also just returned from Paris.

The city's phenomenal rise to the position of undisputed world capital of art in the 1950s to 1970s was one of the consequences of European political developments. The Nazi rule of Germany and the Second World War that began there drove many well-known artists to distant, safe New York. The presence of European immigrants in the New York art scene, their exhibitions in the galleries there and their teaching activities in American colleges, exercised an immense influence on young American painters.

Sophie Taeuber-Arp
Vertical-Horizontal Composition
1927–1928, oil on canvas,
110 x 65 cm (43¼ x 25½ in.)
Museo civico e archeologico, Locarno

The abstract movement of the 1950s had pro-
duced wonderful artists of note. Jackson Pollock,
Willem de Kooning and Mark Rothko particularly
represent that first generation of American artists
through whom New York achieved its leading
position in contemporary art. As a style-setting
epoch, however, Art Informel and Abstract
Expressionism were only able to exercise their
full influence for a short period. Their final
breakthrough in 1958 at the World's Fair in
Brussels, the Venice Biennale and particularly at
the second documenta the following year, simul-
taneously formed the high point and the water-
shed of these movements.

The conquest of abstraction as a global lan-
guage had actually begun in 1953, unnoticed by
the public. Robert Rauschenberg's work *Erased
de Kooning Drawing* marked the definite turning
point and the assault of the next generation of
artists upon the aesthetic canon of their progeni-
tors. In 1953 Rauschenberg asked the famous
Willem de Kooning for an abstract pencil draw-
ing, which he subsequently erased in weeks of
difficult work. Only light traces and damage to
the paper's surface remained of the abstract
composition. Here, the act of destroying existing
values simultaneously marks the onset of a new
artistic orientation.

Kazimir Malevich

b. 1878 in Kiev, Russia
d. 1935 in Leningrad

"The picture's realism consists in the simultaneous demands made by the three great pictorial conditions: the lines, the forms and the colours." — **Kazimir Malevich**

At the Russian Futurists' last exhibition 0.10 (null-ten), which took place in 1915 in St Petersburg, Kazimir Malevich presented 37 new paintings that he labelled Suprematist compositions. Compared with his previous, so-called Cubo-Futurist works, these works revealed a radical reduction in his formal vocabulary. His paintings shocked visitors to the Dobychina Gallery, and Malevich provoked an artistic scandal. *Black Square* was the central work in his installation. It was the simplest composition, and was already accentuated by being hung higher than the other works. Malevich positioned the canvas across a corner and directly below the ceiling, which in Orthodox Russian homes is a place usually reserved for Christian icons. For Malevich, *Black Square* was a modern icon to replace traditional ones. "Modernism", the artist recognised, "can scarcely adhere to the trinity of antiquity, because life today is square." *Four-cornered Figure* was the name Malevich himself originally selected for the *Black Square*.

The painting's canvas is square, although the black quadrilateral delineated within it is slightly out of square. Its contours and black surface also reveal distinctive marks. Malevich did not reject the tradition of painting which his composition was also heir to. One can clearly make out the gestural brushstrokes of the paint application, and the black is applied by no means as evenly as one might expect, given the radical aspirations formulated by the work. Because he applied the paint in several layers the surface is also broken up in numerous places, which reinforces the composition's painterly character. Malevich later painted other versions in various formats, and their surfaces seem more perfect, but thereby also less painterly.

Malevich precisely specified the size of the square on the picture's surface. He consciously avoided filling the entire format with the quadrilateral, instead leaving a white border. Otherwise the painting would have become a pictorial form, an object, and this would have completely contradicted his painterly intentions. Thus the black square placed in the picture's centre creates a proportional balance with its white passe-partout. The black four-sided figure appears neither as a dark hole in the light-coloured surface, nor does the bright border function simply as a frame for the black square.

Malevich's Suprematist compositions of the year 1915 were the first painterly works completely free of any representational link. Instead they lay claim to a realism of their own. Malevich himself backslid from these radical aspirations, however, by entitling a somewhat smaller red square of the same year *Painterly Realism of a Peasant Woman in Two Dimensions*.

(D. E.)

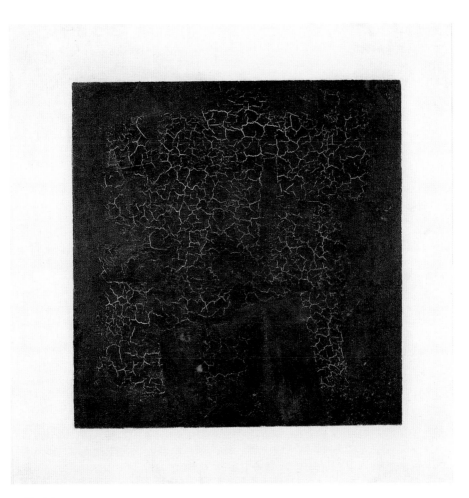

Black Square
1915, oil on canvas,
79.6 x 79.5 cm (31¼ x 31¼ in.)
The State Tretyakov Gallery, Moscow

Alexander Rodchenko

b. 1891 in St Petersburg, Russia
d. 1956 in Moscow

Hanging Room Construction No. 12 (Oval)
ca 1920, plywood, aluminium paint and wire,
61 x 83.8 x 47 cm (24 x 33 x 18½ in.)
The Museum of Modern Art, New York

The *Hanging Room Construction No. 12* is, in its oval version, the only sculpture still in existence from the series of numbered constructions of the same name which the Russian avant-garde artist Alexander Rodchenko created in the years around 1920. As in the other objects which featured circles or triangles – now only extant in the form of reproductions – the elliptic rings of *No. 12* were cut out of a single board in different sizes and connected with wires, so that the oval could be folded out and back together. The piece was made in accordance with the principles of Russian Constructivism, which saw itself as a decidedly political current and to whose founders Rodchenko belonged.

The artist, with his wife Varvara Stepanova and Alexei Gan, formulated his position in the manifesto "Programme of the Constructivist Working Group at the Inkhuk", published on 1 April 1921: "The Constructivist Working Group has made it its purpose to give expression to the Communist idea in physical installations." These physical installations and the organisation of artistic work itself (which was to be coupled with industrial production: the artist was, in line with the prevailing ideology, no longer regarded as an "autonomous creator" but rather as a worker) were to follow the three main principles of Constructivism: "tektonika", "construction", and "faktura". By "tektonika" was understood a functional, or more precisely a politically and socially appropriate use of industrial materials; "construction" determined the pro-

cess and the organisation of these materials for a totally concrete purpose; and "faktura" meant the conscious processing of the materials: the properties of the material, rather than the individual expression of the artist, were to be followed.

Rodchenko's hanging room constructions, which he himself described as "scientific", were created in accordance with this clear schema. They were fully determined by the material conditions, and their formal arrangement and organisational logic were unambiguous and traceable, so that in addition they took account of the group's claim to have developed a universally comprehensible formal language. Nonetheless these works by Rodchenko and his fellow artists (with few exceptions, like for example the wallpapers and carpets designed by Stepanova), had no utilitarian function and can thus be assigned to the experimental, purely artistic laboratory phase of Constructivism. The actual goal of the school, namely to achieve a synthesis between art and industry, and at the same time to redefine the role of the artist and secure him a decisive position in the new Communist society by ensuring that he not only contributed to the industrial production of consumer goods but was also involved in "intellectual production", must be seen in retrospect as utopian and, as the literary critic Peter Bürger showed in his 1974 treatise *Theory of the Avant-Garde*, as having "failed".

(I. D.–D.)

El Lissitzky

b. 1890 in Portschinok, Russia
d. 1941 in Moscow

"We saw that the surface of the canvas ceases to be a picture and turns into a structure round which we must circle, looking at it from all sides, peering down from above, investigating from below." — **El Lissitzky**

The Russian Constructivist El Lissitzky created the painting *Proun R. V. N. 2* in 1923 in Hanover, where he had an exhibition in the Kestner Gesellschaft at the beginning of that year. Following the exhibition Lissitzky received an offer to stay in Hanover and move into an empty studio owned by the Kestner Gesellschaft. The Hanover Merz artist Kurt Schwitters became an important contact person and congenial partner for him. Lissitzky designed the handbill for Schwitters' Merz Matinée, and in 1924 they designed an issue of the *Merz Magazine* together. The painting's unusual title is a tribute to Schwitters and to the city in which the piece was created. R. V. N. refers to Schwitters' transcription of the city name Hanover into "RE VON NAH", which Lissitzky reduced to its first letters R. V. N. At the end of 1923 Lissitzky had to leave the city again, because a serious lung illness forced him to undergo an extended stay at a sanatorium in Switzerland.

Between 1920 and 1925 Lissitzky named all of his compositions *Proun*, a word he himself had derived from the Russian phrase *Proekt utverzdenija novogo* (project for the affirmation of the new). For him they were, as he formulated it in 1921, "stations on our path towards new forms". A *Proun* is therefore a work of transition. Inspired by Lissitzky's interest in Kazimir Malevich's Suprematism, they follow a course of development from picture to architecture; Lissitzky had studied architecture in Darmstadt from 1909 to 1914. In fact, some early *Proun* titles still refer expressly to this architectural connection. In 1920, for example, he created the works *The City (Proun 1E)* and *The Bridge (Proun 1A)*.

From its square format alone the painting *Proun R. V. N. 2* of 1923 can be seen as a programmatic work. Lissitzky avoided using the signal-like colour effects of red planes, selecting only muted brown, grey and black tones for his composition. The motif combines broad flat areas and extremely three-dimensional forms. In the centre stands a light circular area, which he shifted just slightly away from the middle of the picture. This aspect of movement and uncertainty is stabilised once again by the four square areas placed in the painting's corners. They touch and sometimes overlap the light-coloured circle. Three narrow architectural forms with clear but by no means uniform edges of light and shadow float in front of the circular plane. Each of these objects appears to be lit by its own light source. Despite this, none of the forms throws a shadow on any of the other objects or on the light-coloured disk in the background. This also makes the position of individual elements in the space confusing.

Lissitzky's *Proun* works abandoned the illusionistic space of traditional painting. He reversed the idea of a picture being a view out a window into perspective space. In the *Proun* works the composition unfolds against a back wall. The individual components occupy the space between pictorial surface and viewer, and so appear to conquer real space. Compared with the traditional conception of painting Lissitzky thus formulated an idea that was radically new, and one in which the *Proun* works were to be understood as a draft version for future architectural ideals.

(D. E.)

Proun R. V. N. 2
1923, mixed media on canvas,
99 x 99 cm (39 x 39 in.)
Sprengel Museum, Hanover

László Moholy-Nagy

b. 1895 in Bácsborsód, Hungary
d. 1946 in Chicago, USA

Light is the foundation of László Moholy-Nagy's artistic work. As early as 1925 his book *Painting Photography Film* set out an aesthetic theory of light. In the search for techniques "appropriate to the age", he invented the photogram as a new art genre: a pure graphics of light, generated by directly exposing photosensitive paper. Moholy-Nagy also reinterpreted painting using light as a criterion. In 1921–1922 he developed a method of "painting transparency" with the help of "glass architectures". He added a virtual spatial tension resulting from transparent interpenetration within the structure to the abstraction of an architectural structure of elemental forms and colours, reminiscent of Kazimir Malevich and El Lissitzky.

The second phase of his Constructivist pictures, to which *Composition A II* belongs, also shows his endeavours to treat light as a "new plastic medium" on the painted canvas. The coloured parallelograms and circles are almost diaphanous, while one surface overlaps another and the colour tones change as a result. The interplay of shade and illumination emphasises Moholy-Nagy's artistically effective use of light as an aesthetic medium.

In 1924, when *Composition A II* was produced, Moholy-Nagy was involved in the creative atmosphere of the Bauhaus, to which Walter Gropius had appointed him as a professor the previous year. Josef Albers, Wassily Kandinsky, Paul Klee and Oskar Schlemmer were among his colleagues there. The equal status not only of different media and genres, but also of art, crafts and technology was part of an ideal of holistic thinking which Moholy-Nagy shared with many at the Bauhaus. This also involved him designing stage sets, making films, painting, photographing and sculpting. He transferred the concern with transparency to all his fields of activity. The strongest expression of his "light visions" is provided by the *Light-Space Modulator*, whose conception, execution and effect serve as the key to the understanding of his artistic work.

"When the 'light prop' was set in motion for the first time in a small mechanics shop in 1930, I felt like the sorcerer's apprentice. The mobile was so startling in its co-ordinated motions and space articulations of light and shadow sequences that I almost believed in magic" (Moholy-Nagy). It had taken eight years for the dream machine to become reality. The "light prop" was now turning, and created a shadow-play out of the projected light. Even without incident light it represents, with its pierced metal surfaces and its complicated structure of superimposed and interpenetrating elements, a sophisticated version of transparency. Moholy-Nagy used the same geometric elements as in his paintings, but now the construction really could modulate the beam of light.

When he was forced to leave Germany in 1934 under the political pressure of the Nazi regime, he took the cumbersome apparatus with him. He had made the first kinetic sculpture with a height of one and a half metres, after all; that he should not want to leave it behind is understandable.

(J. G. S.)

Composition A II

1924, oil on canvas,
115.8 x 136.5 cm (45½ x 53¾ in.)
Solomon R. Guggenheim Museum, New York,
Solomon R. Guggenheim Founding Collection

Wassily Kandinsky

b. 1866 in Moscow, Russia
d. 1944 in Neuilly-sur-Seine, France

"Necessity creates the form."
— **Wassily Kandinsky**

In the Blue was produced in 1925, the year the Bauhaus had to move from Weimar to Dessau. Wassily Kandinsky had taught at the college since 1922. In the text *Point and Line to Plane,* which appeared in 1926, he further developed his early theory from *Concerning the Spiritual in Art.* The mid-sized painting *In the Blue* differed considerably from Kandinsky's works of the early 1910s. Here the free brushwork gave way to strict geometric forms. A flat paint application replaced modulated colours. Instead of representational allusions to riders, architecture and landscape, one finds the elementary forms of circles, triangles and quadrilaterals. Symbolic design replaces narrative elements.

As in many of Kandinsky's works of the 1920s, the composition of the painting *In the Blue* also includes a circular form at its centre, although it is by no means the dominant element here. The geometric forms are arranged against a blue background. They form a complex structure of discs, circle segments, triangles and quadrilaterals, and are superimposed upon one another in delicate nuances. Kandinsky had encountered examples of such transparency in the glass workshop at the Bauhaus, and like Paul Klee he had integrated it into his painting. On the canvas' surface the forms constitute two complex groups. The large structure at the picture's centre, all elements of which appear to be attached to a dark triangular form, is accompanied by a smaller shape in the painting's lower left corner. Around these two metaforms is a greenish colouration that delicately fades to the blue of the background. This makes the forms appear lit from behind, or surrounded by a radiant corona of colour. This painting has repeatedly provoked comparison of its composition with a cosmic order.

In 1930 Kandinsky confessed in a letter: "In the past few years when I have so often and passionately used circles, for example, then the reason (or cause) is not the circle's 'geometric' form or geometric characteristics, but rather my strong sense of the inner power of circles in their innumerable variations; I love circles today as I earlier, for example, loved horses." In his treatise *Concerning the Spiritual in Art* Kandinsky attributed very specific characteristics to all combinations of forms and colours.

Thus he not only combined forms and colours into an autonomous composition in his paintings, but additionally overlaid them with inner values, moods and tensions. Kandinsky assigned a specific characteristic to every form and every colour: circles symbolised perfection, yellow stood for earthliness and expressed solidity. Different combinations of form and colour would give a red circle, a blue square or a red triangle their respective individual expressive qualities. They could balance or augment one another, such as by placing a sharp colour within a pointed form. The artist spoke of the colour yellow in a triangle as an example of this. Yet one does not have to have read Kandinsky's writings to be moved by his abstract compositions. They communicate not just theoretically, but also and particularly intuitively – and that is their special quality.

(D. E.)

In the Blue
1925, oil on cardboard,
80 x 110 cm (31½ x 43¼ in.)
K 20 – Kunstsammlung Nordrhein-
Westfalen, Düsseldorf

Theo van Doesburg

b. 1883 in Utrecht, Netherlands
d. 1931 in Davos, Switzerland

"Once the means of expression are liberated from all characteristics they are on their way towards the real goal of art: to create a universal language." — **Theo van Doesburg**

Theo van Doesburg, born Christian Emil Marie Küpper, presented himself as a Dadaist under the pseudonym I. K. Bonset. Van Doesburg met Piet Mondrian in 1916; one year later they were the two leading minds of the De Stijl movement in Holland. In the first issue of the magazine of the same name, the group presented two central demands: "The truly modern – meaning conscious – artist has a double task. Firstly: to produce the purely composed artwork; secondly: to make the audience receptive to the beauty of the pure visual arts." No other member of the De Stijl group identified as much with these demands as van Doesburg.

He was committed to extending De Stijl thought beyond the narrow boundaries of painting, architecture and the applied arts. Following the First World War he made numerous international contacts, organised exhibitions, formulated manifestos and held lectures and teaching events. Van Doesburg designed architectural models and planned interiors. It was above all at the Bauhaus in Weimar that he found his ideals of integrated artistic design in all areas of life, and of interdisciplinary education realised. His hopes of a position at the institution, however, were never fulfilled. Instead van Doesburg organised an independent De Stijl course for Bauhaus students in the summer of 1922.

Van Doesburg neglected his own painting during that period, and concentrated entirely on developing his draft designs and projects, and on theoretically formulating De Stijl. Not until 1924 did he once again produce a small group of paintings, which he entitled *Contra Compositions* and which occupied a counter-position to his earlier compositions of 1920. His previous compositions had consisted of harmonic arrangements of square and rectangular flat forms. The pictorial formats were characterised by a large square, accompanied by several other planes. He applied the paint smoothly without visible brushstrokes. Unlike Mondrian, van Doesburg allowed himself a richly graduated colour spectrum.

With the *Contra Compositions* of 1924, van Doesburg took a decisive step away from the harmony and stasis of his earlier works. By tipping the position of his quadrilaterals by 45 degrees, he created a previously unknown openness and dynamic. None of his squares or rectangles are completely drawn in the new works. They all extend beyond the format's boundaries into an imaginary, universal space. Viewers only see fragments of all of the forms. Optically, the diagonals set the block-like forms in motion. Mondrian would later only indicate these boundary transgressions. In this compositional dynamisation and the break with strict horizontals and verticals, Mondrian saw such an affront by van Doesburg against De Stijl's original ideals, that in 1925 he left the group in protest.

(D. E.)

Contra Composition V
1924, oil on canvas,
100 x 100 cm (33¼ x 39¼ in.)
Stedelijk Museum, Amsterdam

Constantin Brancusi

b. 1876 in Hobiţa, Romania
d. 1957 in Paris, France

Bird in Space
1928, bronze,
137.2 x 21.6 x 16.5 cm (54 x 8½ x 6½ in.)
Musée national d'art moderne, Paris

The Romanian sculptor Constantin Brancusi, who was based largely in Paris from 1904, was still strongly influenced by Auguste Rodin at the start of his career. In his sculptures of polished stone (marble), metal and wood, he united inspirations from the French avant-garde, in particular Cubism, with principles of the archaic sculpture and folk art of his homeland to create a brilliant synthesis which, while unmistakable, is difficult to assign to any particular style. All his works however have one thing in common: the reduction, sometimes to the point of abstraction, of the natural model to elemental, archetypal forms. Like almost no other sculptor of classical Modernism, Brancusi knew how to turn the surfaces of his sculptures, the "plastic skin", into a material and visual event. Above all the luminous aura of his bronzes gives rise to fascination as a result of the immaculate smoothness of the metal, polished to a high gloss, which Brancusi liked to contrast with the porous structure of a stone plinth.

A further characteristic of this sculptor is his manner of working in "experimental set-ups": he would modify and vary his forms countless times, trying them out in various materials. Accordingly, there are dozens of versions of *Bird in Space* too. The first studies can be dated to 1922, to be followed the next year by a marble version, first in white marble, then, in 1923–1924, in yellow; the first bronze example was made in 1924, while a further bronze version was the object of a legal dispute with United States Customs, who refused to allow the work into the country duty-free, since it was "obviously" nothing but a dutiable piece of metal. After the execution of the example illustrated here in 1928, Brancusi continued to experiment a number of times with this motif.

Most of the plinths for *Bird in Space* were conceived by Brancusi in such a way that they initialise the kinetic energy of the bird's vital body as it winds its way ethereally into the air. Brancusi seeks to illustrate this self-lifting as a simultaneous impression – as a visual experience, in other words, which is not realised by looking at it from one side only, but rather results from a synoptic integration of many angles of view.

The polished surface of the sculpture has, one is almost tempted to say, a dialectic function. On the one hand it refines the elemental plastic form to absolute perfection, as it emphasises the stringency and clarity of the volumes which never break out of their closed contour. On the other hand its multitude of gloss effects caresses these linear boundaries, and thus it confronts the permanent element of the basic form with the transient element of changing light reflections. Finally, the polish underscores the "weightlessness" of the structure, away from the ground, away from the plinth, up into space. The *Bird in Space* is not simply the image of a natural creature taking off, it is also a synonym for the floating of the sculpted form; it is dematerialised matter.

(N. W.)

Paul Klee

b. 1879 in Münchenbuchsee, Switzerland
d. 1940 in Muralto

This work's title, *Highroads and Byroads*, also stands like a motto over Paul Klee's biography. When he painted this work in 1929, he lived in Dessau and taught at the Bauhaus there. Four years earlier the school had moved to this city from Weimar. Klee's life led him from Berne to Munich to Weimar, where he began teaching at the Bauhaus in 1921, and then to Dessau. He repeatedly undertook longer trips, the most famous being a trip to Tunisia in 1914 with August Macke and Louis Moilliet. "Colour has taken possession of me; no longer do I have to chase after it," he noted in his diary during this stay in North Africa.

Early 1929 also found Klee far from Dessau; for one month he travelled through Egypt. The painting *Highroads and Byroads*, which he created after this journey, appears completely permeated by his impressions of it. Klee's pictures are never pure abstractions; the title, if nothing else, returns them to a figurative or representational order. Klee was a masterful inventor of condensed signs and codes; he used individual symbols and concrete signs, arrows, letters and numbers to direct his viewers' attention.

At more that 80 centimetres in height, the painting is unusually large among Klee's works. Despite this it possesses the sensitivity and delicacy of his intimate drawings. At first glance the composition appears abstract. Across the painting's entire surface lies a filigree network of fine hand-drawn lines, which divide the motif into a grid of narrow rectangles. Yellow, bluish and greenish colours fill these planes and divide the format into a variable structure of rhythmically organised fields. The picture's entire pale surface has the appearance of being backlit. The transparent colours are reminiscent of Egypt's glistening light. The staggered, initially abstract rectangles evoke associations with a landscape of cultivated fields. The horizontal blue stripes at the upper border are thus reminiscent of a river, or of waves rolling onto a beach. Down the centre of the picture runs a series of colour fields, diminishing in perspective towards the top. This must be the highway mentioned in the title. Appended to it on the left and right are the mentioned byways. They are irregular, sometimes broad, sometimes narrow, and wind off towards the horizon. The colouration of these byways is more intense than that of the broad main path; the byways are more varied, more enthralling, and more exciting.

This initially abstract composition by Klee proves at second glance to be an Egyptian landscape, and upon closer inspection to be a metaphor for various styles of living. In that year Klee had celebrated his 50th birthday, and indeed the painting can also be read as an interim appraisal of his life. It describes the possible alternative paths he could take through life, starting from his life experiences until then. In a letter of 13 September 1929 to his wife Lily, Klee complained: "The Bauhaus no longer upsets me, but people demand things from me that are only partly fruitful. This is and will continue to be disagreeable. Nobody can do anything about it except me, and I do not find the courage to leave." In the following year, however, Klee did pursue a new path, and accepted an appointment as professor of painting at the art academy in Düsseldorf. Yet when he finally moved with his family to Düsseldorf on 1 May 1933, the Nazis had already dismissed him from his teaching position.

(D. E.)

Highroads and Byroads
1929, oil on canvas,
83.7 x 67.5 cm (33 x 26½ in.)
Museum Ludwig, Cologne

Piet Mondrian

b. 1872 in Amersfoort, Netherlands
d. 1944 in New York, USA

Composition No. II, with Red and Blue
1929, oil on canvas,
40.3 x 32.1 cm (16 x 12¾ in.)
The Museum of Modern Art, New York

Piet Mondrian's painting *Composition No. II, with Red and Blue* is one of the classic manifestations of a compositional concept he had developed in 1921 while living in Paris. After several years during which he hardly painted, it was there that he started on the compositions of austere black horizontal and vertical lines, filling the spaces between them with red, blue and yellow fields of colour. Although these pictures reveal no natural associations at all and present themselves as pure compositions of strictly ordered lines and planes, a look back at Mondrian's early work shows the consistency with which he had developed these motifs step by step from his earlier depictions of trees and architectural vistas. In the 1929 structure of black lines the tree's dark branches are still present as an idea. Mondrian had continually reduced the natural model until only individual horizontal and vertical lines remained. They give this composition of coloured planes its firm architectural stability.

Through his abstract paintings Mondrian was seeking a new classical ideal of harmony and beauty. Their final execution was preceded by a long series of draft versions and initial attempts. The result is a harmonious balance between the positioning and boundaries of the coloured areas, both in the tension between them as well as in their relationship to the two accompanying white areas. Thereby at the end of the 1920s Mondrian

was working towards compositions that were continually more reductive. *Composition No. II, with Red and Blue* of the year 1929 consists of just five fields, only two of which are coloured. In this work the artist completely left out the primary colour yellow. A large white rectangle occupies the centre instead. The red and blue colour fields have been shifted to the upper edges. This gives the picture its lightness and appears to work against gravity.

Unlike in Mondrian's earlier works, none of the planes of this pictorial composition are enclosed on all four sides by black lines. The main effect of this is to give an impression that the coloured planes extend beyond the format into imaginary space. Mondrian integrated an element in the composition, however, to counterbalance the black bars extending outwards from the painting. The vertical line does not touch the painting's upper edge, but instead ends shortly before it within the red colour field. This compositional device for the black lines is found in almost all his works of those years.

Mondrian uses this to expressly emphasise the composition's subordination to the proportions of the canvas. Mondrian had developed his abstract compositions from a natural model. Ultimately they are no longer representations, but unique artistic creations; they formulate an ideal harmonic counterworld to the experienced creatureliness of nature. (D. E.)

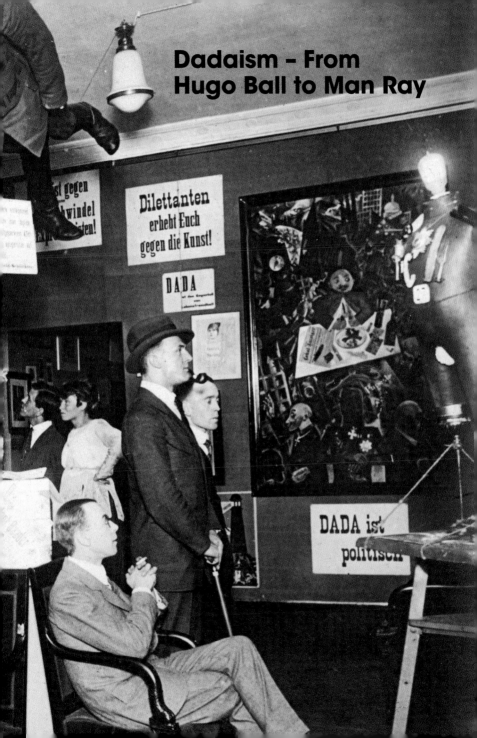

Dadaism – From
Hugo Ball to Man Ray

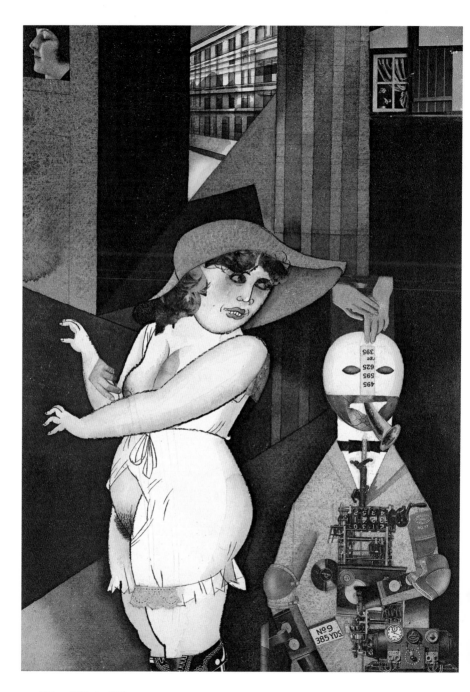

Before Dada Was There, There Was Dada

Dietmar Elger

George Grosz
Daum Marries Her Pedantic Automaton George in May 1920, John Heartfield Is Very Glad of It
1920, watercolour over pen and pencil, Indian ink, collage, 42 x 30.2 cm (16½ x 12 in.)
Berlinische Galerie, Landesmuseum für moderne Kunst, Fotografie und Architektur, Berlin

Pages 262–263
The First International Dada Fair
Standing from left to right: Raoul Hausmann, Otto Burchard, Johannes Baader, Wieland and Margarete Herzfelde, George Grosz, John Heartfield. Seated: Hannah Höch and Otto Schmalhausen. Kunsthandlung Dr. Otto Burchard, Berlin, 5 July 1920

What Is Dada?

In its second issue, which appeared in December 1919, the Berlin magazine *Der Dada* asked its readers the question "What is Dada?" and at the same time suggested a series of possible and impossible answers, ranging from "an art" to "a fire insurance". And the questioner finished by asking another question: "Or is it nothing at all, in other words everything?" It was precisely this assessment, one that refused to tie itself down in the slightest, that came closest to the aims and the spirit of Dada. The formulation hints above all at the contradictions which the Dadaists were only too happy to promote. Dadaism was not exclusively an artistic, literary, musical, political or philosophical movement. Indeed it was all of these, and at the same time the opposite: antiartistic, provocatively literary, playfully musical, radically political but anti-parliamentary and sometimes simply childish. Many of the Dadaists nurtured their double talents accordingly. As performing artists they were no less committed or inventive than they were with visual techniques.

In spite of the numerous manifestos composed by the Dadaists, there was no tight-knit group behind the movement. Nonetheless, there were those in every town or city who acted as their spokesmen. They provided a focus for their many sympathisers, of whom some in turn took part in Dadaist activities only briefly or occasion-

ally. The period during which the Dada movement was active can be dated approximately to the years between the founding of the Cabaret Voltaire in Zürich in 1916 and the early 1920s in Paris, where the movement came to an end.

Dadaism differed from the various artistic and literary trends in the years immediately preceding – Futurism in Italy, Cubism in Paris and Expressionism in Germany – if in no other way than because it enjoyed broad international support. Artists and men of letters in Zürich, Berlin, Hanover, Cologne, New York, Paris and many other cities were in direct contact with each other, taking part in Dadaist activities and making their own contributions to the movement's numerous publications. In Zürich, the city of Dada's birth, its exponents presented themselves to the public chiefly with literary programmes on the stage. In Berlin, Dadaism also saw itself as a political protest. Cologne's Dadaists by contrast concentrated on the development of new artistic techniques of image creation. Numerous magazines, most of them short-lived, served not only the purposes of internal communication, circulating between the international Dadaist centres, but also reached a broader public. Thus the *Ventilator* in Cologne had a circulation of 40,000. While the Zürich Dadaists in 1916 could attract audiences of several hundred – a respectable enough figure – to their literary evenings, their

counterparts in Berlin three years later were filling halls of up to 2,000.

Dadaism was above all the expression of the particular attitude of mind with which international youth reacted to the social and political upheavals of the time. They formulated their opposition in anarchical, irrational, contradictory and literally "sense-less" actions, recitations and visual artworks. On the occasion of the movement's golden jubilee, Hans Arp congratulated it thus: "Before Dada was there, there was Dada." He pointed to two different aspects: Firstly, literati and artists had in earlier comparable situations already had recourse to Dada-like forms of expression. And secondly, every definition of Dada was so vague that it could be stretched to include distant sympathisers and many a fringe figure too.

If Dadaism today is mentioned in the same breath as other stylistic developments of the first half of the 20th century, such as Expressionism and Surrealism, it is first and foremost because the Dadaist artists and literary figures succeeded in finding pioneering creative processes or further developing existing ones.

Zürich - A Hobby Horse Enters the Stage
In 1916 Switzerland was an island of peace in the midst of the bloody battlefield of the Great War. Young artists, pacifists and revolutionaries from all over Europe found refuge here. It was from his base in Zürich that Lenin laid the groundwork for the Russian Revolution; until April 1917 he lived in the immediate vicinity of the Dadaists' Cabaret Voltaire.

In May 1915, Hugo Ball and his lover Emmy Hennings arrived in the city. He had studied philosophy and German literature in Munich, where he had worked at the "chamber theatre" alongside the dramatist Frank Wedekind. In February 1916 Hugo Ball founded the Cabaret Voltaire in Zürich. Those who came to be his most important colleagues in this enterprise were also émigrés, among them Tristan Tzara, Hans Richter and Hans Arp. Not long afterwards, Ball also welcomed Richard Huelsenbeck to the group; the two knew each other from time spent together in Berlin. They all had the same reasons for seeking refuge in Switzerland, which Huelsenbeck expressed in the following drastic terms: "None of us had any understanding for the courage that is needed to allow oneself to be shot dead for the idea of the nation, which is at best an interest group of fur dealers and leather merchants, at worst an interest group of psychopaths, who, from the German 'fatherland', set out with their volumes of Goethe in their kitbags to stick their bayonets into French and Russian bellies."

It was no coincidence that the young literati and artists who started the Dadaist movement in

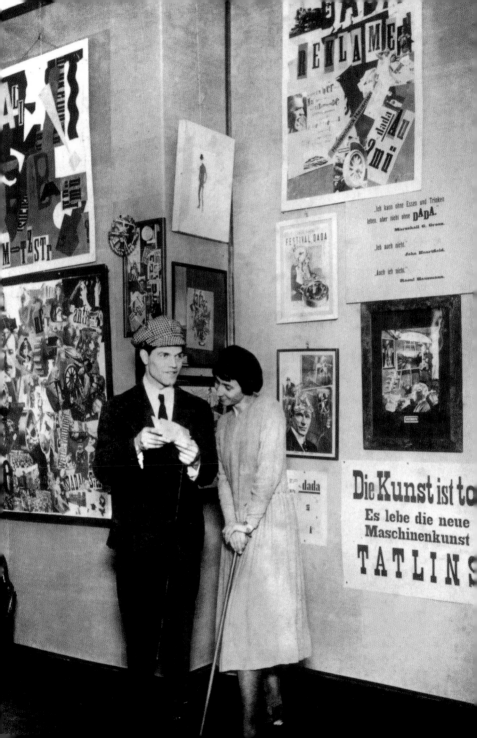

Zürich in 1916 included not a single native-born Swiss. They were brought together here by their detestation of war and their fear of being conscripted to serve at the front. Unlike the Italian Futurist Umberto Boccioni and the German Expressionists Max Beckmann, August Macke and Erich Heckel, they never fell for the naive temptation to transfigure the war into some kind of heroic community experience for the youth of Europe.

The Dadaists reacted with horror and disgust to the brutality of the war, to the mechanical anonymous killing and to the cynical justifications put forward by the powers-that-be on both sides, who sought to use the seeming logic of their arguments to legitimise their war policy.

Hugo Ball himself kept lively memories of the foundation of the Cabaret Voltaire: "I went to Mister Ephraim, the owner of the Meierei and said: 'Please, Mister Ephraim, can I have your hall?' And I went to various friends and said: 'Please, can I have a drawing or a print? I'd like to combine my cabaret with a little exhibition.' I went to the friendly Zürich press and asked them: 'Write a few notices. It's planned to be an international cabaret. We're planning to do some nice things.' I got the pictures and the notices. And so on 5 February we had a cabaret." The modest hall at No. 1 Spiegelgasse had enough room for a little stage and about 50 guests.

The walls were decorated with works by Max Oppenheimer and Hans Arp and masks by Marcel Janco. Every evening, Ball and his friends staged a varied programme of songs, readings, music and dances.

Few if any other names of movements have generated so many myths. Several Dadaists claim to have discovered or invented it. Friends supported now one version, now the other. In the battle of priorities – and not just in the disputes concerning the origin of the word Dada – most Dadaists suddenly became deadly serious. Among the Parisian group in the early 1920s, the honours were accorded to Tristan Tzara. Following his return from Zürich in January 1920, he had claimed to have found the term Dada in the Larousse Dictionary.

The most credible version seems the one which Richard Huelsenbeck put about in his book of memoirs *En avant Dada*: "The word Dada was discovered by chance by Hugo Ball and me in a French-German dictionary... Dada means hobby horse in French." The term is first publicly documented in the preface to the first edition of the magazine *Cabaret Voltaire*, which appeared at the end of May 1916, where Ball reports on the foundation of the Cabaret and goes on to announce: "The next goal of the artists assembled here is the publication of a Revue Internationale. La revue paraîtra à Zurich et portera le nom

Johannes Baader
Postcard to Tristan Tzara
collage
Bibliothèque Littéraire Jacques
Doucet, Paris, Archives Charmet

'Dada'. ('Dada') Dada Dada Dada Dada." In this naive baby talk, the Dadaists found an appropriate expression for their nihilism, their disgust at all bourgeois convention and at the warmongering of the politicians. In its combination of onomatopoeic conciseness on the one hand and freedom from interpretable meaning on the other, the term seemed to be a good war cry in their assault on the traditions of literature and art, as well as on the harmonious order of composition, colour theory and prosody. While the Dadaists could not abolish war, the political power structures or the class system in society, they could make their point by smashing the formal structure of pictures and poems. It was only in Berlin that the Dadaists, under the leadership of Richard Huelsenbeck, George Grosz and John Heartfield, turned this literary and artistic proxywar into an active political struggle.

Hugo Ball was the inventor of sound poems, which became the preferred form for Dadaist stage artists. In the sound poem, traditional order, the interplay of sound and meaning, is abolished. The words are dissected into individual phonetic syllables, thus emptying the language of any meaning. Finally, the sounds are recombined into a new sound picture. This process robs language of its function because, in the view of the Dadaists, instructions, commands and the conveyance of information had deprived language of its dignity. "With these sound poems", said Hugo Ball in justification of their intentions, "we wanted to dispense with a language which journalism had made desolate and impossible." Instead, the Dadaists sought to restore words to their pristine innocence and purity.

Other Dadaists sought to aestheticise their text material by arranging the syllables in such a way as to produce music-like sound-picture verse-compositions through repetition and rhythm. And in fact the Hanover Dadaist Kurt Schwitters did succeed, over a period of ten years, in advancing from such modest beginnings to compose a 40-minute sound-picture *sonata in primeval sounds*, which was structured in a number of movements to which classical tempo indications such as rondo, scherzo and presto were assigned.

In spite of the participation of Hans Arp and Marcel Janco in the Zürich Dada movement, the mood among the literati involved was basically anti-artistic. They were prepared to allow the visual arts some entitlement to a place in the Dadaist movement, if at all, only if they proved themselves radically anti-aesthetic and ahistorical, and liberated from all art-historical role models. A renunciation of traditional work in oils on canvas on the part of the visual artists was one of the consequences of satisfying such demands by their fellow-Dadaists. If the Dadaist

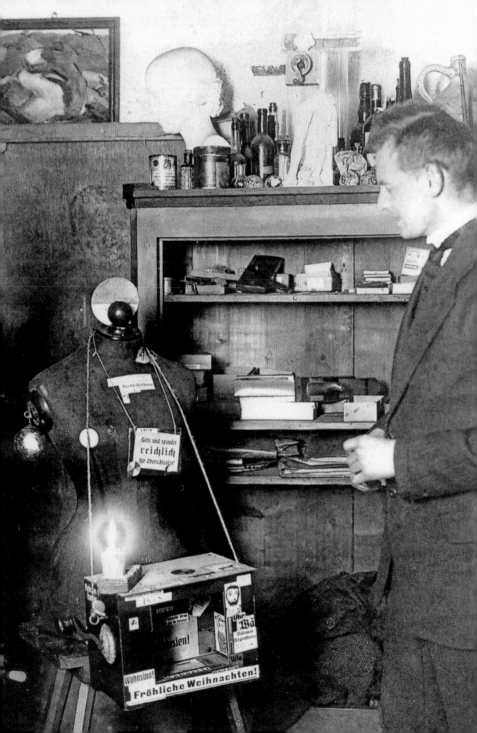

Left
Kurt Schwitters with the assemblage The Holy Affliction
(ca 1920, now destroyed)

Right
First International Dada Fair
catalogue, 1920, with texts by
Wieland Herzfelde and Raoul
Hausmann

artists did rework familiar motifs from art history and integrate them into their own works, then it was always with a disrespectful undertone.

1917 was not out before Hugo Ball withdrew to Ticino. Hans Arp left Zürich in 1919. He went first to Cologne, where he met up with Max Ernst again, and together with him and Johannes Theodor Baargeld established the Cologne Dadaist group. Richard Huelsenbeck had already returned to Germany in January 1917 in order, together with like-minded persons in Berlin, to breathe new life into the Dadaist idea. Dadaism came to an end in Zürich at the latest with Tzara's departure for Paris in January 1920. By this time Dadaism had only just reached the climax of its international triumphal march through Berlin, Paris and New York, as well as less metropolitan locations such as Hanover and Cologne.

Berlin – Dada Is: A Flourishing Business

Richard Huelsenbeck had, as he later himself confessed, temporarily parted company with Dadaism. Indeed, it took a whole year for him to renew his public commitment to the movement with an appearance at the Graphisches Kabinett I. B. Neumann on 22 January 1918. That evening he ignited the spirit of Dada in Berlin with a fire-raising speech. His ideas were spontaneously and enthusiastically taken up in the Reich capital by numerous young literati and artists. "He carried the Dada bacillus to Berlin, where Raoul Hausmann, already infected from birth, was so receptive to the infection that came from Zürich that the bacilli themselves didn't know whether they descended from R. H. or R. H. on their father's side," was how Hans Richter appraised Huelsenbeck's importance as the mid-wife of Berlin Dadaism. "This evening", confidently proclaimed Richard Huelsenbeck, "is intended as a demonstration of sympathy for Dadaism, a new international 'artistic trend', which was founded two years ago in Zürich." In the following months he was joined by, among others, Johannes Baader, George Grosz, Raoul Hausmann, Hannah Höch and John Heartfield. The onomatopoeic term Dada seemed to give expression to their unease at the social situation in Germany, and in the activities of the Zürich group they found preformed possibilities of giving artistic form to their protest.

In early 1919, the Dadaists finally formed a closer association and began to turn to a broader public with numerous activities and publications. The trigger, according to Raoul Hausmann, was the murder of the leading Communists Karl Liebknecht and Rosa Luxemburg on 15 January 1919. "The proletariat was paralysed and could not be shaken out of its narcosis. So we had to intensify the DADA actions: against a world which could not even react manfully to unpardonable horrors," he recalled in his book *In the Beginning Was Dada*. Dada Berlin

evinced a more aggressive expression than its exemplar in Zürich. While the Swiss model was basically a literary cabaret, with a few anarchist features, the Club Dada adopted explicitly political attitudes. The Zürich people expressed their disgust with political events by radically rejecting any attitude of their own and retreating to a nihilist position.

By contrast, the Berlin Dadaists formulated opposition to the war, the Weimar Republic, the Prussian bureaucracy and the conservative bourgeoisie in numerous polemical proclamations, manifestos and public events. Their most important communication organs were the numerous little Dadaist magazines which admittedly vanished after just a few numbers. These included *Der Dada*, edited by Raoul Hausmann, and *Die freie Strasse* (The Open Street), which he edited jointly with Johannes Baader. The Berlin Dadaists had an eye for business in other respects too. They had Dada Tours, which they used to take their ideas and activities to other cities, organised by large event agencies. Tristan Tzara could thus say in 1920 without a trace of irony: "Dada is: a flourishing business."

The attacks of the Berlin Dadaists on the political system were often acerbic in the extreme. They even threatened the destruction of the Weimar Republic: "We will put a bomb under Weimar. Berlin is the Dada Place. No one and nothing will be spared." In impressive fashion, a large-format collage by Hannah Höch dating from 1920 describes better than any other work the mood of the times and the political direction Berlin Dadaism was taking. Its telling title: *Incision with the Dada Kitchen Knife through Germany's Last Weimar Beer-belly Cultural Epoch* (p. 287).

The Berlin group extended Dadaist imagery by taking up the photomontage technique, which, though unknown in Zürich, had important precursors among the Russian Constructivists and Italian Futurists. This technique extended the familiar collage by including photographic fragments, the realism of which imported a new degree of provocation into the genre. Compared with drawings and paintings, however realistic, a photograph is always more credible. In combination with other, typographical design elements, such as newspaper cuttings and printed headlines, photomontage conveys a dynamism, immediacy and actuality impossible in all other means of artistic expression.

However, by 1920 the Berlin Dadaist movement was already in a state of dissolution. Heartfield, Baader and Grosz were beginning to go their own separate ways. Even Raoul Hausmann chose this moment to seek a new way ahead: "Dada was dead, without glory and without a state funeral. Simply dead. The DADAists returned to private life. I declared myself as

Dada Conquers!
1920, exhibition poster for the
re-opening of the Dada-Pre-Spring
exhibition at Schildergasse 37 in Cologne,
28.7 x 40 cm (11¼ x 15¾ in.)
Kunsthaus Zürich

Anti-DADA and a PRESentist, and took up the
fight on another level together with Schwitters."

Hanover – Kernel- and Husk-Dadaists

Raoul Hausmann had met Kurt Schwitters at the
end of 1918 in the Café des Westens, when the
latter introduced himself with the words: "I am a
painter and nail my pictures." The two became
friends at once. However, when Hausmann pre-
sented Schwitters' request for membership of the
Club Dada the next day, he was forced to accept
that "we knew next to nothing of this Schwitters".
But an even more decisive factor was that
"Huelsenbeck didn't like him". Like many others,
Kurt Schwitters was denounced by Huelsenbeck
as imitative, as well as for having an allegedly im-
moral eye for business. "In recent times, Dada-
ism has been embraced by many publishers on
business grounds and by many poets on the
make," he warned in the *Dada Almanac*, pub-
lished in 1920. The surprising commercial suc-
cess of Schwitters' verse collection *An Anna Blume*
only seemed to confirm these fears. Schwitters
himself reacted to his rejection by the Berlin
Dadaists in general and to Huelsenbeck's attacks
in particular with a self-assured polemic of his
own. In a magazine article in December 1920, he
counter-attacked, wickedly distinguishing be-
tween what he called the kernel-Dadaists and
the husk-Dadaists. This was a play on Huelsen-

beck's name, *Huelse* being the German for
"husk". As early as the summer of 1918, Schwit-
ters had joined the circle centring on Herwarth
Walden's gallery Der Sturm in Berlin. Particularly
important was his first solo exhibition, which Der
Sturm staged in July 1919, and in which Kurt
Schwitters first presented his works under the
term "Merz". He had used the word Merz (which
has no meaning in German, but recalls the verb
ausmerzen, to eradicate) as a fragment in one of
his first assemblages, having cut it out of the
name "Kommerz- und Privatbank" (Commercial
and Private Bank) and introduced it into one of
his works. The assemblage was then given the
title *Merz Picture* on the basis of this snippet of
text. Unable to use the term Dada for his art, he
called all his art after this work "Merz".

For Schwitters, the Merz principle was supe-
rior to pure oil painting if for no other reason
than that it did not just use paint, but any artistic
or everyday material whatever. In the process, all
the materials used are subsumed into an abstract
pictorial composition. He once summarised the
creation of these early Merz pictures as follows:
"At first I constructed pictures from the material
which I happened to have conveniently to hand,
such as tram tickets, cloakroom tickets, bits of
wood, wire, string, twisted wheels, tissue paper,
cans, glass splinters etc. These objects are
integrated into the picture either as they are, or

altered, according to the demands of the picture. By mutual comparison they lose their individual character, their individual poison. They are de-materialised and are the material of the picture." Schwitters always went out of his way to stress the aesthetic quality of his works of art, thus emphasising once more the difference between them and the Dadaist objects: "The pure Merz is art; pure Dadaism is non-art; both deliberately." With their political anarchism and their anti-art gesture, the Berlin Dadaists must naturally have felt this, if anything conservative, view of art on Schwitters' part to be a provocation.

Schwitters' Merz art is in no way limited to collages, which he called Merz drawings, or to the larger-format assemblages, the so-called Merz pictures. The term quickly became, for him, synonymous with all his artistic activities. "Merz means creating relationships, preferably between all the things in the world," he proclaimed as early as 1924 in one of his theoretical manifestos, and three years later was able to assert: "Now I can call myself Merz."

Cologne – Dada as Bourgeois Art World?
Cologne was not the centre of a broad Dada movement. The group's activities were focused primarily on the trio of Max Ernst, Theodor Baargeld and Hans Arp. They not only organised the *Dada Pre-Spring* in the Winter brewery in Cologne, but published magazines such as *Die Schammade* and *Der Ventilator*. *Die Schammade* was of decisive importance for the Cologne Dadaists. Via the international authors who had been invited to contribute, they were able to make numerous contacts in the Dadaist centres of Zürich and Berlin. For Ernst, the magazine also marked the interface between his activities as a Dadaist in Cologne and his approach to French Surrealism, whose future spokesman Breton, along with Aragon, Éluard and Tzara sent detailed articles to *Die Schammade*. For Arp, Cologne was no more than a brief stopover on his way to Paris. In 1922 he was eventually followed there by Ernst.

Ernst first and foremost proved to be a brilliant creator of pictures who, like no other artist, knew how to exploit all the possibilities of collage, and in the decades to come, how to try out a succession of new pictorial techniques. "What is collage?" he asked in his "Biographical Notes", and answered in the third person: "Max Ernst for example has defined it thus: the collage technique is the systematic exploitation of the chance or artificially provoked confrontation of two or more mutually alien realities on an obviously inappropriate level – and the poetic spark which jumps across when these realities approach each other." Max Ernst's description of the collage principle is indeed closer to the Surrealist approach to picture creation than to

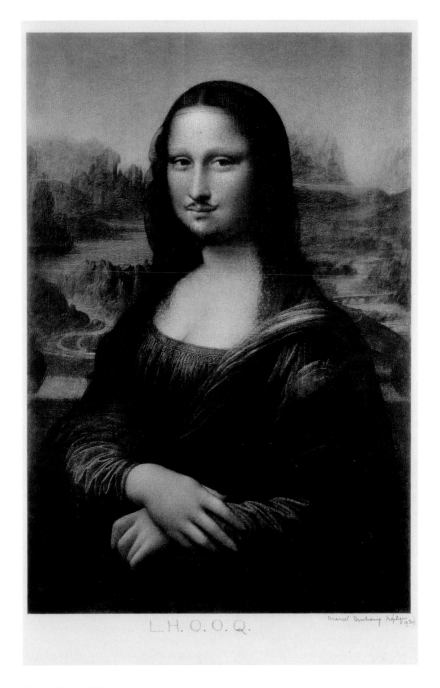

L.H.O.O.Q.

Marcel Duchamp (réplique) 1930

the ironic or aggressively political montages of
the Berlin Dadaists.

New York - Dada Is American

In New York it was likewise chiefly the émigré
European artists who brought the anarchic Dada
impulse to the city. The two Frenchmen Marcel
Duchamp and Francis Picabia met here in 1919
and got together with Man Ray from Philadel-
phia, the gallery owner and photographer Alfred
Stieglitz and the poet and patron of the arts
Walter Arensberg. Cheaply produced magazines
were, for the New York Dadaists too, an important
means of communication with the other interna-
tional centres of the movement.

In contrast to Zürich or Paris, the literary mem-
bers did not claim to be the spokesmen of the
Dadaist movement. Rather, in the persons of
Francis Picabia, Man Ray and Marcel Duchamp,
the visual artists made the most important contri-
butions to New York Dada, introducing develop-
ments that paved the way for much of subsequent
20th-century art. At the same time, their works too
came under the heading of "anti-art". Picabia
drew absurd mechanical constructions which par-
odied the prevailing enthusiasm for technology
and the modern faith in progress. Man Ray used
everyday utilitarian objects and pictorial motifs
which he alienated by combining them with other
materials and less-than-obvious titles.

For Marcel Duchamp's readymades, not even
the Dadaist idea of anti-art is adequate. When in
1917 he presented a signed urinal under the title
Fountain (p. 281) to the jury-less exhibition of the
New York Society of Independent Artists, his in-
tention went beyond a mere salutary provocation
of the academic art business. Readymades are
selected utilitarian objects which are raised to
the status of works of art simply by dint of being
defined as such by the artist and being put on
display in an exhibition. Duchamp was not con-
cerned with the Dadaist rejection and destruc-
tion of the existing concepts of art, but with re-
moving boundaries and taking this process to its
logical conclusion. His readymades stand above
all for a radical redefinition of what can consti-
tute a work of art, how we can perceive it and
how we deal with it. For the first time, the ready-
mades drew the attention of the beholder to the
importance of the context for the definition and
evaluation of a work of art. This redefinition, and
the so-called context debate which it initiated,
made Marcel Duchamp the most influential art-
ist of the 20th century.

Paris - It Is Our Differences
Which Unite Us

The international Dada movement was born in
Zürich in 1916 and buried just six years later in
Paris. But it was in the French capital that it

Max Ernst
Little Machine Constructed by
Minimax Dadamax in Person
ca 1919–1920, pencil and ink frottage,
watercolour and gouache on paper,
49.4 x 31.5 cm (19½ x 12½ in.)
Peggy Guggenheim Collection – The Solomon
R. Guggenheim Foundation, New York

experienced a final and belated heyday. During the war, the young generation of artists had either served at the front or else fled abroad in time to avoid military service. Only after the Armistice of 11 November 1918 did Louis Aragon, André Breton, Philippe Soupault and Tristan Tzara gradually return to Paris. In 1919, Francis Picabia and Marcel Duchamp returned from New York. Their colleague from there, Man Ray, followed two years later. After a stop-off in Cologne, Hans Arp arrived in 1920 in Paris, where he was visited that same year by Max Ernst, who himself moved to the French capital in 1922. Major impetus was given to the Dadaist movement by the arrival of Tristan Tzara in January 1920. Breton had urged him several times to come back from Zürich, writing for example at the end of 1919: "You'll be coming at just the right moment. Life here has become more active." Just six days after his arrival, Tristan Tzara proclaimed the birth of Parisian Dadaism at the first Friday soirée of the magazine *Littérature*.

In Paris too, Dada was first and foremost a literary movement, but in contrast to the Cabaret Voltaire in Zürich, where the Dadaists performed a lively programme of short recitations, poems, musical numbers and dances, their French counterparts expressed themselves chiefly through their numerous publications. It seemed almost as if each of the Paris Dadaists had founded his own mouthpiece in which to publish his own manifestos, essays and poems and those of his friends. One rendezvous for the French Dadaists was the Au Sans Pareil bookshop and gallery, founded in 1919, which staged Max Ernst's first Paris exhibition in May 1921.

André Breton found a metaphor for the Paris group which encapsulated the typical Dadaist oxymoron: "It is above all our differences which unite us," he observed. Thus it is hardly surprising that his alliance with Tristan Tzara, whose arrival on the scene he had awaited with such yearning, broke up again as early as 1921. As the Paris Dadaists had only come together after the war had ended, they lacked any common aim on which to concentrate their rage and their actions.

In the decades to come, Dadaism was revived time and again, above all as a mental attitude. The Dadaist sound poems inspired the Concrete Poets of the 1960s, and the French Nouveaux Réalistes even called themselves Neo-Dadaists to start with. But while they shouted their appreciation of Dadaism from the rooftops, the survivors of the original movement were less impressed by their young admirers. "How dare these people – artists, or whatever you want to call them – how dare they call themselves Dadaists?" asked an angry Richard Huelsenbeck in 1961.

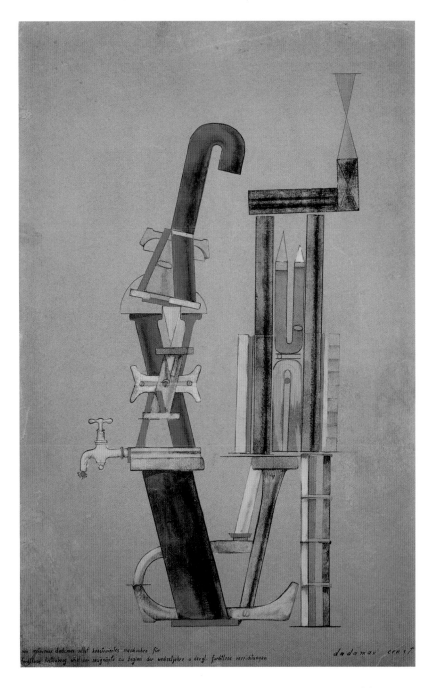

von minimax dadamax selbst konstruiertes maschinchen für
furchtlose bestäubung weiblicher saugnäpfe zu beginn der wechseljahre u. dergl. furchtlose verrichtungen

dadamax ernst

Marcel Duchamp

b. 1887 in Blainville-Crevon, France
d. 1968 in Neuilly-sur-Seine

Fountain
1917/1964, porcelain urinal,
33 x 42 x 52 cm (13 x 16½ x 20½ in.)
Moderna Museet, Stockholm

Marcel Duchamp studied at the renowned Académie Julian and developed into a highly successful painter. Even so, he always remained sceptical where the potential of painting was concerned. It did not satisfy his demands regarding the objectivity and scientific character of art. Thus, for Duchamp, painting could be "only one means of expression among others", as he himself once put it.

Finally in 1915 Duchamp gave up painting almost entirely. Two years earlier, his first readymade had already made its appearance. It was a stool on which a bicycle wheel had been mounted. In 1915 Marcel Duchamp left France for New York. Here he entered his most provocative object, to which he had given the quite neutral title *Fountain*, for the annual exhibition of the Society of Independent Artists.

Readymades are a new autonomous artistic genre invented by Marcel Duchamp. They are industrially produced utilitarian objects, which achieve the status of art merely through the process of selection and presentation. Duchamp did not design these works, but designated objects he had found as works of art by definition. In so doing, he poured a bucket of cold water on the traditional myth of the artist as a creator of genius. He was interested instead in a rupture with conventional public expectations of art, in the limits of what constitutes a work of art, and in their radical extension. All his readymades pose a fundamental question: what are the characteristics and conditions that define an object as a work of art? Marcel Duchamp tried to answer this question for himself in as exact terms as possible. *Fountain* is an industrially produced urinal, to which the artist has made three changes in order to raise it to the status of a work of art: 1. he has placed it on a base or plinth, 2. he has signed and dated it and 3. he has entered it for an exhibition of contemporary art. There was supposed to have been no jury for this exhibition, but the work was rejected nonetheless: this rejection confirmed the aesthetic explosiveness of his concept.

Duchamp's approach assumes that any object whatever can be declared to be art by being equipped with the characteristic attributes of a work of art. In our example, the first of these was the plinth, which treats the urinal as though it were a sculpture, makes it stand out from its surroundings and ennobles it. The inscription "R. Mutt 1917" designates the object as a work of art, because it now has a signature. Marcel Duchamp deliberately did not use his own name, but rather a pseudonym, because for him the signature was an artistic gesture: he was interested in the resulting claim of the object to be a work of art. Finally the object was to be presented to the public at an established art exhibition. Duchamp recognised that an object is defined first and foremost by its context and is perceived differently in different environments. His pioneering achievement for art was to point to the importance of this context for the evaluation of a work of art.

(D. E.)

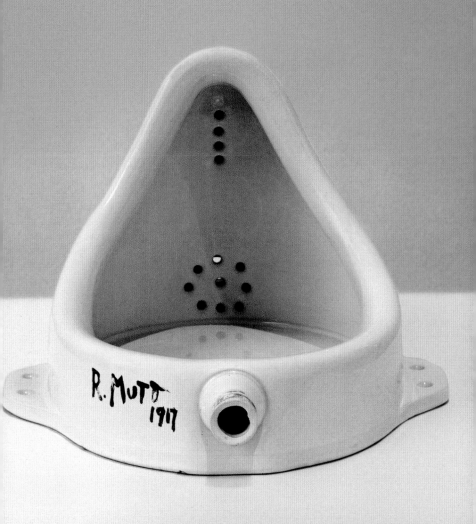

Francis Picabia

b. 1879 in Paris, France
d. 1953 in Paris

*"Dada talks with you, it is everything, it includes everything,
it belongs to all religions, can be neither victory nor defeat, it lives
in space and not in time."* — **Francis Picabia**

Love Parade
1917, oil on cardboard,
96.5 x 73.7 cm (38 x 29 in.)
Private collection

Francis Picabia was the scion of a prosperous family from Cuba. Financially independent, he was an amateur painter in the true sense of the word, that is to say, he painted out of a love for painting. In 1913 he was the only French artist to be able to afford the expensive trip to New York for the opening of the *Armory Show*. He himself was represented at the exhibition with three works.

It was in New York in June 1915 that Francis Picabia began to compose the first symbolic machine pictures. The theoretical concept behind these works was formulated by Paul Haviland in the September issue of the magazine *291*, in which he wrote: "We are living in the age of the machine. Man made the machine in his own image. She has limbs which act; lungs which breathe; a heart which beats; a nervous system through which runs electricity. The phonograph is the image of his voice; the camera the image of the eye. The machine is his 'daughter born without a mother'."

The format, the complex execution and the use of colour make the *Love Parade*, which dates from 1917, the central work in this series of machine motifs. As with many other Dadaist works, here too the artist has integrated the title into the picture. This creates a certain distance between the beholder and the work, thus preventing any emotional approach to the motif. The same purpose is fulfilled by the artless execution, which dispenses with any painterly gesture and instead prefers purely objective, technical and anonymous brushwork. The title of the work, however, suggests an erotic motif, which seems, then, to irredeemably contradict the constructivist depiction. For surely "love parade" has different associations for most beholders. However, and this is true also of this work by Picabia, many Dadaist works have similar subliminal erotic components, which, often articulated precisely in such mechanical depictions, suppress any subjective element.

In this large-format work, Picabia has placed the apparatus of the *Love Parade* in a closed space. On closer inspection, the machine turns out to be composed of two elements, one grey and one coloured, which are connected by rods. The two parts can be identified as the male and female elements in this "love parade". The grey structure consists of two upright cylinders, in which a thin rod, divided at its lower end, moves rhythmically up and down. This construction can be interpreted as the male sexual organ. Its strength and dynamism are transferred via a complicated system of rods with a number of screw threads to the coloured apparatus on the right. This is the female counterpart to the grey shape. The central element in this machine is the vertical brown piston, which rhythmically penetrates the green (female) vessel. Picabia's machine image is in fact an ironic commentary on and a symbol of the role of the sexes in a modern industrial society.

(D. E.)

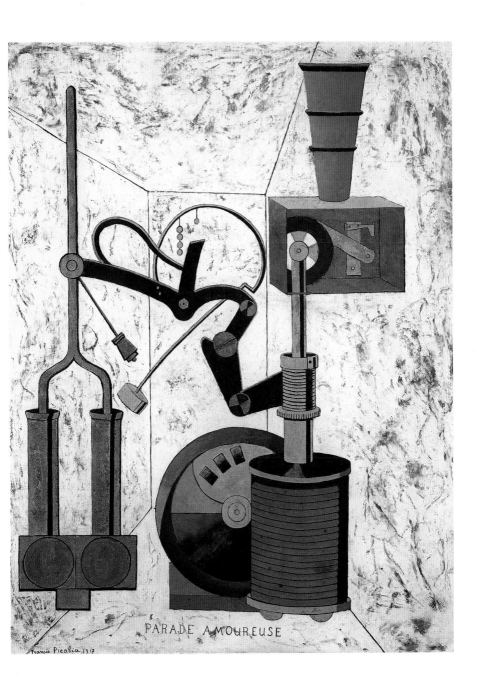

PARADE AMOUREUSE

Francis Picabia 1917

Raoul Hausmann

b. 1886 in Vienna, Austria
d. 1971 in Limoges, France

Raoul Hausmann took his bearings at first from Expressionism and Futurism. After his meeting with the Zürich Dadaists Richard Huelsenbeck and Hans Arp, he became one of the leading figures in the Dadaist movement in Berlin. His visiting card in 1919 identified him grandiloquently as the "President of the Sun, the Moon, and the little Earth (inner surface), Dadasopher, Dadaraoul, Ringmaster of the Dada Circus". His title of "Dadasopher" was bestowed by fellow members of the Dada group in Berlin.

As with the name Dada itself, whose parentage was claimed by, among others, Hugo Ball, Richard Huelsenbeck and Tristan Tzara, the paternity of the photomontage technique was also disputed. Raoul Hausmann claimed to have discovered it in 1918 while on holiday on the Baltic with Hannah Höch. In a photographer's shop window they chanced upon pictures in which the faces of the persons photographed had been replaced by different heads.

The photomontage technique was characteristic of Berlin Dada, where it was a further development of Cubist collage, from which it differed primarily by the use of printed text elements and photographic images. The use of the term "montage" was chosen deliberately in order to deprive these works of any "artistic" character. After all, there was no way the Berlin Dadaists wanted to be seen as artists in the traditional sense. By describing themselves as *photomonteurs* instead, they took up a position in the, to them, far more congenial vicinity of the proletarian industrial workers.

The photomontage *Tatlin Lives at Home* dates from 1920. For years the work, like Hausmann's other important montage *Dada Conquers* (1920),

was thought to be lost. The two pictures hung side by side at the *First International Dada Fair*, held in Dr Otto Burchard's art gallery in Berlin, and can be made out in the background of a photograph showing Raoul Hausmann and Hannah Höch at the exhibition (p. 267). Another photograph taken at the exhibition shows George Grosz and Richard Huelsenbeck holding up a sign with the words "Art is dead. Long live Tatlin's new machine art". Hausmann's photomontage *Tatlin Lives at Home* takes up the theme of this exhortation, by presenting a portrait of the Russian Constructivist and having a complicated mechanism of pistons, wheels, gauges, gears and screws growing out of the crown of his skull. Behind Tatlin's head, the beholder can see a wooden stand supporting a kind of vessel in which there is an organic structure. The numeric inscriptions point to a biology textbook as source. The organic and mechanical worlds are the two opposite poles in Hausmann's photomontage.

According to the title, the subject of the picture is Tatlin's home. And indeed, Hausmann has assembled his pictorial fragments in such a way that the result is a closed room with floorboards. On the left-hand wall there hangs a map. In the background to the right our gaze falls upon the hull of a ship with its propeller. The motifs suggest that Tatlin has put his brain on the stand and exchanged it for a piece of machinery. Thus the picture illustrates a Dadaist utopia in which emotional thought is replaced by mechanical thought. Only thus, according to the Dadaists, could a new (machine) art appear, which would stand up for a mechanical, rational and ultimately peaceful world. (D. E.)

Tatlin Lives at Home
1920, collage and gouache,
40.9 x 27.9 cm (16 x 11 in.)
Moderna Museet, Stockholm

Hannah Höch

b. 1889 in Gotha, Germany
d. 1978 in Berlin

As the only woman in the Berlin Dada movement, Hannah Höch had no easy time of it. For all the proclamations of her male fellow-Dadaists in favour of emancipation, and their political support for equal rights and opportunities for the sexes, as an artist she was not taken seriously by most of the other Dadaists. A telling example of this attitude is the backhanded compliment paid her by Hans Richter in his book of memoirs *Dada Profile*, in which he praises her talent in particular as the "hostess of the Hausmanns' studio evenings", at which she made herself indispensable by "managing somehow, in spite of the lack of money, to conjure up buttered rolls plus beer and coffee".

George Grosz and John Heartfield only consented to her participation at the *First International Dada Fair* in 1920 after massive intervention by Raoul Hausmann. Hannah Höch took her revenge for this mistrust on the part of some of the male Dadaists by producing one of the most impressive exhibits on display. In the catalogue, her unusually large collage is entitled *Incision with the Dada Pastry Knife through Germany's Last Beer-Belly Cultural Epoch*, while the artist herself is listed as Hannchen Höch (a diminutive form).

The work is a splendid snapshot of the year 1920. Hannah Höch has interwoven countless details, figures, portraits, mechanical elements, cityscapes and textual exhortations into her collage. It depicts a situation of upheaval, chaos and contradiction. Thanks to the pictorial fragments' being arranged additively rather than compositionally, the work does particular justice to this prevailing atmosphere. Here we see the representatives of the old, toppled order: Kaiser Wilhelm II, who had abdicated, the crown prince, and Field Marshal Hindenburg. They are confronted by the representatives of the new order: Friedrich Ebert, the first president of the Weimar Republic, and

Hjalmar Schacht, banker and later on president of the Reichsbank. Between we see sports personalities, actors, dancers and acrobats. Hannah Höch has in most cases taken the bodies of her "sitters" from a variety of pictorial sources. The result is a picture populated by clownlike, in some cases disfigured individuals. At the same time the work is a huge panopticon, in the middle of which some of the Berlin Dadaists can be seen at their anarchic tricks. Johannes Baader, Raoul Hausmann and Hannah Höch herself are not difficult to identify. Well-known Dadaist sayings, cut out by the artist from various publications, comment on the political chaos. At the bottom left-hand edge of the picture we can read the exhortation "Tretet Dada bei!" (Join Dada!), while elsewhere we see slogans such as "Legen Sie Ihr Geld in Dada an!" (Invest your money in Dada!) or "Dada siegt!" (Dada conquers!).

Alongside the personalities familiar from politics, the arts, sport and Dadaism, this collage also shows the image of a modern machine world. Diesel locomotives, a carriage of the Orient Express, automobiles and turbines, ball races and gearwheels are distributed over the entire surface of the picture, combining the individual scenes and setting the entire tableau in motion. Among other details, we can recognise New York skyscrapers – with these motifs, Hannah Höch has composed a prophetic picture of a future Berlin, somewhere between a metropolis and a Moloch. The present title of the work, *Incision with the Dada Kitchen Knife through Germany's Last Weimar Beer-Belly Cultural Epoch,* has a double meaning; the word "incision" can also be related to the scissor cut-out by which the picture was created, as well as to the artist's incisive view: she is applying a surgical scalpel to the political events and upheavals of the time. (D. E.)

**Incision with the Dada Kitchen Knife through
Germany's Last Weimar Beer-Belly Cultural Epoch**
1920, collage, 114 x 90 cm (45 x 35½ in.)
Staatliche Museen zu Berlin, Nationalgalerie, Berlin

Kurt Schwitters

b. 1887 in Hanover, Germany
d. 1948 in Ambleside, UK

Since the summer of 1917, Kurt Schwitters had worked for more than a year for the Wülfel iron-works as a technical draughtsman. In the first few years after the end of the war, he produced numerous works in which fragments of machines, wheels and discs occupy a central position in the composition. One of the most important examples of this group of works is the 1920 *Merz Picture 29A. Picture with Flywheel*, which the artist revised 20 years later. Unlike the more modest *Merz Drawings*, for which he primarily used snippets of paper, in his larger-format assemblages, he also employed three-dimensional materials. In *Merz Picture 29A* these include a lid, a piece of cotton-wool, a broken spoked wheel and an iron chain. Two parallel fragments of toothed wheels, extending from the left into the area of the picture, define the composition. All the other elements of the picture are oriented to them.

The *objets trouvés* used here have been painted over – a material construction spreading out against a blue background. The coloured setting of the objects often forms larger units and thus composes a number of elements into a single form, as can be seen particularly graphically in the large light triangle in the middle of the picture. The overpainting serves, first and foremost, the purposes of the total composition and stops the work becoming a mere addition of many small objects on a large surface.

Merz art has always allowed observation and interpretation on a number of levels. In his programmatic text on *Merz Painting*, he says accordingly: "The Merz paintings are abstract works of art. The word Merz means essentially the summarisation of all conceivable materials for artistic purposes, and technically the – on principle – equal valuation of the individual materials… In Merz painting the box-lid, the playing-card or the newspaper cutting becomes the surface, the string, the brush-stroke or pencil-stroke becomes the line, the wire-net, the overpainting, or the stuck-on greaseproof paper becomes the varnish, and cotton-wool becomes the softness."

Schwitters not only dissolves his alien materials in abstract shapes, however, but at the same time allows his *objets trouvés* an illustrative function. The *Merz Picture 29A* thus also presents itself to the beholder as the depiction of a monumental factory hall, in which huge cogwheels and pulleys drive the machines. The quartered rectangular shape, in the top centre of the picture, comes across as the window of a building, graphically illustrating the proportions of the huge machines. However, there is no sign of the enthusiasm for technology which characterised the Italian Futurists. Schwitters' machine park comes across, if anything, as out-of-date, partly defective, and seems to be producing nothing. It is his ironic response to the mood of the times, whose enthusiasm for modern technology was in stark contradiction to the prevailing political chaos. With a scrap of paper on which is written his address in Hanover, Kurt Schwitters has introduced himself into the composition. Hemmed in by cogwheels and pulleys, the artist seems to be in the process of being ground between the wheels of a gigantic machine.

In addition, Kurt Schwitters has also given this mechanical construction a political interpretation. Not, it is true, explicitly and openly, but hidden in a clue which he notes on the reverse of the work: "Instructions for use. From the position where the centre points vertically downwards, the wheel must only be turned to the right, until the right-hand spoke is pointing vertically upwards. It is forbidden to turn the wheel to the left. Kurt Schwitters. 5. 8. 1920." Thus his ironic commentary on the political struggles between the conservative parties and the socialists. (D. E.)

Merz Picture 29A. Picture with Flywheel
1920/1940, assemblage, with original frame
93 x 113.5 x 17 cm (36½ x 44¾ x 6¾ in.)
Sprengel Museum, Hanover, Kurt und Ernst Schwitters-Stiftung

Man Ray

b. 1890 in Philadelphia, USA
d. 1976 in Paris, France

Gift
1921/1940, flatiron, nails,
15.3 x 9 x 11.4 cm (6 x 3½ x 4½ in.)
*The Museum of Modern Art, New York,
James Thrall Soby Fund*

Gift is Man Ray's best-known object. It dates from 1921 and timewise stands on the cusp of his artistic development from New York Dadaism to being one of the central figures in Parisian Surrealism. The work has, however, often been described as an altogether typical object in the spirit of Lautréamont's definition of Surrealism.

For this assemblage, Man Ray took an iron and stuck 14 copper nails to its underside. Following Lautréamont's description of the chance confrontation of a number of objects from different areas of life in an alien situation, for which he adduced the example of an umbrella and a sewing-machine on a dissecting table, we could here speak of the encounter between flatiron and nails, which must surely appear to the beholder as equally nonsensical, illogical, in fact surreal.

However, what we have here is not the confrontation of two mutually alien objects. Man Ray does not allow the materials to retain their own identity, but uses the combination to create an entirely new object, unknown in this form, a mutation of the familiar and useful flatiron. Precisely because the object loses its practical purpose, we have an irredeemable conflict between the functionality of the object and the failure of its function. It is at this point that the attention of the beholder comes to focus on the ironic and Dadaist

potential of the work *Gift*. Man Ray had related another object to the poet Lautréamont, whose real name was Isidore Lucien Ducasse. In 1920 he had created *The Enigma of Isidore Ducasse*, a mysterious object which Man Ray had tied up in a thick sackcloth blanket. It was irregular in shape, with a number of bulges, which however did not permit the enclosed object to be identified. In fact Man Ray had packed Lautréamont's famous sewing-machine together with an umbrella and thus alienated both.

The two objects, incidentally, were soon destroyed, and have only survived in the form of Man Ray's own photographs. Later the artist made several replicas of *Gift* and produced a limited edition (1940), albeit of 5,000, an unusually large number (with 13 nails). This *Gift* however is a deceptive one, disappointing its recipient because it does not fulfil its domestic purpose. The pointed nails would tear the material if ever an attempt was made to use the iron for its usual purpose. In fact however it is worth very much more, because it has a playful value and a value between friends. Marcel Duchamp "defined" Man Ray that same year, 1921, in this spirit as though he were a dictionary entry: "Man Ray, masculine, noun, synonymous with: pleasure in play, enjoyment."

(D. E.)

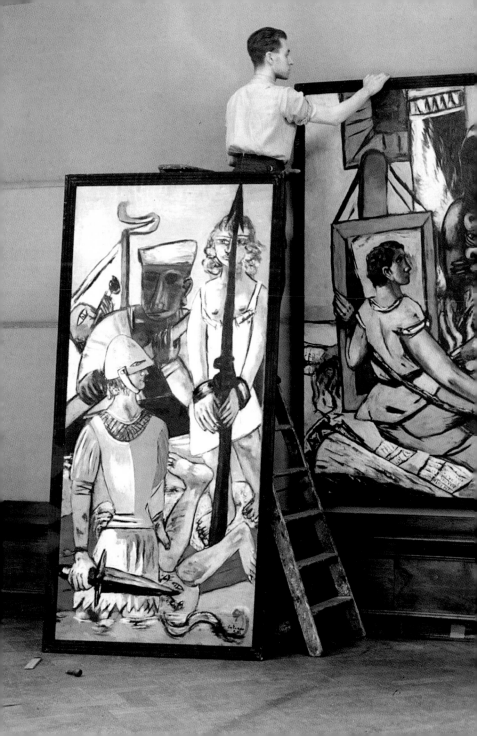

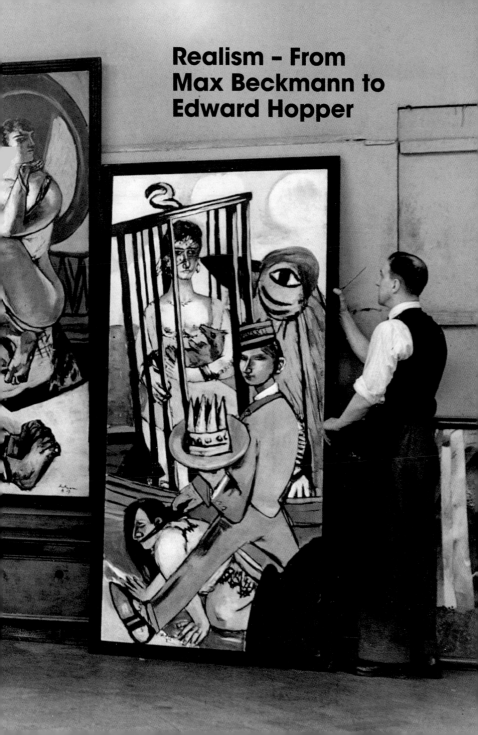

**Realism – From
Max Beckmann to
Edward Hopper**

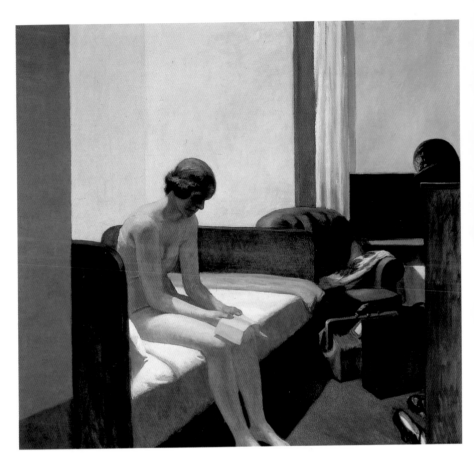

Edward Hopper
Hotel Room
1931, oil on canvas,
152.4 x 165.7 cm (60 x 65¼ in.)
Museo Thyssen-Bornemisza, Madrid

Pages 292-293
Two assistants hanging Max Beckmann's triptych Temptation (1936-1937) for the 20th Century German Art exhibition at the New Burlington Galleries,
London 1938. The exhibition included works by all German artists pilloried in the Degenerate Art exhibition in Munich 1937

The Truth of the Visible

Kerstin Stremmel

The Return of Realism

Following an abundance of stylistic tendencies – Expressionism, Futurism and Cubism – which needed some getting used to at first, the return of Realism in the 20th century occasioned a sigh of relief amongst more than a few art lovers. It was formulated by the art historian Hans Hildebrandt in his 1931 standard work *The Art of the 19th and 20th Centuries* as follows: "Among all the movements of the 20th century, New Realism is the easiest to understand and the most popular. We need only to mention the generally familiar term New Objectivity: no further proof is needed." The popular aspect of this so-called New Realism seems to be that there was nothing really new about it. But in the course of the 20th century, we have departed a very long way from this new clarity.

The spectrum of what is generously understood by Realism ranges from Photo-realism to Capitalist Realism, from Material Realism to Cool Realism, not to mention Relativising Realism. The original semantic field covered by the term Realism – as far as the visual arts were concerned – was more constrained: it denoted a 19th-century artistic style which was the first in the history of art to call itself realistic, and it did this with the express purpose of drawing a line between itself and its idealistic opposite numbers. Gustave Courbet was attacked by art critics as a "realist" on account

of works like *The Stonebreakers*, dating from 1850, with its coarse, pasty technique bereft of any idealising tendency. However, he made a virtue of the criticism. Rejected by the Paris Salon, on the occasion of the 1855 World Exhibition he displayed his pictures in a shed which he christened the "Pavillon du Réalisme". The same year, he composed the influential "Realist Manifesto", which, in full knowledge of existing artistic traditions, advocated an individualistic art which had to come to terms with the mores and customs of its age and of the reality of life around it. However, Realism refers not only to the idea of a particular era, but also to a method of depiction. The term is often used synonymously with Naturalism to refer to an attempt at true-to-life reproduction of external reality. In the history of art, Realism did not begin in the 19th century: realistic tendencies have existed throughout the history of art since Classical Antiquity. By "Realism" in this sense – in contradistinction for example to idealistically oriented programmes – we understand any attempt at the faithful depiction of visible reality in painting, sculpture and the graphic arts.

Realistic depiction can also embrace the interpretation and evaluation of the depicted motif. The most vehement rejection of the representational model of art came in the 20th century: the art critic Clement Greenberg, an advocate of artistic autonomy, expressed it thus:

"What modernist painting has abandoned in principle is the representation of the kind of space that recognisable objects can inhabit."

But even in the 20th century there were variations on the theme of a productive confrontation with reality: variations which contradict the notion that mimesis is synonymous with imitation. As evidence of a new relationship between art and reality, we can adduce the remark with which Paul Klee began his 1920 essay "Creative Confessions": "Art does not reproduce visible things, but renders things visible." And does not even the most precise imitation, the most passive reproduction, represent the expression of a choice?

The confusion surrounding styles in the 20th century is increased still further by the fact that the same terms are applied to very different manifestations of Realism. Thus Nouveau Réalisme and its American offshoot New Realism are terms applied traditionally to the concrete appropriation of "reality" as a logical extension of the concept of the readymade. At the same time, however, the term is also used to characterise, for example, the style of Philip Pearlstein in order thus to suggest that his painting technique is different from earlier manifestations of Realism. And if this were not confusing enough, the same phenomenon is sometimes referred to in different ways; thus Photorealism, by virtue of its technical perfection, is also known as Superrealism or Hyperrealism.

A Question of Form?

For all the optimism shown by Bertolt Brecht in his attempt to characterise the phenomenon – "Realism is not what real things are like, but what things are really like" – there are also problems in delineating the field covered by Realism, for various parties make use of the same form of picture. This was noted already in 1925 by Franz Roh in his foundation work on so-called Post-Expressionism, by which he sought to encompass the "realistic" phenomena of the 1920s: "Thus the left-leaning group, including those within Post-Expressionism, are opening up all the wounds which were trying, prematurely, to close ('in order only to prolong the judgement'), while the right-leaning group, the idyllic party, are closing or cooling the wounds, or seeking, by the generation of inner comfort and warmth, to dry them out. (The fact that both parties use the same Post-Expressionist form of picture is just one of those puzzles of artistic development that we have to accept.)"

The same phenomenon also appears in American manifestations of Realism, where the industrial pictures of Charles Sheeler for example developed out of the anti-academic attitude of the so-called Ashcan School centring on

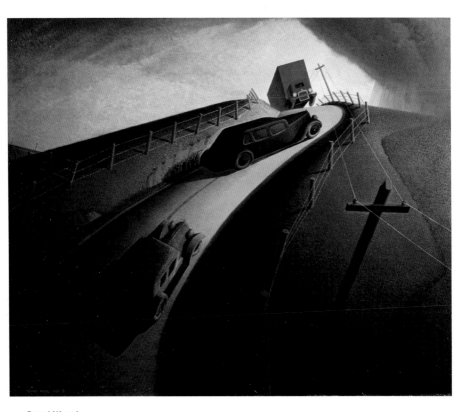

Grant Wood
Death on the Ridge Road
1935, oil on masonite, 99 x 117 cm (39 x 46 in.)
Williams College Museum of Art, Williamstown, gift of Cole Porter

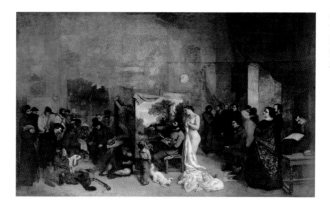

Gustave Courbet
The Artist's Studio
1855, oil on canvas,
359 x 598 cm (141¼ x 235½ in.)
Musée d'Orsay, Paris

Robert Henri, which devoted itself to the ugliness of everyday street-scenes, at the same time as the emergence of rural American Regionalism in the style of Thomas Hart Benton or Grant Wood, with its populist-conservative pictorial world. And it was from precisely this romanticising Regionalism that another pupil of Robert Henri, Edward Hopper, with his subdued pictorial inventiveness, distanced himself as far as he possibly could.

In this sense, it would seem to be questionable, indeed wrong, to see Realism in negative ideological terms, as has often been done, for example by Hans H. Hofstätter in 1961: "The 1930s witnessed an emotional intensification of the Realism of the 1920s, leading directly to the Realistic painting of the Third Reich and later to 'Socialist Realism'."

For one thing, this approach is unfair to the artists of the New Objectivity: no major exponent went over to the "clean" Realism of the Nazis, and most of them were rapidly denounced as "degenerate". Furthermore, in the following period, reality-related forms of expression were anyway not accepted. It is perfectly obvious that the crude Realism of the National Socialists led to a general reaction, and even Franz Roh, the early theoretician of New Objectivity, blamed himself in 1952 for not having recognised during the 1920s that abstraction was the "greatest discovery of our century".

As a result of the Cold War, the "Communist-Nazi" thesis became commonplace, leading at first to a veritable dictatorship of Abstract Art in the West, which only began to soften in the late 1960s. The thesis stated that anyone in the 1950s who painted figurative subjects was a reactionary. Karl Hofer, who had been forbidden to paint during the Nazi era, and whose works were denounced as degenerate, said of himself in the early 1950s: "My container bears the label: sclerotic, retarded, figurative." Western critics, such as the American art expert Alfred Barr in 1953, conducted a passionate polemic against all figurative art, voting for Abstraction on the grounds that Realism and Totalitarianism belonged together.

Subjective Truths
When we consider the works of art that received official approval during the regime of that failed artist Adolf Hitler, we can almost begin to understand this blanket rejection of every figurative approach to the world. The stifling by the Nazis of all avant-garde tendencies and the return to the allegedly "accessible" innocuities of the 19th century was so thoroughgoing as to drag the quality of art production during this period to well below the level of the other dictatorships, Italy and the Soviet Union. It cannot be denied, however, that there are parallels between art

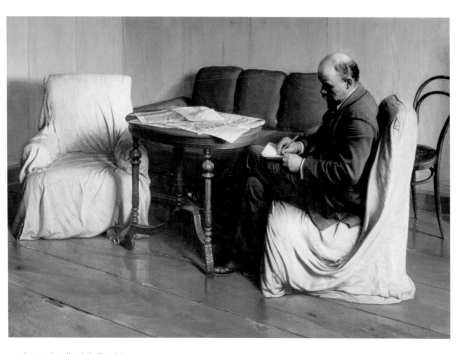

Isaac Israilevich Brodsky
W. I. Lenin at the Smolny
1930, oil on canvas,
198 x 320 cm (78 x 126 in.)
The State Tretyakov Gallery, Moscow

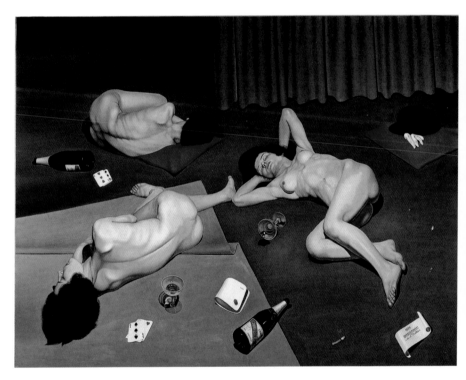

Cagnaccio di San Pietro
After the Orgy
1928, oil on canvas,
140 x 180 cm (55 x 71 in.)
Private collection

Hans Finsler
Electric Light-bulb
1928, black-and-white photograph,
19 x 13.7 cm (7½ x 5½ in.)
Kunstmuseum Moritzburg, Halle

under the Nazi regime on the one hand and Socialist Realism on the other, for neither political system accepted anything which contradicted the official doctrine of social reality. Since the most important criterion for the production of art which reflected this reality was its general "accessibility", one of the results was a uniformity of the formal means employed. This was expressed in 1953 by Otto Nagel, the president of the *Third German Art Exhibition* in Dresden (in Communist East Germany), as follows: "The language of the artists is clear and comprehensible and demonstrates the serious endeavour to meet the just demands of ordinary people. Taking the classical tradition of German realistic art as its starting point, our visual art is starting to raise itself to new heights of beauty." This demand that art be comprehensible, or, in the current phrase, "accessible", was expressed time and again under both political systems, and in addition, both in equal measure claimed to be representing objective truth.

Baldur von Schirach, head of the Nazi youth movements and Gauleiter of Vienna, said at the opening of one exhibition in 1941, that art served "not reality, but truth"; and it goes without saying that the sentimental depiction of the joys of motherhood, for example, in Socialist Realism was inspired by the desire for truthfulness. Socialist Realism, understood as the highest form of artistic development, was to obey the definition coined by Friedrich Engels in respect of Honoré de Balzac: "In my opinion, Realism means, alongside fidelity to detail, the faithful reproduction of typical characters in typical circumstances." Important, then, is not true-to-life depiction of reality in all its details, but the representation of the "essentials", the "truth" about reality, whereby concrete reality must always be taken as the starting point.

We need to remind ourselves in this connection that the Bolshevik Revolution of 1917 had at first promoted the artistic avant-garde. Innovative Constructivists were among those who offered their services to the new regime. But Stalin decided in favour of a different aesthetic – namely that of monumental kitsch. He prescribed Socialist Realism and had himself stylised as its patron. Flattering idealisation can hardly be regarded as an invention of the 20th century, however; portraits of rulers in earlier epochs are also characterised by not showing their sitters "warts and all". But precisely such portraits as this one of Stalin can be adduced as evidence that the description "Socialist Realism" should, to be honest, have been replaced by "Socialist Idealism".

Already in the later years of Communist East Germany, though, non-doctrinaire tendencies were also making themselves felt, and now that all the 20th-century would-be utopias have gone

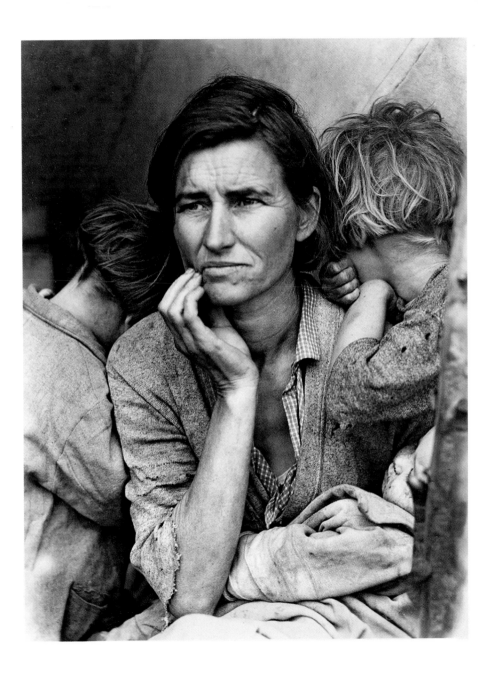

**Walker Evans
Kitchen Wall in Bud Fields'
House**
1936, photograph, gelatin silver
print, 17.5 x 22.5 cm (7 x 9 in.)

**Dorothea Lange
Migrant Mother, Nipomo,
California**
1936, photograph, gelatin silver print,
32.8 x 36.1 cm (13 x 14¼ in.)

the way of all flesh, the question of which truth and which reality artists can work on remains an open one. In principle, we have to ask what kind of relationship exists between the object and its image, for this object is not simply the world as it is, or the world as it looks, and not necessarily the way we see it. Rather, it is a matter of different kinds of transformation, which point to a remarkable phenomenon, namely that Realism is characterised more by differences than by common traits. Those realistic works which capture our attention for reasons other than historical interest seem, universally, to be exceptions to any general definition.

Nothing but Exceptions

Even the Mexican revolutionary painters José Clemente Orozco, Diego Rivera and David Alfaro Siqueiros are regarded as significant special cases. Balthus' tender nymphets are no less an unmistakably autonomous part of the international current of Realism in the inter-war period than Giorgio Morandi's ascetic still lifes, Tamara de Lempicka's metallic women or Edward Hopper's filmic interiors. Philip Pearlstein's involved anonymous nudes are depicted in a way no less singular than Lucian Freud's characteristic naked portraits. And among all these unmistakable artists who are lumped together in extremely loose fashion by the Realist label, there

are some whose individual works are themselves characterised by stylistic pluralism.

One example, as well-known as it is convincing, is Pablo Picasso, who, towards the end of his life, described style as a kind of prison from which he had always succeeded in escaping. So from Picasso we have even one of the first collages, the *Still-life with Cane Chair Weave*, dating from 1912, in which he integrates a fragment of the real world into the picture, making him, if you like, a precursor of Nouveau Réalisme. It is precisely in connection with Picasso's works that we have to ask the fundamental question: what is more realistic, what is the least-falsified image of the real, a fragment of material integrated into a collage, a literal part of reality later claimed by the Nouveaux Réalistes to represent "authentic realism" – or a painted illusion or photograph? To return once more to the concept of uniqueness: the Nouveau Réalisme manifesto mentions that the members of the group are aware of their collective uniqueness.

The Nouveau Réaliste group was composed of such different artists as Arman, César, Christo, Gérard Deschamps, François Dufrêne, Raymond Hains, Yves Klein, Martial Raysse, Mimmo Rotella, Niki de Saint Phalle, Daniel Spoerri, Jean Tinguely and Jacques de la Villeglé, who worked with very different techniques: from *décollage*, in other words the demolition of placards, as

practised by the so-called Affichistes (French *affiche* = poster), to Assemblages, Accumulations and Compressions and on to mobile sculptures made of scrap and waste materials.

There was however a feature which linked them all: the wish for real objects and materials from the everyday world, often waste or scrap, to take on a new presence by dint of artistic alienation. In this way these artists hoped at the same time to provide an unaccustomed view of reality; thus the French critic Pierre Restany, the group's initiator, came up with the formula "Nouveau Réalisme = new ways of perceiving the real". The intention was therefore also to express aesthetic criticism of the consumer world, of bourgeois possessiveness and of a specious commodity aesthetic.

Photogenic Painting

Those who continued to paint realistically in the post-Duchamp world found themselves having to meet stiffer requirements. Apart from a certain aversion to pure depiction, expressed in a reserved attitude towards imitation, photography played a decisive role in the development of painting in the 20th century. Even in the 19th century, its invention had caused numerous painters to abandon visible reality as a subject and to concentrate instead on formal innovation and abstract qualities. This trend continued in

the 20th century, while the establishment of photography as an artistic medium in itself led to painting distancing itself even more strongly from visible reality. In his book *The Photographic Act*, Philippe Dubois spoke of a polarisation which assigned to painting the functions of art and imagination, while photography was accorded those of documentation and reference, concentrating on concrete content.

The common feature of all those artists whose work can be described as realistic seems to be that their techniques represent a confrontation with the medium of photography. This is most obviously true of the Photo-Realists, who since the 1970s have been meticulously copying, in paint, motifs in most cases projected on to the wall by means of a slide projector.

In addition, photography can serve as material for the imagination in all sorts of very different ways. For example we could mention one method used by Eric Fischl, who reassembles photographs and processes them on the computer screen, or Francis Bacon, who uses photographs as the eventually almost unrecognisable starting points for his approximations to reality. This has been taken so far that Gerhard Richter has said in relation to the relationship between the two media: "The photo is not an aid to painting; rather, painting is an aid to creating a photo using the methods of painting."

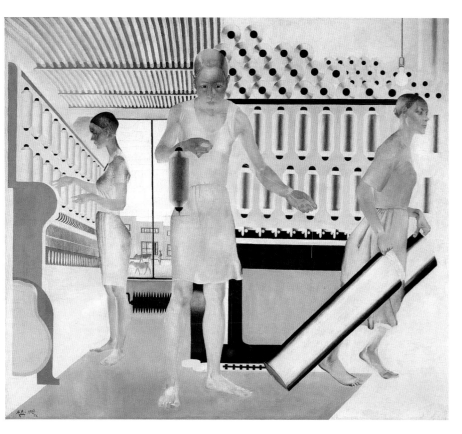

Alexander Deineka
Female Textile Workers
1927, oil on canvas,
171 x 195 cm (67¼ x 76¾ in.)
Russian State Museum, St Petersburg

Anton Räderscheidt
Girl Tennis-player
1926, oil on canvas,
100 x 80 cm (39¼ x 31½ in.)
Pinakothek der Moderne –
Staatsgalerie Moderner Kunst,
Munich

These techniques are far removed from what Michel Foucault critically observed of the conventional practitioners of Photogenic Painting, namely that they used transparencies in the way that Guardi, Canaletto and many others used the camera obscura: in order to trace a projected picture with a crayon and thus obtain a perfectly accurate sketch; in other words to capture a shape. But only in its confrontation with those traces which reality leaves on the photographic plate does 20th-century painting seem to have found itself. The diverse approaches show how little uniformity there is in Realism, in the sense of "dealing with reality".

The tautologies of the Photo-Realists can be linked to the ideas of René Magritte. His 1928–1929 painting *The Treachery of Images*, which he executed in a number of versions, is a reflection on the paradoxical relationship between realistic painting and reality. Beneath an accurately painted object we read: "Ceci n'est pas une pipe", for indeed, the painted pipe is not a real pipe. This playing with reality is reflected in the works of the Photo-Realists, whose starting point is not reality itself, but the indirect reality of the photograph they are using. In this sense the photograph is not merely an aid, as it was, surreptitiously, for 19th-century painters, but the deliberate starting situation for the picture.

Photographic Realism

Quite apart from its fundamental importance for the realistic painting of the 20th century, how are things looking for photography as an autonomous artistic medium? Albert Renger-Patzsch, the avant-garde photographer of the 1920s and early 1930s, answered this question in 1927 as follows: "The secret of a good photograph, which can have artistic qualities just like a work of the visual arts, lies in its realism."

With these words, Renger-Patzsch asserted the autonomy of photography and pointed to his own object-related technique. Like August Sander in the field of portrait photography with his systematic recording of German people and Karl Blossfeldt with his objective photographs of plants, Renger-Patzsch made his own name by photographing objects. With its almost clinical view of the world of objects, his most important publication *The World Is Beautiful*, which appeared in 1928 and was originally intended to bear the simple title *Things*, fits well into an era that included the transformation brought about by the invention of the electric light, which Virginia Woolf described in her novel *Orlando*: "Vegetables were less fertile; families were much smaller. Curtains and covers had been frizzled up and the walls were bare, so that new brilliantly coloured pictures of real things like streets, umbrellas, apples, were hung in frames or painted upon the

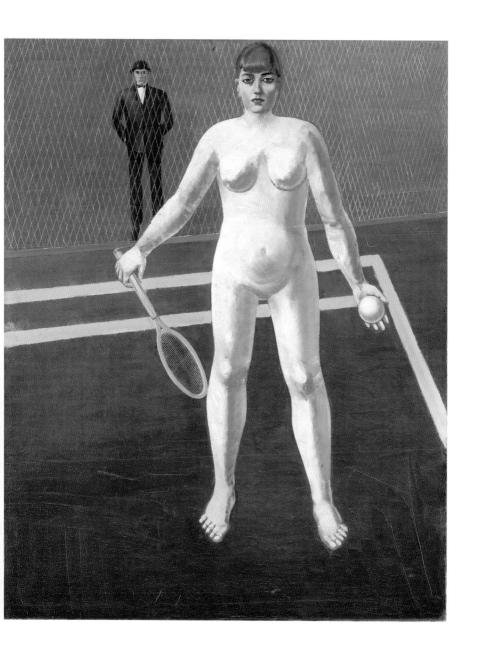

Otto Dix
To Beauty (Self-portrait)
1922, oil on canvas,
140 x 122 cm (55 x 48 in.)
Von der Heydt-Museum, Wuppertal

wood." Orlando's observation is dated 11 October 1928.

The same trust in the expressiveness of the visible was evinced by the American exponents of Straight Photography, who, likewise in opposition to Pictorialism (which was directed to producing a scenic effect), turned to an un-touched-up, "media-appropriate" photography. One of their earliest representatives, Alfred Stieglitz, said in the early 1920s: "There is nothing in my photographs that isn't there – that doesn't originate directly from the photographic object."

But over and beyond these strictly object-related styles, the 20th century saw the establishment of strategies with a different, politico-educational agenda. These too can be called "realistic". In this connection, the most important publicly initiated project was the documentation of the tribulations of the rural population in the Mid-West of the United States, commissioned by the Farm Security Administration between 1937 and 1942. The programme gave rise to icons of 20th-century photography, such as Dorothea Lange's *Migrant Mother* with her children.

There are currently numerous projects which seem to express a periodically recurring need to question reality. Well-known in this context, for example, is the Russian photographer Boris Mikhailov with his merciless social reportage. But while dealing with the subject of Realism, it would not be enough to take account only of "classical" documentation or at least of work in the documentary style. There are staged photographs which can equally make statements about reality, and in principle, part of the importance of analogue photography continues to be that it provides a hint of the real.

Reproducing Reality as Education?

The important role that photography now plays in art has changed its function. We can agree with the photographer and photo-theoretician Allan Sekula in describing the sociological appropriation of photography as instrumental Realism – early anthropological, criminological and psychiatric photography, along with movement studies, was all part of an experiment to link optical empiricism with abstract truth. For a time, there was also widespread hope that people would understand the monstrous nature of war once its horrors were displayed graphically enough to them. It was in this spirit that the pacifist Ernst Friedrich published his book *Krieg dem Kriege* (War on War) in 1924, using 180 pictures of devastation, prostitutes in military brothels, starving children, dead soldiers and – in the chapter "The Face of War" – 24 close-ups of soldiers with horrifically disfiguring facial injuries, in order to make a passionate call for a war on war. Welcomed by numerous intellectuals, artists

and writers, the book had gone through ten editions by 1930, but it was no more able to prevent the next war than were the drastic watercolours of the wounded which Otto Dix painted on the basis of Friedrich's originals, or his anti-war painting *The Trench*, dating from 1924. The pictures of the other so-called Verists on the left wing of the New Objectivity, such as George Grosz and Rudolf Schlichter, who used provocative motifs in order to capture the post-war period, also raise the question of intended and actual effect. *Maimed Working-class Woman*, dating from ca 1924, is, together with drawings like *Worker with Cap* or *Unemployed Man*, a picture from Schlichter's *Gallery of the Nameless*, which was created in parallel with his famous portraits of the 1920s – for example of Bertolt Brecht. With precision, and with less distortion than Grosz, Schlichter captures the feelings of women, and we may presume that this was how the then card-carrying Communist intended to express his critical social commitment.

Some themes raise the fundamental question of whether, and if so through what medium, reality can be appropriately reproduced. Thus there exists a photograph of Buchenwald concentration camp which was taken by Lee Miller shortly after its liberation. She was one of the first to be given a photography permit, and she photographed a pile of corpses, cropping it in such a way that one can realise that it is very much larger than we see on the photo. In the 1950s the painter Rico Lebrun realised his Buchenwald series, undertaking compositional "improvements" with the aim of dramatisation: the pile of corpses comes across as staged and there is nothing to suggest that we only have a detail; the dead are somewhat rounded and the stones on the ground can no longer be made out. In his standard work *The Painter and the Photograph*, Van Deren Coke had this to say about Lebrun: "He has in fact become blind not to the photograph merely, but to reality. The photographer was not blind. However passive the camera, the photographer chose this 'detail', this angle, this exposure… The photographer has seen, and shows us, Buchenwald. The painter shows us only a painting."

Gerhard Richter's *Atlas*, a comprehensive storehouse of our mass-media visual culture, consisting of more than 500 plates and more than 4,000 individual pictures, contains – alongside banal family photos and landscapes – photographs of concentration-camp inmates, which are presented in the immediate vicinity of pornographic photographs. After a number of experiments with out-of-focus or garishly coloured pictures, Richter finally admitted that the horror of Auschwitz was not capable of realistic depiction. The artistic ambition of aestheticisation through

Rico Lebrun
Floor of Buchenwald No. 1
1957, charcoal, ink and casein
on Celotex, 122 x 244 cm
(48 x 96 in.)
The Jewish Museum, New York

the medium of painting seems to be impossible in the face of this subject matter.

Invented horrors can overwhelm the beholder, but as Susan Sontag notes in *Regarding the Pain of Others*, à propos of Hendrick Goltzius' copperplate engraving *The Dragon Devours the Companions of Cadmus*, in which a man is having his face bitten off, it is quite different to shudder at this than at the sight of a photograph of a veteran of the First World War, half of whose face has been shot off. There are, however, present-day examples, for example Richter's cycle dealing with the dead prisoners in Stammheim gaol (members of the Baader-Meinhof terrorist group), or Leon Golub's pictures of violence, which function as comments on how we deal with photographs and can serve as examples of a considered way of coping with depictions of horror.

Seeing Is Believing

We can agree with Leon Golub, who captures repellent human dispositions like no other, in recognising the basic relationship with reality without getting entangled in difficulties of definition: "I didn't say that, necessarily, this is realism, but I did want to get at the real." The hope of changing the world through art has shown itself often enough to be utopian, but Jeff Wall, who with his staged photographs seeks to reproduce social reality and lead us to a reflective receptive attitude, has come up with the maxim that while looking at art may not change the world, it can change the beholder and his or her relationship with the world.

Painting can be self-reflective and realistic without denying the avant-garde developments of the last century. Even at the end of the Modernist era, figurative painting is still possible, and we can often see how undogmatically realistic positions are put forward. What continues to be important is the curiosity to experience art and reality. For, as John Berger has said: "What we can see has always been and continues to be the main source of our knowledge of the world. We take our bearings from what we can see." Even today, we need pictures to make a picture of the world.

Tamara de Lempicka

b. 1898 in Warsaw, Poland
d. 1980 in Cuernavaca, Mexico

Portrait of the Duchesse de la Salle
1925, oil on canvas,
161 x 96 cm (63½ x 37¾ in.)
Private collection

Tamara de Lempicka was born of a patrician Polish family, went to live for a few years in St Petersburg and after the Russian Revolution left for Paris, where she studied under Maurice Denis and André Lhote, from whom she at first adopted a "bourgeois" Cubism which she successfully combined with stylised, plastic figures. In 1938 she went to live in America, later on moving to Mexico where she died after having made relatively unsuccessful excursions into melodramatic social criticism and abstraction. The 1920s and 1930s were the heyday of this "painter of the world".

During this period she celebrated her greatest artistic successes, painting a large number of portraits in her unmistakably cool, almost metallic style. Cubist reminiscences appear only in the background, as in the *Portrait of the Duchesse de la Salle*, which dates from 1925. The dominant feature is the almost lifesize depiction of the duchess in riding gear. She is standing casually with her legs apart on a staircase with a red carpet. The city is visible below, so that she can be seen as dominating that, too. Her face is made up, the crimson lipstick harmonises with the carpet, her cheeks are rouged and a small beauty spot can be discerned on her upper lip. Her right arm is bent, with the hand in the trouser pocket, while she is leaning with her left arm on what may be a banister, but which is covered with a drape.

This robust posture can be seen as altogether paradigmatic of a space-dominating "masculine" body-language to which conventional role assignment is not applicable. Iconographically, Lempicka is moving in the tradition of masculine ruler portraits. The hips and thighs of the sitter are emphasised by the riding coat, whose tails are flung wide open and seem to frame them like a tent, while the left hand is pointing to her crutch, drawing attention thither, as do the trouser legs with their inconsistent cut: the right leg is skirt-like in its bagginess, while the left is skintight over the thigh.

The woman's sex, though covered, is in the dead centre of the picture, apparently an indication of her self-determined sexuality. Self-assured, her deep-violet hair cropped close to her head in the pageboy style with a dead straight parting down the middle, she embodies the archetypal androgynous woman, an image adopted years later by Marlene Dietrich. Looking at photographic portraits of the artist, we realise that like Dietrich, she knew how to mystify her own person and to cultivate the image of a sophisticated, self-assured, active woman of the world.

Just as she wanted to see her own life handed down to posterity as a piece of fantastical self-design, Lempicka always asserted the real existence of the sitter, but it is much more likely to be a fictitious creation, for none of the relevant genealogical reference works contain any mention of a duchess of this name. That could be interpreted as a sign that Lempicka identified with this imaginary sitter, seeing in her the realisation of a self-sufficient woman whose aggressive approach to sexuality could be seen as the leitmotif of her own lifestyle, which was characterised for a while by countless liaisons, making her an icon of Art Deco. (K. S.)

Georgia O'Keeffe

b. 1887 in Sun Prairie (WI), USA
d. 1986 in Santa Fe (NM)

"Nothing is less real than Realism. Details are confusing.
Only by selecting, omitting and emphasising do we advance
to the true meaning of things." — **Georgia O'Keeffe**

With the flower pictures, which Georgia O'Keeffe painted from 1924 until the late 1950s, she is venturing on to terrain with feminine connotations. And yet her pictures, which usually depict large-format close-up details of plants, have nothing to do with conventional still lifes with flowers.

Black Iris III, dating from 1926, is one of these suggestive flower pictures that oscillate between the abstract and the figurative, and inexorably calls to mind the female sexual organs: the dark opening in the centre, which draws the gaze into the depths, is surrounded by delicate, pastel-coloured petals. This sensuous exploration of form, which attracts us through its sparing use of paint and the suggestive shading, had the result that even contemporary critics enthused about the aesthetic balance and the erotic effect. O'Keeffe gave the same attention to the tobacco plant, the camomile and the so-called skunk cabbage, always greatly enlarging individual leaves, which became her personal theme. She gave her reasons in 1962, somewhat tongue-in-cheek: "I realised that were I to paint the same flowers so small, no one would look at them because I was unknown. So I thought I'll make them big like the huge buildings going up. People will be startled, they'll have to look at them – and they did."

Similarly unpretentiously sensuous are the photographs taken of her face and body by her husband, the famous photographer and promoter of avant-garde European art in America, Alfred Stieglitz. Sensitive and without false modesty, these pictures speak of being overwhelmed by what is seen, without robbing it of its aesthetic innocence. O'Keeffe herself said of the Stieglitz photos that they had helped her to find her individuality and to use painting to say what she wanted. However, Stieglitz wanted to nail O'Keeffe down to particular subjects, for he too saw in her art a gender-specific quality realised in artistic expression. But Georgia O'Keeffe was aware that she had been typecast by her flower pictures, and went against Stieglitz's advice by turning to other subjects as well, such as the "masculine" motif of the skyscraper.

Her cityscapes from the years 1925 to 1930 are full of drama. From 1933 she lived on and off in New Mexico, setling for good in 1949. The landscape, with its mountain massifs and remnants of bones and skulls, proved an inexhaustible source of inspiration in the second half of her life. Her technique always oscillated between recognisable gestures on the one hand and reduction on the other, just as her personality seems both to be expressed in her pictures and at the same time to withdraw from them – for example, she never signed her oil paintings on the front. O'Keeffe was the first woman to be given a retrospective in the Museum of Modern Art. That was in 1946. When Georgia O'Keeffe died at the age of 98, she left a consistent life's work whose popularity has nothing whatever to do with lack of quality. (K. S.)

Black Iris III
1926, oil on canvas,
91.4 x 75.9 cm (36 x 30 in.)
The Metropolitan Museum of Art, New York,
Alfred Stieglitz Collection

Max Beckmann

b. 1884 in Leipzig, Germany
d. 1950 in New York, USA

Max Beckmann spent part of the First World War as an ambulance-man. The experience resulted in mercilessly realistic drawings of the wounded, dead and dying. His meticulous observations doubtless led to his subsequent nervous breakdown. In his self-portraits he dissects his own state of mind. One of the best-known, the 1927 *Self-portrait in Dinner Jacket,* clearly depicts someone who has witnessed a lot of things. What we see is a man coming across as self-confident to the point of arrogance with a pronounced, almost bald crown. One hand is resting on his hip, and the other, which is spread in a somewhat mannered fashion, holds the almost inevitable cigarette, which, along with the elegant black-and-white contrast of dinner jacket and shirt, gives him an urbane air: in the 1920s, the dinner jacket in advertising and portrait photography had become the symbol of big-city life.

The picture background is divided into whiteish-grey and black sections; on the left, a doorframe can be seen, which delimits the darkness of a room: the white wall towards the right is repeated in the white of the shirt, the black of the dinner jacket is taken up by the darkness of the room next door. The size of the figure is emphasised by the austerely frontal view seen marginally from below eye level, but what comes across as a result is not pure artistic vanity, but merciless self-questioning: the shadows which form the statuesque face bathe the forehead, nose, chin and one eye in darkness, while the light areas recede to the point where we can share Reinhard Spieler's impression that we are "looking directly into the interior of his head, as though the dominant head would turn out unexpectedly to be a hollow skull". Certainly the form taken by the illumination, which divides the face down the middle, creates a tear or crack which seems continued down the mid-line of the body to the slightly parted legs.

This sinister apprehension which has settled on his face may be the expression of Beckmann's experiences and his realistic assessment of coming political developments. By radically simplifying the shapes and drawing sharp contours, Beckmann in this picture and his entire oeuvre captures the magical element of reality and translates it into painting, which comes across as more monolithic and at the same time more insistent than any precise reproduction. Beckmann links the choice of the dinner jacket as costume with a utopia such as he described in the same year as the painting in an article entitled "The Artist in the State": "The new priests of these new cultural centres have to appear in dark suits, or, on ceremonial occasions, in white tie and tails, if we do not succeed in inventing a more precise and more elegant form of masculine attire. Furthermore, it is essential that working men too should appear in black tie or white. In other words, we hope for a kind of aristocratic bolshevism. A social compensation, the basic idea behind which, however, is not the satisfaction of pure materialism, but the conscious and organised urge to become God oneself." Beckmann's stylisation seems to be evidence of an exaggerated feeling of self-esteem, which arose out of decadence and despair, and still disturbs us modern beholders because the representative character of the picture is contradicted by its evidently cryptic nature. (K. S.)

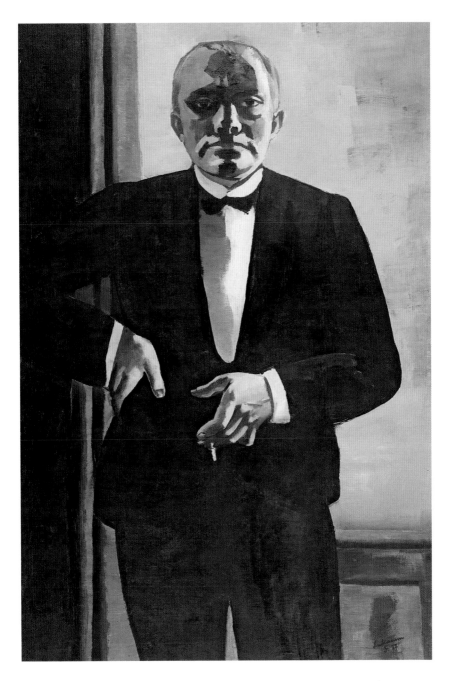

Christian Schad

b. 1894 in Miesbach, Germany
d. 1982 in Stuttgart

Self-portrait with Model
1927, oil on wood,
76 x 61.5 cm (30 x 24¼ in.)
Private collection

Christian Schad is regarded as one of the leading exponents of New Objectivity, and according to Wieland Schmied, is the "prototypical possessor of the 'cool gaze' which distinguishes this movement from earlier forms of Realism".

With his portraits painted in the 1920s, including this 1927 *Self-portrait with Model*, Schad captured the atmosphere of a particular class of society while remaining aloof from it. It is these pictures of an era which form the lasting legacy of the artist. In addition, during a stay in Switzerland which allowed him to avoid military service in Germany, he developed in 1919 a process for the production of contour pictures using light-sensitive photographic plates. Christened "Schadographs" by Tristan Tzara, they brought him a certain renown.

Photographic ways of seeing also influence Schad's paintings: the fragmented townscape behind the couple – the outlines of urban buildings can be made out through the thin curtain material – can be understood as the result of his investigation of photography as a way of capturing the world. The same could be said of the precise depiction of the persons and objects in the picture, for example the meticulously delineated orchid behind the woman, an indication of the sexual charge present in the situation.

The bust of the artist in the foreground is characterised by two things in particular: his sceptical gaze, which seems to be directed straight out of the picture and at the beholder, and a transparent greenish shirt, which emphasises his nakedness, as every single hair on his chest is visible beneath it. This revealing cover increases the tension in the picture because it is in such contrast with the flesh-tints of the woman. The man is obviously sitting on the edge of a bed, the woman with her beautiful body, its nakedness emphasised by the red stocking cut off by the edge of the picture and by the black ribbon round her wrist, can be seen in profile, her pubic region hidden by the man's body – although the beholder's gaze is drawn towards it by the slim index finger of her left hand. Her self-willed face with the sharp nose is marked by a *sfregio*, a scar left by a passionate husband or lover as a sign of his jealousy. According to Schad, Italian women wore this disfigurement with pride, as a sign of how passionately they were loved.

There is however very little passion, let alone intimacy, to be felt in the picture; following the act to which the rumpled bed seems to bear witness, the atmosphere is one of aloof coolness. It was Schad's wish that the decadence of the scene, which precisely captures the zeitgeist in an admittedly privileged class during the 1920s, should not be suspected of illustrating any specific situation. He himself described his paintings as symbols, arising from intuition. What we have is a picture, painted with what has often been described as old-masterly precision, of post-coital alienation, comprehensible also for today's beholders. (K. S.)

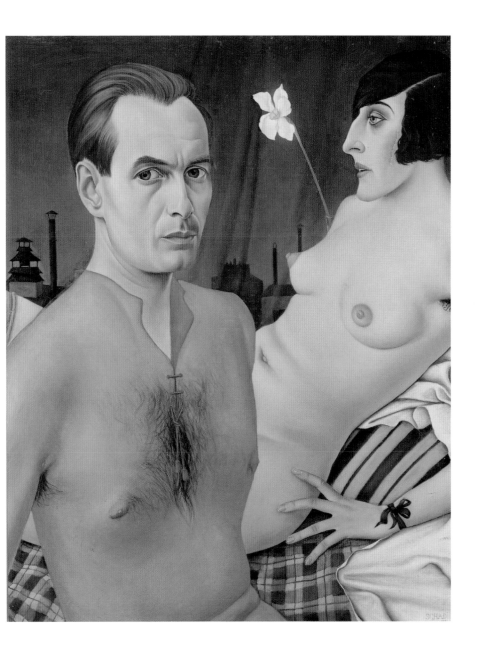

Grant Wood

b. 1891 in Anamosa (IA), USA
d. 1942 in Iowa City

*"I realised that all the really good ideas
I'd ever had came to me while I was milking a cow."*
— **Grant Wood**

It was *American Gothic* that made Grant Wood famous beyond the confines of his home state of Iowa; at the same time it was also the first of his pictures to be bought by a museum. A Regionalist, who, like his fellow artists Thomas Hart Benton and John Steuart Curry was concerned with the restoration of an authentically American style of painting, he was nonetheless influenced by European art, as is evident from *American Gothic*. In the 1920s, Wood visited Europe a number of times, and the frontal double portrait of a farmer and his wife demonstrates his enthusiasm for the detail-obsessed painting of the Low Countries. The difficult-to-decipher mood of the mysterious couple is particularly reminiscent of Jan van Eyck's double portrait *The Arnolfini Wedding,* and at the same time it establishes Wood's familiarity with New Objectivity. Above all, it is intended to reflect Wood's belief that an artist should "paint out of the land and the people he knows best".

Yet Wood's picture, which has since achieved the status of a national icon, and has been adapted by cartoonists and used for photomontages more often than almost any other painting, only appears to depict a sturdy farmer from the Mid-West, with his pitchfork in his hand – in fact, the sitters are Wood's sister and his dentist. The fictitious image of the "Mid-Western pioneers" was intended to exploit the memory of common roots in order to revive an America that was in the process of disappearing. It is not without a measure of satire, and accordingly it was registered by the rural population without any great enthusiasm; no one wanted to be identified with these antiquated implements or such grumpy facial expressions.

There is a photograph of the same name by Gordon Parks dating from 1942, in which the use of the photographic medium creates a very much stronger connection with reality. In a room in which the American flag was displayed, Parks created, in the style of Grant Wood, an austere, frontal portrait of the black cleaner Ella Watson, with a mop in one hand and a broom in the other. She comes across as serious and tired, but in her expression, the beholder may discern a certain pugnaciousness. This woman with her bright eyes behind metal-framed spectacles is certainly not yearning for the return of the 19th century from which Wood's sitters appear to have been plucked. But the double allusion to the painting provides a commentary on the current situation at the time, namely the prevalent discrimination against black Americans even in the "land of the free and home of the brave". Parks' *American Gothic* is not intended to consolidate the status quo: on the contrary, times have changed and these changes demand acceptance by society. (K. S.)

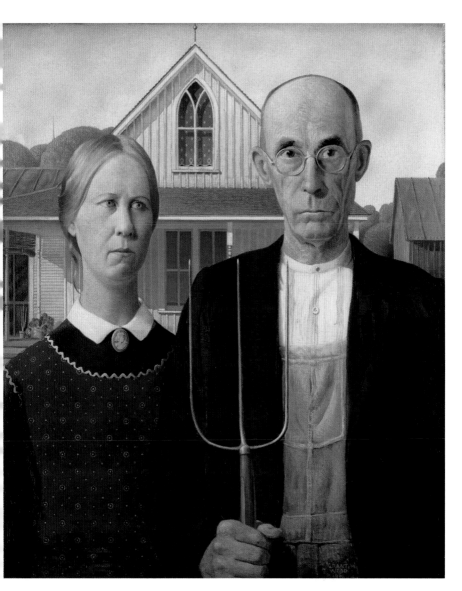

American Gothic
1930, oil on beaver board,
78 x 65.3 cm (30¾ x 25¾ in.)
The Art Institute of Chicago,
Friends of American Art Collection

Diego Rivera

b. 1886 in Guanajuato, Mexico
d. 1957 in Mexico City

As the most important Mexican painter of the first half of the 20th century, Diego Rivera was so well known in the neighbouring United States that he was commissioned there to design and execute large murals in several cities – San Francisco, Detroit and New York.

In 1932, Rivera was invited by the Detroit Arts Commission chaired by Edsel B. Ford to decorate the inner courtyard of the Detroit Institute of Arts with a cycle of frescos on the theme of *Detroit Industry, or Man and Machine*. The Commission chose Rivera because, as one of the directors of the municipal art gallery wrote, he had "built up a powerful narrative style of painting, which makes him, it is safe to say, the only man now working who adequately represents the world we live in – wars, tumult, struggling peoples, hope, discontent, humour and speeding existence."

Rivera began preparations in April the same year, making hundreds of sketches and studies of the individual production phases, which he consulted, together with numerous photographs by the official company photographer when painting the wall surfaces, a process which lasted from July 1932 to March 1933. Rivera's enthusiasm for the commission was so great that he declared himself ready, for the contractual US$ 10,000 fee, to paint not only the 100 square metres of the north and south walls as agreed, but all four wall surfaces, in order to be able comprehensively to depict the relationship between man and machine.

On the smaller east and west walls, Rivera depicted the origins of human life and of technology, that is to say, the new waterborne and airborne technologies. The monumental frescos on the north and south walls are largely devoted to the manufacture of the V8 engine and the bodywork of the new Ford automobile, which had rolled off the assembly line for the first time a few months earlier. The depiction of the factory hall on the south wall was based on studies made by Rivera of the various factories owned by the Ford family, in particular the River Rouge complex also documented by Charles Sheeler. In the medium of the mural, Rivera created an aesthetic of the machine age whose optimism is surprising. In view of the painter's Marxist convictions, the presentation of capitalist production sites is extraordinarily positive, and bears witness to the great fascination they exerted upon him. The comparatively harmonious synthesis of man and machine does not reflect the actual situation of the workers during the Depression, with its unemployment, strikes and public soup kitchens: in 1932, Ford's production was just one-fifth of what it had been in 1929. This mural is painted in Rivera's personal style, a self-willed mixture based on studies of Italian Renaissance frescos and pre-Columbian sculptures from the "land of the gods", combining symmetry and statuesque forms with a narrative technique. The similarity of the central production machine with an Aztec Coatlique figure is striking. While Edsel B. Ford in Detroit issued a declaration in defence of Rivera in the face of public attacks, the artist had less luck with his mural for the Rockefeller Center in New York: there, a portrait of Lenin, which Rivera refused to paint over, led to a major row and the destruction of the picture. (K. S.)

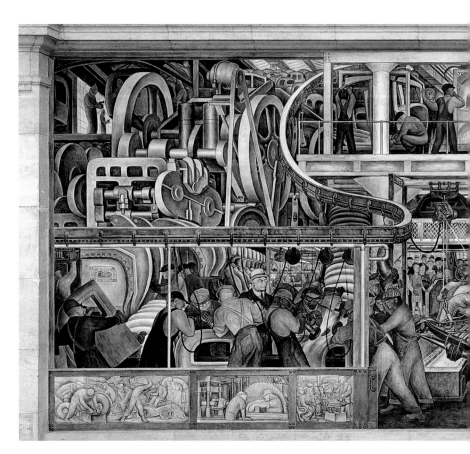

Detroit Industry, or Man and Machine (Detail)
1932–1933, mural, south wall, 4 wall surfaces
each divided into 5, 8 and two times 7 panels,
painted surface in total 433.63 square metres
(4667½ square feet)
Detroit Institute of Arts

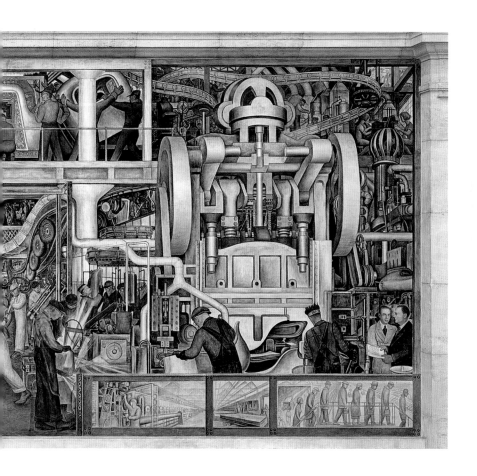

Edward Hopper

b. 1882 in Nyack (NY), USA
d. 1967 in New York

"Hopper is simply a bad painter, but if he were a better one, he would probably not be such a great artist." (Clement Greenberg) This paradox describes the ambiguity in Hopper's work: without painterly verve and with a seemingly naive compositional style he has discovered archetypical codes for modern life in the United States.

Apart from contemporary photography, Hopper was influenced by Hollywood movies. The use of perspective in many of his paintings suggests the tracking shots of a film camera. Reciprocally, with his eye for unusual details and vanishing points, for sharply cast shadows and shrill lighting, he stimulated American movie directors and later the German filmmaker Wim Wenders. The haunting painting *House by the Railroad* (1925) undoubtedly served Alfred Hitchcock as the model for the murder house in his 1960 film *Psycho*.

Hopper has been called a Surrealist of the everyday. If nothing else, his interiors prove that he oriented himself towards the disturbing magic of the banal, as with the painting *Nighthawks*, which has posthumously become an icon of American pop culture. The viewer's gaze passes through the panorama window of a diner and focuses on several late-night guests who are completely isolated from one another and appear more like decorations than living beings. In a painting created ten years earlier, *Room in New York*, it is the loneliness of only two people, a man and a woman, that the viewer finds literally chilling. As though entering the room from a pitch-dark outside world, our gaze pushes forward into the brightness, albeit the very cold brightness, of a living room. Everything seen here, the relatively young couple included, is formally schematised and stenciled – codes of reality! In shirtsleeves, the man sits in a puffy armchair, leaning forward and studying the newspaper. The empty, round tabletop – as much as the horizontally "barred" door in the background – positions itself between him and the woman, who shows him her back while seeming to think or listen to herself. Corresponding with the door, the tall rectangle on the left is perhaps an inward-projecting window casement with horizontal, glazed bars, most likely shimmering bluish-green panes of glass. Of all the interior's consistently cold colours, only the intense reds of the armchair and the woman's dress stand out. Do these bracket the man and woman? No, the emotional and spatial break between them is far too great. One would more likely conclude that, for her partner, the woman has become a household object equal to the armchair, a "standard feature" of what one considers a family and a home. The woman dreams of other matters, perhaps of earlier times. Does she dream of the freedom which only the landscape painting beside the door conjures in this scenario? Compositionally, this landscape is clearly the counterpart of the open space occupied by the room's inhabitants! All the other paintings on the walls are characteristically empty, "blind", featureless and incapable of giving even the comforts of fiction. (N. W.)

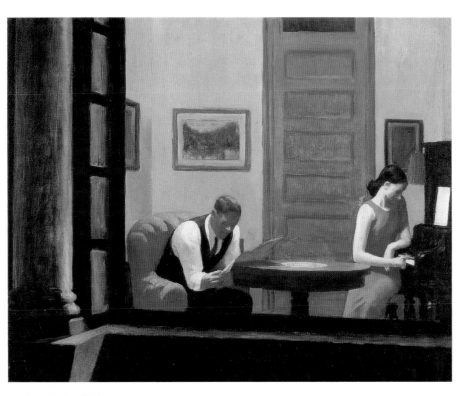

Room in New York
1932, oil on canvas,
29 73.7 x 91.4 cm (29 x 36 in.)
Sheldon Museum of Art, University of Nebraska,
Lincoln, F. M. Hall Collection

Balthus

b. 1908 in Paris, France
d. 2001 in Rossinière, Switzerland

Balthazar Klossowski de Rola was born as the second son of the art-historian and painter Erich Klossowski and the painter Elisabeth Dorothea Spiro, alias Baladine Klossowska, and he continued to assert lifelong that he had never ceased to see with the eyes of a child. Balthus himself was opposed to any interpretation of his pictures. He wanted them to be understood as still lifes, and cheerfully admitted that his painting was concerned with a world that was no longer valid today. When he was ten years old, he made a series of pen-and-ink drawings of a cat which had first adopted him and then run away again, published in an album by his friend and mentor Rainer Maria Rilke. From then on he created an œuvre, limited both in its style and its motifs, whose declared aim was beauty.

The painting *La Toilette de Cathy*, dating from 1933, is based on an early episode in Emily Brontë's 1847 novel *Wuthering Heights*. As a teenager, Balthus lived for a time with friends in Yorkshire, where he discovered the untamed landscape in which this story is set. In Balthus' adaptation of the scene, there is little trace of the atmosphere of gothic romance which pervades the literary original, nor of certain details: the painting depicts Cathy, in a wide-open dressing gown, assisted by her maid Nelly, preparing for an assignation with her admirer Edgar Linton. In the corresponding scene in the novel, Heathcliff, who loves her more than anything else in the world, just happens to be passing after emerging from the stable, but here is depicted by Balthus in elegant clothing. He comes across as tense, seems however not to be calling her to account, but rather makes a withdrawn impression. This is in marked contrast to an Indian-ink illustration of the same motif, in which Balthus depicts Cathy as fully clothed and Heathcliff as turning towards her and her maid with a black look on his face. Balthus explains: "I don't know whether I portrayed myself with Heathcliff's features, but when I look at the drawings today, I see traces of my former rebelliousness."

That Balthus identified with Heathcliff's rebellion against society is confirmed by the way in which he portrayed the character with his own facial features and depicted him in a pose similar to that in which he himself was portrayed by the photographer Man Ray that same year. Cathy by contrast comes across as otherworldly, somewhat wooden in the manner of a Cranach picture, and, as usual with Balthus, has too large a head – Antonin Artaud has described these proportions as those of people with water on the brain. She bears the features of his future wife Antoinette de Watteville, and her pale skin provides a nice contrast with Heathcliff's swarthy complexion.

Balthus never attended an academy, orienting himself by exemplars whom he chose himself, such as Piero della Francesca; as a result, he did not succumb to the eclectic Neo-Classicism of the 1920s and 1930s. In the matter of both form and colour, Balthus came to master expressive qualities reminiscent of frescos. Allegedly he was never able to understand the uproar he caused with his naked nymphets like Cathy, since he always regarded his works as depictions of innocence. His "dear little angels" look like frozen statues, and in his later years became mere stage-props. But in *La Toilette de Cathy* we can still feel the aura of demonic tension which made Balthus the inimitable master of those passions which are both secret and real. (K. S.)

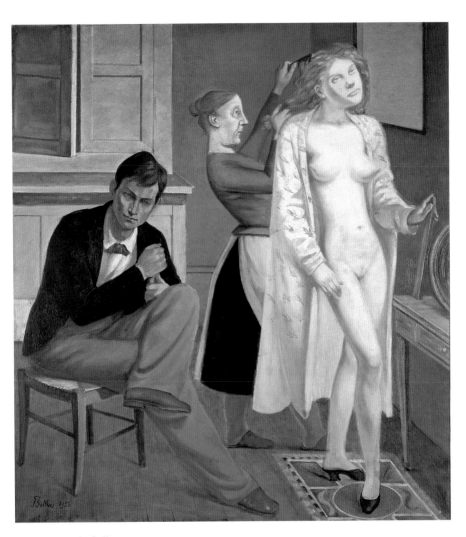

La toilette de Cathy
1933, oil on canvas,
165 x 150 cm (65 x 59 in.)
Musée national d'art moderne,
Centre Pompidou, Paris

Charles Sheeler

b. 1883 in Philadelphia, USA
d. 1965 in Dobbs Ferry (NY)

*"You don't build the house first and then
make a blueprint afterwards."* — **Charles Sheeler**

First Charles Sheeler established himself as a painter, and in 1913 he was represented at the New York Armory Show with six paintings. His devotion to photography, in particular to architectural photography – in which financial considerations also played a part – made him the pioneer of a New Objectivity-related camera art in America, but at the same time, photography served time and again as a source for his paintings. Thus while the legendary photographs of the Ford works, *The Plant*, were commissioned by the company in 1927 as advertising material for the functionality and beauty of the Machine Age, Sheeler used one of the unpublished pictures eight years later as the starting point for his painting *City Interior* – on entering the factory site, he recognised the possibility of using the material for his painting too: "When I arrived, I immediately took the opportunity to open the other eye, and then I thought that maybe I could get a few paintings out of it too."

From a raised vantage point, we are confronted with the smoothness of the machines and their proportions, apparently not imagined with human beings in mind; the small figures moving between the tracks and on the steel walkway serve at best to indicate the scale. Human surroundings, let alone humans to control the machines, can be seen neither in this nor in the other paintings. The precision of the pipes and the raised viewpoint are reminiscent of Sheeler's Straight Photography, but the transformation into painting shifts the view: the fact that the subject is thought worthy of painting seems to make it a source of information, beyond the purely documentary aspect, on changed conditions of life and work.

For reasons of market strategy, Sheeler did not want it to be known that this and other paintings were based on photographs. Still, Sheeler has been accorded recognition by the photographic scene: two decades after he had photographed the conveyors in River Rouge, Walker Evans took a photograph at the same spot. Sheeler's aloof pictures were, as Edward Steichen once said, "objective before the rest of us were". His paintings, which concentrate entirely on the exterior, or surface, are, with their sharpness and clarity resulting from reduction, an illuminating indication of why he and the other "precisionists", who celebrated machines and factories in this decided manner, were also called the "immaculates".

The seemingly sober vision of the industrial plant celebrates a utopian view of progress to which Diego Rivera's frescos also paid homage at the same time and with the same subjects. Apropos of *City Interior*, Winslow Ames had already written emphatically in 1936: "It is not industry as industry seems, but the industry of our dreams, in which are mingled manifest destiny, the grandeur and loneliness of the prairies and the old-fashioned immigrants' belief in sidewalks paved with gold." The impersonality of the photographic original combines with the subdued colour and the monumentality of the painterly approach to create a further "American landscape". (K. S.)

City Interior
1935, aqueous adhesive and
oil on composition board,
56.2 x 68.4 cm (22¼ x 27 in.)
Worcester Art Museum

Felix Nussbaum

b. 1904 in Osnabrück, Germany
d. 1944 in Auschwitz-Birkenau

The man turning towards us is standing in front of the angle in a tall wall which takes up much of the picture. His skin colour looks sickly, and he is somewhat emaciated. From dark eye-orbits emerges a serious, tense look. We can also interpret this look as vigilant or shy, for the way that it is directed towards us over his shoulder from under the brim of his hat, which only increases the shadow, behind a turned-up coat collar, does not correspond to any of the standard portrait poses. The man is standing so uncomfortably close that we can register his stubble beard, but actually we cannot comprehend his standing and turning as a statue-like pose: rather we see him as someone looking fleetingly to one side as he moves on.

A moving-on that is, specially for us, combined with a dual, secretly hasty pointing gesture. For while his eyes are openly looking at us, the man is showing us his ID card, which, because he is holding it so near, as near as his face, can be deciphered down to the last detail. The card has a red overstamp, the words "JUIF – JOOD". This is the bilingual Belgian version of the Jewish ID with which the German occupiers stigmatised all Jewish people throughout Europe between 1940 and 1945, in order to register them thus for persecution, deportation and extermination. And accordingly too, the turned-up coat collar reveals his otherwise half-obscured Yellow Star.

The person secretly revealing himself to us in the twilight of some urban backyard is Felix Nussbaum. A painter of Jewish descent from Osnabrück in western Germany, he had lived in exile since 1933, from 1941 in Brussels, where he hid in basement and attic flats. In horrific conditions, he went on painting underground. His constant fear of detection would have paralysed many another artist. He retained his strength, the fear only spurred him on to more work. Underground, fear, energy – these are the words to describe his dark world of confinement. The wall looms over the man, and compositionally too it is oppressive. The spooky life on the patchy wet plaster behind him reveals painting in oppressive matter-of-factness. Above the truncating effect of the cornice and its strong shadow, we can see a multi-storey tenement block, pruned trees, dark clouds and – like a shimmer of hope – a few white blossoms. There is also some light in a window and on the masonry. But the darkness dominates.

With this self-portrait, Felix Nussbaum testified to the nameless terror of his situation. And also to his obstinate courage in responding to this terror with precise, narrative pictures. Far from all heroics, Nussbaum created a monument with this picture. The message: even when there seems no way out, one must not give up, because in not giving up, the last remains of dignity survive. Nussbaum is therefore not only speaking as an individual from the underground, he is speaking in pictures and gestures vicariously for all his fellow Jews suffering from persecution.

His – in any case meagre – hope of survival was not fulfilled. A few months later (he created a few more pictures in the meantime) Nussbaum was informed on, arrested and taken together with his wife to Auschwitz, where they were murdered. (E. R.)

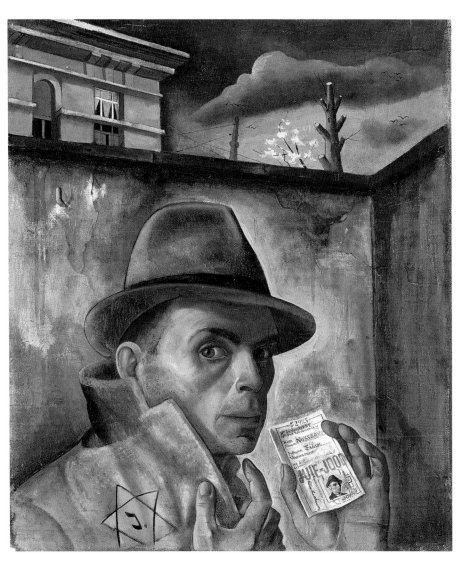

Self-portrait with Jewish Identity Card
1943, oil on canvas,
56 x 49 cm (22 x 19¼ in.)
*Felix-Nussbaum-Haus, Osnabrück, on loan
from the Niedersächsische Sparkassenstiftung*

Surrealism –
From Max Ernst
to Salvador Dalí

A New Declaration of the Rights of Man

Cathrin Klingsöhr-Leroy

René Magritte
Time Transfixed
1938, oil on canvas,
147 x 99 cm (58 x 39 in.)
The Art Institute of Chicago,
Joseph Winterbotham Collection

The Disinterested Play of Thought

What is Surrealism? Searching for a definition, in his "First Manifesto of Surrealism", published in 1924, André Breton resorted to the phraseology of dictionaries and encyclopaedias: "SURREALISM, noun. Pure psychic automatism by which it is intended to express, either verbally or in writing, or otherwise, the true function of thought. Thought dictated in the absence of all control exerted by reason, and outside all aesthetic or moral preoccupations... Surrealism is based on the belief in the superior reality of certain forms of association heretofore neglected, in the omnipotence of the dream, and in the disinterested play of thought. It leads to the permanent destruction of all other psychic mechanisms and to its substitution of them in the solution of the principal problems of life. Have professed absolute surrealism: Messrs. Aragon, Baron, Boiffard, Breton, Carrive, Crevel, Delteil, Desnos, Éluard, Gérard, Limbour, Malkine, Morise, Naville, Noll, Péret, Picon, Soupault, Vitrac."

On reading the names of those who, in Breton's estimation, represent "absolute Surrealism", we might imagine that this is a purely literary movement. However, in a footnote, Breton opens up this new domain to practitioners of the fine arts. He lists Uccello, Seurat, Moreau, Matisse, Derain, Picasso, Braque, Duchamp, Picabia, de Chirico, Klee, Man Ray, Ernst and Masson as members of a group who, without having heard the "Surrealist voice" are nonetheless sympathetic to the cause.

Astonishingly, Breton names not only contemporaries but also previous generations, represented by Uccello, Seurat and Moreau, as if Surrealism were a fundamental intellectual position dating back centuries. However, a look at history will clearly show that, while there were always artists whose works were inspired by dreams, the supernatural, the irrational and the absurd, we can only understand the precise significance of Surrealism as an artistic movement if we see it in the context of a particular period, the years between the two World Wars.

Critique of a Saturated Society

The artists who came together in Paris in the early 1920s shared a deep mistrust of materialistic, bourgeois society, which, they believed, was responsible for the First World War and its terrible aftermath. Not only that, but with its smug, superficial way of life and its belief in the omnipotence of technological and scientific achievement, society had succumbed to a process of degeneration to which the only answer was a revolutionary new anti-art. Already the Dadaists' anarchistic manifestations had attacked outdated ideas and those who clung relentlessly to them. The Surrealists shared some Dadaist ideas, but they set out to be better organised and more relevant to the real

Surrealist flysheet (Papillon)
from the Bureau for
Surrealist Research

world. André Breton, the unifying figure and charismatic leader, who over the next two decades would coordinate activities and rally the troops, envisaged a movement that could really make a difference. Surrealism would not only embrace art and literature but would also play a part, as the "First Manifesto" put it, in "solving all the principal problems of life".

Central to this concept were the ideas of Sigmund Freud, which Breton adapted to suit his own purposes. He regarded Freud's findings as the fortuitous rediscovery of the power of dreams and imagination that had long lain hidden behind the purely rational outlook that predominated at the time. Now, Breton predicted, the psyche would come into its own. A new intellectual tendency would evolve and artists could develop a perspective enabling them to free themselves from the control of reason. Sigmund Freud's contribution had been to define and describe the subconscious mind as a genuine phenomenon that governed human thought and behaviour. Breton translated this understanding into an artistic and literary methodology, based on the subconscious and the imagination which, he believed, had been repressed by rationalism, civilisation and progress. Breton used Freud's theories to inspire those willing to fight against a culture that he saw as threatened by the censoriousness of the super-ego.

In 1916, while working as a junior doctor in the neurology department of a hospital in Nantes, Breton met Jacques Vaché, whose anti-bourgeois attitudes were expressed through his profound admiration of the playwright Alfred Jarry and his nonsensical Dadaist antics. Breton, meanwhile, took a special interest in and kept records of the dreams and thought processes of mental patients.

After Vaché's suicide in 1919, Breton and Philippe Soupault began work on a series of texts based on the technique of "free association", which was published later the same year under the title *Les Champs magnétiques* (The Magnetic Fields). This is now regarded as the first-ever manifestation of *écriture automatique,* described by Breton in the "First Manifesto":

"Completely occupied as I still was with Freud at that time, and familiar as I was with his methods of examination which I had some slight occasion to use on some patients during the war, I resolved to obtain from myself what we were trying to obtain from them, namely, a monologue spoken as rapidly as possible without any intervention on the part of the critical faculties, a monologue consequently unencumbered by the slightest inhibition and which was, as closely as possible, akin to *spoken thought.*"

Pages 340-341
Max Ernst
Rendezvous of the Friends
1922, oil on canvas, 130 x 195 cm (51¼ x 76¾ in.)
Museum Ludwig, Cologne

Persons depicted:
1. René Crevel, 2. Philippe Soupault, 3. Hans Arp,
4. Max Ernst, 5. Max Morise, 6. Fyodor Dostoevsky,
7. Rafael Sanzio, 8. Théodore Fraenkel, 9. Paul Éluard,
10. Jean Paulhan, 11. Benjamin Péret, 12. Louis Aragon,
13. André Breton, 14. Johannes Theodor Baargeld,
15. Giorgio de Chirico, 16. Gala Éluard, 17. Robert Desnos

The Chance Meeting of a Sewing Machine and an Umbrella on an Operating Table

The significance of the method of automatic writing, so often mentioned in the same breath as Surrealism, is far more symbolic than practical.

To the writer, *écriture automatique* stands for the need to allow creativity to feed on the deepest levels of the unconscious, on dreams and hallucinations, and at the same time to exclude rational thought as far as possible.

In his 1934 treatise "What is Surrealism?" Max Ernst recalled how hard it was in the beginning for painters and sculptors to find ways of working that corresponded to *écriture automatique* and to use the techniques at their disposal to achieve poetic objectivity, namely to banish reason, taste and conscious will from the creative process. Theoretical investigations were of no help; only practical experiments would do. Ernst described Lautréamont's "chance meeting of a sewing machine and an umbrella on an operating table" as a well-known, almost classic, example of the phenomenon discovered by the Surrealists, which involved bringing together two or more seemingly incompatible objects on an incompatible surface. This could provoke "the most powerful poetic detonations". Countless individual and collective experiments had proved the usefulness of this procedure. It had also become clear, said Ernst,

that the more arbitrarily the elements were brought together, the more dramatic and poetic the results.

A typical example of this process is collage, of which Max Ernst was the principal exponent. As early as 1919, when the artist was still a leading light among the Cologne Dadaists, he discovered the hallucinatory effects of combining graphic elements from different contexts. Clippings from department-store catalogues, anatomical diagrams and old etchings provided the raw materials for his collages. He cut them up, re-mixed them and presented surprising combinations against a new background. Replying to demands for a purely technical definition of collage, Ernst wrote in "What Is Surrealism?": "While feathers make plumage, glue does not make collage." For him, the process went far beyond the realm of the visual. It was a paradigm of the Surrealist mind set.

"A ready-made reality, whose naive purpose seems to have been fixed once and for all (an umbrella), finding itself suddenly in the presence of another very distant and no less absurd reality (a sewing machine) in a place where both must feel out of their element (on an operating table), will, by this very fact, escape its naive purpose and lose its identity; because of the detour through what is relative, it will pass from absolute falseness to a new absolute that is true and

poetic: the umbrella and the sewing machine will make love. The way this procedure works seems to me to be revealed in this very simple example. A complete transmutation followed by a pure act such as love will necessarily be produced every time that the given facts – the coupling of two realities which apparently cannot be coupled on a plane which apparently is not appropriate to them – render conditions favourable."

In 1936, when Max Ernst expressed these thoughts on collage, he also recognised in retrospect how important the technique of mixing objects and ideas had been to the artistic and intellectual development of Surrealism. Collage had succeeded in making irrationality part of every branch of art, poetry and even science and fashion. With the help of collage, he said, the irrational had found its way into our private and public life.

Surrealism and Painting

Giorgio de Chirico, whom Breton described in the 1924 manifesto somewhat ambiguously as "so admirable for so long", was one of the first painters to attract Breton's attention. In 1925 Breton began publishing, in serialised form, a history of modern painting in *La Révolution surréaliste*. He had come across de Chirico while researching the connections between modern art and Surrealism, and single examples of the painter's early works

had appeared in the magazine. Breton's attitude to de Chirico turned to disapproval after the artist moved away from Pittura Metafisica. Nonetheless, at least before he "fell from grace" by returning to a naturalistic style of painting, Breton was eager to get him on board with the Surrealists. He saw de Chirico's work as fulfilling his main criteria for "Surrealism in painting", a deliberate turning away from reality. Writing of de Chirico, Breton said that the artist's greatest folly was to have strayed over to the side of an army laying siege to a city, which he himself had built and made impregnable.

Mysteriousness and unreality were terms that could not necessarily be applied to Picasso, many of whose works appeared in *La Révolution surréaliste*. Breton was careful not to call Picasso a Surrealist in so many words. Obviously he was aware how significant Picasso's admittance to the Surrealist camp would be for the popularity of the movement. In his book *Surrealism and Painting*, published in 1925, he commented in some detail on Picasso, writing with admiration of the artist's "rebelliousness" and of the studio in which "divinely unusual" figures were fashioned. While some had claimed that there could be no such thing as Surrealist painting, Picasso had lifted the spirit to its highest level, said Breton, going far beyond mere protest.

André Masson
The Villagers
1927, oil and sand on canvas,
80.5 x 64.5 cm (31¾ x 25½ in.)
Musée national d'art moderne, Centre Pompidou, Paris

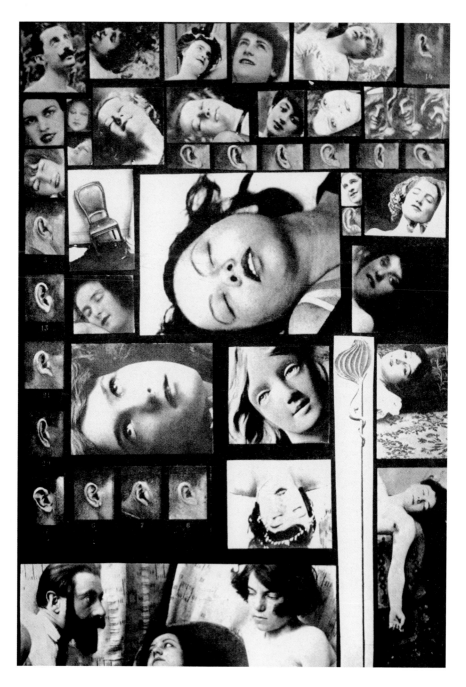

The Surrealists and the Artists around Them

From 1920 an array of artists began to congregate around the Surrealists in Paris. Max Ernst, who had initiated or taken part in numerous Dadaist activities in Cologne, showed his first collages in 1921 at Galerie Au Sans Pareil. Later he described these works as "the miracle of the complete transformation of living beings and objects, with or without change to their physical or anatomical form" – words that capture the surprising and, in the Surrealist sense, the mysterious nature of Ernst's creations.

In 1922 Tristan Tzara, who was one of the cofounders of the Dada movement in Zürich, was enthusiastically taken up by the Surrealists. Tzara collaborated with Man Ray on *Champs délicieux* (Delicious Fields), a book that brought together Tzara's text and Man Ray's Rayographs. Man Ray had invented the process he called Rayography in 1921. This was a photographic method whereby the object to be photographed was placed directly on light-sensitive paper to create a kind of shadow picture.

Some of the Surrealist painters and photographers were represented at an exhibition held from 14 to 25 November 1923 at the Galerie Pierre in Paris under the title *La Peinture surréaliste* (Surrealist Painting). They included Joan Miró, Paul Klee and Hans Arp, as well as Picasso and de Chirico. It was the first group event to focus on painting and bring together the work of the leading Surrealists. They represented the first phase of Surrealism in painting as it took shape during its "heroic" period between the first manifesto of 1924 and the second, published in 1929.

The most important intellectual concept was automatism, the graphic counterpart of free association with words, which led to the "abstract surrealism" of Masson, Miró and Arp, in which biomorphic, soft forms predominated along with sometimes extraordinary textural qualities. By contrast, the Surrealism of Magritte, Tanguy and Dalí, painters who only joined the movement later, was characterised by dream paintings.

The common denominator between them was their visionary, poetic and metaphorical treatment of their subjects. The Surrealists did not paint non-representational pictures. All Miró's and Arp's works, however abstract they may appear, always relate to or at least suggest a subject. These artists continually tried to work towards an internal image which was either improvised through automatism or represented an inner vision.

The Rendezvous of the Friends

A group portrait of the Surrealists entitled *Rendez-vous of the Friends*, painted by Max Ernst in 1922, shows the close contact between writers and

Salvador Dalí
Lobster Telephone or
Aphrodisiac Telephone
1936, telephone with painted
plaster lobster,
18 x 12.5 x 30.5 cm (7 x 5 x 12 in.)
Museum für Kommunikation, Frankfurt
am Main

painters, although the latter are less strongly represented in the picture. Along with Max Ernst himself, we see Arp and de Chirico, as well as a self-portrait of Raphael inserted like a piece of collage. Surrealist writers and poets are joined by Fyodor Dostoevsky, mentioned by Breton in the "First Manifesto", who appears as Raphael's literary counterpart.

The subjects appear alienated, all of them looking in different directions. Johannes Baargeld seems to be taking long strides and making meaningless gestures, while Breton is behind him, staring straight at the spectator, his right hand raised as if bestowing a benediction on the group. Not least, this group portrait by Max Ernst, a snapshot of the year 1922, leads us to question how much cohesion there was between the various members and what it was that held them together.

Parisian Coffee Houses –
The First Surrealist Headquarters

Although membership of the group continually changed and the Surrealists' fields of interest expanded from purely artistic or literary issues to politics and social problems, a constant feature of the movement was the very specific group feeling of the Surrealists. Matta, who only joined in the 1930s, described this in a later interview. "We used to meet in the Flore," he recalled, "apart from us

there was no one there – so it was always the same people. At that time we recognised that we were adopting a certain position. It wasn't that anyone demanded that one should behave in a certain way, like a guy who was out to destroy the whole structure of the bourgeois intelligentsia. It wasn't like that at all. It was much more that we were striving to achieve another kind of intellectual approach – a collective intellectual approach. The Surrealists had a strong group feeling – we worked out problems together. That was what was new."

The history of Surrealism gives the impression that certain subjects and issues always concerned the whole community. Whether it was about the case of Violette Nozière who murdered her father and whose cause was taken up by the Surrealists, or questions of sexuality or political commitment, or such phenomena as dreams, hallucinations and free associations, artists from every field always contributed ideas and works.

For its adherents, Surrealism was a way of life, a kind of existence that left room for playfulness and creativity. It was about living for the moment, with spontaneity and internal intellectual freedom and a lack of materialism, all of which were completely opposed to the values of the bourgeoisie. The Surrealists' preferred meeting place was the café.

The Surrealists met at the Café Certâ, at Le Petit Grillon in the Passage de l'Opéra or at

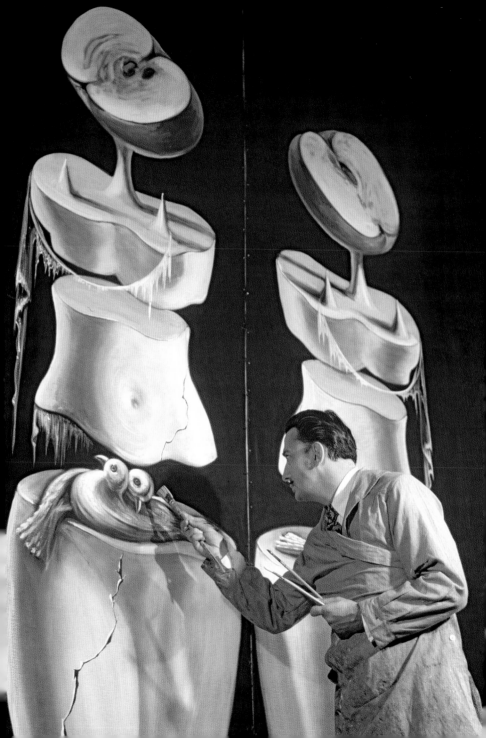

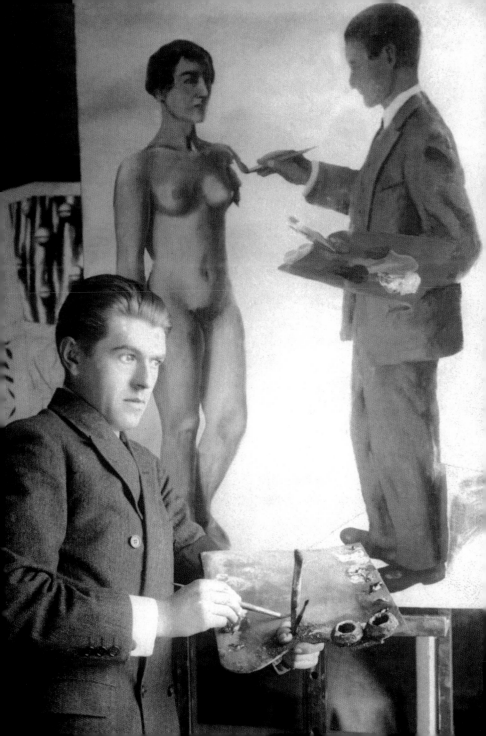

Cyrano on the Place Blanche near Breton's apartment. The Cyrano had nothing in common with the artists' cafés in Montmartre and on the Left Bank, associated with Toulouse-Lautrec or Picasso's Blue Period. It was a favourite haunt of pimps, prostitutes, money changers and drug dealers who, like the Surrealists themselves, went there after seeing a show at the Grand Guignol on the other side of the street. The Cyrano attracted the Surrealists as a place on the margins of society where they could mingle with outsiders and eccentrics.

A Bureau for Surrealist Research

The Surrealists' activities were not confined to literature, poetry and the fine arts. Shortly before the publication of the "First Manifesto of Surrealism" in 1924, the Bureau for Surrealist Research opened in the Rue de Grenelle in Paris and later placed the following revealing advertisement in *La Révolution surréaliste*, the Surrealist journal that also began publication in 1924: "The Bureau for Surrealist Research using all appropriate means aims to gather all the information possible related to forms that might express the unconscious activity of the mind."

The description in Louis Aragon's essay "A Wave of Dreams" underlines the fact that this was an initiative aimed at putting Surrealism to practical use: "We've hung a sculpture of a woman from the ceiling of an empty room, where every day worried men, bearers of heavy secrets, happen by... The visitors, whether born in faraway climes or on our doorstep, contribute to the elaboration of this formidable war machine designed to kill and help decide what can and cannot be achieved. At 15 Rue de Grenelle, we have opened a romantic refuge for unclassifiable ideas and single-minded revolts. Whatever hope lives on in this desperate world will turn its last delirious gaze toward our pathetic little shop. Somehow we must put together a new 'Declaration of the Rights of Man'." The people who formulated the idea of comprehensive social renewal appear in a group photograph taken by Man Ray in December 1924. We see the Surrealists under the sculpture mentioned by Aragon, in front of a painting by de Chirico.

The Bureau for Surrealist Research at first was mostly concerned with intellectual and literary matters. It was from here that the famous Surrealist papillons were distributed. These "butterflies" were small, brightly coloured handbills with headlines such as "Parents, tell your children your dreams" and "If you love love, you'll love Surrealism". To the bourgeoisie these imaginative and entertaining activities did not represent any real affront. This was the view expressed by the Surrealist writer Pierre Naville in his reflections on the sociopolitical relevance of Surrealism.

Precisely because the Surrealist campaigns operated on the level of "morality" the social classes under attack could be sure that the manifestations of Surrealism would never be enough to destroy social or even moral values.

"There is not one of us who would not be happy to see power taken out of the hands of the bourgeoisie and handed over to the proletariat," he wrote in *Légitime Défense* (Legitimate Defense) in 1926. "Meanwhile, however, it is just as necessary that our experiments relating to the interior life should continue, without any control from outside, including from the Marxist side."

Given the divergent individual points of view within the group, Breton's attacks on a number of Surrealist figures in his "Second Manifesto" of 1929 could not have been unexpected. Breton rejected poets and authors of the past, such as Baudelaire, Poe, Rimbaud and de Sade, previously seen as role models by the Surrealists. He also carried out a kind of purge and expelled, among others, Picabia, Tzara, Artaud, Soupault, Masson and Desnos from the movement.

Mysticism of the Inanimate

The tone of Breton's "Second Manifesto", published in 1929, is so mystical it comes as no surprise that parts of the text are concerned with alchemy. Breton regarded himself as the heir to a tradition going back to Nicolas Flamel and the 14th-century alchemists. Now Surrealism was seeking the "philosopher's stone" that would enable the human imagination to "take brilliant revenge on the inanimate". This change of direction launched the concept of the mystical qualities of inanimate objects that typified the later phases of Surrealism, so clearly expressed in René Magritte's paintings. From the "revelation of the remarkable symbolic life of quite ordinary, mundane objects" which Breton demanded – it was only a small step to the creation by the Surrealists of their own objects.

In 1936 an *Exposition surréaliste d'objets* (Surrealist Exhibition of Objects) took place at the Galerie Charles Ratton in Paris. The exhibition focused on the mystification of everyday things that the Surrealists constantly promoted, and presented extraordinarily complex configurations of unrelated objects. In a photograph of an installation at the exhibition we see a showcase containing a series of disparate artefacts, bewilderingly arranged side by side. In the middle is Marcel Duchamp's *Bottle Rack*, an everyday object declared a work of art, created in 1914. To its left is a 1934 sculpture by Max Ernst and nearby Meret Oppenheim's *Fur Breakfast*, made in the same year as the exhibition, alongside African sculptures, *objets trouvés* and complicated wire constructions.

The Riddle of the Everyday

Salvador Dalí was one of the artists who shaped the Surrealist movement in the 1930s. His "paranoid-critical method" led to new departures in art, producing astonishing results, especially in the realm of the Surrealist object. Dalí's concept of critical paranoia made an important contribution to the mystification of the mundane. As André Breton put it: "The uninterrupted transformation of the object under the paranoiac's scrutiny permits him to regard the very images of the external world as unstable and transitory, if not as suspect, and it is, disturbingly, in his power to impose the reality of his impression on others." In Dalí's art, this power is expressed in what has been described as "three-dimensional colour photography of the superfine images of concrete irrationality entirely made by hand".

In his astounding and at times almost unfathomable paintings René Magritte also explored the enigmatic world of everyday things and the magical effect of placing familiar objects in new contexts. His specific contribution lies in the realm of language, or rather the visual representation of his musings on the links between words and images. In the magazine *La Révolution surréaliste* in 1929, Magritte published a sequence of pictures accompanied by captions such as "Some objects can do without a name" above a picture of a rowing boat, or "Sometimes a word serves only to designate itself" above the word "ciel" (sky) with a ring drawn around it. What is called into question is the assumption that calling an object by its name is tantamount to taking possession of it. Magritte questions how we can grasp, understand, order and control the world when we can no longer be sure what things are called.

A new genre – Surrealist film – appeared on the scene in 1929 with the screening of Salvador Dalí and Luis Buñuel's *Un Chien andalou*. The film contains the famous scene in which a razor blade slices through an eyeball, an image that inspired Georges Bataille to reflect in the same year: "The eye, which Stevenson so exquisitely calls a 'cannibal dainty', is for us an object so disturbing that we will never bite it. The eye also occupies an elevated position in horror, being among other things the eye of the conscience. We are also well acquainted with Victor Hugo's poem, the obsessed and lugubrious eye, the living eye so terrifyingly dreamt by Grandville in the course of a nightmare shortly before his death…"

Surrealism as Thought Factory

Compared with other avant-garde movements of the first half of the 20th century Surrealism was attempting to move beyond the definition of the visual image and its function. The concept of opening up the subconscious made it possible to

analyse and undermine the "advanced civilisation" of which the Surrealists were so critical. In this sense, what in particular Surrealist painting achieved had less to do with technical innovation than with a new understanding of art. What mattered to the Surrealists was not the perfect, self-contained work of art, but the procedure through which it was created and the ideas it conveyed. This focus on the subject of a painting, the thinking behind it and not least its title, without which the work would be incomprehensible – we only have to remember Magritte – explains why the Surrealists attached such importance to the relationship between painting and literature. Surrealism saw itself as a movement embracing many artistic genres, a "thought factory" whose products were based on the attempt to address social, artistic or literary problems. It was a collective experience, which came to an abrupt end with the rise of Fascism and the outbreak of the Second World War, when many Surrealists were forced into exile.

After France capitulated, a number of them fled to the unoccupied zone, hoping to find their way to America. Supporters from the United States got together to form the American Committee for Aid to Intellectuals. The organisation found accommodation for the refugees at a château near Marseilles and arranged their passage to the United States Breton, Masson

and Claude Lévi-Strauss left for Martinique in Spring 1941 and onwards to New York. In July 1941, Max Ernst also managed to leave for New York. By August 1941 Man Ray had already returned to the United States and soon afterwards settled in California.

By 1942 New York and its surrounding area had become the centre of Surrealist activity. It was a historically unique situation in which the Surrealists found themselves rubbing shoulders with other émigré artists like Chagall, Léger, Lipchitz and Mondrian. But it was impossible to recreate the atmosphere of Paris. They found it hard to keep in touch with one another. "We missed café life," Max Ernst later wrote. "We had artists in New York, but no art. One person alone cannot make art. It very much depends on being able to exchange ideas with others."

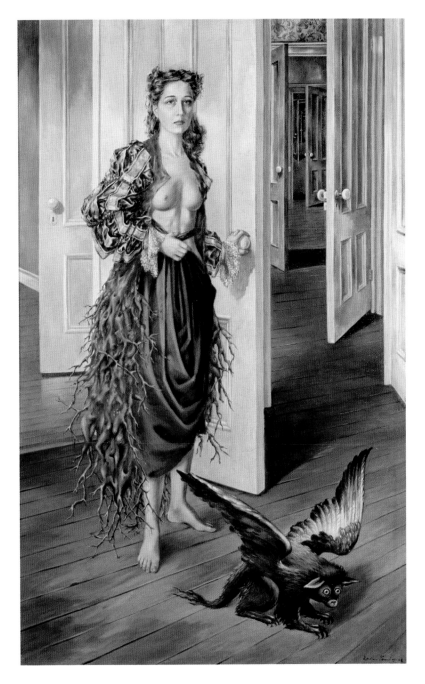

Giorgio de Chirico

b. 1888 in Volos, Greece
d. 1978 in Rome, Italy

"It used to be that painters were mad and picture-buyers clever. Now the painters are clever and the picture-buyers mad." — **Giorgio de Chirico**

The Disquieting Muses
1917, oil on canvas,
97 x 66 cm (38¼ x 26 in.)
Private collection

By 1912, along with statues and monuments Giorgio de Chirico had begun to introduce other figures into the lifeless atmosphere of his paintings. These were huge marionettes, whose anonymity and physical shape recalled both shop window dummies and the lay figures used by artists for anatomical studies. These beings, without arms and sometimes with hinges, nails and strings, sometimes supported by complicated devices, are completely without identity and function merely to convey a mood. We are reminded not only of the mechanised people in Francis Picabia's Dada works, but also of the Cubist deconstruction of the human figure, with which de Chirico became intensely involved in Paris, largely through his close association with Guillaume Apollinaire and Pablo Picasso.

The concept of the world as a stage on which an absurd and meaningless puppet show was played out, an idea that drove de Chirico's "metaphysical" paintings from the very beginning, becomes even more meaningful with the introduction of these fragile jointed figures. In de Chirico's own words: "In the face of the increasingly materialist and pragmatic orientation of our age…it would not be eccentric in future to contemplate a society in which those who live for the pleasures of the mind will no longer have the right to demand their place in the sun. The writer, the thinker, the dreamer, the poet, the metaphysician, the observer… He who tries to solve a riddle or to pass judgement will become an anachronistic figure, destined to disappear from the face of the earth like the ichthyosaur and the mammoth." From this, we can conclude that de Chirico thought the world had become meaningless and that people no longer felt entitled to try to make sense of it.

His representation of *The Disquieting Muses* makes this abundantly clear. They are pictured in the city of Ferrara in front of the former residence of the Este family, whose members were great patrons of the arts. Significantly, this urban palace near which de Chirico lived during the First World War, is forced to hold its own behind a rising stage alongside industrial buildings, factory chimneys and a silo. The rust-red, fortified building looms up against the backdrop of a turquoise-blue sky. At the front of a stage broken up by areas of deep shadow are the two muses – featureless lay figures in classical garb. One standing, the other seated, they are placed among a series of props. These include a red mask and a staff, allusions to the traditional attributes of Melpomene and Thalia, the muses of tragedy and comedy.

Meanwhile, Apollo, leader of the muses, is represented as a statue on a pedestal in the background. He looks as subdued and lifeless as the muses. The spectator has to wonder where he will lead them, given the deeply melancholic state of his headless companions.

(C. K.-L)

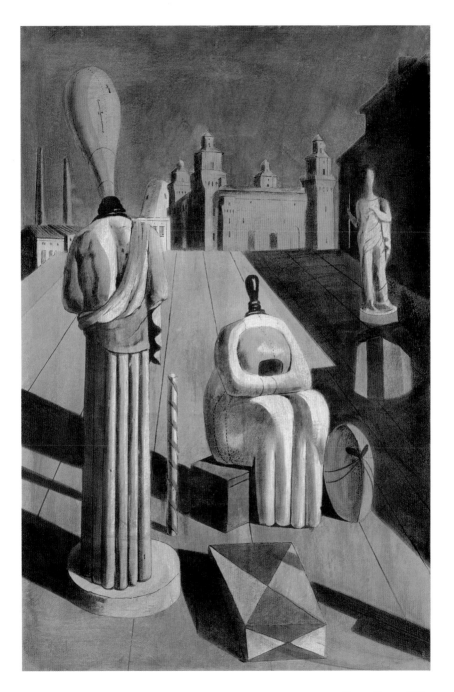

Max Ernst

b. 1891 in Brühl, Germany
d. 1976 in Paris, France

In 1921 Paul Éluard bought *Célèbes* from Max Ernst, whom he had recently met and subsequently visited in Cologne. It was the first of several of his friend's works that Éluard was to purchase. In addition, Ernst painted murals for Éluard's house in Eaubonne.

Célèbes applied the principle of paper collage to painting. The individual elements of this composition are not cuttings from different books, encyclopaedias or catalogues. Instead, Ernst translates the concept of collage, namely the bringing together of an assortment of incongruous and contradictory elements, into a *trompe l'œil* style of painting that simulates different materials. It is precisely the "realism" of the images that produces the "hallucinatory" effect the painter tried to achieve, an effect that Max Ernst associated with collage, as a passage in his autobiographic notes reveal: "One rainy day, in Cologne on the Rhine, my attention was attracted by the catalogue of an institution supplying teaching materials. I saw models of all sorts, mathematical, geometric, anthropological, zoological, botanical, anatomical, mineralogical, palaeontological and so on. Elements of such a different nature that the absurdity of collecting them confused the eye and the senses, provoking hallucinations and giving the objects represented new, rapidly changing meaning. I felt my visionary faculties suddenly so intensified that I seemed to see newly created objects in a new setting. In order to capture this it required only a little colour or a few lines, a horizon, a desert, a wooden floor and suchlike. So I obtained a fixed image of my hallucination" (1919).

In the case of *Célèbes,* the "new setting" is the first sign of another, different reality. The monstrous figure stands in a space that it takes us a few moments to realise is an underwater landscape. In what is supposedly the sky, two fish frolic against a background which, puzzlingly, is punched with holes through which cables protrude. But these are only minor causes of confusion. The beast with its round body and sturdy hosepipe-like protuberance looks like an elephant. It is, in fact, a machine based on a picture of a corn bin that Max Ernst came across in an anthropological journal. He adopted its simple, rounded shape and then added a trunk, which he adorned with a frilly cuff, a horned head and tusks.

The monster's name is taken from a line in a smutty schoolboy poem with sexual connotations, which Ernst remembered from his youth. In this context the de Chirico-style tower on the right of the picture can be interpreted as a phallic symbol. There is also a possible mythological explanation for the presence of the graceful nude figure. Max Ernst could be alluding to the abduction of Europa by Zeus, father of the gods, disguised as a bull. The horned head at the end of the elephant's trunk could refer to the same myth.

(C. K.-L.)

Célèbes
1921, oil on canvas,
125 x 108 cm (49¼ x 42½ in.)
Tate Modern, London

Man Ray

b. 1890 in Philadelphia, USA
d. 1976 in Paris, France

"I photograph the things that I do not wish to paint, the things which already have an existence." — **Man Ray**

Le violon d'Ingres
1924, gelatin silver print, retouched with pencil and Indian ink,
31 x 24.7 cm (12¼ x 9¾ in.)
Musée national d'art moderne, Centre Pompidou, Paris

Man Ray was one of the founders of Dadaism in the United States. He got to know the Surrealists in Paris when he moved to the city in the summer of 1921. Initially he devoted himself to photography, taking portraits of friends and colleagues, in which he created a magical atmosphere through special lighting effects. With the help of Jean Cocteau, Man Ray became portrait photographer to Paris' leading intellectuals and artists, his subjects including Gertrude Stein, Constantin Brancusi and Marcel Proust.

After moving to Rue Campagne-Première, where the photographer Eugène Atget also lived, Man Ray discovered a kind of ready-made form of photography, a process that created images without the intervention of the artist or even a camera. His "Rayographs" – outlines of objects on light-sensitive photographic paper – were exhibited for the first time in spring 1922.

To create a Rayograph, an object only had to be exposed to the light; it seemed to simply have created itself. It was an image of transformation and alienation, a concept that fitted to perfection into the intellectual world of the Surrealists. One of the first published works to contain this new photographic process was a portfolio of twelve images by Man Ray, accompanied by Tristan Tzara's essay "Les Champs délicieux" (Delicious Fields), which appeared in 1922. The feeling of alienation produced by other photographs by Man Ray was

based on the interplay between image and title. *The Enigma of Isidore Ducasse* is the title of a photograph of an object wrapped in a blanket and tied up with rope, while *Le Violon d'Ingres* alludes to the two f-holes that Man Ray has drawn on the back of a female nude. He reinterprets the rounded shape of the young woman, transforming it into the sound box of a musical instrument, so unleashing a whole chain of associations, largely inspired by the title of the picture. We instinctively think of the importance of stringed instruments to the Cubists, who incorporated mandolins, violins and guitars into their complex still lifes. While in Analytic Cubism they were merely lifeless, sexless objects, Man Ray's "violin" gives the photo an erotic aura. This is underlined by the reference to the Classicist painter Jean Auguste Dominique Ingres and his famous *Turkish Bath* (1862), in which the central figure is a nude with her back to the spectator. It is precisely because Ingres has drawn her with such cold precision that she radiates such sensuality. The turban worn by Man Ray's model picks up on Ingres' oriental ambience, but is also an ironic comment on the chilly eroticism of the Turkish bath scene. The title *Le Violon d'Ingres* also alludes to the long tradition of music-making as an allegory for loveplay. From Man Ray's perspective the instrument is simply ready and waiting for the soloist.

(C. K.-L.)

Joan Miró

b. 1893 in Montroig, Spain
d. 1983 in Palma de Mallorca

Stars in the Sexual Organs of Snails
1925, oil on canvas,
129.5 x 97 cm (51 x 38¼ in.)
*K20 – Kunstsammlung Nordrhein-Westfalen,
Düsseldorf*

From 1924 onwards, Joan Miró played an active role in the Surrealists' exhibitions and manifestations. This period also marked a turning point in his work. After an initial phase heavily influenced by Cubism and several paintings that could well be described as "magic realism" Joan Miró turned to a style of painting that would truly express what he called the "sparks of the soul". Enthusiastically, he flung himself into paintings in which monstrous or angelic animals, trees with ears and eyes, and even the odd Catalonian peasant with the cap and rifle typical of the region, stand side by side, but without any apparent connection between them. The element that binds them is an atmosphere far beyond any normal perception of reality. Miró's paintings dating from that era might be termed "visions", namely works that open up a space in which dream, poetry and painting meet. In them, concrete forms melt into cloudy areas of colour over which hover magical signs that mingle with lines of poetry to create a dreamlike image.

Stars in the Sexual Organs of Snails is not only a title added to a painting; the lines of script are also an integral part of the composition. The phrase is written in three lines over spirals of soft, blue paint whose shape and colour carry vague associations with snail shells. The letter "t" of the word "escargot" – snail – is caught up in the large red circle in the upper centre of the painting. The soft rounded shape is penetrated by a shooting star, while its lower section is crossed by a black line that links together several of the soft, blurred forms in the bottom half of the painting. The peculiar content and the irregular lettering recall the process of *écriture automatique*. The painting alternates between hard and soft, precision and fluidity, evoking the indefinable sensation of dreaming with its vague awareness that strange, irrational things are happening.

Meanwhile, *Photo – This Is the Colour of My Dreams,* painted in the same year, explores the divergence between rationality and dreams in a quite different way. This is, once again, a "picture poem" in which the writing is an essential ingredient. Conscientiously, like a little boy in his first year at primary school, Miró has written the black letters on the pale canvas: top left in large letters, "Photo", bottom right "ceci est la couleur de mes rêves". The phrase is illustrated by a hazy blue cloud, setting off a seemingly endless series of questions. Do dreams have colours? Can they be photographed? What is hidden behind the blue cloud? Or are the strange remarks written under the inkblot just a bored schoolboy's joke?

(C. K.-L.)

Hans Bellmer

b. 1902 in Kattowitz, Germany
d. 1975 in Paris, France

Hans Bellmer's *The Doll* represents a unique artistic position – from the outset, other artists, along with critics and above all an incredulous public, have rubbed their eyes in disbelief when confronted with Bellmer's doll games. Although he was befriended by the Surrealists in France, he was ultimately a loner with curious characteristics. His first doll dates from a period in which, repelled by National Socialism, he gave up his work as a graphic artist and turned his back on his German homeland. In his intensive sculptural work, he sublimated the erotic attraction he felt for his then 15-year-old cousin Ursula, and which he sought to shield himself against.

He continued to work intensively on his ideé fixe, creating further dolls from all sorts of materials, in all shapes, colours and functions, mobile and immobile; in addition, he took photographs of them, wrote strange poems about them and finally compiled a documentation in which various interpretations were presented and interpretative models for his art were provided. The dolls have never lost their fascination and represent a form of highly original fantasy.

The complete cycle of dolls comprises three-dimensional jointed mannequins painted and dressed in various ways. Placed in a variety of contexts – for example in a park, beneath trees, on a meadow full of wild flowers, on the steps of a staircase or in a cupboard – they are intended to fulfill certain functions, play variable roles and thus embody individual orientation points for various requirements. That these dolls do not represent mere objects for sexual fetishists is due not least to the coolness and aloofness emanating from them. Their fantastical qualities and the focal point of their aesthetic existence are to be found in their artistic embodiment.

The example in the Centre Pompidou is one of the mobile dolls, which, as Wieland Schmied put it, "are reflected around the navel as the centre of their ball-joint – a monster with two laps, two pairs of legs, two pairs of feet in small black patent-leather children's shoes, and a superfluous head, at the same time fantastical and terrifyingly real, transformable and yet always the same, innocent and unknowing, childlike and perverted, vampire and succubus, a jointed construction of enormous intensity and at the same time one of the most convincing sculptures of our age".

Psychologists see an object not just as such, but also as a substitute for a different object. In this sense, Bellmer's *Doll* is to be interpreted as an object – also a substitute object – for erotic needs. Bellmer's *Doll* is a substitute for the image of a woman as a sexual object and as the subject of countless fantasies which can be projected on to it. As Bellmer put it: "I think that the different categories of expression – posture, movement, gesture, action, sound, word, visual imagery, arrangement of objects – are all born of the same mechanism, and that their origin displays a similar structure. The basic expression, insofar as it is not from the outset intended as communication, is a reflex. To what need, what bodily urge might it respond? … The genitals project onto the shoulders, the leg naturally projects onto the arm, the foot onto the hand, the toes onto the fingers. And so a strange hybrid is created, of the real and the virtual, of what is permitted and forbidden to each of the two elements, of which the one acquires such reality as the other has forfeited."

(W. S.)

The Doll
1932, painted wood, hair, socks and shoes,
61 x 170 x 51 cm (24 x 67 x 20 in.)
Musée national d'art moderne,
Centre Pompidou, Paris

René Magritte

b. 1898 in Lessines, Belgium
d. 1967 in Brussels-Schaerbeek

The Door to Freedom
1933, oil on canvas,
80 x 60 cm (31½ x 23½ in.)
Museo Thyssen-Bornemisza, Madrid

After studying at the Académie Royale des Beaux-Arts in Brussels and working briefly as a commercial artist, René Magritte, impressed by the paintings of Giorgio de Chirico, painted his own first Surrealist picture in 1925. In Paris, Magritte joined the group of Surrealists led by André Breton and from 1927 to 1930 made his home at Perreux-sur-Marne close to the French capital. However, after this relatively short stay, he returned to Brussels where he remained until his death, living a quiet, unspectacular and outwardly normal middle-class life.

The life of the painter, whose public demeanour diverted attention from a real existence devoted entirely to his art, is mirrored in his paintings of seemingly ordinary subjects whose real intention is to point to something hidden, to provoke feelings of insecurity and create an air of mystery. Magritte's landscapes, which constitute a major part of his output, set out to explore these issues, although at first they appear much easier to understand than traditional landscape paintings. The "realistic", eye-catching style of Magritte's painting, his simple clear compositions and his concentration on essentials, are like plain language without any deeper meaning. Only close analysis reveals the ambiguity of his works.

The Door to Freedom is a particularly striking example of the hidden presence of something mysterious. Through a window we see a gentle, hilly landscape. At the end of a broad meadow extending uphill stand several leafy trees, above them a dome of delicate blue sky. This would be a perfectly cheerful image, if it were not clearly breaking up before our eyes. As we look though the window pane, it shatters into a thousand fragments. Pieces of broken glass remain in place like transparent film in front of the vista. The shards that have fallen to the floor are like pieces of a jigsaw reproducing the scene observed through the window.

Was the landscape only painted on the window pane? Is this not a transparent pane at all, but a painting? No clear explanation is possible and so we conclude that the pieces of glass on the painting are a contradiction. The landscape beyond the broken window is still unscathed and visible. At the same time, the broken glass that has fallen to the floor is not transparent but shows pieces cut out from the landscape, while we can still see through the glass that remains stuck in the window frame. We as spectators feel called upon to carry out a visual reconstruction but, try as we may, we cannot achieve any complete certainty. The relationship between reality and painting is permanently destroyed; despite Magritte's talent for creating an illusion, we can no longer sustain any real belief in either image or reflection. The certainty guaranteed by paintings of centuries past, recalled by the *trompe-l'œil* curtain drawn to the sides of the window, is no longer there. (C. K.-L.)

Hans Arp

b. 1886 in Strasbourg, Germany
d. 1966 in Basel, Switzerland

Concrete Sculpture
1934, marble,
37 x 75 x 32 cm (14½ x 29½ x 12½ in.)
Private collection

For several years Hans Arp developed his art against the backdrop of the Surrealist movement in Paris. In 1916, he was one of the group, which included Hugo Ball, Richard Huelsenbeck and Tristan Tzara, who founded the Cabaret Voltaire in Zürich. In 1919–1920 he was in Cologne where he was closely involved with the Dadaists based in the city, especially Max Ernst. In 1924, the year in which André Breton's first "Surrealist Manifesto" was published, Arp finally joined the Surrealist movement, taking part in the first Surrealist exhibition in 1925. On this occasion he showed only pictorial works, since he only began sculpting in 1931, shortly before the creation in 1932 of the Abstraction-Création group of which he was co-founder.

Arp's work could be described as standing between two poles – Surrealism and Abstraction. His early collages are simple and austere and mainly concerned with the exploration of form. Meanwhile, the playfully poetic titles of his work owe more to the traditions of Dada and Surrealism. Arp's working methods allowed room for the "law of chance" and intuition, and his spontaneous, constantly innovative, creative processes were very much in line with Surrealist thinking. Another aspect of his Surrealist-inspired work was his interest in the metamorphosis of the female body, which led to the creation of sculptures recalling Picasso's and Miró's soft and infinitely changeable

forms of the early 1930s. A typical example is *Concrete Sculpture* from 1934 in which a trunk, head and the rounded stumps of legs, which appear to have evolved naturally but in condensed form, capture the sensuous shapes of a female torso. Designed to be freestanding, it can be viewed from several different perspectives.

It has no obvious top or bottom, front or back, as if to underline the idea that it is still in the process of taking shape. Arp saw this process that he called "concretion" as a natural occurrence, as opposed to the creation of a form chosen by the artist, which is a human as distinct from a natural act.

Concrete Sculpture is part of Arp's continuing exploration of this theme. One of the earliest examples from a series of "configurations" in relief dating from 1927–1928 reduces the female body to parts of the shoulders, waist, hips and tops of the legs. A key element in the composition is the strategically placed navel. For Arp this was a symbol of life and fertility, but it does not feature in his 1929 relief of *Amphora Woman*, which shows a small feminine figure in front of a streak of red.

As it draws level with the little female shape, the streak broadens into a wide bowl shape, a recurring motif in Arp's work. This can be interpreted either as a peaceful, feminine refuge from the turmoil of life, or as the belly of a pregnant woman sheltering the embryo. (C. K.-L.)

Pablo Picasso

b. 1881 in Málaga, Spain
d. 1973 in Mougins, France

"If there were just one single truth, it would not be possible to paint a hundred pictures on the same theme." — **Pablo Picasso**

In 1934 Pablo Picasso took the *corrida* as the subject of a series of works ranging from quasi-naturalistic representations to extremely stylised versions of the bullfight. However, none of these works directly depict what happens in the bull-ring. They are more like allegories, a mythical vision that also found expression in Picasso's poetry of the period. The artist saw the bullfight as a ritual sacrifice and placed it on the same level as the cult of Mithras or the Crucifixion. The artist's visual images are echoed in his Surrealist poetry, in such lines as "when the bull with its horn opens the door of the horse's belly" (15 November 1935), or "the horse spills its entrails like flowers that bend the arena, like sand crashing from clocks" (18 April 1935). Picasso wrote of "pain written in large letters all around the arena" (7 November 1935), and "the fine, delicate banquet of death" (20 January 1936). The bullfight reveals a mystery that can be read in the entrails of the horse. It is Holy Communion: "The scent, the stench and the horror of the entrails exploding between the murderer's hands, blood gushes over the horse's belly and the Mass begins…, the love feast of a whole race which plunges its hand into the entrails and searches for the heart from which the bull's life drains away" (7 November 1935).

The 1934 painting *Corrida* is also full of contrasting concepts and emotions – unbridled brutality and carefully thought-out stylisation, the cruelty of nature and its sublimation in the beauty of art. Strong colours, black and white, yellow, red and green, spill into each other in the fight between horse and bull. The drama reaches its culmination in the great wound in the body of the horse, gaping and bleeding in the centre of the picture. The bodies of the two animals are interwoven, the heavy shape of the bull obviously representing evil, while the white body of the horse symbolises innocence. This allocation of roles not only runs through all Picasso's works whose protagonists are the bull and the horse. In *Bull and Horse*, a drawing dating from the following year, it appears even more precise. The bull, whose head shows anthropomorphic features, disembowels the horse and stands with its two forelegs planted in the open wound. While Picasso draws rage and brutality on the bull's face with exquisite precision, he merely sketches the contours of the dead horse, so downgrading it to no more than an anonymous victim.

In this configuration, horse and bull are not only victim and perpetrator; they also stand for woman and man and, ultimately, for innocence and evil, two opposing concepts on which Picasso was to construct his masterpiece *Guernica*. In that monumental painting, the artist's response to the brutal bombardment of the little Spanish town of Guernica, one of the last centres of Republican resistance, the horse and the bull are central figures, the bull portrayed as the ferocious embodiment of evil. (C. K.-L.)

Corrida
1934, oil on canvas,
50 x 61 cm (19¾ x 24 in.)
Private collection

Salvador Dalí

b. 1904 in Figueres, Spain
d. 1989 in Figueres

Around the mid-1930s some of the titles of
Salvador Dalí's paintings had obvious political
connotations. One such example was *Soft Construction with Boiled Beans (Premonition of Civil War)*.
Describing himself as "a painter of internal paroxysms", Dalí told how he painted his "premonition"
six months before the outbreak of the Spanish
Civil War. The picture featured "a vast human body
breaking out into monstrous excrescences of arms
and legs tearing at one another in a delirium of
autostrangulation", which he then "embellished
with a few boiled beans".

How is it possible to appreciate the political
dimension of a painting that displays the same
characteristics as many other "apolitical" works of
the same period? The picture itself – a construction of human limbs, supported by a fossilised
foot and a gnarled hand resting on a small chest
of drawers – provides no information. Occupying
the entire canvas, the structure stands in the bay
of Port Lligat. In the background, banks of clouds
move across an ominous sky. A man's face, riddled
with pain, tops the construction, whose unbearable internal tension contrasts with the apparent
lack of connection between the individual elements. This painfully irreconcilable, and at the
same time completely inorganic relationship
between the various body parts can in fact be
interpreted as a metaphor for the Civil War, which
the artist sees as a fateful catastrophe rather than
a historic event. This point of view corresponds
with the apolitical attitude that Dalí displayed
throughout his life. His anarchism, dressed up as

snobbery, led him to analyse social and political
situations so as to exploit them in his own painting. For example, his glorification of Adolf Hitler,
for which the Surrealists condemned Dalí, sprang
not from admiration of the dictator and his political propaganda, but from what the artist saw as
Hitler's aesthetic and erotic appeal.

Dalí often used political allusions to heighten
the scandalous effect of his paintings. Speaking of
references to Hitler and Fascism in his work he
said: "I was fascinated by Hitler's soft and fleshy
back, always so firmly laced up in his uniform…"
Dalí's apparent exaltation of Fascism led to a clash
with André Breton and finally to Dalí's exclusion
from Surrealist circles. In alluding to contemporary events, Dalí sought the wonderful and bizarre
and the neurotic, in the widest sense of the word,
choosing to tackle clearly political themes for
purely aesthetic reasons. This was at a time when
the Surrealists as a group were debating whether
to take a direct political stand on the side of the
Communists, or to continue to limit themselves to
isolated, purely artistic activities.

It was an attitude that Dalí in no way shared.
Ultimately his works, with their virtuoso painting
and inexhaustible wealth of imagination and subject matter, were always a glimpse into his inner
world. In his own words: "My whole ambition
where painting is concerned consists in materialising mental images of concrete irrationality with
the power-craziest precision…"

(C. K.-L.)

**Soft Construction with Boiled Beans
(Premonition of Civil War)**
1936, oil on canvas,
99.9 x 100 cm (39¼ x 39¼ in.)
Philadelphia Museum of Art,
The Louise and Walter Arensberg Collection

Richard Oelze

b. 1900 in Magdeburg, Germany
d. 1980 in Posteholz

Richard Oelze's painting *Expectation* has a fantasy which is all its own. On the one hand it is one of the most mysterious and uninterpretable works of all, while on the other it has become an icon of the European art of the 1930s, because, like no other picture, it strikes a certain chord which is in harmony with the imagination of the age. In addition it can also be seen as a kind of mirror image of the artist, whose personality remains somewhat of a puzzle to this day.

Oelze was a recluse; even when he was living in Paris, from 1933 to 1935, he maintained only very loose contact with the Surrealists, to whom he had actually felt quite close ever since seeing his first Surrealist pictures in 1929. He painted his own visions, independently of all external influences, whether it be his training (at the Bauhaus), his places of residence (he lived in Worpswede for 16 years), or his fellow artists with a similar cast of mind. He destroyed a large proportion of his œuvre, painting it over in black, tearing it up or burning it.

The atmosphere of *Expectation*, which was painted in Paris, is veiled and overcast; just a few browns and greys are hesitantly bathed in a wan yellow. The focus of the action, such as it is – a mysterious and opaque process – is played out in the broad expanse of the sky. It becomes visible in a dark mixture of streaks and clouds which are depicted gathering wildly and full of movement into something full of tension: distant summer lightning. Sparingly placed shrubs, reminiscent of one of Oelze's early fern-like forest scenes, characterise an expansive landscape, which slopes gently downwards towards dead ground in the centre of the picture. This plain looks like a long-drawn-out area of colour in which nothing happens and nothing is to be seen – a truly blind spot, which the beholder could easily over-look, as it is the source of no stimuli, but which, the longer one looks at it, becomes the second venue for a dramatic event.

For outside of this plain, in the foreground at the bottom edge of the picture, there stands a group of people in city hats and coats, all apparently on the lookout for something. They have their backs turned to the beholder, so that we are looking over their shoulders, so to speak. Only one man and one woman are not looking in the same general direction. The tension in these figures, infectious and almost palpable, constitutes the nucleus of this fantastically charged scene. It seems to be in the nature of impending catastrophes that their early-warning signals are not, or are only vaguely, recognised. Every great disaster starts with small signs which are hardly perceptible. In this sense, the picture may suggest that in 1935 a small group of people were already trying to make out the signs of the general conflagration which not long afterwards was indeed to consume the world. The fantastical aspect of this picture is thus to be sought in this latency and ambiguity, which stylise a contemporary document into a prophetic vision.

Even if it should turn out that Oelze was not painting an artistic premonition of Germany's fate in that period, from the purely aesthetic point of view he has created an incredible picture, from which can be extracted a great deal that was perhaps put into it unconsciously. But the tense waiting alone creates a force field of intensity that, beyond the confines of the frame, captures any beholder. Without any obvious drama in the picture, without any imposed colour games, without unambiguous events and absolutely without any overt didactic gesture, the painter has evoked a tragedy which is without parallel. (W. S.)

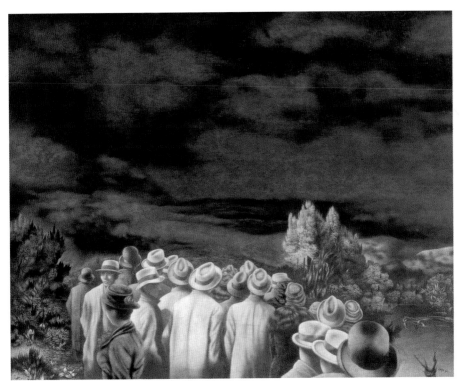

Expectation
1935–1936, oil on canvas,
81.6 x 100.6 cm (32¼ x 39½ in.)
The Museum of Modern Art, New York

*"I would never have had to see a landscape
in order to paint one."* — **Richard Oelze**

Yves Tanguy

b. 1900 in Paris, France
d. 1955 in Woodbury (CT), USA

*"But with Tanguy, it will be a new horizon,
one in front of which the no longer physical landscape
will spread out."* — **André Breton**

Day of Indolence
1937, oil on canvas,
92 x 73 cm (36¼ x 28¾ in.)
*Musée national d'art moderne,
Centre Pompidou, Paris*

In Surrealism, landscape conquered a new dimension, passing through one of the strangest metamorphoses in the history of the field. The Surrealist landscape can best be understood against the background of the new image of nature reflected in modern art as a whole. Put simply, artists' image of nature became blurred, in terms of both form and content, but made up for this loss of clarity by establishing a new, aesthetic totality. Nature no longer needed to be presented to the eye in the form of a composed, atmospheric landscape. Rather, it could find its place entirely in us as viewers, in our psyche and dreams.

One of the continually recurring Surrealist scenes is a landscape of desert plains populated by strange objects, anthropomorphic, vegetable or crystalline configurations, metamorphoses or hybrids of human beings and things, objects existing in airless spaces full of strange perspectives and under a cold, extraterrestrial sky. Especially the French artist Yves Tanguy made a name for himself with such dreamlike vistas from 1926 onwards. The way his horizons with their milky, misty bands cut uninterruptedly through the picture evokes an endless planet, whose banded structures bring natural terrain to mind. But these memories can be no more than vague, due not only to the bizarre utensils and phantasmagorical figures but to the indefinite time of day, season and spatial relationships. In *Day of Indolence*,

Tanguy projects scenery whose eerie, visionary character is heightened by the way in which the figurative elements, rendered with sharp-edged precision, stand out against a ground divided into zones that calls to mind an infinite expanse of desert. In addition, the surreal configurations cast threatening black shadows, suggesting a space that by all rights cannot exist in this alogical world.

Familiar definitions of time and space are invalidated by a faceless landscape in which the aesthetic qualities of landscape seem lost in a void resulting from some apocalyptic disaster. From a high vantage point like that of a universal landscape, our eye surveys this forbidding terrain, illuminated by a threatening cosmic light.

In Tanguy's "landscapes" we overlook a world whose Surrealist perspective cannot be read as a physically rational structure, because it is much too enigmatically encoded. Nor does the high vantage point give us a feeling of mastery, because there is nothing there to be mastered. The landscape draws our eye into it, only to confront it with ciphers that shift the question of the meaning of human life and the world into the realm of the psyche. Its vague memories of visual realities mark this process as a borderline exchange, where dream elements are smuggled with hallucinatory precision into reality and fragments of reality are incorporated in dream.

(C. K.-L.)

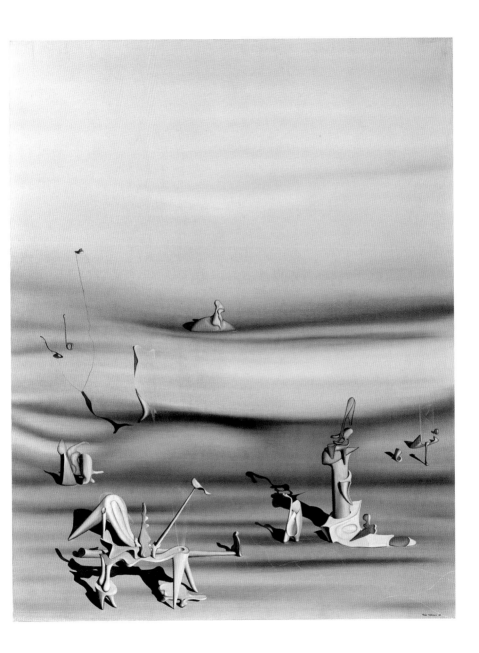

Paul Delvaux

b. 1897 in Antheit, Belgium
d. 1994 in Veurne

Among the most important influences on Paul
Delvaux's artistic development were the paintings
of Giorgio de Chirico and the works of René
Magritte. Delvaux first came across the two artists
in the late 1920s, when he visited an exhibition
that included works by de Chirico and, shortly
afterwards, made Magritte's acquaintance. Like
Magritte, Delvaux worked in seclusion. What
linked Delvaux to the Surrealists was not the feel-
ing – so important to many artists – of belonging
to a group, but the fact that the painter also sought
to create in his art an atmosphere evoking dreams
and unreality. "Surrealism! What is Surrealism?
In my opinion, it is above all a reawakening of the
poetic idea in art, the reintroduction of the subject
but in a very particular sense, that of the strange
and illogical." This was the definition Delvaux
offered during a 1966 lecture.

The strangeness of his paintings dates from
the mid-1930s with the introduction of nude fig-
ures in a world in which the intimacy of naked-
ness is portrayed in a very public setting. In *Dawn
over the City*, a central, male figure – a self-portrait
of the artist – is surrounded by naked women
slowly approaching him as if sleepwalking. They
seem to represent a kind of existence impossible
to reconcile with the normality of everyday life.
As in de Chirico's paintings the "classical" archi-

tecture, with its closely converging vanishing lines,
is no more than lifeless decoration. It is part of a
completely unreal space and provides a backdrop
for encounters without sense or coherence.

"No one here thinks of eating, they are nour-
ished by time, which passes and passes again;
they drink the hours. Now I am in the presence of
Claude Lorrain, but is not the heat, broken by sea
breezes, too strong for this light?" These lines
by the French author Michel Butor on *Dawn over
the City* describe another important feature of
Delvaux's painting: the inspiration of the Old
Masters. Following the principles of collage
devised by the Surrealists, Delvaux combines
dream and painting. Thus he creates an imagined
reality in which the protagonists, like the painter
himself in *Dawn over the City,* seem like intruders
set on causing trouble in the dream world.

However, Paul Delvaux's paintings not only re-
flect dreams, which he depicts using a seemingly
naïve vocabulary. His art could also be termed
mythological, since his paintings possess an en-
coded message only accessible to those who are
familiar with the meaning of the place and its in-
habitants, in other words, those who understand
the language of the subconscious.

(C. K.-L.)

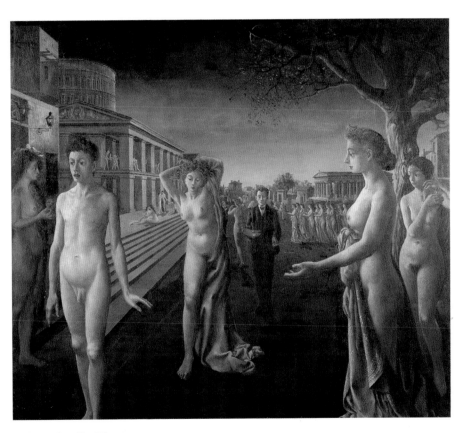

Dawn Over the City
1940, oil on canvas,
175 x 215 cm (69 x 84¾ in.)
Private collection

Matta

b. 1911 in Santiago de Chile
d. 2002 in Civitavecchia, Italy

"Painting always has one foot in architecture, one foot in dreams." — **Matta**

Year 44
1942, oil on canvas,
97 x 127 cm (38¼ x 50 in.)
Staatliche Museen zu Berlin, Nationalgalerie, Berlin

It was in 1937, relatively late in the history of the Paris Surrealists, that Matta (Roberto Sebastián Antonio Matta Echaurren) met André Breton and his circle. Matta had worked in Le Corbusier's studio in the city. "I met them and I was so ignorant that they were not interested in me. But then they looked at my drawings and said 'You are a Surrealist'." In an interview, Matta described his first encounter with a group of artists who would permanently influence his development as a painter. Their support would also help him deal with intellectual problems resulting from his unsatisfactory attempts at architecture. "The question was 'how can we find out more about what a house should actually be, who it should be built for?' In short, who is the guy I am building it for?… Instead of designing houses I designed a state of being – you could call it psychology. I wanted to grasp how the human mind worked. That's why I began to paint without being a painter. I had never been to art school. But how could I represent psychological function? I called the first paintings psychological morphology – morphology of desire, morphology of fear, morphology of pain… We simply do not have the language to express these things…"

Matta's paintings present people in space. His figures, seemingly deprived of their outer covering, with their nerves and emotions laid bare, appear in a space that affords them no refuge or protection and bears absolutely no relation to what we would term a house, room or building. In a 1946 article for *Société Anonyme*, Marcel Duchamp wrote that Matta's most important contribution to Surrealist painting was his discovery of spaces that art had so far left unexplored. Matta, said Duchamp, followed modern physicists in their search for this new space which, although represented on canvas, could not be mistaken for yet another three-dimensional illusion. *Year 44*, painted in 1942, does not depict space but merely lets the spectator experience it. It conveys the feeling of a person enclosed in a space that echoes his emotions. Matta combines different painterly effects to create that impression – bright draughtsman-like structures on an iridescent red and black background. Floating particles of colour alternate with precisely drawn details; vaguely anatomical fragments seem to interact with the surrounding space, letting it dictate their movements.

Matta's concrete drawings also convey a similar feeling of powerlessness. In *Offences*, amid sketches experimenting with movement, dynamics or form, we see couples enacting a series of scenes as in a comic strip. They are involved in sexual, sadistic, even pornographic situations in which they appear to be willing participants rather than victims.

(C. K.-L.)

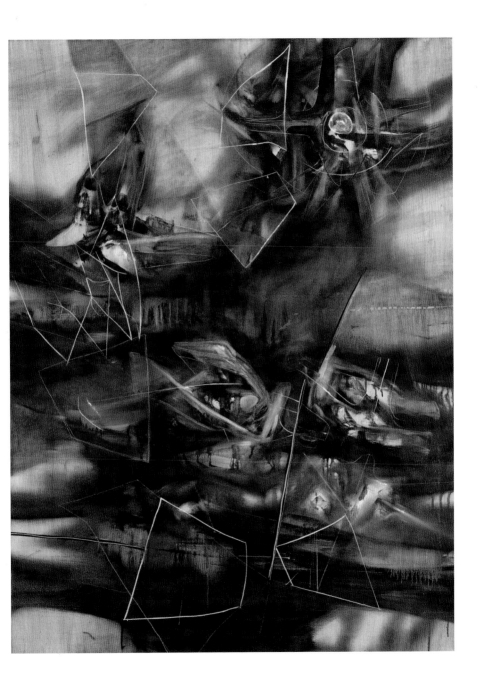

Wifredo Lam

b. 1902 in Sagua la Grande, Cuba
d. 1982 in Paris, France

Wifredo Lam's mature work, created in the 1940s, reflects both the painter's roots in the culture of his native Cuba and his relationship with artists of the European avant-garde. It was under their influence that he rediscovered, and mirrored in his art, the primitivism he had known during a childhood spent in close contact with the natural world.

After training at the Escuela de Bellas Artes in Havana, in 1923 Lam began attending free painting classes in Madrid and continued his artistic education by studying the Old Masters in the Prado. But it was the four years spent in Paris, from 1938 to 1941, that were to be the most decisive for Lam's development as a painter. There, he formed a close relationship with Pablo Picasso, and together they exhibited their work at the Perls Galleries, New York in 1939.

Of course, while he was in Paris, Lam also came under the influence of the Surrealists, whose interest in the supernatural, the irrational and magic was fertile soil for the Cuban painter. "When I was small, I was frightened of the power of my own imagination. At the end of the town of Sagua la Grande, near our house…the forest began… I never saw any ghosts but I invented them. When I went for walks at night I was scared of the moon, the eye of the shadows. I felt I was an outsider, different from the rest. I don't know where it comes from. I have been like that since childhood." The forest of his childhood crops up again in Lam's jungle pictures, which date from the early 1940s, before he fled Fascism and returned to his homeland. In his greatest composition, *The Jungle*,

now in New York's Museum of Modern Art, he intersperses monstrous beings, close relatives of Picasso's surreal creatures of the period, among the Cuban sugar cane. Unlike Picasso, Lam does not create monumental versions of these creatures inspired by African sculpture and primitive art. Instead he stresses their diversity and their omnipresence amid the dense vegetation, through which their constantly murmuring voices seem to penetrate.

"When I painted it, the doors and windows of my studio were open so that passers-by could see in. They cried: 'Don't look, it's the Devil!' And they were right. One of my friends correctly found in the picture a spirit close to that of some representations of Hell done in the Middle Ages. In any case, the title does not correspond with the reality of nature in Cuba, where one does not find jungle, but *bosque, monte, manigua* – woods, mountains, open country – and the background of the composition is a sugar-cane plantation. My painting had to communicate a psychological condition." Both creatures and plants in the jungle display the same metallic materiality. They are bathed in a subdued light that makes them seem like figures in a fantasy, a fantasy that has much in common with the Surrealists' interest in sexuality and violence. Despite all the figurative elements in his work, Lam's stylisation of plant and organic forms appears, in its rhythmic repetition of non-representational forms, to point the way towards Abstract Expressionism.

(C. K.-L.)

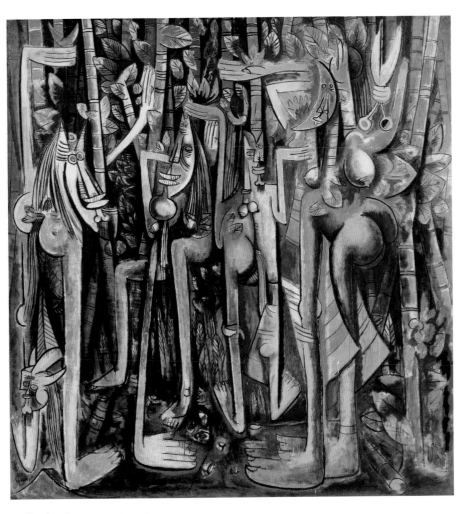

The Jungle
1943, gouache on paper on canvas,
239.4 x 229.9 cm (94¼ x 90½ in.)
The Museum of Modern Art, New York

Frida Kahlo

b. 1907 in Coyoacán, Mexico
d. 1954 in Coyoacán

Appreciation of the Mexican artist Frida Kahlo has reached unheard-of heights in recent years, whether as a result of celebrity collectors such as Madonna or of the Hollywood film of her life. Her political commitment in the Communist Party and her double marriage to the famous Mexican mural painter Diego Rivera have also contributed to the creation of the Kahlo myth. Although her fascinating personality has played a larger role than her art in all this, her painting has also become a focus of interest. Occasionally the artist's tragic fate has come between her art and its interpretation. However, the fact that Kahlo's work represents far more than just the subjective processing of her own experience now seems to be beyond question, and indeed is proven by the art itself.

At the age of six Kahlo fell victim to poliomyelitis, which left her with a crippled left leg. Nonetheless, she managed to recover her mobility and joie de vivre. In 1925, though, when she was an 18-year-old high-school student, she was involved in an accident which totally changed her life. In the course of a collision between a bus and a tram, she was transfixed by a metal rod on one of the vehicles – of the kind used by passengers to hold on to – and it was little short of a miracle that she survived. She suffered 17 fractures, injuries to her spine and abdomen and a crushed foot, all of which kept her in bed for several months.

In order to distract herself from her injuries during this time, she taught herself to paint, and having done so, engaged in self-therapy by painting self-portraits, thus sublimating her physical and psychological suffering on the canvas. For this purpose she was given a special sort of easel as a present, and a mirror was specially fixed to the ceiling. Time and again she was thrown back on her own resources as a result of necessary additional operations over the years. She suffered a number of miscarriages and finally had to undergo an amputation.

One of her most famous paintings, *The Broken Column*, is both unusual and moving. At the time it was painted, her medical condition was deteriorating, and she was required to wear a variety of orthopaedic corsets. The picture depicts Kahlo with her torso opened up to reveal an Ionic column broken in many places, symbolising her injured spine. Her upper body, naked and, like her arms and face, pierced with nails, is in a surgical corset. The figure is set in a desert landscape scarred by deep crevices, and with no sign of life of any kind. From a face with a serious expression, the eyes, wide awake beneath strong, gently rounded eyebrows which join in the middle, look directly at the beholder. The corners of her mouth are marked by a barely perceptible touch of melancholy wakefulness.

This picture is bound to rouse memories of countless European depictions of the martyrdom of St Sebastian. But the shock of this surreally immediate and brutal perception of the opened-up body with its broken column – whose capital, directly beneath the sitter/painter's chin, thus appears to support her head – goes much deeper than this. In a surgical textbook, it may be normal enough to see physical injury depicted as directly as this, but in art, such subjects are always given an aesthetic makeover, and are presented indirectly. To depict suffering thus unveiled is new. The fantastical aspect lies in the shock felt by the beholder on looking at this picture. But it is precisely this openly displayed naturalistic objectivity which is subjectively moving, and from which ultimately no one can escape. (W. S.)

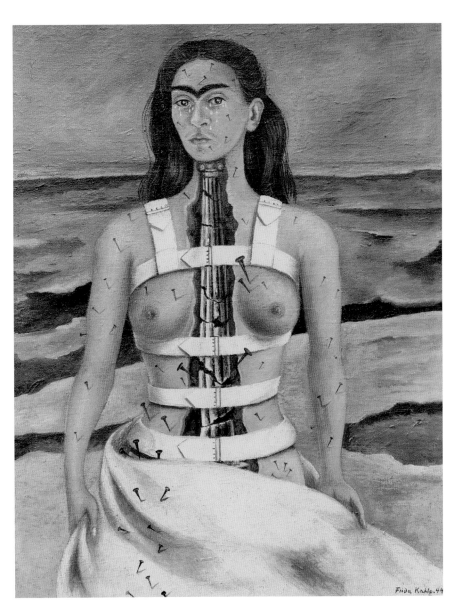

The Broken column
1944, oil on canvas,
40 x 30.7 cm (15¾ x 12 in.)
Museo Dolores Olmedo, Mexico City

Salvador Dalí

b. 1904 in Figueres, Spain
d. 1989 in Figueres

At the centre of this complex and brilliantly exe-
cuted dream painting *Dream Caused by the Flight of
a Bee around a Pomegranate, a Second before Waking
Up* is Dalí's wife Gala. Is she the dreamer or is she
part of the painter's – or the spectator's – vision?
Both the spatial construction of the picture and
its complicated chronology make it hard to find a
meaningful answer to the fundamental question
the work poses.

The stretched-out, naked body of the sleeping
Gala hovers above a rocky promontory. The glis-
tening blue surface of the water in the background
looks supernaturally still, as if to reinforce the
magical silence of the dramatic happenings in the
sky. A fish leaps out of a pomegranate and from its
gaping mouth emerge the head and forepaws of a
tiger. From the maw of the beast a second tiger
springs. The line of its body, ready to attack and
aimed straight at the sleeping woman, is extended
to form a rifle armed with a bayonet, the point of
which is about to stab Gala in the upper arm. In
her dream, the genuinely threatening bee sting of
the title becomes a symbolic stab wound, which
the mind can connect with many other ideas and
images.

In his painting Dalí not only captures the un-
reality of the dream but also encapsulates its com-
plexity. The painter enables us to experience the
multifaceted event in a single moment. The sleep-
ing woman awakens from a dream lasting only
seconds imagining she has seen a long, multi-
layered and complicated film. Likewise the
spectator is aware of the painting's peculiar
chronology. In the space of a moment a series of
monsters too complicated to describe in words
appears above Gala's head. At the same time an
elephant with extraordinarily long, insect-like legs
strides across the horizon bearing an obelisk. It is
a distorted image of a real work of art, Bernini's
famous elephant statue in Rome, which somehow
fits into the strange logic of the dream. At the
same time, we see in the foreground an echo of
the main event in the shape of a pomegranate en-
circled by a bee. To some extent, this is the paint-
er's own interpretation of the picture which he
disguises as part of the dream, in the same way
that medieval painters hid the meaning of their
works behind allegorical references.

Extraordinarily well-versed in the history and
tradition of European painting, Dalí shows the
pomegranate floating between two dewdrops, an
allusion to the pearls of Venus, and casting a shad-
ow in the shape of a heart – a fertility symbol.
The connection between the pomegranate and
the phallic symbolism of the series of aggressors
striking out against the sleeping woman seems to
be a reference to the relationship between Dalí
and Gala, whose importance as the artist's muse,
lover and adviser is well known. Dalí extends the
spatial and chronological structure of the work so
as to make it clear that it is he who has created
both the dream and the masterly painting.

(C. K.-L.)

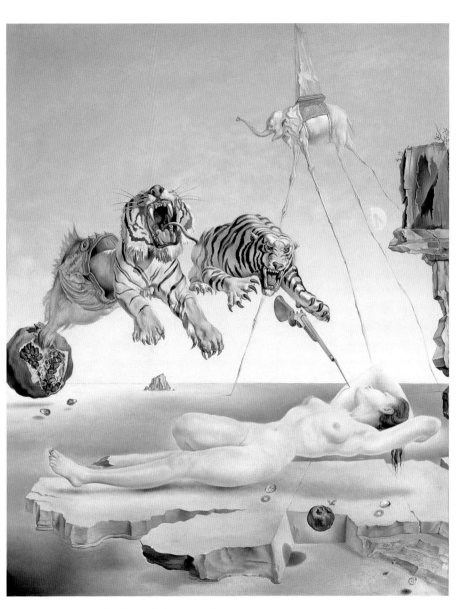

**Dream Caused by the Flight of a Bee Around
a Pomegranate, a Second Before Waking up**
1944, oil on wood, 51 x 40.5 cm (20 x 16 in.)
Museo Thyssen-Bornemisza, Madrid

Jean Fautrier

b. 1898 in Paris, France
d. 1964 in Châtenay-Malabry

In 1940, when German troops occupied Paris, the city lost its position as an art metropolis once and for all. Many important artists had fled to the United States already and were now part of an avant-garde writing the next chapter of art history with the emergence of Abstract Expressionism. Naturally, the development continued in Europe as well and often along parallel routes, but the former dynamic of the scene, which had produced art movement after art movement so quickly, was lost for the time being.

In 1945 one exhibition in particular would prove to be significant for the restoration of art in Central Europe, despite the public's mixed reactions when it was shown in Galerie René Drouin in Paris: *Les Otages*, Jean Fautrier's series of paintings initiated in 1943, were thematically based on the hostages executed by the German forces during the war. After being interned by the Gestapo for a short period, in 1943 Fautrier moved to the suburbs of Paris and led an inconspicuous life under assumed names. At times his artist's studio was in the tower of a clinic, where he heard the Nazi firing squads killing prisoners in a nearby forest. Fautrier created paintings based on this tragedy he never actually saw. In the process, he simplified his earlier, atmospheric style to what André Malraux called "hieroglyphics of pain".

Most of the paintings are carried out using heavily layered paint and show headlike forms haptically arching towards the viewer. Their symbolic faces swim on masses of colour whose surfaces suggest dissolving skin or the creases of an exposed brain. Adrian Searle refers to these images as a strange state of limbo: "In the deformations of his haunting, sculpted heads, Fautrier presents human beings caught in a state between wakefulness and a return to pure matter. Entire portions of the human face have been dragged away, are left unformed or are buried in cinderlike lumps of bronze." In the 1945 painting of a head from late in the series shown here, there appears a kind of branch over the face from which seven pairs of eyes hang like leaves. This almost seems like a symbol of hope in death: the human spirit can even survive being completely humiliated by violence. And the painting's 14 eyes will continue to bear witness to what really happened.

Malraux and other intellectuals of the period see in these paintings not only their topic; more importantly, they see a new style. In this context, Francis Ponge asks: "Do we say at present that the faces Fautrier painted are pathetic, moving or tragic? No: they are thick, traced with wide lines and violently coloured; they are painting." First Fautrier circumscribed the outlines with grand strokes. Then, using a spatula, he modelled on the paper a thick coating of white plaster that took months to dry – a painting technique known as *hautes pâtes* that would also be used by Jean Dubuffet. Finally, Fautrier bathed the surface in fine red glazes resembling thinned blood. His style of painting was soon called Art Informel.

In 1945, Fautrier was still focused on the human figure, which threatened to lose its form. But eventually Parisian artists – like Fautrier himself, Wols and later Hans Hartung – found their way to gestural abstraction under this catchphrase and breathed new life into French art.

(L. E.)

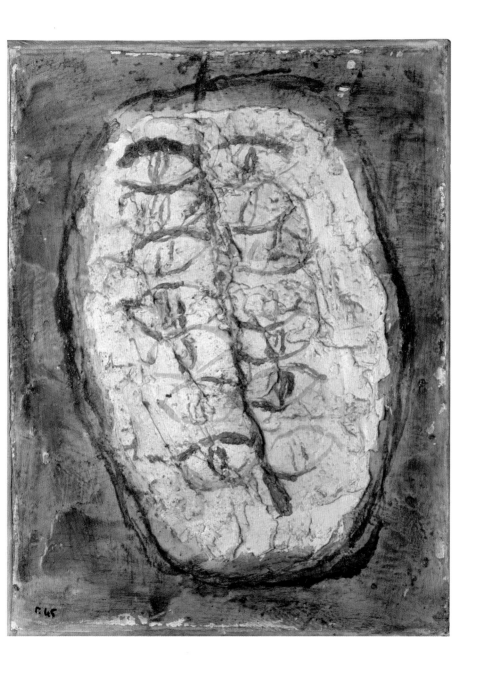

Jean Dubuffet

b. 1901 in Le Havre, France
d. 1985 in Paris

In October 1947 Jean Dubuffet caused a scandal when he exhibited his "portraits" of Parisian intellectuals in the Galerie René Drouin. The security guards had to protect the paintings from attackers who saw in these "smears" an insult to the portrait subjects and an affront to human values.

No wonder this happened: Dubuffet's portraits are the antithesis to a traditionally middle-class genre that portrays poets and thinkers as stylised heads of Apollo. His 22 portraits of great minds mutate to seemingly naive caricatures that are antithesis to noble reasoning. Many of them feature thick masses of paint, which Dubuffet mixes with ash, coal dust and sand, and carves into standardised figures with oversized heads using spatulas and knives: the puckered lips, wrinkles and crooked teeth reveal few of the models' incisive features, but for Dubuffet they are what makes the painting come alive. What matters to him is not an analytical way of seeing, but rather the fleeting and directly perceived vision formulated by Maurice Merleau-Ponty in his 1945 publication *Phenomenology of Perception* and by Jean-Paul Sartre in his 1940 book *The Imaginary*.

Oddly enough, hardly any of the portrait subjects complain. Henri Michaux in particular – whom, like his other friends, Dubuffet paints several times, here as *Henri Michaux acteur japonais* – would have given his enthusiastic approval to the portrait. This poet and painter, who later in life experimented with drugs like mescaline, nurtured a strong interest in the unconscious, and, like Dubuffet, belonged to a post-war art movement that rejected enlightenment and reason in favour of the unspoiled perception shared by children,

mental patients and selected non-European and prehistoric cultures. As early as 1945, Dubuffet visited mental institutes and began collecting works by "irregulars" such as Adolf Wölfli and Aloise Corbaz. In his opinion, they represented the opposite standpoint of the failed "high culture" established during the Second World War and harboured the potential for spiritual renewal. In 1946 an intellectual group developed around Dubuffet, which called for an Art Brut: "The position of Art Brut is to oppose knowledge and what western civilisation (somewhat vociferously) calls 'culture'. It's the decision to begin at zero."

Dubuffet's own paintings primarily emphasise materiality. Their immediately sensual perceptual qualities surpass mere content and reduce the distance between the image and the viewer. And apart from vision, for Western thinking the highest of the senses, the sense of touch, considered the lowest, is activated. This type of aesthetic appeal allows Dubuffet to decisively contribute to the new orientation of the arts after 1945.

Dubuffet's cycle of portraits exemplifies the non-rational attitude of Art Brut and ranks among the first exhibitions to inspire critics to speak of the *informe*, the formless: the compacted material seems randomly and dynamically applied; spills and scratches dominate instead of brushstrokes. These first "formless" paintings, together with those simultaneously created by Jean Fautrier, soon replace the cleverly calculated, geometric abstractions in the wake of the 1920s and forge a path to a new and mystically sensual painting still effective today.

(G. B.)

Alexander Calder

b. 1898 in Lawnton (PA), USA
d. 1976 in New York

Ritou I
1946, hanging mobile: painted
sheet metal, wire and rod, height
81.3 cm (32 in.), span 78.7 cm
(30 in.)

Alexander Calder was the first important American sculptor and one of the most original artists of the 20th century – a distinction he attained by creating an entirely new form of sculpture – the "mobile" – that overturned all the medium's basic assumptions.

Calder was the son and grandson of sculptors, and throughout his childhood was fond of making toys and jewellery from scrap metal. But before he studied art he took a degree in mechanical engineering, and from the beginning his works display the unmistakeable influence of engineering techniques and concepts. He moved to Paris in 1926 and was soon attracted to avant-garde circles. Above all it was the works and ideas of the Surrealists that encouraged his instinctive playfulness. At this time he was fond of making sculptures from wire, of "drawing in space". His first success was his *Circus*, which he carried around in a suitcase. This consisted of the apparatus and characters of a circus, all made from wire and bits of cloth; he would set these out carefully in a miniature circus ring and then give a performance, moving the pieces himself.

"Art was too static to reflect a world in motion," Calder felt. Fascinated by the idea of creating works that move, and persuaded by a visit to the studio of Piet Mondrian that abstract art was the way forward, he eventually began making the works for which he is best known – mobiles consisting of brightly coloured shapes cut from sheet metal and suspended from wires in carefully balanced arrangements that move when touched by a hand or a current of air.

What makes the mobiles so original is that here, for the first time in sculpture, movement is not merely represented or added as an incidental feature, but is the very basis of the sculpture; form is created by movement not by mass. They are also original in technique (constructed from sheet metal and wire rather than carved or modelled), in the use of bright colours (which were inspired by Mondrian), in being abstract and even in their (incidental) incorporation of sound – Calder liked to listen to the "whang they make". None of this relates to traditional sculpture. Even their *mood* is different: they have none of the seriousness of traditional sculptures; nor is there the slightest suggestion of the uneasy mystery surrounding Surrealist sculptures, or of the existential anxiety seen in the works of his contemporary Alberto Giacometti. Playful, fun and seemingly inconsequential, and as such an anticipation of Pop Art, they are closer to the world of children's toys than to the world of high art: "Children adore mobile sculptures and understand their meaning immediately," Calder observed.

Unlike many modern artists, Calder propounded no elaborate theory of art. Yet it seems from various comments that he saw his mobiles – in which unpredictable, ever-changing patterns occur within a precisely balanced system – as representing the universe. For the French philosopher Jean-Paul Sartre, Calder's mobiles illustrate the contingent nature of reality, always beyond our grasp; he saw them as "sensitive symbols of Nature, of that profligate Nature which squanders pollen while unloosing a flight of a thousand butterflies; of that inscrutable Nature which refuses to reveal to us whether it is a blind succession of causes and effects, or the timid, hesitant, groping development of an idea." (C. M.)

Henri Matisse

b. 1869 in Le Cateau-Cambrésis, France
d. 1954 in Nice

During the final years of his life, Henri Matisse in-vented a new technique which involved using scissors to cut shapes out of sheets of paper painted in monochrome gouache, and then assembling them to form compositions. These cut-outs allowed him to renew his work in a far-reaching manner without, however, breaking with the principles which, in the heyday of Fauvism, were at the heart of his creative work: "In a more absolute, more abstract fashion", he said, "I have developed a form purged down to the essentials." By cutting directly into the colour with his scissors, he realised one of his greatest ambitions, namely to solve "the eternal conflict between drawing and colour".

Matisse perfected this technique between 1931 and 1933 in the course of his work on *The Dance* for the Barnes Foundation in order to cope more easily with the monumental dimensions. From 1936 on he used it to design magazine covers. As a result of a major operation in 1941 he had problems standing for any length of time, and could no longer do his work in the studio as before, which was when he went more profoundly into this new means of expression. For Matisse, this was the start of a "second life", and he turned the cut-out into a respectable art form on its own account. Among the results was the album *Jazz* begun in 1943 and published in 1947, whose most famous pictures include *Icarus*: "Icarus with the passionate heart, who fell from the star-strewn sky."

When he saw the book for the first time, Matisse was initially disappointed, for the reproduction with stencils of the 20 pictures led to the loss of the unique character of the originals, that "life of the paper" addressed by André Rouveyre: "The texture of the paper with the play of the light on its flexible corporeality, and also this corporeality itself, all this unites to form a strange something, which loses its essence if it is too abruptly flattened." At least the quality of the relationships between the colours was maintained, and that was the crucial point. In addition, the book as such represents a "volume", carrying within itself a space of its own which arises from the interplay between the luminous colours of the pictures and the whiteness of the sheets, calligraphically inscribed with Chinese ink. It is a space typical of Matisse, such as one finds a few years later in the decoration of the Rosary Chapel at Vence, where he uses large drawings consisting of broad black lines on the white of the wall to create a counterweight to the coloured surface of the glass window opposite.

The picture of Icarus may appear as a symbol of the decorative art which Matisse arrived at with his cut-outs. An art of cosmic significance, as Georges Duthuit emphasised: "Decoration, yes, but only to the extent that the world that surrounds us, the earth and its shapes, the sky and its lights, our decor, are, thanks to its mediation, no longer alien... And their message is so comprehensive that it is content with the plainest language, almost with silence: it is an art which allows us to breathe in harmony with the elements already there for us to use." The picture of Icarus is preceded in *Jazz* by an article entitled "The Aeroplane"; it evokes, as a counterweight to the cares of our everyday lives, in which we are "simple pedestrians", the delights of flying, "when the sun shines forth in splendour and the expanse of the boundless space is palpable, a universe in which we had felt so free for a moment."

(X.-G. N.)

Icarus
1943–1946, paper cut-outs, painted and glued,
64 x 41.9 cm (25¼ x 16½ in.)
Musée national d'art moderne, Centre Pompidou, Paris

Alberto Giacometti

b. 1901 in Borgonovo, Switzerland
d. 1966 in Chur

**Man Crossing a Square
on a Sunny Morning**
1950, painted bronze,
45.7 x 22.2 x 36.5 cm (18 x 8¾ x 14¼ in.)
Detroit Institute of Arts

While visiting a cinema in Paris in 1945, Alberto Giacometti had a revelation, an insight into what he wanted to achieve. This concerned the relationship between representation and reality. The figures on screen turned into ill-defined tonal areas, while on the street outside things appeared intensely real: "Everything was different, the distance and the objects, and the colours, and the silence… That day, reality took on a completely new value for me; it became the unknown, but an enchanted unknown." This enchanted unknown, however, soon took on a troubled character.

He had already become a celebrated sculptor in the early 1930s, as a Surrealist, creating strange, carefully crafted objects that had a dreamlike quality. But he became dissatisfied (dissatisfaction was a driving force throughout his career) and by the mid-1930s he had returned to the human figure, first using a model and then working "from memory". To his horror his figures became smaller and smaller until he could fit them into a matchbox. He had to struggle for years to develop a new style.

The revelation at the cinema provided a promising starting point: "Only from 1946 have I been able to perceive the distance that allows people to appear as they really are and not in their natural size." He now wanted to depict people as he actually *experienced* them, with representation and reality converging. But his experiences of others were problematic. In particular, the "distance" that allowed him to see people as they "really were" became an unbridgeable void separating perceiver and perceived, desire and fulfilment. Others appeared frustratingly remote, elusive, inaccessible. This disturbing sense of separation was rooted in sexual anxieties (the object of desire as unattain-

able), but in his work it acquires social and even metaphysical significance.

It was now that he began creating the works for which he is best known – tall, stick-thin, rough-textured figures hardly more substantial than the wire frames on which they are modelled. Distant, alone and uncommunicative – even, perhaps especially, when in groups – for many these meagre figures vividly expressed the post-war mood of existential anxiety and despair. A typical response was that of writer Francis Ponge: "Man – and man alone – reduced to a thread – in the ruinous condition, the misery of the world… starting from nothing. Thin, naked, emaciated, all skin and bone. Coming and going with no reason in the crowd."

Many of his figures are stiffly erect, their legs together and their arms by their sides; heavy feet are anchored to bases whose disproportionate size further emphasises the insubstantiality of the thinly sketched figures, which seem as if turned into cold matter in a vast and empty universe. But some are becoming active, raising an arm to point or – as in *Man Crossing a Square on a Sunny Morning* – striding forwards. The fact that Giacometti saw the passive figures as female and the active as male again indicates an obsessional sexual component in his works. But such animated figures also introduce a new emotional and thematic dynamic into his petrified world, with antecedents in the walking figures of Auguste Rodin – though there is a stark and revealing contrast in the two artists' conceptions of the human form and the human condition – and also in ancient Greek *kouroi*, the standing male nudes whose step forward marked a key moment in the development of Western sculpture. (C. M.)

Henry Moore

b. 1898 in Castleford, UK
d. 1986 in Much Hadham

"The whole of nature is an endless demonstration of shape and form." — **Henry Moore**

By the end of his career Henry Moore was widely seen as one of the greatest sculptors of the 20th century, his many public commissions playing a key role in making "modern" sculpture widely acceptable as public art.

During the crucial period of his development, in the 1920s and 1930s, Moore synthesised a number of key avant-garde interests and movements. He was strongly drawn to non-European sculpture – pre-Columbian, African and Egyptian – in which detail and realism are subordinated to clarity and monumentality of form. This interest in form is why, when visiting Italy, he studied not only the sculptures of Michelangelo but also the paintings of Giotto and Masaccio. His early works were squat, powerful, simplified figures.

The strong impact of Surrealism led him to the creation of more fluid, biomorphic forms, and that of Constructivism to greater abstraction. In the 1930s his discovery of piercing came as a revelation – holes were not merely empty space but active and vital components of form. In some of his works the subject is fragmented into several detached parts, though in a search for a new coherence rather than as an expression of disintegration. Figuration and abstraction are constantly in a dynamic relationship in Moore's work.

At this stage he was a committed exponent of "direct carving" (carving without preparatory models and detailed drawings) and "truth to materials" (allowing the characteristics of a specific piece of stone or wood – its density, texture, size, tensile strength, grain and colour – to determine how a work develops). This sensitivity to materials reflected a broader commitment to rooting art in nature. Moore regarded "shape" as the most important aspect of sculpture – "There are universal shapes to which everyone is subconsciously conditioned and to which they can respond if their conscious control does not shut them off" – and such shapes were to be found in nature. A great many of his sculptures were directly inspired by the stones, shells, animal bones and bits of wood he collected and drew, and he preferred to see his works set up out of doors, their appearance changing according to the times of the day, the weather and the season. They frequently look like time-worn natural objects.

Throughout his long career Moore focussed exclusively on the human figure, with two subjects being "obsessions" (his own term). The first was the reclining female figure (which often closely resembles a landscape), the second the mother and child, both subjects being examples of the Earth Mother archetype. Among his few male figures his post-war warriors from the 1950s are the most striking, either fallen in defeat or seated, a leg missing and an arm raised in defence – powerful images of psychic trauma. However, shortly after the war Moore also added a seated male figure to the mother and child motif to form an integrated family group, an image of stability and protective nurturing in which both the mother and father hold the child. Partly inspired by the drawings he had made of men, women and children sleeping in the London Underground during the war, his *Family Group* was originally created as an appropriate commission for a school; the theme also had a personal significance, for Moore had just become a father. Above all, it can be seen as an affirmation of basic human values in a world that had only recently seen the ruthless and systematic destruction of civilian life.

(C. M.)

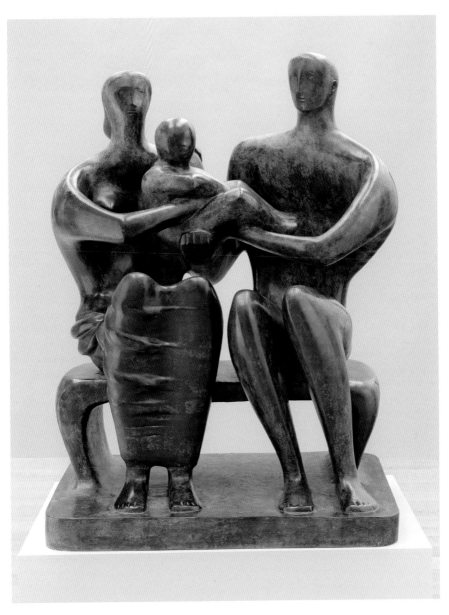

Family Group
1948–1949, bronze, 154 cm (60¾ in.)
Tate, London

Wols

b. 1913 in Berlin, Germany
d. 1951 in Paris, France

Alfred Otto Wolfgang Schulze was 24 years old when he shortened his name to Wols. Wolfgang Schulze had found this combination of initials in a telegram and adopted it. By then the artist was no longer living in Germany, which he had left for France in 1932. In the later 1930s Wols cultivated close contacts in the Paris Surrealist movement. This influence can be clearly seen in his works on paper. Most prominent among his sources of inspiration were Yves Tanguy, Max Ernst and Salvador Dalí. When in 1952 the French man of letters Michel Tapié coined the term *l'art autre*, which also fit the work of Wols, the latter had already died of food poisoning at only 38 years of age.

Wols had long preferred to work on paper, and thereby was always happy to employ various techniques combined or contrasted with one another. He often applied the bold strokes of black ink on top of painterly techniques such as watercolour, opaque white and sometimes oil paint. His compositions, often constructed around a central form, thereby evoke associations with violent intrusion. They seem like wounds and injuries to the picture's surface. Wols first began painting on canvas in 1946. He produced *The Blue*

Phantom five years later, in the year of his death. The title and association with a dark shadowy figure seem to continue some of the artist's earlier Surrealist motifs, but simultaneously allow the work to become a *memento mori*, a premonition of death. A background of bright red and yellow lies behind the dark figure, giving it a brightly glowing aura, and making it faintly reminiscent of an apparition of Christ. An impression like this of a phantom-like apparition, however, is not typical of Wols' painting. The way he applied the paint expressly emphasised its materiality and presence, and the aggressive brushstrokes made it come to life on the canvas. With the back end of the paint brush Wols repeatedly scratched open the surface, leaving nervous marks in the motif.

While in a remark among his aphorisms he named Paul Cézanne as one of his inspirations, in his paintings Wols nonetheless distanced himself from Cézanne's lucid landscapes for the most part: "The painting can have a relationship to nature, like a Bach fugue has to Christ, for it is not an imitation, but an analogous creation."

(D. E.)

The Blue Phantom
1951, oil on canvas,
73 x 60 cm (28¾ x 23½ in.)
Museum Ludwig, Cologne

Abstract Expressionism –
From Jackson Pollock
to Cy Twombly

Arshile Gorky
Water of the Flowery Mill
1944, oil on canvas,
107.3 x 122.7 cm (42¼ x 48¼ in.)
The Metropolitan Museum of Art, New York

A Constant Searching of Oneself

Barbara Hess

Pages 400–401
**Peggy Guggenheim (centre) giving
a cocktail party in the drawing room
of her palazzo**
Venice 1964
Photo: David Lees

The Spatter-and-Daub School of Painting

"We agree only to disagree." According to Irving
Sandler, writer and observer of the art scene, this
was the unwritten motto of that loose grouping of
artists in New York in the 1940s and 1950s who
are generally known as Abstract Expressionists
or "the first generation of the New York School".
In their statements and writings, insofar as they
have been preserved, the artists usually consid-
ered to have belonged to this school resist being
lumped together in this way, fearing that their
very different views on art and aesthetic produc-
tion would be suffocated if subsumed under a
single stylistic description or group name.

"It is disastrous to name ourselves," answered
the painter Willem de Kooning in a panel discus-
sion in 1950 when the former director of the New
York Museum of Modern Art, Alfred H. Barr, Jr.,
demanded: "We should have a name for which we
can blame the artists – for once in history!" Barr's
remark was an allusion to the fact that most artis-
tic "-isms" – such as for example Impressionism
and Cubism – were coined by critics and often
originally applied derisively.

Abstract Expressionism is no exception. On
30 March 1946 there appeared in the *New Yorker*
a discussion of an exhibition in the Mortimer
Brandt Gallery, the first comprehensive presenta-
tion of works by the painter Hans Hofmann, who
had emigrated to the U.S. from Germany in 1932.

The author of the review, Robert Coates, observed
that until then the artist had been accorded little
attention, and explained this in part by his paint-
ing technique: "For he is certainly one of the most
uncompromising representatives of what some
people have called the spatter-and-daub school
of painting and I, more politely, have christened
Abstract Expressionism."

Coates himself had borrowed this description
from another author, probably Alfred Barr. The
term Abstract Expressionism had first turned up
in German as far back as 1919 in the magazine
Der Sturm, which appeared in Berlin from 1910 to
1932 and was especially well-known for its repro-
ductions of Expressionist prints. In the U.S.,
Alfred Barr first used this description in 1929 in
relation to works by Wassily Kandinsky, who in
about 1911 had abandoned any pretence at copy-
ing the world of objects. A few years later, in the
catalogue to the 1936 *Cubism and Abstract Art* exhi-
bition, Barr, from a formal perspective, distin-
guished between two traditions in abstract art:
the first, of a more strongly geometric-structural
tendency, in his view led from Georges Seurat
and Paul Cézanne, via Cubism to the various geo-
metric and Constructivist movements in Russia
and Holland, and had, since the First World War,
become international. "The second – and, until
recently, secondary – current", Barr continued,
"has its principal source in the art and theories of

[Paul]Gauguin and his circle, flows through the Fauvism of Matisse to the Abstract Expressionism of the pre-war paintings of Kandinsky. After running underground for a few years it reappears vigorously among the masters of abstract art associated with Surrealism. This tradition, by contrast with the first, is intuitive and emotional rather than intellectual; organic and biomorphic rather than geometrical in its form; curvilinear rather than rectilinear, decorative rather than structural and romantic rather than classical in its exaltation of the mystical, the spontaneous and the irrational."

The Unwanted Title

In a certain sense, Barr's article was prophetic for many artists who, in the next two decades, were to attract increasing attention as the New York School. Surrealism was one of the influential trends with which American artists were coming to terms, in particular when the coming-to-power of the National Socialists in Germany and the outbreak of the Second World War forced numerous exponents of the Surrealist movement to emigrate to the United States. New Yorkers were also acquainted with Wassily Kandinsky's early abstract works through the collection in the Museum of Non-Objective Art, the future Solomon R. Guggenheim Museum. And so the term coined by Alfred Barr and reintroduced by Robert Coates

gradually found currency. Among artists, though, it was always "The Unwanted Title", the motto of a symposium organised by the painter Phillip Pavia in 1952 for that celebrated association of New York artists known simply as The Club.

The more neutral geographical description New York School – in allusion and in contrast to the École de Paris, which until the 1940s had been regarded as the world leader – was first applied primarily on account of New York's being the most important work and exhibition location for a new generation of artists. The name can be traced back to *The School of New York* exhibition which the artist Robert Motherwell organised in 1951 at the Frank Perls Gallery in Beverly Hills, and which included works by, among others, William Baziotes, Willem de Kooning, Adolph Gottlieb, Hans Hofmann, Robert Motherwell, Jackson Pollock, Richard Pousette-Dart, Ad Reinhardt, Mark Rothko, Clyfford Still and Mark Tobey.

The aesthetic content of what generally goes by the name of Abstract Expressionism occupies a singularly broad spectrum, and this proviso, with its reference to the decided "individualism" within the New York School, has been a kind of a critical platitude since as far back as the late 1950s. The visual differences range from the – in some cases – transparently overlaid colour veils such as those seen in Mark Rothko's paintings –

Willem de Kooning
Two Women in the Country
1954, oil, enamel and charcoal on canvas,
117 x 103.5 cm (46 x 40¾ in.)
Hirshhorn Museum and Sculpture Garden,
Smithsonian Institution, Washington, D.C.

Barnett Newman
Vir Heroicus Sublimis
1950–1951, oil on canvas,
242.2 x 513.6 cm (95¼ x 202¼ in.)
The Museum of Modern Art,
New York

their "abstractness" clear enough, their "expressiveness" less obviously so – via Willem de Kooning's series *Women* – "expressive" enough with their visible deployment of the body, but indisputably figurative in their adherence to the tradition of the female nude – right up to the legendary gestural drip paintings of Jackson Pollock, in whose (literal) outpourings figurative elements can also sometimes be discerned.

The use of paint in the austerely composed, non-figurative pictures of Ad Reinhardt and Barnett Newman appears by contrast reticent and controlled. In his 1955 essay "'American-type' Painting", the influential critic Clement Greenberg noted, in respect of the large-format canvases employed by Rothko, Newman and Clyfford Still, a "more emphatically flat surface"; in their case, one also speaks of Colourfield Painting – a term that, in addition, is used of the painting of the 1960s and 1970s by such artists as Morris Louis, Kenneth Noland, Jules Olitski and Frank Stella, who worked in the aftermath of Abstract Expressionism.

It seems, then, to be neither possible nor productive to try to pin Abstract Expressionism down to a single aesthetic programme or a stable group identity. Accordingly, there seems little purpose in defining which artists are to be counted as Abstract Expressionists, even though art historians have tried time and again to do so, with varying results. Alongside the figures already mentioned, we have included James Brooks, Arshile Gorky, Philip Guston, Franz Kline, Elaine de Kooning, Lee Krasner, the sculptor David Smith and Mark Tobey among the "first generation of Abstract Expressionism"; while the "second generation" of younger artists, or of those who only developed their characteristic techniques in the 1950s, is supposed to include Sam Francis, Helen Frankenthaler and Joan Mitchell. Like every canon in which works and interpretations defined as "worthy of being handed down" are listed, that of Abstract Expressionism is subject to historico-cultural revision. Without a doubt, the female Abstract Expressionists play a special role in this connection. The American art historian Marcia Brennan tellingly noted that women in Abstract Expressionism were "at the same time selectively present and strategically absent"; not until recently has greater attention been paid to the works and working conditions of artists such as Lee Krasner, Elaine de Kooning, Joan Mitchell or Janet Sobel.

Myth-Makers and Ideographic Pictures

The prehistory of Abstract Expressionism begins in the late 1920s and early 1930s. After Black Friday, the notorious Wall Street crash of 25 October 1929, which triggered off a world economic crisis that was to last many years, America's economic

strength fell to a historical low, and unemployment climbed to more than 30 percent. American art at this time was determined by two figurative tendencies: Regionalism, which took its motifs from the lives of the rural population, and Social Realism, which critically portrayed the darker sides of big-city life such as unemployment and isolation. The future Abstract Expressionists, among them Mark Rothko and Jackson Pollock, were influenced by these trends in the 1930s. Since the start of the decade, Pollock, for example, had been studying at the Art Students League with the Regionalist Thomas Hart Benton, whose influence is apparent in works like *Going West* (ca 1934–1935); meanwhile Rothko was formulating his melancholy view of human existence in figurative symbolic big-city motifs like subway and street scenes.

In order to counter the economic distress being suffered by artists, President Franklin D. Roosevelt's Works Progress Administration (WPA) instituted the Federal Arts Project (FAP) in 1935. This enabled numerous artists, including William Baziotes, Willem de Kooning, Arshile Gorky, Philip Guston, Lee Krasner, Jackson Pollock and David Smith, to earn a living from their art for the first time, while also promoting closer links between those involved. One important undertaking by the FAP was the commissioning of works of art for public spaces, primarily exterior murals, whose execution was supervised by, among others, major representatives of the Mexican Muralist movement such as Diego Rivera, José Clemente Orozco and David Alfaro Siqueiros. While it is true that an artist like Arshile Gorky ironically described the social-critical orientation of the FAP's figurative wall-painting as "poor art for poor people", it was later to point the way ahead for the Abstract Expressionists' working methods using large-format canvases. Thus, with his 1943–1944 *Mural*, Pollock created a painting of wall-filling size for the living quarters of the collector and gallery-owner Peggy Guggenheim, and at the beginning of 1947, in his application for a grant from the Guggenheim Foundation, declared: "I believe easel painting to be a dying form, and the tendency of modern feeling is toward the wall picture or mural."

In the years 1936–1937 the Museum of Modern Art staged two exhibitions which provided strong impulses for the younger generation of New York artists: *Cubism and Abstract Art* and *Fantastic Art, Dada, Surrealism*. The latter in particular aroused an interest in the unconscious as a source of artistic expression, and in Surrealist artistic techniques such as *écriture automatique*, a form of pictorial or written expression free of any censorship by the rational mind or the conscious will. Following the example of *écriture automatique*, the self-dynamic of the paint itself came to be increasingly

Jackson Pollock
Composition with Pouring II
1943, oil on canvas,
64.7 x 56.2 cm (25½ x 22¼ in.)
Hirshhorn Museum and Sculpture Garden,
Smithsonian Institution, Washington, D.C.

important in the painting techniques of a number of Abstract Expressionists, for example through the use of highly diluted paint in Arshile Gorky's 1944 picture *One Year the Milkweed*, or in Jackson Pollock's drip paintings. Pollock in addition emphasised his studies of the theories of Sigmund Freud and Carl Gustav Jung, who at the time enjoyed a broad following in the United States. In an interview with Selden Rodman in 1956, he remarked: "I'm very representational some of the time, and a little all of the time. But when you're painting out of your unconscious, figures are bound to emerge. We're all of us influenced by Freud, I guess. I've been a Jungian for a long time… Painting is a state of being… Painting is self-discovery. Every good artist paints what he is."

This view of painting as "self-examination, self-reassurance and self-expression" – a quotation from a panel discussion initiated by *Life* magazine on the subject of "modern art" in 1948 – was definitive for the Abstract Expressionists and their public alike. Mark Rothko, Adolph Gottlieb and Barnett Newman saw themselves, especially during the 1940s, as modern "myth-makers" who, by having recourse to "primitive" and archaic cultures – for example Native American or pre-Columbian art – hoped to create timeless and immediately accessible metaphors and symbols for the condition of "modern man", which was perceived as tragic. Thus Newman, in his preface to the 1947 exhibition *The Ideographic Picture* at the Betty Parsons Gallery, referred to the art of the native peoples of North America and drew a direct parallel between their works and those of his fellow artists such as Hofmann, Rothko and Still: "Spontaneous, and emerging from several points, there has arisen during the war years a new force in American painting that is the modern counterpart of the primitive art impulse."

In the early 1990s the American art historian Michael Leja drew attention to the importance, for the appearance of Abstract Expressionism, of the discourse concerning "modern man", which in 1930s and 1940s America was being carried on in numerous popular science books and magazines: following the experience of the world economic crisis, social injustice and racial disturbances, the appearance of totalitarian regimes, the holocaust and the lapse into barbarity which it implied, the devastation wrought by the Second World War in general and the atomic bomb in particular, American society was dominated by a feeling of crisis concerning the image of humanity, doubt over what was meant by progress and a questioning of the value of science and rational thought. In the discourse concerning "modern man" – who was implicitly seen as male, white and heterosexual – this crisis was not analysed as historically determined, but rather interpreted as

pointing back to so-called "primitive cultures" as an anthropological constant. In this reference system, Abstract Expressionism could be seen – by its publicists such as gallery owners, curators and critics, but also by collectors and a broader public – as a valid expression of this crisis of "modern man", and as a result, according to Leja, took on a central role in the cultural debate of the time.

An Art Scene Comes into Being

The gradual rise of Abstract Expressionism in the 1940s cannot be seen in isolation from the appearance of the New York art world, a dense network of new galleries, magazines, art schools and artist meeting places. The story of an avant-garde art movement like Abstract Expressionism would, according to the sociologist Diana Crane, have taken a fundamentally different course without the continuous expansion of this infrastructure – an expansion, which took place against the background of general growth in the American economy during the 1940s. Thus the painter Max Weber could still observe, in 1936, on the occasion of the First American Artists' Congress Against War and Fascism in New York, that artists were advised, at the start of their careers, to make contacts, but that at the end of their lives their only contact was mostly with the workhouse. Until then, the demand for contemporary American art

was not particularly strong; the market was dominated by European art.

Peggy Guggenheim, niece of the collector Solomon R. Guggenheim, had fled to New York from Europe in the company of Max Ernst in 1941 and opened her Art of This Century gallery in October 1942. There were, according to her colleague Sidney Janis, "maybe a dozen galleries in all of New York." By the early 1950s, according to the art historian and observer of the scene Dore Ashton, about 30, and ten years later this figure had already increased more than tenfold.

In the Art of This Century exhibition rooms – designed by architect Frederick Kiesler as Surrealist environments capable of continual alteration – Peggy Guggenheim displayed not only her own collection of European Abstract and Surrealist art but, by the time of her return to Europe in 1947 had also staged the first solo exhibitions of the works of numerous American Abstract Expressionists, including Jackson Pollock, Hans Hofmann, Mark Rothko, Clyfford Still, William Baziotes and Robert Motherwell. Guggenheim supported the artists by buying their works and commissioning others, and also sold their works to major collections such as that of the Museum of Modern Art.

The artist and dealer Betty Parsons, who opened her gallery in September 1946, took over some of the positions of Peggy Guggenheim's

Kenneth Noland
Half
1959, acrylic on canvas,
174 x 174 cm (68½ x 68½ in.)
Museum of Fine Arts, Houston

Helen Frankenthaler
Seven Types of Ambiguity
1957, oil on unprimed canvas,
242.6 x 178.1 cm (95½ x 70 in.)
Private collection

Morris Louis
Gamma Gamma
1959–1960, acrylic on canvas,
260 x 386 cm (102¼ x 152 in.)
K20 – Kunstsammlung
Nordrhein-Westfalen, Düsseldorf

programme following the closure of Art of This Century, among them Pollock, Rothko and Still; in addition Barnett Newman curated exhibitions for her gallery. Parsons came from a patrician New York family, and in her youth had studied sculpture in Paris under Émile-Antoine Bourdelle and Ossip Zadkine and in California under Alexander Archipenko. Since the mid-1930s, she had exhibited her own works in New York galleries together with artists such as Theodore Stamos, Hedda Sterne and Adolph Gottlieb. Enthusiastic but not particularly businesslike, she lost many of her artists – one exception was Ad Reinhardt – to other dealers. In his preface to the catalogue for the Parsons Gallery tenth anniversary, Greenberg summed up as follows: "Mrs. Parsons is an artist's – and critic's – gallery: a place where art goes on and is not just shown and sold."

Another dealer widely appreciated by artists was Charles Egan. He had gathered his experience by dealing in works by the German Expressionists and the École de Paris, before opening his own gallery at the start of 1946; here, in 1948, he helped Willem de Kooning, who was by then already in his mid-40s, to stage his first successful solo exhibition. Two other influential protagonists of the up-and-coming New York gallery scene were Samuel Kootz and Sidney Janis. Before Kootz set up his gallery in April 1945, he had written a book about *New Frontiers in American*

Painting (1943). His programme encompassed both European and American art; for example his inaugural exhibition included works by the French artist Fernand Léger, then living in American exile, along with others by William Baziotes and Robert Motherwell. By dealing in the works of established and high-priced Europeans, above all Pablo Picasso, Kootz was able to build up a market for young and unknown American artists.

A similar strategy was pursued by Sidney Janis, whose gallery opened in autumn 1948. Janis' career in the art world began as a collector of modern European art, including Pablo Picasso, Paul Klee, Fernand Léger, Henri Matisse, Giorgio de Chirico, Salvador Dalí and Henri Rousseau. In 1944, together with his wife, Harriet Grossman, he published a book on *Abstract and Surrealist Art in America*, in which Pollock, Rothko, Motherwell and de Kooning were also included – artists whose works were later to feature in his gallery.

Alongside the galleries there appeared in the 1930s and 1940s a series of noncommercial exhibition rooms, some of them organised by the artists themselves. An especially important location for an exchange of views was the art school set up in 1933 by the German émigré painter Hans Hofmann. Then, in the autumn of 1948, William Baziotes, Robert Motherwell, Mark Rothko, Clyfford Still and the sculptor David Hare founded an art school under the name of The Subjects of

the Artists, with the aim of distancing themselves from their attribution to "abstract" art and investigating the subjects of the "modern artist": "What his subjects are, how they are arrived at, methods of inspiration and transformation, moral attitudes, possibilities for further explorations, what is being done now and what might be done and so on." After the quick financial collapse of The Subjects of the Artists, the activities of the school were continued by Studio 35, founded in the autumn of 1949.

Doubtless the most celebrated rendezvous was the artists' association known as the Eighth Street Club, called into being in the autumn of 1949 by 20 founder members, including Franz Kline, Willem de Kooning and Ad Reinhardt. Until it closed in the spring of 1962, it was a venue for discussions and lectures, some of which were published, promoting a lively exchange between a variety of protagonists: critics and writers, American and European artists, dealers and museum curators. They reinforced the conviction that the visual art created in the United States was of universal significance – a conviction which was also fired by the attention of the mass media, museums and a new class of collector.

Art in the Cold War

The history of Abstract Expressionism is closely bound up with that phase of post-war history known as the Cold War. By the end of the Second World War at the latest, America – after a period of isolationism in the 1930s – was beginning to define herself as an economic and military power operating on the international stage, whose task was to defend the "free world" against the threat represented by the Communist states of the Eastern bloc. At this stage, America still had a monopoly on nuclear weapons, whose destructive power was manifested, and engraved on the collective consciousness, by the atomic bombs dropped on Hiroshima and Nagasaki in 1945; this power was perceived as a potential threat of global dimensions. The widespread fear of imminent extinction was reflected in different ways, also, in the artistic production of the Abstract Expressionists. Thus the "abstract" Jackson Pollock was expressly striving to take account, in his art, of the concrete situation of the age he was living in. In an interview with William Wright in 1950 he stressed: "It seems to me that the modern painter cannot express his age, the airplane, the atom bomb, the radio, in the old forms of the Renaissance or of any other past culture. Each age finds its own technique."

The role which Abstract Expressionism played in the complex domestic and foreign politics of the post-war period is extraordinarily multilayered. Thus in the international exhibition business it functioned on the one hand as the official

Clyfford Still
Untitled
1956, oil on canvas,
288.8 x 410.2 cm (113¾ x 161½ in.)
Private collection

advertisement of a modern, liberal America, while at home it had no shortage of bitter opponents. Sections of the conservative nationalistic camp berated it as un-American, Communist or mentally sick.

With the onset of the Cold War and in particular during the early 1950s, when the Republican Senator Joseph McCarthy was waging his notorious crusade against (in most cases, allegedly) Communist artists and intellectuals, the debates of the Abstract Expressionists, their adherents and sponsors, seemed however to become largely depoliticised. "Oblique references abounded," remarked Dore Ashton, "but the 1950s were not hospitable to art discussions with political orientation." This retreat on the part of artists was seen by art historians such as Serge Guilbaut as one of the reasons why their art could be reforged as a propaganda weapon in the Cold War, and why, to use Guilbaut's polemical expression, "New York was able to steal the idea of modern art... The avant-garde artist who categorically refused to participate in political discourse and tried to isolate himself by accentuating his individuality was co-opted by liberalism, which viewed the artist's individualism as an excellent weapon with which to combat Soviet authoritarianism. The depoliticisation of the avant-garde was necessary before it could be put to political use, confronting the avant-garde with an inescapable dilemma."

A New American Style of Painting?

During the mid-1930s, the art historian Meyer Schapiro, who taught in New York, could still observe that the term "American art" was necessarily inexact, feigning a fictitious unity. In the art criticism of the 1940s and 1950s, by contrast, more intensive efforts were made to assert the aesthetic overcoming of European models and the superiority of modern American painting. Thus in January 1948 Clement Greenberg proclaimed, in "The Situation at the Moment" in the magazine *Partisan Review*: "As dark as the situation still is for us, American painting in its most advanced aspects – that is, American abstract painting – has in the last several years shown here and there a capacity for fresh content that does not seem to be matched either in France or Great Britain." One logical problem in this debate, however, consisted precisely in the difficulty of discerning the specifically "American" aspect of the new painting in the face of its broad spectrum of artistic positions. Greenberg tried to resolve this in his 1955 essay "American-type Painting". His thesis was that modern painting had made it its goal to investigate its own material conditions and to filter out "the expendable conventions" of the medium, "in order to maintain the irreplaceability and renew the vitality of art": indeed, in order to ensure its viability. And this attack on the conventions of painting – such as three-dimensionality,

illusionism and figure-background relationships – Greenberg saw successfully implemented above all in Abstract Expressionist painting, which at the same time was the first American art movement that was not only respected in Paris, but even imitated.

The message that Abstract Expressionism had overturned European models was still being enthusiastically proclaimed in the early 1960s, when the battles had already long been fought and the overwhelming importance of American art at home and abroad was no longer in dispute. In his 1961 essay "The Abstract Sublime", the American art historian Robert Rosenblum took it upon himself to yet again position Jackson Pollock, Clyfford Still, Mark Rothko and Barnett Newman, with their large-format canvases, inviting the beholder to contemplation, as the challengers of the "international domination of the French tradition, with its family values of reason, intellect and objectivity", and to establish them as the legitimate successors of the Romantic tradition of the 19th century.

In so doing, critics like Greenberg in no way over-looked the fact that Abstract Expressionism in the United States owed its development since the early 1940s to numerous international interactions. The question "Have We an American Art?", which the art critic of the *New York Times*, Edward Alden Jewell, posed in a 1939 book of

that title, could not be answered in a single sentence. Numerous artists in the field of Abstract Expressionism, such as Arshile Gorky, John Graham, Hans Hofmann, Willem de Kooning, Mark Rothko and Hedda Sterne, were European émigrés, as were Rudolph Burckhardt (from Switzerland) and Hans Namuth (from Germany), whose photographs and films created the public image of the Abstract Expressionists that we still have today. Other protagonists, such as Betty Parsons and Sam Francis, studied or worked at least for a time in Europe. And alongside the numerous works by European artists in New York galleries and museums, it was in particular the presence of international artists, especially after the outbreak of the Second World War, that promoted an intensive cultural dialogue.

Barnett Newman

b. 1905 in New York, USA
d. 1970 in New York

"What is the explanation of the seemingly insane drive of man to be painter and poet if it is not an act of defiance against man's fall and an assertion that he return to the Adam of the Garden of Eden? For the artists are the first men."

— **Barnett Newman**

Onement I
1948, oil on canvas,
69.2 x 41.2 cm (27¼ x 16¼ in.)
The Museum of Modern Art, New York

In April 1945 Barnett Newman wrote in an article on Rufino Tamayo and Adolph Gottlieb: "Man is a tragic being, and the heart of this tragedy is the metaphysical problem of part and whole. This dichotomy of our nature, from which we can never escape and which because of its nature impels us helplessly to try to resolve it, motivates our struggle for perfection and seals our inevitable doom. For man is one, he is single, he is alone; and yet he belongs, he is part of an other. This conflict is the greatest of our tragedies…" In the New York art world, Newman was, until well into the 1950s, known above all to many contemporaries as a curator and (often polemical) author. Thus in 1944 and 1946 he had organised exhibitions of pre-Columbian painting for the Betty Parsons Gallery. In these projects, as also in his earlier writings, Newman indicated his interest in "primitive" art – to which his own art was supposed to be the modern equivalent – as the expression of the human search for metaphysical insight.

The birth of *Onement I* was dated by the artist to 20 January 1948, his own 43rd birthday. A rectangular canvas in vertical format, with a partly translucent application of russet paint, is divided down the middle by a narrow orange-red strip, or stripe, of painted adhesive tape with irregular edges. The vertical stripe Newman called a "zip" and indeed, it does both divide and reunite the two halves of the picture like a zip-fastener. For Newman it was "a field that brings life to the other fields, just as the other fields bring life to this so-called line."

The first zips had already appeared in 1946 in a number of pictures such as *Moment* and *Genesis – The Break*. Even so, *Onement I* is regarded as a decisive turning point in Newman's artistic development. In 1965, he described it as the new beginning of his existence: "I realised that I'd made a statement which was affecting me and which was, I suppose, the beginning of my present life, because from then on I had to give up any relation to nature, as seen." In fact Newman referred to *Onement I* having, in his view, a kind of independent existence: "The painting itself had a life of its own in a way that I don't think the others did, as much."

The importance of this image-creation can be seen not least in the fact that *Onement I* was followed by about a year of unusual productivity, in which 17 other works appeared. Thus in *Onement III* (1949) Newman used the same compositional principle as in *Onement I*, while increasing the dimensions of the picture, so that it could be viewed by beholders even more strongly as something with which they were physically confronted. To this extent, *Onement I* and the invention of the zip can be understood as the painterly expression of what Newman already in 1945 was calling the "metaphysical problem of part and whole". And indeed, when one views Newman's compositions from close up, as the artist demanded on the occasion of his second exhibition at the Betty Parsons Gallery in 1951, "man is one, he is single, he is alone; and yet he belongs, he is part of an other."

(B. H.)

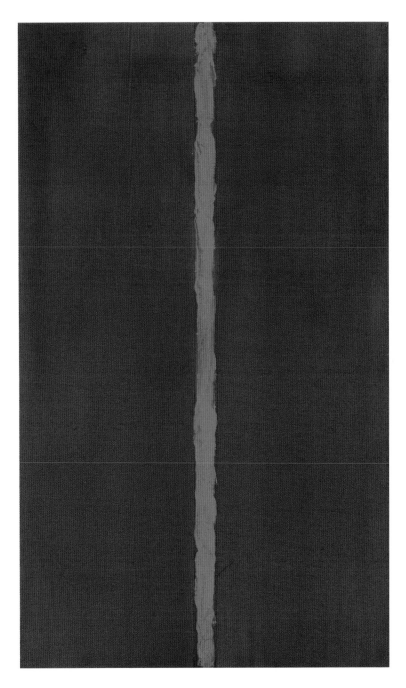

Clyfford Still

b. 1904 in Grandin (ND), USA
d. 1980 in New York

In 1966 Ethel Moore wrote in the biographical notes for the catalogue of an exhibition by Clyfford Still: "When he was 20 he made the first trip to New York, arriving at the Metropolitan Museum of Art before the doors opened. He was, however, disappointed in what he saw. He found something missing, some statement that he felt profoundly and did not find in the work of the European masters. Having decided that he should pursue a more formal art education, he enrolled in a class at the Art Students League but found that disappointing also, and left after 45 minutes." Still remained in the city – this was in 1924 – for a few more weeks, in order to visit more museums and galleries, but the first impression seemed only to be confirmed. "Disillusioned, he shortened his stay in New York and returned West."

These few sentences sketch out the picture of the eccentric American artist in an almost idealising fashion. His "disillusionment" with and rejection of European art, which he saw as "decadent", the fact of his being self-taught, his distancing himself from the big city – New York – and its "corrupt" art scene and finally his departure and return to the American West. In 1945, 20 years after his early disappointment, Still returned however to New York and was living there – with interruptions – during the period of the "triumph of American painting", as Irving Sandler put it. In the mid-1950s, while he refused to take part in exhibitions in New York, this gesture of withdrawal was rewarded by the public, who interpreted it as a sign of his particular artistic authenticity, and it certainly did nothing to diminish his renown. In 1961 Still finally retired to the rural isolation of Maryland.

During the final years of the war, Still had concerned himself, like many of his fellow artists, with myth-laden motifs, but in 1946–1947 he developed his characteristic form of colour-field abstraction, with mostly vertically oriented forms and abrupt, irregular contours, as seen in *1949-H*. The oil paint, applied to the canvas with a spatula, comes across as cracked and intentionally "uncultivated". Within the colour zones there is no shading, and between them there are no figure-to-ground relationships. Still's all-over compositions come across as details of a larger field extending beyond the borders of the picture, which in turn contributes to the unfinished appearance of the picture.

Interpreters of Still's pictures have seen in them time and again references to the wide-open landscape of North Dakota where he was brought up, or to the American West Coast, where he lived and taught in the late 1940s. This brings the aesthetic concept of the "sublime" into play, which was also central for other artists such as Barnett Newman and Mark Rothko: the confrontation of the subject with the idea of infinite size or infinite power in the face of an overwhelming experience (of nature). Still himself promoted this view of things, for example when he wrote in 1963: "The sublime? A paramount consideration in my studies and work from my earliest student days. In essence it is most elusive of capture or definition – only surely found least in the lives and works of those who babble of it the most."

(B. H.)

1949-H
1949, oil on canvas,
203.2 x 175.26 cm (80 x 69 in.)
Albright-Knox Art Gallery, Buffalo

*"Demands for communication are both presumptuous
and irrelevant. The observer usually will see what
his fears and hopes and learning teach him to see."*
— **Clyfford Still**

David Smith

b. 1906 in Decatur (IN), USA
d. 1965 in Albany (NY)

In Abstract Expressionism, sculpture played a subordinate role. Or, as Ad Reinhardt put it in 1957: "Sculpture is no problem. Nobody likes sculpture." The most prominent exponent of this medium in the context of the New York School is without a doubt David Smith, and Reinhardt's mordant observation is in tune with the fact that from the 1930s to the 1950s, Smith was able to sell very few works. It took a grant from the Guggenheim Foundation in the early 1950s to improve his situation.

Smith gathered his first experiences in metalworking outside the field of art: as a student in 1925, he worked as a welder in a Studebaker car factory in South Bend, Indiana. In 1926 he moved to New York, where he studied painting and drawing at the Art Students League from 1927 to 1932. He obtained his knowledge of European avant-garde sculpture primarily from his acquaintanceship with the Russian exile John Graham, who played an important role among the Abstract Expressionists as a conduit of information concerning European art. Inspired by illustrations of the wrought-metal sculptures of Pablo Picasso and Julio Gonzáles in the French magazine *Cahiers d'Art*, Smith created his first sculpture of welded metal in 1933. A welding shop in Brooklyn placed rooms, appliances, materials and technical expertise at Smith's disposal for the production of his sculptures. He moved in 1940 to the neighbourhood of Bolton Landing, New York, a remote township in the Adirondack Mountains, and there built a workshop to his own design, naming it Terminal Iron Works after the factory in New York. Smith described his workplace as "an industrial factory type…because the change in my sculpture required a factory more than an 'atelier'."

Upon his death in a car accident, Smith left a comprehensive œuvre comprising more than 700 sculptures; his productivity, which increased in the final decades of his life, is regarded as partly due to strict organisation of the production process and quasi-industrial form of manufacture. He often described his early employment in the car and railway industry as an important influence, an attitude which was also to become typical of a succeeding generation of American sculptors in the context of Minimal Art.

The process by which *Hudson River Landscape* was created was described by Smith in 1951 as follows: the design "started from drawings made on a train between Albany and Poughkeepsie… On this basis I started a drawing for a sculpture. As I began I shook a quart bottle of India ink, it flew over my hand, it looked like my landscape. I placed my hand on paper and from the image this left I travelled with the landscape to other landscapes. Is my work…the Hudson River, or is it the travel, the vision, the ink spot, or does it matter?"

A landscape is actually a rather unusual subject for a sculptor. Early beholders were surprised by the *Hudson River Landscape* with its, as Rosalind E. Krauss recalls, "insubstantiality of a paper cutout". And indeed, Smith's innovative work can also be described as a calligraphic drawing in three dimensions, bringing together various different elements – hints of bridges, steps, waves and a bird's skeleton – which do not allow the beholder countless views of equal status, but are best seen from the front.

(B. H.)

Hudson River Landscape
1951, carbon steel and stainless steel,
126.8 x 187.3 cm x 42.1 cm (50 x 73¾ x 16½ in.)
Whitney Museum of American Art, New York

Jackson Pollock

b. 1912 in Cody (WY), USA
d. 1956 in East Hampton (NY)

With the creation of more than 50 works, 1950 was the most productive year in Jackson Pollock's career. *Number 1, 1950 (Lavender Mist)*, which appeared in the spring of that year, marks the start of a series of large-format drip paintings. Together with the three monumental horizontal canvases *Number 32, One: Number 31*, and *Autumn Rhythm: Number 30*, all of which also date from 1950, this is often spoken of as one of Pollock's "classic" works: "They are 'classic' in their thorough use of the pouring application and the uncompromising unity which resulted," as an art critic observed in the late 1970s. Their radical formal innovation of a non-perspective spatiality, which arose as the result of the layering of hurled or dripped streaks of paint, had the potential to seriously destabilise the position of the beholder. Parker Tyler in his review of March 1950 coined the metaphor of "the infinite labyrinth" – albeit one with no way out, and to which, as Tyler noted, not even its creator seemed to possess the key: a complex structure of numerous labyrinths, one on top of the other, crossing each other, each consisting exclusively of dead ends.

The 1950 paintings are still today at the focus of considerations of Pollock's work not least because at the time they were painted they were the objects of increased media interest. When in November/December 1950 *Lavender Mist* and other pictures of this period were exhibited at the Betty Parsons Gallery, the prominent society photographer Cecil Beaton used them as the background for a series of fashion photos which were intended to proclaim the "new soft look" in the March 1951 edition of *Vogue*. Above all, however, Pollock himself became a public figure when Rudolph Burckhardt and Hans Namuth photographed and filmed him at work from July to

October 1950. Their pictures created the mythic, sexually charged image of Pollock as "Jack the Dripper" and hero of "Action Painting", making it available to a broad public; the films shot by Namuth were already being shown the following year at the Museum of Modern Art.

The year 1950 represents a caesura in Pollock's career in numerous ways. In October 1950, after the end of Namuth's filming, Pollock started drinking again after four years' abstinence. To his friend Alfonso Ossorio, he described his psychological situation after the Betty Parsons exhibition as an "all-time low". Even though it is problematic in principle to relate biographical and artistic developments directly as through they were cause and effect, the crisis at the end of 1950 does point to a fundamental change in Pollock's work, which went hand-in-hand with a restriction, for a while, to the colour black, and a return to recognisably figurative elements. A whole variety of factors may have played a role.

Lee Krasner, who had been married to Pollock since 1945, thought that he had reached the end point of his artistic development in 1950, and was not satisfied with thenceforth continually repeating himself. But the change in his working method may well have been a reaction to the media image (and the expectations that this involved) which had been created during this year. In June 1951 Pollock commented on his new black-and-white pictures, emphasising among other things his technical virtuosity as a draughtsman. "I've had a period of drawing on canvas in black – with some of my early images coming thru – think the non-objectivists will find them disturbing – and the kids who think it simple to splash a Pollock out."

(B. H.)

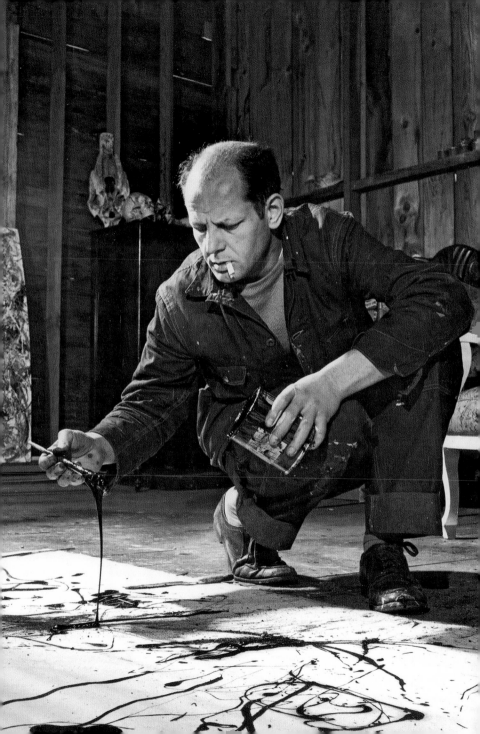

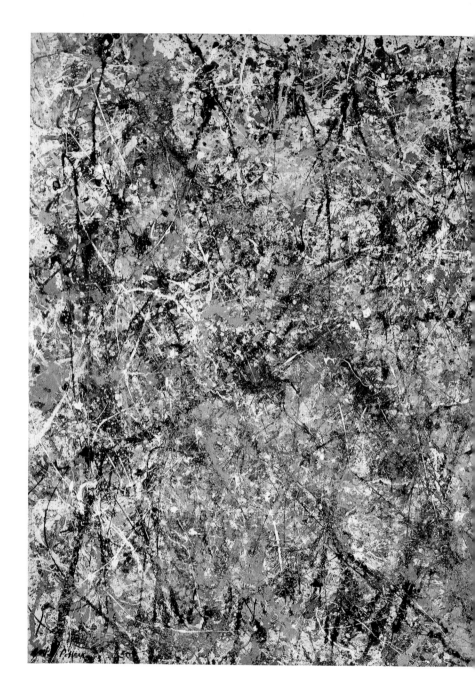

426 — Jackson Pollock

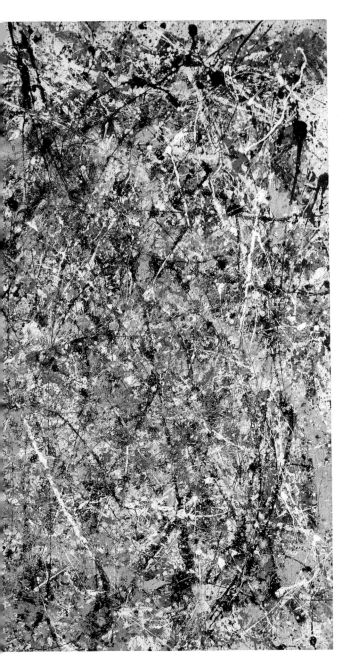

page 425
Jackson Pollock in his studio,
East Hampton 1949
Photo: Martha Holmes

Number 1, 1950 (Lavender Mist)
1950, oil, gloss paint, and aluminium paint on canvas, 221 x 299.7 cm (87 x 118 in.)
National Gallery of Art, Washington, D.C., Ailsa Mellon Bruce Fund

Willem de Kooning

b. 1904 in Rotterdam, Netherlands
d. 1997 in New York, USA

Woman I
1950–1952, oil on canvas,
192.8 x 147.3 cm (76 x 58 in.)
The Museum of Modern Art, New York

If we are to believe what we have been told, Willem de Kooning's doubtless best-known and at the same time most controversial work almost failed to see the light of day. In June 1950 de Kooning, who usually composed his pictures directly on the canvas, had begun work on preparatory drawings for *Woman I*. When the respected art historian Meyer Schapiro visited him in his studio in March 1952, de Kooning had rejected the picture as a definitive failure, and already resignedly removed the canvas from the stretcher. With Schapiro's encouragement de Kooning reworked the painting, however, and soon brought the work to completion.

In March 1953 the picture was exhibited at the influential Sidney Janis Gallery together with five other works from the series entitled *Paintings on the Theme of the Woman*. The magazine *ArtNews* provided flanking support for the event by publishing in the same month a lengthy article about the artist, among other things documenting in photographs the various stages in the difficult gestation process of *Woman I*. The same year as it was exhibited at the Sidney Janis Gallery, the picture was acquired by the Museum of Modern Art.

In spite of this success, de Kooning's *Women* came across to many beholders in the artistic and art-critical penumbra of the New York School, in which abstraction was being celebrated as a progressive achievement in the evolution of contemporary American painting, quite literally as a foreign body. In the œuvre of the artist, the motif of the human figure, by contrast, had been present from the very beginning, and kept turning up, with interruptions during which abstract works came

more to the fore, time and again, as for example in *Woman* (1948), which already heralded the later series.

De Kooning attempted to escape being pinned down to abstraction or figuration, and in 1960 declared in an interview: "Certain artists and critics attacked me for painting the *Women*, but I felt that this was their problem, not mine. I don't really feel like a non-objective painter at all. Today, some artists feel they have to go back to the figure, and that word 'figure' becomes such a ridiculous omen – if you pick up some paint with your brush and make somebody's nose with it, this is rather ridiculous when you think of it, theoretically or philosophically. It's really absurd to make an image, like a human image, with paint, today, when you think about it, since we have this problem of doing it or not doing it. But then all of a sudden it was even more absurd not to do it. So I fear that I have to follow my desires."

The series *Women* was and is controversial not least on account of the seemingly negative image of woman which it presents, in which the depiction of the female figure functions as a projection surface for male aggression. In a wide-ranging discussion, the feminist art historian Linda Nochlin pleaded in 1998 above all for people to view the group of works with a discriminating eye: "I am not sure I can agree with any single evaluation of the *Women* series from the viewpoint of 'positive' or 'negative' gender representation. There is too much ambivalence here. And what, precisely, constitutes 'positive' or 'negative' when a cultural concept like 'woman' (in general) is at stake?" (B. H.)

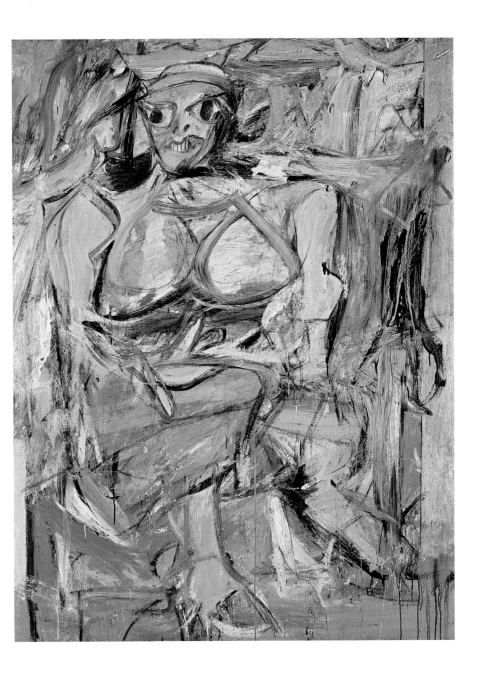

Sam Francis

b. 1923 in San Mateo (CA), USA
d. 1994 in Santa Monica

Saint Honoré
1952, oil on canvas,
201 x 134.5 cm (79¼ x 53 in.)
K20 – Kunstsammlung Nordrhein-Westfalen, Düsseldorf

Sam Francis began to develop his painterly position in the first half of the 1950s. He thus belonged – to use Clement Greenberg's phrase – to the period "after Abstract Expressionism" and to an artist generation which had to confront the dominant influence of artists such as Barnett Newman, Jackson Pollock and Clyfford Still in order to create an independent profile for themselves.

Francis associated the start of his artistic career with a decisive autobiographical experience: in 1943, while training as a pilot for the U.S. Air Force, he had a serious accident, as a result of which he had to spend a number of years lying in a plaster corset. It was in this situation that he took up painting in 1944, an activity to which he ascribed particular healing powers, and ultimately his recovery.

In 1947 he enrolled to study painting at the University of California at Berkeley. At this time, Clyfford Still and Mark Rothko were teaching at the California School of Fine Arts in nearby San Francisco; in spite of what one often reads, Francis was not one of their students, but was certainly familiar with their works through exhibitions in the region. Unlike most of the representatives of the first generation of the New York School, Francis did not reject the European tradition. His decision in 1950 to go to Paris, where he lived until 1957, he explained in an interview in 1988: "I simply wanted to go to Paris; I didn't know what I wanted to do. I went my way. I wanted to be away from the United States. I had the impression that it was a prison and I wanted to see European art.

I wanted to see true painting, no matter which." His primary interest in colourism, in light and colour, received major impetus through the encounter with French painting, in particular with Claude Monet's water-lily pictures, and the painting of Henri Matisse and Pierre Bonnard.

Francis developed his characteristic early-1950s painting technique in 1949–1950: following the all-over principle, the whole surface of the picture is covered in biomorphous forms reminiscent of cells or petals executed in semi-transparent, runny paint. The diaphanous nature of the paint application points to the superimposed colour-veils of Rothko's pictures, while the dripping streaks of paint develop Arshile Gorky's technique of the 1940s. In early-1950s pictures such as *Saint Honoré*, which Francis included in a successful exhibition held at the Galerie du Dragon in Paris, he reduced his colour spectrum to dully glowing white and grey hues, recalling the characteristic milky light of the French capital. Francis himself, however, was less interested in the descriptive function of colour, but constantly raised the question, in his aphorisms, of its spiritual and meditative dimension. According to the art historian Pontus Hultén, Francis, in allusion to Herman Melville's famous 1851 novel *Moby Dick*, had described his brush as the harpoon with which Captain Ahab hunted the white whale. In his later work too, the colour white, in particular as the empty middle of the picture, continued to be of great importance for his painting.

(B. H.)

Ad Reinhardt

b. 1913 in Buffalo (NY), USA
d. 1967 in New York

Number 5 (Red Wall)
1952, oil on canvas,
203.2 x 106.7 cm (80 x 42 in.)
Corcoran Gallery of Art, Washington, D.C.

Unlike the Abstract Expressionist artists Willem de Kooning, Jackson Pollock or Mark Rothko (with whose circle Ad Reinhardt maintained contact, in spite of continually railing against their art) Reinhardt's own work was at no time figurative. From the outset in the 1930s, Reinhardt placed his early post-Cubist collages and his painting strictly in the tradition of abstract art. "It's been said many times in world art writing that one can find some of painting's meanings by looking not only at what painters do but at what they refuse to do," he observed in 1952. For Reinhardt the ultimate resistance consisted in "not confusing painting with everything that is not painting". References to the world of objects or the world of the artist's imagination were thus, for Reinhardt, programmatically excluded. In the painting of Abstract Expressionism, by contrast, he discerned an internal contradiction, which he summed up in 1966 as follows: "The tension between the abstract painters and the Surrealists was clear in the 1930s. Abstract Expressionism mixed them all up."

From 1950 to 1953, Reinhardt worked on series of red and blue pictures in a spectrum of closely similar colour tones, a principle which already points to the barely differentiated, monotone colouration of his extensive series of "black" pictures, which are regarded as Reinhardt's most important achievement. The vertical-format canvas *Number 5 (Red Wall)* is, on the all-over principle, covered with rectangular, in some cases overlapping shapes. The loose arrangement of forms is reminiscent of a collage, a medium in which Reinhardt had taken an intense interest in the 1930s.

It would be inaccurate to describe Reinhardt's red and blue pictures as monochrome, and yet through his use of minimal tonal differentiation he avoided an "interaction of colour", thus achieving a more complex form of unity.

Reinhardt taught in 1952–1953 at the art department of Yale University, where one of his colleagues was the German émigré, the former Bauhaus teacher Josef Albers. In 1950, Albers had begun his best-known and most extensive group of works *Homage to the Square* (p. 463), square pictures in which he investigated the perception of the interaction of three or four square colour fields, in echelon one behind the other. Albers published the results of this investigation in 1963 in the book *Interaction of Color*.

Reinhardt's red and blue pictures of the early 1950s and the transformation that his painting underwent in 1953 are to be seen not least with reference to a confrontation with Albers' project. Thus in his *Chronology*, dating from 1966, he writes, "1953: Gives up principles of asymmetry and irregularity in painting", and, "Paints last paintings in bright colours." While the first change could be seen as a tribute to Albers' *Homage to the Square* (where the pictures are symmetrical and regular), the second decision, namely the renunciation of bright colours, represents a turning-away from Albers' painterly investigations of colour. When the red and blue paintings were publicly exhibited, critics noticed such characteristics as their decorative quality and "beauty", characteristics that Reinhardt sought to remove in his "black" paintings. (B. H.)

Richard Diebenkorn

b. 1922 in Portland (OR), USA
d. 1993 in Berkeley (CA)

"On the farther shore of Abstract Expressionism" was the title in 1996 of the first chapter of a catalogue relating to the San Francisco School. The abstract art which arose from the 1940s to the mid-1960s in the San Francisco Bay Area was for a long time largely regarded as a reflection and further development of influences emanating from the New York School, not least because Mark Rothko and Clyfford Still had taught at the California School of Fine Arts in San Francisco in the late 1940s. Here, though, the question of the autonomy of a West Coast variant of Abstract Expressionism was indeed raised, a variant which was seen to be in itself no less varied and heterogeneous than its East Coast relation.

It is true that artists on both sides of the continent were reacting to a broader international cultural and political situation, and that mutual exchange was promoted by their teaching activities and by joint exhibitions. At the same time, though, a number of local factors have to be taken into consideration, such as the influence of the beatnik subculture in San Francisco, the characteristic West Coast orientation towards Asia and a greater artistic confrontation with the landscape.

Richard Diebenkorn grew up in San Francisco, and after a period of service with the Navy during the Second World War, returned there in 1946. He studied at the California School of Fine Arts, where he took up a teaching post himself in 1947. His painting style, which hitherto had been influenced by Still, among others, changed when he continued his studies in Albuquerque, New Mexico, in 1950–1951; encouraged by the distance he had put between himself and his earlier influences, his application of paint became more fluid, the nuances brighter. In Albuquerque Diebenkorn

also began to take a greater interest in the landscape, as hinted at by the titles of his picture series dating from the first half of the 1950s – *Albuquerque, Urbana, Berkeley*: "Temperamentally, perhaps, I had always been a landscape painter," noted Diebenkorn, "but I was fighting the landscape feeling. For years I didn't have the colour blue on my palette because it reminded me too much of the spatial qualities in conventional landscape. But in Albuquerque I relaxed and began to think of natural forms in relation to my own feelings." This lyrically tinted confrontation with impressions of nature and the landscape was incidentally something Diebenkorn shared with other artists of the second generation of Abstract Expressionism, such as Helen Frankenthaler or Joan Mitchell.

Diebenkorn's *Urbana* series, with its colour fields criss-crossed by lines, was also influenced by two further decisive experiences: the visit of a Matisse retrospective to Los Angeles in 1952 and a flight from Albuquerque to San Francisco the previous year, both of which opened up to the artist a new, abstract way of looking at the landscape, as he recalled in a conversation with Gerald Nordland in 1986: "The aerial view showed me a rich variety of ways of treating a flat plane – like flattened mud or paint. Forms operating in shallow depth reveal a huge range of possibilities available to the painter."

After a figurative intermezzo from 1955 to 1967, Diebenkorn returned in the late 1960s, with his doubtless best-known and most extensive series *Ocean Park*, to the genre of "abstract landscape", a label which *Life* magazine had coined for his work back in 1954.

(B. H.)

Urbana #6
1953, oil on canvas,
175.9 x 147.3 cm (69¼ x 58 in.)
Modern Art Museum of Fort Worth

Robert Motherwell

b. 1915 in Aberdeen (WA), USA
d. 1991 in Provincetown (MA)

"My Spanish Elegies are free associations. Black is death, white is life…
The Spanish Elegies are not 'political', but my insistence that a terrible
death happened that should not be forgot. They are as eloquent as I could
make them." — **Robert Motherwell**

Consisting of more than 200 paintings, the *Elegies to the Spanish Republic* represent one of Robert Motherwell's most extensive group of works. It occupied the artist for more than 30 years. The end of the young Spanish Republic had been sealed in 1939 with the victory of the fascist dictator Francisco Franco following the devastating three-year civil war. *The Elegies* series was not begun until a good ten years later.

The occasion for the black-and-white Indian-ink drawing *Ink Sketch (Elegy No. 1)* was a poem by Harold Rosenberg, "The Bird for Every Bird", which appeared in 1948 in the first and only edition of the magazine *Possibilities* – a project on which Motherwell, Rosenberg, John Cage and Pierre Chareau formed the editorial staff. On the model of the French magazine *Verve*, Motherwell wrote the poem, which has nothing to do with the Spanish Civil War, out by hand and "illustrated" it with an abstract drawing.

The basic elements which were to characterise the whole series are already apparent in the first sketch: the picture surface is rhythmatised by vertical elements, between which oval forms are enclosed. Motherwell was employing the Surrealist technique of *écriture automatique*, to the extent that the first thing he did was apply a spontaneous arrangement of Indian-ink lines to the paper. Unlike Surrealists, however, he did not seek as a next step to create a figurative design from the result, but rather an abstract composition. It was not

until an exhibition at the Samuel Kootz Gallery in December 1950, where Motherwell displayed a number of pictures from the series, that he gave them the title *Elegies (to the Spanish Republic)*.

Elegy to the Spanish Republic No. 34 was described by Motherwell as "one of the half-dozen most realised of the *Spanish Elegy* Series", having been created during what the artist described as a "painting block", in which he spent a lot of time "realising" details. The background colours are a reference to the flag of the Spanish Republic in yellow, red and blue.

In a 1963 interview, Motherwell commented on the *Elegies* as follows: "I take an elegy to be a funeral song for something one cared about. The *Spanish Elegies* are not 'political', but are my private insistence that a terrible death happened that should not be forgot. They are as eloquent as I could make them. But the pictures are also general metaphors of the contrast between life and death and their interrelation." The colours white and black, which play a central role in the *Elegies* series, symbolise according to Motherwell this universal dualism of life and death. Even though Motherwell himself said that the *Elegies* were not political, the topic nevertheless had a political currency, as Spain remained a dictatorship until Franco's death in 1975, and only adopted a democratic constitution in 1978.

(B. H.)

Elegy to the Spanish Republic No. 34
1953, oil on canvas,
203.2 x 254 cm (80 x 100 in.)
Albright-Knox Art Gallery, Buffalo

Philip Guston

b. 1913 in Montreal, Canada
d. 1980 in Woodstock (NY), USA

In the work of Philip Guston, abstraction was an episode which was largely confined to the late 1940s and the 1950s. Like most fellow artists of his generation, he was averse to being called an Abstract Expressionist or to the idea that painting could be fulfilled in a simple self-investigation of the medium. "As a matter of fact, I don't remember in any of the get-togethers I had with painters of that period that that word was exchanged. Nobody ever said, you so-and-so abstract-expressionist, you," recalled Guston in the 1960s.

In the early 1950s, Guston developed a type of picture, new in his work: this consisted of vertical and horizontal brushstrokes, thickly applied, either crossing or cancelling each other out, getting denser towards the centre of the picture and increasing in colour intensity. It is as though a kind of moving veil, "a fog of muted tones", had been laid over the motif. The axial orientation of the brushstrokes has often been compared to Piet Mondrian's "plus-minus" pictures of the mid-1910s which stood at the transition from Cubism to his abstract grid compositions. In addition, Guston's choice of pastel shades in works such as *For M* recalled for many a beholder, on a formal plane, the painting of the Impressionists, so that Louis Finkelstein in a 1956 article in *ArtNews* could speak of Guston's "Abstract Impressionism".

Guston himself described the – figurative or abstract – works of artists who stimulated him as "living organisms" and the painting process as a dialogue with the picture, whose significance was difficult to access even for the painter. As he explained in 1966: "So as I was going to say, for reasons that I do not understand, the late 1940s, early 1950s, when I went into non-figurative painting, although I felt I was even involved with imagery even though I didn't understand the imagery completely myself, but I thought it was imagery, and for some reasons that's not quite clear to me yet and maybe I don't want to be clear about it either…"

This gesture of refusal was interpreted by some critics as a form of repression of traumatic experiences, either private or social, which were vividly present in Guston's painting of the 1930s and 1940s, and which returned with a vengeance in the late 1960s. Thus in the 1930s Guston's pictures were full of the gruesome deeds of the masked members of the racist Ku Klux Klan – a motif from his Southern Californian environment, which in the late 1960s turned up again in his paintings and drawings. Guston shocked sections of the public with his grotesque figures and everyday objects, recalling his early enthusiasm for comics, such as nail-studded shoe soles. From the orthodox perspective of Abstract Expressionism, the return to pictorial narrative was a breach of taboo, "like I had left the Church, and had been excommunicated", he remarked. (B. H.)

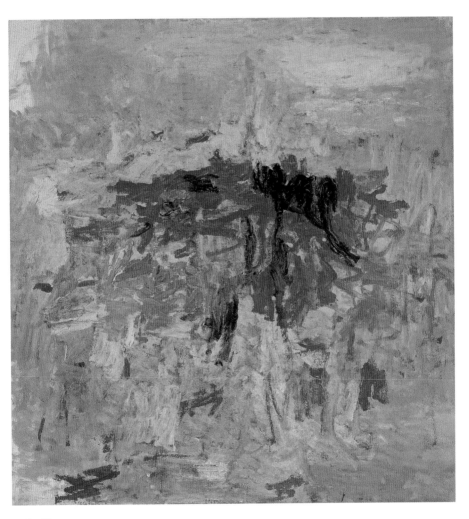

For M
1955, oil on canvas,
194 x 183.5 cm (76½ x 72¼ in.)
San Francisco Museum of Modern Art

Hans Hartung

b. 1904 in Leipzig, Germany
d. 1989 in Antibes, France

T 1956–9
1956, oil on canvas,
180 x 137 cm (71 x 54 in.)
Private collection

In the 1920s Hans Hartung studied at the art academies in Leipzig, Munich and Dresden. His first exhibition took place in 1931 in Dresden, in the Heinrich Kühl Gallery. Four years later Hartung came into conflict with the new rulers of Germany and moved to France, where he fought in the Foreign Legion from 1939 until 1944 (until a serious wound resulted in the amputation of his right leg). In 1946 he was granted French citizenship.

His first attempts at abstract painting date back to the 1920s, but Hartung did not develop his characteristic pictorial language until after the war. No other French painter's work can better be described as lyric expressionism. German Expressionism and French Surrealism were the most significant influences on his style of painting. Hartung further developed Surrealism's *écriture automatique* in his own manner, by condensing the automatic transcription of abstract gestures into a seismographic expression of inner emotional states. In this respect Hartung's approach was very different from that of the American action painters. The latter were interested in transferring onto canvas the movements of the body, unfiltered and unadulterated, while Hartung was after a visualisation of his psychological state of mind on the painting support. He developed the compositions for his works in a state of the most extreme concentration and tension. The actual painting process was usually finished in a very short time. The result was a record of his momentary emotional state.

Hartung's paint application always seemed closer to drawing than painting. The brush marks move across the canvas like a nervous tremor. The titles of Hartung's paintings form a sober antithesis to the emotional process of their creation. The individual elements of the title *T 1956-9* stand for the French title of the painting series (*tableau*), the year it was created, and its sequential number within that year. The layout of its dark scaffolding of lines shifts continually against the light-coloured, spatially indistinct background. The motif appears to float within the picture plane. Hartung's compositions are reminiscent of East Asian calligraphy. Particularly as Hartung continued to develop his theme he also gained a sureness that pushed the aspects of painted automatism ever more into the background, making way for carefully composed stylistic innovation. At that point his compositions became not only more calculated, but also more elegant and decorative.

(D. E.)

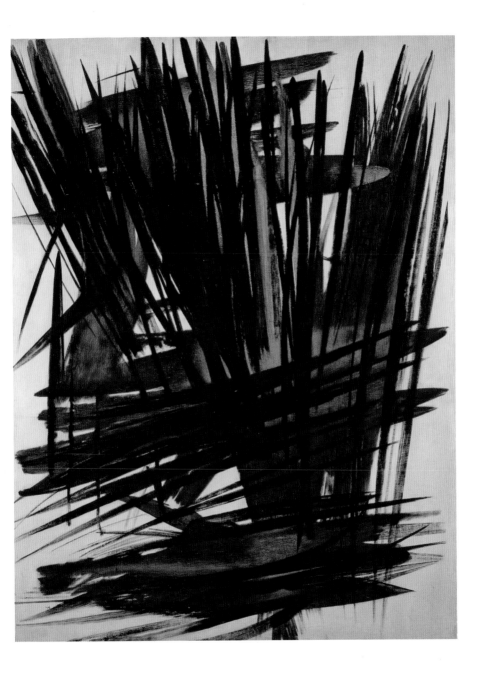

Joan Mitchell

b. 1925 in Chicago, USA
d. 1992 in Paris, France

"My painting is not an allegory, it is not a story. It is more like a poem," declared Joan Mitchell in the 1980s. Mitchell was born into a home that promoted and encouraged her literary and artistic ambitions from her childhood onwards. Her father was a respected doctor who painted and sketched in his spare time; her mother was a poet and published the noted literary magazine *Poetry*.

At an early age, Mitchell herself got to know important works of European art in the collection of the Art Institute of Chicago. In 1947, she moved to New York; from 1948 to 1949 a travel grant enabled her to work as an artist both in Paris and in the south of France. After her return to New York, in 1951 she became, alongside Lee Krasner, Elaine de Kooning and Helen Frankenthaler, one of the few women members of the Eighth Street Club, and participated in major group exhibitions such as the *Ninth Street Show* organised by Leo Castelli in 1951.

Not only experiences of the countryside and the natural world, but also literary texts, often form the reference points for Mitchell's gestural abstractions. The title *Hemlock* (it refers to the conifer) she took from a poem by Wallace Stevens, "Domination of Black", but only supplied it once the picture was finished. The title invites us to interpret the brushstrokes in green and blue – which seem to be hurled outwards from the middle of the picture by some centrifugal force – as the branches of a conifer in a snowstorm. For Mitchell herself, the colour white, which was often dominant in her pictures at this period, had a series of negative meanings, which go beyond its descriptive characteristics: "It's death. It's hospitals. It's my terrible nurses. You can add in Melville's *Moby Dick,* a chapter on white. White is absolute horror, just horror. It is the worst."

In the late 1950s, Mitchell's work came to enjoy increasing recognition. 1957 saw the appearance of the first detailed monograph on her work in *Art News;* in 1958, *Hemlock* was displayed at the exhibition *Nature in Abstraction* at the Whitney Museum in New York, and in this context purchased by the museum.

Unlike the majority of New York artists assigned to the category Abstract Expressionists, Mitchell did not demonstratively seek to demarcate herself from the European painting tradition. On the contrary, she lived and worked from 1955 to 1959 both in the U.S. and in Paris. In 1959 she finally settled in France; thenceforth, her pictures were painted exclusively there, in spite of regular trips to the U.S. This point of time, at the end of the 1950s, also marked a caesura in the post-war art scene. Thus in 1959 Mitchell also took part in the documenta II exhibition in Kassel, which finally sealed the international acceptance of Abstract Expressionism and thus laid the foundations for American art's claim to world leadership in the coming decade.

(B. H.)

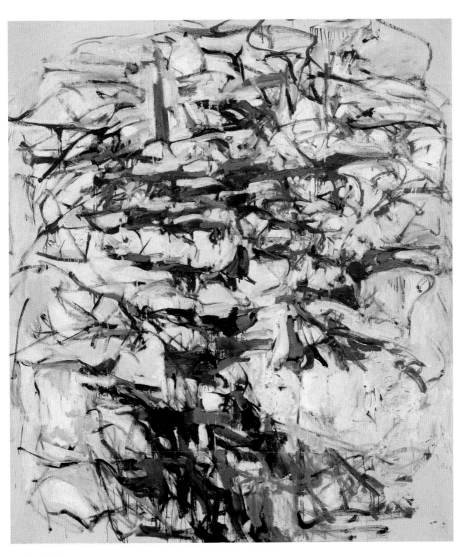

Hemlock
1956, oil on canvas,
231.1 x 203.2 cm (91 x 80 in.)
Whitney Museum of American Art, New York

Adolph Gottlieb

b. 1903 in New York, USA
d. 1974 in New York

*"My favourite symbols were those
which I didn't understand."* — **Adolph Gottlieb**

When the *New York Times* art critic Edward Alden Jewell expressed his "befuddlement" concerning the pictures of Adolph Gottlieb and Mark Rothko, the two artists, in collaboration with Barnett Newman, replied in a letter to the editor, which was published in the paper on 13 June 1943. This reply is still regarded as a kind of manifesto of American painting in the early 1940s. In it, the authors stressed the following aesthetic convictions:

"1. To us art is an adventure into an unknown world, which can be explored only by those willing to take the risk.

2. This world of imagination is fancy-free and violently opposed to common sense.

3. It is our function as artists to make the spectator see our way, not his way.

4. We favour the simple expression of the complex thought. We are for the large shape because it has the impact of the unequivocal. We wish to reassert the picture plane. We are for flat forms because they destroy illusion and reveal truth.

5. It is a widely accepted notion among painters that it does not matter what one paints as long as it is well painted. This is the essence of academism. There is no such thing as a good painting about nothing. We assert that the subject is crucial and only that subject matter is valid which is tragic and timeless. That is why we profess spiritual kinship with primitive and archaic art."

During the 1920s, Gottlieb had studied at the Art Students League and the Parsons School of Design (among other places) in New York, as well as at the Académie de la Grande Chaumière in Paris. During this decade he travelled around Germany and France. His contacts with the European Surrealists confirmed him in his opinion that art could be an expression of the unconscious, and reinforced his interest in archetypal motifs.

Against this background, from 1941 he developed the first of his two extensive groups of works, the so-called *Pictographs*. These go back to an "archaic" or "primitive" imagery, such as the pictograms of the Native Americans, which they embed in grid compositions, which likewise were inspired by narrative pictorial schemas of the Italian early Renaissance as well as by Giorgio de Chirico's Pittura Metafisica.

In 1956–1957 Gottlieb struck out on a new path: the extensive series known as *Bursts* marked the start of a major simplification in the motifs of his painting. On vertical-format canvases, against a spatially undefined, atmospheric background, two vertically arranged shapes, the top one round and more clearly contoured, the bottom one if anything chaotically eruptive, confront each other. The configuration of the two shapes allows numerous interpretations, extending from abstract landscapes to symbols of rival forces. It is revealing that Gottlieb gave the pictures in the *Bursts* series different names – such as *Blast, I* (*1957*), *The Crest* (1959), *Counterpoise* (1959) or *Bullet* (1971) – and thus suggested constantly new interpretations of the motif himself. Gottlieb also translated the motif of the *Bursts* into a series of sculptures, which represent some of the few contributions of this medium to Abstract Expressionism. (B. H.)

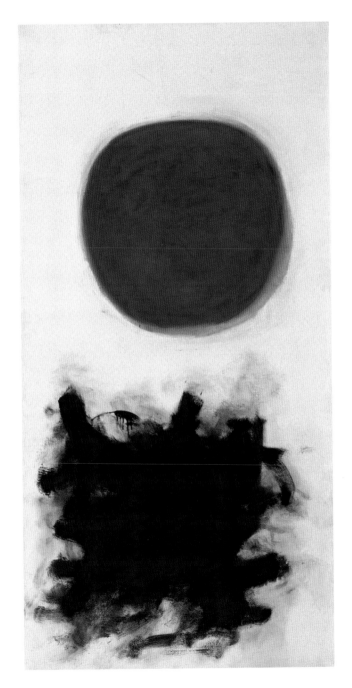

Franz Kline

b. 1910 in Wilkes-Barre (PA), USA
d. 1962 in New York

*"The thing is that a person who wants to explore painting
naturally reflects: 'How can I in my work be most expressive?'
Then the forms develop."* — **Franz Kline**

Untitled
1957, oil on canvas,
200 x 158 cm (78¾ x 62¼ in.)
*K20 – Kunstsammlung
Nordrhein-Westfalen, Düsseldorf*

From the late 1930s until the mid-1940s Franz
Kline often derived the motifs of his then still figu-
rative pictures from his home region, a mining
district in eastern Pennsylvania. The dynamic
compositions of his later abstract works, painted
after the mid-1940s, are often reminiscent of the
characteristic colliery winding-towers of this
region, known there as "tipples", their wooden
structures coming across as rickety and not built
to last. These regional references are further un-
derlined by the titles of the pictures, which refer to
the names of towns or railways in the region.

Even though Kline broadened his colour
spectrum during the course of the 1950s, he is
known above all for his black-and-white pictures.
Clement Greenberg explained this choice (which
was also made by other artists of the New York
School around this time) in his 1955 essay
"'American-type' Painting" as an art-historically
important further development of chiaroscuro:
"And the new emphasis on black and white has to
do with something that is perhaps more crucial to
Western painting than to any other kind." It is true
that Kline had also concerned himself with Orien-
tal art, and as an art student in London in the late
1930s he had collected Japanese prints; for this
reason, his black-and-white pictures were often
linked to Japanese calligraphy, as with *Untitled* in
1957. Kline himself explicitly rejected any such

comparison, as he did not work only with black
paint on a white ground, but also overpainted
black with white and white with black, thus
building up his motifs step by step. His working
method, which involved taking weeks or months
over a picture, during which time he would work
on a number of canvases in parallel, is also not
comparable with the rapid execution of an Indian-
ink drawing on paper. "The Oriental idea of space
is an infinite space; it is not painted space, and
ours is," said Kline in an interview in 1962. "In the
first place, calligraphy is writing, and I'm not writ-
ing. People sometimes think I take a white canvas
and paint a black sign on it, but this is not true. I
paint the white as well as the black, and the white
is just as important."

The starting point for Kline's pictures was of-
ten a spontaneous sketch, which for reasons of
expense he often executed on the pages of tele-
phone directories or on newspaper. In about 1948,
in de Kooning's studio, Kline learnt about the
potential applications of the Bell-Opticon, an
enlargement appliance which allowed drawings to
be projected on to a wall. It was when projecting
some of his black-and-white drawings that Kline
came upon his characteristic technique: transfer-
ring the configurations of the drawings – but with-
out the help of a projector – on to large-format
canvases. (B. H.)

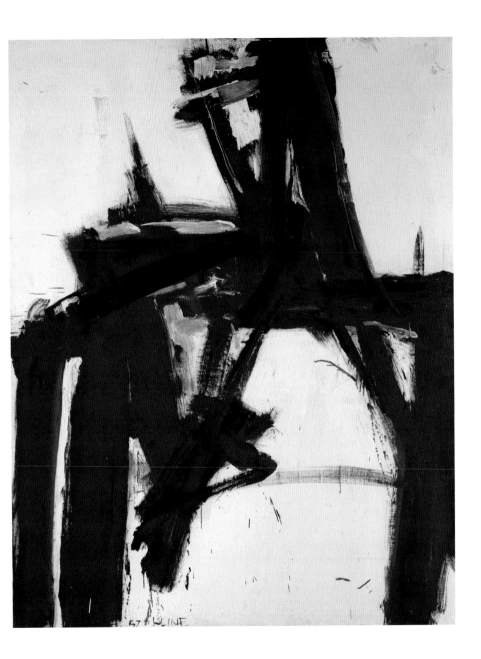

Mark Rothko

b. 1903 in Dvinsk, Russia
d. 1970 in New York, USA

Marcus Rothkowitz was six years old when his family emigrated to the United States for religious reasons. Later he Americanised his name to Mark Rothko and began studying at the renowned Yale University in New Haven. Rothko had his first solo exhibition in 1945 at Peggy Guggenheim's gallery Art of This Century. His work cannot be relegated either to geometric abstraction or to the Abstract Expressionism of his New York colleagues. In his compositions the colours' own values play the central role: one could say Rothko was actually a colourist in the tradition of British painter William Turner, and that he was a mystic of light.

Like no other artist of his generation, Rothko presented his works as a spatial experience. For his gallery exhibitions he selected formats that reached almost to the ceiling, and he filled all four walls of the rooms with his monumental formats. He refused to participate in almost all group exhibitions, and if he did participate in such shows he insisted on having his own room for his paintings. Rothko's ideal was to have a permanent public presentation in one room, comprising paintings he himself had selected. The small exhibition room at the Phillips Collection in Washington, D.C., and the Rothko Chapel in Houston are two of the few examples where he was able to realise this ambition. The designation "chapel" already points to the way Rothko wanted his work to be experienced. Viewers should be able to open themselves to the works, and submerge themselves in the colours. The light should reflect the colour and thus transfer it into the room. The narrowness of some exhibition spaces and the oppressive size of the paintings must have made some viewers feel virtually enclosed within the paintings. Rothko consciously provoked this kind of experience. He once declared, "I also hang the largest pictures so that they must be first encountered at close quarters, so that the first experience is to be within the picture."

In *Red, White and Brown* Rothko layered the three zones of colour to create an atmospheric red colour space. The three colours – red, white and brown – are arranged in a vertical structure. The light white zone below and heavy brown above produce a reversal of weight, and the colours seem to float. Rothko laid out each of the three colours differently. At its edges, the narrow white rectangle blends into its red surroundings, while the orange-red form lying above this produces a delicate transition to the atmospheric colour space. While keeping both colour zones fairly monochrome he applied the upper brown colour in a lively manner, so it appears to be of various thicknesses and in places allows the red beneath it to shine through.

The year in which he produced this composition, 1957, was a turning point in Rothko's work. Looking back he was able to state: "I can only say that the dark pictures began in 1957 and have persisted almost compulsively to this day." Before Rothko's suicide in February 1970, his palette was in fact completely dominated by dark black and grey tones.

(D. E.)

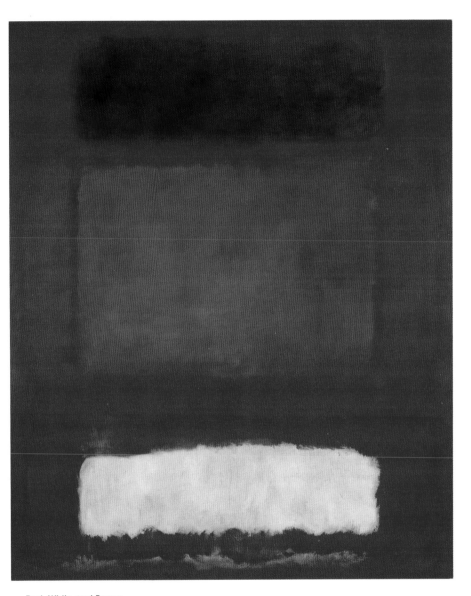

Red, White and Brown
1957, oil on canvas,
252.5 x 207.5 cm (99½ x 81¾ in.)
Kunstmuseum, Öffentliche
Kunstsammlungen Basel

Asger Jorn

b. 1914 in Vejrum, Denmark
d. 1973 in Århus

The paintings of Danish artist Asger Jorn (real name Asger Oluf Jørgensen) have left their stamp on the development of art in the post-war period. His impulses, the archaic motifs and the wild gestures continue to be felt today, for example in the work of Per Kirkeby, and are being taken up by a still younger generation, for example Jonathan Meese and André Butzer.

Jorn went to Paris in 1936, studying under Fernand Léger and Le Corbusier. He spent the war in occupied Denmark. In 1940, together with fellow painters, he founded the periodical *Helhesten* (Horse of Hell), which was an important forum for artistic ideas during the war years. In his own work Jorn tried to combine European Modernism with Danish art and Norse mythology. In 1946 he returned to Paris and formed some important contacts, meeting artists such as Hans Hartung, Wilfredo Lam and Constant. Constant was a crucial encounter: with him Jorn founded the legendary artist group Cobra (1948–1951), which also included Karel Appel, Corneille and Karl Otto Götz. It became the catalyst of his artistic work. Cobra celebrated radicalised subjectivity and the experiment, created form from deformation, gave free rein to spontaneity.

At this time Jorn's painting, indeed his whole artistic mindset, was decidedly anti-bourgeois. He sought for innovative forms of pictorial authenticity, finding models above all in Nordic folk art and the painting of children and the mentally ill. For him, they were pristine and unadulterated. With brushwork that verged on the violent and using contrasting primary colours, Jorn combined figural pictorial ideas with an impulsive gestural abstraction. While figuration was by no means annulled, it was expressively deformed. Thus he found himself at the pinnacle of the avant-garde movements of the time. There are unmistakable parallels between him and the American Abstract Expressionism of Pollock, Kline, de Kooning and Guston, in spite of differences for example in the treatment of figuration. Jorn's *Sell-out of a Soul* (1958–1959) evinces the free gestures that we see in a painting by Pollock – before the viewer has a chance to focus on indefinite figures, the structure comes across as all-over. Within Europe, the paintings have a close relationship with so-called Primitivism, artists like Dubuffet, Wols and Fautrier.

In *Disturbed Grief* the characteristics of Jorn's painting come together in vivid form. The large canvas is dominated by a raw, deliberately coarse simplicity. The elemental colouration is dominated by black and white; above all in the lower part of the picture these colours are given almost pure red, yellow and blue accents. The strong contours, vaguely reminiscent of Picasso, give the structure of the painting a rhythm, and keep it floating between figuration and abstraction. The figures which can be vaguely made out in the pictorial confusion are driven almost to dissolution by the emphasis on impulsive painterly expression. They come across like children's drawings, but in this large format their naivety seems somehow threatening. Jorn increased the deliberate openness of his work by means of a curious procedure for finding titles for his pictures: he would often ask someone else to suggest a suitable one for him. In this way he sought to release the pictures from his own ideas and open them up to more varied possibilities of interpretation. (J. A.)

Disturbed Grief
1957, oil on canvas,
162 x 130 cm (63¾ x 51¼ in.)
Stedelijk Museum, Amsterdam

Hans Hofmann

b. 1880 in Weißenburg, Germany
d. 1966 in New York, USA

Pompeii
1959, oil on canvas,
214 x 132.7 cm (84¼ x 52¼ in.)
Tate Modern, London

After more than 40 years teaching art, in, among other places, renowned colleges in New York and Provincetown, Massachusetts, in 1958 Hans Hofmann closed down his institutes and began to devote himself primarily to his own painting. In the Abstract Expressionist art scene Hofmann was perceived as an influential teacher rather than as an artist, which may have contributed to the fact that only when he was in his 60s was his work to be seen more frequently in solo exhibitions.

Irving Sandler has pointed to the fact that this delayed reception was also due to the cultural climate in New York during the 1940s and 1950s: for one thing, Hofmann's painting in the eyes of curators and younger fellow artists betrayed too much of the influence of the French legacy of Cubism and Fauvism; for another, his optimistic artistic and textual statements hardly fit into a context in which artists such as Adolph Gottlieb, Barnett Newman and Mark Rothko were continually emphasising that the subjects of their art were "tragic and timeless". "Throughout his long career as a painter, teacher and theorist, one would be hard-pressed to find a stroke or word that is melancholy, bitter, ironic or disenchanted," remarked William Seitz, the curator of a comprehensive Hofmann retrospective in the Museum of Modern Art in 1963. Hofmann was "*the* hedonist of Abstract Expressionism, robust and generous", a description which Irving Sandler doubtless used in allusion to another European "hedonist": Henri Matisse, with whom Hofmann had studied in Paris.

In his 1948 essay "Search for the Real in the Visual Arts", Hofmann created the painterly principle with which his name is still linked today: "Depth, in a pictorial sense, is not created by the arrangement of objects one after another toward a vanishing point, in the sense of the Renaissance perspective, but on the contrary (and in absolute denial of this doctrine) by the creation of forces in the sense of *push and pull*."

As there was no way of creating "real depth" in painting by boring a hole in the canvas, Hofmann rejected any perspective illusionism and demanded instead that the intrinsic flatness of the two-dimensional canvas be emphasised. Spatial effects should be generated exclusively through colour contrasts, as in *Pompeii*: flat rectangles in dissonant red, orange and magenta hues contrast with accents in green, blue and turquoise, and create a visual dynamic without disturbing the impression of a wall-like surface. The title of the picture and the dominance of the warm colour tones point to the ancient city on the Mediterranean which was covered in volcanic ash when Mount Vesuvius erupted in 79 AD.

Hofmann's teaching activities not only exerted an influence on the practice of a younger generation of American artists, but also largely shaped formalistic art criticism, which found its most pronounced expression in the writings of Clement Greenberg. Greenberg pointed expressly on a number of occasions to the inspirations he had derived from Hofmann's lectures. (B. H.)

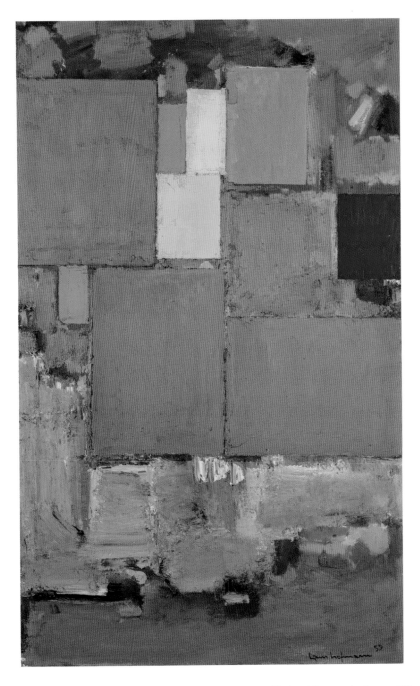

Yves Klein

b. 1928 in Nice, France
d. 1962 in Paris

Yves Klein, whose career was cut short by his early death after only eight years as an artist, has enjoyed the status of a cult figure in Europe for a little while now. Before that the artist, who at positively breathtaking speed "revalued" traditional art values, was largely unrecognised as an avant-gardist. Today when we hear his name we think immediately of his monochrome blue paintings; we think of the fascinatingly intensive colour tone, the "IKB" or International Klein Blue, which uses a particular artificial resin as a binding agent to guarantee the gloss of the pure pigment (a formula which Klein, despite a persistent legend to the contrary, never patented). And we think of the young naked female bodies heavily smeared with this blue, who, as "living brushes", left impressions of themselves on canvas: abstracted, dematerialised signs of their corporeality, mystical colour patterns somewhere between image and gesture. These made Klein at the time a red rag for conservative critics, and for feminists, who saw in such actions not the "spiritualisation" of the flesh, but rather the opposite, camouflaged under the guise of art.

The essential thing about the sequence of so-called monochromes that began with Klein's "blue period" is not the monochrome as such (Klein was after all not the inventor of this reduction principle in the sphere of colouration); what was crucial was the ambitious function that the colour took on. The picture support impregnated with the so overwhelming blue conveys the effect of an indefinite spatiality. The saturated tone becomes an unfathomable depth, a spiritual echo of those melancholy yearnings and dreams of distant lands, which connected the painting and poetry of the Romantic Movement with the blue. The gaze is submersed in the substance of this IKB in its fascinating bottomlessness. If we think of the Tachism, which dominated the Parisian art scene in the late 1950s, of Abstract Expressionism or of Art Informel, of the eruptive gestures, in other words, which were transferred to the canvas, there could be no conceivably greater contrast than the meditative "void" of Klein's monochromes.

This characterisation of the monochromes is necessary if we are to understand the alchemistical transformation which Klein set in motion when, from the late 1950s on, he added natural sponges to these blue grounds. If the pure monochromes intend the disappearance of the visible, the return of painting to the all-over of pristine nothingness, the substance of the sponges, saturated with paint, evokes a new corporeality. At the same time, the structures generated by the sponges occupy the imagination of the beholder. One thinks of primitive organisms on the ocean floor which assemble to form an ornamental configuration. Irrespective of such a semantic, it must also not be forgotten that a sponge relief like the one shown here evokes a sensitive optico-kinetic effect: depending on the position of the beholder, the colour impression varies in the most delicate nuances, and above all there is a change in the shadow pattern, which contributes essentially to the total effect. (N. W.)

Blue Sponge Relief
1958, sponges, gravel, pure pigment
and artificial resin on laminated wood,
200 x 165 cm (78¾ x 65 in.)
Museum Ludwig, Cologne

Lucio Fontana

b. 1899 in Rosario, Argentina
d. 1968 in Comabbio, Italy

According to the artist Otto Piene, Lucio Fontana's idea of the *tagli* (slashes) goes back to a chance event: during the preparations for an exhibition in the winter of 1958–1959, Fontana encountered difficulties, slashed an unsuccessful canvas in frustration and immediately realised the potential of this gesture. Since then it has been given a variety of interpretations. The gaping incisions, whose edges, depending on the technique, curl ouwards, or as in *Concetto Spaziale, Attese,* inwards, are reminiscent of ritual scarification or of the female genitalia. For Fontana the openings in the monochrome canvas, backed by black gauze, also suggested the void, nothingness or the infinitude of space.

Fontana's idea of penetrating the surface of the painting and thereby integrating real space into the picture plane can however be traced back to the immediate post-war years. It was as early as 1949 that he made what he called his greatest artistic "discovery" with the first *Concetto Spaziale*: he perforated a metre-square sheet of paper mounted on canvas with numerous holes. In their irregular circular and spiral arrangements these recall constellations or spiral nebulae. From then on almost all of Fontana's works were given the title *Concetto Spaziale*.

In the late 1940s, the artist, who was born in Argentina in 1899, and until 1947 divided his time between his homeland and Milan, could already look back on an artistic career lasting a quarter of a century, during which he had mostly worked as a (predominantly figural) sculptor. His studio was destroyed by the bombardment of Milan during the Second World War, a historic caesura, which forced him to reorient his artistic activity. He then launched a new artistic movement in northern Italy.

His *White Manifesto* of 1946 and the *Spazialismo* art movement took up the ideas and motifs of Futurism; while abandoning the latter's aggressive rhetoric and glorification of war, it shared the enthusiasm of the Futurists for dynamism, speed and technology, and also their desire to transcend Italy's seemingly insuperable art-historical legacy, such as the illusionist perspective of the Renaissance.

In 1950 it was still as a sculptor that Fontana was invited to take part in the prestigious Venice Biennale. He always understood his slashed and perforated canvases, which he produced in a multitude of variations right up to his death in 1968, as a continuation of his sculptural, space-oriented ideas by other means. And so he surprised the Biennale jury with the presentation of 20 perforated canvases: a clever way of introducing his new technique to maximum public effect.

(B. H.)

Concetto Speziale, Attese
1959, watercolour on canvas,
91 x 91 cm (36 x 36 in.)
Private collection

Frank Stella

b. 1936 in Malden (MA), USA

Die Fahne hoch!
1959, enamel paint on canvas,
308.6 x 185.4 cm (121½ x 73 in.)
Whitney Museum of American Art, New York

The large-format painting *Die Fahne hoch!* (The Flag on High!) by Frank Stella confronts viewers with such power, consistency, radicality and self-assuredness that one is inclined to see it as the pinnacle of a lifelong artistic development. When the painter first presented the work in December 1959 at the New York Museum of Modern Art's exhibition *Sixteen Americans,* he was only 23 years old, and had just finished studying at Princeton University. Stella's *Black Paintings* of this year formulate an extreme artistic position from which he progressively freed himself in the years that followed. While in the first versions of his *Black Paintings* he still positioned the bands of paint parallel to the edges of the paintings, in later motifs of the so-called *Diamond Pattern* series they run at an angle of 45 degrees. Not until a later phase did Stella give up black completely and begin using a metallic aluminium paint. At the same time he reversed the hierarchy between painting support and motif, in that the painting support's exterior contour now followed its interior pattern of stripes.

In the New York art scene at the end of the 1950s Stella's concentration on the non-colour black in his *Black Paintings* was no longer provocative. Robert Motherwell, Jackson Pollock and Franz Kline had already produced black compositions. Stella's works, however, were radically different and new. At the centre of the canvas two light-coloured lines form a cross. Stella painted right-angled black bands, approximately eight centimetres wide, at close intervals. There are only horizontal and vertical bands in this painting, and they always run parallel to one another. Stella explicitly attempted to avoid painterly perspective, and the width of the black stripes was another way to achieve this. For although he applied the black paint to the unpainted canvas, which shows through as white lines between the black bars, traditional seeing habits cause viewers to initially perceive the motif as narrow light-coloured lines on a black background. While one could speak of painterly illusionism in this respect, this actually reverses the relationship of figure and ground, thus simply emphasising the painting's flatness. "What you see is what you see," was Stella's most famous and often repeated statement regarding his paintings. This formulation refers to the anti-illusionistic character of his pictorial concept.

Stella's painting style denies all interpretations that go beyond visible form. The imagery is not symbolic and it negates the idea of a painting as a view out a window onto a world view created by the artist. Stella consciously avoided using traditional oil paint and preferred industrial enamel paint. At eight centimetres, the stretcher frame was exactly the same depth as the width of the black stripes, making the picture plane into a picture box.

In this context only the piece's German title is confusing. *Die Fahne hoch!* quotes the first line of the notorious Nazi "Horst Wessel Song". As another painting title Stella selected the words *Arbeit macht frei,* the cynical inscription over the gate at the concentration camp Auschwitz. Stella himself, who studied history at Princeton, spoke of the repressive political atmosphere such titles expressed, and that he wanted them to be understood as personal associations, but by no means as interpretive approaches for viewers. In view of the portentousness of such titles, however, a contradiction remains. (D. E.)

Cy Twombly

b. 1928 in Lexington (VA), USA
d. 2011 in Rome, Italy

Cy Twombly belongs to the second generation of Abstract Expressionists. His early work shows the influence of Robert Motherwell, with whom he studied in 1951 at Black Mountain College. Soon, however, Twombly began systematically to challenge the painterly gesture in his own work, drawing while wearing a blindfold or with his left hand to hinder his execution. In the mid-1950s, he began to cover his canvases with scribbles resembling handwriting using pencil on oil paint. These works are frequently likened to a child's doodles, but the fact that Twombly was introducing an element of existential doubt into normally self-confident Abstract Expressionism is more significant. Although he still was using the whole canvases as surfaces in the manner of Jackson Pollock's all-over painting, he filled them with his own insistently questioning self-reflection.

By 1961, Twombly had also geographically distanced himself from the New York School. He lived in a historical palazzo in Rome, had been married for two years and had a young son. This period saw colour – mainly shades of red – returning to his paintings, which now have titles alluding to classical themes and the great tradition of Roman art: one is called *The School of Athens* after Raphael's fresco, while *The Age of Alexander* refers both to the Hellenic conqueror and to the name of Twombly's son. At first glance, these themes appear to be reflected in the titles alone, but one can also find in the painting themselves motifs that refer back to Rome and the legacy of antiquity.

The picture shown here is untitled, although it bears the inscription "Roma 1961" and reminds one of the City of Seven Hills through its diagonally ascending composition and the house- and roof-like forms in the upper middle section. However, if you stand in front of the painting, what is most striking is not the landscape-like composition as a whole, but how heterogeneous the painterly touch is. A phallus is clumsily doodled on the canvas, and elsewhere there's a heart or an eye. Top left, there's a series of numbers up to 15: maybe it goes on further, but one cannot tell, because they are painted over with white in the same way as the artist's name in the centre of the picture. Clumps of colour straight out of the tube cling alongside big splashes that look like burst paint bombs. Furthermore, the determinant diagonals look as if they have been dragged across the pictorial ground by the fingers of a paint-covered hand. It looks like a wall covered in graffiti – like the scrawlings on a toilet wall that one will find today, or left over from the days of ancient Rome.

The eye jumps back and forth across the painting, finding small, unspectacular pictorial events all over that appear unplanned, more like nervous short circuits in the creative process. Twombly's gestures have almost become private, and his repertoire of recurring symbols and forms no longer has anything to do with Expressionism. For his contemporaries, this art was too rough and simple, and it would be almost two decades before the glimmering, site-specific atmosphere could be recognised in the paintings. In Roland Barthes' retrospective assessment: "The inimitable art of Twombly consists in having achieved a Mediterranean effect using materials (scratches, smudges, smears, little colour, no academic forms) that have no analogy with the great Mediterranean radiance."

(L. E.)

Untitled
1961, oil, wax crayon, crayon
and pencil on canvas,
202.5 x 240.5 cm (79¾ x 94¾ in.)
Private collection

Josef Albers

b. 1888 in Bottrop, Germany
d. 1976 in New Haven (CT), USA

In his artistic practice, Josef Albers was also a scientist: throughout his life he was fascinated by the subjectivity of perception in regard to colour, surface and space. As a painter, art theoretician and teacher (first at the Bauhaus in Weimar and Dessau, from 1933 on at the legendary Black Mountain College in North Carolina) he was a seminal figure for the development of non-objective art, in particular in the United States, where he taught numerous young artists including Robert Rauschenberg, John Cage, Kenneth Noland and Donald Judd, and later at Yale also Eva Hesse and Richard Serra.

Albers' works are precisely composed optical confusions. He experimented with ambiguous geometric forms and occupied himself intensively with the relativity of colour. Albers interpreted vision as an interactive process: in his main theoretical work *Interaction of Color* (1963) he describes colour as the interaction of "factual facts", in other words objective optical data, and "actual facts", the subjective visual experience.

The work group entitled *Homage to the Square* is doubtless one of Albers' best-known efforts today. He only started on it at the age of 62, and by the time of his death in 1976 had created more than 1,000 *Homage* pictures. The group thus constitutes an intense late work. The structure of the paintings is austerely relational and is based on precise reductionist decisions. For example, no motif may be repeated except the format itself in gradations. Mostly four, but sometimes just three squares seem to be superimposed or arranged in perspective echelon. The composition follows the proportion of one to two to three: downwards the intervals are single, laterally they are double, and upwards they are threefold. Thus we have the characteristic bottom-heaviness of the picture,

which Albers could then fill with colour, so to speak, and interpret the colour both two- and three-dimensionally. But he was never interested in whole series of experiments; every picture is a one-off and painted to achieve a specific effect, which Albers made clear with supplements to the title such as *Homage to the Square: Tenacious* or *Homage to the Square: Warm Silence*. In these pictures, incidentally, Albers used identical colours but in different combinations, in order to generate a totally different total impression through this means alone.

To understand Albers' pictures it is very important to understand his approach to painting and craftsmanship: he worked without masking tape, in order to ensure that the areas did not have sharp contours. He applied paint with a palette knife, leaving edges untreated, so that at transitions one colour would intermesh with the other to create intense optical combinations. Particularly important was the light: Albers used a chalk ground consisting of six to ten layers, in order to make the colours glow. All the *Homage* pictures were painted under fluorescent light. Albers painted with the surfaces lying flat on a table, above which the strip lights were installed alternately warm–cold–warm–cold. A second table was illuminated with tubes in the sequence warm–warm–cold–cold, and all of the pictures were subjected to both stages. Albers never mixed his colours, but used industrially produced paints straight from the tube, noting the name and product number on the back of the picture like a formula. In this way he ensured the comparability of the colour tones, which in other pictures, in new combinations, often appeared entirely different.

(J. A.)

Homage to the Square: Tenacious
1969, oil on masonite,
61 x 61 cm (24 x 24 in.)
Mr. and Mrs. Lee V. Eastman Collection

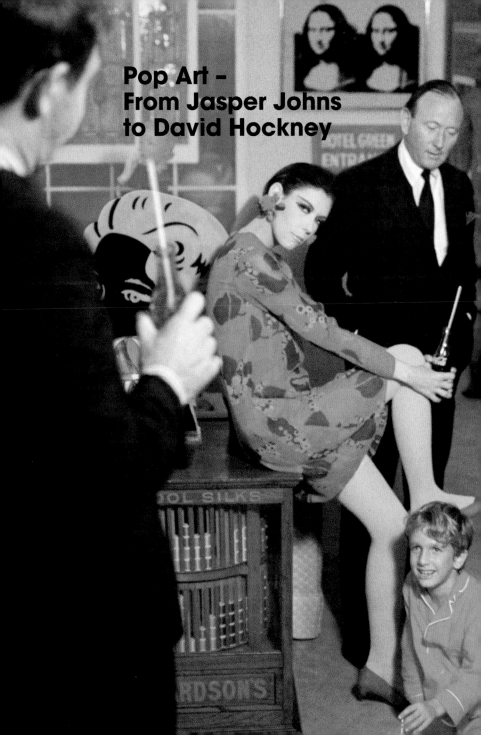

Pop Art –
From Jasper Johns
to David Hockney

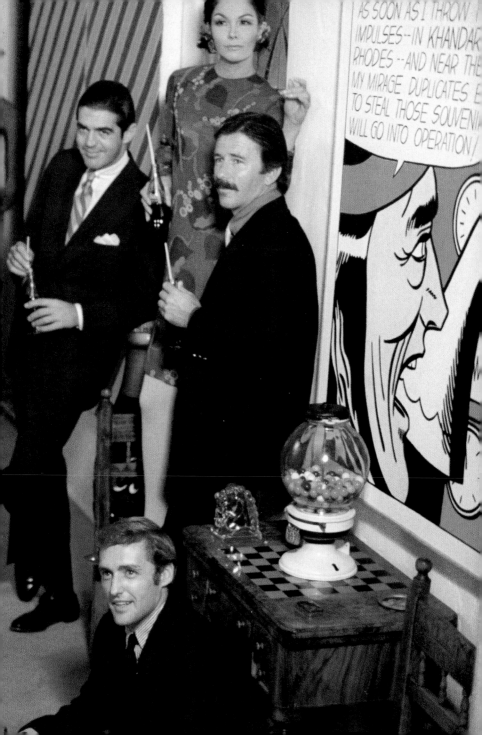

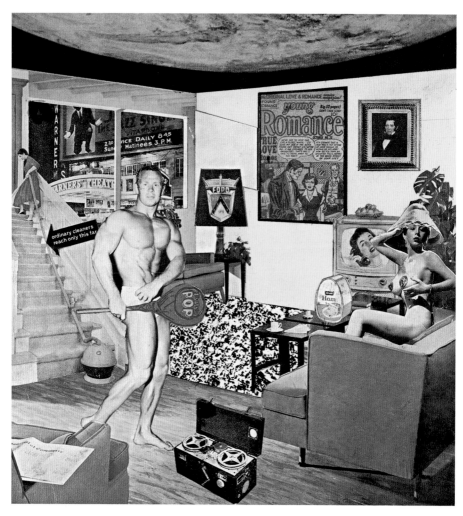

Richard Hamilton
Just what is it that makes today's homes so different, so appealing?
1956, collage, 26 x 25 cm (10¼ x 10 in.)
Kunsthalle Tübingen

Pages 464–465
At Dennis Hopper's home,
Los Angeles 1965
Photo: William Claxton

The Tension between Art and Reality

Klaus Honnef

The Success of Pop

Its godfather demurred, saying he did not suggest the baby's name. At least not in the form that has since become a household name worldwide: Pop Art. Mere modesty, British understatement? Lawrence Alloway, an English art critic who later moved to New York, qualified the notion that he had coined the term Pop Art. "Furthermore, what I meant by it then is not what it means now. I used the term, and also 'Pop Culture', to refer to the products of the mass media, not to works of art that draw upon popular culture. In any case, sometime between the winter of 1954–1955 and 1957 the phrase acquired currency in conversation…"[1]

By the time Alloway put this straight it was 1966, and Pop Art had long soared from its launching pad in modest shows at art schools and tiny private galleries into the orbit of the contemporary art sphere. Yet the geographic location of its success was not England, where a handful of young architects, authors, artists and intellectuals had early on discovered the charm of the brash vocabulary of the commercial mass media and established an informal committee, the Independent Group, at the Institute of Contemporary Arts in London. The key location was the United States,

where, almost simultaneously and with no knowledge of British developments, young artists began to charge the language of art with the visual jargon of the streets. More precisely, the place was New York, and even more precisely, Manhattan. Names like Roy Lichtenstein, Claes Oldenburg, James Rosenquist, Tom Wesselmann, Andy Warhol, Robert Rauschenberg and Jasper Johns. Their paintings and sculptures celebrated the idiom of urban culture – advertising, comics, photography, design – with sometimes affirmative, sometimes ironical or critical intent.

The enthusiasm generated by Pop ever since it first saw the light of day in small exhibitions has still not cooled. On the contrary, it has continually grown. An artist like Andy Warhol is just as much a pop idol as the latest movie or music superstar. And not without reason. In retrospect, Warhol appears to be the most significant, because most consistent, representative of Pop Art. The only surprising thing is that despite the fact that no one seriously questions his artistic rank, he enjoys a popularity accorded to no other visual artist, with the possible exception of Picasso. So one man, at any rate, has evidently succeeded in bridging the still deep chasm between demanding art and wide popularity. From the start, an abundance of misunderstandings and misconceptions surrounded the group of Pop Artists who broke with many of the conventional ideas about art and yet

[1] L. Alloway, "The Development of British Pop", in: L. R. Lippard. *Pop Art* (1960), 1970, p. 27.

at the same time confirmed many others. Conceptions of art had already become relatively flexible. Art itself had ensured this by raising the continual breaking of rules to the status of a system. The designation "avant-garde" lent a spurious uniformity to a seemingly endless sequence of unconventional works that began to shake the serious academic art world in Paris in the last quarter of the 19th century, and whose liberating impulses soon spread in space and in time. Although many a later artist thought the term avant-garde, used so loosely as to become meaningless, ought to be given back to the military, it quite aptly described the attitude behind a consciously modern art.

At the heart of Pop Art, there lies a dilemma which at the same time represents its most important capital. Ambivalence is that multiplicity of meaning which enables art to overcome its ties with its own period; it should not be confused with arbitrariness. Works of art would be arbitrary if they provided a clear answer to every conceivable question or challenge. They change their nature depending on the point of view from which they are seen, and yet nevertheless retain a validity that transcends the idiosyncrasies of time.

Robert Rauschenberg, one of the forerunners of Pop, stated he had never seen a more beautiful sculpture than Marcel Duchamp's urinal titled *Fountain*. By saying this, Rauschenberg stood the French artist's intention on its head. When he presented a vulgar utilitarian commodity in an art exhibition, the second Armory Show of 1917, Duchamp hoped to provoke a certain reaction. His aesthetic goal was to replace an art designed to please the eye – he called it "retinal art" – with an art of the intellect. Not the object as such was important to him but the train of thought it would touch off in the context of an unfamiliar environment. Thanks to Rauschenberg's fruitful misunderstanding, Duchamp was suddenly installed in the genealogy of Pop, as if he had been interested in trivial everyday surroundings rather than in challenging the art world.

Pop and Avantgarde

On 13 September 1962, the Museum of Modern Art held a symposium on Pop Art, for no visible reason, neither an exhibition nor a purchase having occasioned it. Thanks to its exemplary collection and its groundbreaking modern exhibitions, the museum had long gained an international reputation as an unsinkable avant-garde flagship. The early date of the symposium was nevertheless surprising. At the time, Pop had hardly spread beyond the small, Tenth-Street galleries where works

[2] S. Kunitz quoted in A. Umland, "Pop Art and the Museum of Modern Art: An Ongoing Affair", in: *Pop Art – Selections from The Museum of Modern Art*, New York 1998, pp. 10–23.
[3] P. Selz, quoted in A. Umland (see note 2).
[4] Hilton Kramer, quoted in A. Umland (see note 2).

Jasper Johns
Painted Bronze (Savarin Can)
1960, painted bronze,
height 34 cm (13½ in.), ø 20 cm (8 in.)
in the artist's possession

of its protagonists had been shown. It had not yet arrived at the better Manhattan galleries. Nor had the term Pop yet entered common usage. It was still vying for acceptance with other names, such as Neo-Dada, New Sign Painting or New American Dream. The painting and sculpture department of the Museum of Modern Art owned only six works in the genre.

The camp of Pop enthusiasts was underrepresented on the podium. In truth, it consisted of only a single person: Henry Geldzahler, a young assistant curator at the Metropolitan Museum of Art. Peter Selz, who had organised the meeting and worked at the time as curator in the MoMA exhibitions department, was quite frank about his scepticism regarding Pop. Yet in the crossfire of opposing opinions one key question stood out: Is Pop Art art at all? And by art, the participants meant exclusively modern art, the art of the avant-garde. According to their virtually unanimously held view, the avant-garde represented an art liberated from the mode of depiction, or in expert jargon, "non-representational" art. The standards of aesthetic expression were set solely by art itself – artists were precluded from looking at reality. While Selz censured Lichtenstein for having supposedly translated comic strips "almost directly" into his paintings, the poet and critic Stanley Kunitz accused Warhol's pictures of Campbell's Soup can labels (p. 495) of having been mechanically repro-

duced without the aid of a pencil. Geldzahler's objection that Lichtenstein, at least, had made artistic incursions into the structure of his patterns was greeted by general laughter, then countered by the famous art historian and author Dore Ashton, who maliciously replied that he, Geldzahler, could only have observed that through a magnifying glass.

In the eyes of its prominent opponents, Pop lacked revolutionary elan in the artistic sense. Its "signs and slogans and strategems come straight out of the citadel of bourgeois society," averred Kunitz, "the communications stronghold where the images and desires of mass man are produced."[2] Then Selz struck a further blow, alleging that Pop artists represented "the spirit of conformity and the bourgeoisie."[3] Hilton Kramer summed up the objections with a connoisseur's eye, declaring that Pop was "indistinguishable from advertising art." Both ultimately attempted to "reconcile us to a world of commodities, banalities and vulgarities."[4] In view of such intentions, Kramer insisted that Pop Art must be resisted at all costs. Above the heads of the debaters hovered, like a kind of superfather, the powerful Clement Greenberg. A profound and eloquent critic and man of learning, Greenberg had once provided the theoretical underpinnings for American abstract art and, with his essays and subtle influence, had materially contributed to its worldwide reputation.

Left
Peter Blake
On the Balcony
1955–1957, oil on canvas,
121 x 91 cm (47¾ x 36 in.)
Tate, London

Right
David Hockney
Henry Geldzahler and
Christopher Scott
1969, acrylic on canvas,
213 x 305 cm (84 x 120 in.)
Private collection

With consciously polemical intent, Greenberg projected the German term "kitsch" onto the visual phenomena of mass culture. "Simultaneously with the entrance of the avant-garde," he wrote, "a second new cultural phenomenon appeared in the industrialised West: that thing to which the Germans give the wonderful name of kitsch: popular, commercial art and literature with their chromeotypes, magazine covers, illustrations, ads, slick and pulp fiction, comics, Tin Pan Alley musicals, tap dancing, Hollywood movies etc. etc."[5] It was time, Greenberg added, to inquire into the why and wherefore of this long-neglected phenomenon. Disregarding a few of the genres on Greenberg's negative list, its items add up to the preferred repertoire of Pop Art.

Early Influences

Anyone who sets out to find a historical point of departure for Pop is bound to arrive at Dada or Duchamp. The parallels are more than obvious. Thanks to intelligently composed snippets, the firmament of commercial imagery already shone in the Dada collages of Raoul Hausmann and Hannah Höch, George Grosz and John Heartfield. Max Ernst's phantasmagorical universe was shaped of cuttings from popular illustrations. Scissors and

[5] C. Greenberg, "Avantgarde und Kitsch" (1939), in: *Pollock and After*, London 1985.

paste replaced brush and paint, and illustrated magazines supplanted the media of art. On the other hand, the discovery of mass culture by Pop artists was preceded long before by the Cubists, who pasted newspaper clippings into their paintings, or the American artist Stuart Davis, who depicted a bottle of mouthwash in his painting *Odol*, 1924. The list of possible predecessors could be extended even without once mentioning a Realist.

Pop Art in Great Britain

That the works of British Pop artists were dominated by a frank fascination with the brash factory-made imagery of consumption and the culture of commerce, was not surprising. While the United States experienced a phase of economic prosperity in the 1950s and 1960s and private consumption reached record peaks, Great Britain's economy recovered only slowly from the devastating consequences of the Second World War. When the dreary London streets were gradually brightened by the glamour of commercial advertising and the dreams of Hollywood, artists were as unable to resist their spell as the broad public.

Richard Hamilton, who had made replicas for Duchamp, encountered the visual temptations of consumer culture with mixed feelings. His collage *Just what is it that makes today's homes so different, so appealing?* (1956), a wonderful early example of the aesthetic watershed, brought standard figures

from the realm of trivial imagery into a modern
overfurnished apartment. The work was intended
for publication in the catalogue for the exhibition
This Is Tomorrow, held at the Whitechapel Gallery,
London, in 1956. It also served as the poster motif.

To his way of thinking, Hamilton noted, the
point of the exhibition was not so much to find art
forms as to test values. The Independent Group
opposed those who were primarily concerned
with "creating a new style". They rejected the
notion that "tomorrow" could be expressed by es-
tablishing rigorous formal concepts. "Tomorrow"
would merely expand present-day visual experi-
ences. What was needed, Hamilton continued,
was not a definition of the serious work of art but
the development of a potential perspective, in or-
der to be able "to accept and apply the continual
enrichment of visual material." All of the work of
British Pop artists, including Hamilton, since the
1950s, said Alloway, showed that they "accepted
industrial culture and assimilated aspects of it in-
to their art"[6] in an eclectic and all-embracing way.

The artists had no intention of denying the pri-
macy of art in dealing with the visual challenges
of mass culture. Instead, they set out to adapt a
largely unexploited repertoire – material, as

Hamilton called it – from advertising, movies and
television which could be used to infuse new life
into "high" art, whose once compelling power
seemed on the wane. By so doing, Hamilton, like
every like-minded artist, committed a sacrilege
on Greenberg's definition of the avant-garde. He
focussed on the effects of artistic possibilities.
"If the avant-garde imitates the processes of art,
kitsch… imitates its effects,"[7] decreed Greenberg.
The slightest contact with commercial culture
would infect art and irreparably sully the purity of
the artist's intentions. Peter Blake, Richard Smith,
Derek Boshier, Patrick Caulfield, David Hockney,
Allen Jones and Peter Phillips did address the
visual forms of popular culture to varying extents
and with different intents, but they all blended
selected set pieces from the commercial idiom
into a subjective artistic language and reshaped
them in terms of their personal vision. Their ges-
tures were cool and objective, almost abstract, or
as if borrowed second-hand. In terms of their ar-
tistic procedures, their impersonal and prefabri-
cated touch, they were related to the hard-core
American Pop artists.

In his painting *On the Balcony* (1955–1957),
Peter Blake arrayed the entire arsenal of indus-
trially produced imagery: magazine covers from
Life and *Weekly Illustrated*, picture postcards,
photos of pop stars, a parade of royals, a picture
of Sir Winston Churchill with King and Queen, a

[6] R. Hamilton, "Notizen zu meiner Arbeit", quoted in R. G.
Dienst, *Pop Art*, Wiesbaden 1965, p. 86.
[7] C. Greenberg, "Avantgarde und Kitsch" (see note 5), p. 47.

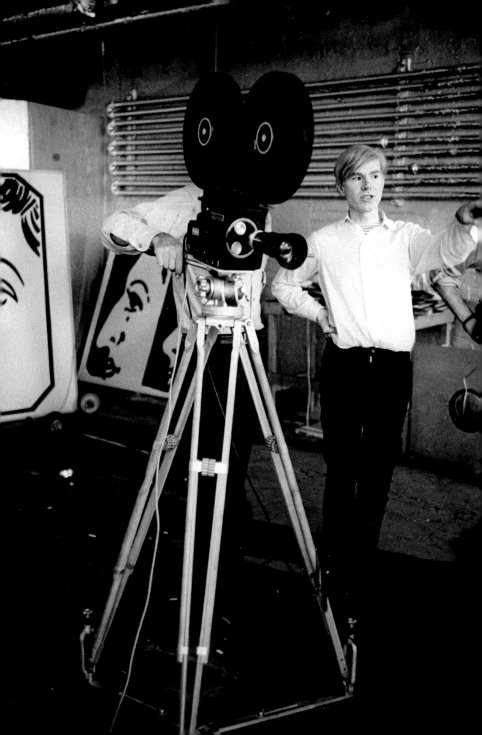

New York Mirror

WEATHER: Fair with little change in temperature.

Vol. 37, No 296

MONDAY, JUNE 4, 1962

C

129 DIE

(UPI RADIOTELE photo)

IN JET!

Andy Warhol
129 Die in Jet
1962, acrylic on canvas,
254.5 x 182.5 cm (100¼ x 72 in.)
Museum Ludwig, Cologne

caricature. On the same level he arranged repro-
ductions of paintings, including Manet's *Balcony*
from 1868. These are accompanied by mundane
commodities such as a half-empty bottle of min-
eral water or soda pop, a margarine package, a
newspaper and many others. The provocation lies
in the mixture. Everything is painted with equal
attention to detail. The result is a painting of ex-
traordinary aesthetic delicacy, a painted collage
and, if you will, a clever retranslation of a "progres-
sive" artistic technique back into Old Masterly
terms.

Allen Jones brought the fury of the feminists
down upon his head. When he emphasised the
breasts, buttocks and legs of his female models to
the point of fetish worship, the verdict was clear:
sexism. Later he created a series of sculptures de-
picting a table, chair and hat stand, that – contro-
versially – used the female figure. These had been
modelled in clay and cast into fibreglass and then
clothed with gloves, boots and corsets. Still, Jones'
objects did not leave the familiar system of art;
they merely stretched it to the breaking point.
He denied having been inspired by commercial
imagery. A head with a necktie under it, Jones
averred, was a "phallic totem image", and thus not

a part of "popular iconography".[8] Private notions
and obsessions were likewise the motive force
behind David Hockney's artistic universe. His
apparently childlike graphic style lent his pic-
tures an aura of carefree innocence, and their
often bright illumination a touch of unreality.
Geldzahler, a friend to whom Hockney devoted a
few portraits, doubted that the artist had any affin-
ity with Pop Art. His reasoning was surprising,
since it detached Hockney's work from contem-
porary influence. His "sources and exemplars,"
said Geldzahler, "are more likely to be the poets
George Herbert and Andrew Marvell or Degas and
Toulouse-Lautrec than this morning's headlines.
Curious as he is intellectually, he has little room in
his working aesthetic for the cascade of data that
crackles about us like static."[9]

None of the British artists of his generation
devoted himself more uncompromisingly to the
spirit and look of commercial culture than Peter
Phillips. His characteristic paintings adapt the
bizarre configurations of the illuminated decor on
pinball machines with their lightning flashes and
aggressively tempting pin-up girls, and blow them
up to a format that veritably blasts the viewer with
an incessant fire of visual stimuli. During a two-
year stay in New York (1962–1964), Phillips bought
an airbrush of the kind he had long considered
using and began to execute his cool imagery with
a technique equally as detached. With his radical

[8] A. Jones, quoted in L. Alloway (see note 1), p. 65.
[9] H. Geldzahler, "Hockney: Young and Older", in:
David Hockney. A Retrospective, Los Angeles 1988, p. 19.

waiver of personal touch, his frank idolisation of commercial imagery and his use of unusual formats, Phillips was not only the most rigorous of British Pop artists but the one with the greatest intellectual and visual affinity to the Americans.

Pop Art in the USA

What distinguished the American artists from the British, their unfiltered Pop ideology, was the result of a break between cultural developments in the U.S. and the European tradition. At exactly what point in time this occurred, cannot be said with certainty. At any rate, the break was provoked and furthered by the burgeoning of that commercial culture which Greenberg denounced as "kitsch". Lichtenstein, Oldenburg, Rosenquist, Wesselmann and Warhol were habitual beneficiaries of the American Way of Life. In addition, during, after or in parallel with their art studies, all of them practised commercial art, either voluntarily or as a way of earning a living. Lichtenstein gained experience as a technical draughtsman and designer of windows and sheet metal products. Oldenburg, from a well-off family, tried his hand at journalism and published drawings in illustrated magazines. Rosenquist worked as a billboard painter for a time and Wesselmann as a cartoonist for newspapers and magazines, in

order to earn their living. The best-known and most successful commercial artist among them was Warhol, who did brilliant mannerist drawings for shoe ads. "Yet all of them," as Lucy Lippard explained, "were artists first and foremost, devoting their energies to serious painting... They have all steered away from the slick advertisement that imitates the modern fine arts."[10]

In the capitalist U.S., success was no stigma – it meant public recognition, even fame, despite the fact that this tended not to be openly admitted. Jasper Johns, whose work is generally associated with Pop, was once moved by a derogatory remark Willem de Kooning made about his dealer, Castelli, to cast two beer cans in bronze, carefully paint labels on them and place them on a pedestal. De Kooning had maintained that Castelli could sell anything as art, even beer cans. And Johns proved de Kooning right.

While Johns kept the option between art and reality open, Robert Rauschenberg plastered his mostly huge-format paintings with all manner of things from the mundane world and charged them with reality. Reproductions of newspaper articles, press photos and pin-ups, street signs, letters, wire, wood, grass, even stuffed chickens and goats populated his painting surfaces. Heterogeneous found objects were embedded in gesturally painted passages, and what might have been a disorganised jumble was coerced into a disparate aesthetic

[10] L. R. Lippard, *Pop Art*, Munich 1968.

unity. Yet the selected actual materials did not entirely fuse with the art. Fields of tension developed between the territories of the artistic and the real. Downtown Manhattan, a vital milieu abounding in artistic talent, was the site of the first group and solo exhibitions of Lichtenstein & Co. Happenings gave vitals impulses to the scene. The artists knew each other through common projects, friends or goals. Oldenburg, like Jim Dine and Lichtenstein, got on extremely well with Allan Kaprow. Rosenquist had gone to school with Oldenburg and Robert Indiana. Despite their intensive training as fine artists, they were all more deeply rooted in commercial culture than Johns or Rauschenberg, Kaprow or the British Pop artists. Their studies had not been limited to art, nor did they immediately succeed in making their mark on the art scene. They had to first detour through various fields of popular culture.

So it is not surprising that after their initial halting attempts in an Abstract Expressionist vein, these artists began to search for aesthetically unexploited and visually powerful forms of imagery and found them in the broad visual repertoire of mass culture. After all, they were experts in the field. The artists appropriated this effervescent idiom almost unchanged, merely adapting specific characteristics to their artistic needs and intentions. They were not satisfied with simply transferring comics, food brands, design, photography,

film and its personnel into the context of art, *à la* Duchamp. Instead, they as it were aesthetically improved the products of popular culture and lent them a permanent, if precarious, value. Pop artists divided up the range of visual popular culture among themselves, and as soon as they had staked their claim to a certain segment, they began to subject it to variation after variation. Lichtenstein voted for the visual schemata of cartoons. Warhol abandoned comics as soon as he saw Lichtenstein's pictures, turning instead to the compelling emblems on soup cans, detergent boxes and soft-drink bottles, then progressing to photographic reproductions of movie stars, accidents or world-famous works of art. Oldenburg produced home appliances and foodstuffs – in unusual materials and on unusually large scales. Wesselmann discovered the hidden desires of the suburban homestead and Rosenquist painted irritating billboard-like images in modish colours of jet fighters, women's legs and cars garnished with spaghetti in tomato sauce. After rapidly staking their claims, these artists proceeded to shape their prefabricated vocabulary into individual brands that might superficially be described as styles.

A further point of agreement consisted of an impersonal artistic treatment of visual motifs and a cultivation of the smooth, perfect paint application of professional commissioned work. The resulting paintings provided no insight into their

makers' mood, mental state, thinking, feelings or aspirations. No one would maintain that Lichtenstein was obsessed with comics, or Warhol with soup cans. Lichtenstein condensed the narrative line of cartoons and its rapid progression from frame to frame into a single, characteristic image. He unified the image, honed it to a point. In his vision of comic imagery, Lichtenstein expressed what the photographer Henri Cartier-Bresson called the "decisive moment". The formulaic visual language of his patterns – which were never taken from recent comic books, but already had a certain patina – permitted Lichtenstein to evoke effusive feelings such as fear and horror, love and hate, without drifting into cloying sentimentality. An ironic overtone frequently reverberated in his pictures, especially when Lichtenstein translated outstanding paintings of classical modernism into the terms of his semiotic and chromatic system. "If a commercial advertising firm had a mind to really knock the public out for a hard sell, they might use one of Wesselmann's paintings,"[11] said Jill Johnston, aptly pointing out the narrowness of the gap between commercial and supposedly noncommercial art.

Wesselmann, who created Pop icons with his series of *Great American Nudes*, explained: "I use a bill-board picture because it is a real, special representation of something, not because it is from a billboard."[12] What might appear puerile and tasteless when seen on a street, takes on an unexpected freshness when encountered in an art gallery or museum.

Rosenquist executed his compositions using the same methods he had learnt as a billboard painter. His decision to expand the painting area to dimensions that viewers could not take in at a glance likewise went back to sophisticated advertising strategies. The artificial world of Rosenquist's art excluded all ordinary reality and replaced it by the artificial reality of popular culture, fascinating and threatening in one. In his compositions an F-111 jet fighter plane might extend across 26 metres of spectacular painting, a gigantic tank appear on diaphanous packaging foil and a VW Beetle mutate into a horrifying insect.

Oldenburg maintained the greatest distance to the culture industry. His art was shot through with fine irony and a covert love of anarchy. Oldenburg reproduced mass-produced consumer articles in papier-mâché and other absurd materials, rendering them useless for any meaningful purpose, or blew them up to such a monstrous scale that they exploded the familiar context and seemed to rock the foundations of civilisation itself. Only in the commercial cinema of an Alfred Hitchcock does the insurrection of objects take on a similarly frightening aspect.

[11] J. Johnston, quoted in L. R. Lippard (see note 1), p. 112.
[12] T. Wesselmann, quoted in R. G. Dienst (see note 6), p. 133.

Tom Wesselmann
Great American Nude
No. 98
1967, 5 canvases arranged
one behind another on
3 levels, 250 x 380 x 130 cm
(98½ x 149½ in. x 51¼ in.)
Museum Ludwig, Cologne

The Pop artist par excellence is doubtless Andy Warhol. He represented Pop not only in his art, but in his own person. Everything that made Pop revolutionary was contained in his work. And he rightly rejected the assertion that Pop was a "counter-revolution". He linked up with artistic ideas that involved neither exaggerated individual-ism nor reflection on aesthetic models. In modern mass media and their technical possib-ilities he discovered an artistic potential suited to modern mass society. Warhol transferred their techniques, materials and forms, with slight retouchings, into the aesthetic field of art. By so doing, Warhol inten-sified the "identity crisis" of painting, which Johns had triggered with his flag (p. 485) and target paintings, into an identity crisis of modern art per se. His posthumous pictures of the movie star Mari-lyn Monroe (p. 497) – were they painted portraits or mythical icons? Warhol's art undermined the re-maining bastions of art-as-art and used the popu-lar media to breach its walls.

In a "Factory" established for the purpose, the indefatigable Warhol oversaw a production of paintings on a division-of-labour, assembly-line basis. The process was half mechanical, half man-ual, employing the silkscreen technique, which

had become a favourite of commercial artists after the Second World War. That the execution was in-tentionally sloppy represented a concession to aesthetic reservations regarding the perfection of popular massproduced imagery. By repeating the same motifs over and over again in endless series, he reflected the standardisation of industrial mass-production. On the other hand, incessant repetition was a time-tested means used by the cultural industry to inculcate the significance of spectacular events.

As director and producer of documentary and feature films, he catapulted himself into cinema history. Warhol was not only the "cool" producer and observer; he was a virtuoso player on the key-board of the cultural enterprise and consciously exploited its rituals for his own purposes. With his canny and slightly subversive activity, Warhol put an end to the fiction according to which a non-commercial approach was an infallible sign of extraordinary art. Erwin Panofsky noted as early as 1936: "Noncommercial art has given us Seurat's *Grande Jatte* and Shakespeare's sonnets, but also much that is esoteric to the point of in-communicability. Conversely, commercial art has given us much that is vulgar or snobbish (two aspects of the same thing) to the point of loath-someness, but also Dürer's prints and Shake-speare's plays."[13] And the images of Pop Art, advertising, motion pictures…

[13] E. Panofsky, "Style and Medium in the Motion Pictures", in: *Three Essays on Style*, Cambridge, Mass and London 1995, p. 119.

Robert Indiana
The Big Eight
1968, acrylic on canvas,
220 x 220 cm (86½ x 86½ in.)
Museum Ludwig, Cologne

Jasper Johns

b. 1930 in Augusta (GA), USA

The by now inevitable question as to the identity of this painting was not raised until ten years after its completion, when the critic Alan Solomon asked whether it was a flag or a painting that represented a flag. It is both, according to the artist's various answers to this question. On the surface, the work possesses many traits of the American star-spangled banner: appearance, the congruence of ground and motif, proportions. Then, too, the painting, in analogy to the flag, consists of three separate parts fitted together: a field with stars, and adjacent fields with red and white stripes to the right and below. In other words, it is a montage. Each star, as in the original, is a separate piece, adhered to the ground. What initially appears to signal an artistic context turns out to correspond to real circumstances. He had dreamed of painting the "Stars and Stripes", the artist explained his baffling decision to treat this subject, and he wasted no time in putting the dream into practice. In fact, he did not depict a flag, but painted the flag. The flag is not the motif of the picture; the picture is a flag. On first view, the subject and painting surface are identical.

From this we may conclude that Jasper Johns was right when he said that the theme of the painting was painting itself – painting in the physical sense, as brushstroke, colour, object. The encaustic technique employed is difficult to handle, because the medium, liquid wax, solidifies quickly and immediately fixes every gesture. Its traces remain visible. Johns began with enamel, but since the drying process lasted too long, he changed to encaustic. The translucent strokes reveal loosely collaged pieces of newspaper underneath. These shimmer through the painted surface and serve as the actual background for the flag's stripes.

In light of a more precise analysis, various layers of meaning crystallise out of this painting with the laconic title *Flag,* that convey complex relationships between reality and art without any clear statement of position, in analogy to the American flag itself. Viewed soberly, the banner is nothing but a printed or dyed and hemmed piece of cloth. Yet in fact it is a symbol of national and social identity in the United States. When the artist executed this painting, the phenomenon of war influenced his view of the world. War in three variants: the Cold War between East and West, the U. S. and the U. S. S. R. competing for world dominance; the hot war in Korea, which had just come to an end; and Senator McCarthy's witchhunt on intellectuals, which was still underway and poisoning the American cultural climate. *Flag,* in many people's eyes a milestone on the road to Pop Art, was viewed by others as an attack on patriotic feelings.

(K. H.)

Flag
1954, encaustic, oil, collage on cloth,
mounted on plywood,
108 x 154 cm (42½ x 60¾ in.)
The Museum of Modern Art, New York

Robert Rauschenberg

b. 1925 in Port Arthur (TX), USA
d. 2008 in Captiva Island (FL)

Attached to the point of the traffic sign reading "one way" is a cord that connects the canvas with a dark, wooden box lettered "open" on the floor. Painting was equally a part of life and art, Rauschenberg once declared, and established his position as an artist in the gap between them. The cord might be seen to embody his stance. It connects heterogeneous things, both actually and symbolically. Various mundane objects are affixed to the canvas in an aesthetically interesting way. The central horizontal axis is emphasized by four notebooks with painted metal covers. These vie for attention with the street sign that literally leads the eye "one way". The surface also contains a photograph of the dome of the Capitol in Washington, D. C., a car licence plate, and scattered digits and letters. These things are overlapped, tied together and accentuated by passages of spontaneous brushwork, which perform the same function as the cord for the three-dimensional objects.

Rauschenberg aptly called the series of works to which *Black Market* belongs "combine paintings". He brought art, which had been spirited into the realm of the sublime and absolute under the aegis of Clement Greenberg and abstract painting, back down to earth by subverting the rigid categories and aesthetic theory of the avant-garde. Just the fact that his works were neither pure paintings nor pure sculptures, but united both disciplines, reflected the tendency of Rauschenberg's intentions.

A friend of the composer John Cage and the dancer Merce Cunningham, and a former student of Josef Albers at Black Mountain College, Rauschenberg organised key happenings and participated in others before beginning to concentrate on space and plane. He is considered one of the forerunners of Pop Art. Yet although his art incorporated much of what would be exhaustively treated by Pop – such as the symbols of transportation and typography – its thrust was different. It was not on the glamorous aspects of urban civilisation that the artist cast his eye but on the used and discarded, things whose glamour had been tarnished, if they ever possessed it at all. His works lend new dignity to the unspectacular, and in retrospect they appear to have much more in common with Abstract Expressionism than with Pop Art. (K. H.)

Black Market
1961, canvas, wood, metal, oil paint,
152 x 127 cm (60 x 50 in.)
Museum Ludwig, Cologne

Claes Oldenburg

b. 1929 in Stockholm, Sweden

Bedroom Ensemble 2/3
1963–1969, installation,
303 x 512 x 648 cm
(119¼ x 201½ x 255 in.)
*Museum für Moderne Kunst,
Frankfurt am Main*

Claes Oldenburg objected to high-flown interpretations of his work. The foodstuffs, he wrote about this collection of pastries in a showcase, were naturally not edible. A little thought was enough to reveal that they were not real but manifestations of art that were self-sufficient rather than serving purposes of any kind. Oldenburg took nine different products of an average pastrycook's imagination, made plaster versions of them, and painted some in an Expressionist manner. A blueberry pie, a few scoops of ice cream, a toffee apple, a banana split, arranged on plates or platters – traditional products often advertised as "home made", yet mostly straight from the factory. In the present case, however, they are truly "hand made", by the artist. Most of these supposed delicacies were shaped of coarse canvas or muslin, dipped in plaster, spread over a wire framework, and finally painted. The difference from the originals is immediately obvious. Neither in terms of form nor colour is any exact resemblance to food strived for, quite unlike, for example, the astonishingly real-looking wax displays in Japanese restaurants. Rather, we gain the impression that the artist's miniature sculptures were primarily intended as parodies of Expressionist painting and sculpture. On the other hand, he alludes to the great tradition of Netherlandish still-life painting, those magnificent depictions of poultry, fish, hams, vegetables and fruit which, apart from physical enjoyment, celebrate the skill of the artists and moreover, in the manner of conspicuous consumption, shed light on the hedonism of their clients and the shadow of memento mori it casts.

Yet Oldenburg's acid humour warns us against overestimating such links: "I am for the art of … sat-on bananas", he once declared. By the way, *Pastry Case I* is a key document in the history of Pop Art. It is a re-creation of a work in the legendary show *The Store*, held in the Green Gallery in Manhattan in 1962. The dealer Sidney Janis purchased it there for $324.98 and included it in his renowned Pop exhibition *New Realists*, which opened on 1 November of the same year. This exhibition brought together American and European Pop artists such as Lichtenstein, Oldenburg, Warhol, Klein, Arman and Niki de Saint Phalle. It is generally considered to have marked the international breakthrough of Pop.

(K. H.)

Pastry Case 1
1961, burlap and muslin soaked in plaster,
painted with enamel, in glass-and-metal case,
52.7 x 76.5 x 37.3 cm (20¾ x 30 x 14¾ in.)
The Museum of Modern Art, New York,
Sidney and Harriet Janis Collection

Peter Phillips

b. 1939 in Birmingham, UK

Although he is considered the most American of British Pop artists, Peter Phillips took the European tradition as the framework for his paintings. He looked far back into history, to a period before the renewal of art brought about by the Renaissance. In view of the formal nature of his preferred iconography – as in the present combination of lion and eagle, two mythological creatures, in a single visual context – Phillip's explanation seems surprising. Obviously his visual language was derived from the storehouse of popular culture. The stereotypical character of the depiction, drawing and palette leave no doubt about this. On the other hand, he has arranged the elements in this early composition in the way that medieval artists used to tell the stories of the Bible, in simple, separate fields that occasionally overlap at the edges. Phillips describes his pictures as combinations of spatial, iconographic and technical factors working together in a single motif. In pre-Renaissance painting, he adds, there is a complex visual situation with a central image and other, related scenes depicting a story or a phenomenon. The centre of the present composition is occupied by two lion's heads in a circle. They are approach-

ed by an eagle with mighty wings, depicted against a dark-green background. These are likely familiar manufacturing trademarks that consciously allude to the mythological significance of the animals and their symbolism of courage and power. Today mythology no longer serves its erstwhile function of explaining the world, but is merely exploited to create an effective image for commercial products. The ensemble is topped by schematically rendered rays in alternating red and yellow, and two discs enclosed in triangles, below them two stars, yellow and black on a white ground, both labelled "star".

Despite its figurative forms the painting has an abstract appearance. It is executed like a blueprint, yet the things depicted do not go with one another. It is solely their arrangement, repetitions and correspondences that lends them aesthetic plausibility. In *Lion Versus Eagles* – a title, incidentally, that reverses the visible fact – a sort of integrative visual model of narration comes into effect whose content, rather than being conveyed by a sequence of images, results from a merger and interweave of heterogeneous visual elements. (K. H.)

Wayne Thiebaud

b. 1920 in Mesa (AZ), USA

Pumpkin pie, lemon meringue pie, wild berry cake and chocolate meringue pie. Four varieties of cakes laying here on plates as if in a glass display case in a self-service cafe, three plates side by side, and it all probably continues for a few metres to the right behind the bit cut off by the edge of the picture. In this composition, the production of the pastry is a pictorial theme as well, since this is recognisably mass-produced frozen food. So it's not just a still life that is waiting in line for someone to take away, but the painting connotes the whole culture of food that these artificial delicacies stand for.

Wayne Thiebaud had his breakthrough at the advanced age of 42 with his first exhibition in New York. He exhibited about 40 pictures of foodstuffs, which seemed to fit perfectly into the context of the up-and-coming Pop Art. In the same year he also participated in one of the most important early group shows by pop artists, *New Paintings of Common Objects* at the Pasadena Art Museum, in which Andy Warhol, Roy Lichtenstein, Jim Dine, Ed Ruscha and others were also involved. Thiebaud's professional background – he had earlier worked as an illustrator for Disney productions and as a commercial artist – fitted in well with the movement, as did his way of working in series, but his paintings were strikingly different nonetheless.

With Thiebaud, pleasure in consumption played a much greater role than any critical engagement with the enticing but impersonal symbolism of advertising. The painter was interested in "what happens when the relationship between paint and subject matter comes as close as I can get it – white, gooey, shiny, sticky oil paint spread out on top of a painted cake to 'become' frosting. It is playing with reality – making an illusion which grows out of an exploration of the propensities of materials." It is striking here how far Thiebaud is removed from the core of Pop Art. He addresses the same issues as Oldenburg and Warhol, but he behaves like a pastry chef in the ranks of the Pop Art brigade and, in contrast to the factory-produced wares depicted, the subjects of his art are lovingly and individually hand-coated with a thick impasto. Thiebaud's painting is realism in the classical sense. Even if he often orchestrates articles into revue-like compositions, his interest always remains alert to their specific natures.

Thiebaud does not just paint pastries: in addition to other confectionery and fast food, he has also produced urban landscapes with sharply distorted perspectives as well as figure paintings, where he somewhat primly drapes his people side by side just as decoratively as a still life. Nevertheless, the cakes and pastries are still his trademark. How did that happen? "It started out just as a sort of crazy problem to set for myself to orchestrate abstract elements with the subject matter. As soon as I did that, I couldn't help but look at it and laugh, 'That certainly has to be the end of me as a serious painter – a slice of pie.' But I couldn't leave it alone. It just seemed to be the most genuine thing which I had done." It is also this special, most ambiguous authenticity, in the pursuit of which he elevates an artistic product as a consumer item to the subject of art as a commodity that accounts for the enduring status of these paintings.

(L. E.)

Pies
1961, oil on canvas,
55.9 x 71.1 cm (22 x 28 in.)
Private collection

Andy Warhol

b. 1928 in Pittsburgh, USA
d. 1987 in New York

When Andy Warhol first exhibited his pictures of Campbell's soup cans in July and August 1962 – 32 all told – he presented them in the way tinned foods are offered for sale in a supermarket, in orderly, evenly spaced rows. Quite in keeping with the guidelines of "product placement", in other words, commercially oriented aesthetic considerations. The site of the demonstration, however, was no ordinary supermarket in Los Angeles, but the Ferus Gallery, a pioneer in the propagation of Pop Art. The paintings cost 100 dollars each, compared with 29 cents for the original. In terms of technique, the pictures were a semi-mechanical product – a mixture of painting, silkscreen and a stamp process, practices partly manual and partly industrial in nature. Although a superficial glance revealed no differences between the individual, 50.8 x 40.6 cm (20 x 16 in.) images, they in fact differed in a key detail, each representing a different kind of soup, an individual taste beneath the monotony of the packaging.

The exhibition represented a conscious provocation, triggered not only by the mundane motif and its stereotyped depiction, but by the parallels purposely suggested between art gallery and supermarket, art trade and food trade. For Warhol, who had studied sociology, the social context in which a work of art is presented was just as important as its specific subject, and the subject itself invariably reflected its social background. Campbell's soups, Coca Cola, Kellogg's Cornflakes and Brillo detergent, industrially produced commodities of American civilisation, lent the dignity of art by Warhol, shaped the life of the American middle class, of which he was part, as much as sex and death.

A later, enlarged, and isolated version of the tomato soup can, might convey the erroneous impression that Warhol was out solely to apotheosise an idiom of popular culture. In fact its social effects were equally important to him. "What made America fabulous," Warhol once explained, "was that it established a tradition in which the richest consumers basically bought the same products as the poorest. You could watch television and drink a Coca Cola, and you knew the president drank Coke, Liz Taylor drank Coke, and there you were, drinking Coke, too. A Coke was a Coke, concluded Warhol, and no amount of money could buy you a better one."

This insight perhaps explains why he set out to achieve something similar in the field of art. With the aid of standardized production methods, Warhol infused art with the magic of the perpetually same. After photography had entered the cultural scene as the "great leveller" (Jonathan Crary), Warhol followed its cue in the field of art. (K. H.)

Andy Warhol was a master of the celebrity cult. He played a virtuoso game with pre-formed perceptions, with images from the realm of the familiar. From 1962 on, portraits played a major role in his œuvre, even though he was not a portraitist in the traditional sense of the word. Warhol sent the first client who wanted to commission a portrait from him into a photo booth. His portraits therefore were based on photographic originals which he revised using multiple techniques.

After Marilyn Monroe took her own life with an overdose of sleeping tablets on 5 August 1962, a sensation industry set about creating her apotheosis. Warhol played an artistic part in this process in his own way. He had just begun to experiment with photographs of film stars when the news of Marilyn's death broke. Now.he produced memorial pictures with iconic status, a transfiguration of the star into a transcendent sphere through the power of the picture. And in doing so, he put his finger on the nerve of popular culture. By pointing to a charismatic life as a star and its moments both tragic and glamorous, the artist directs attention back to the public who generated, fed and at the same time consumed the myth of the star. Warhol had noticed early on this interaction between popular culture and consumerist compulsive behaviour. It was one of the many driving forces behind his art.

The picture is based on a still taken during the filming of *Niagara* (1953). It is an aspect of the star cult that the photograph diminishes detachment and unapproachability. Yet a nearness, however it comes about, created by the photo always remains stylised, being condensed from one's own desires and fantasies. Warhol was perfectly well aware of this. He cut out the head and had a serigraphic screen made. The first prints on canvas were in black and white, individually or in as many copies as required. Warhol went a stage further and prepared the canvases with patches of colour to underlie the individual parts of the face. Some were larger, in order to factor in the variations that arose as a result of the intentionally irregular printing process. Often the quantity of colourant changed, often the print slipped, but Warhol always accepted the result. Thus all the works, no matter how mechanically they came across, had an autograph quality, an artistic signature. Since the underlying picture is not rejected, but artistically reshaped, an effect is created that a star photo as such can hardly achieve.

With *Gold Marilyn Monroe* (1962) he then indeed exploited the pictorial effect of the icon. He placed a single relatively small Monroe portrait on the canvas and sprayed the remaining surface in metallic gold paint. Hovering over the gold ground like a Madonna, Marilyn acquired an eternal top place in the collective pictorial memory of modern star icons. Other stars didn't have to die to obtain their Pop image. For Liz Taylor, Warhol succeeded, with *Early Colored Liz* (first produced in 1963) in forming a new personality from the stereotype of mass-distributed star photos. Idols of the silver screen are not famous for being magnificent, but for being famous. Warhol transcended this ideology of the Hollywood dream machine. (R. K.)

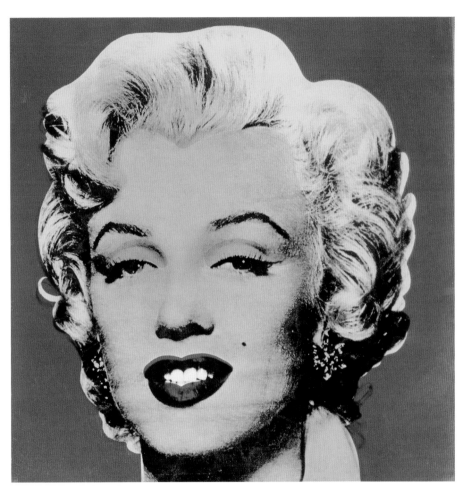

Marilyn
1964, silkscreen print on canvas,
101.6 x 101.6 cm (40 x 40 in.)
Private collection

Tom Wesselmann

b. 1931 in Cincinnati (OH), USA
d. 2004 in New York

The Mondrian is a copy. The bottles, toast, bananas, apple, glass of Coke and table expand the chapter of *trompe l'oeil* in the field of art. Real, on the other hand, are the cabinet, its contents, the fluorescent tube, and the faucet with soap and soap dish. Out of paint, paper, wood and these consumer commodities, Wesselman has fabricated a cross between a kitchen and bathroom. Three levels of the real are interlocked in this assemblage: reality *per se*, photography and painting. However, photographic elements turn out to be painted, painted elements turn out to be coloured prints, and real things turn out to be elements of an art work, at least in light of the modernist definition of art.

As soon as something is shown in a museum, the spotlights of art fall upon it and illuminate it as a work of art. On the other hand, the work of art included in *Still Life*, a framed copy of a Mondrian painting, takes on an aspect of the real, since its use as an item of interior decoration reduces its artistic meaning, causes its intellectual dimension to pale. The photographically rendered foodstuffs, finally, have the character of hallucinations, and the remaining things that of trivial pieces of decor,

like the Mondrian copy. Pop Art was never as linear as many critics maintain. The context in which works of art are perceived was often the underlying theme. The conditions in which a work is manifested influence its perception. Such tensions between the levels of the real are reflected in the formal tensions in Wesselmann's assemblage – the tension between illusionistic painting and actual object, between plane and space, between art and decor.

After he had painted his famous *American Nudes* series, Wesselmann turned to the subject of still life. And as there, he veritably conjugated this genre in an extended series of works. The focus of this series was no longer woman as object, but her domestic environment, the kitchens and bathrooms of middle-class suburban homes. The sexual connotations were toned down, but not eliminated, as the chance encounter of pointed bananas and round apples indicates. As a rule, fruit stands for male and female, phallus and breast, in Wesselmann's art, including *Still Life No. 20*. The sexual obsessions seep through the façade of respectable, prudish American life like butter through waxed paper. (K. H.)

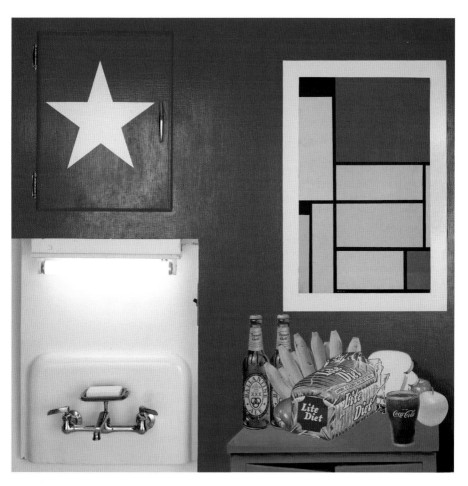

Still Life No. 20
1962, mixed media,
104 x 122 x 14 cm (41 x 48 x 5½ in.)
Albright-Knox Art Gallery, Buffalo

Ed Ruscha

b. 1937 in Omaha (NE), USA

In the 1960s, Los Angeles was considered the Pop Art capital of the American west coast. Of course, the strategies of the artists working there significantly differed from those in the Pop capital New York, where confronting consumer culture and iconic imagery mattered most. On the west coast, Realist artists (like Wayne Thiebaud) worked beside artists who used a conceptual approach to painting and included other media. Ed Ruscha is perhaps the most important figure among the latter group.

Ruscha's 1962 breakthrough came with a series of paintings in the same format, on which he painted single words. The best-known of these works, *Actual Size*, emphasises the artist's conceptual interests: "I give myself a set of restrictions that I call it my duty to express, and so most of the objects I make are actual size, even to the point of my using that in the title of the picture…" The object in this painting is a can of Spam – a brand name for canned meat – which flies straight across a bright surface with a comet's tail following behind it. Above this, the word Spam appears again, painted in large yellow letters in a dark-blue sky. "Words exist in a world of no-size," adds Ruscha, exploring this topic in the relation between both painted word samples. In addition, the painting alludes to the fact that the first American astronauts ironically called themselves "spam in a can".

During this period, Ruscha quickly developed his art in a variety of media. In 1963 his first artist's book appeared, *Twenty-six Gasoline Stations*, whose title is likewise its content: photographs of 26 gas stations located along Route 66, between Ruscha's L.A. residence and his birthplace, Oklahoma City. All the photographs showed simple views of the stations shot from the opposite side of the road and given only brief captions. Through this sober cataloguing of an everyday apparition, this landmark publication led the way to subsequent artists' books from Minimal and Conceptual artists.

In the same year, Ruscha developed what may be his best-known painting from one of the photographs: *Standard Station, Amarillo, Texas* (ill. p. 472), a work in which his connections to Pop Art become especially evident. The inconspicuous gas station is monumentalised by a massive diagonal form stretching from the painting's bottom-right to the upper-left corner. From a schematic drawing completed in flat, primary colours, the station seems to mutate into a stylised over-dynamic version of itself. The gas pumps stand in a row like elite guards. The Standard sign towers far above the beholder, whose point of view is at ground level. The pattern play of light caused by three headlights heightens the scene even further – and that's precisely the point for the artist: "It has to be called an icon. That's the main thing about the painting. It sort of aggrandises itself before your eyes. That was the intention of it, although the origins were comic…a comic comment on the idea of speed and motion in a picture." The hyperactive diagonal cutting straight through the painting serves Ruscha as the formula for bringing speed into a building, which in the frenzy of its movement can't even remain still for long enough to fully materialise. (L. E.)

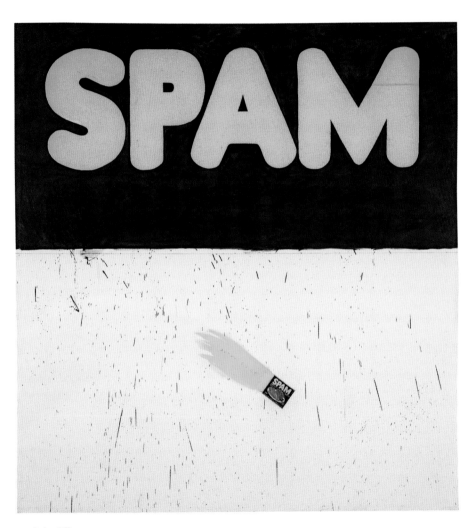

Actual Size
1962, oil on canvas,
183 x 170 cm (72 x 67 in.)
Los Angeles County Museum of Art

James Rosenquist

b. 1933 in Grand Forks (ND), USA

The shadow that fell on the great movie star's reputation was cast by her own daughter, who posthumously described Joan Crawford as a "bad mother" in a detailed book. Everything was secondary to the actress's career, she stated: not only her private life but her little daughter. Crawford had often played career women on screen – hard, goal-oriented and successful – in a strange symbiosis of art and life, 30 years before James Rosenquist portrayed her. But is this really a portrait, or just the opposite? The painting was based on a magazine illustration, which was probably itself done from a photograph. In this image Crawford's external trademarks have hardened into an almost caricatural cliché: the wide-open eyes with plucked eyebrows and false eyelashes, the routine smile congealed into a lopsided grimace, the permanent-waved hair. Her face is a mask that stares beyond the viewer into the distance. The original ad was apparently for a "mild" cigarette, but the artist has cut off the text, leaving a likewise truncated cigarette in the star's left hand as an indication. In fact, Rosenquist has robbed the ad of its effect, its message and function. It surprisingly turns out to be a purely aesthetic phenomenon, a painted montage of various typefaces, positive and negative, a poster-like autograph card rendered in carefully gradated colours of the kind often found in soap ads. Various red and ochre tones against a background of grey and greenish bands set the colouristic scene.

James Rosenquist's canvas is doubtless a counterpart to Warhol's more famous depictions of Marilyn Monroe, from which it basically differs only in terms of a more painstaking rendering and the lesser degree of attention it attracted. The reason for this lies in the model. In art, Crawford's persona never underwent the transformation into an icon that Monroe's did, despite the fact that the two actresses occupied the same level in the Hollywood pantheon. Admittedly, Crawford was of an earlier generation. Her last great box-office success, *Whatever Happened to Baby Jane*, 1962, directed by Robert Aldrich and with Bette Davis playing her rival, already lay two years in the past when Rosenquist picked up his brush. In the meantime, the diva had switched to a managerial career in the beverage business. And unlike Monroe's, her career was for the most part of her own making rather than being determined from outside. Crawford embodied the type of the emancipated woman – in both fiction and reality. And because Rosenquist's painting is not a portrait, it tells more about the mechanisms of the entertainment industry that transforms human beings into images than about the psychology of its sitter.

(K. H.)

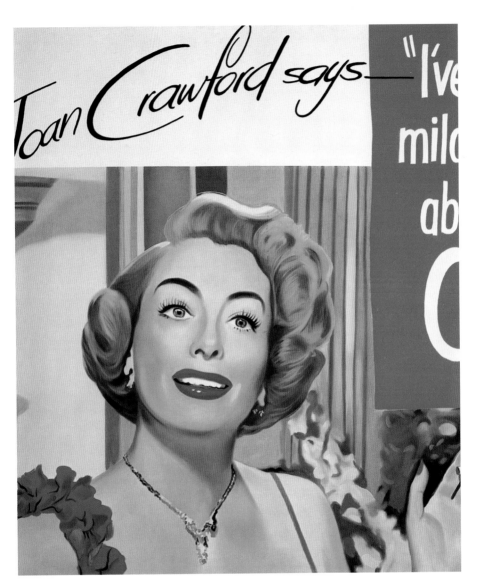

Untitled (Joan Crawford)
1964, oil on canvas,
92 x 78 cm (36¼ x 30¾ in.)
Museum Ludwig, Cologne

Richard Lindner

b. 1901 in Hamburg, Germany
d. 1978 in New York, USA

Richard Linder is an artist between two worlds. He grew up in the Weimar Republic, and the roots of the New Objectivity style, the caricaturesque traits of a George Grosz or Otto Dix and the geometric shapes of an Oskar Schlemmer are all visible in his art: "My work is really a reflection of Germany of the 1920s. It was the only time the Germans were any good. On the other hand, my creative nourishment comes from New York and from pictures I see in American magazines and on television. America is really a fantastic place." More than most of the refugees who fled National Socialism, Linder found a homeland and his artistic voice in the New World. Among Pop artists, he was considered a kind of pioneer, which inspired Peter Blake to include him as the only visual artist on the cover of the Beatles' *Sgt. Pepper's Lonely Hearts Club Band* album. But Lindner distanced himself from this classification: "I am not a Pop artist. I myself am really a hard-edge painter. If I were a collector, I would buy mostly abstract paintings."

In Germany, Lindner worked as a commercial graphic designer. Soon after Hitler's coming to power, he and his wife emigrated to Paris to escape persecution because of their Jewish origin. In 1939, after the outbreak of the war, he was interned by the French police and only in 1941 did he finally secure passage on a ship to New York. Unlike many artists who fled to the United States at this time, he quickly found work as a graphic designer, established himself socially and even landed a teaching position. Then, in the early 1950s, his dream to work as a freelance artist finally became a reality.

From the beginning, his work is inspired by his new homeland. The majority of his stylistic elements are already formed – flat, two-dimensional compositions and an arsenal of protagonists extracted from the streets of New York: seedy but weak men, women in corsets and leather outfits and chubby child prodigies. *Coney Island II* is a work from Lindner's mature phase, when city-related themes held most of his attention – some of these paintings even have street names as titles. At this period, Coney Island has already become a rundown amusement park which is in the hands of the underworld by night. A suspicious-looking male figure wearing sunglasses looms in the centre of a dark background brightened on the left by a light shaft. The exposed flesh colour under the man's coat proves that he has little to set against the approach of the charging Panther Woman – a combination sturdy variety act and superhero personifying irresistible energy. While the man takes on the traditional role of a lion trainer, encircled as he is by a hoop, the woman's leap will send her plunging through his chest as she jumps the smaller ring encircling his heart.

Lindner is not working through any personal story here. What concerns him are the sexual roles and a gender discourse that feeds from everyday observations. "In my paintings, it is the woman who is more brilliant, stronger and sadder than her mate," he stated, whereby what remains in the end is the existential separation of the sexes and the the individual thrown back on itself – although Lindner's art always put on a game face behind the satire. Ultimately, what Lindner discovered in the New World is that all of life is a sideshow: "Everything in the United States – even the art – is an Italian carnival, is Coney Island. And I painted that too." (L. E.)

Coney Island II
1964, oil on canvas,
178 x 132 cm (70 x 52 in.)
Private collection

Roy Lichtenstein

b. 1923 in New York, USA
d. 1997 in New York

What especially stimulated his interest in cartoons, Roy Lichtenstein once said in an interview with critic, curator and photographer John Coplans, was the contrast between highly emotional content and "cool" means of depiction. Especially in the many paintings of young women done during the first half of the 1960s, Lichtenstein staged this contrast with amazing virtuosity, lending the compositions a vibrant tension. In *M-Maybe,* an attractive blonde directs her blue-eyed gaze at us, yet seems to look past us, preoccupied with her own thoughts. Head resting in her left, white-gloved hand – a traditional visual metaphor for melancholy – she wonders, as the balloon reveals, why she has been made to wait in vain. Apparently some man has stood her up. The everyday nature of this situation immediately triggers empathy on our part. It is certainly not hard to identify with this girl – were it not for the standardised way in which the artist depicts her. This puts the despondent girl at an undefinable, vague distance, in view of which our budding empathy turns out to be a special form of hypocrisy. The relationship between picture and viewer suddenly seems based on false premises. The artificiality of the style corresponds to the stereotyped female image derived from comic books, and also to the cheap sensations this image was designed to elicit in us, which suddenly put us in the role of Pavlov's dogs. The artist skilfully exploits the gap between the world and individual consciousness. He heightens comic-book clichés by honing his technique to an apex of forcefulness: primary colours, strong contrasts, and striking, unifying drawing. This amounts, so to speak, to an optimisation of the popular aesthetic.

Lichtenstein always emphasised that he aesthetically improved the vulgar aesthetic of cartoons. His first step in making a painting was to project the original on canvas with the aid of a slide projector, thus creating an analogy on the technical level between mechanical production and the world of trivial feelings. Then the face was covered with a dot pattern – a relic of the printed original, divested of its function to take on an aesthetic life of its own in the work of art. (K. H.)

M-Maybe
1965, magna on canvas,
152 x 152 cm (60 x 60 in.)
Museum Ludwig, Cologne

Sigmar Polke

b. 1941 in Oels, Germany (now Oleśnica, Poland)
d. 2010 in Cologne, Germany

Couple II
1965, oil and enamel on canvas,
200 x 139.5 cm (78¾ x 55 in.)
Private collection

Sigmar Polke's large-format *Couple II*, dating from 1965, shows a man and a woman against a background which is partly white and partly evokes an abstract painting in red and yellow tones. The work falls into the phase of so-called Capitalist Realism, a term introduced in 1963 by Polke together with painters Gerhard Richter and Konrad Lueg, in ironic allusion to Socialist Realism on the one hand and Western consumer society on the other. Thus in Polke's picture the couple, with their stereotyped appearance (the woman has blonde hair in the style of the time and is wearing pink nail varnish with her pastel-green dress, while the man has a dinner jacket and black bow tie), their harmony and their stuck-on smiles, look as if they had come straight out of an advertising brochure.

Under the influence of American Pop Art (whose interest in trivial culture Polke shared) and the formal language of Andy Warhol's silk-screen prints (in which Warhol isolated his motifs, which derived from the world of commodities and advertising and from the mass media and the entertainment industry, and raised them to the status of icons) the figures are heavily stylised instead of realistically presented down to the last detail. They even seem to have been painted "badly" in their coarse sketchiness,: see for example the eyes, or the whole face of the man, shown in profile, or the skewed mouth of the woman. More

still, on her face and décolleté there are intrusive coloured dots with black edges, which are not random markings or mistakes on the painter's part, but deliberately placed there. It is precisely in these dots that we see not only an unambiguous concept, which *Couple II* follows, but Polke's general confrontation with the medium of painting, which in this case is underscored by the inclusion of both figural and abstract style elements. Polke parodies quite consciously (and for the beholder quite obviously, thanks to the deliberate discontinuities in the picture) both the formal vocabulary of gestural expressive painting, as well as figural approaches, using his painting to subvert current pictorial conventions along with diverging connotations of their stylistic elements.

At the same time *Couple II* can be read not only as a (humorous) commentary on the general artistic discourse, for example the debates triggered by the appearance in 1960 of the much-read essay "Modernist Painting" by the American art critic Clement Greenberg, reflecting on the medium of painting and its particular qualities and characteristics, as well as on the dichotomy between high and popular culture or between "avant-garde" and "kitsch". Rather, Polke is making a critical comment with his work, entirely in the spirit of the self-named school of Capitalist Realism, on the social conditions of his time.

(I. D.-D.)

George Segal

b. 1924 in New York, USA
d. 2000 in South Brunswick (NJ)

Originally George Segal was a painter, for ten years. Disappointed by the limited possibilities of painting to evoke three dimensions, he turned to sculpture, a medium in which he remained true to his artistic convictions, adhering to an empirical approach. It would nevertheless be misleading to associate him with that current which, primarily in Europe, is known as realism. Realism is merely one of many frameworks within which an artist can deal with reality. Segal, in contrast, is more interested in reality pure and simple than in a vision that manifests itself in the form of an artistic statement. His attitude is shaped by the pragmatism of American culture. He had created a space, Segal once said, and that which strived to fill the space with a volume, which was known as sculpture. There could be no more concise statement of his aims.

Segal made his first sculpture in the year 1958. *Woman Washing Her Feet in a Sink* is another of his earliest works. It contains every trait that is typical of his art: a plaster figure, the immediate surroundings that define its existence in space, the real objects that anchor it in reality. Instead of artistically modifying things based on a certain notion of reality, Segal presents them in combination with the figure of the title, the only element subjected to aesthetic transformation. The figure was created from a living model, with the aid of plaster-soaked bandages. But rather than using the resulting hollow mould to create the final figure, as in conventional sculpture, Segal lent the provisional stage of the modelling process the seal of finality. The traces of the process of making remain visible. In consequence, a subtle relationship of tension develops between the plaster figures and real objects in Segal's sculptural ensembles, comparable to that between photographic image and photographed motif. Beyond this, a sense of oppressive loneliness engraves itself in our visual memory – the image of a woman of uncertain age in shabby surroundings, doing something in which nobody is particularly interested. Not a motif for voyeurs, and therefore not especially photogenic.

(K. H.)

David Hockney

b. 1937 in Bradford, UK

British artist David Hockney is several things at once: painter, draughtsman, designer, photographer and author. From the outset, he knew that the artistically new can only be created by critically confronting the old – or via competing contemporaneous concepts. According to him, innovation is only possible on the basis of exploratory work executed in the arsenal of art history. Hockney's virtuosity is precisely rooted in allowing traditions and references, whether as quotes or as parodies, to repeatedly flow into his own constructions, seemingly without the slightest effort. This at first glance uncomplicated creative process, which, in reality, is thought out to the last detail, ensures him a leading position in the annals of 20th-century art. It's questionable, however, whether much is gained by classifying his work Pop Art. By juxtaposing controversial stylistic devices since the 1960s – placing an abstract lineament, for example, next to a relatively illusionist, painted object – he plays an audacious game of deception which anticipates Postmodernist strategies. But obviously, the visually subtle and often ironically interrupted methods used to analyse the living and viewing habits of the consumer world are, in fact, something that Hockney shares with other Pop Artists. A formal game of deception and, content-wise, an analysis of the American way of life come together in one of his best-known works, *Sunbather*. On the surface, the subject satisfies all the clichés associated with a smart Californian paradise (in which Hockney himself lived many years). Near the painting's upper edge, a young man lies naked on his towel on the stone border of a swimming pool. His flesh-coloured buttocks contrast with the rest of his firm, suntanned body and will probably trigger homoerotic connotations with one or the other viewer.

While this uppermost part of the image, despite being somewhat schematised, conforms to a naturalistic way of seeing, and the slightly diagonal composition of the man's body quotes the spatial perspective passed down since the Renaissance, the remaining three-quarters of the painting's square format break with this mode. They form an almost monochromatic blue-green surface riddled with yellow, snaking lines. A comparison with other Hockney paintings from this period proves that the viewer can interpret these lines as ripples in the pool. Water is never motionless, and light reflexes and movement patterns invariably play across its surface. At that time, Hockney repeatedly faced the challenge of having to depict such transitory effects. But as opposed to solving the problem "impressionistically", he handled it rather "conspicuously": movement was simplified to the kind of flat ornamentation that could also be found in advertisements.

For perceptive viewers who keep studying this image for some time, the irritation in *Sunbather* is less the result of the aforementioned mix of styles, but rather the compositional imbalance. The agility of the abstract, snaking lines seems to oppress the reclining figure and limit his place in the painting to a "claustrophobic" zone. The cliché of a life in luxury unmasks itself to reveal a psychological prison. (N. W.)

Sunbather
1966, acrylic on canvas,
183 x 183 cm (72 x 72 in.)
Museum Ludwig, Cologne

Lucian Freud

b. 1922 in Berlin, Germany
d. 2011 in London, UK

To this day, the taciturn, publicity-shy, interview-avoiding painter Lucian Freud hates other people watching him work. The grandson of Sigmund Freud, born in Berlin, he emigrated to London in 1933 and remained in his second home as a reclusive worker-by-eye, becoming a British national in 1939. His central theme has always been the human figure, the naked person, his or her unsentimentally and unprogrammatically denuded appearance: nature, warts and all.

Most of his sitters are people from his familiar environment: family, friends, fellow artists. By painting, he interrogates the material texture of their bodies. He sees psyche and world materialised in them in equal measure, and he seeks to reproduce this as directly and unsymbolically as possible. Without a doubt, he is following in the great "realistic" tradition of the 19th century. And of course, he has been compared more often than not to his famous grandfather. Both Freuds had, it is said, their subjects lying on the couch, so to speak, the one in order to penetrate the resistance of repression in order to get through, psycho-analytically, to true causes in the emotional sphere, the other in order to read, artistically, in the revealed skin the hidden interior, including his own. Both were, it is said, detectives using different means and methods to find what can only be made manifest on the surfaces of life.

But while Sigmund proceeded from the symptom level to draw conclusions about the condition of the unconscious, Lucian remained with the phenomena of flesh and skin. His field of observation encompasses in particular worn-out and extinguished bodies. The skin is his criterion, according to which the emotional state and life-story of an individual, the lost or exhausted state of an existence, can be studied or characterised, but not judged. Skin is the boundary between body and life-story. Thus Freud became the specialist in pale skin, marked by liver-spots and with the veins showing through, in sagging breasts, obesity, carelessly spread legs and inflamed eyelids. Often the subject is depicted sleeping, coming across as ill or even dying. When they do seek eye-contact, they do not conceal their sadness.

And when Freud paints self-portraits, in other words looks at himself in the mirror while painting, it almost seems as though he had to transfer to his own act of reflexion, his dislike of being looked at by others. As though even the dumb mirror were loquacious. That's why in this 1965 picture the mirror must be taken into account as a factor in itself. The glass is tilted in such a way that it draws the eye of the beholder from bottom to top, and conversely reveals the eye of the painter, directed at himself, as suffering and surly, not so much condescending as dejected. We are looking up into a monotonous, barren ceiling, the corner of the artist's mouth, nostrils and eye-orbits forming a focus no less distorted than it is precise. The figure looks at us like the ceiling – all colours and none – or the coldly illuminating hollow of the lampshade: dull and sharp at the same time. It is just the two children on the floor in the background, on a different level of reflection, who are relaxed as they watch the proceedings.

(E. R.)

Reflection with Two Children
1965, oil on canvas,
91.5 x 91.5 cm (36 x 36 in.)
Museo Thyssen-Bornemisza, Madrid

Georg Baselitz

b. 1938 in Deutschbaselitz, Germany

When Georg Baselitz painted his lifesize picture *The Shepherd*, Germany was being pervaded by the last vestiges of Art Informel, and the Pop Art import from the United States was celebrating its decisive triumph. *The Shepherd* has no more to do with strident criticism of the consumer society than it has with total abstraction. If there was an influence here, then most likely it was the gestural existentialism of Baselitz's teacher Hann Trier. |*The Shepherd* was painted in 1966 as one of the series of so-called "hero pictures". With them, Baselitz not only laid the foundations of his own career, but also laid bare a broken human image, stripped of all renown and legend, and revealing heroism as a farce.

The Shepherd confronts us as a coarse, gigantic, clumsy figure, apparently unsteady on his feet, in a barren, apocalyptic landscape against a cold sky. His indefinable uniform torn open, the torso is revealed to the crutch. A whip is hanging from the shepherd's left hand. A small head is perched on broad shoulders, mouth and eyes are half open from exhaustion, the gaze goes right past the beholder into the void beyond. Between the bare feet of the figure a goose puffs up its feathers like the last domestic creature on earth, while in the distance we can see the remains of buildings or machinery. The colours of the painting are cold: the sky is mint green, the body pink, the jacket and trousers dirty white, black and light brown. In places dark red turns up as though from wounds, for example in the beak of the goose and the bandages on the arms. All the contours are abrupt, in a manner typical of the artist, as though they wished to lay bare the nerve ends of the broken body and the furrows of the ravaged landscape.

The Shepherd is, in his bizarre decomposition, anything but a guardian or a hero. He comes across as clumsy and ill-proportioned, like a distorted image of what in the Nazi period one might have regarded as a dignified warrior. By tearing out the former masculine ideal from the then largely repressed collective memory and giving it a monstrously mannered face, Baselitz became a troublemaker even before 1968. And yet he dispensed with any illustrative caricature-like depictions such as Max Beckmann or Otto Dix gave us after the First World War. Without moralising, Baselitz places his shepherd in the emotionally charged tradition of German painting, which he himself described as "ugly": Albrecht Dürer, Caspar David Friedrich and Emil Nolde convey an expressive, romantic and melancholic attitude with which Baselitz (who called himself after his rural birthplace) identified so much that his "heroes" should also be understood as hidden selfportrayals, who seem to ask, with Hölderlin, "Where am I going?".

The homeland as a landscape of rubble, populated by ravaged heroes: it is easy to imagine the shock that these provocations triggered in the land of the economic miracle. *The Shepherd* could stand for a new beginning of art after 1945, which occupied itself with the caesuras and traumas of a new human type in a subtle, sceptically reflecting manner.

(G. B.)

Gerhard Richter

b. 1932 in Dresden, Germany

Ema (Nude on a Staircase), one of Gerhard Richter's best-known and best-loved paintings, is a complex portrait pervaded by several iconographic levels at once. Stylistically, the picture belongs to an early group of photo paintings; but the lucid colouring and painterly surface transparency of this 1966 creation cause it to stand out from the artist's other works of the same period.

In the photo paintings of the 1960s, Richter's painting technique asserts itself against its younger competitor, the photographic medium, whose special qualities the artist transfers to his painted representations. Unlike the majority of Richter's motifs, the source material for *Ema (Nude on a Staircase)* is drawn from neither an illustrated magazine nor a private family album. Instead, Richter staged and photographed the model himself and then created a painting based on this colour photograph. The photographic image was shot one quiet weekend on the staircase of his first studio, located on Fürstenwall in Düsseldorf, and it shows his first wife at that time, Mrs. Marianne (Ema) Richter.

Although the life-size, unclothed model on the two-metre tall canvas moves directly towards the viewer, Richter's sensitive technique, applied to all the contours and the body shining out from the dark environment, avoids any references to voyeuristic nudity. On the contrary, his delicate treatment of the motif produces an image full of grace and empathy. The signature on the back of the canvas is the key to understanding this painting. Richter was uncommonly precise about dating the work to May 1966. Seven months later, his and Ema's daughter, Betty, was born. The painting is a declaration of love. However, the picture is just as much a programmatic sideswipe at Marcel Duchamp and the verdict he issued on painting. In June 1965, at the Museum Haus Lange in Krefeld, Germany, Richter saw the Duchamp retrospective that was touring several European institutions. Almost a year later, he painted his wife in the manner of Duchamp's 1912 Cubist painting *Nude Descending a Staircase* (p. 115) in protest at Duchamp's assertion that painting was outdated and no longer relevant for the artistic avant-garde. Retrospectively, in a 1991 interview, Richter clarifies his position with regard to Duchamp at that time: "His painting *Nude Descending a Staircase* annoyed me a bit. I admire it very much, but I couldn't accept that it meant a certain style of painting was over. So I did the opposite and painted a 'conventional nude'."

Via this "conventional nude", Richter not only succeeds at creating a highly intimate document of his family situation, but also uses the private portrait to argue on an art history level; in the discourse of artistic disciplines, he convincingly takes a stand for the traditional medium of painting. (D. E.)

Francis Bacon

b. 1909 in Dublin, Ireland
d. 1992 in Madrid, Spain

Isabel Rawsthorne Standing in a Soho Street
1967, oil on canvas,
198 x 147.5 cm (78 x 58 in.)
Staatliche Museen zu Berlin,
Nationalgalerie, Berlin

A turbulent youth led Francis Bacon only gradually to painting: born in Dublin in 1909, he moved to London during World War I, and it was here as early as 1926 that he had a major split with his father. A sojourn in the wild Berlin of the 1920s followed, after which he returned to London in 1929 – the path to Bacon's artistic career was anything but straight. He had never studied painting at art college, and the first steps towards exhibiting individual paintings were laborious. Not until he was 40, in 1949, did he have a solo exhibition in London which attracted any degree of attention.

From his interviews with the critic David Sylvester we can learn a lot about Bacon's attitude: "The sitter is someone of flesh and blood and what has to be caught is their emanation." Even as a young man, when it was still a risky thing to do, Bacon had acknowledged his homosexuality. In particular the lust and arousal associated with sado-masochistic practices, and the suffering of sexually stimulating pain, constituted a basic experience for him. He also understood his painting as a painful nervous stimulation. In many ways the distortions, contortions, extremes of expression and defamiliarisations in Bacon's portraits concretize his own temperament and his impulsive manner of transforming everything corporeal into painterly metaphors of fragile human existence.

The inspiration for this portrait of his friend of many years, Isabel Rawsthorne, came from a photograph that John Deakin took of her outside a shop-window in the lively streets of London's Soho district. Isabel Rawsthorne, whose third husband was the composer Alan Rawsthorne, was a painter and stage-set designer. As a model for Jacob Epstein, André Derain, Pablo Picasso, Alberto Giacometti and Francis Bacon, she had inspired all these artists, since the 1930s, with her temperament, described as exotic and extremely mercurial, to paint numerous portraits of her. She was Bacon's best friend and his portraits which he painted of her over many years point to an intense personal relationship.

The staging of the picture is based on compositional techniques which Bacon used regularly. The surface of the picture is divided up into a number of colour zones, into which, first of all, the "spaceframe" brings some depth. Isabel is standing within this set of lines in a pose borrowed from the photograph, but showing a montage of different elements. The head derives from other studies that Bacon had painted of her. In three-quarter profile, the basic lines of the face are traced in broad brush-strokes. The expression of the features, colour-alienated in green and white, comes across as almost animal-like. Isabel's body is presented immovably frontally, but the turn of the head, which does not come from the photo, seems to direct her attention to the front of the car and the passers-by. These latter, at least three in number, if not four, are blurred into a mass of colour, and in the brisk brush-work seem to be faster than the car, at the very least conveying a fugitive impression.

Bacon's contrasting of the solid forms with clear outlines on the one hand and dynamically blurred colour-fields on the other, serves in this picture too to play off figure and background, surface and volume, against each other, using the medium of colour. (R. K.)

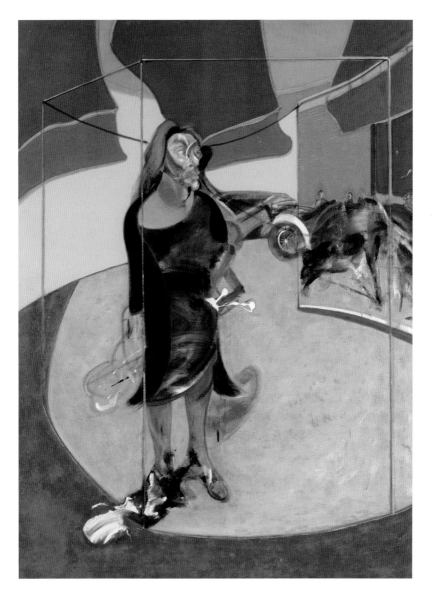

"Looking at, say, that portrait you like of Isabel in the street,
isn't it really a successful interlocking of clearly illustrational marks
with highly suggestive irrational marks, which has some marks
serving one purpose and other marks the other purpose?"
— **Francis Bacon**

Fernando Botero

b. 1932 in Medellín, Colombia

The woman sits on the bed undressing. Her legs are crossed and the freshly painted toenails shimmer as she draws the negligé over her head, seemingly frozen in a pose that hides most of her face while it reveals her body. The satisfied little smile that lingers on her lips shines out clearly, though. The man lies in the bed behind her; he is already asleep. He seems of childlike proportions in relation to the bed and especially the voluminous woman. Less like a lover, rather an attribute to her which signifies her emotional completeness. In the trust and joy with which she bares herself to the gaze of the viewer lies a contentment that is at the heart of the painting.

The woman's figure is – and here is where an engagement with Fernando Botero's art usually must start – massive, she is huge, she is fat. When asked why he is painting only fat people, Botero usually evades the question: he doesn't necessarily see them as such, but if they were, then they're not about caricature, but rather a certain sensuality of form. This, he says, comes from his upbringing in Columbia. There the arts were rare, no museums existed, so when he did encounter painting, he expected a specially bountiful beauty to transport him beyond the drab realities of life.

In 1960, Botero had moved to New York, where Abstract Expessionism reigned supreme. While he made the acquaintance of painters like Willem de Kooning (with whom he shared that some people considered their portrayal of women lacking in respect) or Mark Rothko, he didn't fit the scene at all. He didn't seem influenced by any of his peers, rather by the old masters like Dürer or Caravaggio, whom he paraphrased in his work. Thematically, Botero stayed in Columbia, portraying the everyday and the ruling classes, the priests and militiamen, from a perspective that mixed seemingly naive admiration with a keen sense of the absurd.

Still, Botero denies that the purpose of his works is satirical: "My style of painting can show no hatred. If you look at the picture, you rather feel love, because of the many colours, the voluptuous forms." However, through his love, the artist subverts the power of the ruling elite: "You start painting the head of a dictator. Then you begin stroking him, you're so pleased with him, so you give him an affectionate kiss." There is no image of tyrannical power that can survive this kind of affection.

Looking back on *The Lovers,* one now immediately sees how it centres on the power relations between the sexes. The painting may be good-natured, almost droll, but it is very precise in its description of prevailing conditions and in their partial subversion.

(L. E.)

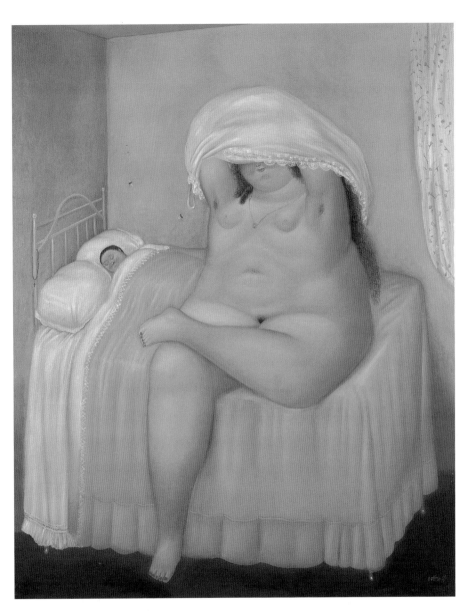

The Lovers
1969, oil on canvas,
190 x 155 cm (74¾ x 61 in.)
Private collection

Konrad Klapheck

b. 1935 in Düsseldorf, Germany

Though Konrad Klapheck is often associated with Magic Realism – a term from the 1920s that aptly characterises the mysteriousness of his objective painting – his images of household appliances elude clear categorisation. What began in 1955 with a depiction of a typewriter would develop over the following four decades into a painstaking devotion to technical objects whose obsessive repetition verged on the approach of Conceptual Art. Klapheck's simple and precisely rendered steam irons, water faucets, typewriters and sewing machines, given ironic titles with either male or female connotations as in *The Mother-in-Law*, have the effect of enigmatic icons of technological civilisation. Yet Klapheck was not concerned with a critique of such apparatuses like the concurrently emerging Pop Art.

The Düsseldorf painter, as Werner Hofmann put it, created the "illusion of an ordered world" in which things were strangely animated and yet appeared cold and distant. Hence *The Mother-in-Law*, on the one hand, evokes a threatening face seen through the eyes of a child who associates the sewing machine with a feared person. On the other hand, the very perfection of the motif – the precise contours, metallic surface sheen, the painstaking paint application and finely delineated brand name – establish a distance between viewer and object, making it appear nonhuman and monumental. Lacking any connection with a figure or other objects, the machine seems self-contained, impenetrable – and nevertheless eloquent.

As Klapheck lent his appliances a mental life of their own and a sexually connotated symbolism, his oeuvre bears a certain affinity with Surrealism. In fact, in Paris as a young man he met André Breton, whose influence is similarly evident in Klapheck's paintings as that of his teacher, Bruno Goller, who also painted objects. The famous ideal of beauty described by Lautréamont in his *Songs of Maldoror* – a key text for the Surrealists – as the chance encounter of a sewing machine with an umbrella on a dissecting table, seems likewise to have been internalised by Klapheck. This is in keeping with the fact that the artist traces his inspiration back to his boyhood, when he was fascinated by his deceased father's wardrobe. To this day, he explains, his paintings help him to deal with past and present relationships.

The unconscious mind, that great theme of Surrealism – for Klapheck it provides the background against which he develops an image like *The Mother-in-Law*. Still, his works have nothing in common with veristically rendered dream sequences *à la* René Magritte or absurdly ramified technical compositions like those of Francis Picabia. Instead, Klapheck presents thought-images reflecting the spirit of West Germany in the 1950s, which was dominated by ideas of progress and thinking in terms of roles. In its prototypical emblematic character, *The Mother-in-Law* simultaneously exudes anxiety and transcendence. Probably no other artist has so skilfully torn down the garden fence between nostalgic domesticity and futuristic monstrosity as Konrad Klapheck. (G. B.)

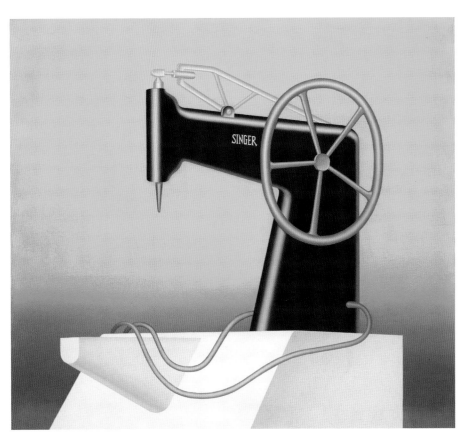

The Stepmother
1967, oil on canvas,
85 x 100 cm (33½ x 39¼ in.)
Private collection

Chuck Close

b. 1940 in Monroe (WA), USA

In the late 1960s Chuck Close began to use photography to help him paint his large-scale portraits, mostly in acrylic. Objectivity is the goal of a painter who uses the raster technique to transfer greatly enlarged projections on to his monumental canvases and in this way to depict his friends and himself in exact detail.

The merciless precision of his technique can be seen in this large-scale *Big Self-Portrait* dating from 1968. Greasy strands of hair are falling across his shadowed face; they also, in untidy fashion, frame his face, on which every hair of his stubbly beard can be distinguished, while on his bare chest a number of hairs can be seen, and the distortion makes his shiny nose look pointed. Close makes no secret of the fact that he is following the indirect reality of one or maybe more photographs, reproducing the specific flaws of the original. Thus particular parts of the face, the ears for example, are somewhat blurred, as in a photograph taken with a camera whose depth of focus does not extend to the whole picture.

A strict fidelity to nature which merely captures the external likeness of a face without doing justice to the sensuous and intellectual individuality of the sitter has often been vehemently criticised, especially in the 19th century following the introduction of photography, culminating in the topos of the "dead mirror", to demarcate naturalistic or photographic reproduction of nature from the authentic art of a creative subject. Thus Friedrich Hebbel in 1859 issued a sarcastic polemic in which he attacked the "dull realism that takes the wart just as seriously as the nose on which it sits". But it is precisely the unprejudiced nature of this procedure that fascinates Close: "The camera is objective. When it records a face it can't make any hierarchical decisions about a nose being more important than a cheek. The camera is not aware of what it is looking at. It just gets it all down. I want to deal with the image it has recorded which is black and white, two-dimensional, and loaded with surface detail." His pictures are uninteresting if we regard them as mere reproductions of reality. As an analytical method, as a commentary on the photographic view, by contrast, interest in their artificiality and flatness is appropriate as a way of teaching how a picture should be read. This picture is not a consistently naturalistic reproduction of reality, although this criticism of Close's works – that they owed their existence to reactionary forms of depiction – has often been made; rather, with his colossal heads, Close is translating the photographic perception of reality into fierce presence.

Close uses different photographs for different parts of the picture, so that he can be said to use both analytic and synthetic techniques, the latter working with different focuses and bringing them together. The concentration on different focuses is the reason for his technique also being called Sharp-Focus Realism. He himself has described his technique as the attempt to filter his ideas through the camera – he is interested in artificiality rather than illusion.

(K. S.)

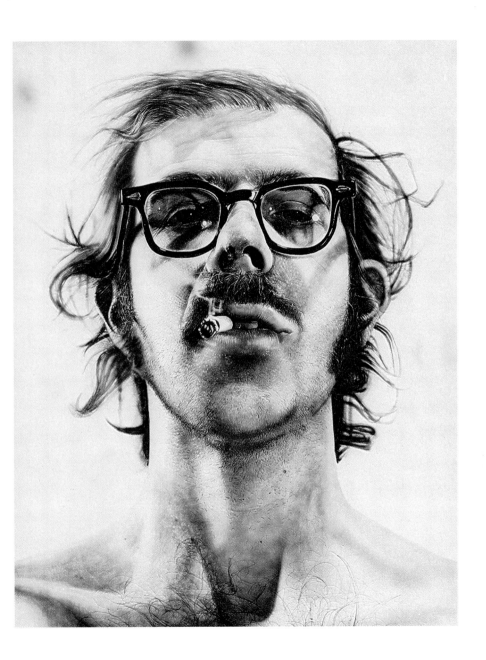

Louise Bourgeois

b. 1911 in Paris, France
d. 2010 in New York, USA

Louise Bourgeois had to wait many decades before finally being accorded the attention and recognition of the international art world, which she deserved. It was only in 1982 that the Museum of Modern Art in New York staged a long-overdue retrospective, which boosted the career of an artist who was by then already 72 years old. One of her most impressive exhibitions was doubtless the great retrospective at the Tate Modern in London to mark her 95th birthday. Here she presented aspects of her extensive oeuvre on paper, including the pen-and-ink drawings called *Pensées plumes* and further drawings in India ink, charcoal, gouache and pencil, but above all her sculptures in bronze, latex and marble.

In the mid-1930s Bourgeois devoted herself at first to Surrealist painting. It was her teacher Fernand Léger who introduced her to sculpture. From the 1960s she increasingly addressed the themes which were thenceforth to dominate her work: the respective opposites of sexuality and death, shelter and dependence, the female and the male. But above all it was her family history that was the focus of her work: her birth in Paris in 1911, her childhood spent in her parents' tapestry workshop, her overbearing father who later deserted the family, her marriage to Robert Goldwater, a well-known art historian, her move to New York in 1938, her three sons.

Bourgeois had a very close relationship with her mother, a weaver. She dedicated what are probably her best-known works, the *Mamans*, to her: spiders some nine metres high in bronze. These creatures, usually associated with disgust and fear, have completely positive connotations for the artist, standing for love, protection and security.

Bourgeois is also known for sculptures depicting both male and female genitalia, which play pleasurably with psychoanalytical interpretation and sexual symbolism. Nothing in her work is unambiguous; for each piece there are a number of possible readings and interpretations. For example, her work *Cumul I* – a sculpture in smoothly polished white marble – shows a group of figures that evoke a wide range of associations. On the one hand they recall penises, but at the same time also breasts. In addition, the rounded points could be eyes, sometimes open wide, sometimes half-closed. The manner of production, the perfect curves and the highly polished, shining surface make the work a desirable fetish. Through their lack of distinct sexual identity – the sexual organs being detached from the body – the hermaphroditic figures stand for autonomous organisms put on a level with human beings. And so the beholder can also view the sculpture as a group of human individuals huddled together shrouded in sheets, some lying, some crouching. This interpretation gives the work a touching element. It is astonishing that an object made from such a cold material is able to express warmth and shelter to such a high degree.

(C. O.)

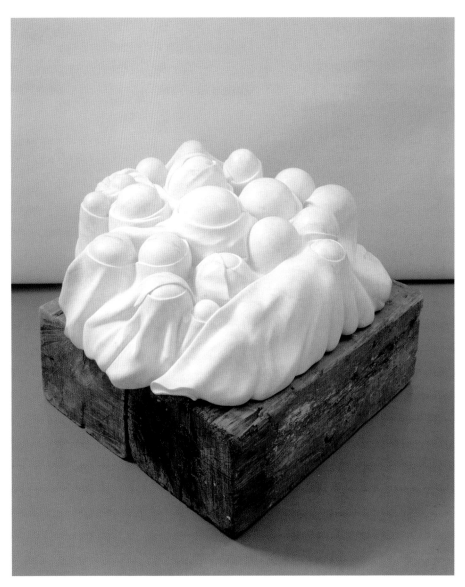

Cumul I
1969, marble, wooden plinth,
56.8 x 127 x 121.9 cm (22¼ x 50 x 48 in.)
Musée national d'art moderne,
Centre Pompidou, Paris

Dieter Roth

b. 1930 in Hanover, Germany
d. 1998 in Basel, Switzerland

Large Landscape
1969, squeezing, cheese on sandpaper,
shrink-wrapped in plastic bag,
95 x 65 cm (37½ x 25½ in.)
Dieter Roth Foundation

Dieter Roth's artistic practice embraced painting, sculpture, assemblage, printmaking, drawing and numerous artist books, and pursued a radically experimental approach, which has left a lasting, mark on the contemporary art discourse. Alongside his own artistic work and numerous collaborations, for example with Arnulf Rainer, Richard Hamilton and Stefan Wewerka, Roth also occupied himself with such disciplines as literature, film and design, and fragments of these gained entry into his art. The combination and mutual determination of aesthetic production and the daily rhythm of life formed the starting point for Roth's conceptual and experimental approach.

In the mid 1960s, Roth, after occupying himself for many years with geometric and kinetic concepts, broke with traditional pictorial and material conventions by introducing foodstuffs as an artistic medium. Sausage, cheese, milk and chocolate replaced paint, clay, wood and everyday objects and became the main materials. They were of course subject to organic processes. In the resulting sculptures, prints and pictures, the process of decay is an integral component of the artwork. Neither the artist himself, nor museums or collectors, were or are permitted to intervene in this natural decay, or undertake further conservation measures. The growth of mould, other forms of decay, and the melting of the foodstuffs thus become an uncontrolled process with an aesthetic of its own. *Large Landscape*, dating from 1969, is part of a series of sunsets and landscapes of the late 1960s, which are among the most important, and also the most popular editions by the artist. Roth placed a piece of cheese on sandpaper in a plastic bag and exposed it to a pressing, flattening the objects by horizontal pressure.

In this work, Dieter Roth made reference to an important genre in painting, and thus commented on existing painterly conventions and pointed to an "outside" of the material. Cheese is not used to represent cheese, but serves as a material to represent the landscape. In this process, the focus is not on the "sabotage" of the material, but rather on sounding out new possibilities. In this way, Roth pushes concepts of Nouveau Réalisme to the limit. No longer is it everyday objects which become part of a picture or sculptural composition, but life's essentials, foodstuffs, which, additionally, direct the focus of attention to process and impermanence. A monumental manifestation of this radical approach is Dieter Roth's *Mildew Museum* (1992–2004), which the artist set up in Hamburg during his lifetime: a *Gesamtkunstwerk*, which institutionalises Roth's concept of transient art on two floors. (P. S.)

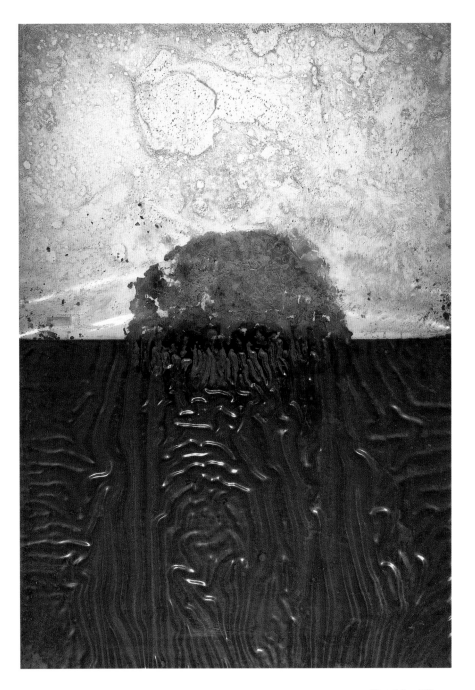

Minimal Art –
From Dan Flavin
to Richard Serra

Agnes Martin
White Flower
1960, oil on canvas,
182.6 x 182.9 cm (72 x 72 in.)
Solomon R. Guggenheim Museum,
New York

Pages 532-533
***Exhibition view* Primary Structures,**
Jewish Museum, New York 1966.
In the foreground a work by Donald
Judd *Photo: Fred W. McDarrah*

What You See Is What You See

Daniel Marzona

Seemingly Unassuming Objects

An everyday fluorescent tube fastened diagonally to the wall; rough wooden beams or metal plates laid in simple patterns on the floor; boxes made of metal or Plexiglas placed in simple arrangements; cubes and other basic geometric forms made of plywood, aluminium or steel – these would be some of the ways to describe the works of numerous artists who were active in New York and Los Angeles in the early 1960s.

When these "sculptural" works were first put on display in New York galleries in 1963, and a little later in museums, most art critics – not to mention the public at large – were at first totally unprepared for what they saw. The art scene in the American metropolis was at that time still fairly easy to follow: Pop Art was celebrating a triumphal march – at least from the commercial point of view – and, in the form of a major exhibition at the Museum of Modern Art, was at last being consecrated by the high priests of Modern Art. Otherwise the dominant trends were still the partly abstract, partly figurative painting of the Abstract Expressionists, and what was known as Post-Painterly Abstraction.

The confusion brought about by the seemingly unassuming objects that now burst on to the American art scene is clear enough from the variety of terms used by the critics when seeking to describe the "new works" of this hard-to-understand phenomenon: ABC Art, Cool Art, Re-jective Art, Primary Structures, Literalist Art were some of the most prevalent. Ultimately they settled on Minimal Art, which was first used by the English art-philosopher Richard Wollheim in 1965. It is however remarkable that Wollheim, in his essay entitled "Minimal Art", when illustrating his thesis that a minimalisation of artistic content had been apparent in numerous works over the previous 50 years, did not adduce as an example a single one of the artists who were soon to be lumped together under precisely this description. Wollheim's analysis is concerned rather with the Neo-Dadaists, with Ad Reinhardt and most of all with the readymades of Marcel Duchamp.

In the strict sense, there are only five artists whose objects, sculptures and installations can be subsumed under the term Minimal Art: Carl Andre, Dan Flavin, Donald Judd, Sol LeWitt and Robert Morris. On the one hand, the discourse on the artistic movement which later became known as Minimal Art took shape largely in the course of confrontation with the works of these artists, while on the other it was precisely they, Donald Judd and Robert Morris above all, who first staked out and largely determined the theoretical foundations of the movement.

Donald Judd in his studio
New York ca 1966
Photo: Bob Adelman

Historical Preconditions for Minimal Art in Painting

Jasper Johns and Robert Rauschenberg were among the first artists, who, with their 1950s works, challenged the various forms of Abstract Expressionism. Rauschenberg's *Combines* (p. 487) and Johns' *Targets* and *Flag Paintings* (pp. 485) bore witness to a new way of thinking about pictures. In these figurative works, the painting was accorded the status of an object that shared the beholder's space. Instead of looking into the picture, or being embraced and overwhelmed by a large-format expanse of colour, the viewer was constrained to look at the surface of a flat picture.

In the late 1950s painters such as Kenneth Noland and Frank Stella began to radicalise the ideas developed by Johns in the field of abstract painting. In 1958–1959 there appeared a series of pictures that were to play an important role in the development of Minimal Art. Frank Stella, who at this time shared his studio with Carl Andre, was working on his *Black Paintings*, which in their simplicity and lack of expressivity consistently ignored traditional questions of painterly composition. Stella used a house-painter's brush and commercial enamel paints to create black stripes of identical width which evenly covered the whole pictorial space in a graphic pattern laid down precisely before he started. In the narrow spaces between the stripes, the unpainted canvas remained visible, as did the guidelines drawn with pencil and ruler.

These early pictures by Stella are so important for the development of Minimal Art because, on the formal plane, they anticipate features which a few years later were to return in the three-dimensional objects of the Minimalists. In addition – and this is perhaps still more important – in his works Stella radicalised the anti-illusionist tendencies within American painting to an almost unsurpassable extent by totally flattening the pictorial space, displaying its object-like character for all to see and rejecting a priori any referentiality in the depiction. "What you see is what you see," was the famous tautology in which Stella summed up his concerns as a painter.

The idea of the picture as object seemed to have run through all its potential fairly quickly, and thus played out for many artists it soon lost its charms. In about 1963, Dan Flavin, Donald Judd and Sol LeWitt turned away from painting to concentrate on working on and with objects in real space. This movement away from the wall into the room gave rise to an art that could no longer be harmonised with the traditional conventions of Modernism. For while painting, because of its multiple ambiguous pictorial space and inevitable illusionism, was rejected and abandoned as being ultimately inadequate, Minimal Art rejected the foundations of modern sculpture perhaps even

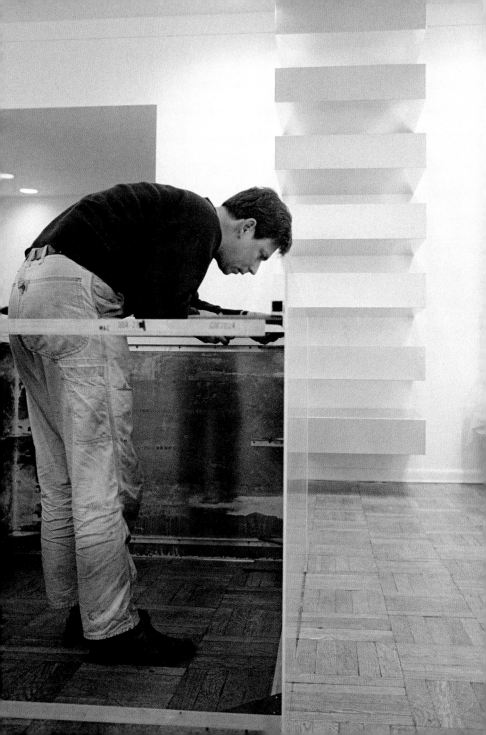

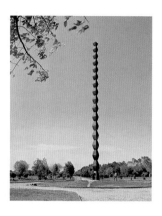

Constantin Brancusi
The Endless Column
1937–1938, cast iron and steel,
height 29.35 m (96.3 ft)
Tirgu Jiu, Romania

Fred Sandback
Untitled, from Ten Vertical Constructions
1977, coloured acrylic yarn
Dia Art Foundation, Dia:Beacon, New York

more clearly. The three-dimensional works of Andre, Flavin, Judd, LeWitt and Morris refer neither metaphorically nor symbolically to anything beyond themselves and can no longer be translated back into anything pictorial.

By emphatically concentrating on the concrete experience and perception of the work in question in its specific context, Minimal Art rejected a metaphysics of art and thus not least changed the role of the beholder, who was no longer required, in an act of silent contemplation, to reflect on the unchanging significance of the work of art hanging or standing in front of him. Rather he now actively perceived the work which was sharing his space, to reflect on the process of this perception, thereby charging it with significance.

Upheavals – Transformations of the Object

Although the five central artists of Minimal Art are all part of the same generation and have all without exception lived in New York at the latest since the early 1960s, they created their respective œuvres in relative independence one of another and on the basis of undoubtedly different preconditions and positions. Their artistic approaches, if compared on formal and conceptual planes, at once evince at least as many differences as similarities, and can be clearly demarcated one from another.

Carl Andre

Carl Andre has always emphasised the importance of Frank Stella's *Black Paintings* for his own art, but his early work was concerned with the sculptural tradition, taking an interest above all in the Romanian sculptor Constantin Brancusi and later the pioneering work of the Russian Constructivists. It was for this reason that, alone among the Minimal artists, he retained, without any ifs or buts, the term sculpture for his work.

In 1960 Andre, with the *Element Series*, conceived a group of works which already exhibit important aspects of his mature œuvre. As he did not have the money to execute his concept, the *Element Series* existed for more than a decade as no more than a series of pencil drawings on squared paper – different configurations of identical rectangles. Only in the early 1970s was Andre able to execute eight selected concepts. Identical, industrially produced blocks of wood are combined into simple structures, the individual elements being held in place by the force of gravity alone. The spectrum of sculptures belonging to the series ranges from *Herm*, a single vertically upright beam, via *Inverted Tau*, an inverted "T" formed of two beams, to *Pyre*, a cuboid consisting of eight blocks placed one on top of the other.

With the use of prefabricated materials, the unconnected arrangement of individual identical elements within each work and the limitation to

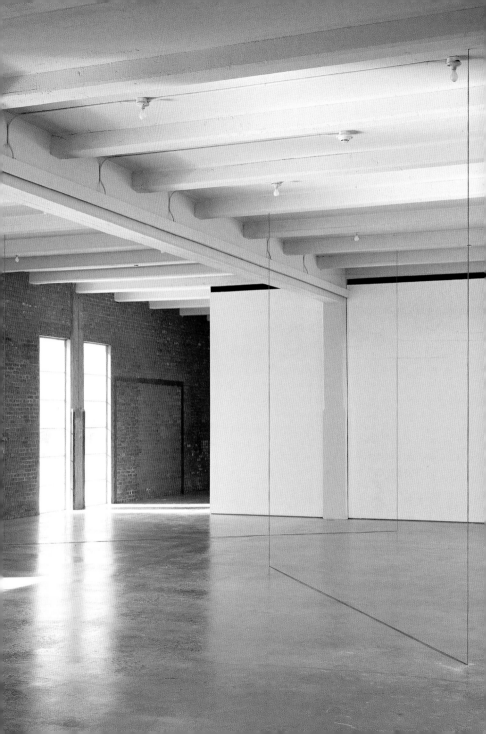

relatively simple basic shapes, the *Element Series* already evinces three important characteristics which we find in Andre's work to this day. Two others were added in the mid-1960s. In 1966 Andre displayed *Lever* in the *Primary Structures* exhibition. This consisted of a line of 137 beige bricks, placed with their long sides juxtaposed, nearly nine metres in length and with one end against a wall. *Lever* was the first of Andre's sculptures to relate unambiguously to the floor and to emanate its effect from the floor into the exhibition room. The same year, Andre incorporated the entire floor of the Tibor de Nagy Gallery in New York as an integral part of the *Equivalent Series*. Eight different formations of 120 bricks each of two layers one on top of the other covered the floor of the gallery, the free floor space between the individual structures being no longer perceptibly separable from the work itself.

Since 1967, Andre has used prefabricated thin, mostly square metal plates, which he has laid out into squares or linear formations, arranged according to simple mathematical principles. When in 1967 he covered the entire floor of the Konrad Fischer gallery in Düsseldorf with steel plates, many anxious visitors asked where the art actually was. The gallery owner, amused, was forced to point to the floor. The art was beneath their feet, unnoticed. Lying flat on the floor, and with no "Keep Off" signs, these works appear, by taking possession of a site, to have had the entire interior space pressed out of them. The site is thereby redefined. Thus these works are deprived for the first time of a characteristic of modern sculpture hitherto thought to be essential: their volume. By not forcing the basic materials he uses into their final shapes by such traditional techniques as welding, moulding or carving, Andre expresses his rejection of a concept of sculpture in which the materials are refined. In Carl Andre's work, a particular material remains what it is, and points to nothing beyond itself.

Almost always conceived for a particular exhibition situation and mostly installed by the artist himself, the works in metal executed in 1967–1968 complete a redefinition of sculpture, one which gradually arises from the work itself, described by Andre as follows: "The course of development: / sculpture as form / sculpture as structure / sculpture as place."

Dan Flavin

Dan Flavin's work developed in a far less straightforward manner than that of most of his fellow Minimalists. Between 1958 and 1961, he produced a comprehensive collection of watercolours, Indian-ink drawings, calligraphic poems and paintings which were all still clearly rooted in the tradition of Abstract Expressionism. It was above all the gestural Expressionism of Franz Kline and

Minimal Art
exhibition catalogue Kunsthalle
Düsseldorf, 1969

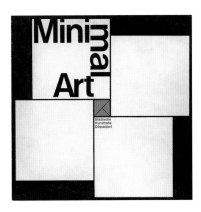

Robert Motherwell that seemed to have left the deepest marks on Flavin's work during these years.

In the winter of 1961, the young artist had worked through enough art-historical role models – and in the form of a series of mysterious wall objects which he called *Icons*, he set out for new pastures. These *Icons* are boxes attached to the wall, mostly painted in one colour, to whose sides Flavin fastened various kinds of light bulbs and fluorescent tubes. These first experiments with artificial light obviously take up what was then the widespread trend toward the "picture as object", but at the same time they already point beyond it. For to the extent that the electric light seems to dissolve the shapes of the *Icons* while radiating into the room, some of these works contain within them the potential for room-related installation art.

On 25 May 1963, Flavin experienced his much-quoted artistic breakthrough. It was on this day that he decided to fasten a standard commercial eight-foot fluorescent tube diagonally to the wall of his studio. Immediately enthused by the result and the implications of this operation, the *Diagonal of May 25, 1963 (to Robert Rosenblum)* (p. 551)was for Flavin the foundation stone of one of the simplest and yet most fascinating artistic systems of the second half of the 20th century. From now on his work developed (if it is possible to talk of a de-

velopment in this context) using nothing but industrially produced fluorescent tubes, which he compiled into arrangements of varying complexity.

From 1966 onward, Flavin's works became increasingly site-specific and installation-like. He conceived gallery and museum exhibitions consistently to take account of the architectural particularities of the site in question. It is an astonishing experience to see the transformation of an exhibition room in which Flavin has meticulously positioned his different-coloured fluorescent tubes – corners overlap, appear double or seem to dissolve, whole corridors come across as dematerialised and begin to blur in the reflections of the light, barriers composed of fluorescent tubes sometimes bar access to the room which they illuminate.

Flavin's installations not only have their effect on the architecture, they also inexorably integrate the beholder. They no longer put across to the viewer the feeling that he is facing a visible object, but rather that he himself is a light-bathed component of a visually perceivable situation. The decisive moment in this perceptual structure lays not so much in the participation of the beholder, as in the realisation that the visible is, on principle, seen not from without, but from within.

Even so, Flavin must not under any circumstances be misunderstood as some light-mystic.

For all the obvious differences between them, Flavin shared with the Minimal artists the opinion that a modern work can only represent itself. For this reason, Flavin always rejected any metaphysical, let alone mystical, interpretation of his œuvre. Thus he laconically described his works as "proposals" and the fluorescent tubes as "image-objects". The extent to which his project had moved away from the classical categories of art was expressed by Flavin himself: "I feel apart from problems of painting and sculpture but there is no need to re-tag me and my part. I have realised that there need not be a substitute for old orthodoxy anyhow."

Donald Judd

In 1957 Donald Judd painted pictures he later disparagingly referred to as "half-baked abstractions". His breakthrough on the road to overcoming any form of illusionism came only in 1961, with pictures that mostly depict simple formal elements on a monochrome background. In 1962 he produced the first of his mural reliefs, still painted in oils, but just a year later he finally abandoned painting in favour of work with three-dimensional objects. It is extraordinary that the development of his oeuvre between 1957 and 1963 took place almost entirely in camera. For more than five years, Judd refused every offer to exhibit his works in public. During this period, most New Yorkers

with any interest in art were familiar with the name Judd more as an art critic than as an artist. His reviews, which appeared regularly from 1959 to 1965 at first in *Art News* and then in *Art International* and *Arts Magazine*, were notorious for the abrasiveness of their prose style.

In December 1963, the Green Gallery staged Judd's first solo exhibition. Alongside a few mural reliefs, he exhibited a total of five objects, which were all placed directly on the floor. Judd had made them all by hand, using mostly plywood and metal components, and painted them in a uniform colour: cadmium red light. The box shape, which he later used time and again in different versions, was already present here in two works of almost identical format. On the top of a rectangular box he had inserted a metal tube, while in the same place on a second box semicircular grooves fan out at proportionally increasing intervals. The total impression created by the exhibition at the Green Gallery in respect of material, colour and form was remarkably homogeneous and altogether programmatic. Even at this early stage, it revealed an irreversible movement away from painting and towards work in three dimensions, extending into real space. Although clearly derived from painting, the exhibited objects and reliefs bore witness to the fact that Judd's analysis of the conditions of painting led to the conclusion that ultimately this genre was untenably illusionist and

naturalistic; this was before he had formulated his ideas on the subject in interviews or in his famous essay "Specific Objects". Instead of suggesting an illusory space, Judd wanted to employ a truly abstract art to use and define real space.

The reaction of the critics was mixed. Brian O'Doherty described the exhibition in the *New York Times* as "an excellent example of 'avant-garde' non-art that tries to achieve meaning by a pretentious lack of meaning", while other critics even claimed to discern figurative references in the objects. But Judd was not deterred, and unperturbed he struck out further along the road towards an art which encompassed space. Not entirely convinced by the look of his handcrafted works, in 1964 Judd began to exploit the potential of industrial production techniques by commissioning the family firm Bernstein Brothers to manufacture his objects. From now on, he created an abstract-geometric art of cool elegance, from which all subjectivism seemed to have been exorcised. Various materials, like differently coloured Plexiglas and a range of metals, were combined in ever-changing variations and forms. Novel processing techniques also enabled Judd to dispense with painting his objects, their colour now being an integral element of the respective material, inseparably fused with its surface.

Judd soon went beyond the simple made-to-measure tailoring of his objects by starting to exploit the possibilities of serial mass production and constructing his works from identical components which at first consisted of simple horizontal rows. 1965 saw the appearance of his first *Stacks*, in which metal boxes were attached to the wall at equal intervals in a vertical column. A little later, Judd had coloured transparent Plexiglas inserted into the tops and bottoms of the metal boxes of his *Stacks*, which made their perception considerably more complicated.

Alongside the multi-component works, between 1964 and 1968 Judd continued to work on one-part monochrome mural reliefs, in which the surfaces reveal projecting elements, the gaps between which get bigger or smaller according to mathematical principles that are not immediately apparent. The – for Judd – essential element of holism in his objects was in his view independent of whether the work consisted of one part or more. As long as there was no element of hierarchical composition or any unnecessary details in a work, it could be put together from a number of components without losing its perceptual unity.

Sol LeWitt

In 1960, Sol LeWitt took a job at the Museum of Modern Art, where he met the artists Dan Flavin, Robert Mangold, Robert Ryman and the critic Lucy R. Lippard, who were also employed there. His work began to undergo a visible change. In

Robert Morris
Two Columns
1961, plywood and acrylic,
2 parts, each 244 x 61 x 61 cm
(96 x 24 x 24 in.)

1961–1962 LeWitt developed his first austerely geometric monochrome *Wall Structures* (pp. 553), strange objects of painted wood which occupy a place somewhere between paintings and reliefs.

In a group exhibition organised by Dan Flavin at the Kaymar Gallery in 1964, LeWitt displayed two works which in spite of their dissimilarity already anticipate important aspects of his more mature œuvre. *Table with Grid and Cubes* (1963) unites two basic forms, the grid and the cube. On a square table, whose top is divided into 16 squares painted in different colours, three equal-sized cubes each with a different number of sides are arranged seemingly haphazardly. All the elements of the work are directly accessible to the eye of the beholder, although the logic of their arrangement is not immediately apparent. On the other hand, *Box with Holes Containing Something* (1963), is, as its name suggests, a cube with a perforated side mounted on a wall; the something it contains is a photograph of a nude woman: this is, by contrast, definitely not accessible to the eye of the beholder.

The work functions in a sense as a hiding place which does not yield up its secret entirely. In his later serial works, LeWitt often played with the idea of elements that remain hidden, although their presence is obvious by dint of the systematics underlying the work.

Serial Project No. 1 (ABCD), dating from 1966, ushered in a further lasting shift of emphasis in LeWitt's work. The project consists of a systematic arrangement of numerous closed and open cubic shapes and two-dimensional squares. For better ease of viewing, the formations are arranged in nine separate squares, which in their totality form a grid structure more than four metres square. The scheme underlying the arrangement of the structures on the floor is not immediately apparent to every beholder. What we have is all the "relevant" combinations of closed and open cubes and squares, which in turn contain closed or open cubes and squares.

LeWitt started to work in a serialist, conceptual manner, concentrating on the shape of the cube as its basic module and combining them by reordering the series. The works were now, as a general principle, made in a factory in aluminium or steel according to the instructions of the artist, and without exception painted white in order to minimise the effects of the material. In the serial works, the underlying idea or concept assumes primary importance, whereby LeWitt remains tied to a material realisation in order to convey it. The work as executed is to be understood as the information-bearing visualisation of the immanent idea.

Robert Morris

In the second half of the 1950s, Robert Morris was active in San Francisco both as a painter and as a member of the avant-garde dance ensemble led by Ann Halprin. Here he got to know Simone Forti and Yvonne Rainer, who moved with him to New York in order to join the Judson Dance Theater. In New York he soon took up sculpture alongside dance. The first apparently "Minimalist" works, such as *Column*, appeared in 1961, albeit still on the periphery of the Fluxus movement. Originally intended for publication in a Fluxus anthology and later withdrawn by the author, Morris composed the statement "Blank Form" at this point: "Some examples of Blank Form sculpture:

1. A column with perfectly smooth, rectangular surfaces, 2 x 2 x 8 ft, painted grey.
2. A wall, perfectly smooth and painted grey, measuring 2 x 2 x 8 ft."

In contrast to the artists already discussed, it is impossible in the case of Morris between 1961 and 1964 to talk either of an artistic breakthrough or of a logical development in his work. During these years he worked both on austerely geometric sculptures of unparalleled simplicity, and on objects which often either reflected the production process or else used a paradoxical combination of language and object to question traditional ideas of representation. The *I-Box* (1962), for example, when closed shows the letter (representing the pronoun) "I" inlaid in the wood and provided with hinges. When the box is opened, we see an I-shaped photograph of the naked, grinning artist. Morris here creates a short-circuit which shows up the discrepancy between the abstract linguistic conception of "I" and its concrete visual representation. This not only confuses the beholder, but also awakens him or her to the fact that the idea of the self as something absent is ultimately incapable of appropriate representation.

After still displaying geometric-abstract works along with mysterious objects at his first solo exhibition at the Green Gallery in 1963, Morris staged his much-vaunted *Plywood Show* at the same venue in December of the following year, exhibiting nothing but simple geometric structures. A total of seven sculptures were distributed around the rooms of the gallery and in some cases made explicit reference to the architecture of the exhibition space. The works were without exception made of plywood, and painted light grey. A large square was suspended from the ceiling on wires about two metres above the floor, and a triangular shape took up one corner of the room, while yet another work in the form of a beam occupied the space above head-height between two walls in the entrance hall. In the approximate centre of the gallery, a rectangular shape of considerable length was laid on the floor parallel to the wall. All of the objects were placed in such a way that the

Robert Mangold
Three Squares within a
Triangle
1976, acrylic and pencil on canvas,
145 x 183 cm (57 x 72 in.)
Private collection

beholder could comfortably walk around them.
The simple forms and the uniform grey in which
they were painted gave the works, if anything, a
visually uninteresting appearance. Their place-
ment, and the absence of internal relationships,
seemed conversely to emphasise their relation-
ship to the beholder and to the room.

In 1966 Morris translated the idea of cons-
tantly changing situation-dependent perception
into the concept of a series of works whose
appearance itself now constantly changed. These
differed from the objects whose shape and size
were clearly defined to the extent that they were
composed of elements some of which were identi-
cal and some not. During the exhibition at the Leo
Castelli Gallery in March 1967, Morris changed the
spatial arrangement of the individual components
every day. In the process his concern was to
ensure that the respective arrangements could
always be perceived as a totality in the sense of
a Gestalt to which the individual elements were
subordinated.

In a certain sense, Morris' "variable" works
already herald the exit from Minimalist object art
which manifested itself in 1968 in the form of his
felt pieces and his article titled "Antiform". While
in his 1966 "Notes on Sculpture" Morris had still
described form as the most essential characteris-
tic of sculpture, he now wrote: "Disengagement
with preconceived enduring forms and orders for
things is a positive assertion. It is part of the
work's refusal to continue aestheticising form by
dealing with it as a prescribed end." The way was
free for a new aesthetic in which the work was not
regarded as the end product, but as the starting
point of an art seen as an open process.

Tony Smith
Free Ride
1962, painted steel,
203 x 203 x 203 cm (80 x 80 x 80 in.)
The Museum of Modern Art, New York

Dan Flavin

b. 1933 in New York (NY), USA
d. 1996 in Riverhead (NY)

**The Diagonal of May 25
(to Robert Rosenblum)**
1963, cool white fluorescent light,
244 cm (96 in.)
Private collection

Dan Flavin began his career as an artist in the late 1950s with abstract paintings that revealed the clear influence of the gestural abstraction of Robert Motherwell and Franz Kline. In 1961 the artist started to explore new territory, experimenting with electric lights. He began to attach light bulbs and tubes to boxes hung on the wall. He called these rather obscure works icons.

On 25 May 1963 he had his artistic breakthrough when he attached a single fluorescent tube diagonally to his studio wall: *The Diagonal of May 25 (to Robert Rosenblum)*. From that moment on, Flavin began to use everyday light fixtures as his only material and medium. They are given objects, industrial readymades that he does not alter structurally or functionally. Instead, he uses the limitations of the medium to extend the concept of light, how it functions and how we perceive it. Within this simple concept, he challenges the configuration of the space the work is going to occupy in a highly complex way.

When delineating a "proposal" for a specific place, Flavin often uses combinations of tubes arranged in simple series that expand into the exhibition space. In his early works with fluorescent light, Flavin reveals a puritan simplicity, using few elements and placing them in unnoticed corners of portions of walls. An untitled piece from 1964 is composed of a long, thin, white tube and a thicker, shorter red one centred directly below and placed horizontally on the wall. It has a pale fuchsia colour due to the convergence of the white and red lights. The pink glow alters the perception of the room's space and the almost visible vibrations of light inside the fluorescent tube extend to the surrounding architecture, coating it with a layer of pulsating light. People within the space experience a metamorphosis of skin shade as well as a stillness around them. Sound becomes dulled until the only noise heard is the vibration of the gas in the electrified tubes. The horizontal positioning at eye level gives the object the status of reference point within the now indefinite atmosphere of the room. The fluorescent tube and the wall thus become a single new entity. There is a sense of absoluteness in the experience of Flavin's work and, at times, a violence in the radically dislocated space.

(D. M.)

Sol LeWitt

b. 1928 in Hartford (CT), USA
d. 2007 in New York

A ladder-like object created with a linear sequence of five squares from which a three-dimensional cube projects outward one interval below the top of the line, *Wall Structure – Five Models with One Cube* marks a transition from individual, handmade works to the serial pieces from 1966 to 1967 that soon led to a radically conceptualised and methodical approach to art and the making of objects.

Sol LeWitt has determined beforehand the overall measurements as well as the ratio between the visible cubic space and the square models. The work is considered a wall piece, but its horizontal or vertical placement on the wall surface is not defined. It is the installer's decision and responsibility to choose the hanging direction; thus LeWitt refrains from imposing a system on his system. *Wall Structure* is one of many possible configurations in a broader sequence LeWitt could have realised; the cubic extruded frame, located in a different position within the square series, would redefine the configuration of the structure without changing its overall dimensions.

The multiple permutations LeWitt develops in his pieces are manifestations of a geometrical and mathematical system based on predetermined parameters, as well as derived from common industrial materials like aluminium, steel sections or concrete blocks. LeWitt considers the planning and generation of the sequential scheme the work itself, thus its material execution is not a necessary act and could be realised by anyone according to the artist's specifications. The physical object is secondary to its generative concept.

This principle is best exemplified in LeWitt's *Wall Drawings* begun in 1968. The first wall drawing was executed by LeWitt himself at the Paula Cooper Gallery, but soon assistants and the artist's friends were enlisted to draw them directly on gallery or museum walls all over the world, following the artist's clear instructions and specific design. The same work could be realised repeatedly in different locations and could look different depending on the limitations of the actual wall.

Although the works of LeWitt seem to follow logical principles, his premises and concepts are often completely irrational. According to the artist there is no contradiction, since "irrational thoughts should be followed absolutely and logically". LeWitt's white framework adopts a geometric system of coordinates which exists in the viewer's own space, thus representing a conscious decision to maintain a direct relationship to the public realm: the viewer is intended to be aware of his own self during the act of perception, which is an important component of the work itself. (D. M.)

Robert Ryman

b. 1930 in Nashville (TN), USA

*"It's not a matter of what one paints, but how one paints.
It has always been the 'how' of painting that determined the work –
the final product."* — **Robert Ryman**

Between 1949 and 1952 Robert Ryman studied music in his home town of Nashville. In 1952 he moved to New York in order to become a professional musician, and began to study with the jazz pianist Lennie Tristano. Ryman first encountered the New York art world through a job as an attendant at the Museum of Modern Art, where he befriended Dan Flavin, Robert Mangold, Sol LeWitt and his future wife Lucy Lippard. In 1954 he decided to give up his career as a musician and to work exclusively as a painter. During the following ten years Ryman continued his experimental investigation of painting's foundations as an autodidact.

During his early years Ryman used mostly oil paint, which he often applied in thick brushstrokes to unstretched and unprimed canvases. His work received its first public attention in 1966, when he took part in the important *Systemic Painting* exhibition at the Guggenheim Museum in New York. Although only remotely related, Ryman's work became well known by the end of the 1960s within the context of Minimal Art.

Beginning in 1965, Ryman began to change from his early thick white brushstrokes and the later smooth white monochromes to paintings that began to use groupings of horizontal bands of paint that varied in thickness from painting to painting. This new systematic approach to painting was a way to further remove any pictorial or illusionist element and further the relationship of paint as paint to the surface. Thirty-three hand-painted bands of paint roughly five centimetres wide make up the horizontal composition of this painting. The brush can be seen as starting at the left border and traveling to the right, finishing at the edge. The dimensions of the painting's borders determine the compositional length of the bands, allowing us to see the contents of the painting as being determined by its size.

Ryman, in making groups of formally related paintings, would often use the same size of brush and same brand of oil paint for the whole group. This insured a formal, if not industrial, relationship to the painting as opposed to a personal, pictorial one. The title of the painting *Winsor 5* refers to the name of the manufacturer of the oil paint. The number 5 was used to identify this particular painting for the same reason, simply to differentiate it from others, not for formal or sequential reasons.

(D. M.)

Winsor 5
1966, oil on linen,
159.5 x 159.5 cm (62¾ x 62¾ in.)
Private collection

Eva Hesse

b. 1936 in Hamburg, Germany
d. 1970 in New York, USA

Accession III
1968, fibreglass, polyester resin and plastic,
76.2 x 76.2 x 76.2 cm (30 x 30 x 30 in.)
Museum Ludwig, Cologne

Eva Hesse studied painting at the Cooper Union School of Art in New York as of 1954. At that time she painted her first Abstract Expressionist works. In 1957 she began attending courses at the Yale School of Art and Architecture, where she was taught by Josef Albers. In addition to Informel and serial paintings, Hesse started working on numerous objects made of the most varied of materials. In the short span of time between 1964 and her death in 1970, she produced an oeuvre of about 70 pieces which took up and reinterpreted the paradigms of the then dominant art movements, Pop Art and Minimal Art – serialism, repetition, raster patterns, the cube, the use of industrial materials and processes. The fragile and seemingly organic materiality of Hesse's works humanise the cool austerity of Minimalist object art.

In 1967 Hesse first used a professional manufacturer in producing an object, for the series *Accession*. She had open-topped metal or Plexiglas cubes made in which – depending on the size – up to 8,000 holes were punched. Probably to reestablish the balance between own and outside production, she threaded short pieces of plastic tubing through these holes, an obsessive process that involved months of work. This resulted in small taut loops on the outside of the cube that give the impression of weaving; inside, by contrast, the ends of the tubing create a brush-like surface. This formal contrast between outside and inside, tamed and wild structure, hard shell and soft kernel, conjures up all sorts of associations.

Expanded Expansion reveals further levels of meaning in Hesse's art. Semi-transparent upright fibreglass rods at irregular intervals are leaning in a row against a wall. Hesse stretched elasticated gauze between the rods. To a degree, the width of the sculpture is variable, depending on how far the rods are separated from one another. By allowing fibreglass to harden on different cardboard tubes and then removing the hardened mass from the tubes, Hesse emphasised the individuality and distinctiveness of elements that only seem identical at first sight and whose uniqueness is emphasised in the skilled personal production process.

It is difficult to display *Expanded Expansion* now as important parts of it have deteriorated so much that the sculpture could collapse. There has been much debate about whether it is permissible to reconstruct the work. Opponents of such an undertaking allude to the fact that the artist was aware of the ephemeral nature of the materials she used. From this perspective, the materiality of Hesse's works points to the motif of *vanitas*. Her œuvre can be understood in terms of a life conflict borne out in art and characterised equally by happiness and loss, a conflict in which the absurdity of her time becomes visible – an artistic whole made up of fragments. (D. M.)

Carl Andre

b. 1935 in Quincy (MA), USA

> *"What my sculpture has in common with science and technology is an enormous interest in the features of materials."* — **Carl Andre**

Like almost no other artist of his generation, Carl Andre developed and built on his work with great consistency. From 1958 to 1966, he prepared the basis of his artistic approach, starting with hand-worked wooden sculptures and going on to floor-related works that completely involve their surroundings. In early interviews and statements Andre declared that he was interested in "sculpture as place", and having achieved this he developed his œuvre within parameters he defined himself. Andre's concept of "sculpture as place" can be regarded as extremely modern, although it also has archaic features.

Andre grew up in Quincy, a small town on the Massachusetts coast that has many abandoned quarries around it. In 1954 he travelled throughout England visiting several historical sites, including Stonehenge. Many of Andre's outdoor sculptures exhibit references to the elementary simplicity of such stone-age monuments, for example, his *Stone Field Sculpture* from 1977, which covered a large lawn area and was made up of 36 heavy erratic blocks, each weighing up to eleven tons.

Steel-Magnesium Plain consists of 36 square steel and magnesium tiles laid in a square. The plain starts at one corner with a steel tile beside which the other tiles are placed alternately, resulting in a chessboard pattern. This sculpture is one of Andre's *Plains*; 36 elements in two different metals, 18 of each, which the artist arranges in a square. Due to the different materials, each work makes a different impression despite the same configuration of 36 tiles. Because of the surface structure of the two materials, the overall combination of steel and magnesium seems dull; unlike, for example, aluminium or copper, they do not brightly reflect the light. Homogenous in appearance, the elements in *Steel-Magnesium Plain* seem to move closer together; the plain laid out on the ground draws the room to it, while at the same time seeming to repel it due to its opaque, cohesive character.

The work appears to have clicked in with the molecular structure of the surrounding room so that none of its elements can evade being revaluated. The eye is compensated for this strict reductionism by the grey and brown shades of the steel and magnesium tiles: white walls, light brown flooring and greyish-brown metal are the new elements in this sculpture. *Steel-Magnesium Plain* inevitably integrates its surroundings as an integral component of the work. The beholder too is forced to collaborate more actively than usual in experiencing the work by being challenged not just to enter the exhibition room but also to walk on the exhibited works. (D. M.)

Steel-Magnesium Plain
1969, steel and magnesium,
36 parts, each 9.5 x 30.5 x 30.5 cm (3¾ x 12 x 12 in.),
overall 9.5 x 182.9 x 182.9 cm (3¾ x 72 x 72 in.)
Private collection

Donald Judd

b. 1928 in Excelsior Springs (MO), USA
d. 1994 in New York

"The first fight almost every artist has is to get clear of old European art." — **Donald Judd**

Untitled
1969, copper, 10 units,
each 23 x 101.6 x 78.7 cm (9 x 40 x 31 in.)
Solomon R. Guggenheim Museum, New York

Untitled from 1969 consists of ten almost square, highly polished copper units, arranged one on top of the other. This reflects an important aspect of Minimal Art, the relative independence of its forms from the tyranny of dependent, fixed relationships. Sculptures could be arranged serially or not, depending on the wishes of the artist. In Judd's case, some of his pieces have been shown with a different number of elements in keeping with the restrictions of the given space. Seemingly autonomous, his works cannot be perceived without considering their relationship to the space they occupy and influence.

The meticulous installation of his works was always of great importance to Judd, who often complained about the temporary and improvised nature of gallery shows. In 1971 he discovered the small town of Marfa in Presidio County, Texas. From 1973 to 1984 he realised, with the help of the Dia Art Foundation, one of the largest art projects ever undertaken by a single artist. By the late 1970s Judd had also begun to centre his private life on Marfa, and started to live there with his two children. Following disagreements with the Dia Art Foundation, the place was transformed into

The Chinati Foundation in 1986. In vast indoor spaces and largescale outdoor installations, Judd created a perfect environment for his and some of his contemporaries' work. At the former military base of Fort D. A. Russell in Marfa, Texas, the visitor will find many of Judd's major and early works, as well as important pieces by John Chamberlain, Dan Flavin, Carl Andre, Roni Horn and others permanently on view.

Judd first started using Plexiglas in 1964, which complicated the perception of his pieces greatly. From then on a play began between open and closed volumes, mass, reflections and transparency undermining the simplicity that Judd theoretically held so dear. Compared with the Minimalist works of Robert Morris dating from the same period, his works had a lot more to look at and became increasingly complex. As with Larry Bell, Dan Flavin and other artists during the 1960s, their decision-making process was restricted by the limited colour choices commercially available, which constituted yet another welcome removal of the "artist's touch". The industrial world decided the colour choices, not the art world.

(D. M.)

Richard Serra

b. 1939 in San Francisco, USA

One Ton Prop (House of Cards)
1969, lead antimony, 4 plates,
each 122 x 122 x 2.5 cm (48 x 48 x 1 in.)
The Museum of Modern Art, New York

Much of Richard Serra's work stems from the artist's direct action on a selected material to explore possibilities like transformation, deformation, loss of physical integrity or balance. His sculpture is created using common and non-precious materials, most often the Corten steel used in commercial construction, or in his early work molten lead. Lead is a heavy but soft and malleable metal relatively easy to melt, and when still in a liquid state can be scooped and thrown to harden into lead splashes or drops. In 1968 Serra began heating and throwing lead in an attempt to explore the physicality of the creative act, as well as investigate the possibilities that emerge when metal is freed from its solid state. In a famous photograph taken in the warehouse of the Leo Castelly gallery, Serra appears like a goggled Zeus throwing lead thunderbolts at walls and corners. The resultant lead forms were both the physical evidence of his act and its sculptural surrogate.

In *One Ton Prop (House of Cards)* four plates of lead use their own heavy weight to hold each other up in a house of lead cards. The rough-hewn irregular edges display a disregard for preciousness, or worse, "finish". Process is implied by the energy used to cut the thick, unwieldy lead and to put the piece together. There is also the element of danger present if the house of cards were to fall. This precarious quality became an increasingly important element of Serra's work.

In Serra's public sculptures, such as *Tilted Arc* (1981) and the *Torqued Ellipses* (1997), the viewer could walk around and through these gigantic works of Corten steel and feel at certain points that the work was going to come down on top of them. Looking up one could see apertures of light, but no direction. In the case of *Tilted Arc*, these qualities of the sculpture caused a public controversy that was unprecedented in the United States. Many city workers who entered the building daily felt offended by the austerity and massiveness of the sculpture and began to complain soon after its installation. A long process of public hearings and petitions finally led to its removal from the Federal Plaza in lower Manhattan.

In contrast, the viewer is taller than the 122-centimetre (48-in.) plates of *One Ton Prop* and can walk around it, taking care not to upset the piece

(D. M.).

Joseph Beuys

b. 1921 in Kleve, Germany
d. 1986 in Düsseldorf

Fat Chair
1964, wooden chair, fat, wax, wire,
94.5 x 41.6 x 47.5 cm (37¼ x 16½ x 18¾ in.)
Hessisches Landesmuseum Darmstadt

Joseph Beuys' *Fat Chair* of 1964 exemplifies the artist's extended view of art: it consists of an ordinary wooden chair on which is placed an object made of what were then, for the art world, the unusual materials of fat and wax shaped into a prism; additionally a piece of wire is wound coarsely and seemingly carelessly around the backrest. Since the 1950s, Beuys had developed his so-called sculptural theory, according to which a sculpture is not something static, but a process that implies movement and is played out between two poles: chaos and form. While Beuys equates the first with warmth, the second stands for coldness.

In the process, the shaping of the materials, which Beuys quite deliberately selected not only for their material qualities, but also for their "spiritual" properties – charging them accordingly with a particular significance – became a mediating principle between the two poles. Thus fat, with its ease of transformability (its viscosity changes with temperature from a soft, or even fluid, mass into something quite hard) illustrates not only Beuys' sculptural theory of movement between warm and cold, between chaos and order; as energy-giving food, it stands, in addition, for his idea of a spiritual warmth.

This expresses on the one hand Beuys' endeavour to exert a psychological influence on the beholder, and to transport processes of change from art into life; on the other, his ideas, conveyed by the materials and displayed before the recipient, illustrate the "shamanic" aspect with which the artist was always associated.

His personality is hard to dissociate from his work, something which is due in part to the myth formation which Beuys himself encouraged in numerous interviews, lectures and discussions. His selection of materials is partly based on a biographical event which the artist described as a key experience, namely the "Tatar legend", according to which, after his plane crashed in the Crimea in 1943, wounded and suffering from hypothermia, he was covered in tallow and wrapped up in felt by the local Tatars. In an interview with Georg Jappe in 1977, Beuys said: "I would probably never have thought of felt had it not been for this key experience. I mean of these materials, fat and felt."

Against this background it is not hard to understand that fat and felt represent, in Beuys' art, not only energy, warmth and insulation, but also a healing force. In the same spirit, the wire on the *Fat Chair* can be interpreted as an element that is there to conduct this healing force, to create a transition between the art object and the surrounding space along with the viewer, whose consciousness, ultimately, the artist aims to affect and transform. This concept finally led Beuys to his idea of the "social sculpture", which stands for a whole mass of utopian visions and an artistic practice to change society, in which every individual will contribute his or her creative skills and spiritual forces to the shaping of the "social organism". (I. D.-D.)

Brice Marden

b. 1938 in Bronxville (NY), USA

Brice Marden had already developed a very individual painting style by the early 1960s when he was still a student at Yale University's School of Art and Architecture. The works dating from this period are almost without exception dominated by the colour grey, within which he generated an unexpectedly broad spectrum of nuances, sometimes verging on silver or olive green, sometimes showing brown to violet influences. Marden first received public recognition with a solo exhibition at the Bykert Gallery in New York in 1966. For most of the pictures at this exhibition he used a new technique, mixing paint, turpentine and molten beeswax to soften the obtrusive shine of the oils and to lend his surfaces a particular opacity.

Many of these works had a further peculiarity. Marden left a small strip along the bottom edge unpainted, where drips of paint from the surface above would gather. In this way he stressed the manual production process and reminded beholders of the canvas as a physical object. In fact in his monochrome paintings a close inspection will reveal minor irregularities such as cracks and brush smears, which he deliberately left in order to avoid a mechanical impression. This technique is however very discreet, and in no way testifies to any search for individual expression such as we find in the Expressionist style with its thick application of paint and unmistakable drips.

The critic Lucy R. Lippard was the first to emphasise the depersonalised aspect of Marden's works. While the generation of Robert Rauschenberg and Andy Warhol still treated Abstract Expressionism with irony, for Marden it was apparently of no interest at all. As idiosyncratic

communication tools, his paintings occupy a singular position, which turns neither on the reproduction of visible reality nor on a maximally objective abstraction that totally excludes any irregularities. The pictures may be abstract, but they are in no way entirely free of objects and emotion.

For Pearl demonstrates these qualities particularly neatly. For this work – which consists of three panels and was originally called *A Mediterranean Painting* – Marden worked from sketches he had made in the South of France. Blue, red and green were the colours he had seen all along the French coast and now wanted to accommodate on canvas. But then there was an abrupt change. "The painting was made in about three days, and in the process Janis Joplin died, and the whole thing just kind of turned into a dirge for her." He changed the sequence of colour tones into one which, after Joplin's death in October 1970, was inspired more by "her" colours than those of the landscape.

Marden's concentrations of colour on an area of canvas can express perceptions of nature no less than the emotion of personal ties or cultural experiences. Often his titles, and sometimes also the choice of format – as in *For Helen* (1967), whose dimensions relate to the measurements of his wife – provide coded hints, but not complete answers. "The more open, the more imaginative you are when you deal with something, the much better experience it will be," said Marden in 1976 to explain the sensitivity necessary when beholding his art, which, ultimately, is deliberately independent.

(J. G. S.)

For Pearl
1970, oil and beeswax on canvas, 3 panels,
244 x 251 cm (96 x 98¾ in.)
Private collection

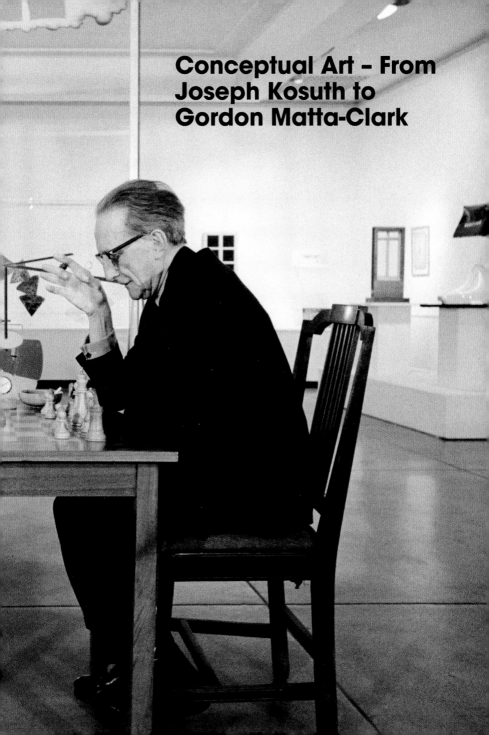

Conceptual Art – From
Joseph Kosuth to
Gordon Matta-Clark

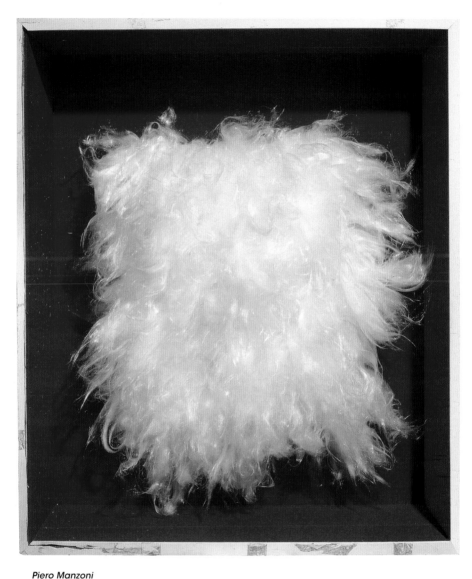

Piero Manzoni
Achrome
1961–1962, artificial fibre,
61.5 x 46 cm (24¼ x 18 in.)
Fondazione Piero Manzoni, Milan

Pages 568-569
Marcel Duchamp and Eve Babitz
playing chess at the Duchamp
retrospective
Pasadena Art Museum, Los Angeles 1963
Photo: Julian Wasser

Ideas, Systems, Processes

Daniel Marzona

An Art without Object

What is art? How is its context to be defined? Can art be created or perceived when it is no longer bound to an aesthetic object? Can art be political or is art per se integrated into political contexts? Can the discourse about art itself constitute art? How can the authority to make appropriate judgements on art be extended from a small circle of insiders to a large number of "stakeholders"?

These and many other issues were raised by various works which in the late 1960s radically questioned the traditional idea of what art was, and which, more for want of a better name than anything else, are lumped together under the term of Concept Art – or more properly Conceptual Art. For in retrospect, the artistic approaches and intentions of the artists involved in the foundation of Conceptual Art prove to have been far too heterogeneous for us to talk of a unitary style or even of an artistic movement.

The expression "Concept Art" first cropped up in an American context in 1961. In his essay of the same name, published in 1963, the Fluxus artist Henry Flynt uses the term to refer to a kind of art whose actual distinguishing feature is the way it deals with language. A few years later, the term Concept Art had already been replaced by Conceptual Art. This term was invented by Sol LeWitt, an artist whose works from the outset had not been exclusively language-oriented. His essays

"Paragraphs on Conceptual Art" (1967) and "Sentences on Conceptual Art" (1969) brought the term to the attention of a broader public and in a sense specified what was to be understood by it. In 1969 the English artists' group Art & Language published the first number of the magazine *Art-Language*, which was subtitled "The Journal of Conceptual Art", and that same year the young concept artist Joseph Kosuth declared: "All art (after Duchamp) is conceptual (in nature) because art only exists conceptually."

So what is or was to be understood by the term Conceptual Art? One way or another, all the essays by artists mentioned above express the fact that within Conceptual Art there is an emphasis on the "thought" component of art and its perception. In the course of the 1960s, normative definitions of art began to crumble, and thus younger artists, often with an excellent academic education, started to reinterpret the essence of art in extended analyses. Thus, not only art itself, but also its institutional context, became the centre of attention, subjected to comprehensive criticism in artistic practice. Many artists expressed their worries about traditional forms of marketing art, and so ways were sought of getting away from the idea of artworks as decorative objects for well-heeled buyers.

In these and other experiments, the idea, or conceptual structure, of the art work began in the

late 1960s to liberate itself from the material reali-
sation, which was seen by many artists as subordi-
nate or even superfluous. Accordingly new ways of
presentation and distribution of this often "object-
less" art had to be found, which significantly dif-
fered from traditional forms of display. Now a
catalogue or invitation card could replace the
traditional exhibition, and a telegram, an inter-
view or a brief notice could be a valid contribution
to an exhibition. At a stroke, art was understood
as a special form of information, which was often
presented as a combination of photography and
text. The beholder was now being urged to take
part in the art actively, sometimes at considerable
expenditure of effort.

Conceptual Art has often been described as a
theoretically top-heavy, over-intellectual art form.
And it is certainly true that many artists, in the
development and underpinning of their work, do
indeed use theoretical models which have been
developed in other disciplines. The later linguistic
philosophy of Ludwig Wittgenstein, logical posi-
tivism, French structuralism and in particular
the semiotic writings of Roland Barthes, the criti-
cal theory of Herbert Marcuse and much more
besides all flowed into the matrix on the basis of
which new forms of artistic expression were tried
out.

Maybe even more significant than the diverse
fragments of theory which are reflected in Con-
ceptual Art was the merciless confrontation with
aesthetics on the part of the art critic Clement
Greenberg and his adherents, which claimed uni-
versal validity until well into the 1960s. Greenberg
argued on a strictly formal plane: in an unmistak-
able affinity with the epistemology of the philoso-
pher Immanuel Kant, Greenberg was of the opin-
ion that it was the task of every artistic genre to
question its fundamental conditions in order, self-
reflectively, to arrive at its own essence.

The Art of the 1960s and the Crisis
of Modernism

After a decade which in the United States had
been dominated by the Cold War, the McCarthy-
led anti-communist witch-hunt and bigoted
prudery, in the early 1960s the time seemed
ripe for major changes in culture and society.
In Europe, after years of economic growth, a new
generation began to take a critical look at the role
played by their parents' generation in the Second
World War. Political utopias were revived and
vehemently debated in student circles. The social
reality of bourgeois capitalism was no longer un-
critically accepted on either side of the Atlantic,
and on both sides, a search was started for alter-
natives or at least reforms. In this climate, art
could no longer continue living in its ivory tower
where the beautiful, the true and the good
reigned supreme.

Marcel Duchamp
The Box in a Valise
1935–1940/1971, cardboard with
miniature replicas,
photographs and colour
reproductions, 41 x 38 x 10 cm
(16¼ x x 15 x 4 in.)
Private collection

In Europe, the Situationists and the artists of
the Cobra group forced a politicisation of art,
while in the U.S. the international Fluxus move-
ment formed around the architect, artist and
organiser George Maciunas. In the early 1960s,
this movement explicitly took up the political uto-
pianism of Russian Constructivism, and at the
same time rediscovered the instruments of
humour and irony which had been tried out by
the Dadaists, in order to break open the fossilised
formal-aesthetic view of art.

The Minimal artists started to theorise on the
perception of their objects. Robert Morris, for
example, referring to gestalt theory, assumed a
whole-body, rather than a purely visual perception
of his extreme reductionist works. In this way, a
temporal dimension was introduced to artistic
perception, which in a different way also came
about with the happenings of the Fluxus artists,
having already been anticipated a decade earlier
in avant-garde music by the artist and composer
John Cage.

In December 1966 the 25-year-old Dan
Graham published a curious article in *Arts Maga-
zine*, which at first sight looks like a sociological
essay and in dry descriptive fashion looks at the
serial architecture of provincial America. On a
double-page spread, roughly equal-sized blocks
of text and colour photographs alternate. Among
other things, Graham presented the individual

building types, listed the male and female predi-
lections regarding colour, listed the combinations
of different building types possible in a block of
eight buildings and garnished this bald informa-
tion with amateur photographs.

The importance of this unassuming article is
not confined to the fact that in *Homes for America*
Graham was applying a basic principle of Minimal
Art – the juxtaposition of identical elements – to
the typographical design of a magazine article by
giving equal treatment to blocks of text and pic-
tures. The laconic work points beyond this to a
central reason for the crisis in Modernism. For
how can an essential subjectivism be upheld in
art, how can art be credibly understood as an
autonomous expression of artistic individuality, if
in our modern consumer society subjectivity itself
is reduced to the choice between mass-produced
goods? The contradiction, which becomes obvious
in Graham's article between an increasingly de-
individualised society and an aesthetic which
makes subjective expression absolute, is per-
ceived by many artists; in early Conceptual Art
it was thematised time and again.

Analyses and Language Games

While the West Coast of the United States saw
artists like Ed Ruscha, John Baldessari and Bruce
Nauman striking out for conceptual shores in, if
anything, an intuitive manner, a group of artists

associated with the gallery owner Seth Siegelaub in New York were working on a theoretically oriented re-underpinning of art. Robert Barry, Douglas Huebler, Joseph Kosuth and Lawrence Weiner each evolved their own concepts, in which the traditional art object evaporated, so to speak, in different ways.

Until 1967 Lawrence Weiner had worked on pictures which related unambiguously to Minimal Art. He deliberately left the colouration and size to his buyers or clients, and sought in addition to eliminate the expressive element of painting as far as possible by the use of a standardised application of paint. The concept of the picture series already seemed more important than the individual results of the realisation, and for this reason Weiner dispensed with signatures on his pictures. A little later he began to question on principle the point of actually executing his works at all, and in 1968 he drew up a programmatic statement, which was to accompany the publication of his works from then on. Theory and art at the same time, it states:

"1. The artist may construct the work.

2. The work may be fabricated.

3. The work need not be built.

Each being equal and consistent with the intent of the artist the decision as to condition rests with the receiver upon the occasion of receivership."

From then on, Weiner presented his works in the form of statements which made frequent use of past participles. Works such as *Six Ten Penny Common Steel Nails Driven into the Floor at Indicated Terminal Points* (1968) or *A Wall Stained by Water* (1969) baldly describe actions, processes or states of materials and present these as facts. Although Weiner did go on "fabricating" some of his works right on into the 1970s, every fabrication, whether by himself or by others, was for him just one of infinitely many possibilities of equal worth. The declared equivalence of the different states of his "word sculptures" manifests not only a rejection of object-linked aesthetics, but also an ethical and political attitude, because his view of art, among other things, attacks the status of the work of art as simply a commodity available to the few. In an artist text of 1969, Weiner emphasised the libertarian and egalitarian aspects of his approach: "People, buying my stuff, can take it wherever they go and can rebuild it if they choose. If they keep it in their heads, that's fine too. They don't have to buy it to have it – they can have it just by knowing it… Art that imposes conditions – human or otherwise – on the receiver for its appreciation in my eyes constitutes aesthetic fascism."

In a line of development comparable with that of Weiner, in about 1968 Robert Barry and Douglas Huebler – who had undertaken investigations rooted in Minimal Art in the fields of painting

(Barry) and sculpture (Huebler) – reached a point at which occasionally the work of art literally dissolved into thin air. After Barry had experimented for a short time with the bracing of almost invisible nylon threads, he began to work soon afterwards with totally invisible materials. For the – since famous – group exhibition *March 1969*, conceived by Seth Siegelaub essentially in the form of a catalogue, Barry's contribution consisted of the announcement that on the morning of 5 March he would release two cubic feet of helium into the atmosphere. Previously he had already exhibited works consisting of inaudible radio waves. But while these works were still based on actually present, albeit sensorily imperceptible physico-chemical phenomena, Barry soon extended his interest to the sphere of the human (sub)consciousness.

For the 1969 *Conception* exhibition in Leverkusen, Barry entered five verbal communications which related to unconscious processes. Works such as *Something Which Is Unknown to Me, But Which Works upon Me* and *Something Which Is Very Near in Place and Time But Not Yet Known to Me* can no longer be unambiguously defined, and must on principle mean something different to every recipient. In their open linguistic form, these works by Barry resign themselves to the loss of concrete reference in order to set in motion mental processes in their recipients. Thus Barry's verbal communications are basically only the starting points of works that embrace the totality of the mental activity they initiate on the part of the recipient.

"The world is full of objects, more or less interesting; I do not wish to add any more. I prefer simply to state the existence of things in terms of time and/or place," wrote Huebler in 1969, shortly after he had started work on projects which could draw upon, as material, virtually at least, the totality of all documentable facts.

Huebler's *Location* and *Duration Pieces* each follow rules laid down arbitrarily in advance, according to which events and spatial and/or temporal relationships are documented which are not accessible to direct perception. In the arrangement of text, cards and photographs, Huebler thus presents a record of reality that in his constructed system becomes recognisable as a function of space and time.

For the *Duration Piece #6*, for example, Huebler had a square measuring about 2 by 2 metres in the entrance zone of the Siegelaub Gallery strewn with sawdust. The young artist Adrian Piper was instructed to photograph the gradually dissolving square over a period of six hours at 30-minute intervals, and to stick the resulting polaroids to the gallery wall in non-chronological order. The photographs, and the description of what had been done, together constituted the work, so that

John Baldessari
Trying to Photograph a Ball So That It Is in the Center of the Picture (detail)
1972–1973, 38 colour photographs, framed, 88.9 x 99 cm (35 x 40 in.)

it was left to the imagination of the beholder to understand the process as documented.

The artistic approaches of Barry, Weiner and Huebler are in accord in two central points: they all relate to a reality, albeit one not always accessible to the senses, and reject the presentation of objects in favour of the use of language, although their conception of language can differ drastically. Weiner's project understands language as a transitory vehicle and as a material that can take on sculptural qualities when it is read. Barry by contrast understands the linguistic form of his works as a possibility of describing or triggering visually non-perceptible energetic processes, while Huebler, in the fusion of language and document, brings art closer to the everyday and at the same time noticeably extends its area of reach.

Joseph Kosuth developed, from a particular interpretation of the readymades and the insights of positivist linguistic philosophy, a form of Conceptual Art which strictly rejected any relationship to reality. From his early works, which, like *One and Three Chairs* (1965–1966), still presented a real object in association with its representation as a photographic image and dictionary definition, Kosuth quickly pressed forward to purely abstract concepts, whose dictionary definitions he enlarged, unchanged by the negative process, onto photographic paper. As Kosuth wanted at all costs to avoid any pictorial interpretation of his

works, it was not long before he rejected the presentation of his investigations on photographic paper, and began to publish them in the advertising columns of magazines.

The central importance of Duchamp's readymades lay for Kosuth in their allegedly tautological structure. From his point of view, they say nothing more than: "This object is art because it is art." In his 1969 essay "Art after Philosophy", Kosuth transferred the idea of the tautological structure of the readymade into art as such: "What art has in common with logic and mathematics is that it is a tautology; i.e. the 'art idea' (or 'work') and art are the same and can be appreciated as art without going outside the context of art for verification."

In England in 1968, Terry Atkinson, David Bainbridge, Michael Baldwin and Harold Hurrell founded the joint project Art & Language. Starting out from the methods of linguistic philosophy, the group presented in various forms the results of their investigations and analyses, which at first addressed the logical contradictions of Minimalist aesthetics, dissected different systems of the production of meaning and later critically questioned the ideological conditions of the institutionalisation of art. Conversations, classes, art criticism and philosophy were part of an open discourse, which was then itself viewed as art. From the mid-1970s the history of Conceptual Art itself became

the focus of the theoretical reflections of the group and its changing membership.

Serial Systems

Alongside the purely linguistically understood forms of Conceptual Art, at the same time there developed from Minimal Art conceptual approaches relating to mathematical-geometric, temporo-spatial, typological and biographical systems. The conceptual component of Minimal Art became evident for the first time in the exhibition organised by Mel Bochner in 1966, entitled *Working Drawings and Other Visible Things on Paper Not Necessarily Meant to Be Viewed as Art*. Bochner displayed four identical books, in which he photocopied sketches, drawings, blueprints, construction descriptions and other material given to him by a few Minimal artists, juxtaposed without further commentary. With its simple form of presentation, Bochner's project anticipated the unpretentious exhibition practice of later Conceptual Art, and at the same time raised the question of who was responsible as "author" for the exhibition.

Not long afterwards, Bochner turned to projects that addressed the issue of the often contradictory relationship between visual and conceptual perception. In his *Measurement Rooms*, for example, he imposed an abstract system on the empty exhibition rooms by measuring them

out exactly and noting the measurements of the individual zones on adhesive strips placed in the middle of the edges of the walls. In this way, Bochner contrasted the geometrically abstract and the actual existence of the exhibition rooms, which were now both accessible to the perception as a result of his intervention.

In its strict consistency, the artistic approach of Hanne Darboven is certainly comparable to that of Bochner. Her first works, which are based on the mathematical abstraction of the calendrical system, appeared in 1968. In elaborate procedures, Darboven worked out the pictorialisation of previously determined periods of time – sometimes a particular year, or maybe a whole century – in a many-part series of drawings.

From each date of the period in question, she drew the crossfoot (the sum of the digits) and frequently complicated the numerical results by subjecting them to further arithmetical operations. Each figure was inserted into a graphic grid, the result being complex diagrams in which the phenomenon of time is reflected in dual fashion. Darboven's handwritten sequences of figures point not only to the continuity of the historical course of time that they represent, they are also in a sense a kind of index to the real time actually spent on their own creation.

Since 1966, the Japanese artist On Kawara has been painting pictures in which there is nothing

to be seen apart from the date of the day in question painted in white on a monochrome background. The pictures are painted using a time-consuming technique and if one is not finished by midnight it is destroyed. The *Date Paintings*, which vary in size and colour, form part of the *Today Series*, in which Kawara objectifies his own biography up to the present and in a sense transforms it into a real-time system that continues until his death.

In the 1960s many artists working in the conceptual field discovered the potential of seriality locked away in the reproduction media of film and photography. Thus as early as 1963 John Baldessari documented the happening of banal events in photo sequences, while Ed Ruscha, in artist books like *Twentysix Gasoline Stations* or *Nine Swimming Pools*, presented a number, fixed in advance, of intentionally "art-less" photographs, which on his own admission he classed as readymades.

Performance, Intervention and Critique of Institutions

In the late 1960s, the political climate on both sides of the Atlantic had become increasingly polarised. In the United States hundreds of thousands protested against the madness of the war in Vietnam, and in Europe student protest movements attracted large numbers. People took to the streets in masses, in order to demonstrate for a socialist society, and with ever-increasing frequency skirmishes with authorities took place in Paris and in Berlin in 1968 escalating into street battles that lasted for days and saw injuries and deaths on both sides. Art was not left unscathed by these events either, and artists started to work more and more often in openly political contexts. At the same time as the body was entering into art more and more conspicuously as a medium and as a bearer of experience, female artists in particular were taking up a feminist critique of social discrimination. Other conceptual approaches focused their interest on interventionist projects on the analysis and criticism of the institutional conditions in which art had to work.

For Bruce Nauman, art is everything an artist does in his studio. In accordance with this process-oriented view of art, in 1967 he began to capture on video ordinary and absurd actions in his studio. In *Slow Angle Walk (Beckett Walk)* (1968) we see the artist parading a prescribed course up and down his studio for 60 minutes, using an uncomfortable gait. Alongside his video performances, in which he tried out the deployment of his own body as an artistic material at an early stage, at the same time he developed complex installations which also demanded a certain degree of physical effort from his audience. His *Corridor* pieces had to be walked through by exhibition-goers, and Nauman often complicated

On Kawara
Mar. 23, 1974
from Today Series, 1966 to
the present, acrylic on canvas,
20.3 x 25.4 cm (8 x 10 in.)
Private collection

the experience of the work by the use of monitors and video cameras, which he linked up in closed-circuit systems. Unlike Nauman, who always avoided direct contact with the public, some artists continued the Fluxus tradition of happenings and performances, but with different methods and contents.

Vito Acconci worked in the late 1960s with a whole variety of forms of performance. For example, his *Following Piece* (1969) pursued the idea of totally subordinating his person to another's behaviour. Every day over a period of three weeks, Acconci followed someone selected at random until the person disappeared into a building not accessible to the public. He meticulously catalogued the daily course of events and documented them with photographs. In other performances, he got the public to witness body-related actions or interactions, which often reached the limits of what was physically or psychologically tolerable.

Since 1969, Mierle Laderman Ukeles has been using her Maintenance Art to attack gender-specific role-assignments and social marginalisation; she does this by demonstrating as art, in her performances, the act of cleaning a public room, and thus inciting a re-evaluation of certain areas of activity that are traditionally associated with women.

Martha Rosler devotes herself more subtly to the same topic in her video performance *Semiotics*

of the Kitchen (1975). The video shows the artist in an apron in the kitchen demonstrating the use of kitchen utensils in alphabetical order, until, obviously frustrated and bored, she starts waving a knife wildly in the air. The work not only criticises the deadliness and stupidity of the cliché that a woman's place is in the home, and as it were the confirmation and duplication of this stereotype in film and on television, but seems on another level also to be ironically questioning the value of semiotics: that is to say, the analysis of the relationship between signifier and signified.

Conceptual Art – Then and Now

The forms of Conceptual Art tried out between 1966 and 1975 can hardly be interpreted as a uniform movement in respect of either medium or content. Even so, four areas can be made out, often not easily distinguishable from each other, within which Conceptual Art has contributed to a comprehensive renewal of our understanding of art.

– Firstly, to separate the conception and material realisation of the work of art, and to equate the one with the other, leads to a fundamental neglect of the artist's craft and says goodbye, so to speak, to the idea of the work of art as a holistic aesthetic formation.

– Secondly, analytical strategies come up against the modernist dogma of the essentially

visual nature of art, a dogma which soon loses its claim to universal validity in the face of artistic practices that radically negate the aesthetic content of art.

– Thirdly, the contextual conditions of art, its status as commodity and its circulation are thematised in artistic projects which, at least in the short term, will succeed in shaking the status quo of the distribution and presentation of art.

– Fourthly, the game with the possibilities of publicity and its functional analysis becomes the focus of different approaches in which art surrenders its autonomy and becomes anchored in a socio-political context.

Much of what in the early years of Conceptual Art manifested itself on uncertain ground and with a critical intention has come to be taken for granted in the last 35 years, so that the term now has a firm place in contemporary artistic vocabulary. The effects of Conceptual Art are far-reaching, and the work of artists such as Jenny Holzer, Sherrie Levine, Cindy Sherman, Louise Lawler, Richard Prince and others would be unthinkable without the creative confrontation with its founding fathers and mothers. After the crucial opening up of the definition of art, the following decades saw a pluralistic differentiation of art, which, depending on point of view, was sometimes frenetically welcomed under the banner of Post-Modernism, and sometimes condemned as a descent into self-indulgence. In any case, ever since it has been impossible to establish binding criteria for the assessment of art. However, this made little impression on either the art market or the institutions, for both grew to a previously unknown degree during the same period.

If we look at the present day, we can state that the seriousness and responsibility with which the early Conceptual artists subjected the foundations of all aspects of art to critical revision has today given way to a largely ironically playful, detached and ideology-free art practice, whether it is conceptual or not. In step with social reality, art has also changed, and maybe the integrity, utopian naivety and political claims of Conceptual Art can only be understood against the background of a period in which the radical change in art and society was still a real possibility for a young generation.

Bridget Riley
Arrest 2
1965, acrylic on linen
195 x 190 cm (76¾ x 74¾ in.)
The Nelson Atkins Museum of Art,
Kansas City

Joseph Kosuth

b. 1945 in Toledo (OH), USA

The early work of Joseph Kosuth is regarded by many as a prime example of the Conceptual Art practice of the 1960s. As early as 1965, Kosuth came to a novel view of art, which programmatically advocated a strict separation of aesthetics and art. For Kosuth, the task of art consists in constantly questioning its own essence and, in extended analyses, to contribute to the clarification of the question of what art is. Art works are understood by Kosuth in the framework of his conception as analytical proposals, which, by reason of their tautological structure, cannot contain any statements about facts external to art.

1965 saw the appearance of the first works, such as *One and Three Chairs* (p. 577), which show real objects together with their photographic and lexicographical representations. At the same time, Kosuth was working on neon pieces, which like *A Four Color Sentence* represent as an object precisely what the verbal information says. A little later, Kosuth raised the degree of abstraction in his works once more, when, in 1966, in connection with his *First Investigation*, he started to enlarge the dictionary definition of abstract terms such as "meaning" or "nothing" on photographic paper. All the works in this series bear the title *Art as Idea as Idea*, whereby Kosuth on the one hand stresses the tautological character of art as such, and on the other makes clear that not the actual photographic plates, but the ideas to which they give expression, are what is to be understood as art. Purely verbal definitions here replace the formerly pictorial content of art, which is now no longer to be judged in aesthetic categories. Since Kosuth seeks to avoid conventional interpretations of his works as pictures or art objects at all costs, in his *Second Investigation* from between 1968 and 1969, he dispensed with any presentation of objects, by publishing categories from the thesaurus anonymously in magazines and other public media. Although they have obviously left the traditional art context, Kosuth understands these works too as "comment on art".

In 1969 Kosuth published in the magazine *Studio International* his essay "Art after Philosophy", in which he laid out in detail the theoretical foundations of his work, seeking to distinguish it from other forms of Conceptual Art. Thus he categorically rejected the application of the term "Conceptual Art" to the artistic approaches of Lawrence Weiner, Douglas Huebler or John Baldessari, since their work still related to a reality external to art. From Kosuth's point of view, "pure Concept Art" had to abandon any reference to traditional materials and techniques and present itself exclusively in conceptual form. One sentence in "Art after Philosophy" summarises Kosuth's attitude: "The 'purest' definition of Conceptual Art would be that it is an inquiry into the foundations of the concept 'art', as it has come to mean." Only in later, post-1970, works did Kosuth extend the fundamental question of meaning into philosophical, literary and psychoanalytical contexts.

(D. M.)

Bruce Nauman

b. 1941 in Fort Wayne (IN), USA

Window or Wall Sign
1967, neon,
150 x 140 cm (59 x 55 in.)
Kröller-Müller Museum, Otterlo

Before Bruce Nauman earned his Master of Arts at the University of California Davis in 1966, he had already studied mathematics and physics, and for a short while also music. While studying art, it soon became clear to him that he was hardly interested in a continuation of artistic work within the traditional parameters.

1965 saw his first fibreglass sculptures, which leant against the wall in a fragile condition or else simply lay on the floor. Many of these early sculptures by Nauman are characterised by their unfinished state, as they were often only shaped to the point where the idea underlying the work became clearly visible. At the same time, the "raw state" of the work often emphasised the specific qualities of the respective material. Nauman thus distanced himself from Minimal Art, which, particularly on the East Coast of the United States, was beginning to focus on the *production* of contemporary art. Nauman's early sculptures already show a pronounced interest in the possibilities of working with the body, many of the mysterious objects being casts of parts of the artist's own.

Physical activities of a wide variety provided the focus of numerous video works that Nauman made in his studio from 1968 on. In their absurdity and obvious meaninglessness, the filmed actions of *Bouncing Two Balls between the Floor and Ceiling with Changing Rhythms* or *Wall/Floor Positions* (both 1968) can be compared to the plays of Samuel Beckett. Often, a deliberately contrived aimlessness and senselessness determines the action. In any case, they bear witness to Nauman's creed that art was what the artist did in his studio. That the results of doing this need not always be planned is shown by Nauman's multi-part photo collage *Composite Photo of Two Messes on the Studio Floor* (1967), which depicts materials heaped at random on the floor – in a sense leftovers of past activities.

Window or Wall Sign formulates a claim on art and the artist, which, in view of the other results of Nauman's investigations of the question of what art is, seems clearly obsolete. In any case, it remains unclear whether the message – "The true artist helps the world by revealing mystic truths" – is to be taken seriously or ironically. The choice of the means with which Nauman brings his statement across, however, hints at an ironic parody of the formulation of artistic declarations of intents. For the garish neon sign, which originally hung in the window of Nauman's studio in San Francisco, competes for attention with any old colourful advertisement for beer or cigarettes. (D. M.)

The true artist helps the world by revealing mystic truths

Robert Smithson

b. 1938 in Passaic (NJ), USA
d. 1973 at Tecovas Lake (TX)

By the time of his premature accidental death in 1973, Robert Smithson had become a key figure in Land Art. Besides the diverse sculptures, films and drawings he produced, his theoretical texts were primarily responsible for his (self-declared) position as a spokesperson for the art that was taking place beyond the boundaries of studios and art institutions. His articles, lectures and interviews are a brilliant and boisterous mixture of art criticism, of scientific theories of thermodynamics, crystallography and geology, of media theory, of science fiction and horror films, and of the theory of post-modern literature and symbols. These texts are an important reason for his cult status today.

Smithson invented the labels "Site" and "Nonsite", thereby announcing the tension between exterior and interior space. With these conceptual notions he attempted to compose a real and traversable "place" in exterior space in such a way that it would change into a transportable and abstract artwork: the *Nonsite*. He placed materials collected from the outdoors into metal containers that were reminiscent of his Minimal sculptures' serial organisation and geometric vocabulary of form. On the exhibition wall parallel to these he showed texts, photographs and maps of the location. These were dissimilar analogies and metaphors for the non-present places. "By drawing a diagram, a ground plan of a house, a street plan to the location of a site or a topographic map," explained Smithson, "one draws a 'logical two dimensional picture'. A 'logical picture' differs from a natural or realistic picture in that it rarely looks like the thing it stands for."

Smithson conceived most of the *Nonsites* during 1968. That October, he showed a *Nonsite* for the first time in the groundbreaking exhibition *Earth Works* at New York's Dwan Gallery. When gallerist Konrad Fischer invited him to Düsseldorf at the end of the year, he went on an excursion to the waste dumps of the Ruhr district with industrial photographers Bernd and Hilla Becher. Smithson collected slag, a waste product from steel mills, in the extensive industrial landscape around Oberhausen, and photographed the ravaged, abandoned area.

In the gallery he then presented five progressively taller painted steel containers, into which he had simply dumped the slag. On the gallery wall he exhibited photo collages: 25 snapshots of the area were arranged in five rows of five photographs each. Below these was a photocopied map of the industrial area, on which the slag's site of origin was highlighted. Below the map, handwritten notes provided purely factual information about what one could see there (map number, size and colour of the containers, etc.)

"What you are really confronted with in a nonsite is the absence of the site," Smithson emphasised in an interview later. "It is a contraction rather than an expansion of scale. One is confronted with a very ponderous, weighty absence. What I did was to go out to the fringes, pick a point in the fringes and collect some raw material. The making of the piece really involves collecting. The container is the limit that exists within the room after I re- turn from the outer fringe. There is this dialectic between inner and outer, closed and open, centre and peripheral. It just goes on constantly permuting itself into this endless doubling, so that you have the nonsite functioning as a mirror and the site functioning as a reflection."

(M. L.)

Nonsite, Oberhausen, Germany
1968, five enamelled steel containers with slag,
25 photographs, and pencil on a photocopied map
Friedrich Christian Flick Collection at Hamburger Bahnhof, Berlin

Alighiero Boetti

b. 1940 in Turin, Italy
d. 1994 in Rome

Self-taught, Alighiero Boetti began his artistic career in the mid-1960s. In 1967 he first exhibited his works in the Christian Stein gallery in Turin. Since the start of his artistic activities, Boetti had taken an interest in dualist structures and in a wide variety of aspects of time. His 1966 *Lampada annuale*, for example, lights up just once a year for eleven seconds, in order to symbolise "the countless events that happen without our knowledge or involvement". In other works, such as the drawings from the *Lavori a biro* series or the embroidered maps, the phenomenon of time is incorporated into the duration of their production, and is thus an integral component of their conception. In 1971 Boetti first went to Afghanistan, and continued to spend lengthy periods there every year until the Russian invasion of 1979. Right up to his death in 1994, Boetti had numerous projects executed by Afghan carpet weavers, such as his *Mappe del mondo*.

For the *Lavori a biro*, executed as their name suggests with a ballpoint pen, Boetti mostly commissioned students who, in a laborious and time-consuming process, made drawings on usually large-format sheets of paper in accordance with his instructions. Many of these drawings show in the top left the alphabet, and an arrangement of commas, hardly decipherable at first glance, which cover the entire expanse of the paper and as white holes stand out from the rest of the paper, which is completely covered in biro ink. Not only was the production of this work very time-consuming, but so is its perception. Not

infrequently, the alleged chaos follows a complex logic. For the arrangement of the commas corresponds to a complex coding system, where they are each, by virtue of their position and the intervals between them, to be assigned to a particular letter of the alphabet. Only those who know the code can decipher Boetti's spoken message.

The dialectic of order and chaos, which the *Lavori a biro* symbolise in impressive fashion, and, in a sense, abolish, is reflected on another level in the game that Boetti has been playing with his name since 1968. In a simple act, Boetti anchored dualism as the creative principle in his own name, when he split his forename and surname, thenceforth calling himself Alighiero e Boetti. As if to symbolise the reconciliation of this inner polarity, the 1977 photomontage *Gemelli* showed two images of the artist walking hand-in-hand along an avenue. One of the form-determining elements in many of Boetti's works is the squaring of texts or numerical progressions, first experimented with in 1970. The work *Millenove-centosettanta*, which has been executed in numerous versions, shows the written-out form of the calendar year in which it was created in horizontally ordered rows. The square, which encompasses 49 fields, thus encodes the simple information, i.e. the year, transferred from numerical to verbal form. Many of Boetti's later works use different, increasingly complex, systems of information coding, either by superimposing pictorial and verbal elements, or combining different models of description.

(D. M.)

Millenovecentosettanta
1970, wood relief,
49 x 49 cm (19¼ x 19¼ in.)
Nationalgalerie im Hamburger Bahnhof, Staatliche Museen
zu Berlin, Sammlung Marzona, Berlin

Marcel Broodthaers

b. 1924 in Brussels, Belgium
d. 1976 in Cologne, Germany

Museum of Modern Art, Department of Eagles
1968–1972, top: vacuum-formed plastic plate,
84.5 x 121.5 cm (33¼ x 48 in.); bottom: photomontage
on card, framed 65 x 100 cm (25½ x 39¼ in.)
Private collection

In the early 1950s, Marcel Broodthaers was a poet who earned his living as a bookseller. In 1963, in a symbolic act, he coated 50 unsold copies of *Pense-Bête*, a collection of his poetry, with plaster of Paris and thus created his first sculpture, which in a sense made his poetry impossible to read. The purported abandonment and literal silencing of literature thus went hand in hand with the start of a career as a visual artist, whereby the multiply ambiguous intermeshing of word and object or picture, which already characterised *Pense-Bête*, can be regarded as paradigmatic for Broodthaers' art. Basically, Broodthaers the artist was always a poet at heart, and his work is just as clearly in the tradition of the Belgian painter René Magritte as in that of the French poet Stéphane Mallarmé.

Always searching for the meaning and transfer of meaning in the relationship between signifier and signified, Broodthaers has left an œuvre of extraordinary complexity, which reveals a high degree of moral intensity. Broodthaers strictly forbade himself to repeat anything, and neglected market considerations, indeed often deliberately boycotting the market altogether. Although he always maintained a critical attitude to the fusion of art and politics, as evidenced by his dispute with Joseph Beuys, many works evince subtle criticism of a bourgeois view of art that saw contemporary art first and foremost in terms of its monetary value and the possibility of increasing the same. In late works, Broodthaers extended this critique to a general criticism of the contextual conditions of contemporary art production.

There is hardly a medium or a material that Broodthaers did not use in his twelve years as a visual artist, which ended with his early death in 1976: film, photography, sculpture, painting, assemblage, print, graphics and text all served as means of expression, whereby ideas always interested him more than their perfect concrete realisation.

The *Museum of Modern Art, Department of Eagles,* set up in Broodthaers' apartment in 1968, soon expanded to become his most extensive artistic project. This virtual museum consisted at first only of a few empty packing cases and numerous art postcards, and was intended to serve as a forum for the cultural and political debates which in the wake of the Paris riots of May 1968 soon developed in Belgium too.

By the time Broodthaers displayed his *Museum of Modern Art, Department of Eagles* in the Kunsthalle Düsseldorf in 1972, it had grown considerably larger. In his capacity as curator, Broodthaers had assembled a huge number of objects, many of which were on loan from international museums. In order to caricature the normative and up-lifting act of displaying objects in museums, Broodthaers provided many of his exhibits with labels which, in allusion to Magritte's famous picture *The Treachery of Images* (1928/29), contained the warning "This is not a work of art". By so doing, Broodthaers turned Duchamp's readymades gesture on its head, thus regaining some of its subversive strength.

(D. M.)

On Kawara

b. 1933 in Kariya, Japan
d. 2014 in New York, USA

I Got Up
1973, postcards with rubber stamp, 21 parts,
each 8.9 x 14 cm (3½ x 5½ in.)
*Nationalgalerie im Hamburger Bahnhof, Staatliche
Museen zu Berlin, Sammlung Marzona, Berlin*

After On Kawara had visited far-flung parts of the world on extended journeys, he settled in New York in 1965. While his early paintings were still figurative, in the mid-1960s he developed an artistic concept that, while still in principle belonging to the painting genre, liberates it from any expressiveness, and instead concretises the abstract and immaterial phenomenon of time through the medium of painting.

In January 1966 the first painting in the *Today Series* appeared. The artist from the outset understood the painting as a connected work, which would only be consummated with his death. The principle of the series has not changed to this day and in the works, there is nothing to be seen but the date of the day on which Kawara produced it. This date is immaculately painted with perfect craftsmanship on a monochrome ground. As for his *Date Paintings*, depending on the format, up to three pictures can be painted in a day. If a work is not completed by midnight on the day in question, however, Kawara destroys it.

The way the pictures are produced is time-consuming and labour-intensive. First, the canvases are primed with up to five coats of paint. For the dates, which are painted by hand, Kawara then needs up to seven layers of white paint. In the early years of work on the *Today Series* in particular, Kawara stuck newspaper cuttings from the day in question on the back of the picture. For every picture, he also made a cardboard box, lined on the inside with newspaper.

Alongside the *Today Series*, a short time later Kawara started other sequences of works, some of which involve the regular dispatch of postcards. For the project *I Got Up*, started in 1968, he sent two postcards every day to friends or acquaintances. On the backs of the cards there is a rubber stamp with the message "I Got Up" and beside the date, the exact time and place that he did so. In this way, Kawara transfers the transitory moment of getting up, of awakening thought, to the focus of an eccentric communication system.

The central purpose of Kawara's art seems to be to convey an idea of a duration filled with consciousness. While his *Today Series* preserves the past as the present in the picture, his works *One Million Years – Past* (1969) and *One Million Years – Future* (1981), presented in book form, give us the opportunity to place the duration of temporal perception (both of the individual and of the entire human species) in a superordinate perspective. *One Million Years – Past* lists, in ten books and more than 20,000 pages, the numerical designations of a million years. The year 1969 forms the start of a sequence of dates going back into the past. *One Million Years – Future* goes forward on the same principle from the year 1980. The duration of an average human life is represented by a few lines of a page of a book, and the whole of human history takes up just a few pages in one of the ten books. Kawara dedicated these works respectively to "all those who have lived and died" and to "the last one". (D. M.)

Nam June Paik

b. 1932 in Seoul, Korea
d. 2006 in Miami, USA

Global Groove
1973, multi-monitor installation,
video, colour, sound, 30 min
*Installation view, Deutsche Guggenheim,
Berlin 2004*

Even with his first exhibition *Exposition of Music – Electronic Television* (1963) in the Galerie Parnass in Wuppertal, Nam June Paik made video history by demonstrating on twelve prepared sets how manipulable the still-young mass medium of television was. At that time Paik was working under the influence of the Fluxus movement. He moved to New York in 1964, where he became acquainted with the cello player Charlotte Moorman. Together they carried out numerous performances in which Moorman was "dressed" by Paik in video objects, or made music with such objects.

As early as 1966 he created *TV-Cross*, his first multi-television video sculpture. Around 1970, together with the Japanese electrical engineer Shuya Abe, Paik developed a video synthesiser which allowed him to change the basic structure of the electronic image material. Parallel to this he began to experiment with the closed-circuit method, and in 1974 created one of his first sculptural feedback installations, entitled *TV-Buddha*.

The list of his innovative accomplishments could easily be continued, for example by mentioning the experiments Paik carried out with laser beams at the beginning of the 1980s. Originally, however, Paik trained as a musician and composer. A meeting with John Cage in Cologne in 1958 and Paik's work there in the radio station WDR's studio for electronic music, inspired him to create sound collages in which he combined various sound elements, noises and classical music.

This collage principal can be seen again in video works like *Global Groove*. *Global Groove* was actually a government commission from the United States to promote international understanding, requested in the year 1971 when the

Vietnam War had still not come to an end. Both visually and acoustically, Paik strung together 21 sequences from different cultural areas, including both high and popular culture: two go-go dancers appear, a Navajo Indian sings and plays drums, Korean dances are performed, a black African is seen fist fighting, and a Japanese commercial for Pepsi-Cola flashes by. Paik used material from public television stations just as he used excerpts from his own work, in which roles were played by some of his friends: John Cage, Charlotte Moorman and the poet Allen Ginsberg. Eastern and Western modes of life, which Paik connects in his own life history, stand side by side. Some shots are additionally processed by a synthesiser. A portrait of U.S. president Richard Nixon seems completely distorted, while the media theorist Marshall McLuhan, in a shot taken from the work *McLuhan Caged* (1970), is also barely recognisable.

In *Global Groove* Paik plays with the structure of advertisements, so-called video clip aesthetics, which were perfected at the beginning of the 1980s by MTV in its music clips. The quick progression of the sequences concentrates the audiovisual material into a pattern, the individual contents of which can only be comprehended with difficulty. Paik visualised a global synchronisation, which would have both advantages and disadvantages. In his work with television and video Paik was always aware of this Janus-faced character of the medium. At the beginning of the videotape *Global Groove* a voice from off-camera announces: "This is a glimpse of a new world when you will be able to switch on every TV channel in the world and TV guides will be as thick as the Manhattan telephone book." (S. M.)

Gordon Matta-Clark

b. 1943 in New York, USA
d. 1978 in New York

As a student, Gordon Matta-Clark worked as Dennis Oppenheim's assistant on a number of Land Art projects. In 1968 he graduated in architecture from Cornell University, and a year later went to New York, where at first he devoted himself to various activities. In the early 1970s, alongside his artistic activities, he worked on the alternative exhibition project *112 Greene Street*, and was involved in the foundation of the cooperative restaurant Food, likewise in SoHo, which was chiefly frequented by artists. This soon became the regular meeting place for those artists who had joined together to form the Anarchitecture group, of which Matta-Clark was destined to become the outstanding member.

While Matta-Clark's early projects already revealed an interest in the phenomenon of transformation, they were however not yet integrated into the architectural context which was to be characteristic of his works post-1972. Thus for *Photo Fry* (1969) in the John Gibson Gallery he had photographs fried in hot fat, or, for *Cherry Tree* (1971), he planted a cherry tree in a dark cellar, and its death a few months later, was the completion of the process that represented the work.

From 1972 Matta-Clark started to concentrate his activity on architectural interventions. It was not the invention and erection of new structures, but the deconstruction of existing architecture, often incorporated into unambiguous urban contexts, that characterised his approach. Matta-Clark regarded empty buildings not just as material, but as a metaphor for social and political conditions, which he implicitly criticised with his work on and in architectural complexes which were no longer of any value to the community. The earliest works that he realised actually on a building include *Pier In/Out* (1973), for which he used a metal cutter to remove a large rectangle from a corrugated iron wall together with part of a window. Alongside photographs documenting the operation on this warehouse, *Pier In/Out* also exists as a sculpture: Matta-Clark mounted the fragment of wall on a metal plinth.

With the support of the gallerist Holly Solomon and her husband Horace, Matta-Clark was able in 1974 to execute *Splitting*, his largest project to date. The couple bought a piece of land in Englewood, New Jersey, with the intention of demolishing the suburban house that stood on it. At the artist's request, Solomon agreed to allow the building to be used for this project. Matta-Clark's work on *Splitting* took some four months, and the result was the transformation of a prime example of anonymous architecture with no distinguishing features into a spectacular manifestation of contemporary sculpture. In time-consuming and laborious procedures, Matta-Clark split the house vertically into two halves. In order to make this incision even more visible, he lowered the level of one half, so that the crevice broadened into a wedge-shaped opening affecting the whole façade. Later he cut off the four corners of the house at second-floor level, and displayed them as sculptures at a number of exhibitions. In addition he documented his operation on the unassuming house at 322 Humphrey Street, which was definitively demolished two months later, in photographs and photo collages.

(D. M.)

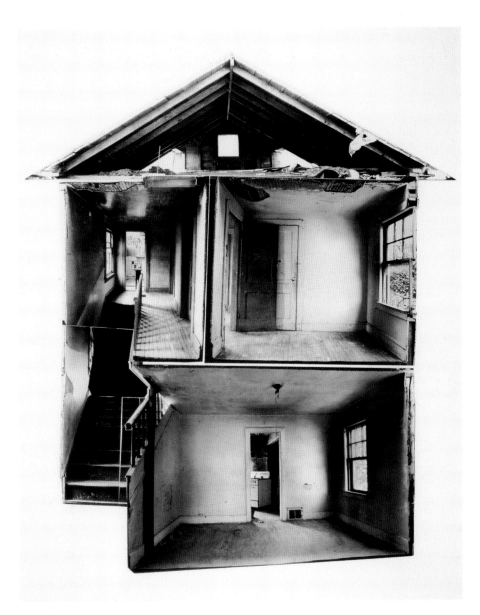

Splitting
1974, photomontage,
101.6 x 76.2 cm (40 x 30 in.)
The Museum of Modern Art, New York

Robert Morris

b. 1931 in Kansas City (MO), USA

For the international group exhibition *Sonsbeek '71*, Robert Morris was given the opportunity to carry out his plans for a quasi-architectural, large-scale observatory. Curator Wim Beeren organised the exhibition not just in Sonsbeek Park in Arnhem, but in various locations throughout Holland, in order to offer every artist an environment corresponding to their artistic interests. Morris searched for a suitable place on the periphery, in a zone between ocean, land and city, which he finally found close to Santpoort (Velsen). It is not just in terms of cost and construction time that plans differ from the observatories conceived by Charles Ross or James Turrell. Morris' *Observatory*, which was demolished after the end of the *Sonsbeek '71* exhibition, remained by programmatic intention on the narrow borderline between sculpture and architecture.

It consisted of two concentric rings of earth, which in this location were inevitably reminiscent of a dike. The outer ring with a narrow water-ditch had an undulating shape, and was divided into segments by a triangular entrance and two V-shaped indentations in the mounds. For the inner ring, earth was dumped against a palisade made of wooden slats, in which four openings had been cut beforehand. From a westerly direction viewers came to an axis oriented eastward in the area of the inner ring. Here, two of the openings were lined up with notches on the outer ring, which were reinforced by solid granite slabs and oriented on the sunrise during the summer and winter solstices. On the prolongation of the axis beyond the two rings, one looked out at a third indentation marked by two large, square steel plates, which the sunrise accentuated during spring and autumn equinoxes.

In 1977 Morris, in cooperation with the Stedelijk Museum in Amsterdam, was able to rebuild the work in Oostelijk (Flevoland) in Holland. The structure is now overgrown by grass and fits unobtrusively into the polder landscape, the very flat marshland reclaimed by using dikes.

The circular, axially oriented spatial structure and the various views out of and into it are intended to imply movement, just as was also characteristic (Morris believes) of prehistoric observatories. "The overall experience of my work derives more from Neolithic and Oriental architectural complexes. Enclosures, courts, ways, sightlines, varying grades, etc, assert that the work provides a physical experience for the mobile human body… The work's temporal focus – the marking of the four annual sunrises of seasonal changes – moves it beyond a simple, decorative spatial structure." The definition of sculpture supported by the arguments of phenomenology and Gestalt psychology, and which Morris represented in the 1960s, echoes in these sentences. At that time, he led the call for constant, simple forms, so that varying perceptions of the sculpture in space could arise due to its gestalt, its shape. The particular site of the presentation is also of decisive significance for *Observatory*: "The work lies in that buffer zone or interface between the wild and the inhabited… It is on that boundary, at the beginning of the dunes, that the work exists – not as an enlarged photograph of a remote monument, but as an accessible place between the cultivated and the natural." (M. L.)

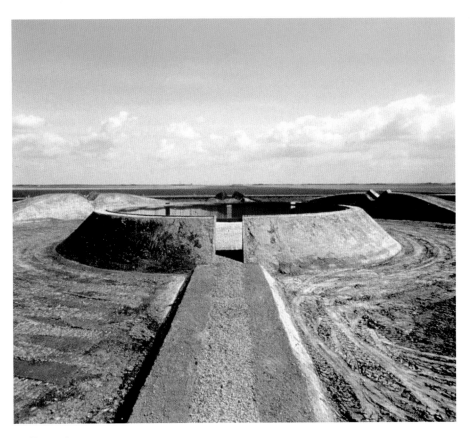

Observatory
1971/1977 (permanent installation),
Oostelijk (Flevoland), Holland;
earth, grass, wood, steel, granite,
water, Ø 91 m (298½ ft)

Christo and Jeanne-Claude

Christo Vladimirov Javacheff
b. 1935 in Gabrovo, Bulgaria

Jeanne-Claude Denat de Guillebon
b. 1935 in Casablanca, Morocco
d. 2009 in New York, USA

Valley Curtain

1970–1972, Grand Hogback, Rifle, Colorado; curtain made of 12,780 square metres of orange nylon fabric, width 381 m (416¾ yd), height 111 m (121 yd) on the sides and 55.5 m in the middle (60¾ yd)

In the summer of 1970, Christo and Jeanne-Claude planned a curtain in a valley. In the surroundings of Aspen, Colorado, the artists had searched for a valley across which they would be able to hang a gigantic, orange-red-coloured curtain. They chose the colour to form the most striking harmony with the surrounding countryside, because Colorado means red in Spanish. In the Grand Hogback range of the Rocky Mountains, twelve kilometres north of the town of Rifle, they finally found a mountain gap that was ideal for their plan: *Valley Curtain*. The extensive logistical and technical preparations, press conferences and permit applications began in the autumn of 1970, and contracts were signed with the private landowners, various companies and officials. The Valley Curtain Corporation, founded expressly for this purpose, was to look after financing the costly enterprise through the sale of drawings, collages and models, but also of Christo's works of the 1950s and 1960s.

As in all of their large-scale projects, Christo and Jeanne-Claude initially had to overcome much resistance. They particularly had difficulties with the first engineering company they hired and with the relevant authorities – primarily with the State Highway Department, which was responsible for granting the permit to work above the highway. While the curtain was elevated in October of 1971, it unfurled prematurely and was destroyed. The project was postponed until the spring of 1972 and a new curtain was sewn. When on 10 August 1972 the last of 27 lines holding the curtain's 12,780 square metres of orange nylon fabric were raised, it was a perfect sensation. Art lovers, collectors, onlookers, art critics and a host of filmmakers had been waiting for this moment. Yet the next day they had to take the curtain down once more due to a storm.

The curtain threatened to become a gigantic sail, capable of developing a force that could not be held. The coordinator of the enterprise, Jan van der Marck, chronicled the overwhelming spectacle: "Nobody but the artists and the engineers had quite anticipated the awesome pressures on the curtain; it strained and groaned in the gentlest breeze. At twenty knots the wind load on the curtain equaled the force needed to propel two ocean liners at full speed."

Yet for Christo and Jeanne-Claude the 28 hours that the curtain obstructed the valley was by no means the fatal end to their idea. For them the 28 months of its construction counted just as much as the final day: "We had been warned by our *Valley Curtain* engineers that the curtain should have air holes in it, or it would stay a very short time, and it did stay little. And it will be very dangerous to build, but we should go through that to do it. And of course, this is our privilege. We are happy that the *Valley Curtain* was exactly as we wanted it."

(M. L.)

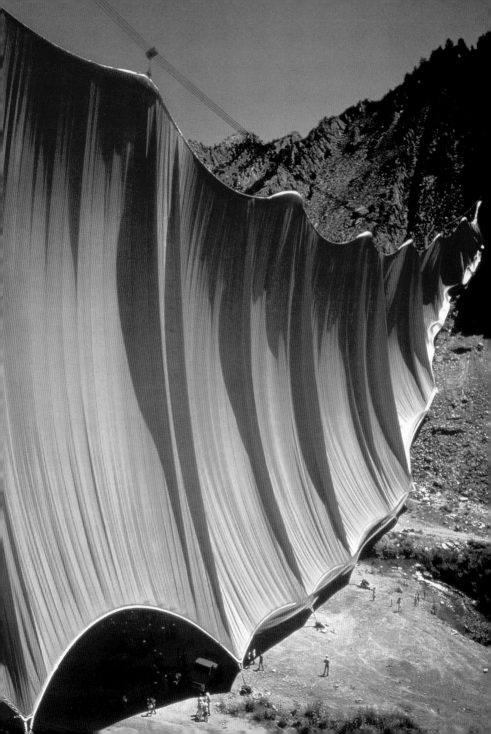

James Turrell

b. 1943 in Los Angeles, USA

The light projections that James Turrell has been developing since the mid-1960s to be shown inside museums have a unique haptic quality. Between 1968 and 1971 Turrell participated in the Los Angeles County Museum of Art's Art and Technology programme, and there his close cooperation with the scientist Edward Wortz, who was researching the conditions of perception in space for NASA, would greatly influence his ideas. In his installations, one almost believes oneself capable of grasping the light; the projected light seems to solidify into a block or a cube-shaped space. The usual context of perceivable, tangible spatial depth dissolves, and the pieces create the unreal impression that one is in a boundless field of pure, coloured light.

The experience of boundlessness while flying, and his work on his *Skyspaces* in interior rooms, awakened Turrell's desire to have at his disposal broad spaces and almost unlimited dimensions. He therefore began, in the mid-1970s, to plan his largest and most expensive project involving light, which is not yet finished today.

Seventy kilometres north-west of the small town of Flagstaff in Arizona, a gravel road branches off the highway and leads between brushwood and bushes to the project site. The trapezoidal cinder cone of a long extinct, approximately half-million-year-old volcano, the Roden Crater, juts out of a lava field where the ground shimmers with dull copper tones and rust-reds. The volcanic cone rises about 300 metres above the Painted Desert that lies to the north, and is one of the so-called San Francisco Peaks, a sprawling volcanic region.

After buying the crater and 400 square kilometres of pastureland around it in 1974, Turrell designed a system of rooms, connecting passageways and lookout points for *Roden Crater*. Advised by scientists and the New York architectural office SOM, the artist designed the installation as a type of observatory, the primary purpose of which is the intense perception of light. The path starts at a small lodge halfway up the volcano's south slope. From there one climbs further upward to a concrete gate. Behind this lies a circular room, the *Sun and Moon Space*, with a tiny opening in the ceiling through which a beam of light enters. In this foyer begins the climb through the approximately 350-metre, semicircular *Alpha Tunnel* into the mountain, until you reach a bright room built on an elliptical ground plan, the *East Portal*, which has an oval panorama window built into its ceiling. After going through another section of tunnel, you arrive at the installation's centre, the *Eye of the Crater*. Turrell explains, "The entrance from the tunnel into the crater space is made through an intermediate space which is similar to the earlier *Skyspaces*. The space at the top of this chamber creates a sense of flat closure of transparent skin. Steps proceed out of this chamber in such a way that the entrance does not occlude vision of the sky from the tunnel. Passing through the flat, transparent plane, the sense of closure recedes to a curved skin within the larger space of the sky."

The various tunnel passageways function according to the principle of a camera obscura. Sun, moon and planets should cast their light in specific positions in the volcano's interior in such a way that their image appears on projection surfaces at the end of the passageways. Turrell plans a highly subtle and spiritual performance of the stars, which is intended to lead the viewer to the boundary of what is barely visible.

(M. L.)

Roden Crater
1974 (ongoing), Flagstaff, Arizona,
volcano crater

Walter De Maria

b. 1935 in Albany (CA), USA
d. 2013 in Los Angeles

When Walter De Maria showed his *Bed of Spikes* – five rectangular high-grade steel plates with sharply pointed square steel bars – in New York's Dwan Gallery, *Time* magazine celebrated him as a "High Priest of Danger". A serial aesthetic, numbering systems and technically perfect industrial production made this 1969 exhibition a highlight of Minimal Art, even though the steel spikes presented an obviously intentional and real threat to the viewer. With a good sense for promotional effectiveness, the Dwan Gallery mailed out a release form that each invited guest had to sign, indemnifying the gallery and the artist from legal responsibility in case of an accident. It was an unconventional, almost spiritual staging of danger, perfection and beauty.

In the mid-1970s De Maria once again planned a project with stainless steel rods for a particular location, this time for an installation in the New Mexico desert. For five years he had searched the states of California, Nevada, Utah, Arizona and Texas for his ideal site that was to be level and remote, and at the same time the setting of frequent thunderstorms. After making a small prototype in 1974 in Arizona, he worked from June to October in 1977 to create the *Lightning Field* on a plateau north of Quemado, New Mexico. Within an area measuring 1 mile x 1 kilometre, he vertically embedded 400 steel bars with points on their upper ends in concrete foundations in the desert floor. The elegant, long stainless steel rods are regularly spaced at 66-metre intervals. By means of extremely accurate measurement, their upper tips all lie at the same level, and because the ground is uneven the rods are of various lengths. With an average height of 6 metres, the rods catch the sun's first rays even before it can be seen above the horizon. The rods become almost invisible when the sun is high around lunchtime, and appear to continue to glow long after sundown. Yet the sublime interplay between art and nature is revealed above all during a thunderstorm, when the rods are struck by lightning.

The relationship between people and space is of vital importance to De Maria, and traversing the immense field opens up ever-new perspective arrangements, viewing angles and vanishing points. The artist has therefore planned visits with extreme care, and viewing reservations must be made by writing to the Dia Art Foundation, which commissioned and now maintains the installation. No more than six visitors may be on the property at any one time, and they must remain there for at least 24 hours (a little cabin set up specifically for this purpose serves as a shelter). Some visitors consider the restrictions to be an annoying authoritative gesture, yet it is a necessary part of the artistic concept: only in this way can the individuals fully experience the great space.

De Maria published "Some Facts, Notes, Data, Information, Statistics and Statements" about his work in the magazine *Artforum* in 1980. Here he exhaustively provided the technical figures and calculations required to produce *Lightning Field*, in order to demonstrate the installation's perfection. The sum of all the facts, however, is not what is important to him in the work. No sequences of numbers or photographs can completely describe *Lightning Field*. It must be experienced directly on location, and the artist describes this in this manner: "Isolation is the essence of Land Art." (M. L.)

The Lightning Field
1977, New Mexico; 400 stainless steel rods,
area 1.6 x 1 km (1 x ¾ miles),
height 6.2 m (20¼ ft.), Ø 5 cm (2 in.)
Dia Art Foundation, New York

Post-Modernism –
From Cindy Sherman
to Glenn Brown

A More Fully Human World than the Older One

Hans Werner Holzwarth

The term "post-modernist painting" was first used in the 1870s, when modern art was still young: the otherwise negligible Victorian painter John Watkins Chapman used it programmatically to promote a type of painting that was to transcend Impressionism. Although this artistic form rapidly developed in the Post-Impressionism of Seurat, Cézanne and van Gogh, it was to be another century before Post-Modernism actually became a byword, and even then initially only in architecture and literature and only later with reference to art.

Fredric Jameson, one of the movement's leading theorists, opened his book on the subject with the following statement: "It is safest to grasp the concept of the postmodern as an attempt to think the present historically in an age that has forgotten how to think historically in the first place." Jeff Koons, who, as the central figure of the new generation in the 1980s was labelled by the critics as both Post-Pop and Neo-Conceptual, hazarded the historical view in *Statuary* from 1986, a series of sculptures cast in stainless steel that opened up a whole panorama between folk and official art. At the top end stands the figure of the French Sun King, about which Koons says: "*Louis XIV* is a symbol for me of what happened to art since it has been given freedom. It is a symbol of how artists have exploited art... The piece tries to be as seductive as possible, to use anything that it can

to seduce a viewer." From this quotation, one can see that post-modern art's self-referentiality does not necessarily lead to a random mix of styles without much regard for content, as has often been said of Post-Modernism. The attempt to "think the present historically" might lead to a constant focus on the new and the latest (not for nothing did Koons call one of his series *The New*), but it also leads to very committed, often political art. To quote Jameson again: "Modernism also thought compulsively about the new and tried to watch its coming into being...but the postmodern looks for breaks, for events rather than new worlds... Postmodernism is what you have when the modernisation process is complete and nature is gone for good. It is a more fully human world than the older one, but one in which 'culture' has become a veritable 'second nature'."

Accordingly, post-modern art takes what it needs from culture, from media images and earlier art and in so doing comes closer to life than its forerunner, Pop Art. When Richard Prince and others use Duchamp's conception of the readymade to create a whole new Appropriation Art, the point is no longer only about a change in the understanding of art, but also about political themes such as intellectual and material property. Because the world is more strongly defined by the role of the individual, it also means that due to the influence of the

media the personality of the artist plays a bigger role in the individuality of art, as is shown in various ways in the self-dramatisation of artists such as Cindy Sherman, Martin Kippenberger and Julian Schnabel. Stylistically, today's scene seems to be completely heterogeneous and incapable of stylistic categorisation, embracing figurative painters such as Doig, Rauch or Brown, abstractionists such as Oehlen, Wool or Milhazes, seemingly objective photographers such as Struth or Gursky and openly critical artists such as McCarthy or Ai Weiwei – yet all these artistic positions are about an art which keeps close to the real world, calling on the artists to take a clear stance – "a more fully human world", that is.

Cindy Sherman

b. 1954 in Glen Ridge (NJ), USA

Untitled Film Still (#7)
1978, black-and-white photograph,
25.4 x 20.3 cm (10 x 8 in.)
The Museum of Modern Art, New York

This black-and-white photograph with the non-title *Untitled Film Still (#7)* shows a slightly lascivious-looking woman standing in a sliding door (likely a hotel room at a summer resort), dressed only in a white slip and garter belt, wearing dark glasses and holding a martini glass in her left hand. It is part of Cindy Sherman's series *Untitled Film Stills*, 80 uniform-format photographs taken between 1977 and 1980 that brought the American artist's international breakthrough.

There were parallels between this series and the concurrent *Pictures* exhibition, curated in 1977 by the art critic Douglas Crimp at Artists Space in New York, and the theory that then arose and subsequently became known as Appropriation Art – the adoption of pre-existing visual material and a concern with mechanisms of cultural representation. As a result, Sherman's *Untitled Film Stills* attracted great interest in the context of the art discourse and made her one of the most discussed of contemporary artists. This circumstance rested on the complexity of the series, reflected in its staging and disguising and play on diverse female role models and the concomitant critique of stereotypes and clichés. Added to this were strategies of fake and repetition, as well as a critical involvement with central constructs of art theory, such as authorship, authenticity and originality. Sherman herself acted as protagonist and model in her photos, being also responsible for the settings, make-up, costumes and props – and not least for the technical process of photomaking, the majority of the stills being taken with a delayed shutter release. This is evident from some of the images, such as *Untitled Film Still (#6)*, where a highly visible shutter extension cable reveals the deception involved.

Sherman is simultaneously the subject and object of her works, not only subverting conventional gender roles, such as the attribution of passivity to women and activity to men. Moreover, she quite generally deconstructs the illusion of firm identities by restaging scenes from fictitious films, in which, for example, sexy housewives, seductive Lolitas (see *#6*), languishing lovers or waiting wives are depicted in a visual language reminiscent of 1950s and 1960s B-movies. By purposely introducing slight inconsistencies and emphasising "interim moments", Sherman draws viewers into a trap. On the one hand, the sense of recognition tempts the male voyeuristic gaze and manipulates it by means of staging and faking. Female viewers, on the other hand, feel little urge to identify with these non-idealised supposed starlets. This reveals the mendacity of photographic illusions, as the artist explains, a deception that daily suffuses advertising, magazines and the mass media. (I. D.-D.)

Richard Prince

b. 1949 in the Panama Canal Zone

Untitled (Cowboy)
1980/1984, ektacolour photograph,
114.3 x 76.2 cm (45 x 30 in.)

Together with fellow artists Cindy Sherman and Sherrie Levine, Richard Prince is assigned to the Pictures generation, which appeared in New York in the mid-1970s. In the context of Appropriation Art, they saw the copying of existing works as an important component of their artistic strategy. Prince had no problem using the term "pirating" for this procedure: he hijacks the picture motifs of advertising or the entertainment industry with various media – photography, painting or sculpture – and in the process relativises the traditional concepts of authorship, originality and aura. His *Cowboys* are now among the most sought-after objects on the art market. One of them fetched US$ 3.4 million in 2007, the highest price ever paid for a photographic artwork. Prince had the idea for the technique and motif while working for Time Life in 1977: "I had to archive the editorial contributions. By the end of my graveyard shift from six in the evening to six in the morning I had torn all the articles out of the magazines, only the advertisements were left."

During these night shifts new variations of the Marlboro Man kept falling into his hands, always idealising the cowboy on horseback as the ideal of American manhood. Prince began to photograph the already highly constructed and staged motifs and to enhance their artificiality still further by making them more grainy and varying the crop-ping, size and colour. Thus he condensed the advertising motif into a phantasm of the primal American man: lonesome, accompanied only by the "taste of freedom and adventure" and, in the variant shown here, braving nature (raincoat), dominating the beast (lasso) and gesticulating in the dark as though he were conducting the universe. For Prince, the cultural reshaping of reality, and in particular the trashy, trivial myths of everyday American culture –fictions that are seductive for almost everyone – are the real truth behind a reality characterised by consumerism and the media. His re-photographs isolate, frame and exaggerate them, and thus emphasise subtexts of social codes. In a certain sense Prince, who in his private life is a passionate collector of books, manuscripts and art, is thus compiling an artist's museum of everyday American culture. Whether it's the *Cowboys*, the *Girlfriend* photos taken from motorbike magazines, the *Nurse Paintings* based on the motifs of romantic pulp fiction or his idiosyncratic car-body work objects, Prince reflects the contents and accessories of male fantasies, acts as a chronicler of the archetypal macho obsessions of the "Mad Men" of our Western world. In so doing, while he underscores their anachronistic character, he also bears witness to their almost undiminished influence.

(K. S.)

Julian Schnabel

b. 1951 in New York, USA

Julian Schnabel virtually conquered the art world overnight with his first solo exhibition at the Mary Boone Gallery in New York City. He was the right painter at the right time: boisterous, demanding, brimming with creativity and affectations – and meant for an art scene that seemed based on commerce and self-presentation. "I'm the closest thing to Picasso that you'll see in this fucking life!" is one of the sayings attributed to him. From these words one can glean the self-irony of an artist known for painting in his bathrobe and slippers and pulling off his breakthrough as a bull in the China shop of art criticism with paintings covered with broken plates.

Schnabel himself saw the plate paintings as his artistic breakthrough. He vividly described the moment of inspiration: in a hotel room in Barcelona, he envisioned a painting inundated with broken plates and how it would perfectly fit the complete backroom. He imagined how the reflection of the plates broke up the picture surface, how the shattered everyday object appealed to him and how the plates seemed to resound and tell stories of human tragedies – all of that long before he even got started. "It was that radical moment that an artist waits for. I wanted to make something that was exploding as much as I wanted to make something that was cohesive. I didn't know what the painting was supposed to look like. I didn't know how much drawing I was supposed to put on it. It was an act of desperation which I needed to hurry home to realise." After he had solved various technical issues and found the proper glue, he searched for a way the new medium could be applied. "There had to be something else…in the same physical way that our veins are inseparable from our bodies. Then

I literally started to paint veins on the painting. The veins echoed the broken fragments, the broken fragments the canyons. I had something in my studio, I thought it was alive."

In *Lolita*, Schnabel begins with these veins, whose darkness pervades the entire painting and build forms in the process. Below, in the middle, appears a female torso from which a tree grows – spreading over both panels of the two-part painting in the form of the medieval representation of the Tree of Jesse, the family tree of Christ. The right side of the woman (from the viewer's perspective) is still being painted by the point of a brush that transforms into a closed parasol in the upper part of the picture. Under the parasol, as a porcelain figure, is a woman bringing two empty baskets: an allegorical representation of a drought-ridden summer without a harvest? All of this action takes place within the bottle of a female body, as implied by the suggested lines of the shoulder and neck near the top edge of the painting – details which further solidify the metaphorical discourse between fertility and infertility. This is apparently all the reference to the title *Lolita* expressed here, alongside a winking allusion to the iconic garden scene in Kubrick's 1962 film, in which Lolita remains hidden behind her large heart-shaped sunglasses. The figure on the left, with its carrot-like body, stands in an exactly reversed relation to the parasol, while its round, pill-shaped head corresponds with the forms of the plates. This shows once again that, rather than from an iconographic programme, the structures and meanings derive from lines determined by fragments of plates on a compositional and associative basis.

(L. E.)

Lolita
1980, oil, plates and bondo on wood,
241.3 x 213.4 cm (95 x 84 in.)
Private collection

Jean-Michel Basquiat

b. 1960 in New York, USA
d. 1988 in New York

As part of his great debut exhibition in New York in 1982, this painting represents Jean-Michel Basquiat's breakthrough into the official art discourse of his time. This was the year in which Basquiat finally bade farewell to his pseudonym Samo, with which he had aroused attention on the New York graffiti scene, in order henceforth to devote himself to the "more traditional" artistic media of painting, sculpture, collage and drawing. Certain aspects of the formal vocabulary of his graffiti along with an element of immediacy were, however, always present even in his new works.

In *Untitled,* Basquiat devotes himself to the internal processes, the inner life of a head. The depiction of the skull forms the central figurative element in the picture – it may be a self-portrait, or else an allegory of the modern individual, the almost unidentifiable fragment of text, "head of", in the top half of the picture is open to many-layered interpretations. Outward facial features, such as eyes, nose and mouth, fuse in this composition with the abstract representations of inward processes. These are strongly characterised in their formal implementation by the accumulation of a whole variety of elements and forms. Construction and deconstruction, order and chaos take place formally and conceptually in equal measure. Thus geometric elements and lines lay down an almost cartographic structure, which is then partly overlaid and obliterated again by scribbles and undefined areas of colour. An urban

mechanism seems to have taken up residence in the inside of the head. In addition, the striking motif of the seam or suture in this work turns up both in the interior of the skull and in the background. In its symbolic multiple ambiguity, it points to thematic complexes relating to wounding, pain and violence, as well as to healing and the bringing together of disparate, broken and devastated elements.

Art-historical and Street Art references are recognisable in equal measure in Basquiat's formal language and choice of motif. Thus the skull figure as an iconographic and symbolic element can be read not only as pointing to the Baroque *vanitas* still-life, but also as a political and generally familiar image of death and taboo. Basquiat thus reveals his interest in the styles of art of past centuries, as well as in everyday motifs, media images and the history of culture in general.

It is the interplay of Neo-Expressionist aesthetics, simultaneity of motifs and references as social commentary and the fusion of text and picture that have given Basquiat his unique position in the art world. Even so, his biographical background as a self-taught artist, his rapid rise to success in the art scene (partly due to the close collaboration and friendship with Andy Warhol) and his early death even today form a mythical smokescreen that overshadows his real contribution to the artistic discourse of the 1980s.

(P. S.)

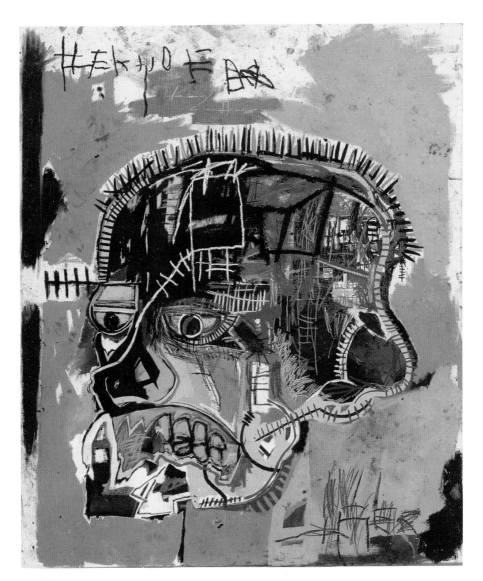

Untitled
1981, acrylic and mixed media on canvas,
205.7 x 175.9 cm (81 x 69¼ in.)
The Eli and Edythe L. Broad Collection, Los Angeles

Eric Fischl

b. 1948 in New York, USA

Eric Fischl studied at the respected California Institute of the Arts and developed his painting style after abstract-Conceptual beginnings. Although his characteristic brushwork is stylistically related to the American Realism of the 1920s, his art, always depicting new motifs, comes across as very contemporary. His scenes of everyday life in American suburbs, dating from around 1980, open up intimate insights. A pubescent boy is standing in a children's paddling pool at night-time and masturbating. A naked girl is sprawling on a bed and allowing a boy to stare between her legs. A father is lying naked on a sunbed and clutching his no less naked daughter to himself. Over everything hangs an atmosphere of emotional abuse and latent violence.

The subtle and particularly complex *The Old Man's Boat, the Old Man's Dog* also belongs in the context of these early pictures. It shows, snapshot-like, five people on the deck of a motorboat. A Dalmatian is panting over the body of the naked woman in the centre of the picture. Her titillatingly protruding buttocks are further emphasised by tanlines. The scene is dominated by the man leaning against the edge of the boat in a macho manner. At his feet lies the woman like a captured prey. His penis points directly towards her abdomen. He also seems to have taken possession of the dog, as well as the boat, if both, as the title suggests, belong to the "old man". Cool, almost impudent, he gazes at the beholder, a beer can raised to his mouth. But the tense calm lying over the boat seems about to break: the dark sky and the choppy sea presage a storm, for which at most the young woman in the lifejacket seems prepared.

At the beginning, Fischl painted from memory, then he started to work from photographs. "Photography makes everyone look off balance, awkward. It started to inform me about body language," he said. Sometimes he compiled his motifs from a number of different shots. Then he began to paint from digitally processed photographs, as for example in his *Krefeld Project*, dating from 2002–2003. For three days, he had an actor couple act out scenes of domestic life in the Krefeld villa Haus Esters, scenes which he captured in countless photos. He then processed them on the computer, and translated them into painting – into genre pictures of a relationship full of intimacy, but also full of silence, ennui and sex seemingly devoid of emotion and indeed devoid of pleasure.

Whether it is his insights into a desolate family life, the numerous beach scenes or the dreary parallel lives of an aging couple: in every case the drama of the subtext plays out in the bodies of the protagonists. Fischl exposes them to garish, unflattering light, depicts flabby bellies, wrinkles, sunburnt skin, facial expressions out of control, revealing gestures. And in so doing he dissects the relationship between men and women, between intimacy and the public arena, between nakedness and the social role, between boundaries and their transgression.

Sexuality, violence, loneliness, old age: what we have is always the voyeuristic, desiring or impudent gazes which time and again haul the beholder, too, into the boat. Not just on the outing in *The Old Man's* Boat do these paintings reveal the extent to which we all seem to be at sea.

(K. S.)

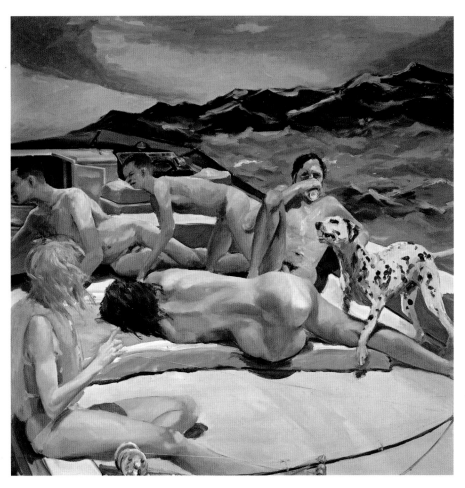

**The Old Man's Boat,
The Old Man's Dog**
1982, oil on canvas,
213 x 213 cm (84 x 84 in.)
Private collection

Barbara Kruger

b. 1945 in Newark (NJ), USA

Untitled (Your Comfort Is My Silence)
1981, photograph, unique, framed,
142 x 101.5 cm (56 x 40 in.)
Private collection

Like other women artists classed as "feminists" who came to fame in the 1980s, Barbara Kruger turned away from so-called equal rights feminism in the wake of the discourse around Post-Modernism. Instead of following the question whether women were formally accorded the same rights as men in the social order, she increasingly focused on the all-important concept connected with the social discrimination of women: the concept of power.

In this way, she aimed at revealing the deeper mechanisms of the patriarchal system, which shortly before – in the context of British feminist cinema studies – had been explored by reference to psychoanalysis, which was understood as a "political means". Thus the theoretician Laura Mulvey, in her influential 1975 essay "Visual Pleasure and Narrative Cinema", advanced the structuralist argument that the female in patriarchal culture stood as "a signifier for the male other" and thus occupied the position of passive vehicle of meaning in contrast to the male as an active producer of meaning. According to this thesis, woman is not she who represents but who is represented. She is the object of representation, making her status that of an image-being, yet this image is that of the "absent gaze", as the art historian Sigrid Schade once put it – that is, she is a "surface" and a "projection screen" shaped and dominated by the desiring and fetishising male

gaze, which moreover is inscribed in cultural perception per se. This construction of the unconscious determines and shapes both the psyche and the mentality of society and its representative apparatus, which is partially responsible for the (re)production of stereotyped images and depictions and, concomitantly, for the formation of identities and maintenance of asymmetrical gender relations.

It is against just this background that Kruger's "sharp-tongued" text-image combinations, derived from advertising, with their black-and-white and red contrasts and uniform typeface (Futura Bold Italic) should be understood. They embody in the proverbial sense the then-raging battle of women – and the artist herself – against the roles assigned to them. Thus *Your Comfort Is My Silence* shows a man in a hat who clearly represents the "law of the father" and "authority of the man or husband" and – as the (sub)text indicates – forbids the female recipient to speak by holding his index finger to his mouth. By quite consciously bringing this phrase together with a universally understandable gesture in a collage and superimposing part of the text over the controlling and inscribing gaze, Kruger symbolically dissolves its power and renounces the patriarchal system in proxy for all women.

(I. D.-D.)

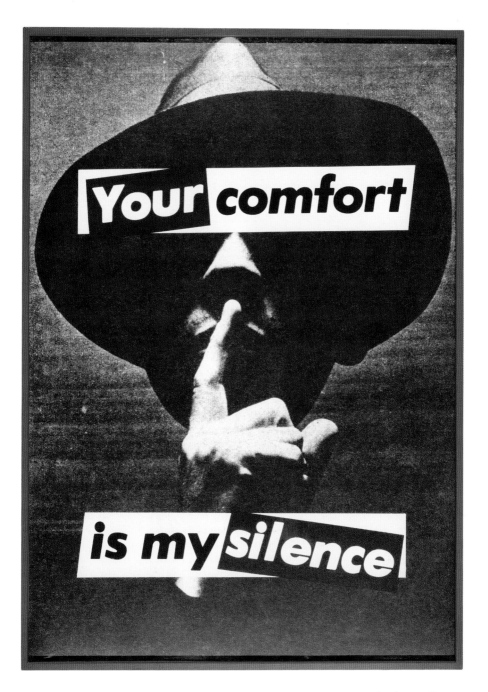

Keith Haring

b. 1958 in Reading (PA), USA
d. 1990 in New York

The name of Keith Haring is linked first and foremost with his large, poster-like pictures. But the œuvre that Haring left behind after his early death at the age of 31, is much more varied, comprising paintings, drawings and sculptures as well as murals and stage sets, a range of painted objects, temporary works for the public space and a number (no one can say how many) of designs for commercial products.

Like almost no other artist, Haring understood how to combine art and life. He made himself and his art public, and to this end used the methods of urban communication culture. Billboards, house fronts and flysheets were his first "painting supports". With his marker always ready at hand, Haring first covered the urban space of New York with his signs and signets, and only later the exhibition space in museums. For his art, as his legendary *Subway Drawings* on the empty advertising spaces in New York's underground stations demonstrated, was not meant for the traditional art market, but primarily for the public at large.

His pictures quickly impressed themselves on passers-by. Their content consisted of things known to all. Comics, commerce and commodities were the favourite sources from which Haring drew his inspiration. In spite of the easy legibility of these "icons", as he himself called them, his pictures do not dispense with profound contents. On the contrary, they are many-layered, emotionally charged and timelessly relevant. Aids, drug abuse, nuclear war and apartheid were the preferred themes. Haring functioned as a commentator on American society, taking a critical stance in artistic form. Over the years, his messages bore witness to a generation and for many came to symbolise 1980s America. Haring's hallmark is the line, applied directly and without any preliminary sketches. The line is evenly drawn, becoming a contour, a figure, an icon. Haring largely dispensed with detailed refinements, integrating few graphic elements such as dots and dashes, and using a simplified palette of pure colours. He made the pictogram genre with its typical strokes his own, raising the icon to the status of art, designed to be read quickly and easily.

Among his best-known pictorial icons is the "radiant child", a figure on all fours surrounded by a nimbus. The rays of the nimbus are a positive symbol, standing for particular strength and energy. In the untitled work shown here, these qualities are threatened. White lines on a deep black ground describe, in much reduced fashion, the scenario of a nuclear incident. The baby appears majestically in the middle of a mushroom cloud, flanked by two dogs. The consequences of such an occurrence are made graphically clear. All life between heaven and earth is literally "crossed" out with thick red crosses. Just two winged beings float down from heaven. The warning message is unmistakable.For Haring, it was an important, perhaps the most important, aspect of his art that it should convey specific statements and successfully communicate them. He was a political commentator as well as a humorous cartoonist. And he always believed in the possibility of changing the world through his art.

(A. K.)

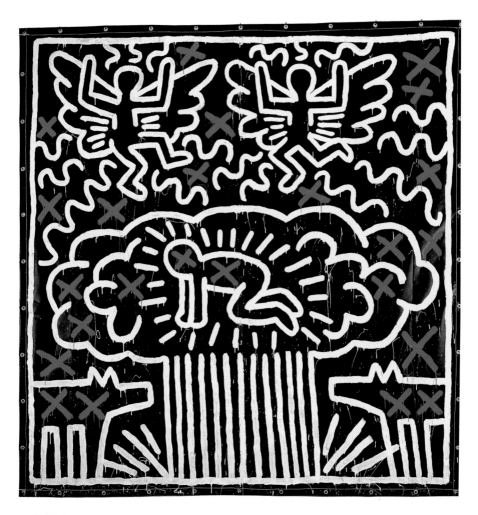

Untitled
1982, vinyl paint on vinyl tarpaulin,
305 x 305 cm (120 x 120 in.)
Private collection

Anselm Kiefer

b. 1945 in Donaueschingen, Germany

Urd Werdande Skuld (The Norns)
1983, oil, shellac, emulsion and fibres on canvas,
420.5 x 280.5 x 6 cm (165½ x 110½ x 2¼ in.)
Tate Modern, London

Probably the simplest way to describe Kiefer's creative work is "preservation of memory". However, what the artist composes on gigantic canvases, between weighty book covers and as monumental installations is more than a schoolmasterly recourse to history. In an atmospherically concentrated and technically many-layered approach, Kiefer re-traces a global cultural memory such as is to be found in the earliest sources: classical mythology, Nordic sagas, Jewish mysticism, cosmological theories, alchemistical experiments and atomic physics permeate Kiefer's work as do borrowings from the heavily charged themes of his homeland, including Germanic myths, Richard Wagner's *Ring of the Nibelung* or Paul Celan's "Death Fugue". Using lead and oils or organic materials such as straw or sunflower seeds, he creates an arsenal of motifs – scorched earth, ruined temples, warplanes – which evokes not only the old traditions, but also memories of recent history. His central concern is a poetic search for purpose and spiritual home, whose burden of guilt resulting from the Holocaust the artist seeks time and again to work off.

From 1980 to 1983, during a period when gestural figurative painting in Germany was labelled "Neo-Expressionism", he painted pictures of dark, coarsely strutted interiors borrowed from the monumental edifices of the National Socialists. One of these is *Urd Werdande Skuld (The Norns)*. It depicts the ruin of a stone-built, temple-like barrel vault, characterised by extreme central perspective, which reinforces the pull of the demonstration of power that emanates from this demagogic ideal structure. In the lower centre of the painting a fire glows, like that of an archaic sacrificial ritual. The death cult in the elitist thinking of the Third Reich, which understood itself as the manifestation of a 2,000-year-old culture, is the leitmotif of this suggestive picture. But Kiefer does not tread water in mere historicism. By writing out the names of the Germanic goddesses of fate – Urd (what has become), Verdandi (what is becoming) and Skuld (what is to become) – in one of the ceiling arches, and having cords like threads of fate hang down from them, he constructs a bridge between the ages: in Wagner's *Ring of the Nibelung* the Norns read the downfall of the gods off a rope, the rope breaks and the era of myths ends in favour of the rationalist modern age.

It almost seems as if Kiefer, too, with his Norns, wanted to rekindle something new, since the cords against the background of the geometric architecture come across as soft fibres which are beginning to smother the old. In this sense, the diverse elements of German memory fuse into a holistic structure of melancholy, horror and fascination that goes far beyond mere criticism of the Third Reich.

Kiefer's source is a collective spiritual archive whose content he retrieves in ever-changing combinations. *Urd Werdande Skuld (The Norns)* shows how looking into a ruin can open up a broad panorama of history and summon up vital strength for the present. (G. B.)

Mike Kelley

b. 1954 in Wayne (MI), USA
d. 2012 in South Pasadena (CA)

"My process is project-oriented. I begin with certain themes to work around," Mike Kelley explained in 1988. "Then pieces grow out in a number of parallel ways: in texts, drawings, objects and finally a performance." As he works in a multitude of media, Kelley's art can be difficult to categorise, while its thematic core has been consistent in its exploration of different forms of mythology: from the nativity of Superman to the fictional recollections produced by false memory syndrome.

Kelley started *Plato's Cave, Rothko's Chapel, Lincoln's Profile* in 1985, linking three possessives of mythical potential mostly because they sounded so well together. The artist approached the shared structure of their myths through formal connections, between chapel and cave and between their story fields (Lincoln's assassin Booth had a horse blind on one eye, which would relate to the darkness of a cave and to the sombre hues of the paintings in Rothko's chapel...). The details of the myths easily translate into iconography, and while the artist laid bare the process of myth-making, the viewer still cannot help but feel the power.

The elements of the series in different media could be combined, for example in a 1987 exhibition at the Massachusetts Institute of Technology. In a central room, whose walls were made up of monochrome planes that evoked Rothko, artificial fireplaces served as the light source for a low-end staging of Plato's Parable of the Cave, riffing on its thought that the appearance of reality was just a shadow of a higher truth. One could reach the room from an adjacent one which showed a series of black-and-white paintings in illustration style. Some of these directly took up the project's title heroes, some added other mythologies, like Nazi war caves or Kryptonite.

A painting titled *Exploration* hung across the doorway, leaving only a low gap through which to enter. It depicted the suggestive inner body of a cave and seemed to equate spelunking with the art viewer's quest for quasi-religious experience. The text it carried began soberly, "When spelunking sometimes you have to stoop... sometimes even crawl", only to finish with the command: "Crawl, worm." The art addressed the viewer in godlike terms, requiring a gesture of both submission and trust.

The worm, as a simple tube-like organism, relates to the central tube in *The Eternal Circle*, where it is cut open with a knife, so that its life breath fizzes out. A sort of gaseous thought balloon circumscribes this image, juxtaposing two faces: a sad clown and a resigned-looking sombre type whose dropping features stand against the smiley form of his open neck. Between the two faces stand an infinity sign within downward and upwards arc – illustrating the inescapability of this eternal circle – and houses with smoking chimneys commanded by a factory whistle. The anthropomorphised whistle is a staple feature in early animations from Disney's *Steamboat Willie* (1928) onwards, and it seems instructive to read the painting with filmic tropes of that time in mind: the protagonist in King Vidor's classic silent *The Crowd* cannot reconcile his American Dream-driven aspirations with the whistle-ruled world of work and has to finally humiliate himself as a sandwich man in clown costume to be allowed his drab existence. A similar cycle of undead survival could be suggested in the painting, where the cut throat, oozing a clear substance, seems merely a passing annoyance...and after all it's in the mythology of the worm that the parts live on when the body is cut in two.

(L. E.)

Eternal Circle
(From Plato's Cave, Rothko's Chapel, Lincoln's Profile)
1985, acrylic on paper, 191 x 160.6 cm (75¼ x 63¼ in.)
Private collection

Günther Förg

b. 1952 in Füssen, Germany
d. 2013 in Freiburg i. Br.

Untitled
1988, acrylic on copper on wood,
190 x 90 cm (74¾ x 35½ in.)
Private collection

Günther Förg started out as an abstract-minimalist painter during his studies, creating uniform monochromes over a black ground. Later he gradually gave himself more room to manoeuvre: he experimented with special painting supports such as aluminium panels or lead sheets beaten around a wooden core, and sometimes switched his focus to wall painting and especially photography, where he made a name for himself in particular with architectural photos of classic modernist buildings. After 1986, Förg returned to abstract painting with an extended range and freer composition. His paintings from this period are mostly determined by colour areas derived from American Colourfield painting, but Förg adds a reference to classical modernism in their rigorous construction. The artist prefers to work in series, so there are whole sequences of equal-sized images illustrating various ways of arriving at a composition within certain parameters of colour and spatial distribution.

Förg approaches Colourfield painting, which in the U.S. often had a spiritual background, from a sober European perspective. In this, he was able to build on the achievements of the abstract painters among the students of Joseph Beuys – for example Blinky Palermo, who died well before his time. However, Förg was less interested in the conceptual supplementation of abstraction that was cultivated in those circles. "For me," he says, "abstract art today is what you see, and nothing more." He is interested in painting for its own sake, and accordingly the colour areas in his paintings are lively and open, the individual brushstrokes can still be seen – something one can also observe in the Constructivist tradition of Piet Mondrian, whose treatment of surfaces is restrained but still always leaves clear brush marks.

The painting presented here comes from a small series of four variations in different colours in which the artist has left four or six copper-coloured vertical stripes in a monochrome surface blank. If one looks closely at the course of the brushstrokes, one discovers that those between the stripes follow them vertically, until they go around the ends of the stripes on each side, while the upper and lower edges of the painting have been executed with a horizontal motion – no different from the easy way that any of us would fill in a surface ourselves. The recessed stripes are painted over with a thin brown layer, so that the copper base that shines through the paint everywhere appears loosely modelled. Anyway, the artist sets no store by any detailed surface analysis using microscopic material evaluation. "At best, the viewer should hardly notice the support and the application of paint," he says. "The idea, the strategy or the attitude must carry the day."

The idea here is to explore the principles of ground and perspective, of living colour and hermetic metal – and of course there is also an art-historical reference, for the sixfold vertically fractured colour surface is more than a little reminiscent of some of Lucio Fontana's slashed canvases: the Italian artist even created a yellow painting with six similarly adjacent slits. He called such pictures "spatial concepts", and Förg's tribute reveals a preoccupation with his own spatial strategies. (L. E.)

Martin Kippenberger

b. 1953 in Dortmund, Germany
d. 1997 in Vienna, Austria

The three central characters in German painting of the 1980s, Martin Kippenberger, Albert Oehlen and Werner Büttner, formed an artistic focus of their own, from which emanated various action programmes (catalogues, music CDs), clearly often working together. To an extent they represent a particular tendency within the Neue Wilde, the New Wild Ones.

Their programmatic idea was: art with its innovations can only liberate itself if it makes transparent its sometimes exaggerated, indeed megalomaniac illusions of its own significance. And it must do this by taking ad absurdum the market mechanisms driving it in this direction. If you choose your moment in the economic cycle, with a bit of luck you can have success in precisely this market. Irony, including self-irony, is the key to success. And this irony must come from within, it must not consist only in defamiliarisation and turning things on their head, but must rather use its own means to be creative. It must not spare any field of life or culture, it must track down the idiocy behind every slogan, the hypocrisy in every morality, the seed of madness and triviality in every oh-so-significant item of culture.

This total irony is not presented in a spirit of binding commitment, let alone with a demand for political consistency, but rather in art's own free and cheerfully subversive game of self-destruction. In Martin Kippenberger's case this game had a totally existential character: his early death in 1997 was due to alcoholic excesses.

His 1988 self-portrait is intentionally titled *Untitled*. Usually, after all, his works live by those qualities of parody which find their expression in verbose and clumsy titles. "Untitled" here means, then, that speechlessness and stylelessness can also stand for speech and style; that quotation and mockery are bearers of serious reflection even where to all appearances they are anything but serious. The composition follows accordingly. Small if anything and shifted to the side and the bottom of the picture, the painter is standing in front of his "creation". Before we have a chance to reflect on this, the meticulously modelled, anatomically and carefully unsuccessful plasticity of a man dressed only in passion-killer underpants compels a "pitying" smile. He stands there paunchy, unsophisticated, stubble-chinned, with the worried expression of someone who, so to speak, has just opened a fridge door to find that there are no drinks. Painted in luminous colours on flat stone-grey and mustard-yellow areas is the mysterious cage in front of him, with which the man in the underpants is thoughtfully tampering. Evidently what we have is the free interplay of things, forms and quotations. We could identify a playpen, a winding tower, a walking frame, a hamster's cage. It is all "heavy" and delicate at the same time. Embedded in the middle is the familiar political emblem of the "hammer and sickle". The sickle in turn is mutating into the "sun of freedom".

Kippenberger previously modelled these motifs sculpturally in nonsense designs. The mobile cage was deployed in front of the door of a Cologne publishing house as a monumental briefcase-holder, the hammer-and-sun sculpture as an ersatz pot-plant. Thus a meaning is thrown together from numerous components, but this meaning can only be interpreted by those who venture into the cage. The artist as joker and trap-setter is standing by. He is pulling the strings, combining in one person the roles of meaning-bestower and meaning-denier.

(E. R.)

Untitled
1988, oil on canvas,
240 x 200 cm (94½ x 78¾ in.)
Private collection

Jeff Koons

b. 1955 in York (PA), USA

Ever since his entry into the art world, Jeff Koons has been causing violent and controversial public reactions. The 15 work groups the artist has created to date have dealt with elements of kitsch, beauty, desire, banality and pop as well as sexuality and pornography. His often huge and highly polished sculptures, paintings, photographs and reliefs constantly oscillate between appearance and reality, and so does the image of the artist that Koons has constructed around himself over the years.

Even in his early work groups, Koons displayed an interest in the interplay between everyday imagery, the readymade and art-historical references. Accordingly, the choice of objects Koons uses in his sculptures is always in line with his critical view of commodity fetishism. For example, in his series *The New* (1980–1987), the artist combines brand new vacuum cleaners with fluorescent lights and displays them in Plexiglas boxes that look like showcases. In the process, the household articles are illuminated either from behind or below by the light tubes – in the style of a seductive advertising strategy. In this series, Koons breaks with the pure concept of the readymade by integrating light sources into the sculpture – these introduce references to American Minimalism while giving an edge to his criticism of consumerism and sales strategies. The complexity and diversity of the possible levels of interpretation is generated by an interaction of the diverse elements. That same idea of fusing different, sometimes polarising elements, drives the artist's next work groups further ahead, culminating in the *Banality* series from 1988, which gets to the heart of the matter, using a discrete formal vocabulary unifying an iconography of popular culture and references to the Renaissance, the Baroque and especially to Rococo. Here Koons breaks free from the readymade for good, no longer combining existing objects but images from our cultural memory and generally familiar symbols from the catalogue of the visual language of the everyday life, which then materialise in the sculptures and mirrored reliefs. Kitsch figures, teddy bears, pop stars and cartoon characters are portrayed in colourful, highly decorated wood and porcelain and thus elevated to objects of beauty and desire.

The most striking example of this is *Pink Panther* – a sculpture made from porcelain, where the cult figure of the Pink Panther hugs a half-naked female torso. The fusion of popular and high culture seems to manifest itself in this grotesque embrace. Binary categories such as kitsch and aesthetics or banality and sacrality are completely blurred. Making the piece in porcelain – a very valuable material that traditionally symbolises beauty and innocence – raises the sculpture to the level of a holy relic of the profane. Mass taste is translated into art, and is radically thrown back at the viewer. (P. S.)

Damien Hirst

b. 1965 in Bristol, UK

E.M.I.
1989, glass, faced particleboard, beech,
wooden dowels, plastic, aluminium and
pharmaceutical packaging,
137.2 x 101.6 x 22.9 cm (54 x 40 x 9 in.)
Museum Brandhorst, Munich

E.M.I. originates from 1989, the same year that Hirst finished his studies at London's Goldsmiths College. A year earlier he had organised *Freeze*, the legendary show that launched the success of the Young British Artists. A few years later, Hirst would become famous both in England and in the art world as a whole, not least due to his tiger shark preserved in formaldehyde. Today his works are among the most coveted trophies in the art market.

As with Hirst's later medicine cabinet variations, *E.M.I.* is outwardly reminiscent of a painting: through its positioning on a wall, through its construction, which gives it a framed appearance, and through its picture-like format. The medicines are arranged according to the respective body parts: headache remedies on top, medicines for the stomach in the middle and foot medication at the bottom. In this way, they sketch a picture of the body – not by any illustration of its anatomy, but by means of the substances that it lacks. They show people as deficient, vulnerable, fragile: in short, as ephemeral beings. The display cases with their pills, tinctures and bandages also represent an altar for our times, a place of quasi-religious hope for redemption. They promise relief, healing and survival – channelled through the gods in white, the pharmacists and doctors. However, as a clearly visible symbol for the body's vulnerability and decrepitude, they are also in the tradition of *vanitas* and *memento mori* images. The medicine cabinets are closely linked with another group of works by Damien Hirst: his *Spot Paintings* from 1988 onwards. As a child, Hirst once poisoned himself with tablets that he had mistaken for Smarties. Where the pills later found their way into his work in the display cases, the round, colourful chocolate dragées returned in the circular blotches of colour in his *Spot Paintings*. Also, the London restaurant Pharmacy, which Hirst furnished like a chemist's shop right down to the very last detail in 1998, can be structurally understood as a reversal of his childhood experience: in the same way that the little Damien mistook medication for sweets, the customers at this pharmacy got food instead of pills.

Hirst inflated the promises of healing that the medicine cabinets give into huge arrangements of pills, where thousands of brightly painted cast bronze pills lie on tiny shelves in metre-wide reflective steel encasements. Here, the pills have abandoned their functionally-designed packaging and are now emphasising their colourful, candy-like shapes, making the relationship between the cabinets and the *Spot Paintings* even more apparent. In this way, the medicine cabinets, the *Spot Paintings* and the preserved animals from the Hirst's *Natural History* series show that, in the light of the inevitability of death, neither the possibilities of medical science nor those of art are anything more than a placebo.

(K. S.)

Robert Gober

b. 1954 in Wallingford (CT), USA

When Robert Gober began in 1989–1990 to create hyperrealist objects in wax, he had already, after a short, meteoric career, become one of the most noticed contemporary artists in the United States. What had drawn him to public attention were defamiliarised reproductions of everyday objects, with which he combined a multitude of intuitive memories: washbasins, playpens, urinals, dog baskets. With changes to their form that sometimes involved Minimalist reduction and sometimes Neo-Surrealist complication, Gober charged things with associations, turning them into the eerie furnishings of a house in which no one was really at home any more. In his *Drains* for example he stressed the cross shape and turned the place where the water, and our gaze, whirl down into a dark, unbounded, threatening world, a resonance space of ecclesiastical prohibitions and promises.

Gober's childhood was marked by particular burdens, because his homosexuality developed under the constraints of a puritanically conservative, strictly Catholic family home. This biography is reflected in the particular psychosocial and sociopolitical sensibility of his oeuvre. Since 1990 Gober has no longer devoted himself primarily to things on which he inscribes the traces of ambivalent bodily sensations, but to the body itself. A casual experience was the cause: "I hate to travel... Then I was in this tiny plane sitting next to this handsome businessman and his trousers were pulled above his socks and I was transfixed in this

moment by his leg." He shaped the cast of a perfectly normal leg in wax, applied hairs one by one to the shin and calf with a pair of tweezers beneath a heat lamp and dressed it conventionally: in trousers, socks and robust but worn shoes. At exhibitions Gober installed the leg in such a way that it looked as if it was sticking through the wall at the level of the wainscoting, projecting into the exhibition room and thus into the beholder's space as an eerie, physically obtrusive partial object.

In the 1990s, the leg motif underwent further developments. On the one hand Gober cut it down to a wax shoe, in whose insole hairs were sprouting, while on the other he modelled whole abdomens and defamiliarised them in the manner of Surrealist object-fusions with candles, plugholes or musical scores, the latter inspired by a motif in Hieronymus Bosch's *Garden of Earthly Delights*. And in the ever more complex room tableaux, to which he continually added works, the references to sexual connotations, to transience, to Catholicism, to discrimination and violence against homosexuals become more intense.

But it is always true what Alexander Braun in his monograph on the artist wrote: "Gober's works do not represent anecdotes, but emotions. Gober's works function like fragrance diffusers in the room, but instead of diffusing scents, they diffuse eerie atmospheres."

(K. S.)

Untitled
1990, beeswax, wood, leather shoe,
cotton fabric and human hair,
29.5 x 15.9 x 51.1 cm (11½ x 6¼ x 20 in.)
The Cleveland Museum of Art

Paul McCarthy

b. 1945 in Salt Lake City, USA

Paul McCarthy has been working in the field of performance for more than three decades. He was one of the most important artists from the West Coast of America in the 1970s, whose actions significantly influenced a young generation including Mike Kelley, Jason Rhoades and John Bock, and yet his complete works have only recently been receiving the international recognition due to them.

Again and again, McCarthy attacks deeply rooted clichés and behavioural norms through his works. He dismantles the image of the Wild West that is equally glorified in both America and Europe, he puts Disneyland's idealised world under pressure, and in dealing with topics in his work like sexual intercourse, masturbation, rape or child abuse, he attacks established ideas of decency and morals. The methods he uses to achieve this get under one's skin, and can be offensive. McCarthy acts as if possessed in front of the camera. He exhibits infantile traits as when, for example, he smears about liquids like ketchup or urine; he mutilates himself – or rather ersatz body parts made of plastic – as well as wrecking the scenery in which the action takes place. He shouts out loud, urinates in the corner and altogether makes a gigantic mess, which places the viewer in a state of emotional tension somewhere between amusement and revulsion.

McCarthy's work initially developed from painting. He interpreted as actions the painting of the late 1960s and 1970s, and from this basic approach has incessantly developed new performances. In *Whipping a Wall and a Window with Paint* (1974), for instance, McCarthy strikes out around himself with a big piece of cloth dipped in paint. The empty room with the window facing the street is marked by the traces of this movement, which is inevitably reminiscent of the drippings by the Abstract Expressionist Jackson Pollock.

Bossy Burger marks a turning point in the artist's work. This is the first performance in which McCarthy used a film set. The narrative is thereby provided with a fixed, pre-structured location. In 1991 the artist acquired the TV-studio set of a hamburger restaurant called Bossy Burger from the American sitcom *Family Affair*. McCarthy installed the set in the Rosamund Felsen Gallery in Los Angeles, using a full range of professional TV equipment to record his actions there for one day, during which he strictly excluded the public. He edited the material for two days, and then showed the one-hour final cut of the performance on two monitors amongst the ruined scenery. McCarthy employed his entire performative repertoire. He appeared dressed as a cook, thereby wearing the mask of the *Mad* magazine icon Alfred E. Neuman, and smeared various food and liquids around to produce a great mess. He produced, among other things, a hysterical emotional outburst, cut the tips off two fingers of his gloves, demolished the furnishings of the set and painted penises on pieces of paper.

By using the stage set from a TV series he simultaneously illustrated the way in which media mechanisms function. The remnant of the studio set is not only a relic of a past action, but is also the starting point for a further performance in *Bossy Burger.*

(S. M.)

Bossy Burger
1991, video, colour, sound, 59 min 8 sec

Albert Oehlen

b. 1954 in Krefeld, Germany

Albert Oehlen's wide-ranging artistic practice, which takes in painting, collage, computer images, drawings, floor mosaics and carpets explores the possibilities and limitations of painting in the contemporary context.

Since the early 1990s, his painting has embraced a continuously expanded range of representational and abstract elements and resources, including computer-generated ink-jet prints, which are partially reworked and super-imposed. However, Oehlen considers the dicho-tomy of the binary concepts "abstract" and "figurative" to be obsolete and describes his style somewhat tongue-in-cheek as "post-non-figurative".

In the early 1980s, in what was to some extent a response to minimalist and conceptual trends, he joined Werner Büttner, Georg Herold and Martin Kippenberger in developing a new attitude in art – a type of painting just as critical and offensive as it could be (self-)ironic and emotionally charged.

His *Self-portrait with Shitty Underpants and Blue Mauritius* from 1984 shows many characteristics of this phase of his work. Even the title ironically reflects the artist's personality and social position. Formally, the work is characterised by a heterogeneous image structure uniting both figurative motifs – the self-portrait of the artist – and abstract elements. The artist's figure is placed against an undefined background, with only slight linear interventions suggesting architectural fragments. Some areas are worked out in great detail, while others are left very open and indistinct.

Oehlen's interest in openness and a certain impurity or even "duplicity" in the execution of his work already becomes apparent here.

(P. S.)

**Self-portrait with Shitty Underpants
and Blue Mauritius**
1984, oil on canvas,
240 x 260 cm (94½ x 102¼ in.)
Private collection

Christopher Wool

b. 1955 in Boston, USA

If you look at the way that painter Christopher Wool's work has developed throughout his career, the year 1993 seems to mark something of a turning point. In the mid-1980s, he had become known for pictures in which he used rollers or stamps to apply simple floral patterns; minimalist variations on all-over painting using enamel paint on aluminium plates. Then, in 1987, he created the word paintings that quickly became his trademark: shiny black letters with scruffy blotted edges crowded together or superimposed on a white ground, applied in the sort of stencilled lettering used on crates.

The first of these images dared the viewer to abandon his previous life: "Sell the house, sell the car, sell the kids" – a quote from the movie *Apocalypse Now*. Others shouted for help, threatened to make trouble or cheered on a fugitive: "Run dog run." In 1992, Wool put an end to the series for the time being; the final messages were almost offensive in their directness: "Fuck 'em if they can't take a joke." "This is art with a gun in its back," one critic described it. Wool had the reputation of an artist with street credibility and he was a painter whom you could like even if you championed Conceptual Art.

The themes that would occupy Wool in coming years were already present here. He continued to pursue them with a constant shifting of emphasis: by spraying the paint graffiti-style, by permitting colourful accents in some of the paintings and by extending his work on the negative image of obliteration. It appears that from the very beginning, Wool has not changed his artistic concept and while 1993 may have been an important year for the reception of his work, it was not a watershed for him personally: "I've always considered what I do as making paintings...picture-making. Certain critics didn't see it this way; they thought I was involved in a deconstruction of painting, a critique of painting and a kind of anti-painting. Ironically for those who were against painting this misconception allowed them to actually 'appreciate' my work." Because the idea that painting can also be a profoundly conceptual art form now seems self-evident, the exceptional consistency running through Wool's œuvre from its early days until today is much easier to see. (L. E.)

Apocalypse Now
1988, alkyd and flashe on aluminium,
213.4 x 182.9 cm (84 x 72 in.)
Private collection

Ai Weiwei

b. 1957 in Beijing, China

Han Dynasty Urn with Coca-Cola Logo was created in 1994 following Ai Weiwei's return to Beijing. The artist had used his years in New York for a detailed confrontation with the readymade *à la* Duchamp, with the Pop Art of the 1960s and the technique of assemblage. While earlier works still kept closely to the pure readymade concept, or else explored combinations of objects and materials, *Han Dynasty Urn with Coca-Cola Logo* united Ai's existing interests with an autonomous formal vocabulary and conceptual approach, and thus marks a turning point in his artistic practice.

The title of the work refers purely descriptively to the combination of two elements in this sculpture: a Chinese urn of the Han Dynasty (206 BC– 220 AD) bears the logo of the modern American product Coca-Cola. This, formally quite minimal, intervention on the part of the artist – the traditional vessel is modified by a hand drawing of the logo – opens up, conceptually, a broad complex of layers of meaning. Here are reflected not only the politico-cultural relationships between China and America, or the whole of capitalist Western society, and China's relationship to itself, but also the relationship between tradition and progress, antiquity and the modern world, crafts and art. The urn can be interpreted here as symbolic of China's history: pottery products were regarded for centuries, alongside silk and porcelain, as the hallmark of China; the Coca-Cola logo by contrast can be seen as symbolic of Western capitalist society. In addition, the urn relates to the cultural and aesthetic values of the ceramic craft, while the logo opens up clear Pop Art references.

Chinese tradition is, in a sense, overwritten with Western trademarks and thus revalued. So does the value of this urn fall as a result of this modification, or will it rise, because henceforth it constitutes a contemporary work of art? How are things assigned value, and for what reason? Who is the author of these values, and who authorises them? Such questions can never now be avoided when we are talking about Ai's sculptural, photographic and performative works.

In his hitherto most elaborate project *Fairytale*, a performance that Ai Weiwei realised for documenta 12, the artist invited 1,001 Chinese people to Kassel between 12 June and 9 July 2007. The guests came from various regions of China and were selected from among several thousand applicants. In addition the artist, to match the number of guests, placed 1,001 wooden chairs dating from the Qing dynasty (1644–1911) in the exhibition halls. With this project, Ai thematised not only questions of migration, globalisation and cultural exchange in general, but radically questioned the role of the artist as subject, as well as the issue of authorship. (P. S.)

Han Dynasty Urn with Coca-Cola Logo
1994, Han Dynasty urn, paint,
25.5 x 28 x 28 cm (10 x 11 x 11 in.)
Private collection

Beatriz Milhazes

b. 1960 in Rio de Janeiro, Brazil

Beatriz Milhazes blends the formal vocabulary of European abstraction with Latin American idioms in a carnivalesque opulence and luscious colours. The approach of the Rio de Janeiro-born artist is rooted in Brazilian modernism. Milhazes' prime idol is the woman painter Tarsila do Amarat. In the 1920s, Amarat was co-founder with Oswald de Andrade of the legendary *Movimento antropófago*, a movement self-confidently opposed to the domination of European modernism and the view of Latin American culture as merely exotic. The term "anthropophagy" was intended in the sense of a cultural counter-assimilation: "eating the other". Since then Brazilian artists have adapted and transformed modern European art into an autonomous cultural tradition.

Milhazes' painting can best be understood in light of this tradition. In her large-format, intensely coloured pictures she combines abstract and semiabstract elements such as dots and circles, bradings and bands into dynamically composed all-over patterns. Flowers, organic ornaments, traditional embroidery patterns – the plant metaphor is omnipresent in every abstractly stylised shape. The blossom, quintessence of naturally proliferating abundance of colour and form, functions as a key motif and link between a great range of objective, free and abstract types of depiction. "I could not be geometric in the way of using cubes, squares, rectangles or triangles," Milhazes once said. "I needed elements that I could develop and use like the shape of a flower representing some motif. But the shape of this flower is less important than its colour; even if I had a good, beautiful shape of a flower, it would never work unless I had chosen the perfect colour." In Milhazes' hands, abstraction is not merely analytical or serial. It develops organically, with a kind of visual musicality.

O Beijo, one of Milhazes' relatively early paintings, translates as "The Kiss". This title occurs frequently in her œuvre, and can be understood as an allusion to Gustav Klimt and his flat, ornamental style (p. 107). This version of *O Beijo*, too, shows the sophistication with which Milhazes explores, as she puts it, the "delicate border between handicraft, decorative art and modernism". The rhythmically pulsating interweave of circular forms, reminiscent as much of Sonia Delaunay's paintings as of embroidery and lace, possesses a beauty that is also disturbing. Milhazes operates with Op Art effects: "You don't have a real centre of the composition, and your eyes are always moving," she explains. "It's rather disturbing, even vertigo." The complex interlockings of the arrangement follow no definable logic, instead growing out of a weeks-long working process.

Milhazes has developed a collage-like painting technique that is much in evidence in *O Beijo*. First she establishes the picture ground, usually consisting of large colour fields, then in a second step creates the composition per se as a layering of countless pictorial elements. These she paints on plastic foil, then, when the paint is dry, she pulls it off the foil and adds these motifs like transfers to the existing composition. As she never paints after sketches, this process permits her to freely take a composition in new directions – and build up a hypnotically ornamental bouquet.

(J. A.)

O Beijo
1995, acrylic on canvas,
193 x 299.7 cm (76 x 118 in.)
Private collection

Thomas Struth

b. 1954 in Geldern, Germany

To work in thematic series is at the core of Thomas Struth's artistic practice. His first such series, which he has continued to this day on a global terrain, was of townscapes. He began it while still a student at the Düsseldorf Art Academy: in 1976 he presented the first 49 black-and-white shots in which the defining motifs were central-perspective views of deserted Düsseldorf streets. The views confront the spectator with something familiar by presenting it like a "sight" in traditional photography. In this way Struth conducts analyses of random streets in a faceless German city reconstructed after the war and investigates their structures. The works also marked his move from the painting class of Gerhard Richter to that of the art photographers Bernd and Hilla Becher.

While Struth's urban perspectives concentrate on ordinary townscapes and show their specific character in the process, between 1995 and 2003 he photographed what were already de facto "sights". He sought out "cult" locations at which either cultural tourists or religious pilgrims perform a whole variety of acts of veneration. At first sight the photographs hardly differ from the countless shots taken by amateur photographers at these locations, although there are important differences. Struth's large-format colour prints and the outstanding technical reproduction make every detail visible; even more important, he plays a deliberate game with the visitor's position.

In illustrations of such places, people normally seem to be unwanted, or else they're only allowed to appear smiling against the venerable backdrop. Struth by contrast integrates location and event. He waits for a telling configuration of visitors who have come to admire, to pray or for no reason at all.

Whether at sites of Christian devotion, in Buddhist temple complexes or at secular cult sites, Struth's photographs always reflect cultural behaviour. When he takes a photograph of El Capitan, a huge granite monolith in the Yosemite National Park in California, he shows at the same time parked cars, along with tourists marvelling at, and photographing, this symbolic national monument. Ironic, but also sympathetic, Struth undertakes a subtle analysis of mankind's relationships to its cultural heritage, using photography above all as an analytic-structural and communicative medium.

(J. G. S.)

El Capitan, Yosemite National Park
1999, c-print, 176 x 223 cm
(69¼ x 87¾ in.)
Private collection

*"In my photographs I endeavour to make it possible
to halt, or to encourage people to look closely, combined
with the desire to interfere."* — **Thomas Struth**

Peter Doig

b. 1959 in Edinburgh, UK

Peter Doig's paintings lead the beholder to strange places. The scenarios are almost always embedded in mysterious landscapes. Often we see individual people sitting in boats or standing on shores, gazing fixedly at the viewer. The locations Doig chooses for the scene are, not infrequently, exotic-looking places, forested or with palms and rivers.

Characteristic of many of Doig's paintings is a palpable and downright uncanny detachment. On the one hand this is clearly an effect of the perspective: the figures or buildings are always seen from a certain distance. In many cases it is a stretch of water that produces this distance, or a forest, as in his *Cabin* series, dating from the early 1990s, whose pictures always show the same building: Le Corbusier's *Unité d'habitation* apartment block in the French town of Briey. The building, which consists of individual concrete segments, is partly hidden by a dense, dark forest. The individual, garish white "cabins" which can be seen through the branches of the trees, come across as eerie, alien, indeed threatening, almost like a death's head emerging from the dark of the forest. The painter experimented in the course of the series with additional elements designed to shield the view. Over-dark tree trunks and a tangle of foliage combine with abstract, splodge-like leaves, or, as in *Concrete Cabin*, white reflections.

Doig experimented with the principle of fading in numerous other works. It often seems as though the surface of the picture is dissolving into thousands of tiny patches of colour. Or it is as though a heavy veil of mist had been laid over a landscape.

What might have been there before has disappeared as a result of measures designed to create detachment, or has at least been withdrawn from view for a time, until only vestiges are left.

Reflection (What Does Your Soul Look Like) is a good example of how the painter deletes pictorial information by the addition of abstract elements and at the same time manages to add a totally new, magical plane. A figure, invisible apart from his shins and feet, is standing by a pond or river, in which both the person and the surroundings are reflected. At the same time, leaves and other undefinable things seem to be drifting on the surface of the water. In contrast to similar works, what we do not see here is what is actually reflected, in other words a concrete referent. The beholder must have faith that what is reflected in the water "really" exists, for we only have the reflected image.

It is precisely with this lack of clarity that Peter Doig plays. We see clearly assignable elements in the surface of the water, which may belong to possible surroundings (trees, branches, leaves, the man himself), but then again undefinable forms appear. White, cloud-like areas make their way across the pictorial space, encountering black, red and green formations, and everything gets entangled in a misleading, sprinkled texture of colour. So what is real, what is illusion? The visual disorientation, which Doig has arranged here, prevents access to a rational space. A strategy which maybe keeps the public at a distance at first, but on a second level opens up a new and fantastic world.

(C. O.)

Concrete Cabin
1991–1992, oil on canvas,
200 x 240 cm (78¾ x 94½ in.)
Leicester Arts and Museums Service

Neo Rauch

b. 1960 in Leipzig, Germany

The scene is the edge of a forest, palely lit beneath a night sky streaked with bright vertical stripes. On the side of a small street, the scaffolding on a simple prefabricated building is made up of beams in four colours, one side red, then blue, yellow and green. Two workers are balancing a beam onto a spatially inconsistent higher level within the structure, another is standing there looking a bit lost with his wheelbarrow, in which he is balancing a growth made from building foam – or perhaps this is dense, viscous smoke rising from it. The street in front of the house has been ripped open and cables in the same four colours are running from the hole and wrapping themselves around a cable drum.

Neo Rauch stands for the return of a figurative painting, which, with its many narrative elements and evocative allusions, invites one to read the pictures – even if one will usually conclude that the exact subject eludes readability. Rauch likes to say that the viewer should above all comprehend his art on a purely pictorial level: "Making a painting in a very abstract sense is essentially my work and the subjects are only a hobby." Of course, he is saying this with a wink, because his paintings are like a challenge for the viewer to unpack the classical tools of iconography. Still it is also true that the artist does not follow a fixed scheme of meaning but instead pursues his private myths, current images and sometimes even his dreams, and so, for all their identifiable references to reality, his paintings ultimately work on a subjective level – which not even the artist himself has to be able to decipher.

Das Haus (The House) initially catches one's eye due to its formal qualities. While the narrative level is reduced to just a few elements, the painting is defined by the abstract plane of the striated sky. However, if we start looking into a motif on which this sky could be based, we might find a clue in the first image of *Die Himmel* (Skies, 1969), a book object by Anselm Kiefer, who re-used a photograph of Albert Speer's Cathedral of Light at the Zeppelin Field in Nuremberg in 1937. The night sky there displays the same striations, the image follows the exactly same composition – this congruence makes the atmospherically uncomfortable sky in Rauch's own painting even more uncomfortable. Are the cables in the foreground supplying power for the light show? Is the simple building, which one would not want to call a house, a sort of control centre?

Some of the same picture elements reappear in Rauch's *Der Neubau* (The New Building) from the same year, but with a different emphasis. Two men are lifting a beam here as well – but now it is a complete prefabricated apartment block to be placed in a landscape according to plan. Again there is a worker with a wheelbarrow; this time the clouds of smoke rising from it are unmistakeable. The gesture of the worker with his hand to his brow and a historical building hovering upside down on the picture plane send a clear message: what we do here is absurd, the actual idea which should be behind building a new house is turned on its head. Something is wrong in *Das Haus* too, but the suspicious events remain cryptic, acting as an element in a plot that gives the landscape its atmosphere. This fits Rauch's much-quoted statement about painting as a continuation of dreaming by other means. As in a dream, the visible and the symbolic merge to form a mysterious image of indubitable psychological consequentiality.

(L. E.)

Der Neubau
1996, oil on canvas,
217 x 290 cm (85½ x 114¼ in.)
Private collection

Andreas Gursky

b. 1955 in Leipzig, Germany

Bonn, Bundestag
1998, c-print,
framed 284 x 207 x 6.2 cm
(111¾ x 81½ x 2½ in.)

Andreas Gursky prefers shots taken from afar. The distance helps to focus the view on the whole. Whether in his landscape pictures, which usually show people engaging in outdoor leisure pursuits, in his stock exchange pictures or in his industrial photographs taken at the production sites of Siemens and other global players – a certain distance to the subject gives a good overview of what is going on. That makes the artist's preoccupations easy to identify: the representation of the socio-cultural phenomena of human existence, the relationship between human beings and technology and people in (optimised) production environments.

Although Gursky had initially been cautious in his use of digital manipulation, from the mid-1990s on he increasingly availed himself of the new technology. It enabled him to work on his ideas with more precision. From then on, all his images were computer-generated. However, his interventions do not seem to be particularly manipulative. One rather gets the impression that the artist is using his montages to emphasise things that are already there. Gursky's painstakingly composed crowds are particularly impressive. Formally, these can be divided into two groups. First, there are his "patterned" works, shots of glassed-in building facades and production facilities, which use geometric architecture to make work processes and leisure activities visible. Then there are overflowing crowds, which the photographer shows at mass gatherings or – as

in his stock exchange images – at work. The *F1 Pit Stop* series from 2007, which in each image shows two Formula One teams in action, is quintessential in this respect. Gursky arranged a considerable number of people in pristine white overalls and helmets into epic compositions. The environment and the spectators, who are watching the scene from inside a high building, are almost swallowed up by the gloom. The focus is clearly on the drivers and mechanics, who are anonymous in their helmets, emerging from the darkened background. Here as in his striped layouts, which display an affinity with Constructivism, Gursky is flirting with a historic pictorial style – that of the Baroque.

The photograph *Bonn, Bundestag* may be an anomaly, since it combines elements of both "people-montages" described above. Thus a typical grid structure is discernable, predetermined by the design of the Plenary Chamber of the Bundestag in Bonn. At the same time, the people – here politicians – are not aligned with a grid, but instead arranged in clusters. While most of them are standing still, some are indistinct because of motion blur, whilst others are rendered unrecognisable by reflections, window frames and pillars. Adding to the thematic focus on nature, the economy and leisure mentioned above, *Bonn, Bundestag* is the first of Gursky's works to describe an aggregate state conditioned by political structures.

(C. O.)

Glenn Brown

b. 1966 in Hexham, UK

"I'm rather like Dr Frankenstein, constructing paintings out of the residue of dead parts of other artists' work." That is what Glenn Brown says about his own methods and one can almost take him literally, because he actually does take all the elements in his art from different sources. The subject comes from one old painting, the colour scale from another and the title is often provided by a pop song. In this form of Appropriation Art, the tactic of acquisition is a declaration of love for the art being quoted – but, of course, nothing here is as simple as the first glance would suggest. The seemingly broad impasto brushstrokes of the paintings are in reality meticulously modelled strand by strand out of an extremely thin layer of paint – like a micro-illusionistic *trompe l'œil*. It is not the subject that is depicted here, let alone earlier art in a copy – the paint itself is what Brown is painting. This becomes particularly effective when his templates stem from artists who work in a gestural mode, such as Rembrandt or, in the case of the picture presented here, the Anglo-German painter Frank Auerbach. Brown has repeatedly taken on several of his studies called *Head of JYM* (here a version from 1973), devoting the same obsessive care on rendering the reproductions that Auerbach dedicated to the original model.

In Auerbach's painting, the figure is brought to the canvas with almost clumsy brushstrokes. The end-result still seems unfinished; the painter is interested in the process rather than the consummate moment. By calling his own treatment *The Marquess of Breadalbane* (after an insignificant portrait of a nobleman from the 19th century), Brown is already pointing to the transformation he submits the central figure to: without changing any detail of the composition, Brown straightens it up, inserts it into an oval and replaces the dull dark-coloured background with a deep sky streaked with clouds, in front of which the figure's silhouette and magnificent head of hair become blurred like cotton wool. In the centre of the picture, Brown again lovingly paints the paint, or better yet, he paints the painting. On the figure's face and neck he follows each of Auerbach's brushstrokes, but out of the earlier artist's loose style he creates a kind of organic perfection. Three colour values seem to sit unmixed on the artist's brush, running into one another with the harmony of woodgrain.

The carefully modelled paint recalls Roy Lichtenstein's *Brushstrokes* from the mid-1960s, which were also a tribute to the medium of painting. However, with his illusionistic effect, Brown is aiming more for a particularly surreal atmosphere. This becomes probably most obvious in his outer space landscapes, which he based on the work of science fiction illustrator Chris Foss. *Exercise One* from 1995 is named after a song by Joy Division and is dedicated to the band's singer, who killed himself at a young age. A solitary iceberg drifts through the universe – a perfect image to the last line of the song: "Time for one last ride, before the end of it all." Brown mirror-inverted Foss' original, removed a spacecraft with a single crab claw that was towing the iceberg in the illustration and so arrived at another, far more evocative image.

"If a painting can't be as interesting as good pop music," Brown once said, "then it should give up." It is this demand for unconditional emotionality here that communicates itself directly to the viewer.

(L. E.)

Glossary

Compiled by Hajo Düchting

Abstraction (Lat. *abstrahere* = to deduct, remove). In visual arts, abstraction on the one hand means the stylistic reduction of an object into its quint-essential aspects – in this respect, all imagery is an abstraction of reality – while on the other it is a term describing a stylistic movement in modern-ist art distinguished by a complete absence of any concrete objective reference. This may be charac-terised by free compositions of colours and shapes in accordance with geometrical organis-ing principles (Constructivism), by showcasing the artist's body-motoric gestures or by particular colour gradients (Abstract Expressionism and Art Informel). The history of art has witnessed re-peated altercations between proponents of ab-stract versus figurative art, which ultimately stand for differing philosophical approaches to the nature of reality itself.

Academy The designation of a scientific body or institute of learning. The name comes from Plato's school for philosophers, which was located in a grove at the sacred site of the hero Akademos outside the walls of Athens. In modern times, academies have modelled themselves on the Academia di San Luca, which was founded in Rome in 1593, where budding painters were taught by recognised artists according to a formal curriculum. With the advent of modern art in the 19th century, academic instruction in painting was increasingly seen as formulaic and superfi-cial and artists began to study in private schools or teach themselves.

Action Painting The term Action Painting as a description of the gestural abstraction of painters of the New York School in the late 1940s was taken from an article by the American critic Harold Rosenberg entitled "The American Action Painters" in *ARTnews* magazine in 1952. It can

probably be traced back to Jackson Pollock, who said his work was really all about the physical act of painting. At that time, Franz Kline and Willem de Kooning also created abstract paintings using accentuated physical gestures.

Aesthetics A term taken from philosophy that, until the 19th century, applied to the theory of the perception of beauty, regularity and harmony in nature and art. According to Immanuel Kant, one takes a disinterested pleasure in a piece of art, which is geared towards the perception and meaning of the object without any consideration of criteria such as "beautiful" or "ugly". New aesthetic (semiotic) theories stress the depen-dence of aesthetic judgement on the specific system of signifiers according to which it is formed. Today, this mainly involves consideration of the context from which a work of art emerges as well as social influences on the perception of the viewer.

Appropriation Art An art approach that involves taking objects, pictures or texts out of their origi-nal cultural context and placing them in a new one (different from plagiarism or forgery). Usually seen as a technique that was part of Conceptual Art in the United States, Appropria-tion Art was first presented in *Pictures*, an exhi-bition curated by Douglas Crimp at Artists Space in New York in 1977. Richard Prince, Sherrie Levine, Joseph Kosuth, Jeff Koons and Barbara Kruger all make use of appropriation strategies in their work.

Art Brut (*see* Naive Painting).

Arte Povera (Ital.: poor art). A term taken from Jerzy Grotowsky's theory of the theatre by Italian critic Germano Celant in 1967 and applied to

the work of a group of artists living in Italy, who worked with objects and installations. The group included Jannis Kounellis, Mario Merz, Luciano Fabro and Giuseppe Penone. In contrast to "rich art", Celant sees Arte Povera as a socio-critical art form that employs a new aesthetic of simple materials to explore the alienation that separates over-technologised societies from natural ways of life.

Art Informel A term for the abstract-gestural style of painting that emerged in Paris around 1945, running parallel to the development of American Abstract Expressionism. The French critic Michel Tapié coined the term in 1950, originally applying it to Wols's works, then later to those of Jean Fautrier, Jean Dubuffet, Georges Mathieu and others. In informal painting, a picture is created by a spontaneous process that aims to reflect the artist's psychological experience.

Art Nouveau An international artistic movement of the late 19th and early 20th centuries, embracing the entire range of applied and fine arts, architecture and interior design, fashion, dance, painting and the graphic arts. Known in Germany as Jugendstil, elsewhere also as Modern Style, Stile Liberty etc., and in Austria as Sezessionsstil. (The German name was inspired by the art magazine *Jugend*, which was founded in Munich in 1896.) Art Nouveau set out to respond to the uniformity of industrial mass production and the formal rigidity of historical painting with an imaginative and sensual type of art characterised in particular by a decorative, ornamental style with flowing lines and vibrant plant forms. Important protagonists in painting included Ferdinand Hodler, Gustav Klimt and Max Klinger.

Assemblage (Fr. *assembler* = to assemble). Used for works in which traditional two-dimensional painting is expanded three-dimensionally by integrating concrete objects into it. Precursors of

this technique can be found in the works of Duchamp, Picasso and the Dadaists; classic examples are Robert Rauschenberg's Combine Paintings, highly contrasting fusions of expressive painting and real everyday objects, and works of the "New Realism" (*see* Nouveau Réalisme).

Avantgarde A term taken from French military terminology, meaning a small vanguard of specially trained soldiers. Introduced into art by Charles Baudelaire, it denotes the uncompromising will to modernity and renewal. Of the attempts to postulate scientific parameters for an avant-garde, Renato Poggioli's book *The Theory of the Avant-Garde* (1962), in which he drew attention to determining sociocultural factors, is of particular significance (*see also* Bohemian). Peter Bürger's *Theorie der Avantgarde* (1974) investigates the critical content of avant-garde art and observes its neutralisation through its integration into the social canon. Critics such as Clement Greenberg, on the other hand, insist upon the socially explosive force of artistic innovation.

Bauhaus The Bauhaus was founded by the architect Walter Gropius in Weimar in 1919 through the merger of the Academy of Fine Arts and the School of Arts and Crafts set up by Henry van de Velde. In its checkered history (Weimar 1919–1925, Dessau 1925–1932, Berlin 1932–1933), the Bauhaus sought to realise the notion of a "fusion of the arts" that had already been propagated by Art Nouveau and the Deutscher Werkbund: namely the synthesis of art, crafts and industrial mass production. Gropius brought in important modern artists such as Johannes Itten, Lyonel Feininger, Wassily Kandinsky, Paul Klee, László Moholy-Nagy and Oskar Schlemmer to prepare the students for their work as "designers" both in propaedeutic lessons (the Vorkurs, or preparatory course) and in the school's workshops. Not until 1925 did the Bauhaus start to gain the profile of an organisation based on rationality and functionality for which it became

famous, and it only really enjoyed its greatest reception after 1945 in the United States, where many of its members emigrated after the National Socialists had shut down the school in 1933.

Bohemian The term Bohemian (taken from the French word *bohèmien*, meaning a gypsy from Bohemia) signifies a subculture of intellectual fringe groups in social systems that allow individuals enough freedom to hold demonstratively anti- or asocial views and behave in an anti- or asocial manner. This way of life is particularly widespread in artistic circles belonging, or aspiring to belong to the avant-garde.

Bourgeois Culture By the French term bourgeoisie, one understands the ruling class that underpins the power structure of a (capitalist) society through material ownership and social status. In the cultural field, it means a conservative, conventional, backwards-looking aesthetic.

Canon (Gr.: rule, measure). A generally accepted selection of exemplary works of art or literature. Whether it is at all possible to create a canon and whether it makes sense to do so is the subject of intense debate; today it is usually understood as the outcome of a process of interpretation with no claim to permanent validity. Nevertheless, within the constant social and intellectual state of flux, there are always works of both old and new art that take on a quasi-canonical character since they are at the heart of the current discourse.

Classicism A European cultural epoch between 1770 and 1830, in which classical antiquity served as the artistic model to emulate. There were also classicist tendencies in 20th-century art, especially the return to the human form and harmonic proportions between the two World Wars (Picasso et al.).

Cobra In 1948, an international group of artists and writers from Copenhagen (Co), Brussels (br) and Amsterdam (a) came together in Paris under the name Cobra. Their leader was the Belgian poet Christian Dotremont, and members included the Dane Asger Jorn and the Experimentelle Groep from Holland with Karel Appel, Corneille and Constant. Rejecting geometrical abstraction in particular, but also Art Informel, which they saw as a merely gratuitous exercise, the group set out to create an experimental, anti-aesthetic and primitive figurative art that gave an uninhibited and comprehensive picture of life based on an antisocial perception of society. The artists took their ideas from drawings by children and the mentally ill, as well as so-called primitive art and Norse myths.

Collage (Fr. *coller* = to stick). A picture glued together from various materials such as paper, scraps of cloth or bits of wood. In 1912, Pablo Picasso and Georges Braque started to integrate printed paper and cloth into their pictures. The Dadaists and Surrealists owed a lot of their most important inspirations to collage (e.g. Max Ernst). Russian avant-garde artists also used a combinatory collage technique in their paintings and sculptures that radically challenged the traditions of Western painting.

Colourfield Painting A style of painting, represented by Mark Rothko, Clyfford Still and Barnett Newman, that developed within Abstract Expressionism after 1948 as the antithesis to Action Painting. Here, evenly applied colour fields created spatial suggestions and meditative atmospheres. Colourfield Painting was an important influence on Analytical Painting, which started in Europe in the late 1960s (Daniel Buren in Europe, Robert Ryman in the U.S.).

Composition (Lat. *componere* = to put together). The integration of individual parts into a unified, often intentionally harmonic whole. In painting,

this means the organisation of motifs on the canvas to create an interplay between lines, forms, tonal values, colours, perspective and motion. Even informal gestural painting functions according to particular laws of perception, which means it is still actually composed.

Constructivism Around 1915, the Russian artist Vladimir Tatlin founded a geometrical style of art that he and his fellow artists called Constructivism. Their works combine compositional elements of Cubism and Futurism with Kazimir Malevich's aesthetics (Suprematism). These artists rejected both the direct representation of the real world and all abstraction from it, and attempted to create a completely new reality using simple constellations of form in painting (El Lissitzky, Alexander Rodchenko), sculpture (Naum Gabo, Antoine Pevsner) and architecture (Vladimir Tatlin). Around 1925, functional-constructivist tendencies emerged at the Bauhaus through the Hungarian artist László Moholy-Nagy. In the Netherlands, constructivist ideas were advocated by the De Stijl group.

Deconstructivism Deconstruction has served as the rallying cry for a series of currents in philosophy, architecture, art and literature since the 1960s. The term was coined by Jacques Derrida and described both a philosophical approach and a method of interpretation that aesthetics could use to reveal hidden layers of meaning within a work.

De Stijl The artistic movement founded by Piet Mondrian and Theo van Doesburg in Leiden in 1917 was not just aiming to renew painting but also to stylistically influence the whole living environment. Via their magazine by the same name, *De Stijl*, the artists propagated their aims in various manifestos and texts, including Mondrian's "neo-plasticism", a type of painting reduced to basic or non-chromatic colours (black, white or grey) and geometric forms that strove to express a universal harmony. In addition to painting and sculpture, the movement's principles were especially influential in architecture.

Divisionism (*see* Neo-Impressionism).

École de Paris After the First World War, the collective term École de Paris was used for the artists of the French cultural capital. The Spaniards Pablo Picasso, Juan Gris, Salvador Dalí and Joan Miró, the Germans Max Ernst, Wols and Hans Hartung, the Russians Marc Chagall, Serge Poliakoff and Chaim Soutine and the Frenchmen Henri Matisse, Georges Braque and Fernand Léger were amongst the most important artists who made their contributions to various artistic movements while they were based in Paris.

Écriture automatique (Fr.: automatic writing). Inspired by the French writers André Breton and Philippe Soupault, *écriture automatique* was developed in the visual arts after 1920. This involved attempts to put impulses arising from the unconscious in a trance-like condition into written or graphic form.

Existentialism The term refers to the French school of existential philosophy, the main representatives of which were Jean-Paul Sartre, Simone de Beauvoir, Albert Camus and Gabriel Marcel. Existentialism does not believe in any externally directed moral or spiritual imperative but in mankind's sole responsibility for its own affairs, which no imaginary divine being can possibly influence. Nevertheless, human beings must choose freedom of their own will, accept it as their destiny and face up to their existence. These ideas were important in European Art Informel as well as in American Abstract Expressionism.

Fauvism Catching sight of a bronze statue by the neo-classical sculptor Albert Marque on display amongst works by Matisse and other painters at

the Salon d'Automne in Paris in 1905, the art critic Louis Vauxcelles is reputed to have said it was "Donatello parmi les fauves" (Donatello amongst the wild beasts). This gave rise to the catchword Fauvism, denoting a short-lived (1904–1907) movement in French painting that was characterised by a formal simplification and enhancement of colour through the use of contrast. Henri Matisse, Georges Braque, André Derain, Maurice de Vlaminck, Kees van Dongen and Raoul Dufy were among the artists belonging to this movement.

Fin-de-siècle A catchall term for the cultural situation in Europe at the close of the 19th century, which was characterised by a widespread apocalyptic mood. Fin-de-siècle art was defined by its preoccupation with sexuality, death and excess. A forward-oriented modernism formed as an avant-garde movement in reaction to this type of cultivated decadence.

Fluxus An international artistic movement in the 1960s, whose performance art was akin to happenings but still largely maintained the division between artist and public. Events followed a sort of score that, as in music, allowed concepts to be developed through improvisation. The aim of these performances, in which artists such as George Maciunas, George Brecht, Alan Kaprow, Nam June Paik, Charlotte Moorman, Joseph Beuys and Dieter Roth all played a part, was to create an awareness of sensual perception and break down the traditional distinctions between genres.

Gesamtkunstwerk A work of art unifying various artistic disciplines such as music, poetry, architecture and painting. The idea of the Gesamtkunstwerk emerged in the Romantic period and appeared in Richard Wagner's essay "Art and Revolution" in 1849. In Wagner's concept of music drama, the individual art forms were subordinated to a common purpose. Similar ideas later circulated at the Bauhaus and various artists (e.g. Kandinsky) absorbed them into their artistic programmes. Nowadays, the term overlaps with multimedia cultural events that address all the senses simultaneously.

Gestalt Theory Gestalt theory derives from the fundamental conviction that the whole is more than the sum of its parts and that overall impressions dominate perception as a result. Beyond its original psychological ambit, the theory has found its way into aesthetics (Rudolf Arnheim) and is used to explain the laws of perception in art.

Gestural Painting The use of physical exertion to apply paint usually makes this a highly emotional form of painting that thematically lays bare the self-expression of the artist's ego (e.g. in Abstract Expressionism and Art Informel).

Graffiti A collective term for images, letters, words or symbols applied to public surfaces (walls or transportation), usually by people working anonymously in different techniques. Although it has been known since ancient times, opinions of graffiti remain highly polarised: whereas many revile it as vandalism and prosecute its practitioners, others see it as an art form. Spray painting, for example, was originally part of the subcultural scene but, since the end of the 1970s, it has also found an audience in the mainstream art world (Jean-Michel Basquiat, Keith Haring).

Happening In 1958, the American artist Alan Kaprow coined the term "happenings" to describe a series of sequences of everyday actions that he conducted at the Reuben Gallery in New York with the participation of members of the public. His aim was to enhance their capacity for experience and make them aware of habitual behavioural mechanisms. The improvised events involved the use of a lot of common objects. John

Cage, Claes Oldenburg and Robert Rauschenberg were among those who took part in Kaprow's happenings.

Iconography The academic discipline dealing with the identification, description and inter-pretation of the content mostly of art images. In particular, iconographical research addresses provinces where concepts are expressed figura-tively, such as allegory, mythology and symbolism, as well as Christian themes and attributes. At the beginning of the 20th century, important schools of iconography grew up around Aby Warburg and Erwin Panofsky with the aim of deciphering the mythological, allegorical and humanistic themes of Renaissance and Baroque painting.

Installation A usually temporary, large-scale, site-specific and three-dimensional work of art, often situational, using all manner of materials and media as well as time, light, sound and mo-tion (light art, sound art, media art). El Lissitzky's *Proun Room* (1923) and also Claude Monet's series of water lily paintings at the Orangerie in Paris (1927) are considered to be the first ever installations as we understand the term today.

Jugendstil (*see* Art Nouveau).

Kitsch A normally pejorative term for something sentimental and trivial; in art often used for a work seen as decorative and lacking in substance. The distinguished American critic Clement Greenberg saw kitsch as the antithesis of the real avant-garde. Since the advent of Post-Modernism, however, the term "kitsch" has also stood for a number of aesthetic phenomena with positive connotations. Jeff Koons, for instance, uses the trappings of consumer culture as the starting point for his alienated, often hugely ironic para-phrasing.

Land Art Also known as Earthworks or Earth Art, Land Art is a movement that emerged in the mid-1960s in which the landscape itself serves as an artistic medium. Remote, hard-to-reach and usually very desolate places (such as the Californian desert or Utah's salt lakes) are typical Land Art settings. Its practitioners use artistic interventions in existing natural environments to awaken new perceptions and encourage an all-embracing environmental awareness. The best-known exponents of Land Art include Robert Smithson, Richard Long, Walter de Maria, Michael Heizer and Robert Morris.

Memento mori An expression with its origins in the Middle Ages that acts as a reminder of hu-man mortality. An underlying theme in particular in still life, it can be found in all artistic periods. Motifs typical of so-called *vanitas* still life in painting include wilting flowers, fly-ridden apples, upset wine glasses, skulls and so on – objects symbolising the transience of life. The idea of the memento mori has survived into the modern era and can be found in an attenuated form and free of any religious connotations in the works of Paul Cézanne, Salvador Dalí, Man Ray and Andy Warhol.

Modernism A complex sociocultural term gener-ally denoting the transition from a static conser-vative social structure to a mobile, flexible state that is open to progress. According to current perceptions, the modern age began in the mid-19th century and accelerated its development around 1900 with a plethora of scientific and technical inventions and discoveries and a rapid succession of innovations in the visual arts such as Fauvism, Cubism etc., which is why the term "Classical Modernism" is also applied to the early decades of the century. The era of modernism came to a close with the ebbing of stylistic inno-vations from the end of the 1960s onwards (*see* Post-Modernism).

Nabis (Heb.: the prophets, the enlightened ones). A group of artists formed in Paris in 1888 that was

heavily influenced by Paul Gauguin's painting. Following his elucidations of "synthetic art", which were passed on by Paul Sérusier, the group of artists (including Pierre Bonnard, Maurice Denis, Félix Vallotton and Éduard Vuillard) aspired to an ornamental and decorative simplification of motif, elevating form and colour to symbolic signifiers. A sentence coined by Maurice Denis in 1890 could hold as a leitmotiv for painting in the 20th century: "A picture, before it is a warhorse, a nude, an anecdote or whatnot, is essentially a flat surface covered with colours assembled in a certain order."

Naive Painting First discovered by modern artists and then subsequently by authorities such as the art historian Wilhelm Uhde, naive painters that won recognition were the customs officer Henri Rousseau in 1885, the postal clerk Louis Vivin in 1889, the cleaner Séraphine Louis in 1912, the circus performer Camille Bombois in 1915 and the gardener André Bauchant in 1927. Uhde exhibited a selection of their works in Paris in 1928 as "Painters of the Sacred Heart". Jean Dubuffet also saw himself as an exponent of an outsider art, which he called Art Brut, and aimed to emulate the spontaneous, unreflecting forms of artistic expression fed by the unconscious in the mentally ill, children and also Sunday painters.

Naturalism (*see* Realism).

Neo-Impressionism A school of painting that developed out of Impressionism. It attempted to produce an "optical mix" in the eye of the beholder through a systematised technique of painting small, adjacent dots of pure colours. This technique became known as Pointillism or, where small separate brushstrokes of unmixed colour were used instead of dots, Divisionism. Important exponents were Georges Seurat, Paul Signac and Giovanni Segantini.

New Objectivity (*see also* Verism). The German term Neue Sachlichkeit was coined by Gustav F. Hartlaub in 1923 to describe a group of widely differing artists who, after the convulsions of the First World War, sought to counter abstraction and the pathos of Expressionism with values that were once again objectively identifiable. The great painters of the 15th century and, especially, Romantic painting were its models. In 1925, Hartlaub made a precise distinction between two currents within the group, dividing it into a "left wing" including George Grosz, Rudolf Schlichter, Christian Schad and Otto Dix, which had a sharply realistic, often subversive, socially critical form of expression, and a "right wing", which sought to portray motifs in a more romantic and idyllic manner.

New York School Collective term for American Abstract Expressionist painters living and working in New York in the 1940s and 1950s.

Non-figurative Art Also known as non-objective or non-representational art, this term is often used as a synonym for abstract painting. Used more precisely, non-figurative works do not emanate from the abstraction of a motif but from its pure form, which is why the term is usually applied to the totally abstract works of Constructivism and Concrete Art.

Nouveau Réalisme (New Realism). At the end of the 1950s, movements in Europe and the United States displaying a new interest in everyday reality emerged in reaction to Abstract Expressionism. In the United States, Robert Rauschenberg and Jasper Johns were paving the way for Pop Art. In Paris in 1960, the critic Pierre Restany founded the Nouveaux Réalistes group, which included Arman, César, Daniel Spoerri, Jean Tinguely, Yves Klein and the so-called Affichistes Raymond Hains and Jacques Mahé de la Villeglé (Fr. *affiche* = poster). All artists integrated everyday objects into their works, which

led to yet new forms of expression (Assemblage, Combine Painting).

Op Art Short for Optical Art, which involves the use of optical irritations to create illusory motion. Based on Josef Albers's investigations into the interaction of colour, artists such as Bridget Riley and Victor Vasarely developed colour-form structures that generated optical effects and psychophysical processes in the eye of the beholder.

Orphism A poetic word coined by the art critic Guillaume Apollinaire to describe the painting of his friend Robert Delaunay, who started to shift his Cubist style towards more abstract, intensely contrasting colour forms in 1912. The optical vibrations generated by these simultaneous contrasts created false impressions of depth as well as illusions such as colour-light suggestions. Apollinaire, who was working on his book of poetry *The Bestiary, or The Parade of Orpheus* at the time, wanted the term to reflect the elements of music and motion in the paintings as well as the rhythm and tone of the mutually stimulating colours.

Performance Art actions originating in the 1970s where, in contrast to happenings, the artists usually perform in an exhibition room without any input from the public. Simple, primary situations are depicted, focusing on the individual's own self-awareness in time and space as well as of his or her own body (Body Art). Performance remains an important artistic medium. Artists who have created significant performances include Vito Acconci, Bruce Nauman, Gilbert & George, Mike Kelley and Paul McCarthy.

Perspective In the evolution of modern art, the central perspective prevailing since the Renaissance, by which a realistic spatial impression is rendered on a flat surface, has time and again been displaced by two-dimensional representations. Since Cubism, spatial values have been communicated by other pictorial signifiers, such as light-dark contrasts, colour perspectives, textures, interlacing, overlapping and transparency. Today, earlier formats such as the medieval perspective of meaning, where the size of the elements in a painting is proportional to their importance, have reappeared in the vocabulary of figurative painting.

Pictorialism A photographic style around the turn of the 19th to 20th centuries characterised by painterly imitation or distancing (blurring, radical cropping, flowing transitions, a preference for night-time or foggy scenes, and art subjects such as landscapes, portraits and nudes). Negatives and prints were often further processed in order to create the effect of painting. The aim of this was to make photography appear on a par with painting. The best-known exponents of Pictorialism were the Americans Alfred Stieglitz (who edited the magazine *Camera Work*) and Edward Steichen.

Pittura metafisica A style established by Carlo Carrà and Giorgio de Chirico in 1915, which strongly emphasised the motif and showed it in an extremely striking light. Figures appear in mysterious contexts, often in dramatically aligned *théâtre en ronde* settings with weird shadow effects. The figures are hardly human in these paintings, but so-called *manichini* (shop window dummies), "faceless people" embodying a sinister, arcane aspect of the world. Despite this style's brief life, its ideas inspired the New Objectivity movement in Germany and Surrealism in France.

Plein-air (Fr.: open-air [painting]). A term from French Impressionism denoting the outdoor painting these artists preferred to working in a studio, so as to catch the light directly in front of the object.

Pointillism (*see* Neo-Impressionism).

Pop Culture Evolving from the end of the 1950s out of everyday consumer products, popular leisure pursuits (films, music, TV, new media) and the growing cult of celebrity, was a popular culture that became the breeding ground for Pop Art. After Pop and Post-Modernism had put an end to the sharp division between high and low art, aesthetics also started to focus on themes from popular culture (comics, TV series, music), treating their influence on perception and imagery in the same way it did with art itself.

Post-Impressionism A term particularly popular in English-speaking countries embracing all the artists and styles emerging from Impressionism or developing the style of Impressionism. Leading exponents were Paul Cézanne, Vincent van Gogh, Paul Gauguin and the Nabis (*see also* Neo-Impressionism).

Post-modernism In architecture and design, Post-Modernism denotes a stylistic movement originating in the 1960s that, in contrast to functionalist Modernism, favoured a "voluble" style of composition and made widespread use of historical quotations. In the visual arts, Post-Modernism has become more of a vague collective name for all contemporary artistic trends that have emerged since 1978 that – in opposition to Conceptual Art and drawing on older styles – displays an often ironically subversive, sensual and spontaneous approach to colour and form.

Pre-Raphaelism The Pre-Raphaelite Brotherhood was founded by William Holman Hunt, John Everett Millais, Dante Gabriel Rossetti and others in London in September 1848 to work out a more contemporary artistic stance than the current academic doctrine and to stimulate historical painting with new themes. These were mainly taken from medieval sagas and literature, but also from the Bible and Shakespeare's plays. The artists – who were later joined by Edward Burne-Jones, who became the most important

of the later Pre-Raphaelites – took the linear, two-dimensional painting of the Siena school and the Florentine Quattrocento from the time before Raphael as their models.

Rayonism A movement founded by the Russian artists Michail Larionov and Natalia Goncharova, based on abstract Cubo-Futurist elements. Its aim was to express the dynamics and radiant power of light.

Readymade A term first used by Marcel Duchamp in 1916 to describe everyday objects such as a bottle rack, a print or a bicycle wheel that he, with little or no change, declared to be works of art and gave titles to (e.g. his famous urinal, which he called *Fountain*). The readymade is frequently seen as the 20th century's most important artistic innovation and remained of central importance up to and beyond Conceptual Art because it allowed everyday artefacts to be used in art.

Realism A general term for a neutral manner of representation that stays close to the actual appearance of things, repeatedly discernable in the visual arts. Realism in the 19th century (also known as Naturalism) can be defined as an attempt to give the clearest possible picture of contemporary reality and make its fundamental contexts comprehensible. Its most important exponents included Gustave Courbet and Camille Corot. Modernism also displays many realistic tendencies, from the New Objectivity through 1960s Pop Art and Photorealism to today's figurative painters (e.g. Neo Rauch).

Sampling A term taken from pop music signifying the adoption of elements from existing image, sound or text materials and their subsequent transferral into a new context. Sampling plays above all with the formal characteristics of the processed materials. In contrast to quotation, this involves an independent reinterpretation

that often leaves the original sources completely in the dark.

Series A sequence of works by one artist investigating and treating a particular phenomenon, theme or artistic principle. Claude Monet was one of the first to create series featuring the same motifs (cathedrals, haystacks); the principle later became especially popular amongst the exponents of Minimalism and Conceptual Art (e.g. Sol Lewitt and Donald Judd).

Situationism The Situationist International was a group of Marxist-oriented European artists and intellectuals founded in 1957 which was mainly active in the 1960s. The Situationists influenced the political left, especially against the background of revolutionary events in Paris in May 1968, as well as the development of methods of the modern communications guerrilla and the international art scene. The group's actions were aiming at a "revolution of everyday life", which was to be primed through the construction of situations where human needs could be better satisfied. The group's greatest impact was in the theoretical field; its leading thinkers were Asger Jorn and Guy Debord.

Socialist Realism A doctrine established by Maxim Gorky and others and adopted as state policy by the Communist Party of the Soviet Union's Central Committee in 1932, to which all the arts had to conform: art was to portray "reality in its revolutionary development". Bold, easily comprehensible depictions of revolutionary events and everyday life in the Soviet Union were the order of the day. It was hoped this would provide the (Soviet) people with a political, moral and aesthetic education, and criticism was unwelcome.

Still Life In art-historical terms, a still life is the autonomous depiction of an arrangement of – for the most part – everyday objects, selected and composed according to content and aesthetic criteria. In the Baroque, still life developed into a distinct genre of painting; in Modern Art, it was important as a testing ground where formal innovations could be tried out. Among others, Paul Cézanne, Henri Matisse, Pablo Picasso and Giorgio Morandi all produced important examples of still-life painting.

Structuralism A collective term for interdisciplinary approaches to research, which methodically investigate structures and interrelationships in the largely unconsciously functioning mechanisms of cultural symbols. Structuralism understands and interprets both languages and cultural correlations as sign systems. In the 1960s and 1970s, Structuralism was also a buzzword in the art scene and was criticised as a fad.

Suprematism A term coined by Kazimir Malevich in 1915 to mean "pure abstraction" and thus the ultimate visualisation of the spirit or the spiritual. With his famous *Black Square*, which was put on show in 1915 at the "last Futurist painting exhibition" 0.10 in St Petersburg, Malevich had hit upon a visual way to reify these ideas, which he also continued to proclaim in his manifestos into the mid-1920s. Suprematism was also a source of inspiration for Constructivism.

Verism The political wing of New Objectivity. Artists such as Otto Dix, Christian Schad, George Grosz, Conrad Felixmüller and Rudolf Schlichter adopted a critical stance towards the society of the Weimar Republic and declared their solidarity with the aims of socialism or communism.

Video Art Since the advent of the portable video camera at the beginning of the 1960s, video recordings have been used to document ephemeral art forms such as Land Art, Body Art, Performance Art or happenings. This was accompanied by the emergence of experimental video, where the film

is manipulated to artistic ends. Video art can also mean the combination of any number of appliances to form a large-scale sculpture or multiple projections created using video projectors. Important exponents of video art include Bruce Nauman, Nam June Paik, Bill Viola, Pipilotti Rist and Sam Taylor-Wood.

Young British Artists (YBA) A group of young British artists that formed in 1988, most of whom had graduated from Goldsmiths College. They caused a sensation with their Freeze exhibition in London's Docklands; the exhibition *Sensation* followed in 1997. Damien Hirst and Tracey Emin are two of the most important and best-known artists in the group, which works with shock tactics and themes drawn from youth culture (sex, drugs and death).

Index of Persons

Biographical Notes on the Authors

J. A. – Jens Asthoff is a freelance author, critic and translator living in Hamburg. He writes for *Artforum, artnet Magazine, Camera Austria, Kunstforum, Kultur & Gespenster* and other magazines, as well as for catalogues, and is the editor of *BE-Magazin*. For TASCHEN, he has written in *Art Now 2* and *Art Now 3* among other books and translated *Minimal Art* into German.

U. B.-M. – Ulrike Becks-Malorny, Dr. studied painting in Geneva and art history in Bochum and now lives in Bonn. Gaining her doctorate in 1990, she now works as a curator and freelance art historian. TASCHEN has published her books *Wassily Kandinsky, Paul Cézanne* and *James Ensor*.

G. B. – Gesine Borcherdt is an art historian and the editor of *artnet Magazine* in Berlin. In addition, she regularly publishes catalogue texts on contemporary art and is preparing her doctorate at the Humboldt University of Berlin with a thesis on Emil Schumacher.

G. C. B. – Gian Casper Bott has worked at the Herzog Anton Ulrich Museum in Braunschweig and at the Kunstmuseum Basel and the Kunsthaus Zürich. He is the curator of various exhibitions and the author of *Der Klang im Bild* as well as *Seance: Albert von Keller and the Occult*. His book *Still Life* was published by TASCHEN.

I. D.-D. – Izabela Dabrowska-Diemert studied art history and cultural sciences at the Humboldt University of Berlin, as well as museum studies at New York University. She participated in the publication of *Metropolitan Views: Kunstszenen in London und Berlin* and *Berlin, Berlin. Kunstszenen 1989–2009*.

H. D. – Hajo Düchting, Dr studied art history, philosophy and archaeology. His doctoral thesis was on Robert Delaunay. He is a professor of painting and colour theory at the MediaDesign Academy Munich. Among his numerous publications on modern art, *The Blue Rider, Paul Cézanne, Wassily Kandinsky, Robert and Sonia Delaunay* and *Georges Seurat* were published by TASCHEN.

L. E. – Lutz Eitel studied art history and English studies and currently works as a freelance author and translator in Leipzig. His most recent publication was *Rudolf Reiber: German Skies*; among other projects for TASCHEN, he translated *Collecting Design* into German. He blogs at tonotfallasleep.blogspot.com.

D. E. – Dietmar Elger, Dr. studied art history, literary theory and history at the University of Hamburg. He was curator for painting and sculpture at the Sprengel Museum in Hanover, and since 2006 he directs the Gerhard Richter Archive of the Dresden State Art Collections. His books *Expressionism, Dadaism* and *Abstract Art* were published by TASCHEN.

A. G.-T. – Anne Ganteführer-Trier studied art history, German literature, and modern history in Bonn. She was curator of various exhibitions, for example on August Sander, Candida Höfer, and Jeff Wall, as well as at the Photographische Sammlung/SK Stiftung Kultur, Cologne (August Sander Estate). She works as a freelance author and is representative for photography and contemporary art at Villa Grisebach Auctions. Her book *Cubism* is a TASCHEN publication.

K. G. - Karin H. Grimme is a Berlin historian and art historian. She works as curator, author and academic advisor for various museums, exhibitions and other media. Her emphasis lies on European art and history of the 19th and 20th centuries. Her books *Impressionism* and *Jean Auguste Dominique Ingres* were published by TASCHEN.

B. H. - Barbara Hess is a freelance author and translator living in Cologne. She studied art history in Cologne and Florence. Her numerous publications on modern and contemporary art have appeared in *Camera Austria, Texte zur Kunst* and other art magazines. Her books *Abstract Expressionism, Lucio Fontana, Willem de Kooning* and *Jasper Johns* were published by TASCHEN.

H. W. H. - Hans Werner Holzwarth is a freelance book designer and editor based in Berlin, with numerous publications mainly on contemporary art and photography. For TASCHEN he has edited, among other titles, *Jeff Koons, Christopher Wool, Albert Oehlen, Neo Rauch* and *Ai Weiwei*.

K. H. - Klaus Honnef, Prof. Emeritus of Photography Theory at the Art University Kassel, was a temporary and visiting professor at numerous German universities and colleges as well as the co-organiser of documenta 5 and 6 in Kassel. He was the curator for over 500 exhibitions worldwide and the author of numerous books, which include *Art of the 20th Century, Andy Warhol* and *Pop Art*, published by TASCHEN.

R. K. - Roland Kanz, Prof. Dr. teaches art history at the University of Bonn. His books and studies focus on painting, sculpture, architecture and art theory from the Renaissance to Modernism. His book *Portraits* was published by TASCHEN.

C. K.-L. - Cathrin Klingsöhr-Leroy, Dr. studied art history, archaeology, and German literature in Regensburg, Bonn, and Paris. Previously curator

of the Fritz Winter Foundation at the Bayerische Staatsgemäldesammlungen in Munich, she is currently director of the Franz Marc Museum in Kochel am See. Her book *Surrealism* was published by TASCHEN.

A. K. - Alexandra Kolossa, Dr. studied art history, German studies and business, gaining a doctorate in 2003. She lives and works in Düren. Since 1998, she has worked as a freelance author and curator specialising in contemporary art. Her book *Keith Haring* was published by TASCHEN.

M. L. - Michael Lailach, Dr. gained a doctorate in art history. He is a curator and director of the Berlin Art Library's Book and Media Art Collection. He has published works on book art and 20th-century artists' books, on Intermedia Art of the 1960s and the Marzona Collection. His book *Land Art* was published by TASCHEN.

U. L. - Ulrike Lorenz, Dr. studied aesthetics and archaeology. She gained her doctorate with a thesis on the avant-garde architect Thilo Schoder. She directed the Gera Art Collection, Otto Dix House and the Kunstforum Ostdeutsche Galerie. Since 2009 the director of the Kunsthalle Mannheim, she is the author of numerous publications. Her book *Brücke* was published by TASCHEN.

S. M. - Sylvia Martin, Dr. of Art History, trained at the Düsseldorf Museum of Art and worked as research assistant at the Museum Kunst Palast in Düsseldorf. Since 2005 she is the assistant director of the art museums of Krefeld. Her publications include *Anonymous Sculptures, Allora & Calzadilla, Falling Right into Place, Video Art, Ceal Floyer* and, published by TASCHEN, *Futurism*.

D. M. - Daniel Marzona studied art history and philosophy at the Ruhr University Bochum. From 2001 to 2004 he was curator at the P.S.1 Contemporary Art Center in New York. From 2007 to 2014 he curated the Konrad Fischer Gallery in Berlin.

In 2014 he opens his own gallery in Berlin. He is a co-founder of the publisher Navado Press. His books *Minimal Art* and *Conceptual Art* are TASCHEN publications.

C. M. – Chris Murray is the editor of the books *Key Writers on Art, Encyclopaedia of the Romantic Era* and the *Hutchinson Dictionary of Art*. He is also author of a short introduction to 20th-century sculpture for TASCHEN.

X.-G. N. – Xavier-Gilles Néret is a philosophy professor and teaches esthetics at ESAA Duperré and at Sorbonne. The main focus of his work is poetry, art, and philosophy, with a special interest in avant-garde movements. He is author of *Henri Matisse, Cut-outs* for TASCHEN (the 2010 SNA Book Award winner by public vote).

C. O. – Christiane Opitz studied applied cultural sciences in Lüneburg. Since 2008 she is director of the art society Palais für aktuelle Kunst in Glückstadt. She lives in Hamburg and writes for numerous art magazines, publications and journals such as *BE-Magazin, Szene Hamburg* and *Missy Magazine*.

E. R. – Ernst Rebel, Prof. Dr. is an art historian and art educator. He gained his doctorate at the University of Munich in 1979, and postdoctoral qualification in 1988. Since 1992 he is professor of art history and its didactics at the University of Munich. Special areas of focus: printed graphics, Albrecht Dürer, portrait art (publication *Self-Portraits* from TASCHEN) and questions of art education methodology.

J. G. S. – Julia Gwendolyn Schneider studied cultural science, American studies and aesthetics in Berlin, as well as cultural studies in London. She works as a freelance art critic in Berlin and writes, in particular, for *Springerin, Camera Austria* and the daily newspaper *die tageszeitung*. She has researched contemporary art scenes in Kyrgyzstan, Singapore and Australia, among other locations.

K. S. – Karin Schulze, Dr. studied philosophy and German studies. She works as a freelance journalist in Hamburg and writes for *Spiegel Online, Vogue, Monopol* and *Financial Times Deutschland*, among other publications.

W. S. – Walter Schurian, Prof. Dr. studied psychology, sociology and anthropology. Until his death in 2012 he was emeritus professor for psychology at the Westfälische Wilhelms-Universität. He is the author and editor of numerous publications related to art and psychology. His book *Fantastic Art* was published by TASCHEN.

K. S. – Kerstin Stremmel, Dr. studied art history and German studies in Cologne and Bonn. She gained her doctorate in 2000 with a thesis on "Visual Dictums. New Photographic Representations of Visual Art Classics". She works as a freelance author for the newspaper *Neue Zürcher Zeitung* and other publications. Since 2013 she has been documentalist of the Theaterwissenschaftlichen Sammlung Cologne. Her book *Realism* is a TASCHEN publication.

P. S. – Polina Stroganova studied applied cultural sciences at Lüneburg University and was the director of the gallery 401contemporary in Berlin and London. Since 2014 she has been director at Proyectos Monclova in Mexico-City.

N. W. – Norbert Wolf, Prof. Dr graduated in art history, linguistics, and medieval studies at the Universities of Regensburg and Munich, and earned his PhD in 1983. He held visiting professorships in Marburg, Frankfurt, Leipzig, Düsseldorf, Nuremberg-Erlangen, and Innsbruck. His extensive writings on art history include many TASCHEN titles, such as *Diego Velázquez, Ernst Ludwig Kirchner, Caspar David Friedrich, Expressionism, Romanesque, Landscape Painting,* and *Symbolism*.

Photo Credits

The publishers would like to express their thanks to the photographers, galleries, private collectors, museums and archives for their kind support in the production of this book and for making their pictures available. If not stated otherwise, the reproductions were made from material in the publisher's archive. In addition to the institutions and collections named in the captions, special mention must be made of the following:

10-11 akg-images **14-15** Bridgeman Images/Roger-Viollet **16** Bridgeman Images **17** ullstein bild/The Granger Collection **19** Rheinisches Bildarchiv, Cologne **20** Artothek. Photo: Blauel/Gnamm **23** RMN. Photo: Hervé Lewandowski **24** Collection Musées de Pontoise, Musée Tavet **25** Corbis. Photo: Gertrude Käsebier **26** Bridgeman Images **28** RMN. Photo: Bulloz **29** Corbis/Edimédia **31** Fine Arts Museums of San Francisco, Legion of Honor and de Young Museums **33** akg-images **35** RMN. Photo: Hervé Lewandowski **37** RMN. Photo: Hervé Lewandowski **39** Bridgeman Images **41** © 2016. Photo The Philadelphia Museum of Art/Art Resource/Scala, Florence **43** Bridgeman Images **45** The National Gallery, London **47** © Tate, London 2016 **49** © 2016. © Photo Josse/ Scala, Florence **51** The National Gallery, London **53** © 2016. The Museum of Modern Art, New York/Scala, Florence **55** akg-images **57** © 2016. The Museum of Modern Art, New York/Scala, Florence **59** Bridgeman Images **61** akg-images **63** © 2016. The Museum of Modern Art, New York/Scala, Florence **65** The Philadelphia Museum of Art, Chester Dale Collection, Philadelphia **67** akg-images **69** © 2016. The Museum of Modern Art, New York/Scala, Florence **71** © SMK Photo **73** Artothek. Photo: Hans Hinz **74-75** © Mucha Trust, 2011 **76** RMN. Photo: René-Gabriel Ojéda **78** Central Art Archives. Photo: Jouko Könönen **79** Bibliothèque royale de Belgique, Brussels **81** Artothek. Photo: G. Westermann **84** Oberösterreichisches Landesmuseum, Linz **85** ullstein bild/The Granger Collection **86** akg-images/Imagno **87** © 2016. Photo Scala,Florence/Heritage Images **88** © Tate, London 2016 **89** bpk | Museum der bildenden Künste, Leipzig | Hans-Dieter Kluge **90** RMN (Musée d'Orsay). Photo: Hervé Lewandowski **91** akg-images **93** Staatsgalerie Stuttgart **95** akg-images **97** Artothek **99** © 2016. Photo Scala, Florence **103** akg-images **105** © 2016. Photo Scala, Florence **107** Artothek **109** Bridgeman Images **110-111** Bibliothèque nationale de France **112** Collection Centre Pompidou, Paris, Dist. RMN **116 left** RMN (Musée Picasso, Paris). Photo: J. G. Berizzi **116 right** Fondation Beyeler, Riehen/Basel **117** Bridgeman Images/ Archives Charmet **118** Rue des Archives/The Granger Collection, NYC **121** akg-images **123** Centre Pompidou/Bibliothèque Kandinsky **124** Collection Centre Pompidou, Dist. RMN. Photo: Philippe Migeat **129** Courtesy David King Collection, London **131** © 2016. The Museum of Modern Art, New York/Scala, Florence **133** akg-images **135** Kunstsammlung Nordrhein Westfalen, Düsseldorf. Photo: Walter Klein **137** Solomon R. Guggenheim Museum, New York/Solomon R. Guggenheim Founding Collection **139** Sprengel Museum Hanover **141** Albright-Knox Art Gallery, Buffalo **142** The Philadelphia Museum of Art, Philadelphia **145** © 2016. Museo Thyssen-Bornemisza/ Scala, Florence **146-147** Kirchner Museum Davos **151** akg-images **154** Artothek **157** akg-images **158** akg-images **160** ullstein bild/The Granger Collection **162** akg-images **165** akg-images **167** Artothek **169** Artothek **171** akg-images **172** akg-images **175** Artothek. Photo: Blauel/Gnamm **177** akg-images **179** Artothek **181** Artothek **183** Artothek **185** Artothek **187** Artothek **189** Artothek **191** akg-images **195** Artothek **196-197** Rovereto, Mart, Archivio del '900, fondo Russolo **201** akg-images/Archives CDA/Guill **204** Corbis. Photo: E. O. Hoppé **205** Artothek. Photo: Josef

S. Martin **206** akg-images **207** akg-images **210** Artothek **212** akg-images **213** akg-images **215** akg-images **217** © 2016. Photo Scala, Florence **219** Artothek **221** Bridgeman Images **224-225** Collection Centre Pompidou, Paris, MNAM, Bibliotèque Kandinsky, Photo: Nicolai Suetin **226** akg-images **229** Artothek. Photo: Peter Willi **230** Artothek. Photo: Blauel/Gnamm **234** Austrian Frederick and Lillian Kiesler Private Foundation. Photo: K. W. Herrmann **238** Artothek **240** Sprengel Museum Hanover **243** Museo civico e archeologico, Castello Visconteo, Locarno **247** © 2016. The Museum of Modern Art, New York/Scala, Florence **249** Sprengel Museum Hanover **251** Solomon R. Guggenheim Museum, New York/Solomon R. Guggenheim Founding Collection **253** Bridgeman Images **255** Stedelijk Museum, Amsterdam **259** Rheinisches Bildarchiv, Cologne **261** © 2016. The Museum of Modern Art, New York/Scala, Florence **262-263** bpk **264** akg-images. Photo: Erich Lessing **267** Rue des Archives/PVDE **269** Bridgeman Images **270** Sprengel Museum Hanover, Kurt Schwitters Archiv. Photo: Michael Herling/Aline Gwose **271** bpk **273** Kunsthaus Zurich **276** akg-images **279** Solomon R. Guggenheim Museum, New York **281** akg-images **285** Bridgeman Images **289** Sprengel Museum Hanover, Kurt Schwitters Archiv. Photo: Michael Herling/Aline Gwose **291** © 2016. The Museum of Modern Art, New York/Scala, Florence **292-293** Getty Images/Topical Press Agency **297** Williams College Museum of Art, Williamstown **298** RMN (Musée d'Orsay). Photo: Hervé Lewandowski **299** Bridgeman Images **300** Artothek **301** Stiftung Moritzburg, Halle **305** Artothek **307** Artothek **308** akg-images **311** Courtesy The Estate of Rico Lebrun and Koplin Del Rio Gallery, Culver City CA **317** Artothek **319** Bridgeman Images **321** The Art Institute of Chicago, Friends of American Art Collection, 1930.934. Photo © The Art Institute of Chicago **323** Hulton Archive/Getty Images **331** Wor-cester Art Museum, Worcester, Elizabeth M.Sawyer Fund in memory of Jonathan and Elizabeth M. Sawyer **334-335** Philadelphia Museum of Art, gift of Jacqueline, Paul and Peter Matisse in memory of their mother Alexina Duchamp **343** Collection Centre Pompidou, Paris, Dist. RMN **344** Collection Centre Pompidou, Paris, Photothèque **345** akg-images **348** Les Archives de l'Art contemporain en Belgique/Musées royaux des beaux-arts de Belgique, Brussels **353** Bridgeman Images **355** Artothek **357** Artothek **361** Kunstsammlung Nordrhein-Westfalen, Dusseldorf. Photo: Walter Klein **363** akg-images **367** Bridgeman Images **369** Bridgeman Images **371** © 2016. Photo The Philadelphia Museum of Art/Art Resource/Scala, Florence **373** Artothek **375** Collection Centre Pompidou,Paris, Dist. RMN **377** Fondation Paul Delvaux St. Idesbald, Belgium **379** bpk | Nationalgalerie, SMB | Jörg P. Anders **381** © 2016. The Museum of Modern Art, New York/Scala, Florence **383** akg-images **387** Collection Centre Pompidou, Paris, Dist. RMN. Photo: Philippe Migeat **389** Courtesy Landau Fine Art, Montreal, Canada **391** Courtesy Gagosian Gallery. Photo: Robert McKeever **393** CNAC – MNAM, Dist. RMN **395** Bridgeman Images **397** The Henry Moore Foundation, Perry Green, © Tate, London 2016 **400-401** Bridgeman Images **402** bpk | The Metropolitan Museum of Art **405** akg-images. Photo: André Held **411** Bridgeman Images **413** K20 – Kunstsammlung Nordrhein-Westfalen, Dusseldorf **415** Bridgeman Images **417** Time & Life Pictures Pictures/Getty Pictures. Photo: James Burke **419** © 2016. The Museum of Modern Art, New York/Scala, Florence **423** Whitney Museum of American Art, New York **425** Time & Life Pictures/Getty Pictures. Photo: Martha Holmes **426-427** Bridgeman Images **431** K20 – Kunstsammlung Nordrhein-Westfalen, Dusseldorf **433** Corcoran Gallery of Art, Washington, D. C. **435** Modern Art Museum of Fort Worth **439** San Francisco Museum of Modern Art, San Francisco **441** Fondation Hans Hartung et Anna-Eva Bergman **443** Whitney Museum of American Art, New York **445** Whitney Museum of American Art, New York **447** Artothek **449** Artothek. Photo: Hans Hinz **451** Stedelijk Museum, Amsterdam **453** © Tate, London 2016 **455** Rheinisches Bildarchiv, Cologne **459** Whitney Museum of American Art, New York **461** Courtesy Galerie

1000 Chairs

1000 Lights

Decorative Art 50s

Decorative Art 60s

Decorative Art 70s

Design of the
20th Century

domus 1950s

Logo Design

Scandinavian Design

100 All-Time
Favorite Movies

The Stanley Kubrick
Archives

Bookworm's delight:
never bore, always excite!

TASCHEN
Bibliotheca Universalis

20th Century
Photography

A History of
Photography

Stieglitz.
Camera Work

Curtis. The North
American Indian

Eadweard Muybridge

Karl Blossfeldt

Norman Mailer.
MoonFire

Photographers A–Z

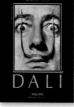
Dalí. The Paintings

Hiroshige

Leonardo.
The Graphic Work

Modern Art

Monet

Alchemy & Mysticism

Braun/Hogenberg.
Cities of the World

Bourgery. Atlas of
Anatomy & Surgery

D'Hancarville.
Antiquities

Encyclopaedia
Anatomica

Martius.
The Book of Palms

Seba. Cabinet of
Natural Curiosities

The World
of Ornament

Fashion. A History from
18th–20th Century

100 Contemporary
Fashion Designers

Architectural Theory

The Grand Tour

20th Century
Classic Cars

1000 Record Covers

1000 Tattoos

Funk & Soul Covers

Jazz Covers

Mid-Century Ads

Mailer/Stern.
Marilyn Monroe

Erotica Universalis

Tom of Finland.
Complete Kake Comics

1000 Nudes

Stanton.
Dominant Wives

Imprint

TASCHEN EACH AND EVERY TASCHEN BOOK PLANTS A SEED!
TASCHEN is a carbon neutral publisher. Each year, we offset our annual carbon emissions with carbon credits at the Instituto Terra, a reforestation program in Minas Gerais, Brazil. To find out more about this ecological partnership, please check: www.taschen.com/zerocarbon
Inspiration: unlimited. Carbon footprint: zero.

To stay informed about TASCHEN and our upcoming titles, please subscribe to our free magazine at www.taschen.com/magazine, follow us on Twitter, Instagram, and Facebook, or e-mail your questions to contact@taschen.com.

Illustration page 2:
Mark Rothko, *No. 13 (White, Red on Yellow)*, 1958, oil and acrylic with powdered pigments on canvas, 242.2 x 206.7 cm (95 3/8 x 81 1/8 in.), The Metropolitan Museum of Art, New York © bpk | The Metropolitan Museum of Art | Lynton Gardiner

Printed in China
ISBN 978-3-8365-5539-5

Modern Art
Dietmar Elger, Anne Ganteführer-Trier, Karin H. Grimme, Barbara Hess, Hans Werner Holzwarth, Klaus Honnef, Cathrin Klingsöhr-Leroy, Sylvia Martin, Daniel Marzona, Kerstin Stremmel, Norbert Wolf

With contributions by Jens Asthoff, Ulrike Becks-Malorny, Gesine Borcherdt, Gian Casper Bott, Izabela Dabrowska-Diemert, Hajo Düchting, Lutz Eitel, Roland Kanz, Alexandra Kolossa, Michael Lailach, Ulrike Lorenz, Chris Murray, Xavier-Gilles Néret, Christiane Opitz, Ernst Rebel, Julia Gwendolyn Schneider, Karin Schulze, Walter Schurian, Polina Stroganova

Edited by Hans Werner Holzwarth and Laszlo Taschen
Text editing: Lutz Eitel
Editing team: Elisabeth Maria Hofmann, Julia Schneider
Additional image research: Reuel Golden
Translations: Christopher Cordy, John W. Gabriel, Sean Gallagher, Karl Edward Johnson, Michael Scuffil, Isabel Varea, Karen Williams
Proofreading: Sharon Sloan
Project management: Inka Lohrmann
Design: Birgit Eichwede
Production: Thomas Grell